HUMANISM AND POLITICS

HUMANISM & POLITICS

Studies in the Relationship of Power and Value
in the Western Tradition

ALBERT WILLIAM LEVI

BLOOMINGTON INDIANA UNIVERSITY PRESS LONDON

TO

UTE AND DAVID

WHO HAVE GIVEN ME A NEW LIFE
AND PROVED THAT PAST AND PRESENT
CAN LIVE TOGETHER IN HARMONY

Preface

THE WRITING of this book has occupied the better part of my scholarly time for the past three years. It is the second of a series of works in the history of ideas and the philosophy of culture of which *Literature, Philosophy and the Imagination* was the first, and a further work in progress, *Philosophy as Literature,* will, I hope, be the third. *Humanism and Politics* is the witness to my conviction that scholarship also has its contribution to make in a time of troubles, and that the joining of the humanistic imagination with the problems of a concrete politics is a consummation devoutly to be wished.

My acknowledgments must be both personal and institutional. I should like first of all to express my thanks to Washington University and to its Chancellor, Thomas H. Eliot, for calling me to fill the David May Distinguished University Professorship in the Humanities. Its generous allowance of scholarly time makes it not a mere retreat for contemplation but a veritable invitation to accomplishment. Without the leisure which it affords for scholarship, my book would have been a later and a poorer thing.

I want also to express my thanks to the Rockefeller Foundation for a grant to investigate the state of social philosophy in Czechoslovakia and Yugoslavia in the winter of 1962–1963. Although I published no report on my findings at that time, my investigations at the Academies of Science and the Universities of Prague and Bratislava, of Zagreb and Beograd gave me an interest in, and appreciation of, current Marxist philosophy which has borne both scholarly and personal fruits. I was subsequently invited to attend the Dubrovnik Congress of 1963, to lecture under the auspices of the State Department in Zagreb and Beograd in the winter of 1964–65, and to lecture and participate in symposia at the International Summer School of the University of Zagreb on Korcula in 1964 and 1967. These experiences have added immeasurably to the background which

is responsible for Chapters IX, X, and XI of this book. And they have shown me that ideological differences need be no insuperable barrier to the philosophical fellowship of generous minds.

Once more, as a matter of principle, I have previously published none of the studies comprising this book, although in three cases I have presented them orally as works in progress. Chapter VIII, "Humanism and Warfare: Machiavelli, von Clausewitz, and Herman Kahn," was delivered as the 1965 Anna Randolph Darlington Gillespie Lectures at Chatham College. I should like once again to thank Miss Gillespie and Chatham's President, my friend Dr. Edward D. Eddy, for the hospitality of the college on that occasion. Chapter II, "Erasmus and Montaigne: Two Models of a Humanistic Politics," were Lilly Lectures, sponsored by the Philosophy and Religion Department of De Pauw University in February, 1967. Chapter IX, "Art and Politics: The Continuum of Artistic Involvement: Picasso, Brecht, and Pasternak," is the much expanded version of a lecture, "Literature and Politics," given at Korcula in the summer of 1964 and subsequently published in Serbo-Croatian in the *Praxis* collection *Smisao i Perspektive Socijalizma* (Zagreb, 1965).

<div align="right">ALBERT WILLIAM LEVI</div>

St. Louis
January 22, 1968

Contents

HUMANISM AND POLITICS

One | Introduction

THE STUDIES which follow are a product of our times. For, although their subjects are "bookish," the emotional climate in which they have their origin is not merely so. They deal less with current power problems than with the more subtle relations which political ideas bear to the fabric of a total civilization, and they therefore claim to be a contribution to the philosophy of culture rather than to the science of politics. Yet they are, I think, politically relevant in the mood from which they spring.

Just after the First World War Paul Valéry wrote a short essay entitled "The Crisis of the Mind." That is a long time ago —1919—but the words were prophetic. "We later civilizations," said Valéry, ". . . we too now know that we are mortal . . ."

We had long heard tell of whole worlds that had vanished, of empires sunk without a trace, gone down with all their men and all their machines, into the unexplorable depths of the centuries, with their gods and their laws, their academies and their sciences pure and applied, their grammars and their dictionaries, their Classics, their Romantics, and their Symbolists, their critics and the critics of their critics. . . . We were aware that the visible earth is made of ashes, and that ashes signify something. Through the obscure depths of history we could make out the phantoms of great ships laden with riches and intellect: we could not count them. But the disasters that had sent them down were, after all, none of our affair.
Elam, Nineveh, Babylon were but beautiful vague names, and the total ruin of those worlds had as little significance for us as their very existence. But France, England, Russia . . . these too would be beautiful names. *Lustiania,* too, is a beautiful name. And we see now that the abyss of history is deep enough to hold us all. We are

aware that a civilization has the same fragility as a life. The circumstances that could send the works of Keats and Baudelaire to join the works of Menander are no longer inconceivable; they are in the newspapers.[1]

What I wish to say in this book is predicated on the same sense of mortality and impending catastrophe that informs these words of Valéry—out of a tragic recognition that the abyss of history is deep enough to hold us all, that our civilization has the same fragility as a wrong decision in the White House, or the dance of atoms in the brain of a Kremlin dictator who has lost his sense of balance. The circumstances which could send the works of Proust and Picasso, of Wallace Stevens and Stravinsky to join the works of Menander are no longer inconceivable; they are in the daily newspapers!

In this disorder of mind, it is not unnatural to seek consolation against the causes of our anxiety in the past—in the register of our humanistic memories, historical triumphs, traditional parade of values. For when the sources of our fear lie at least in part in the specter of technological barbarism, it is obvious that it is not to science that we must turn for our salvation, but to the humanistic imagination. Any politics presupposes an idea of man. And in a universe where man devotes so much of his energy and intelligence to the building of machinery, where in fact the entire planet has become one enormous piece of machinery and man a sort of industrious insect, it is perhaps not so strange that war itself has been patterned on the model of an insecticide, and that nuclear warheads mean not the politics of honorable rivalry, but *extermination*. In such a world the scientific chain of meaning can no longer have the honorific standing which it enjoyed in the days of Galileo, Newton, and Descartes.[2] Science has been mortally wounded in its moral ambitions and put to shame by the cruelty of its applications.

But to put it this way is perhaps to miss the point. For the sources of our malaise lie not in the operations of the scientific understanding so much as in the compromised judgments which stand in the background of political decision, and the root dilemma of the modern world is therefore bound up with the problematic existence of a humane politics.

Politics itself in the contemporary world has been cruelly compromised. Two words alone testify to its shame: *Auschwitz* and *Hiroshima*, and the fateful question is whether the rever-

berating echoes of these two words do not signify the bank-ruptcy of every politics whatsoever. Power is a coefficient of states of mind, as will itself is precipitated out of antecedent patterns of belief. The whole of our social structure is grounded in expectation and trust, and so the entire universe of law and politics is itself a mythical universe—a construction based on the stories which a people tells itself to unfold the meaning of its life. It is a commonplace that these stories are full of vagueness and hope, but poetically constructed, venera-ble, articulate, and complete. In this lie both their fragility and their strength. "The whole race," wrote Wallace Stevens, "is a poet that writes down the eccentric propositions of its fate." "Whatever perishes from a little more clarity is a myth," said Valéry. *Auschwitz* and *Hiroshima* suggest a dreadful clarity, and it may be this clarity from which the political myth has all but perished.

One must, of course, distinguish between a rhetorical politics —the practical politics which always goes on under the aegis of an insincere rhetoric—and the politics of ideas and ideals. For it is the latter which has suffered a mortal blow. And the proof lies in that ultimate indication of political insincerity—the contradiction between the public routines and the private feel-ings. For our political perspective reveals a world officially bursting with optimism and privately full of despair. It may seem histrionic to put it in this fashion, but I do not believe it is false to the facts. Writers, artists, philosophers; one by one they reveal the bleakness of the scene, the sense of extremity, *the new estimation of politics as an affront to culture.*

Norman Mailer speaks for the writer:

Probably we will never be able to determine the psychic havoc of the concentration camps and the atom bomb upon the unconscious mind of almost everyone alive in these years. For the first time in civilized history . . . we have been forced to live with the suppressed knowledge . . . that we might be doomed to die as a cipher in some vast statistical operation in which our teeth would be counted and our hair saved, but our death itself would be unknown, unhonored, and unremarked, a death which could not follow with dignity as a possible consequence to serious actions we had chosen, but rather a death by *deus ex machina* in a gas chamber or a radioactive city . . .[3]

Martin Heidegger speaks for the philosopher:

This Europe, wretchedly blinded, forever on the brink of self-slaughter, lies today in the great pincers between Russia on the one hand and America on the other. Russia and America are, from a metaphysical point of view, the same: the same desolate frenzy of technology unleased, and of the rootless organization of the Average Man. When the furthermost corner of the globe has been technologically conquered and opened to economic exploitation, when any event whatsoever in any place whatsoever at any time whatsoever has become accessible with any speed whatsoever, when we can "experience" simultaneously an attempt on the life of a king in France and a symphony concert in Tokyo, when time is no longer anything but speed, momentariness and simultaneity, and time as history has vanished from all the life of all the nations, when the boxer passes as the great man of a people, when the millions numbered at mass meetings are a triumph—then, yes, then, the question still grips us like a ghost through all these phantoms: what for?—where to?—and what then? [4]

For Mailer the response to our collective condition was for a number of years the path of disaffiliation—to divorce himself from society, to exist without political roots, to follow the rebellious imperatives of the self away from the more conventional requirements of social order. For Heidegger the response was neither as adolescent nor as extreme, but it has led him also, I think, to sink his considerable efforts in the more private concerns of a romantic metaphysics, and to avoid the creation of a social ethic, or a philosophy of law, or a theory of modern society. Mailer lived in the heart of the urban metropolis as if it were a jungle of anonymity and sensation. Heidegger was solitary in the Black Forest which surrounds Freiburg, like some St. Simeon Stylites of the metaphysical imagination. In each case and with an individual appropriateness, the political response was—withdrawal.

It would be false to say that this withdrawal is a unique property of the modern situation. Surely it is intensified, but the relations between politics and culture have always been ambiguous and subject to contrary evaluations. One side has always seen politics as "an affront to culture" whether it be illustrated by Cromwell's irregulars pulling down the walls of Glastonbury Abbey or by Shakespeare's Brutus, "murdering from philosophy." The other has even been willing to view politics aesthetically, seeing it almost as an art form, distinguishing various "styles of politics"—even, in the manner of Burckhardt, seeing the Italian city states of the Renaissance

with their ruthless foreign policy and brutal internal politics no less than the paintings of Carpaccio or the equestrian statues of Verocchio as "works of art." The examples are perhaps extreme, but they do not falsify the fact that politics has always exerted alternatively fascination and repulsion on the humanistic mentality, and that this has precipitated a delicate ballet of advance and withdrawal, a dialectic of embracement and rejection which testifies to an underlying ambivalence. Mann's Settembrini in *The Magic Mountain* expresses (surely with Mann's irony) the extreme claim. "We admit that we are political, admit it openly, unreservedly. We care nothing for the odium that is bound up with the word in the eyes of certain fools . . . The friend of humanity cannot recognize a distinction between what is political and what is not. There is nothing that is not political. Everything is political!" [5] But the other side is represented by Valéry's fastidious distaste. "I know almost nothing about practical politics, though I am convinced that it involves everything I abhor. Nothing, surely, could be more impure, more a mixture of things I dislike to see together, such as bestiality and metaphysics, might and right, religion and selfishness, science and histrionics, instincts and ideas." [6]

Valéry's distaste for practical politics is based not only on his instinctive dislike for its mixture of "bestiality and metaphysics," but also on his innate conviction that the mixture was unequal, and that there was indeed too much "bestiality" and too little "metaphysics." This was expressed not only in his cynical remark that politics is "the art of making people pay for, fight and torture one another for something they neither know nor care about," but in his more persuasive observation that it is of the very essence of violence and warfare that they try to settle in a short time, and by a sudden dissipation of energy, difficulties and conflicts which need to be dealt with by the subtlest analyses and the most delicate tests—precisely because a rational politics searches for the most valid and stable equilibrium, and because such equilibrium is itself to be predicated on a conception of human life and worth which is at bottom metaphysical.

Political cynicism is cheap, and in recent times there have been moments when it has almost seemed to be the exclusive monopoly of Valéry's fellow countrymen. Bernanos too has referred to the modern state as "that half-usurer, half-policeman whose eyes are on all the locks and whose hands are in all the pockets." [7] And in a famous lecture, "France before the

World of Tomorrow" (in words which directly recall our pas-
sage from Heidegger) he has said: "I have no desire to get lost
in 'the game of politics,' as they like to say in fashionable
jargon. I have no intention of opposing capitalism to Marxism,
because capitalism and Marxism are two aspects, or if you
prefer, two symptoms of the same materialistic civilization, of a
civilization invaded by materialism the way a fat man is in-
vaded by fat." [8] But a moment later Bernanos, in contrasting
free individualism with the totalitarian regimentation he ab-
hored, predicted that "the world of tomorrow will be either
Cartesian or Hegelian." The remark is neither cryptic nor
subtle, and if it shows that M. Bernanos prefers the French
"style" of politics to the German, it indicates likewise that his
conception of politics too is inseparably connected with con-
cepts, with ideas, and with metaphysics.

It is, I think, inevitable that it should be so, for the concepts
of politics are difficult to contain within the narrow limits of a
pragmatic political science concerned exclusively with the exer-
cise of power as a fragmented section of the total human enter-
prise. Two circumstances make it difficult. The first is the
historical connections of politics with other areas of human
culture. The second is its symbolic role in human life. Both are
proof that a title like *Humanism and Politics* is not a device to
bring together two totally disparate ideas, but to restore in
thought what has always proved to be an organic connection.
When, a generation ago, Gilbert Murray wrote his brilliant
and challenging study of Aristophanes, he was of course dealing
with a great comic dramatist—one who was first and foremost a
man of letters. But the man who wrote *The Wasps* and *The
Birds* and *Lysistrata* was at the same time an ardent pacifist and
a passionate conservative whose plays, for all their irresistible
humor and sly satire, are a political statement and breathe the
spirit of politics. But it is a politics of a particular quality.
Murray says of it: "Even his politics are the politics of a literary
man, greatly moved by the *spirit* of a policy, its cruelty, its
unfairness, its vulgarity, and not so much by its material re-
sults." But is this not precisely what a humanistic politics is all
about? And can there be a rightful separation between an ideal
exercise of power, the ethical standards within which it is
grounded, and the literary master works through which it is
expressed? One may well ask: What weight has the work of
Montaigne and Erasmus, of Shakespeare and Schiller, of
Buechner and Brecht and Camus on an age of atomic weapons

and thermonuclear war? But the posing of the question itself suggests an irony which is inherent in criticism of our modern life. There is, I think, an ill-defined no-man's-land occupied jointly by politics, philosophy, and imaginative literature, and it is this relatively terra incognita which it is to be our business to explore.

It is a no-man's-land which it is easy to caricature, a terrain which is often merely the land of exile for pretentious writers and inflated literary sentiments. And indeed in *The Magic Mountain*, in the person of the verbose liberal Settembrini, Thomas Mann has done so:

Thus Hans Castorp came to hear something about Dante, and certainly from the lips of authority. He was not too much inclined to believe implicitly all Settembrini said; he considered him too much of a windbag for that. Still it was an interesting conception, this of Dante as the wide-awake citizen of a great metropolis. And now Settembrini went on to speak of himself, and to explain how the tendencies of his immediate forebears, the political from his grandfather, the humanistic from his father, had united in his own person to produce the writer and independent man of letters. For literature was after all nothing else than the combination of humanism and politics; a conjunction the more immediate in that humanism itself was politics and politics humanism. Hans Castorp did his best at this point to listen and comprehend . . .[9]

Without the most careful historical and philosophical exegesis this triple equation is facile and empty—a perfect net to trap the *Zivilisationsliterat* against whom Mann's early *Betrachtungen eines Unpolitischen* (Meditations of an Unpolitical Man) was directed. But even with Mann, time and totalitarianism have had their revenge. The "unpolitical" man was literally forced into exile by an inhumane politics, and the serious essays of his later years were to serve as an atonement— a bitter corrective for his earlier standpoint, since they pursued just that historical and philosophical exigesis which had as its aim the restoration of precisely the triple equation which *The Magic Mountain* so sarcastically calls into question.

Politics has always had its historic connection with other areas of human culture. Shakespeare's history plays are unintelligible without reference to the myth of Tudor sovereignty, as those of Brecht are meaningless separated from the illusions of the Marxist mentality. The histories so carefully composed by Mommsen, Burckhardt, and von Ranke in each case reflect a

political attitude, and the alternative evaluations of the French Revolution by, for example, Thiers and Mignet, de Maistre and de Bonald, Louis Blanc and Michelet, Tocqueville and Renan represent a political confusion and a strife hardly less than that exhibited by the events about which they were concerned.[10] "These experts on the Terror," writes Valéry with his usual wit, "agreed with each other precisely as Danton agreed with Robespiere—although with less extreme consequences. I do not say that the impulses of the mind are one bit less positive in writers than in men of action, but in normal times the guillotine, luckily, is not at the disposal of historians." [11]

But my point is not simply that political considerations are apparent in the constructions of the dramatic imagination and influence our interpretations of history. It is also that where humanism enters into the mainsprings of action through the channels of university education, its aim is the production of that classic clarity and balance which is, hopefully, one of the ingredients of a humane statesmanship. It may even be said that nineteenth century education in the humanities was a success precisely to the extent that it provided leaders whose humanist culture was not irrelevant to their political effectiveness. Guizot and Macaulay are surely cases in point, and even Bismarck is inseparable from the culture of post-Napoleonic Göttingen. Since the *Republic* of Plato and Aristotle's *Nicomachean Ethics* it has been the humanist dream to produce political leaders (and perhaps even a political electorate) who, trained to magnanimity, might, like Aristophanes, be moved not simply by the effectiveness, but also by the cruelty, the unfairness, and perhaps also the vulgarity of a proposed public policy. So long as thought is relevant to action, and ideals are relevant to legislation, the exercise of power will have philosophical roots, and the presuppositions of administrative procedure will be grounded in explorations of the realm of humanistic values.

But it is also the case that in the contemporary world politics plays not only a virtual, but also a symbolic role. And this is, I think, both significant and essentially new. To poets and novelists of course it has long been apparent. More than a decade ago, Isaac Rosenfeld, writing of Sartre in *The New Republic,* remarked: "One need only write of political experience, and the writing will sound with the full underground tonality, for politics is the underground of our time." [12] The suppressed reference is, of course, to Dostoievsky and it is apt, for all of his

most profound writing is concerned with interior monologue
and the hermetic temporality of the inner life. The dominance
of the subjectivist principle in Dostoievsky is allied with the
spirit of the *Confessions* of St. Augustine and with the tradition
of Christian inwardness which actually in the nineteenth cen-
tury became a climate of opinion, so that confession, autobiog-
raphy, and the interior monologue became established conven-
tions on which the novel of that time could draw.[13] And this
means essentially that the basic problems (which were moral
and religious) showed themselves in intensely personal terms.
In our day all this has been reversed. Politics has become the
idiom of the age, and today the deepest problems of the human
self reveal themselves in the garments of political concern. It is
not by accident that Mann, after the great political refusal of
his youth, should in his later years have finally admitted: "In
our time the destiny of man presents its meaning in political
terms."

It is not the basic nature of human life that has changed, but
only the conventions of its expressiveness. Karl Jaspers has
written much on the phenomenology of the human condition,
and in so doing, he has elaborated those "extreme" or "inescap-
able" situations (*Grenzsituationen*) within whose absolute lim-
its the necessities of human life are set: conflict, suffering, guilt,
death.[14] They are eternally with us. Only, today the center of
conflict has shifted from individual wills to the interests of
mighty national powers, the suffering we anticipate is that of
the survivors of Hiroshima, the guilt that consumes us is that
apropos of Dachau and Oranienburg and Auschwitz, and the
death that we fear most is that of which Norman Mailer has
spoken; the gas chamber or the radioactive city—in short, that
which is the product of political murder!

In 1962 Jean-Paul Sartre and Simone de Beauvoir joined the
demonstration at Richelieu-Drouot against the French govern-
ment's Algerian policy; as violence broke out, they prudently
hastened into a bistro just off the Boulevard Haussmann.[15] The
patron quickly shut the door after them and remarked: "J'ai
trois enfants, je ne fais pas de politique; la politique, c'est des
intérêts supérieurs." (I have three children. I don't meddle
with politics. That's for higher interests.) His hand traced in
the air heaps of gold: "D'énormes intérêts; ça nous dépasse."
(Huge interests! Beyond our conception!) This in some meas-
ure testifies to the scope and magnitude of political conflicts in
the world today—their transcendence of the sphere of knowl-

edge of the common man. But the new dominance of politics means much more than this. It means, in fact, the ascendancy of a new literary style—a new *mode of perception*.

Dostoievsky's great novel *The Possessed* and Camus's interesting contemporary play *Les Justes* are both works with a political subject matter. Moreover they deal, respectively, with the beginning and the end of the same political movement—the individual terrorism of the young Russian students—that "proletariat of undergraduates" as Dostoievsky called them—which dominated the Russian political underground from the time of the American Civil War to the abortive Russian uprising of 1905. Each, moreover, is based on an actual event. In 1869 the corpse of a murdered student was found in a pond near the Moscow Agricultural Academy. He had been a member of a revolutionary student group, and was the victim of his fellow conspirators, the crime having been inspired by their leader Sergey Nechayev. Dostoievsky drew the plot of *The Possessed* from this sensational murder. The sinister Pyotr Verkhovensky is modeled on Nechayev, the details of the murder as disclosed at the public trial are closely followed, and, indeed, Dostoievsky in the letter accompanying the presentation copy of *The Possessed* which he sent to the Crown Prince (the future Alexander III) called it "almost an historical study." Camus is equally explicit. His plot stems from the murder of the Grand Duke Sergey by the student Kaliayev in 1905, actually following history even to the astounding interview between the Grand Duchess and her husband's murderer; and in his preface to *Les Justes* Camus says to the reader: "One must therefore judge merely the extent to which I managed to give plausibility to what was true."

So much for the extreme similarity of the two literary enterprises. But it is the difference which is striking; and this does not consist merely in the author's politics—in the attitude to the event which has inspired the plot. Dostoievsky hated all liberalism as he feared all revolutionary tendencies, and *The Possessed*, with its negative presentation of Verkhovensky and even Stavrogin, is the brilliant product of that fear and hatred. Camus, on the contrary, is of the liberal left, and although he tries to show in *Les Justes* that even political rebellion has limits and must be judged according to a higher system of values, his sympathy and admiration for his heroes Kaliayev and Dora are complete. It is not however the difference of political standpoint which is crucial, but rather *the differing*

importance of the concept of the political itself. The Possessed does indeed have a political subject matter while Dostoievsky's other works, such as *Crime and Punishment* and *The Brothers Karamazov* and *The Idiot,* do not, but the essential standpoint —the philosophical mode of perception—in all four cases is the same. The problems are not political, but moral and religious, and they find expression in an anguish that is intensely personal. The political impinges on Verkhovensky, and above all on Stavrogin, but its consequence is precisely a magnification of those individual responses which express implicitly that Christian subjectivism of which we have spoken. But in Camus it is completely otherwise. His Kaliayev and Dora, his Boris and Alexis are individuals, to be sure (otherwise the play would be a failure), but individuals truly hounded and fettered and *possessed* by the demon of the political which speaks through their every act, and throws the claims of the personal life onto a scrap heap of insignificance. *The Possessed* has a political subject matter which Dostoievsky uses for the assertion of values which are essentially nonpolitical, but *Les Justes* gives to the political a symbolic significance which completely justifies Mann's claim that the destiny of man presents itself in political terms in our time.

The contrast between Dostoievsky and Camus in the literary sphere finds, I think, its parallel in the philosophical domain as well. And here we may refer simply in passing to the rather surprising changes which have taken place in the tradition of existentialism from its proper groundings in the nineteenth century to the preoccupations of its French practitioners in the twentieth. Kierkegaard and Nietzsche are the nineteenth century founders, and like Dostoievsky, whether they are propounding the crucial importance of the act of individual decision or the centrality of the existential emotions of self-contempt and guilt, bad conscience and dread, their emphasis is on the subjective psychology and not on politics. Not only in Camus, but in Sartre and Merleau-Ponty as well, contemporary French existentialism and phenomenology, influenced by Marxism to be sure, but not only for this reason, have turned to a philosophical consideration of contemporary politics and social action. Thus Sartre has made existentialism into a series of footnotes to Marx, Camus has devoted his most sustained polemic to the problem of political rebellion (*L'Homme révolté*), and in *Humanisme et terreur* and *Les Aventures de la dialectique* Merleau-Ponty has with a subtle intelligence investigated

the ambiguities of history and the presuppositions of political action. Each of these French thinkers has attempted to demonstrate that existentialism is relevant to politics not merely because it has originated an ontology which purports to illuminate the political necessities of violence, but because the emotions to which it has called attention are precisely those which are generated within the political arenas of our time. "One cannot," as Merleau-Ponty has said, "be an existentialist merely at will, and there is more existentialism—in the sense of paradox, discord, anguish and determination—in the stenographic reports of the Moscow Trials than in all the works of Heidegger." [16]

Of the three, however, it is Camus, I think, who speaks with accents most responsive to the political anguish of our time, who in his awkward sincerity has attempted to explore the philosophical implications of the events which Mailer can feel only emotionally—the anonymous death of the concentration camp and atomic destruction, and to sense moreover that these are not satanic accidents, but of the essence of the politics of our time, and also that they stem not from an infernal "mindlessness," but are themselves the product of ideas—even of a political metaphysics. Camus makes this clear in the very first lines of *L'Homme révolté*.

There are crimes of passion and crimes of logic. The line that divides them is not clear. But the Penal Code distinguishes between them by the useful concept of premeditation. We are living in the era of premeditation and perfect crimes. Our criminals are no longer those helpless children who pleaded love as their excuse. On the contrary, they are adults, and they have a perfect alibi: philosophy, which can be used for anything, even for transforming murderers into judges.[17]

This is explicit recognition of how political violence has altered its face since the time of those naïve students who murdered the Grand Duke Sergey in 1905. But it is more. For it also sees that the gas chamber and the radioactive city—the reality of today —are sustained by arguments which transform them into "logical" crime. Politics in the modern world seems to imply murder. And, as Camus says, in an age of ideologies we must make up our minds about murder. If it has rational foundations—if the system of values by which it is justified is valid, then however great the human horror of anonymous death, our period

has significance. But, on the contrary, if it has no such rational foundation, no *valid* system of values to serve as its justification, then we must simply and categorically end the madness into which we have been plunged. The work of Camus is therefore also an investigation of the theme of "humanism and politics," and I have referred to it not so much to elicit a comparison between his task and my own much more modest one as to suggest the climate and the ambience which have produced our mutual necessity. For the studies which follow, even in claiming to be a contribution to the philosophy of culture rather than the science of politics, do, I am afraid, carry a message. Even to have chosen a theme like "humanism and politics" is expressive of an attitude toward the modern world.

There remain, I think, only a few words to be said about how these two concepts, "humanism" and "politics," are to be understood. In neither case do I want to define them too narrowly at the outset. For it must surely be clear that almost any definition will be "persuasive," and therefore represent an attitude and therefore beg the issue. This is inevitable, and I want to make my own position clear. It is perhaps expressed most explicitly in the subtitle which I have chosen for this book: "Studies in the Relationship of Power and Value in the Western Tradition." These are the two crucial concepts—*power* and *value*—and it is the nature of their relationship which constitutes one's attitude toward politics. When (as we have seen) Valéry defines politics as "the art of making people pay for, fight and torture one another for something they neither know nor care about," this is an implicit indictment of an exercise of violence separated from any valuational standpoint which could give it meaning. And when with an equal cynicism Bernanos defines the modern state as "that half-usurer, half-policeman whose eyes are on all the locks and whose hands are in all the pockets," it is equally an indictment of types of social order which have lost their ability to satisfy the needs of positive security and accomplishment, and have therefore deteriorated into empty, but oppressive, forms. Each of these indictments is a criticism of "power" without "value." But this separation of power and value is not only a target for the personal cynicism of two humanists who have expected too much—it is also the built-in presupposition of a type of positivistic political science which has become all too influential in the modern world. For when one defines politics in the Lasswellian vein as "who gets what when," or as "the study of influence and the influential,"

or as "the pyramid of subordination and superordination," or
as "the structure of coercion and consent," or, when in the
quasi-Marxist tradition since Lenin, one defines the state as
"that institution which enjoys a monopoly of the instruments of
legitimate violence," the very presupposition seems to be a
political object seen as pure power and separated from all
axiological considerations which render the subject indetermi-
nate, problematic, and humanly significant. Again, I do not
wish to denigrate a positivistic political science. It has its place.
But its standpoint is not mine.

There is a philosophical tradition at least as old as Hegel
which sees the life of politics as one of the forms of human
alienation. But if this is so, it is because there is a politics
divorced from value and a politics grounded in value—the
former mindless and blind, the latter thoughtful and expressing
its own type of philosophical vision. What is at stake here is
precisely the definition of power itself. *Fictitious* power, as
Rebecca West has told us, is the power to order and to be
obeyed. But *real* power is *the power to direct one's environ-
ment toward a harmonious end*. Valéry would have agreed. For
the butt of his objection was a situation where the concept of
the common good seems to have been lost, where basic trust in
men and institutions has gone by the board, where the func-
tions of government and the enforcement of law have become
entirely a matter of caprice, favoritism, and routine, and where
political parties fight to enjoy the baser advantages of patron-
age rather than for the privilege of regulating a nation accord-
ing to a moral idea. Our recent experience with totalitarian
governments has shown that without the moral guiding idea
the concept of "law" is an empty notion indeed. "What is called
'socialist legality' in the U.S.S.R.," writes Oscar Gass, "has shal-
low roots. But indeed, under great stress, there are *no* deep
roots for laws and liberties except moral and political convic-
tions. Historic traditions, consolidated interests, and lawyers'
techniques—all come to nothing in a high wind. Whoever
doubts should look into the ignominious history of the
Rechtsstaat in the central Europe of our time." [18]

The relevance of the moral guiding idea is what gives to
politics its justification, and our attitude toward the exercise of
power is itself a test of our humanistic intentions. Valuable
human experience (creative work, family intimacy, the enjoy-
ment of the arts) simply *is,* it does not order, and yet *its being* is
the end of life and civilization. Politics not simply is, it com-

mands, issues imperatives, orders according to law, but in itself it is no end, but the means to ends given outside the realm of its competency. But this attitude is not given automatically. It is a humanistic product. The distinctions between politics as means and politics as end, between a politics divorced from value and a politics grounded in value, between the fictitious power of being instantly obeyed, and the real power to create harmony and integration in the chaos of life, are distinctions grounded in the very nature of humanism. We arrive then at the heart of our political paradox. And it is this: that the very form in which "politics" is to be defined is itself a "humanistic" problem.

How, then, shall we define "humanism"? In the broadest sense it is, perhaps, simply *the quest for value:* all that opposes the specifically human to a "transcendence" which is too recondite and a "nature" which is too neutral and unfeeling; the vital, the organic, and the human, that is, against the merely mechanical; human freedom, fortune, and fate against the operations of an impersonal causality; will against force; value against fact; the humane against the brutal. But already we have compounded confusion and introduced ambiguity, and when we further add to this the traditional and historical accretions: belles lettres, the literature of Greece and Rome, Renaissance recovery, careful textual analysis combined with a love of the old, the guild of aristocratic scholarship in the fifteenth and sixteenth centuries, and the like, all sense and clarity have dissolved into a neutral fog.

When Montaigne in the essay "Du Repentir" asserted that "Each man carries within himself the entire form of the human condition," and went on to explain that, while some authors communicate to their readers by virtue of some special status or qualification (as grammarian or poet or jurist), he is the first to do so simply through his essential human nature as Michel de Montaigne,[19] he came close to a simple formulation of an integral humanism. And when St. Augustine in a famous passage charted the geography of the universe by distinguishing "the things above man" (the realm of the divine), "the things below man" (nature), and those concerns "on the level of man" (customs, morals, institutions), he indicated as clearly as possible in what respect humanism is to be distinguished both from naturalism and transcendentalism. In each case the humanism is without sentimental overtones: rather a sensitiveness to the abstract quality of what is human, than the love and

sympathy for human beings *in concreto* which is usually called humanitarianism, but which nonetheless is somehow inescapably attached to the original meaning.

It is a conjunction which has haunted the humanistic imagination from the moments of its origin. If the term *humanitas* was invented by the Romans to indicate the literary and philosophical treasures which they appropriated from the Greeks, it included both a reference to *erudition* and to *practice*—to the scholarly skills required for the act of appropriation, and to the actual moral effect which this appropriation was to have on character and cultivation. But even here there was some attempt to restrict the term so as to exclude from it the notion of promiscuous benevolence. Aulus Gellius, writing in the second century A.D., makes this abundantly clear.

Those who created the Latin language and those who spoke it well do not give the word *humanitas* the vulgar meaning which is synonymous with the Greek work *philanthropia,* which means an active kindness, a tender benevolence for all men. But they give the word the meaning which the Greeks attach to *paideia,* which we call education, knowledge of the fine arts. Those who show the most taste and disposition for these studies are the most worthy to be called *humanissimi.* For man alone among all living beings is able to devote himself to cultivating a study which for that reason has been called *humanitas.*[20]

This was indeed the meaning given to the term by Varro and Cicero, and perhaps also by those "great patricians of the mind" (as Benda calls them) like Erasmus and Spinoza, Malebranche and Goethe. But if the attempt here is to exclude the sentimental, this does not also mean the moral, for such an exclusion simply cannot be made. Montaigne's "entire form of the human condition" is unintelligible without reference to aesthetic cultivation and moral wisdom. Indeed, it is precisely with reference to the conduct of life that the great humanists of the fifteenth and sixteenth centuries oriented their scholarship and interpretive skills. Eramus, for all that he disliked scientific inquiry, was committed to the painstaking enterprise of textual emendation. But it is important to distinguish logical method in the humanities as a means from the employment of the method as an end in itself. Humanists from Petrarch to Erasmus were primarily interested in recovering not the manuscripts, but the wisdom of the ancients. It was simply an accident of the sociological conditions governing the transmission

of the written record that the purification of a corrupt text was a necessary precondition for a contemplation of the wisdom which it contained. This was true not only with respect to the Greco-Roman, but also to the Biblical tradition, and this is why St. Jerome, Wycliff, and Luther, no less than Bruni, Colet, and Eramus, utilized the methodical technique of literary scholarship. The very basis of the distinction between the humanism of Erasmus, on the one hand, and that of Estienne, Casaubon, and Scaliger, on the other, is that the former always recognized as a means what the latter pedantically exalted into an end in itself.

It is important neither to forget nor to underestimate the moral element in humanism. And this is why I have found it most useful (if perhaps also more than a little ambiguous) to define it as *the quest for value*. The heart and center of the humanist approach is the recognition of a dualism between man and nature, coupled with an assertion that the rightful concern of man is his own humanity—his world of value and quality. This assumes not only the existence of standards of value which are not merely arbitrary, but the human freedom to commit oneself to values through an act of will. Humanism as a great historical tradition in Western culture shows itself most strongly in its moral and prophetic vein—as *a recall to moral order*. It is the small voice, thin but firm, which points the narrow way, and defends the spirit against the constant temptation toward relapses into brutalization. A colleague and good friend of mine has written of humanism as the conscience of the Renaissance.[21] It is an apt and excellent phrase—but it is too narrow. "Humanism" belongs not only to the Renaissance —and it is "the conscience" of every age!

In the essays which make up this book I want to explore the bright thread of humanism as it runs through the mottled fabric of the various areas of culture impinging on politics, and in this way bring to bear (perhaps tangentially) the heritage of classical humanism on the political exigencies of the present. Humanism today experiences a political crisis which threatens its very existence, and requires just that rigorous examination of conscience which has always been its *raison d'être*. And if the complaint still remains that my use of "humanism" is ambiguous, then let us accept it and make the most of it. For, if my root meaning is, as I have said, *the quest for value*, I am content that there should cling to it likewise connotations from the sixteenth century, the connections with art and literature

and history, the relations of *litterae humaniores* to humane concern, and that quality of moral earnestness which has been its constant accompaniment from Erasmus to Camus.

The essays which follow fall, rather naturally, into three groupings: historical, comparative, and contemporary. Under the first I have included two studies from the sixteenth century: "Erasmus and Montaigne" and "The Politics of Shakespeare's Plays." To begin with the sixteenth century is, in some sense, arbitrary, for the quest for value in politics goes back at least as far as Plato and Aristophanes and Plutarch. But to have taken Socratic humanism as my starting point would have been to overextend my canvas, and I have chosen rather to begin in the high Renaissance where humanism as an historical movement has its most noble flowering. My comparison of Erasmus and Montaigne is indeed meant to contrast two quite different approaches to the political life—from men who are both authentic humanists, but whose commitment to political boundaries, and indeed whose whole sense of the meaning of political life is profoundly different. Here already is prefigured the eternal dialectic of political involvement and withdrawal.

To include also a study of the politics of Shakespeare's plays is, I know, to tempt the gods. The subject seems so endless, and I am also aware of the doubts of A. C. Bradley [22] and others as to whether any reasonable conjectures as to Shakespeare's political views and feelings can be formed by a study of the plays. It is a doubt I in part share, but then I do not attempt any inference from the plays to the man. My subject is not Shakespeare's political beliefs, but the politics of Shakespeare's plays, and I am interested in the latter not so much as personal documents, but as mirrors and testimonials of the Elizabethan age in which nobility, magnanimity, and the quest for order slip surreptitiously between the grosser lines devoted to "the Tudor myth." The gleanings may be scattered and lean, but they form another variation on the humanist theme.

The next two studies, "The Great Refusal: The German Withdrawal from Goethe to Thomas Mann" and "Friedrich Schiller: The Playwright as Politician," are also in some sense to be taken together. The first illustrates the persistent German conception that politics and culture are antithetical, and that the humanism of the artist and writer should express itself in extrapolitical territory. The second—almost as if in dialectical opposition—shows how perhaps the greatest national dramatist of the German-speaking world explored the political universe,

clothing the humanistic message of the Enlightenment in political terms. Again, as in the case of Shakespeare, my purpose is less to deal with Schiller personally as a political figure than to examine the attitudes he represents in the light of cultural history. And the presentation of the political dramas of Shakespeare and Schiller is not without mutual relevance, for each stands on an opposite side of the great divide—the French Revolution of 1789—which marked the turning point of the political history of the Western world and ushered in the modern era of the European political consciousness.

My "comparative" section also includes four studies, each dealing with three major figures, and they are meant to explore the relations of politics, respectively, with history, with the drama, with warfare, and with the artist. The reason for having chosen three figures in each case is to indicate degrees of relevance and involvement. Thus the first study, "History and Politics," dealing with Burckhardt, von Ranke, and von Treitschke, is meant to demonstrate an ascending series in *the politicizing of historical research,* while the second, "The Drama and Politics," uses Buchner, Brecht, and Hochhuth to show how, since the French Revolution, *an increasing directness of the political message* has come to be embodied in the play. My chapter "Humanism and Warfare" is a more oblique, but I hope no less strong and convincing, commentary on the political climate of our times. By a study of three famous war treatises, Machiavelli's *L'arte della guerra* of the sixteenth century, Carl von Clausewitz's *Vom Kriege,* written just after the conclusion of the Napoleonic Wars, and Herman Kahn's *On Thermonuclear War,* first published in 1961, I wish to indicate how over the centuries the philosophical attitude toward warfare has altered—with ironic but at the same time tragic diminution of the depth of humanistic concern. The last study in this section, "The Continuum of Artistic Involvement," holds up a mirror to the artist as political victim, again in terms of degrees. It includes Picasso, the trimphant artist using politics for his own purposes and the slave of none; Brecht, whose political stance was in theory clear, but in practice ambiguous, always walking the narrow pathway beside an abyss; and Pasternak, the bourgeois artist in the proletarian country, unpolitical by nature, and blasted by a politics which in the end he was never really able to understand.

The last section, "Contemporary," contains two studies, one on existentialism, the other on Marxism, because, as I have

suggested above, it is primarily within the context of these two intellectual movements that the problem of humanism in politics has been raised as a vital and even self-conscious preoccupation of our time. And in the case of each there are dialectical oppositions within the intellectual climate which will repay the most careful study. It is not only (as I have shown elsewhere [23]) that there are both a "tender-minded" existentialist social philosophy of the "spiritual Right" (Jaspers and Gabriel Marcel) and a "tough-minded" existentialist social philosophy of the "revolutionary Left" (Sartre, de Beauvoir, Merleau-Ponty, Camus) ; within the revolutionary Left there is also, between Sartre and Camus, an opposition of the most crucial importance, and it is to that crisis of existentialist humanism that I have devoted the first study in this section.

But within official Marxism, likewise, the issue of humanism has at last come to a head. In general it is the problem of a more old-fashioned Marxism versus a more modern one, the texts of the young Marx versus the texts of the later, the pretentions of orthodox Marxism to be irrefutable science, and the claims of a revisionist Marxism to be at the same time moral vision. These issues, treated in the second study of this concluding section, not only have intellectual relevance but are embodied in the most practical politics of the daily newspapers. It is perhaps even possible to say that the Marxist enigma—and the issue of humanism and terror which lies at its center—is the most fateful question of our age.

Two / Erasmus and Montaigne:

Two Models of a Humanist Politics

Erasmus of Rotterdam: Citizen of the World

IN 1934, one of the most crucial and problematic years in modern German history, Stefan Zweig wrote a small but influential book, *Triumph und Tragik des Erasmus von Rotterdam,* published soon afterward in English simply as *Erasmus of Rotterdam.*[1] It was a volume of obvious praise, seeing Erasmus as the greatest and most brilliant star of his century, whose reputation had fallen on evil days of neglect, and whose works, written in an obsolete and supranational tongue—the elegant Latin of the sixteenth century humanists—lay unread, gathering dust on their massive folios. For Zweig, Erasmus was of all the writers and creators in the West "the first conscious European, the first to fight on behalf of peace, the ablest champion of the humanities and of a spiritual ideal." Erasmus, proclaimed Zweig, set his face against every form of fanaticism; he took it as a matter of course that a man had a right to his own opinions; he felt it to be his vocation to fight for universal lucidity. Thus his hatred of war, of nationalist divisions, of narrow partisan sentiments.

Zweig's book needs to be read not only against the testimony of the centuries, but against that of his own time. For in the context of the rising flood tide of Hitlerian power the book has a peculiar and poignant resonance. As Gibbon in his *Decline and Fall of the Roman Empire* at once testifies to the forces at work in the declining Roman imperium and in the silver age of Georgian England, so Zweig's book witnesses the fate of rationality both in the age of Luther and in the epoch of Hitler.

Speaking of the spirit of faction and of the passion of hatred in
Erasmus' time, but also as if in uneasy, and only half-convinc-
ing soliloquy with himself, Zweig says:

Idealists as well as those who know human nature, those who be-
lieve in the ultimate achievement of unity among men, cannot af-
ford to blink the fact that their work in this cause is perpetually
menaced by irrational passion; they need to realize in all humility
that at any moment the floodgates of fanaticism may burst open;
and, pressed forward by the primal instincts lying at the base of all
that is mortal, the torrent of unreason will break down the dams
and inundate and destroy everything that impedes it. Nearly every
generation experiences such a setback, and it is the duty of each to
keep a cool head until the disaster is over and calm is restored.
It was Erasmus' tragic destiny to live through such a time of storm
and stress. He, the most unfanatical, the most antifanatical of men,
living at a moment when the supranational ideal was taking a solid
hold upon European thinkers, had to witness one of the wildest out-
breaks of national and religious mass-passion that history has ever
had to relate.[2]

Zweig himself belongs quite obviously to the party of Eras-
mus, and we are hardly surprised when a moment later he
appeals almost wistfully to the monumental calm of the Ger-
man Enlightenment, where the intellectual and literary elite of
a nation could hold aloof from religious and social disturbances
and with undivided mind contemplate the welter of passion on
the political stage, and where an archetypical figure like
Goethe, undisturbed amid the tumult of the Napoleonic Wars,
quietly continued his work. In the now trite comparison of the
respective temperaments of Luther and Erasmus, Zweig's sym-
pathies clearly lie with the latter, and with humanistic distaste
he notes how "Luther's heavy peasant fist destroyed at one blow
all that Erasmus' delicate penmanship had so onerously and
tenderly put together." It was—as William Carlos Williams has
somewhere phrased it—"a reply to Greek and Latin with the
bare hands," and it is clear that Zweig's preference lies with
"humanism" in the sense of its aristocracy, latinity, and detach-
ment.

Only three years after the publication of Zweig's book—also
in the heyday of Hitlerian power—Georg Lukacs, the great
Hungarian Marxist critic, published his notable work *The
Historical Novel*. Although this remarkable book dwelt most
on the classical form of the historical novel and the changes

which it underwent in "the period of bourgeois realism," Lukacs concluded with a chapter entitled "The Historical Novel of Democratic Humanism" in which, although Zweig's biography of Erasmus could not conceivably be called an historical novel, Lukacs nevertheless goes out of his way to attack the book, the ideas for which Zweig stands, and, indeed, the very figure of Erasmus himself as an intellectual hero within the pantheon of Western culture.

Lukacs' Marxist interpretation is predictable. He sees in Zweig's view of Erasmus a kind of stubborn halting at a harmless liberal humanism which is characteristic of a large segment of the Western intelligentsia in the pre-Hitler period—a stance which makes "humanism" and "revolution" into mutually exclusive opposites, and thus tragically "fixates" the "false" humanism of the liberal German bourgeoisie. But Lukacs goes further. For to draw Erasmus of Rotterdam as the model type of humanist is to him an historical error no less than a falsification of values.

But Zweig, unlike . . . above all Heinrich Mann, does not bravely draw the conclusion that the old and favored humanist type, whom he has drawn with such love in the figure of Erasmus, is not only condemned to defeat by his alienation from the problems of popular life, but as far as the basic questions of humanism are concerned is more limited, restricted and therefore on a lower level than those who have the courage and ability to derive their ideas from living contact with popular life.[3]

Lukacs sees Zweig's choice of Erasmus as the model type of humanism as a distortion of the historical picture, for to him humanism must be militant, not detached, involved with the masses of the people, not aristocratically aloof, and as a consequence he praises Friedrich Engels, who put forward Leonardo da Vinci and Dürer as the great men of this period rather than "scholars of the book who do not wish to scorch their fingers." What Lukacs seems to object to primarily in both Zweig and Erasmus is the attitude that the masses represent the principle of irrationality which makes humanism inevitably "an ideology of renunciation," causing its practitioners to retreat from the arena where the very destiny of mankind is being decided. In his opinion these views are rooted in an ignorance and mistrust of the people and in a false and abstract aristocracy of the spirit which, although they are indeed to be found among humanists of the Renaissance and the Enlightenment, yet compromise the

social responsibility of humanism and distort the essence of its meaning.

In the two divergent estimates of Erasmus to be found, respectively, in Georg Lukacs and Stefan Zweig we have ample evidence that the accepted pattern of humanist virtue is itself a matter of historical dispute. And although my own sympathies in this matter lie much more closely with Zweig than with Lukacs, I have presented the liberal-democratic and the Marxist alternatives in the interpretation of the meaning of Erasmus' life, not to force a choice between them but to indicate that even in the matter of the relation of humanism to politics there may be important alternative models. The comparison of Luther and Erasmus is an old story, reviving the ancient humanist dialectic of advance and retreat in face of the political arena; even that between Erasmus and Machiavelli, generally based on a comparison of the former's *Institutio principis christiani* with the latter's *Il principe,* asserting that Erasmus upholds the classical Platonic position while Machiavelli is the advocate of the ethics and politics of Thrasymachus, is interesting, even if, as I think, quite mistaken. But comparative treatments of Erasmus with both Luther and Machiavelli introduce deep moral prejudices which beg the issue, and I therefore find it more rewarding to compare Erasmus with Montaigne. These two represent equally possible, and perhaps equally admirable, models in the matter of the humanist approach to the political life.

Both Erasmus and Montaigne would, I think, be equally suspect to Lukacs, not merely because they were aristocrats of the spirit, deeply suspicious of the common people,[4] placing their chief political hopes in princes and in monarchies, but because of their shrinking from the dangerous excesses of partisanship—not out of cowardice, but through a humanistic confidence that the fanatical hatreds of political and religious factions can be tempered somehow by those who stand above the battle and use their influence and diplomacy to preserve "the civilization of rational dialogue" and the precarious communication of enemies. Marxism itself, intensely partisan by origin and ideology, forces the rupture of class opponents with all the weapons at its disposal, and thus contains at its very source an ingredient intrinsically hostile to the mediating genius of an Erasmus and a Montaigne. For, hate them as it may, Marxism also respects the powers of the forceful opposition, seeing in the very rage of political fanaticism the unrestrained outbreak of

important social forces. Thus it is with a certain perverse moral consistency that Lukacs could be expected to admire Erasmus less than Luther, and Montaigne less than the passionate Duc de Guise. But this is to miss the point of their genius—particularly that of Erasmus—and it is to this that I should like briefly to turn.

For the last twenty years of his life (he died in 1536) Erasmus was known as the prince of humanists and the primate of literary Europe.[5] Whether he was at Basel or at Freiburg, he was inundated by gifts: silver cups and coins, sables and nuggets of gold, cameos and rings, fine linen from Hungary, ermine from Poland, horses from the Archbishop of Canterbury, and candies from the nuns of Cologne. They were tributes not only to his brilliant intellectual and scholarly gifts, but to the absolute sincerity and enduring moral purpose of his life. For Erasmus was neither a profound nor an original thinker, but a man of great erudition and capacity for work who used both of these gifts in the presentation of a few simple moral ideas which he embodied in his writings, one after another, throughout a lifetime with classical documentation, logical cogency, and irresistible eloquence. He was neither a speculative philosopher nor a poet, but rather a moralist who used all the philological tools of a skilled grammarian [6] to support a rhetoric which in its Renaissance simplicity is the analogue of that of Cicero or of St. Jerome, who was his own favorite among the Latin Fathers.

But in the end what counts for a humanistic politics is "the Erasmian spirit." It is a spirit which has, to be sure, been nourished on the languages and literatures—*linguae et bonae litterae, politior literatura*—but which has cherished them less for their intrinsic values as skills and techniques than as bridges to the moral wisdom embedded in the Scriptures and in the classical masterpieces of Greece and Rome. And the heart of that moral wisdom Erasmus found in the attitude of toleration and the spirit of compromise. As his great editor and admirer P. S. Allen has said: "To Erasmus nothing was more distasteful than controversy. For the speculative pursuit of truth he saw that the prime requisites were freedom from heat and passion . . . His instinct was to lay stress upon the points on which men agree, and to postpone decision where there were differences." [7] It was inevitable therefore that in the religious struggles which were to follow the extremists of both sides raged against him because he was not with them. The moderates, on the contrary, looked to him as the one hope of Christianity, the Church, and

a united Europe. But in general it was as Montaigne was to say later: "I incurred the disadvantages that moderation brings in such maladies. I was belabored from every quarter: to the Ghibelline I was a Guelph, to the Guelph a Ghibelline." [8] For, like Montaigne after him, Erasmus hated schism and he dreaded disorder; like Montaigne, he was fated to live in an age of rising schism and disorder, and, as with Montaigne also, this produced in him a certain uncontrollable bitterness and indignation. But in Erasmus' case the disillusionment came late, for the harsh beginnings of the Protestant Reformation coincided with only the last twenty years of his life.

At almost the same moment when Machiavelli was writing *The Prince,* in deep despair over the sufferings of a fragmented and war-torn Tuscany, Erasmus was writing his own *Education of a Christian Prince* in a mood of optimism and hope.[9] Erasmus was now fifty, the ripe scholar, the friend of princes, the recognized intellectual leader of Europe. This treatise (*Institutio principis christiani*) —to which I shall turn in a moment— represents his most mature and his richest political thought. It states succinctly (if somewhat unorginally) his hopes for the Christian world—peace, harmony, and prosperity, under which can be cultivated education, true religion, and the discipline of humane letters. It was a time (1516) when Erasmus' hopes ran high—a mood expressed to perfection in the letter of February 26 of that year which he addressed from Antwerp to the distinguished theologian, Wolfgang Fabricius Caputo:

Now that I see that the mightiest princes of the earth, King Francis of France, Charles the Catholic King, King Henry of England and the Emperor Maximilian have drastically cut down all warlike preparations, and concluded a firm and, I hope, unbreakable treaty of peace, I feel entitled to hope with confidence that not only the moral virtues and Christian piety but also the true learning, purified of corruption, and the fine disciplines will revive and blossom forth; particularly as this aim is being prosecuted with equal zeal in different parts of the world, in Rome by Pope Leo, in Spain by the Cardinal of Toledo, in England by King Henry VIII, himself no mean scholar, here by King Charles, a young man admirably gifted, in France by King Francis, a man as it were born for this task, who besides offers splendid rewards to attract and entice men distinguished for virtue and learning from all parts, in Germany by many excellent princes and bishops and above all by the Emperor Maximilian, who, wearied in his old age of all these wars, has resolved to find rest in the arts of peace: a resolve at once more becoming to

himself at his age and more fortunate for Christendom. It is to these men's piety then that we owe it that all over the world, as if on a given signal, splendid talents are stirring and awakening and conspiring together to revive the best learning.[10]

As was usual with him, Erasmus saw an unmistakable relationship between political peace and the advancement of culture, and at this particular moment—the calm before the Lutheran storm—he dared to hope that an era of tranquillity is ushering in a new golden age of learning with a great revival of medicine at Oxford, Roman law in Paris, and mathematics at Basel, and with the knowledge of the three languages, Greek, Latin, and Hebrew, publicly accepted in the schools as instruments for making Christian purity and simplicity shine forth from the crucial texts. But ten years later the bubble had burst; the intemperance of Luther and the ferocity of the embittered leaders prevented Erasmus from joining the Reformation, and in his letter of November 11, 1527 to Martin Bucer he saw "a cruel and bloody century ahead." By the year before his death all this had come to pass. Writing to Bartholomew Latomus from Basel on August 24, 1535, Erasmus catalogued the terrors and the rumors of terror:

Many French nobles have fled here for fear. . . . A like terror has seized the English, from an unlike cause. Certain monks have been beheaded and among them a monk of the Order of St. Bridget was dragged along the ground, then hanged, and finally drawn and quartered. There is a firm and probable rumor here that the news of the Bishop of Rochester having been co-opted by Paul III as a cardinal caused the King to hasten his being dragged out of prison and beheaded—his method of conferring the scarlet hat. It is all too true that Thomas More has been long in prison and his fortune confiscated. It was being said that he too had been executed, but I have no certain news as yet. Would that he had never embroiled himself in this perilous business and had left the theological cause to the theologians. The other friends who from time to time honored me with letters and gifts now send nothing and write nothing from fear, and accept nothing from anyone, as if under every stone there slept a scorpion.[11]

Twenty years had served to alter the face of Europe. The mightiest princes no longer furthered the cause of peace, but brutally crushed all religious opponents within their borders. Henry VIII was no longer "no mean scholar" but the executioner of John Fisher and Thomas More. And those "splendid

talents" which had been "stirring and awakening" to bring about the revival of humane letters were now uncommunicative and dumb with fear "as if a scorpion slept under every stone." All this was the fruit of fanaticism—of the uses of power to compel the mind in its commitments so that only one dogma was acceptable and must be forced on the universe—irrevocably splitting the human community into friends or enemies, heroes or criminals, adherents or opponents, true believers or heretics. As Erasmus viewed it in the last years of his life, it was with the inevitable bitterness of one who knows instinctively that to assert the validity of only a single system of existence is to promote a fissure in the heart of humanity. Erasmus' unwavering faith in "a consensus of reason," in an inherent "persuasiveness" of ideas which might finally unite the humanistically educated and the humanely oriented of every nation and religion and philosophical school into a single voluntary community of the mind was the very antithesis of fanaticism. And this was why the progress of his disillusionment and bitterness was registered in the alteration of his attitude toward Luther.

Writing to Luther on May 30, 1519 from Louvain, telling him of the inexpressible commotion his writings had aroused in this Roman Catholic center of learning, it was as if the very intemperance of the orthodox has brought him closer to Luther's side, and, although he took pains to establish his characteristic neutrality and hatred of violence, he yet found things in Luther's scholarly activity to admire and commend:

Best greetings, most beloved brother in Christ. Your letter was most welcome to me, displaying a shrewd wit and breathing a Christian spirit.
I could never find words to express what commotions your books have brought about here. . . . The whole affair was conducted with such clamorings, wild talk, trickery, detraction and cunning that, had I not been present and witnessed, nay, *felt* all this, I should never have taken any man's word for it that theologians could act so madly. You would have thought it some mortal plague. And yet the poison of this evil beginning with a few has spread so far abroad that a great part of this University was running mad with the infection of this not uncommon disease.
I declared that you were quite unknown to me, that I had not yet read your books, and accordingly neither approved nor disapproved of anything in them. I only warned them not to clamor before the populace in so hateful a manner without yet having read your books: . . . Further I begged them to consider also whether it were

expedient to traduce before a mixed multitude views which were more properly refuted in books or discussed between educated persons . . .

There are persons in England, and they are in the highest positions, who think very well of your writings . . . As for me, I keep myself as far as possible neutral, the better to assist the new flowering of good learning; and it seems to me that more can be done by unassuming courteousness than by violence. It was thus that Christ brought the world under His sway . . . The poisonous contentions of certain persons are better ignored than refuted. We must everywhere take care never to speak or act arrogantly or in a party spirit: this I believe is pleasing to the spirit of Christ. Meanwhile we must preserve our minds from being seduced by anger, hatred or ambition; these feelings are apt to lie in wait for us in the midst of our strivings after piety. I am not advising you to do this, but only to continue doing what you are doing. I have looked into your Commentaries on the Psalms; I am delighted with them, and hope that they will do much good.[12]

Seven years later the amicability was at an end. Not only had Luther attacked Erasmus personally, but his uncontrolled nature was threatening the conviviality of the European world. A letter to Luther of April 11, 1526 from Basel shows in Erasmus' own hostile excitement the depth of his concern.

Your nature is by now known to all the world, but you have so tempered your pen that never have you written against anyone so frenziedly, nay, what is more abominable, so maliciously. Now it occurs to you that you are a weak sinner, whereas at other times you insist almost on being taken for God. You are a man, as you write, of violent temperament, and you take pleasure in this remarkable argument. . . . You imagine, I suppose, that Erasmus has no supporters. More than you think. But it does not matter what happens to us two, least of all to myself who must shortly go hence, even if the whole world were applauding us: it is *this* that distresses me, and all the best spirits with me, that with that arrogant, impudent, seditious temperament of yours you are shattering the whole globe in ruinous discord, exposing good men and lovers of good learning to certain frenzied Pharisees, arming for revolt the wicked and the revolutionary, and in short so carrying on the cause of the Gospel as to throw all things sacred and profane into chaos. . . . What you owe me, and in what coin you have repaid me—I do not go into that. All that is a private matter; it is the public disaster which distresses me, and the irremediable confusion of everything, for which we have to thank only your uncontrolled nature, that will not be guided by the wise counsel of friends, but easily turns to any excess

at the prompting of certain inconstant swindlers. I know not whom
you have saved from the power of darkness; but you should have
drawn the sword of your pen against those ungrateful wretches and
not against a temperate disputation. I would have wished you a bet-
ter mind, were you not so delighted with your own.[13]

I have taken some pains to present the ambience of Erasmus'
disillusionment and his progressive coldness toward Luther not
simply to retail once more the trite historical events of the early
sixteenth century, but rather to show that implicit in this atti-
tude of Erasmus was a "political" position, and that the very
partisan demands of the Protestant Reformation served only to
throw into contrast a philosophy not only of intellectual toler-
ance, but of acute political disengagement.

This disengagement is not theoretical, but personal—not a
matter of failing to meditate on how the good society should be
constituted and what are the conditions for its achievement,
but rather of how the personal life should be lived and the
attitudes which a free man should assume toward those claims
of place, party, ideology, and institutions which are constantly
asserted against him. The complete politics of Erasmus is thus
constituted both by the rather uncomplicated political philoso-
phy which he put forth and by the life which he led, and a brief
consideration of these two will show, I think, not a questiona-
ble incompatibility but a definite congruence.

Although Erasmus' literary fame in his time rested primarily
on the *Adages* [14] and the *Colloquies* and in our own on *The
Praise of Folly,* his political theorizing is to be found princi-
pally in the *Institutio principis christiani* and in his numerous
writings against war, chiefly the *Dulce bellum inexpertis* of
1514, the *Querela pacis* of 1517, and the later *Utilissima consul-
tatio de bello Turcis inferendo* of 1530. This latter begins with
the words: "All monarchs are cut from the same cloth. Some
are busied with collecting the sinews of war: some with leaders
and machines; but hardly any are planning for the betterment
of human life, which is the ultimate source of every thing else
. . ." It is the same Aristotelian emphasis on a politics of
humane values which had dominated the *Education of a Chris-
tian Prince* fifteen years earlier, but again a disillusionment
with the "realism" of late Renaissance politics shows through.
As disillusionment it was not markedly personal. Throughout
his life Erasmus was on good terms with many kings, popes, and
princes, and it is a token of his mildness and discretion as well

as his great intellectual and moral power that he remained in the good graces of all: Charles V as well as Philip I, Henry VIII as well as Francis I. But even if this amiability gained him freedom of association with scholars from opposing countries, like More, Colet, Budé, Vives, and Melanchthon, even if his peculiar blend of intellect and courage enabled him to transcend hostile national boundaries, his position as "citizen of the world," which might have permitted him to view impersonally the seething caldron of European politics, always sustained an element of moral indignation transmuted into the perhaps nobler metals of irony and rational criticism. Despite the security of his personal position, he understood the need for reform in church and state and sought this wholeheartedly and continually through the only resources of which he was master: humane letters and the power of critical insight.

On June 17, 1516 Froben, the printer of Basel, informed Erasmus that his *Institutio* had come off the press.[15] It was therefore contemporary with and a part of the same general impulse which produced More's *Utopia* (1516) and Machiavelli's *The Prince* (1513). Less imaginative than More's work, less realistic than Machiavelli's, it yet shared with both the basic conviction that political improvement was a function of the moral transformation of the prince. It was written at a moment when Erasmus himself was recognized as the intellectual light of Europe and as councillor of the youthful Charles V (an honorary post procured for Erasmus by a new patron, John le Sauvage, Chancellor of Brabant). His treatise had perhaps more chance of actual influence than Machiavelli's work, dedicated out of despair to the grandson of Lorenzo the Magnificent. At any rate it contains Erasmus' ripest and most mature political meditations, and it expresses all of his humanist hopes for the Christian world—peace, reconciliation, moral elevation, and material prosperity.

It would be pointless to overlook its literary and aristocratic bias; both the mistrust of the common people, with which Lukacs was so unsympathetic, and the curiously academic faith in the power of the classics to mold character and to direct practice. The prince to whom Erasmus would entrust the state should not only excel in all the requisite kingly qualities of wisdom, justice, moderation, foresight, and zeal for the public welfare, but his education should be "fortified as by certain efficacious drugs against the poisoned opinions of the common people." It is as if in the mind of Erasmus the very moral

integrity of the prince depends on his being removed from "the
sullied opinions and desires" of the masses.[16] The heart of the
Erasmian politics is, of course, the Aristotelian ideal of aristoc-
racy—the union of power and moral virtue, the crucial distinc-
tion between the true prince and the tyrant, the constant insist-
ence that force without goodness is immoral and that without
wisdom it means chaos and the destruction of all order. But to
the Greek ideal Erasmus, in true Renaissance fashion, adds
those metaphors of rulership derived from the Christian tradi-
tion. Naturally the good prince's attitude toward his subjects
should be that of a paterfamilias to his children, for what else is
a kingdom but a great family, and what is the king if not the
father of his country? This is only following the example of
God Himself, absolute monarch of the universe, containing all
values within His being and surpassing all others in His wis-
dom and goodness, who desires only to help those with whom
He is entrusted. The concept of political "trusteeship" rules the
Erasmian politics and softens it as the concept of national
weakness and need softens the politics of Machiavelli. The
admonition which Erasmus directs to his prince therefore ex-
presses a certain idealistic unworldliness: "Hold rather this
thought: These thousands of souls depend on my sincerity
alone; they have entrusted themselves and the protection of all
their worldly goods to me alone; they look upon me as a father.
. . . Never forget that 'dominion,' 'imperial authority,' 'king-
dom,' 'majesty,' 'power' are all pagan terms, not Christian. The
ruling power of a Christian state consists only of administra-
tion, kindness, and protection." [17]

In his faith in the power of the classics to mold character and
direct practice, Erasmus is the child of his time and the very
epitome of Renaissance humanism. For Machiavelli, too, Livy
was a crucial source of political wisdom, and Montaigne, speak-
ing of the work of Tacitus, could say: "It is a nursery of ethical
and political reflections for the provision and adornment of
those who hold a place in the management of the world." But
Erasmus differs from both Machiavelli and Montaigne in two
important respects. His emphasis is ethical and religious rather
than pragmatic and worldly, and he therefore favors the Chris-
tian and the Greek sources over the Roman, the moral philoso-
phers over the historians. Erasmus would have his prince read
Proverbs and *Ecclesiastes,* the *Lives* and *Moralia* of Plutarch,
Aristotle's *Politics* and Cicero's *Offices,* and, above all, the
works of Plato. About historians he has the most serious reser-

vations. One must be on guard against Herodotus and Xeno-
phon—they are pagans and often describe the worst type of
prince. Sallust and Livy are hardly any better. To humanism
the ability of classical literature to serve as a paradigm of
practice was an article of faith, and it would be tempting to
compare the content of the political doctrines of Machiavelli,
Montaigne, and Erasmus on the basis of their respective intel-
lectual commitments to Livy, to Plutarch and Tacitus, to the
Old Testament and Plato.

That the congruence would not be complete is clear. For if
Erasmus' devotion to Plato is matched by Montaigne's to Plu-
tarch, both are highly conservative in their attitude to political
innovation and social change. The prince, says Erasmus,
"should avoid every novel idea in so far as he is capable of
doing so; for even if conditions are bettered thereby, the very
innovation is a stumbling block. The establishment of a state,
the unwritten laws of a city, or the old legal code are never
changed without great confusion." [18] Both are also committed
to a policy of reconciliation. Erasmus' treatise ends with the
characteristic peroration against war for which he has become
famous, and it is perhaps at this point that his principles di-
verge most markedly from those of Machiavelli. Machiavelli is
both theoretician and practical politician, and he can write a
treatise on warfare in an attempt both to modulate the Floren-
tine practice and to revive the soldierly virtues of the Roman
republic. For his prince, therefore, war and the theory of war
are primary business. But the practical disengagement from the
passions of *Realpolitik* gave Erasmus this advantage: his horror
of physical conflict became transmitted into principles of prud-
ence which should guide the prince himself. From war, says
Erasmus, "comes the shipwreck of all that is good and from it
the sea of all calamities pours out. . . . A good prince should
never go to war at all unless, after trying every other means, he
cannot possibly avoid it. . . . Let him consider how disastrous
and criminal an affair war is and what a host of evils it carries
in its wake even if it is the most justifiable war—if there really
is any such thing as a war which can be called 'just'." [19]

The strictures against war which end the *Education of a
Christian Prince* of 1516 are the very center of two of Erasmus'
most famous works, the *Dulce bellum inexpertis* (War Is
Sweet to Them Who Know It Not), which appeared the year
before, and the *Querela pacis* (The Complaint of Peace) which
appeared the year after. War, pestilence, and the theologians—

these, Erasmus once said, were the three great enemies with which he had had to contend throughout his life. The years 1515–17 (which he spent chiefly at Basel and Louvain) were largely given over to combat with the first.

I have spoken of Erasmus' horror of physical conflict. But his permanent hatred of war was not simply the expression of mild or timid temperament. It was also grounded in his very sense of the meaning of the humanist tradition and humanist principles. *The Complaint of Peace* is a rather short treatise, in form a lament by Peace, who grieves at the way in which the rulers of Europe, forsaking their Christian heritage, plunge their peoples into destructive conflict. But its center is not the sense of political imprudence but moral indignation. War is a barbarity repugnant to the Christian way of life. "God made man unarmed," says Erasmus. "But anger and revenge have mended the work of God and furnished his hands with weapons invented in hell." [20] The destructiveness and the agony are horrible enough, but it is the anger and the revenge which are the worst, for they are the causes from which the disastrous consequences follow. The spectacle of human bloodshed is barbaric enough, but it is in the corrupt passions of the human heart that it has its origins.

Erasmus' attitude toward war is half instinctive horror, half a meditated argument growing out of his sense of the meaning of human dignity and decorum. "Even the common people," he asserts, "in the ordinary language of daily conversation call whatever is connected with mutual good will, humane; so that the word humanity no longer describes man's nature merely in a physical sense; but signifies humane manners or a behavior worthy the nature of man acting his proper part in civil society." [21] Here is the very essence of Renaissance humanism; the identification of "humanity" with "the humane," so that those value properties which express his moral potential are intrinsic to man's nature. Humanism demands decorum less as social tact than as humane consideration, and the humanist criterion of acts will always be that of "behavior worthy the nature of man acting his proper part in civil society." In this moralized version of Platonic and Aristotelian insight lies the rationale for the Erasmian rejection of war.

It would perhaps be more just to call it a Christianized version of the Greek ethos. *The Complaint of Peace* quotes richly from Psalms, Isaiah, and St. Paul, and the *Dulce bellum*

inexpertis singles out for its scorn and indignation those churchmen who call a war holy, those priests who go into battle, and those monks who, in the press of war, "bear before them the sign of the cross" and "with things so devilish mingle Christ." [22] Erasmus had never forgotten that in 1507 he had seen the warlike Pope Julius II enter Bologna at the head of his troops, and in one of the colloquies, "Julius Exclusus," he portrays him swaggering outside the gates of heaven, amazed to find that Peter will not let him in. In the *Colloquies* Erasmus' resource is ironic humor, but the moral outrage in which it is grounded is more frankly expressed in the *Dulce bellum inexpertis*. War was shocking to every side of Erasmus' complex and sensitive nature, physically, morally, aesthetically. It was inhuman, impious, ugly—the epitome of barbarism to one committed above all to culture and the values of civilization. He had the misfortune to live at a time when the glorification of the military life was in full sway, when armaments were increasing, when that fanaticism which regards organized robbery and murder as a sacred imperial mission was slowly mounting out of war-torn Italy into England and France. Erasmus saw the lust for bloodshed and the appetite for conquest as motives which were as much a violation of the standards of an authentic humanism as they were incompatible with the true spirit of a still outwardly acknowledged religion. In his travels, no less than in his meditations, he had doubtless experienced war's ugliness as well as its cruelty, and the description which appears early in the *Dulce bellum inexpertis* recapitulates both the strength of his moral repugnance and physical loathing.

Now, then, imagine in thy mind that thou dost behold two hosts of barbarous people, of whom the look is fierce and cruel, and the voice horrible: the terrible and fearful rustling and glistening of their harness and weapons; the unlovely murmur of so huge a multitude; the eyes sternly menacing; the bloody blasts and terrible sounds of trumpets and clarions; the thundering of the guns, no less fearful than thunder indeed, but much more hurtful; the frenzied cry and clamour, the furious and mad running together, the outrageous slaughter, the cruel chances of them that flee and of those that are stricken down and slain, the heaps of slaughtered, the fields overflowing with blood, the rivers dyed red with man's blood. And it chanceth oftentimes that the brother fighteth with the brother, one kinsman with another, friend against friend; and in that common furious desire oftimes one thrusteth his weapon quite through the

body of another that never gave him so much as a foul word. Verily, this tragedy containeth so many mischiefs that it would abhor any man's heart to speak thereof.[23]

The description may sound quaint to a generation raised on the horrors of Dresden and Hiroshima—something more like a Renaissance woodcut of the battle of Fornovo or a detail of Uccello's "Rout of San Romano"—but it recreates the mood of blast and terror of any serious battlefield, and it rivals the human misery of the son who has killed his father and the father who has slaughtered his son on the field of Towton, which the youthful Shakespeare presents in the second act of Part III of *Henry VI*.

Erasmus' politics of moral trusteeship and his strictures against war are the theoretical counterpart of a temperament geared to the transcending of partisan conflicts and a life expressive of extreme cosmopolitanism. For cosmopolitanism itself is in a sense only the personal politics of disengagement. In Erasmus this disengagement means an alienation from the intimacy of national ties and the commitment to a national tongue —to any limitation, in fact, imposed by family, party, profession, native land. It is expressed in the telling symbolism of extreme openness and universality in the relationship to place and language.

Montaigne is an interesting mixture of humanistic principles and national pride. In Erasmus the humanism is the purer, for it is uncompromised by any dedication to nationalistic feeling. Montaigne's *Essais* are written in a clean Gallic idiom which served to fix the mold of the classical French of Descartes and Racine; Erasmus' elegant Latin is that of Renaissance humanism at its purest—not a vernacular, but a supranational tongue, symbolizing the universality of Renaissance humanistic scholarship as the Latin of Newton's *Principia*, three generations later, symbolizes the universality of late Renaissance science.

For Erasmus Europe was not divided into different countries whose boundaries were formed by rivers and mountain ranges, nor were social classes as such the object of his concern. He recognized but two strata of society: an upper aristocracy of the mind and feelings, and a lower one, plebeian, even barbarous, not because it was lowly and ill-born, but because it did not participate in the world of rhetoric and scholarship, of books and educated speech (*eloquentia et eruditio*), where he himself lived and which he took to be the milieu of man's true estate.

And the consequence was that throughout the great cultural centers of Europe he was always a visitor, always a guest, never adopting the manners or ways of life of any specific caste or nationality, never acquiring a single living language. Freiburg or Venice, Antwerp or Paris, Cambridge or Basel, Turin or Louvain, were for him a library, a printing press, and a dozen or so men of culture with whom he could converse in elegant and polished Latin. It was according to his own preference. "I wish," he wrote in a letter to Zwingli (September 5, 1522) "to be called a citizen of the world, the common friend of all states, or, rather, a sojourner in all."

It is perhaps ironic that Erasmus was known as "Erasmus of Rotterdam," for although this reference to his origins was part of the convention according to which he was called, his relations to Holland were tenuous indeed. Although in one of his adages, the "Auris Batava," he praised everything in Holland that was dear to him, and although it is said that his last words were in Dutch, his distaste for the narrow-mindedness, intemperance, and coarseness which he associated with the land of his birth reinforced the rootlessness so characteristic of his temperament.[24] Erasmus belonged not to the nationally committed, but to the cosmopolitan branch of the fellowship of humanism, and this expressed both the impulse closest to his nature and a rationally formulated ideal. Insisting on freedom of movement and occupation and the absence of ties and obligations, it followed naturally that he should be repelled by national obsessions and almost completely untouched by the national prejudices, hates, and aspirations as well as by the social, political, and religious ambitions so characteristic of the early decades of the sixteenth century. And if he held to the finally futile hope of purifying and making reasonable a corrupt Catholicism without destroying the cosmopolitan unity which was one of its chief appeals to him, it was for reasons similar to his lifelong commitment to the Latin language.

Although the Erasmian politics propounded an aristocratic ideal, and although the community of humanism in the sixteenth century was an intellectual elite, it was not a closed society. No one could be denied entry into this spiritual guild because of race or nationality. Anyone was eligible to become a humanist if he desired education and culture and pursued the life of humane letters. In this concept alone lies a profound critique of the raging nationalism of the sixteenth century. Languages, which had hitherto formed as impenetrable a bar-

rier between nations as mountain ranges, must yield to the language of cosmopolitanism. In the Latin of the humanists lay the clue to a universality as broad as that which had created the *Pax Romana*. Linguistic internationalism was Erasmus' unconscious response to the concept of a stern national allegiance whose human ideal was too narrow. The presupposition of such a position is that Europe is one unified culture or that the world is our common home, and, indeed, Erasmus writing to the French humanist Budé (in his Frenchness and his patriotism a true ancestor of Montaigne) expressed himself in this vein. "That you are very patriotic will be praised by some and easily forgiven by everyone; but in my opinion it is more philosophic to treat men and things as though we held this world the common fatherland of all." It is a sentiment which the Stoics expressed in the dying years of the antique world, but it was even more appropriate as a guide to reconciliation in an age of religious fanaticism and political strife.

Erasmus' dedication to the Latin language is only one side of his commitment to universalism and the ultimate democracy of the spirit which that entails. For precisely as humanists from Machiavelli to Montaigne believed in the power of humane letters to inculcate ideals and soften practice, Erasmus, in sharing this belief, attempts the widest possible dissemination of their message. By the very character of his scholarly work he deepened the international character of Renaissance civilization. His *Adages*, which went through sixty editions in his own lifetime, did much to "democratize" the message of classical learning, and his critical editions of the Church Fathers and the New Testament, if more limited in their appeal, yet had as their aim the dissemination of human enlightenment. Even these, like the *Adages* and the *Colloquies*, were written with an explanatory and clarifying intent, not difficult and pedantic as we have grown to expect from their modern counterparts, but chatty and companionable, full of anecdote and wit. Behind all is the democratic magic of the newly instituted vogue of printing. Erasmus loved books—for their format as well as their content—and the closeness of his relations with the great printers of his time—Aldus of Venice, Froben of Basel, Maertensz of Louvain—in whose houses he lived while finishing his manuscripts, receiving the galleys still wet with ink, searching for the printer's errors—was but the overt and personal manifestation of a passion for publicity and clarification. To restore the ancient wisdom to life, to widen the appeal of the classics, to

place them in the hands of thousands of readers, in the hope that they would promote a common understanding, was his life work. And it indicates to what extent his politics was the politics of culture.

It was to be a culture which knew no boundaries, and the symbol of this universality was Erasmus' own restlessness and his impatience with the urgencies of place. A rootless intellectual, moving constantly for reasons of health or scholarship or civil commotion, he never lived longer than seven years consecutively in one place. Educated early at Deventer and Steyn, he studied theology in Paris, although his doctorate was from Turin. He made six visits to England, none of them long, living for a time in London with Thomas More or, at John Fisher's urging, teaching for a semester at Cambridge. He explored the libraries of Italy for manuscripts, but left Bologna to live briefly in Aldus' house in Venice, whence he moved north to Constance and Strasbourg and down the Rhine to Antwerp. Louvain attracted him through its university and a few friends, although the conflicts of the Lutheran revolution penetrated here too and sent him to the placid city of Basel, to his friend the printer Froben, with hope for quietness in which to work, delivered from the claims of partisanship. But the Protestant Reformation invaded Switzerland also. Basel in 1528 was on the verge of civil war, and Erasmus moved to Freiburg where, plagued by illness and disenchantment, although well received, he continued his work, returning to Basel only in his last years.

Erasmus' life is a story of journeying and refusal. A teaching post at Louvain, a chair of theology at Cambridge, even the prospect of a cardinal's hat in Rome filled him with mistrust. What he wanted was the intellectual and spiritual freedom of the unattached, and so the story of his wandering is one of an obstinate and resolute search for independence. In late middle life he wrote to Servatius Roger: "You want me to settle on a permanent abode, a course which my very age also suggests. But the travellings of Solon, Pythagoras and Plato are praised; and the Apostles too were wanderers, in particular Paul. St. Jerome also was a monk now in Rome, now in Syria, now in Antioch, now here, now there, and even in his old age pursued literary studies." [25] The rationale is disingenuous, and the true motivation perhaps obscured, but if the life of Erasmus spreads itself over the cultural centers of the European heartland, this is but a symbol of that politics of disengagement and withdrawal which has always exerted its lure on the humanistically in-

clined, although few have found the courage of Erasmus to pursue it to the bitter end.

Erasmus is interesting for us today, I think, because he provides a prime example of one of the variants of a humanistic politics—of that kind which withdraws from political fanaticism in the name of a universal lucidity, holds that there is an undeniable relationship between the preservation of political peace and the advancement of culture, champions the humanities as a spiritual ideal which can fruitfully enlighten political practice. But such a man not only knows that he must guard his freedom of thought with all his resources, but that in the name of a permanent openness he can never pledge himself unreservedly to any narrow ideology. Such men are the natural peacemakers, arbitrators, and reconcilers, but the price that they may have to pay is rootlessness and withdrawal. More realistic politicians would hold that Erasmus had, in fact, a wholly unpolitical mind—that he was too far removed from the practical politics of law, government, and social influence to understand the requirements of force, of opportunism, of momentary necessity. But this will always be the retort of "politics" against "ethics," of the marketplace against the ivory tower, of partisan narrowness against cosmopolitanism. Erasmus, like Seneca or Epictetus, was "a citizen of the world," perhaps the first "good European" before Goethe, and if he seemed to have all the weaknesses of the scholar writing from his study—the aristocratic leanings, the latinity, the detachment—it was to keep uncompromised the possibility of rational understanding and moral agreement which is the permanent hope and the only ultimate excuse for the living of the political life.

Michel de Montaigne:
Citizen of Bordeaux

To anyone who reads extensively in the *Essais* of Montaigne, whether for the first time or the hundredth, it is clear that he is in the presence of a *French* personality. Montaigne's opinions are highly individual, his inspiration, whether he is quoting from Lucretius or Plutarch or Martial, is classical, the bent of his mind has been molded by the tradition of Western humanism, but the tang and flavor of his language, the peculiar twist of his intuition is intensely French.[26] In this he contrasts profoundly with the European mentality and the bland latinity of Erasmus. And as their literary quality and philosophical rheto-

ric are different, so is the temperamental expression of their respective political styles.

In many ways, of course, they are much alike. Both are humanists in their view of philosophical problems through the perspective of the Greek and Latin classics. Both belong to "the third force"—to the moderate middle in politics which tries to reconcile the partisan conflicts of religion and party in the name of a higher truth which rests on the variability and plasticity of human powers.[27] Both hate war and bloodshed and see in civil strife a travesty on the demands of Christianity. And as Erasmus in a preceding generation tries to reform Catholicism without exploding the world in a frenzy of Lutheran passion, so Montaigne, experiencing in France the full consequences of the schism which Erasmus was unable to prevent, tries to reconcile the Huguenots and Catholics of his nation and to combat the fratricidal madness which he was forced to witness throughout his life. The letters of sweet reasonableness which Erasmus sends out from Basel, Cambridge, and Louvain have their practical parallel in the delicate negotiations which it fell on Montaigne to make between the Duc de Guise and Henry of Navarre after the massacre of 1572 and ten years later between Navarre and the king himself (Henry III).[28] Both are exercises in the diplomacy of humanism.

As exercises they differ profoundly, and they express to perfection the fundamentally different qualities of the two men. The end (reconciliation) is the same, but the means differ enormously in kind and effectiveness. To Erasmus the diplomacy of humanism means faith in an epistolary persuasiveness. To Montaigne it is the reluctant but able assumption of the responsibilities of political negotiation. The literary counterpart of this assumption is the reflections contained in Montaigne's essay "Of the Useful and the Honorable."[29] It is an essay dominated by the problems of politics: the role and nature of political negotiation, the obligations of public service, the vexed but perpetually obtrusive question of the relationship between morality and power. But unlike Erasmus, whose cloistered life made commitment to principle easy and engagement in the politics of everyday life repugnant, Montaigne was able to draw the line between the compromising of an issue and the compromising of the self. His realism—somewhat like Machiavelli's, although intensely French—made him recognize that both the public and the private life are full of imperfections, that in every government there are necessary

offices which are not only abject but vicious. Politics is not only
the art of the possible but also the implementation of the
necessary, and those who must sacrifice their honor and their
conscience (as the ancients sacrificed their lives) for the good of
their country command his pity if not his respect. "We others,"
he says with some irony, "who are weaker, let us take parts that
are easier and less hazardous. The public welfare requires that
a man betray, lie, and massacre. Very well. But let us resign this
commission to more obedient and supple gentlemen." Mon-
taigne's own quality as a negotiator is clearly displayed.

In what little negotiating I have had to do between our princes, in
these divisions and subdivisions which tear us apart today, I have
studiously avoided permitting them to be mistaken about me and
deceived by my outward appearance. Generally men of this profes-
sion take pains to conceal their thoughts and feign a moderate and
conciliatory attitude. As for me, I reveal myself in my strong opin-
ions and my personal manner. An inexperienced negotiator, almost
a novice, who would rather fail in my mission than not to be true to
myself! But up to now it has been my good fortune that few men
have passed between one party and another with less suspicion and
with more favor and privacy.

It is obvious that this mutual respect was based not simply on
Montaigne's professional skill but on his qualities of personal
moderation. Looking on princes and the guardians of states
with loyalty and civic affection, but without being motivated by
conspicuous self-interest, his political attachments could be
moderate and unfeverish in an age given over to feverishness
and fanaticism. Anger and hatred, as he saw, lie outside the
domain of reason, and all legitimate and equitable intentions
are capable of reconciliation without sedition and bloodshed.
But this is not to say that his temperament kept him withdrawn
and above the battle. Almost as if in reproof of the extreme
detachment of Erasmus he could assert: "To keep oneself wa-
vering and divided half and half, to hold one's allegiance mo-
tionless and without inclination in a time of one's country's
troubles and of civil dissension, I find neither handsome nor
honorable."

His own sympathies were never in doubt—conservative, loy-
alist, Catholic—but his conduct is proof that political commit-
ment does not mean the mortgaging of the soul to every form of
opportunism, and that even those who espouse a cause com-

pletely may do so with such order and temperance that they modulate the public passion and lend a calming influence to the public storm. Montaigne was only fourteen when his city, Bordeaux, revolted against the royal power only to be brutally put down by the Duc de Montmorency. He was hardly thirty when the Huguenots were massacred at Vassy by the Duc de Guise. And he was in his ripest manhood when both the Duc de Guise and Henry III were assassinated within a year of one another by political extremists. He therefore knew with the intimacy of direct acquaintanceship the rationalizations by which inner bitterness and the hatred born of self-interest are transformed into "duty," how treacherous and malignant conduct is made an expression of "courage," and how the appetite for unbridled violence masks itself as zealousness for a "holy" cause.

Montaigne's talent for mediation sprang partly from a reasoned faith in the efficacy of persuasion and partly from a natural discretion. "Nothing," he said, "keeps us from getting along comfortably and in good faith between two hostile parties. Conduct yourself in this case with an affection, if not equal (for it may allow of different measures), at least temperate, and which will not engage you so much to either one that he can demand everything of you. And also content yourself with a modest measure of their favor, and with swimming in troubled waters without wanting to fish in them." Curiosity as to the details of intrigue was not his characteristic; he had no desire to share the secrets of princes, and this indifference permitted him to perform, even in negotiation, limited and conditional services, untouched by treachery and deceit. He was thereby enabled to preserve the good conscience of a free man. But his extreme respect for law was also tempered by a common sense which recognized (if it did not admire) the function of duplicity in public life. Montaigne made a constant effort to keep separate the public and the private, the inner and the outer, self-interested ambition and the public good, knowing realistically that, while will and desires are a law unto themselves, actions must receive their law from public regulation. But the very nature of the time in which he lived was a living demonstration that, as he put it, "Innocence itself could neither negotiate among us without dissimulation nor bargain without lying." And so, he continues, "Public occupations are by no means of my seeking and what is required of me professionally, I perform in the most private manner possible."

It is a harsh judgment on any society when there seems to be
an unbridgable gap between private lives and public routines
—between personal honor and political dishonesty—and it can
lead either to profound disillusionment or to a realistic accept-
ance. Erasmus was often prey to the first. Montaigne is more
usually expressive of the second. "I do not want," he says with
his usual irony, "to deprive deceit of its proper place; that
would be to misunderstand the world. I know that it has often
served profitably and that it maintains and feeds most of men's
occupations. There are lawful vices as there are many either
good or excusable actions that are unlawful." His recognition
of the factual gap between morality and legality, coupled with
his own incorruptibility (his sense, that is, of the sacredness of
his sworn word and his personal honor), places him midway
between the picture which the Elizabethans painted of the
Machiavellian stance in politics and the unworldly purity of
the Erasmian position. Insofar as he could use his personal
integrity in the public service he did so, but he held it inadmis-
sible that he should himself lie, betray, or commit perjury in
the intricate business of diplomacy. But the personal dilemma
of the realistic politician was well known to him, and the per-
plexities which it suggests are accorded his pity. Any political
commission which compromises the self is a burden and a
punishment, but it is the sign of a corrupt and badly consti-
tuted society that this should be the case. For wherever public
affairs are bettered by personal immorality or, conversely,
where to remain an honest man is to endanger the public
welfare, there is a thread of injustice woven into the very fabric
of political life. Montaigne's assessment of the dilemma of
princes is as realistic as Machiavelli's, but enriched by some
compassion for the guilty responsibility of the private charac-
ter.

The prince, when some urgent circumstance or sudden and unex-
pected accident of state necessity makes him deviate from his word
and his faith or otherwise forces him from his ordinary duty, should
attribute this necessity to a blow from the divine rod. Vice it is not,
for he has abandoned his own reason to a more universal and
powerful reason; but it is certainly misfortune. So that to someone
who asked me "What remedy?" I replied: "No remedy." If he was
really racked between these two extremes it had to be done. But if
he did it without regret, if it did not grieve him to do it, it is a sign
that his conscience is in a bad state.[30]

This entire essay, "The Useful and the Honorable," short as it is, is a rich examination of the perplexities of political life, uncompromising in its personal integrity, but compassionate to the compromises which public responsibility must make, and it, too, outlines the principles of a humanist politics—one equally cognizant of the inner and the outer necessity. If it leaves one with a sense of ambiguity, this is not because Montaigne's principles are disguised, but because he is everywhere cognizant of the vague factuality of the political life. The imperatives of practice are never (like some logical demonstration) derived from the certainty of ethical premises. The political life is too variable and too rich, too spectacular and too problematic to be governed by fixed canons of morality. There is in Montaigne's political reflections a strong element of prudence, although this never leaves his basic sense of the incorruptibility of the inner life wavering or in doubt. He always writes with that wariness toward fixed doctrine which is the natural skepticism of one who knows that at any moment history may prove him wrong —that the most recent decision of his king may liquidate his static presuppositions—but the immutability of his self-awareness remains the rock on which he is content to build. He knows that there are political exceptions to ethical mandates, although any exceptions to the natural rules of morality are sickly, dangerous, and rare. To these "necessities" we must yield only with great moderation and circumspection, and it is this sense of the rule *and* its exception which gives to Montaigne's politics its earthy actuality. "No private utility is worthy of our doing this violence to our conscience; the public utility yes, when it is very apparent and very important." This is not Erasmus, but it is not quite *Realpolitik* either, for it refuses to find the validity of a political act in its utility, and it conspicuously disallows that moral rationalization by which the shallow equate the "useful" and the "honorable."

Montaigne's reflections concerning the useful and the honorable are the fruit of political experience, of a life largely devoted to civic responsibility. And yet, with the general temper of the *Essais*—their depth and subjectivity, their emphasis on skepticism and rationality, self-knowledge and self-mastery, their scholarly humanism expressive always of a willingness to find guidance in books and in the ancient sages—it is somewhat difficult to reconcile the lawyer, jurist, French patriot and civic office-holder, the frequenter of courts, the respected associate of dukes and princes, and the confidant of kings. But they are one

and the same; the author "consubstantial with his work." And if it seems a paradox of humanism, yet it was a fact of sixteenth century European life that those who had formed their intellectual lives on the precepts of Plutarch and Seneca, Livy and Epicurus and Sextus Empirius, could yet function as Chancellor to the King of England, or parliamentary secretary to the city of Florence, or mayor of the city of Bordeaux. Montaigne, like Thomas More or Machiavelli of the preceding generation, presents the humanistic mentality in a political garb.

Montaigne came to this political avocation both by parental example and by training. Between 1530 and 1554 his father, Pierre Eyquem, had successively occupied the offices of first jurat, provost, assistant mayor, and finally mayor of the city of Bordeaux, and, although Montaigne in later years recalled that in his boyhood he had seen his father aged by public cares and deeply disturbed by the public turmoil into which he had been flung, yet his selflessness and public spirit must have early instilled in his son a sense of civic duty. Destined early by his father for the life of a magistrate, after graduating at thirteen from the college of Guyenne, Montaigne was set shortly to the study of law, probably at the University of Toulouse, which was already famous in this domain. At any rate, in 1554 Montaigne's father, newly elected mayor of Bordeaux, gave up his own seat in the Court of Aides of Perigueux and shortly thereafter bought a seat on it for his son. Thus only twenty-one when he entered on his public career, Montaigne served as councilor to the Perigueux court for three years, and when, in 1557, it was by royal order incorporated into the Parliament of Bordeaux, he continued to sit in this larger body for the next thirteen years. The details of his public service are not our concern here, but the fact that from twenty-one to thirty-seven his life was spent in this fashion is not irrelevant to the political attitudes expressed in the *Essais*. The judgment of his contemporaries and of his biographers testify to Montaigne's political temperance and sagacity. As a magistrate for fifteen years he displayed extreme moderation amid a swarm of violent colleagues, and showed himself ever docile to duly constituted legal authority in a parliament noted even in royal circles for its turbulence and insubordination.[31] This experience alone would qualify him to be known not merely by the title of "Lord of Montaigne" but also by that of "Citizen of Bordeaux."

But there is, of course, more. During the period of his magistracy Montaigne was often at the court in Paris. It is certain (as

he records in the essay "Of Vanity") that he was attracted by the vivid life of the city, and perhaps in his early manhood (and despite his explicit disclaimer in the essay "Of the Useful and the Honorable") by ambition for advancement. The *Essais* give many evidences that between 1558 and 1565 Montaigne was frequently and often for long periods absent at the court. The records of the Parliament of Bordeaux show that in September, 1559 he was away on the service of the king, and that in November, 1561 he was given a confidential mission to pursue "certain affairs" in Paris. Thus, during the reigns of both Henry II and Charles IX he is supposed to have served as an intermediary between Bordeaux and Paris in the interest of mitigating the bloody opposition of Huguenots and Catholics. But neither the life of a magistrate nor that of a courtier was precisely to his private taste, and in 1570, disillusioned (if not actually disgusted) with public life and the slavery it entails, he retired to his Chateau of Montaigne. An inscription found at this chateau early in the nineteenth century, in the cabinet adjoining Montaigne's library, is testimony to the mood and the motivation of this retirement. "In the year of Christ 1571, at the age of thirty-eight, on the last day of February, anniversary of his birth, Michel de Montaigne, long weary of the servitude of the court and of public employments, while still entire, retired to the bosom of the learned virgins, where in calm and freedom from all cares he will spend what little remains of his life, now more than half run out. If the fates permit, he will complete this abode, this sweet ancestral retreat; and he has consecrated it to his freedom, tranquillity, and leisure." [32]

The fates did not permit, and Montaigne's subsequent "freedom, tranquillity, and leisure" were but intermittent. In the first place his relationship with the court was never completely severed. In 1571 it was made official when at the request of his friend, the Marquis de Trans, Charles IX appointed him Chevalier of the Order of St. Michael, probably in recognition of his fifteen years of loyal service in the Parliament of Bordeaux. Six years later Henry of Navarre made Montaigne a gentleman of his chamber. Thus, within the space of a few years, he held the same honor under two rival monarchs, an ardent Catholic King of France and a determined Protestant King of Navarre. If nothing else, this would have testified to his moderateness and lack of fanaticism. In a political situation of extreme delicacy, Montaigne seems to have been at once a loyal adherent of the

royalist and Catholic cause without any tincture of that fanatical partisanship which explodes an uneasy equilibriun into violent and irreconcilable opposition. Despite his clear personal affection for Henry of Navarre he opposed all attacks which the Huguenots made on the authority of the king, as he was later to be equally against the intransigence of the Catholic League in opposing Navarre as the legitimate successor of Henry III, thus endangering the security of France.

Following the St. Bartholomew's Day massacre in 1572 Montaigne in Paris attempted a reconciliation between Navarre and the Duc de Guise, which proved unsuccessful. The wounds of division were at this moment too recent and too deep. After the massacre the reformed faith spread among the lower classes. Resistance was organized in the south and Henry of Navarre became its center. His triumphs forced on Henry III in 1576 the Peace of Monsieur, which rehabilitated the victims of St. Bartholomew and gave new freedom of worship to the Protestant adherents. But a second conflict arose, in which the king was now triumphant, and in 1577 a new peace was signed at Bergerac. But, especially around Montaigne's city of Bordeaux, all were restless and uneasy. Twice the Prince of Condé tried to take the city for the Huguenots from Marshal Biron, the mayor and the king's lieutenant-general in Guyenne. Thus the civil war kindled and spread until it had invaded the very region in which Montaigne hoped to secure his freedom, tranquillity, and leisure.

In 1580, after the appearance of the first edition of the *Essais* (a copy of which Montaigne presented to Henry III), and after serving at the siege of La Fère, Montaigne left with a few friends for a seventeen-months' trip through Switzerland, Germany, and Italy. In Rome, in early September, 1581, he heard that he had been elected by the jurats to his father's old post of mayor of Bordeaux. Certainly loath to be called again to the formal obligations of civic responsibility, Montaigne returned to France slowly—he had perhaps hoped to be made ambassador to Venice—in no haste to take up his duties, only to find in late November the following letter from Henry III awaiting him at his estate of Montaigne:

Monsieur de Montaigne, because I hold in great esteem your fidelity and zealous devotion to my service, it was a pleasure to me to hear that you were elected mayor of my city of Bordeaux; and I have found this election very agreeable and confirmed it, the more will-

ingly because it was made without intrigue and in your remote absence. On the occasion of which my intention is, and I order and enjoin you very expressly, that without delay or excuse you return as soon as this is delivered to you and take up the duties and services of the responsibility to which you have been so legitimately called. And you will be doing a thing that will be very agreeable to me, and the contrary would greatly displease me.[33]

Montaigne was of the opinion that he had been elected out of a desire to honor the memory of his father, but it is much more probable that it was because of his qualities of loyalty, moderation, and discretion, recognized by all parties in the current conflict and making him agreeable to the four royal powers who might have had a hand in the election: Henry III, Henry of Navarre, Catherine de' Medici, and Marguerite de Valois. At any rate, he entered into his duties with some misgivings. The role of mayor of Bordeaux was largely administrative. He presided over the council, represented the city on ceremonial occasions, and supervised the enforcement of the laws. But a certain part of his duties also involved political discretion. It was his function to maintain Bordeaux loyal and obedient to the King of France, to prevent any troops hostile to Henry III from entering the city, to see that no faction within was able to overthrow the government or interfere with its legitimate administration.[34] The first two years of Montaigne's administration were fortunate: there was a lull in the civil war, but he was reelected for another two-year term and it was during this period that his position became extremely delicate. Henry of Navarre, chief of the reformists, was formally governor of Guyenne, but the king's own representative, his lieutenant general and a firm Catholic, was now the Marshal Matignon, a man of great coolness and ability whom Montaigne had met at the siege of La Fère and whose efforts to pacify the province were carried on with a moderation and prudence which inspired Montaigne's respect.

Toward the end of 1583 the political situation again became grave. Henry of Navarre, irritated by proceedings at court, again began to stir up strife in Guyenne. For Montaigne the situation was difficult indeed. His duty was to remain loyal to Matignon, who represented the kingly power. But his personal admiration and respect were for Henry of Navarre. Characteristically, in May, 1584 he served as mediator between Matignon and Navarre, and seven months later Navarre with a train of

forty of the highest noblemen arrived at the Chateau of Mon-
taigne, where they stayed four days. His ability to remain loyal
to his sovereign without compromising his personal judgment
about Navarre is only another proof that Montaigne's political
conduct gave him an eminent right to represent in his more
leisurely meditations the politics of humanism. That, unlike
Erasmus, he was an active politician who played his part and
exercised his influence on the course of public affairs in six-
teenth century France gives added weight to the political phi-
losophy embedded in the *Essais*.

That political philosophy—hence the type of humanistic pol-
itics which Montaigne represents—has two major tenets: to
keep strong the spirit of reconciliation, and to maintain the
integrity of the self. Both are given strong expression in the
essay "Of Husbanding Your Will," in which Montaigne frankly
considers the conditions and the consequences of his four years
in office as mayor of Bordeaux.[35] The first is summed up in the
acknowledgment: "Except for the knot of the controversy, I
have maintained my equanimity and pure indifference"; the
second in the motto: "My opinion is that we must lend our-
selves to others and give ourselves only to ourselves." Both, I
think, spring from that same reserve with which the cultivated
guard their privacy against the excessive exigencies of a public
though secondary demand. Montaigne, as his phraseology goes,
is "touched" by politics, not "possessed" by it; and if he feels
that he has not infrequently been pushed into the management
of public affairs, he has "assumed" his burdens, not "sought
after" them, allocating to them his just "concern" but not his
"inordinate passion." The terms suggest a just measure of the
political effort, a reluctance to engage the self beyond the per-
sonal demands of dignity and honor, but an equal uneasiness in
rejecting the claims of civic duty as they impinge on one who is
both loyalist and patriot. "Messieurs of Bordeaux," says Mon-
taigne frankly, "elected me mayor of their city when I was far
from France and still farther from such a thought. I excused
myself, but I was informed that I was wrong, since the king's
command also figured in the matter." Yet he confesses himself
proud to be in the same company as Monsieur de Lansac and of
the Messieurs Biron and Matignon, both Marshals of France.

His account of his administrative qualifications almost seems
like a register of Keats' "negative capability," for he finds
himself without memory, vigilance, vigor, and experience, but
also, and on the same account, without hate, ambition, avarice,

and violence. It is practically as if the Stoic *ataraxia* had become a presupposition of effective political management, as if prudent inactivity had become the only antidote to fanaticism and innovation. "I had nothing to do," says Montaigne, "but conserve and endure, which are noiseless and imperceptible acts." The adjectives are striking, for they somehow suggest that the lurid publicity of politics requires a protective coloring of quiet anonymity and that it might be desirable to assimilate the techniques of statesmanship to those of hermetic diplomacy.[36] But it is the attitude of mind which counts almost more than the political style. Unlike Erasmus, Montaigne is, I think, a patriot, one to whom the welfare and the prestige of France are of considerable concern, and yet he writes almost with the sangfroid of some modern like Sartre or Celine: "He who desires the good of his country as I do, without getting ulcers and growing thin over it, will be unhappy, but not stunned to see it threatened either with ruin or with conditions of survival no less ruinous." It is not that he does not care. His is rather the deliberate stance of one whose moral consciousness has been molded on the Stoic model and whose reading in Plutarch and Seneca and Cato the Younger has formed a criterion of judgment by which the requirements of political involvement may be justly assessed. Montaigne prides himself on his coolness and dispassionateness; equanimity and indifference are for him moral qualities of the highest value; he desires for himself "a gliding, obscure, and quiet life." But when duty requires the assumption of political power and responsibility, it should be according to the paradigm of the private life—not the histrionic outbreak of violence and trouble, but that very orderliness, that "gentle and mute tranquility" which accompanied Montaigne's administration of the mayoralty of Bordeaux and which was later to be the chief source of his pride in looking back on this period of his life.

It is the stoicism of Montaigne which distinguishes the inner self with its requirement of perfect integrity from the dutiful public servant with his bland selflessness and moderation, which gave him so strong a sense of the distinction between personal and functional authority, which permitted him to say: "The Mayor and Montaigne have always been two, with a very clear separation." But what is equally clear is that the same personal strategy of limited political self-engagement which regulated his administrative life also frees him from the feverish factionalism of his time.

I do not know how to involve myself so deeply and so entirely. When my will gives me over to one party, it is not with so violent an obligation that my understanding is infected by it. In the present broils of this state, my own interest has not made me blind to either the laudable qualities in our adversaries or those that are reproachable in the men I have followed. People adore everything that is on their side; as for me, I do not even excuse most of the things that I see on mine. A good work does not lose its grace for pleading against my cause.

He is frankly partisan, but without personal passion and not beyond justice and public reason:

I want the advantage to be for us, but I do not fly into a frenzy if it is not. I adhere firmly to the healthiest of the parties, but I do not seek to be noted as especially hostile to the others and beyond the bounds of the general reason. I condemn extra-ordinarily this bad form of arguing: "He is of the League, for he admires the grace of Monsieur de Guise." "The activity of the king of Navarre amazes him; he is a Huguenot." "He finds this to criticize in the king's morals: he is seditious in his heart." And I did not concede even to the magistrate that he was right to condemn a book for having placed a heretic among the best poets of this century. Should we not dare say of a thief that he has a fine leg? And if she is a whore, must she also necessarily have bad breath? [37]

It is an admirable quality and again it reminds us of the temperate reasonableness of Erasmus. And it is particularly noteworthy in seventeenth century France, where Erasmus' prediction of "a cruel and bloody century ahead" was fulfilled less than fifty years after it was made. Erasmus' middle life was lived on the brink of a volcano. Montaigne's middle life saw the volcano in full eruption, and his political perceptions are geared to an age of passion and bloodshed. It is therefore both paradoxical and just to say that the politics of humanism represented by both Erasmus and Montaigne, grounded as it was in Christian gentleness and Stoic *ataraxis,* was at the same time *a politics of crisis.* For in the end, there came to dominate the consciousness of both Erasmus and Montaigne the same distressing perception—the slow and painful awareness that they were living in a monstrous and unnatural age. The first few pages of Montaigne's essay "Of Physiognomy" are dominated by the sense of outrage, of helpless indignation at the spectacle of his country's brutal civil war:

Monstrous war! Other wars act outward; this one also acts against it-
self; eats and destroys itself by its own venom. It is by nature so ma-
lignant and ruinous that it ruins itself together with all the rest, and
tears and dismembers itself with rage. We see it dissolving of itself
rather than for lack of any necessary thing or through the power of
the enemy. All discipline flies from it. It comes to cure sedition and
is full of it, would chastise disobedience and sets the example of it;
and employed in defense of the laws, plays the part of a rebel
against its own laws. What have we come to? Our medicine carries
infection.

I often doubt whether among so many men who meddle in such a
business a single one has been found of so feeble an understanding
as to have been genuinely persuaded that he was moving toward ref-
ormation by the worst of deformations; that he was heading for his
salvation by the most express ways that we have of very certain dam-
nation; that by overthrowing the government, the authorities, and
the laws under whose tutelage God has placed him, by dismember-
ing his mother and giving the pieces to her ancient enemies to gnaw
on, by filling the hearts of brothers with parricidal hatreds, by call-
ing the devils and the furies to his aid, he could bring help to the
sacrosanct sweetness and justice of the divine word.[38]

This is not only reminiscent of Erasmus, but also of the last
chapter of Machiavelli's *The Prince,* and it looks forward to
the fearful mistrust of civil warfare which informs all of Shake-
speare's early history plays and which was to find its final
philosophical rationale in Hobbes' *Leviathan.* And in some
respects the positive outcome of Montaigne's political philoso-
phy is not unlike that of Hobbes. For despite his mistrust of
theory, Montaigne did indeed produce something very like a
theory—a form of conservatism perhaps more akin to Burke or
T. S. Eliot than to Hobbes, but mistrustful of novelty, innova-
tion, and reform, and grounded in a faith in the virtues of
Catholic and royalist tradition. In the section of the essay "Of
Physiognomy" from which I have quoted, Montaigne recog-
nized that for the last thirty years every Frenchman has daily
seen himself on the verge of the total overthrow of his fortunes,
and for all his stoic resolve can hardly deny the cost to the
repose and tranquillity of his spirit owing to his having passed
his life "amid the ruin of my country." But, participant as he
had been forced to be, his favored role was still that of observer
and commentator:

As I seldom read in histories of such commotions in other states
without regretting that I could not be present to consider them bet-

ter, so my curiosity makes me feel some satisfaction at seeing with my own eyes this notable spectacle of our public death, its symptoms and its form. And since I cannot retard it, I am glad to be destined to watch it and learn from it.[39]

What he learned from the disorders of his age—the lessons of a cynical and realistic politics, an extreme political conservatism, further meditations on the interpenetration of the public and the private—is carefully detailed in his essay "Of Vanity."

This essay reeks with his sense of the corruption of the age—a period in which each individual makes his contribution of treachery, injustice, tyranny, or cruelty, and where it is the common experience to find the laws disregarded, the courts partisan, and the magistrates corrupt. "I see not one action, or three, or a hundred, but morals in common and accepted practice so monstrous, especially in inhumanity and treachery, that I have not the heart to think of them without horror; and I marvel at them almost as much as I detest them." In such a world all utopian reforms seem ludicrous, and those imaginary, artificial descriptions of ideal governments (in which the ancients delighted and over which they exercised their dialectic) prove academic and ridiculous. Montaigne's political position is paradoxical, for in an age which by his own account could hardly be worse, he falls back on the resources of custom and tradition:

Not in theory, but in truth, the best and most excellent government for each nation is the one under which it has preserved its existence. Its form and essential fitness depend on habit. We are prone to be discontented with the present state of things. But I maintain nevertheless that to wish for the government of a few in a democratic state, or another type of government in a monarchy, is foolish and wrong.[40]

In this conservatism the convictions of the humanist habituated to look back to the ancients for the codification of his values come to the support of the natural inclinations of the provincial noble landowner. Nothing presses a state so hard as the appetite for innovation; nothing lends shape so easily to tyranny and injustice as the lust for change. Partial dislocations are difficult and dangerous enough, but with the effort toward total reform comes total injustice. "But to undertake to recast so great a mass, to change the foundations of so great a structure, that is a job for those who wipe out a picture in order to

clean it, who want to reform defects of detail by universal confusion and cure illnesses by death."

His conservatism is radical, for although it does not deny the surgeon's ability to kill the diseased flesh, Montaigne is more skeptical of his ability to make the natural flesh grow again and to restore the part to its former healthy condition. Thus, he equates "change" with "ruin" and finds that the commonwealth of Christendom is crumbling about his ears. That his property of Montaigne has so far escaped pillage and bloodshed in such a stormy neighborhood occasions his profound thanks, but he knows that it is by good luck rather than by justice, and he dislikes a civil necessity which forces him to owe his safety to the kindness and benignity of the great rather than to the equal protection of the laws. "Right" and "authority" should be the backbone of the commonwealth, not "reward" and "favor." But in the general corruption the virtues of the private life are inapplicable to public affairs, and that same sense of the disjunction between private morality and public opportunism rises once again in this essay as it did in "Of the Useful and the Honorable," to mobilize Montaigne's disgust. In the strife that is tearing France to pieces and dividing it into irreconcilable factions he sees that even the best resort not to a pure and sincere virtue but to dissimulation and lying, and he even admits in his own conduct that once, having tried to employ in the service of public dealings ideas and rules of conduct which he had learned in private life, he found them inept if not positively dangerous—as he says, "a scholastic and novice virtue." He has learned that the affairs of the world—practical politics—require "a virtue with many bends, angles, and elbows, so as to join and adapt itself to human weakness; mixed and artificial, not straight, clean, constant, or purely innocent." [41] Again the moral is almost Machiavellian, but unwittingly so, for neither Machiavelli nor Montaigne is without the deeper substrata of values which humanism inherited from the ancient and medieval tradition. Only, the purity and the innocence are lacking, and if these are still discernible in Erasmus, it is surely because of his inexperience with the world of practical politics. They are but the vestiges of some mythical golden age which after the fall, must seem to merely be "a scholastic and a novice virtue."

In this chapter I have tried to compare Montaigne and Erasmus as two possible models of a humanist politics, but not primarily as the representatives of the distinction between political

knowingness and political innocence. Rather, what I have had
in mind is indicated by the subtitle: Erasmus as "Citizen of the
World"; Montaigne as "Citizen of Bordeaux." For, as Erasmus'
personal politics of disengagement expressed itself in the aliena-
tion from birthplace and national tongue, so Montaigne's life
of public officeholding and political involvement finds deep
symbolic expression in his feeling for the French language and
the love and pity and attachment which he feels for the soil of
France and his sense of dutiful loyalty toward the king, who em-
bodies its claim on her sons. On the surface this is not always
clear, for Montaigne was anything but a narrow chauvinist; he
was too steeped in the spirit of Stoic cosmopolitanism not to
profess it in the *Essais* as an abiding ideal and as a personal pre-
dilection. But the professions are sometimes deceptive, and it
is always wisest to note the practice as well as the theory.

Montaigne has told us that as a child he spoke Latin before
he spoke French, and the *Essais* quote lavishly from the Latin
classics. Especially when he speaks of the Latin language is he
all praise.[42] The language of Ovid and Virgil and Lucretius has
no need of the petty conceits and verbal tricks of the vernacu-
lar; it is natural and vigorous, sinewy and solid, and its great
practitioners have given it body less by innovation than by the
muscularity of their usage, stretching, bending, extending it for
their purposes. When Montaigne goes on to compare it with his
native tongue, it is all to the disadvantage of the latter. In
French there is abundant "material," but something less of
"form," and although its native jargon of hunting and war is a
generous soil from which to borrow, and its vocabulary is abun-
dant, Montaigne finds it "insufficiently pliable and vigorous,"
and he says: "It ordinarily succumbs under a powerful concep-
tion. If your pace is tense you often feel it growing limp and
giving way under you, and that when it fails you Latin comes to
your aid." But the very language of the *Essais* gives him the life.
Here are a boldness and a muscularity which can compete with
anything in Horace or Tacitus, with an occasional figure of
speech from Paris, or Bordelaise idiom, or a phrase of Gascon
vintage thrown in. (Montaigne himself says: "I do not avoid
any of the phrases that are used in the streets of France; those
who would combat usage with grammar make fools of them-
selves.") The *Essais* reek of the countryside of Guyenne and the
streets of Bordeaux, and whatever lip service Montaigne as a
good humanist finds it necessary to pay to the language of
ancient Rome, his own speech (unlike the elegant Renaissance

Latin of Erasmus) is redolent of place and rooted in the country of his birth.

Something very similar is true of Montaigne's relationship to place and nationality. He admits to "a greedy appetite for new and unknown things" which from time to time causes him to turn aside from governing his house in order to travel.[43] In principle he considers it a good thing to have before one's eyes that diversity of lives, ideas, and customs which testifies to the perpetual variety of the forms of human nature. And he has excellently stated the maxim of cosmopolitanism which is a bulwark of the humanist tradition: "I consider all men my compatriots, and embrace a Pole as I do a Frenchman, setting this national bond after the universal and common one." Moreover, his veneration for Rome is passionate and romantic: he values it as the only common and universal city where every man is at home, and he glories in the fact that he has been made the gift of honorary Roman citizenship: "Being a citizen of no city, I am very pleased to be one of the noblest city that was or ever will be." [44]

But the evaluation, like the honor itself, is somewhat ceremonial, and Montaigne's veneration for Rome is based on her "meaning" rather than her personality. For elsewhere he cannot restrain his typical Gallic love of Paris, and here the feeling is close, genuine, and intensely personal:

I do not want to forget this, that I never rebel so much against France as not to regard Paris with a friendly eye; she has had my heart since my childhood. And it has happened to me in this as happens with excellent things: the more other beautiful cities I have seen since, the more the beauty of Paris has power over me and wins my affection. I love her for herself, and more in her own essence than overloaded with foreign pomp. I love her tenderly, even to her warts and her spots. I am a Frenchman only by this great city: great in population, great in the felicity of her situation, but above all great and incomparable in variety and diversity of the good things of life; the glory of France, and one of the noblest ornaments of the world. May God drive our discords far from her! [45]

But it is not true that Montaigne is "a Frenchman only by this great city." He is a country gentleman, born and reared in Guyenne, with all the feelings for native soil and real property which this entails, and the *Essais* are studded with frequent and involuntary testimonials to this local feeling. "I am nearly always in place, like heavy and inert bodies. If I am not at

home, I am always very near it." "My father loved to build up
Montaigne where he was born; and in all this administration of
domestic affairs, I love to follow his example and his rules, and
shall bind my successor to them as much as I can." [46] Nor is he
without distinct feeling for the people of Bordeaux, however
paternalistic (and even patronizing) this feeling may be: "I
wish them all possible good, and certainly, had an occasion
arisen, there is nothing I would have spared for their service. I
bestirred myself for them just as I do for myself. They are a
good people, warlike and idealistic, yet capable of obedience
and discipline and of serving some good purpose if they are well
guided." [47] It is impossible to imagine Erasmus writing so of the
people of Deventer or Rotterdam or The Hague, and it defines
the distance between two models of a humanistic politics—the
one rootless and universal, the other anchored to France and
torn between affection and horror for the murderous impulses
of her people.

Erasmus and Montaigne are both humanists: in their com-
mitment to values which transcend national boundaries, in
their faith in a traidition which has deep roots in the ancient
world, in their espousal of a politics of reconcilation. But the
restless mobility of Erasmus, his nervousness before any de-
mand of civic responsibility or political obligation, is countered
by Montaigne's active career as politician, negotiator, and
public servant. Here already is prefigured the eternal humanist
dialectic of political involvement and political withdrawal.
Both Montaigne and Erasmus had a conception of politics
which required that it be broadly humane, but Erasmus' purity
—one would almost say his delicacy before the possibility of
contamination—keeps him from any form of active political
participation. In Montaigne the sense of civic responsibility is
strong, the consciousness of obligation to Bordeaux, to Guy-
enne, and to France is overwhelming, and the long years of
public service which were its consequence moved the political
center of gravity of humanism further away from the library
and the study into the areas of parliamentary debate, civic
administration, and court negotiation. In Erasmus is the purity
of an ideal without practice; in Montaigne is the practice of an
ideal without complete purity. Both represent the politics of
humanism as the sixteenth century gave it birth and be-
queathed it to the mercies of a later age.

Three / The Politics of Shakespeare's Plays

IT IS perhaps necessary to provide a word of
explanation as to why one interested in the politics of human-
ism should turn from Montaigne and Erasmus to the politics of
Shakespeare's plays. Erasmus, despite his gestures of withdrawal,
wrote a political treatise, and he hoped to mediate through rea-
son the political conflicts of his time. Montaigne, jurist, cour-
tier, mayor of Bordeaux, was employed for many years in sensi-
tive political positions, and his *Essais* are studded with the
political meditations which were their consequence. But Shake-
speare was neither a manifest political philosopher nor a practi-
cal politician, but a studied poet, busy actor, successful writer
—the greatest dramatist in the English language.

And yet in the sixteenth century the drama could no more be
divorced from political concern than the informal essay or the
rhetorical epistle. No central European could write without
cognizance of the Lutheran revolution; no Frenchman without
taking some account of the political schism that was devastating
his country; no Englishman without an ever-present awareness
of the threat of imperial Spain and the uncertainty of the
queenly succession. How seriously the great Elizabethans took
politics can be easily learned from a careful reading of Spenser
or Sidney, Bacon or Ben Jonson, and in this respect Shake-
speare is no exception. The drama is by nature topical, for if a
great poet presents in it the outlines of his sense of life, that
sense is rooted in the contemporary, and even where it uses an-
achronistic means, they serve to explicate a political philosophy
relevant to current experience. *Troilus and Cressida* may deal
with the Trojan War, but its conception of "degree" is the very
marrow of Elizabethan political presupposition. *Julius Caesar*
may detail the last moments of republican Rome, but it medi-

tates also on the meaning and the consequences of civil dissension. *Measure for Measure,* set in medieval Vienna, may be founded on an event said to have taken place in Ferrara in the Middle Ages, but its bitter exploration of the contingencies of legal authority constitutes a political statement of the uses and abuses of the law immediately applicable to any exercise of political power.

It is, of course, necessary to distinguish between the merely topical and a considered political philosophy, between the dramatization of political emotions which ignite a popular spark and the systematic portrayal of a consistent political attitude. In 1592, when military expeditions to the continent were still popular in England, Shakespeare's portrayal of the heroic patriotism of Talbot in Part I of *Henry VI* became a mirror of general feeling, but eighteen months later, with the fiasco of the Islands Voyage, military glory began to be regarded with cynical eyes and Falstaff's parody of Hotspur's commitment to honor in Part II of *Henry IV* found popular response. Falstaff's acceptance of bribes to excuse the best recruits for the army was the mirror of a common public scandal, although a year later the fanfare of the departure of the Earl of Essex for Ireland revived a latent patriotism which was to find direct expression in the chorus which preceded Act V of *Henry V* and throughout that heroic play.[1]

In an age without systematic channels of public communication, gossip, rumor, and alarm were constant, and the theater could be a sounding board for public apprehension, just as in an age where political censorship was strict and no free discussion of matters of state was tolerated, men might find in the contemporary drama a subtle political commentary if not an outright criticism. It is now accepted as almost a cliché that for some reason the followers of the Earl of Essex found a curious parallel between the reign of Queen Elizabeth and the story of the deposition of Richard II; that the queen herself recognized this parallel; and that three days before the open proclamation of the Essex rebellion the conspirators with explicit political intentions bribed the Chamberlain's players to act *Richard II* at the Globe.

Shakespeare's fifteen great years between *Henry VI* and *Coriolanus* (1592–1607) were haunted by the ghost of the Spanish Armada, by the threat to Calais from the Spanish in the Low Countries, by rebellion in Ireland and riots in London, and by ever-present anxiety lest the question of the succession should

lead to civil war. It is not to be forgotten that *Richard II* was produced during a year of rioting in London (1595), *Henry V* and *Julius Caesar* in the year of Essex's expedition to Ireland and his disgrace (1599), *Coriolanus* in a year of further troubles in Ireland and riots over the threat of enclosures (1607). And it is noteworthy that although kingship, its duties and responsibilities as well as the problem of loyalty to the sovereign, were constant Shakespearean themes, they do not recur in serious fashion in any play written after the death of Queen Elizabeth in 1603.[2]

All this may be interesting if not obvious, but it does not justify the inference that there is a consistent politics which underlies the whole body of Shakespeare's plays. Topicality may be unavoidable in living drama, but political allusions do not necessarily indicate an unvarying political attitude, and what we need to answer is the question whether there is indeed a "politics" in Shakespeare's plays as there is in those of Schiller or Sartre or Brecht—a depth and consistency of political concern which finds expression in a distinctly political weltanschauung. A.C. Bradley would have answered our question in the negative, for in discussing *Coriolanus* he asserted that a political conflict is never the center of interest in Shakespeare and he seriously doubted "whether any reasonable conjecture as to Shakespeare's political views and feelings could be formed from study of this play and of others."[3] But this is to state the issue at its most problematic, for to seek the playwright's political "views and feelings" is to require an inference from the given dramatic materials as to what they indicate about a personality largely unknown. Such an inference would indeed be dangerous, and it is for this reason that I have purposely chosen to examine not "Shakespeare's politics" but "the politics of Shakespeare's plays." Here we can, I think, agree with Louis B. Wright and Virginia Freund in their introduction to *Henry V*, where, in speaking of the play as concerning events taking place between Lent of 1414 and May, 1420, they say: "Though Shakespeare was not a professor of political science, he was interested in the political problems implied in these episodes of history . . . Indeed, *Henry V*, perhaps better than any of the other history plays, does mirror Elizabethan ideas concerning the ruler, the state, and warfare in the national interest."[4] Whether it is his own unique philosophy or whether it simply "mirrors" Elizabethan ideas concerning "the ruler, the state, and warfare in the national interest" is less important than

whether it is reducible to a pervasive and consistent body of doctrine. And here, I think, our answer may very well be in the affirmative.

The conclusion is therefore that although Shakespeare did not face political problems in the same way as Erasmus and Montaigne, and although he was in no sense a practical politician (except as any man of the theater must be so in his professional dealings), he does express the same kind of humanistic politics—the politics of conservatism. Erasmus' concern for peace and Montaigne's abhorrence of civil war are both based on the values of permanence and security. Shakespeare's own politics represents *the quest for order* and it is stated once and for all in Ulysses' famous speech in *Troilus and Cressida* (I, 3) :

> The heavens themselves, the planets, and this center
> Observe degree, priority, and place,
> Insisture, course, proportion, season, form,
> Office, and custom, in all line of order.
> And therefore is the glorious planet Sol
> In noble eminence enthroned and sphered
> Amidst the other. . . .
> But when the planets
> In evil mixture to disorder wander,
> What plagues, and what portents, what mutiny . . .
> Commotion in the winds, frights, changes, horrors,
> Divert and crack, rend and deracinate
> The unity and married calm of states
> Quite from their fixture? O, when degree is shaked
> Which is the ladder to all high designs,
> The enterprise is sick. How could communities,
> Degrees in schools, and brotherhoods in cities,
> Peaceful commerce from dividable shores,
> The primogenity and due of birth,
> Prerogative of age, crowns, scepters, laurels,
> But by degree, stand in authentic place?
> Take but degree away, untune that string,
> And hark what discord follows. . . .
> Strength should be lord of imbecility,
> And the rude son should strike his father dead;
> Force should be right, or rather right and wrong,
> Between whose endless jar justice resides,
> Should lose their names, and so should justice too;
> Then everything include itself in power,
> Power into will, will into appetite.

And appetite, an universal wolf,
So doubly seconded with will and power,
Must make perforce an universal prey
And last eat up himself. . . .

Dr. Tillyard has made much of the way in which ethics and cosmology here combine to form "the Elizabethan world order," and he has borrowed Lovejoy's conception of "the great chain of being" to explicate Shakespeare's equivalences of hierarchy in the natural and in the social world.[5] No sensitive reader of Shakespeare can be unaware of his constant citation of the correspondences between the cosmos and the body politic, of his political images drawn from the infinite fountain of nature. But what is important is less the cosmology and the imagery than the political awareness which uses them for its purposes. Like Montaigne's enormous fear of "novelties" in politics is Shakespeare's apprehension of the commotions, changes, horrors which may rend "the unity and married calm of states quite from their fixture," and this notion of "fixture" is but the static image of any conservative view of the political life. But the fixity itself is but a hope for the maintenance of hierarchy and degree. No humanistic politics of the Renaissance, whether Erasmus' or Montaigne's or Machiavelli's or Shakespeare's, could free itself from the aristocratic presupposition—from the vision of a state based not on a regrettable, but on a necessary and desirable, social stratification. Hierarchical organization, monarchy, class divisions, inequality; these are the very postulates of the humanistic politics of the sixteenth century. And when T. S. Eliot in a moment of candor alienated most of his literary contemporaries by classifying himself as "classicist in literature, royalist in politics, and Anglo-Catholic in religion," he could have been speaking for Erasmus, Montaigne, and Shakespeare as well as for himself. What has a distinctively reactionary flavor in the twentieth century would have been a matter of common acknowledgment in the sixteenth.

It is necessary to recognize this fact if we are to understand in what sense the politics of Shakespeare's plays, even if it is not a "democratic" one, is still a "humanistic" politics, for there are values in conservatism itself which, as they express themselves in *Richard II* and *Henry V*, *Measure for Measure*, and *Coriolanus*, are worthy of exploration. Marxists who read Ulysses' speech on "degree" can identify all the devices of the reaction-

ary mentality: the horror of change, the equation of justice
with monarchical rule, the reading of inequality into the very
structure of nature and the universe. But they themselves can
be charged with the same errors in reverse: the deification of
change, the equation of justice with proletarian rule, the read-
ing of dialectical development into the very structure of nature
and the universe. I say this not to force a choice between them,
nor to denigrate the validity of the Marxist criticism (for there
is a Marxist humanism just as there is a Shakespearean or an
Erasmian), but to suggest to what extent in these matters we
are the slaves of the zeitgeist and of historical perspective.

Shakespeare's politics expresses *the search for order* as two
hundred years later Schiller's politics was to express *the search
for freedom,* and the consequences are apparent in the contrast
of their respective attitudes. Schiller in *Maria Stuart* presents a
portrait of Queen Elizabeth which no Elizabethan would have
dared to recognize, and in his *Don Carlos* a picture of regal
tyranny (as to some extent Goethe also does in *Egmont*) which
the mind of the sixteenth century would call by another name
and take for granted. But the most marked divergence between
the two types of politics comes in the evaluation of rebellion
and civil war. If "form" and "fixity" are the guide posts of a
rational politics, as the Elizabethans believed, then civil dissen-
sions are the worst that can befall a state, and indeed this is the
political moral of the great Yorkist tetralogy (the three parts of
Henry VI and *Richard III*) which reflects Shakespeare's first
meditations on politics. Therefore it can truly be said that this
tetralogy implicitly expresses the same fear of civil strife and
faith in strong centralized monarchical authority which is to be
supported by all the arguments of philosophical genius by
Thomas Hobbes in his *Leviathan* two decades later.[6] But with
Schiller (and Goethe too) all is different. Monarchical or aris-
tocratic rule easily slides into despotism, and romantic revolt
may be the road to liberty. It is, of course, the experience of the
French Revolution which has made the difference. Shakespeare
and Schiller lie on opposite sides of this great divide in the
history of modern Europe. It is the ideology of the French
Revolution which has forced the revaluation of *civil war as
emancipation,* and if therefore we see the Shakesperean poli-
tics of "degree," "fixity", and "order" as radically conservative,
if not reactionary, it is because we too, no less than the Marx-
ists, are the heirs of the eighteenth century and of a revolution-

ary tradition. But surely there are certain elements in a conservative politics which we may admire, and the search for order no less than the search for freedom has relevance for the constitution of a humane politics. To the expression of this search for order in Shakespeare's dramas I should now like to turn.

It has gradually become clear that the great series of history plays which a young and inexperienced dramatist of twenty-eight began in 1592 and completed in 1599 are political through and through. It was once popular to believe that these eight plays, forming a continuous chronicle of English history beginning with the reign of Richard II in 1377 and ending with the death of Richard III in 1485 (though not, of course, composed by Shakespeare in the order of their historical chronology [7]) were conceived simply as "good Elizabethan theater"—dramatically exciting to the "groundlings" and blood-stirring for the patriots of Tudor England, but without moral continuity or specific philosophical intention. True, some scholars tended to view them in the light of the appraisal of Thomas Heywood, Shakespeare's contemporary, who, in his *Apology for Actors* (1612), wrote of the history plays of his time that they "have made the ignorant more apprehensive, taught the unlearned the knowledge of many famous histories, instructing such as cannot read in the discovery of our English Chronicles. . . . Plays are written with this aim: . . . to teach the subjects obedience to their King, to show the people the untimely ends of such as have moved tumults, commotions, and insurrections, and to present them with the flourishing estate of such as live in obedience, exhorting them to allegiance, discouraging them from all traitorous and fellonous stratagems." Seen in this light the great series, *Richard II, Henry IV, Henry V, Henry VI, Richard III,* if it represents a further impulse of the playwright, must have been consciously chauvinistic; as Tudor propaganda to make an implicit contrast between the miserable past of Plantagenet, Yorkist, and Lancastrian dissension and the admirable Elizabethan present, to sustain obedient enthusiasm for the queen, and perhaps also (as Heywood first suggests), in an age when books were expensive (and few could read, even if they could afford Thomas More's *Life of Richard III* or Edward Hall's *The Union of the Two Noble and Illus-*

trious Families of York and Lancaster), to produce as a kind of Brechtian "living history" the historical epic of the English past.

Much of this may be true, and the three parts of the very early *Henry VI* in particular and even sections of the more masterfully constructed *Richard III* are strikingly formless and episodic, as might indeed be necessary to have the crucial political events of English history between Agincourt and Bosworth Field (1414–1485) crammed into the fading daylight of four London afternoons. But if the three parts of *Henry VI*, followed by *Richard III*, were presented serially in such a fashion, it would at once become clear that this Yorkist tetralogy, taken as an organic whole, does make an explicit political statement, and that Shakespeare's meaning here could be read not simply from the bright rhetoric of the speeches of dukes and kings, but from the very structure of the total plot and the insistent registration of the dramaturgic order. Precisely the same might be said of the later and more structurally perfect Lancastrian tetralogy of *Richard II*, Parts I and II of *Henry IV*, and *Henry V*. It is clear then that Shakespeare's great history plays contain expressions of his political "thought" exhibited both through the patterning of his plots and through the peculiar patterning of attitudes exemplified by the dukes and kings who are the bearers of his message.[8]

When Exeter, functioning like some Greek chorus, ends Act IV, Scene 1 of Part I of *Henry VI* with the words:

> But howsoe'er, no simple man that sees
> This jarring discord of Nobility,
> This shouldering of each other in the Court,
> This factious bandying of their favourites,
> But that it doth presage some ill event.
> 'Tis much, when sceptres are in children's hands;
> But more, when Envy breeds unkind division,
> There comes the ruin, there begins confusion.

it is as if the entire moral of the play had been placed in burning letters long before the bloody conclusion of its last act. When in Part III of *Henry VI* Warwick, dying, displays through his sick heart the vanity of rule in these words:

> These eyes, that now are dimm'd with Death's black veil,
> Have been as piercing as the mid-day Sun,
> To search the secret treasons of the World:

> The wrinkles in my brows, now fill'd with blood,
> Were liken'd oft to kingly sepulchres:
> For who liv'd King, but I could dig his grave?
> And who durst smile, when Warwick bent his brow?
> Lo, now my glory smear'd in dust and blood,
> My parks, my walks, my manors that I had,
> Even now forsake me; and of all my lands,
> Is nothing left me, but my body's length.
> Why, what is Pomp, Rule, Reign, but earth and dust?
> And live we how we can, yet die we must.

it is as if a meditative dramatist had reached outside the frame of power to negate the very pageant which his vision of England's past had created. And when finally Henry V on the eve of Agincourt utters in revery:

> 'Tis not the balm, the sceptre, and the ball,
> The sword, the mace, the crown imperial,
> The intertissued robe of gold and pearl,
> The farced title running 'fore the king,
> The throne he sits on, nor the tide of pomp
> That beats upon the high shore of this world—
> No, not all these, thrice-gorgeous ceremony,
> Not all these, laid in bed majestical,
> Can sleep so soundly as the wretched slave,
> Who, with a body filled, and vacant mind,
> Gets him to rest, crammed with distressful bread;

it is as if the whole royal drama of conscience and responsibility had come to a head in the mortal uncertainty of political crisis. These speeches are the entrance into a mind brooding over an historic panorama which it did not create, and raising questions which it cannot answer even as the historical data which it has appropriated are patterned and controlled by a dramatic impulse concordant with the political myths of its time. Shakespeare's history plays are tantalizing in the implication that they have imposed a controlling idea over a rude multiplicity of historical particulars. What, then, is the nature of this idea?

An older generation of Elizabethan specialists made a persuasive case that this "idea" was none other than "the Tudor myth" itself—the controlling fiction which, beginning with Henry VII, the Tudor dynasty imposed on the somewhat discordant "facts" of the English past to mask the weakness of its claim to the throne by emphasizing its role in the salvation of

the commonwealth from over a century of anarchy, chaos, and misrule.[9] This case was based on scholarly assumptions—by an examination of Shakespeare's source material, of the nature of English historiography in the sixteenth century, by a tracing of the exaggerations and distortions introduced by successive historians from the time when Humphrey of Gloucester commissioned Tito Livio to write the official biography of Henry V (a Latin work translated into English in 1513) through the publication of the second edition of Raphael Holinshed's *Chronicles* in 1587—the work on which Shakespeare is believed to have most immediately drawn. Extremely important was the detailed consideration of the intermediate links in the transmission of the legacy—the definitive forging of the Tudor myth in the complete *English History* of Polidore Virgil of Urbino, commissioned by Henry VII in 1507, Thomas More's *History of Richard III,* which begins the defamation of Richard's character which Shakespeare himself is so enthusiastically to underwrite,[10] and Edward Hall's chronicle of English history from Richard II to Henry VIII, first published in 1548—that epitome of the Tudor view of history whose scope and range were precisely those covered by Shakespeare in his two historical tetralogies. Hall read the chaotic period of English history from the illegal deposition of Richard II to the "benign" assumption of the throne by Henry VII after Bosworth Field as "the hundred years of treason and dissension," brought to an end only by the union of the houses of Lancaster and York in the marriage of Henry VII to Elizabeth, daughter of Edward IV, and in that gracious prince's pursuance of a politics of reconciliation. Shakespeare saw it that way too, and the great speech of Richmond (Henry VII) which concludes *Richard III* is at once the end of his consideration of his nation's history and the apotheosis of that view of its own meaning and destiny which the Tudor dynasty enforced on its innocent subjects.

> We will unite the White Rose and the Red.
> Smile heaven upon this fair conjunction,
> That long have frowned upon their enmity!
> What traitor hears me, and says not amen?
> England hath long been mad and scarred herself;
> The brother blindly shed the brother's blood;
> The father rashly slaughtered his own son;
> The son, compelled, been butcher to the sire:
> All this divided York and Lancaster,

Divided in their dire division,
O, now let Richmond and Elizabeth,
The true succeeders of each royal house,
By God's fair ordinance conjoin together!
And let their heirs (God, if thy will be so)
Enrich the time to come with smooth-faced peace,
With smiling plenty, and fair prosperous days!
Abate the edge of traitors, gracious Lord,
That would reduce these bloody days again
And make poor England weep in streams of blood!
Let them not live to taste this land's increase
That would with treason wound this fair land's peace!
Now civil wounds are stopped, peace lives again:
That she may long live here, God say amen!

It is undeniable that Shakespeare speaks here in accents which Elizabeth herself would have vastly approved, and that they probably found an answering chord in an Elizabethan audience more interested in quiet commercial prosperity and a quotidian peace than in internal political rivalries and foreign adventures. But to assume that they represent the sum and substance of Shakespeare's political message is one-sided indeed. Shakespeare's politics may be congruent with the Tudor myth; it is not exhausted by it, and therefore those older accounts in their careful examination of the sources and of Tudor historiography smell of the airless study and the dusty archives. They tell us of the context within which Shakespeare is embedded. They do not recognize the immediacy with which his history plays speak to a modern audience which has experienced the Spanish Civil War, the Moscow treason trials, the totalitarian police state, and Hiroshima. It has been left for a brilliant Marxist dramatic critic, Jan Kott, member of the Polish Peoples Army and the Polish Underground Movement during the Second World War, and now professor of literature at the University of Warsaw, to exhibit the political meaning in his *Shakespeare—Our Contemporary*.[11]

Kott reads Shakespeare's history plays much as Simone Weil reads Homer's *Iliad*, seeing in them the appeal to naked force which turns the political process into something not unlike Cocteau's *machine infernale*, but with this addition: the incidents of Yorkist and Lancastrian violence are seen as the direct embodiment of contemporary (and therefore of "eternal") political reality. Some years ago a young British actor played Hamlet in careless blue jeans and a black turtleneck sweater,

and a few decades before that, in the heyday of Hitlerian
power, *Julius Caesar* was put on in New York with Caesar
wearing the suggestive dark uniform of a Nazi storm trooper.
But these efforts to play Shakespeare "in modern dress" are
superficial indeed compared with the rigor and obsessiveness of
Kott's Shakespearean interpretation. For by the appeal to mere
costume and spectacle they hope to suggest what Kott discerns
instinctively behind the Elizabethan costumes and the Shake-
spearean diction—the repetitive mechanism of a meaningless
historical process. Thus, without the mediation of devices
which are intrinsically theatrical, he is predisposed to see the
fall of Hastings in *Richard III* like the fall of Beria or Buk-
harin in Stalinist Russia; the execution of Lord Scroop, the
Earl of Cambridge, and Lord Grey in *Henry V* like the execu-
tion of those taken in the unsuccessful plot against Hitler's life.
Kott's sense is not of Shakespeare's historicity but of his *imme-
diacy*.

Shakespeare is like the world, or life itself. Every historical period
finds in him what it is looking for and what it wants to see. A reader
or spectator in the mid-twentieth century interprets *Richard III*
through his own experiences. He cannot do otherwise. And this is
why he is not terrified—or rather, not amazed—at Shakespeare's
cruelty. He views the struggle for power and mutual slaughter of the
characters far more calmly than did many generations of spectators
and critics in the nineteenth century. More calmly, or, at any rate,
more rationally. Cruel death, suffered by most *dramatis personae,* is
not regarded today as an aesthetic necessity, or as an essential rule in
tragedy in order to produce *catharsis,* or even as a specific character-
istic of Shakespeare's genius. Violent deaths of the principal charac-
ters are now regarded rather as an historical necessity, or as some-
thing altogether natural.[12]

But even beyond the "naturalness" of violent death there is
something in Shakespeare's history plays which reinforces
Kott's intuition of the real world. It is the sense of mechanism,
of blind repetitiveness (and therefore of essential meaningless-
ness) which one derives from the great chain of Shakespeare's
history plays in its entirety. Between Richard II and Bosworth
Field is a century of conflict and treason divided almost artifi-
cially into a sequence of reigns. "But when we read these
chapters chronologically, following the sequence of reigns, we
are struck by the thought that for Shakespeare history stands
still. Every Chapter opens and closes at the same point. In every

one of these plays history turns full circle, returning to the point of departure. . . . Each of these great historical tragedies begins with a struggle for the throne, or for its consolidation. Each ends with the monarch's death and a new coronation. . . . But every step to power continues to be marked by murder, violence, treachery. And so, when the new prince finds himself near the throne, he drags behind him a chain of crimes as long as that of the until now legitimate ruler." [13]

One king is murdered in the Tower, another stabbed on the field of battle. Princes in line to the throne are drowned, smothered, or run through with steel. Men confer in secret groups. The Tower awaits new prisoners. Assassins are hired. Some of the dukes are brave, others are cruel, some are cynical and world-weary, a few are demonic. Almost all are ambitious. "But when we finish reading one chapter and begin to read the next one, when we read the Histories in their entirety, the faces of kings and usurpers become blurred, one after the other. . . . And yet emanating from the features of individual kings and usurpers in Shakespeare's History plays, there gradually emerges the image of history itself. The image of the Grand Mechanism. Every successive chapter, every great Shakespearean act is merely a repetition." [14]

It is ironic that Kott, the dedicated Marxist, should discern in Shakespeare's history plays an image of the meaningless repetitiveness of history. For Marxists are trained to view the world—even the capitalist and the aristocratic world—as a manifestation of the Hegelian destiny; of an historical process working itself out toward an imminent and preordained goal. That Kott should find in Shakespeare the historical process, violent and relentless, but without aim, a great machine moving endlessly, and approve, is perhaps a quiet demonstration of the dramatic change in the weltanschauung of the Marxists of central Europe from Marx's quaint nineteenth century optimism to the emotions of an almost existentialist disillusionment and absurdity engendered as much by Stalin's murderous bureaucracy as by Hitler's nightmare police state.

It is quite understandable that Kott in his political realism should be skeptical of an intelligence as sharp as Shakespeare's being taken in by a fiction as patently incongruous with reality as the Tudor myth.[15] For the wise, benevolent, and devout Queen Elizabeth had cut off the head of Mary Stuart when Shakespeare was only twenty-three (five years before he began his *Henry VI*), and was in the process of sending some fifteen

hundred of her subjects to the executioner's block, among them ministers of the realm, doctors of law and of theology, generals, admirals, learned judges, great prelates of the church. With this before the eyes of every discerning Elizabethan, how was it possible for the subtle Shakespeare to see the fifteenth century as a barbarous prehistory whose irrational violence Elizabeth had extirpated in the course of a calm and benevolent rule? But the issue is deeper and more philosophical than this. It is a matter of two divergent dramatic approaches to history.

There are, says Kott,[16] two fundamental types of historical tragedy. The first, which is Hegelian (and also very near to the views of the early Marx), is based on the conviction that history leads in a definite direction. The second, more ancient, but at the same time more modern,[17] originates in the conviction that history has no meaning and is endlessly repeating its cruel cycle before the eyes of the astonished spectators. The first sees tragedy (perhaps as in Brecht's *Galileo* or Schiller's *Don Carlos*) as consisting in the price which the individual pays for being born too early or too late for his time. But the second finds the individual in every age "caught in the works," the victim of a Hobbesian politics which sweeps through its course like some tempest or tidal wave of nature. "It seems to me," says Kott, "that the latter concept of historical tragedy was nearer to Shakespeare, not only in the period when he was writing *Hamlet* and *King Lear,* but in all his writings, from the early Histories up to *The Tempest.*" And this is why he settles on *Richard III* as the very epitome of Shakespeare's political intuition. In *Richard II* Shakespeare exposed the tottering conception of kingly power, but in *Richard III* he showed the crumbling of the entire moral order. *Richard III* is not only the mirror of Machiavelli and the whole modern conception of political expediency and opportunism prefigured, it is also a demonstration, almost geometrical in its neatness, that history is little more than a gigantic slaughterhouse.

Kott's account of the Shakespearean view of politics and of the doctrine of the meaninglessness of history on which it is based is both passionately argued and dramatic, but in the end it is, in my opinion, no more persuasive than the older accounts which viewed Shakespeare as the literal slave of the Tudor myth. The one sees the politics of Shakespeare's plays as too inseparably connected with a propagandistic and clearly articulated pattern of English history; the other sees it as based on no pattern at all except that of the eternal recurrence of irrational

violence. But the exaggerations of each seem to me to be based on an identical error of critical method—that of extrinsic criticism. Dr. Tillyard and Miss Campbell are too antiquarian. They insist on interpreting Shakespeare in the light of the historiography which preceded him. Jan Kott is too modern. He insists on interpreting Shakespeare in the light of the real politics of the twentieth century. None of them addresses himself to the purely internal evidence of the history plays. But if we turn to this latter enterprise for a moment, we shall find, I think, that there *is* a pattern in the history plays, and that this is closer to the Tudor myth than to mere formlessness, although it departs from its purely political (and perhaps reactionary) conception of order in the direction of one more in line with ideal ethical presuppositions.

The basic difficulty with Kott's interpretation of Shakespeare is that he reads the plays atomistically, one by one, as individual rather than as interrelated and as serially presented entities, and this permits him such judgments as preferring the Shakespearean vision expressed in *Richard II* or *Richard III* rather than that in *Henry IV* or *Henry V*. But this eclecticism is logically denied him by the obviousness of Shakespeare's holistic and organic procedure. Shakespeare's essential politics is not to be discerned in *Richard II* rather than *Henry IV*, in *Richard III* rather than *Henry V*, but in all four together—in the pattern which is gradually revealed in the Yorkist and the Lancastrian tetralogies considered as dramaturgic wholes.

In the sense that *Henry VI* and *Richard III* detail the rise and fall of the house of York, and that *Richard II, Henry IV,* and *Henry V* show how out of the deposition of Richard Plantagenet, last of the medieval English kings, came the rise and consolidation of Lancastrian power, it must be admitted that English history, rather than the fortunes of any individual tragic hero, has become the focus of Shakespeare's concern. Despite the fact that Richard II and Richard III are skillfully drawn characters, and that Henry V is given almost epic stature as a landmark in England's past, Shakespeare does not (as Tolstoy and Stendhal did, or as he himself did later in *Troilus and Cressida, Anthony and Cleopatra,* and *Measure for Measure*) use history as a background for tragic action, but rather makes it the center of the play. If, indeed, there is a single historical perspective behind all of the history plays, it is used in the service of an organized political awareness. "History," as a later British historian was to say, "is past politics,' and the rise and

fall of political dynasties pose for consideration all of the classic problems about political power. No one knows this better than Shakespeare. And this is why the history plays (as well as the Roman plays and other complicated masterpieces like *Macbeth, Hamlet,* and *Measure for Measure*) are constantly concerned with such derivative themes as that of the nature of kingly justice, the limits of royal authority, usurpation, the right of subjects to rebel, the relations of politics to the natural and the divine orders, and the political role and status of the lower classes. In the history plays in particular these derivative themes become one prolonged meditation on the nature of kingship.

In every age politics moves in uneasy tension between the poles of morality and legality. There is always the rule of law and custom. And there is always that which outrages the moral consciousness of mankind. The Middle Ages and the Renaissance had their political theorists too, men concerned with the rule of law, the legitimacy of violence, and the nature of divine right. Shakespeare was not a political theorist, but the Yorkist and Lancastrian tetralogies nevertheless present an implicit political theory to be extracted by an examination of the dialectical structure of the plays. For such an examination reveals Shakespeare's consciousness caught up in the perplexities growing out of the three major dimensions of power: its strength, its constitutional legitimacy, and its moral validation.

The first part of *Henry VI* lacks dramatic unity. It is episodic, as is not unnatural considering its source in the chronicles of the Hundred Years War. It seems clear that Shakespeare has included episodes which should elicit either the delight or recognition of his audience: Joan of Arc picking out the disguised Dauphin among the throng of French Nobles, the death of Salisbury at the siege of Orléans, Talbot outwitting the Countess of Auvergne, the heroic but needless death of Talbot and his son before Bordeaux, the excitement of the confrontation of York and Somerset in the rose garden, which Shakespeare invented to dramatize the conflict between Lancaster and York. Lacking the classic logic of tragic plot construction, the complication, climax, and denouement which since Aristotle had been the means for generating dramatic excitement, Shakespeare in *Henry VI* uses the more *ad hoc* device of dialectical opposition—of antagonistic forces in constant confrontation. England against France is the central opposition, symbolized in the struggles between Talbot and Joan of Arc; but as the play progresses, the more fateful oppositions of internal

dissension become the center: Gloucester against Winchester, Richard of York against Somerset, the red rose of Lancaster against the white rose of York. And the death of Talbot through the desertion and neglect of Somerset and Gloucester and the humiliating peace which England is forced to conclude with France point up the tragic moral of internal disorder. England's glory falls before the "jarring discord of nobility," the triumphs of the short-lived Henry V are dissolved in the womanly weakness of that "effeminate Prince," Henry VI. Henry VI himself, who gives the play its title, does not appear before the third act, and in his first appearance shows his incapacity to curb the violent passions of his powerful uncles.

> Uncles of Gloucester, and of Winchester,
> The special Watchmen of our English Weal,
> I would prevail, if prayers might prevail,
> To join your hearts in love and amity.
> O, what a scandal is it to our Crown,
> That two such noble Peers as ye should jar?
> Believe me, Lords, my tender years can tell,
> Civil dissension is a viperous worm,
> That gnaws the bowels of the Commonwealth.

The perception is acute—in fact, like Exeter's speech later, it points the moral of the play—but force of will, the power of personality to resolve the discord is tragically lacking.

The second part of *Henry VI* continues the recital of civil discord, showing it as it gradually seeps down from the lords to their serving men, and at last breaks out in an open insurrection of the lower classes—Jack Cade's rebellion, which occupies all of Act IV, the longest single sequence of the play. The discontent of the nobility is still the generating center although the alignment of antagonisms has shifted somewhat. Henry's strong, ambitious, and unsympathetic French queen and Suffolk represent one faction, Humphrey, Duke of Gloucester, and his ambitious wife another. But the real new power is that of Richard of York, who now (II, 2) openly asserts his claim to the throne through descent on the female side from the third son of Edward III, Lionel, Duke of Clarence, and is supported in his claim (quiescent for the moment) by Salisbury and his powerful son Warwick. These three agree to bide their time in the face of Suffolk's insolence, Beaufort's pride, and Somerset's ambition until these have worked the ruin of the weak and

virtuous Henry VI. By the time Cade's rebellion has been put
down, this is accomplished, and York can rise in open mutiny
and defiance, killing his major enemies and causing the timid
king to flee. The last act ends as he wins the Battle of St. Albans
(1455) and stands resolutely in line for the English throne.
Thus the theme of the work is the fall of Humphrey of Glouces-
ter and the rise of Richard of York against a background of
general restlessness and the weakness and incompetence of the
legitimate king.

Two things of political interest stand out in this play: the
ironic and contemptuous portrayal of the lower classes in rebel-
lion, and the mounting images of upper class violence. Jack
Cade, who in actual history was a man of some consequence,
reflecting certain legitimate grievances against the general dis-
order and joined sympathetically by certain country squires
and members of the lesser nobility, is here a mere caricature—
an ignorantly inflated clothier, advocating a crude commu-
nism, a meaningless license for all, and a violent overthrow of
the current regime for its own sake. His anti-intellectualism is
directed against all those guilty of the crime of being able to
read and write; a man is in league with England's enemies if he
is able to speak French, and is self-convicted of traitorously
corrupting the youth of the land by erecting a grammar school.
Under the reign of Cade the realm will be held in common, all
will be maintained at public expense, money will be abolished,
but also kitchen pots will be capriciously redesigned, the drink-
ing of beer will be interdicted, the public sewers will run claret
wine for a year, all public records will be burned, all will be
dressed in the same livery, and Cade himself will rule like a
king, stabling his horse in the heart of the city and sampling
every maid before she is married. In short, the redress of lower
class grievances and the prospect of lower class power mean the
ascension of the demagogue and the loud misrule of chaos.

Is Shakespeare here, as usual, losing no opportunity for
comic relief at the expense of the artisan class? Is he simply and
unconsciously mirroring the ultraconservative bias of the
Tudor myth? Or is he perhaps exhibiting the curious defensive
antagonism of his small-town Stratford youth, spent in the
company of sons of petty craftsmen, against the class from
which his own father had probably emerged? There is no defin-
itive and satisfactory answer, but there is no doubt that in the
Jack Cade scenes of *Henry VI* the mood shifts between the

humor which Shakespeare was later to invoke through the artisan class in *A Midsummer Night's Dream* (1595) and the contempt for it so characteristic of the Roman plays, *Julius Caesar* (1599) and *Coriolanus* (1607). The problem of the portrayal of the populace in Shakespeare's plays is complex and difficult but its careful tracing would afford, I think, one clue to the nature of his political presuppositions.[18]

The second part of *Henry VI*, even more than the first reflects an increasing tempo of internal violence. Gloucester is murdered. Suffolk is put to death on his way to exile. Cade strikes off the head of Lord Say and is, in turn, run through in Iden's garden. York kills Clifford, and Richard of York kills Somerset in the Battle of St. Albans. But for all of this we have been prepared by the early imagery of the play. Scenes 1 and 2 of Act III abound in the metaphors of malevolent nature. The queen compares Gloucester to a crocodile or a poisonous snake rolling in a bed of flowers. York speaks of him as a hungry eagle placed to guard a chicken. Suffolk compares him to a fox, enemy to the flock, his chaps stained with crimson blood. The serpent's sting, a scorpion's nest, the Commons "like an angry hive of bees," a serpent with forked tongue, murdering basilisks, lizard's stings, the serpent's hiss, and brooding screech-owls make their way one after another into the speeches of the king, the queen, Warwick, Suffolk, and Salisbury, to paint a nature "red in tooth and claw" as mirror of the sinking commonwealth. Young Clifford in the last act, entering the field of civil war to find his father dead, declares his vengeance:

> O War, thou son of hell,
> Whom angry heavens do make their minister,
> Throw in the frozen bosoms of our part
> Hot coals of vengeance. . . .
> O let the vile world end,
> And the premised flames of the last day,
> Knit earth and heaven together. . . .
> My heart is turn'd to stone; and while 'tis mine,
> It shall be stony. . . .
> Henceforth, I will not have to do with pity. . ..
> In cruelty, will I seek out my fame. . . .

And as if in measured antiphony his enemy, Richard of York, enters to speak a final battle invocation which is at once a

taunt, a judgment of the gentle pious king, and the ruling
temper of the entire play:

> Sword, hold thy temper; heart, be wrathful still:
> Priests pray for enemies, but Princes kill.

"Princes kill"—if this sums up the deepening violence of the
second part of *Henry VI,* it holds also for the third, which
shows the entire nation plunged into the miseries and cruelties
of civil war. Before Parliament, under threat of violence,
Henry VI resigns the succession to Richard of York and his
sons, on condition that York swear to continue to serve him for
his lifetime and to end the civil war. But under the urging of
his sons Edward and Richard, York breaks his oath, the war is
resumed, and York's forces and Queen Margaret's meet. Clif-
ford mercilessly stabs the boy Rutland, youngest son of York,
and York himself is taken by the royal forces, mocked with the
death of his son, crowned with a paper crown, and then also
stabbed to death by Clifford and Northumberland. York's sons,
learning of their father's death, band together with Warwick
and meet the king's forces at the Battle of Towton and it is here
that in a famous scene (II, 5) Shakespeare shows at once the
gentle and meditative nature of Henry VI and the ultimate
horrors of civil warfare. Sitting on a molehill apart from the
battle, the king yearns for a quiet and bucolic life away from
the cares and responsibilities of kingship when he is joined by
two wildly grieving men—a son who has killed his father in the
battle and a father who has killed his son, and the three hold
what is virtually a ritual lament against the internecine miser-
ies of civil war. The son recognizes the corpse of the father he
has slain and the king cries out:

> O piteous spectacle! O bloody times!
> While lions war and battle for their dens,
> Poor harmless lambs abide their enmity.
> Weep, wretched man: I'll aid thee tear for tear,
> And let our hearts and eyes, like Civil War,
> Be blind with tears, and break o'ercharg'd with grief.

A father enters bearing the dead body of his son and repeats:

> O pity God, this miserable Age!
> What stratagems? how fell? how butcherly?

> Erroneous, mutinous, and unnatural,
> This deadly quarrel daily doth beget?

It is a scene of lamentation and pathos in which the gentle and sympathetic king joins in the wild grief of his bereaved subjects. But the ultimate irony is not lost, and the political message glimmers through the tragic mist. Had Henry VI been less gentle and less desirous of the scholarly and pious life this civil dissension might never have arisen. The weak and sympathetic monarch is himself finally responsible for the bloody carnage at which his heart quails and his eyes shed tears.

Although it comes in the second act, this scene is in many ways the moral climax of the play and the remainder mere denouement, continuing the slaughter, further reducing Henry VI to a cipher, and setting York's eldest son on the throne as Edward IV. But despite the fact that in actual history this king enjoyed a long and relatively prosperous reign (1461–1483), Shakespeare is basically uninterested in him, and his reign seems brief and insignificant. His hesitation in proclaiming himself king emphasizes his weaker side, and his romantic and politically indiscreet marriage to Lady Elizabeth Grey is used primarily to set the historical stage for the next play to come. There can be little doubt that the remainder of *Henry VI* is simply a vehicle to establish the rising power and consummate villainy of Richard of Gloucester, York's younger son and brother to Edward IV. As early as the third act (scene 2) Richard makes his famous speech in which he dreams of sovereignty, descants on his physical deformity, asserts his insatiable thirst for power, declares his determination to hew his way to the English crown with a bloody ax if necessary, and proclaims himself the sly, dissembling, and smiling murderer who could "set the murderous Machiavel to school." It is clear that out of the chaos of Henry VI's gentle incompetence is emerging a demonic figure of great political self-assertiveness and moral evil. Thus the primary function of the remainder of *Henry VI* is to concentrate the bloody violence of civil dissension and political struggle, so long dispersed among the nobility of the commonwealth, in the single person of Richard of Gloucester. It is he who stabs Prince Edward, son of Henry VI, at the Battle of Tewksbury, he who in person murders the deposed and imprisoned Henry in the Tower in the penultimate scene of the last act. The play closes in uneasy quiet with Edward IV sitting on the royal throne "repurchased," as he says "with the blood

of enemies," and ironically feeling secure that he has "swept suspicion from our seat," and that he has "my Country's peace and Brother's loves." But it is an irony which is lost neither on Shakespeare nor his audience. The end of *Henry VI* is but the prelude to *Richard III,* the ominous calm before the cataclysmic storm.

Let us turn to the sequel. Of all Shakespeare's plays perhaps only *Hamlet* has generated more critical excitement, drawn more various and contradictory contemporary interpretations than *Richard III.* The play is early, its basic plot is of a simplicity bordering on melodrama, and yet its ambiguous atmosphere, suggesting some strange amalgam of Aeschylus, Seneca, Plautus, and Marlowe, has precipitated a flood of modern critical interpretations. Coleridge and Masefield [19] see in Richard the terrible consequences of powerful and self-confident intellect. Dowden [20] transforms this into a demonic intensity of will in one who is "an intense believer in the creed of hell." Sir Edmund Chambers [21] finds two motives in the play: the theme of moral retaliation, which makes this a play of fateful Nemesis, and the portrayal of the political life according to the cold-blooded doctrines of Machiavellian statecraft which issues in sheer joy in the technique of villainy, but he also adds the undoubted insight that Richard III is a consummate *actor,* manipulating persons with enormous artistry and with a powerful rhetoric at his constant command. Tillyard [22] combines the Nemesis theory with Shakespeare's commitment to the Tudor myth, thereby making the play's chief end "to show the working out of God's will in English history." Kott,[23] denying this, as we have seen, all unknowing makes a return to one of the themes of Chambers: *Richard III* as the crumbling of the entire moral order, the mirror of a Machiavellian statecraft, and a demonstration of the ultimate meaninglessness of history. And A. P. Rossiter [24] adds another variation to the theory of Richard as actor which Chambers had suggested earlier. He thinks that between Part III of *Henry VI* and *Richard III,* Richard of Gloucester has "grown a new dimension—that of mocking comedian," part symbol of evil, part comic devil, "and chiefly, on the stage, the generator of roars of laughter at wickedness." This interpretation makes a good third of the play into a kind of grisly comedy "in which execution is the ultimate and unanswerable practical joke." It is obvious that Sir Laurence Olivier's *Richard III* owes much to Rossiter, and also that there is a certain sardonic resemblance between Kott's view and

Rossiter's, but in the end neither has come as close to the actuality of the play as the older theory of a moral Nemesis in the service of the Tudor myth. For this theory permits us to derive from the Yorkist tetralogy as a whole the ultimate moral of a dialectical politics.

I have no intention of returning to the well-known content of the play. It is only necessary to remember how it ends, with Richard dead at Richmond's hands, and to note the importance which Shakepeare attributes to the latter's few appearances in the body of the tetralogy. In Part III of *Henry VI,* in a scene so fragmentary that it often goes unremarked (IV, 6, one which Shakespeare may just possibly have inserted in the play after the writing of *Richard III*), Somerest introduces the youthful Henry, Earl of Richmond, to Henry VI and the latter intones prophetically (if somewhat irrelevantly to the business at hand) :

> Come hither, England's Hope:
> (*Lays his hand on his head.*)
> If secret Powers suggest but truth
> To my divining thoughts,
> This pretty Lad will prove our Country's bliss.
> His looks are full of peaceful majesty.
> His head by nature framed to wear a Crown.
> His hand to wield a Sceptre, and himself
> Likely in time to bless a Regal Throne:
> Make much of him, my Lords: for this is he
> Must help you more than you are hurt by me.

In *Richard III,* although his hovering offstage presence haunts the play, Richmond does not actually appear until his call to arms in the last act, and his meditation on the eve of the Battle of Bosworth Field, his prayer to God (V, 3) :

> O Thou, whose captain I account myself,
> Look on my forces with a gracious eye:
> Put in their hands thy bruising irons of wrath,
> That they may crush down with a heavy fall
> The usurping helmets of our adversaries;

exactly anticipates and parallels that which Shakespeare is to put into the mouth of the epic hero Henry V before the Battle of Agincourt (*Henry V,* IV, 1) :

> O God of battles, steel my soldiers' hearts,
> Possess them not with fear! Take from them now

> The sense of reck'ning, if th' opposed numbers
> Pluck their hearts from them.

Richmond's oration to his soldiers does justice at once to the sacredness of his cause, to the official view of Richard III, and indicates the extent to which the Tudor ideology, looking askance at the deposition of Richard II, could yet justify the right of deposition against tyrants who had usurped the throne. Here already is prefigured that concern with the issue of legitimacy which the Lancastrian tetralogy is soon to take up and exploit.

> God and our good cause fight upon our side:
> The prayers of holy saints and wronged souls,
> Like high-reared bulwarks, stand before our faces.
> Richard except, those whom we fight against
> Had rather have us win than him they follow.
> For what is he they follow? Truly, gentlemen,
> A bloody tyrant and a homicide;
> One raised in blood and one in blood established;
> A base foul stone, made precious by the foil
> Of England's chair, where he is falsely set;
> One that hath ever been God's enemy,
> God will in justice ward you as his soldiers;
> If you do sweat to put a tyrant down,
> You sleep in peace, the tyrant being slain.

The political meaning of *Richard III* is not to be found in its beginning or its middle, but in its conclusion, for this is what permits us to see that Shakespeare's argument concerning ideal kingship is contained (in its moral segment) in the dialectical progression of Henry VI, Richard III, Richmond (Henry VII), and that it provides a commentary on the necessary strength of power and its moral validation. Henry VI is pious and good, but his weakness violates every practical demand for a strong central authority to ensure political order. Richard III is demonically strong, with a will of iron, but his ends are questionable and his means thoroughly evil. Under each the commonwealth suffers an equal but opposite defeat. But Henry VII (Richmond), we are to believe, combines the lacking qualities of both. He has Richard's powerful will to be exercised in the service of the commonwealth. He has Henry's good intentions, but with the ability to give them embodiment. Thus Shakespeare's political position is clear. In Henry VI resides an irrele-

vant virtue; in Richard III, an inadmissible vice. The ideal politics is that of Henry VII, and if one asks why Shakespeare never produced a history play dealing with the reign of this king, the answer is easy enough. When three years later he turned to consider the fortunes of the house of Lancaster, and after three years completed that tetralogy with the idealized portrait of Henry V, he would have found the task redundant. For in *Henry V* he had, on a heroic canvas and in bravura colors, explicitly painted the political ideal of successful kingship which the rough preliminary sketch of Richmond in *Richard III* is meant to suggest.

The problem of politics is the problem of power, and the moral problem of politics is the problem of the moral uses of power. In the Yorkist tetralogy, Shakespeare's political universe therefore has two axes: that of "strength—weakness" and that of "goodness—evil," and the way in which these two intersect constitutes the clue to his reading of English history from the death of Henry V to Henry Tudor's accession to the throne. But when in 1594 or 1595 Shakespeare, after an excursion into romantic comedy (*Two Gentlemen of Verona, Love's Labour's Lost*) again turned to chronicle history and its political implications, his concern was less with "morality" than with "legality," and also less with those offenses of a king which might affront the common moral consciousness of mankind than those which indicated administrative incapacity for the role of kingship. This too is a deeply political preoccupation. Power is exercised by men, and when men's authority is in question it is either because of some doubts concerning the legitimacy of their right to rule or some demonstrated lack of that personal authority which is indispensable in leadership. Shakespeare's political universe has another dimension—that of "usurpation —legitimacy," a dimension which, in the case of a society still dominated by a feudal theory of the divine right of kings, roots politics no less in the divine intentions and in the order of nature which deity has in consequence established than in the more prosaic relations of property ownership and social stratification, and his reading of English history from the late Middle Ages to the Battle of Agincourt is dominated by the twin problems of kingship: personal competence and legal right. Shakespeare's Lancastrian tetralogy, *Richard II, Parts I and II of Henry IV,* and *Henry V,* no less than his first, will be found to have a profoundly dialectical structure, although in this case that structure will emerge in the course of his determined

explorations of the relation between personal authority and legal legitimacy in the exercise of royal power.

Richard II has exercised a particular fascination over commentators on the history plays—and for good reason. The gorgeousness of its language (not unnatural since its title figure is a poet manqué), its quasi-medieval pageantry (borrowed in part perhaps from Berner's Froissart, as Tillyard has suggested), and the formal ceremony at once of its verse forms and the occasions of its plot (the tournament without action, the deposition scene, Richard's parting from his queen, and even his grief at Pomfret are all hardly more than ceremonious occasions) all seem to show Shakespeare and with him Elizabethan England taking regretful leave of the colorful medieval past. But this has its political implications also. In no other play of Shakespeare's is there such explicit reference to the doctrine of the divine right of kings, and since this doctrine is placed in the mouth of one whose personal qualities make him obviously unfit to rule, the political paradox is stated at its boldest.

Even as sober an historian of medieval political theory as Ernst Kantorowicz [25] makes constant reference to the medieval elements in Shakespeare's play: to the concept of the king *Dei gratia,* to the problem of his arbitrary acts, and to that of the change of sovereigns under circumstances of stress. And he shows, too, how the concept of legitimacy has its mystique—its justificatory metaphysics (or "theology" as he calls it) which passes an uninterrupted legacy to the Elizabethan age. Kantorowicz quotes a little known Elizabethan text, Plowden's Commentaries, to show (in another connection) the political presupposition which underlies the tragedy of *Richard II:*

The king has in him two Bodies, a Body natural and a Body politic. His Body natural is a body mortal, subject to all infirmities that come by Nature or old Age . . . But his Body politic is a body that cannot be seen or handled, consisting of Policy and Government and constituted for the Management of the public weal and this Body is utterly void of Infancy and Old Age and other natural defects . . . and for this cause what the king does in his Body politic cannot be invalidated or frustrated by any disability in his Body natural . . .[26]

Richard's "body politic" is based on "fair sequence and succession," as York early in the play asserts. For Shakespeare and

Elizabethan England could not forget that he was the last of the medieval kings—the last, that is, to rule by hereditary right stretching back at least as far as the Norman Conquest. With his deposition at the turn of the fourteenth century the inherited certainties of "fair sequence and succession" come to an end. The kings of England for the next three hundred years are essentially kings "made," not "born," successful usurpers or the sons and grandsons of successful usurpers who owe their rulership to powerful noble supporters, the consent of a weary Parliament, and the desperation of a citizenry fearful of the dislocations and disruption of civil war. There is certainly a strong element of pathos in *Richard II* and this grows in large part out of Richard's sensed contrast between the eternity of his right and the ephemeral nature of his actual tenure, between his blustering and self-deceptive speech:

> Not all the water in the rough rude sea
> Can wash the balm off from an anointed king.
> The breath of worldly men cannot depose
> The deputy elected by the Lord.

and his bitter and ironic meditation on mortality:

> For God's sake let us sit upon the ground
> And tell sad stories of the death of kings!
> How some have been deposed, some slain in war,
> Some haunted by the ghosts they have deposed . . .
> . . .for within the hollow crown
> That rounds the mortal temples of a king
> Keeps Death his court; and there the antic sits,
> Scoffing his state and grinning at his pomp . . .

Richard's "body politic" may claim the eternal tenure of divine sanction, but his "body natural," with all that belongs to it of greed, weakness, and administrative incapacity, holds within it the seeds of his deposition. John of Gaunt on his deathbed has foretold that "His rash fierce blaze of riot cannot last"— that the vanity and extravagance, the expenditures on brocades and velvets, lascivious music, and the latest fashions from Italy will take their toll in human carelessness, economic injustice, and general misrule. And in fact the valid charges against him —that he is basely led by worthless flatterers, that he has unjustly fined and taxed nobles and commons alike, not for public benefit but for private extravagance—are substantiated by his

unlawful confiscation of Bolingbroke's lands, money, and goods, which is the initiation of his downfall. And yet, not even his enemies dare claim that his deposition is legal. Shakespeare and sixteenth century English historiography with him see the subsequent political events as haunted by a sense of wrongfulness and guilt, that with Richard II the king's eternal body is in fact suborned by the defects of his natural qualities.

It is characteristic of Shakespeare's history plays that they deal with thought and feeling less than with action, and that the test which they propose for ideal kingship lies in the realm of deeds rather than words. We have already seen in Henry VI the royal saint baffled by action—the meditative man incompetent in the practical mastery of the world. Shakespeare's contrast between Richard and Bolingbroke, which is always (and rightly) seen as the very center of *Richard II,* reiterates the same moral, but in this case political weakness is equated not with moral blamelessness but with an aesthetic approach to the world. Shakespeare's Richard II is a poet, enamoured of the show of things, aesthetic surfaces, the forms and the ceremonies, the pageants and celebrations severed from the significances which they cloak and the events which they celebrate. And his love of language too shows a dreamlike immersion in sounds and gesticulations for their own sakes. What he lacks are political competence and moral seriousness; qualities which appear here in Bolingbroke (the future Henry IV) in abundant measure.

Bolingbroke's triumphant seizure of the throne and Richard's deposition symbolize (as Chambers has seen) [27] "the triumph of efficiency over imagination," of pure practicality over the aesthetic way of life. But this registers not only a philosophical conflict but a sociological event of real magnitude. The world of medieval pomp has already been replaced by a more commonplace, a more practical, a more commercially oriented universe—one shared in by the dramatist, who is soon to be a solid Stratford landowner, and the prosperous Londoners [28] who flocked to his portrayals of England's historical past. Shakespeare's portrayals of Henry IV (both in *Richard II* and in Parts I and II of *Henry IV*) show him rich in the virtues of prudence, economy, decisiveness, and judgment, but with little culture and little heart. As for subtlety of intellect or depth of imagination, they are beyond him.

It is clear that Shakespeare has judged Henry IV, and found his kingship wanting, not so much out of nostalgia for the

qualities of Richard II as out of the sense of wrongfulness and regret that this rule cannot be sanctioned by legitimacy, and in this the spirit of the medieval past lingers to take its revenge even on the pragmatic age which has supplanted it. Toward the end of *Richard II* (IV, 1) the Bishop of Carlisle prophesies the disorders and mutinies which will follow if Bolingbroke is proclaimed king, and Part I of *Henry IV* fulfills this prophecy, showing the rebellion of the Percies (only finally resolved on the field of Shrewsbury) and the king now much aged, shaken, and worn with care as the result of the administration of a kingdom which is not his by right. The unweeded garden of *Richard II* has become the furious nature of civil butchery, and Worcester and Northumberland, Mortimer and Glendower have arisen to revenge the usurpation of the unloved king. That they fail is for him no vindication. Part II of *Henry IV* continues with the fatal legacy. The sleepless king (III, 1) bemoans the sickness in the body politic and recollects that it was foretold by the deposed Richard. The Archbishop of York, a subject who acknowledges the sacredness of kingly power yet is galled by its abuse, finds in the wrongs and diseases of the commonwealth the apology for armed insurrection. Throughout, the atmosphere of the play is one of uneasiness, unrest, and political disorder.

In purely political terms the two parts of *Henry IV* play a strictly intermediate and transitional role. They look back to the unlawful deposition of *Richard II* and they look forward to the ideal kingship of *Henry V*. They detail the atmosphere in which Henry IV reaps the fruits of his usurpation and in which the young Prince Hal gains that education in humanity which is to fit him for kingly rule as neither ambition nor practicality fitted his father. His victory over Hotspur, his seeking for experience even among the most dissolute of his future subjects, and his final submission to the stern righteousness of the Lord Chief Justice are stages in the education of a Christian prince which even an Erasmus could not have foreseen, for they are based not on *the precepts* of Plato and the New Testament, but on *the example* of trial in battle, of the revealing company of bawds and thieves, and the recognition of a legal authority based on immemorial demands for established order. It has sometimes been objected that there is an implausible discontinuity between the sober achievement of Henry V and the wild, youthful Prince Hal, whose escapades are the juice and joy of those who read *Henry IV,* but it can be argued that the very purpose of

Henry IV is to display the realistic stages in the "progress from
dissolute heir apparent to responsible monarch." [29] What might
seem like "moral regeneration" is, in fact, simply "a growth in
political understanding," and the development of Prince Hal is
the study of a political education in the achievement of that
personal authority which grows out of a deep knowledge of
every social stratum of the commonwealth. The turpitude and
irresponsibility which he experienced in the taverns and bordel-
los of Eastcheap were but metaphors for that general disorder
which grew out of his father's usurpation; but to learn this
lesson of social disintegration, Shakespeare seems to be imply-
ing, is the first step in the achievement of responsible sover-
eignty.

Many commentators have (mistakenly, I think) found a
falling-off in the dramatic quality of *Henry V* as compared to
that of its two predecessors, but there seems to be little doubt
that in this play Shakespeare is presenting his (and England's)
epic specifications for ideal kingship. In the very first scene the
Archbishop of Canterbury and the Bishop of Ely attribute to
him qualities of piety, scholarship, political judgment, and
martial talent—a man in whom the theoretical and the practi-
cal are united, "full of grace and fair regard." His response to
the French ambassador:

> We are no tyrant, but a Christian king,
> Unto whose grace our passion is as subject
> As is our wretches fett'red in our prisons.

states his quality admirably; not merely that he is a Christian
monarch, but that he demonstrates to perfection how in the
figure of a king must lie a natural congruence between the
personal and the political quality, submission of the people to
constituted authority, submission of kingly passion to the dic-
tates of natural reason.

In no other play (except perhaps in a less serious context in
Measure for Measure and *Coriolanus,* and the passage from
Troilus and Cressida already quoted) does Shakespeare state so
clearly the organic theory of the political state, whose necessary
division of labor suggests analogy with the animal world:

> For government, though high, and low, and lower,
> Put into parts, doth keep in one consent,
> Congreeing in a full and natural close,
> Like music.

> Therefore doth heaven divide
> The state of man in divers functions,
> Setting endeavor in continual motion;
> To which is fixed as an aim or butt
> Obedience; for so work the honeybees,
> Creatures that by a rule in nature teach
> The act of order to a peopled kingdom.

To "teach the act of order to a peopled kingdom"—this also is the vocation of the ideal monarch, and the perennial theme of the Shakespearean politics—the quest for order—returns here to show itself as the underlying motive in the definition of ideal kingship. The notable achievement of Henry V is the establishment of an order based on consecrated authority, and that this is crowned by victory in France is more a consequence than a direct aim. Shakespeare is primarily interested in the conditions of kingship, not the results, and this means, I think, that what takes place on the eve of Agincourt is for him more important and more significant than the overwhelming victory on the field the following morning. For that serious and moving conversation between the disguised king and the three lowly soldiers, John Bates, Alexander Court, and Michael Williams, in the night before the battle is a scene almost unique in Shakespeare, where a king sits and speaks with commoners in a dialogue which dignifies and does honor to the common reason of them both. It deals with the problem of might and right, and of the responsibility of those who give orders and of those who obey, and it is one of the few scenes in Shakespeare where simple subjects are given the dignity of serious argument and moral concern. Most of Shakespeare's common folk are flawed with coarseness and stupidity. Most of Shakespeare's kings are shrouded by the pathos of distance. That Henry V can sit thus and speak thus is a tribute to that humanity which he has learned less from his cold-blooded father than from Bardolf and Pistol, Mistress Quickly, and, of course, Falstaff.

Henry V is blessed with a sense of reality which is completely lacking in Richard II, and the human quality sufficient to command the love and respect of his subjects, totally missing in his father Henry IV; and in this implicit contrast too is revealed the political dialectic of the great Lancastrian tetralogy. With a logic almost Hegelian, Shakespeare has stated his political message. Richard II has legal legitimacy without question, but he lacks personal authority. Henry IV has both personal

authority and practical competence, but the stain of usurpation spoils his reign. Henry V possesses both the legitimacy of an enthusiastic commonwealth and the personal authority of a strong leader knowledgeable of the thoughts and feelings of his subjects. In the orderliness of his personal self-control lies the promise of a sustained order in the body politic.

The heart of Shakespeare's politics lies, I am convinced, in the history plays which occupied him almost continuously from 1592 to 1599. For this there may be several reasons. It was a period of political unrest in Elizabethan England, which might for an artist be reflected in the political preoccupation of his work. And the chronicle sources to which he turned—Hall and Holinshed—themselves held to a view of history which was at once political and didactic—to see the English historical past as a source of political principles which should have relevance for the Tudor present. The next serious play to which he turned his hand was *Julius Caesar* (also dating from 1599 and probably immediately following *Henry V*), and although this, too, is in a very real sense a political play, in it are already to be found tendencies which are to lead Shakespeare away from the external realm of political action to the more hermetic universe of conscience, moral meditation, and *Innerlichkeit*.

It is tempting (for purposes of simplicity) to find this change in atmosphere attributable to the change in sources. For Shakespeare found the theme of *Julius Caesar* in Plutarch,[30] and Plutarch is not really an historian, but a moralist. His primary interest is not in politics or the fortunes of republican and imperial Rome, but in personal character and individual action, the motives for action, and how the consequences of these actions exhibit the advance of moral values in an indifferent world. His interest in "policy" is (as Gilbert Murray said of Aristophanes) not so much in its material results as in its spirit, and in the spirit of those by whom it is proclaimed: their sense of duty or justice or humanity, their arrogance or grace in the enjoyment and exercise of political power. His mind is geared to the ethics of Aristotle rather than to the organic politics of Plato.

But there is another possibility also, and it has been put forward in Granville-Barker's famous essay, "From *Henry V* to *Hamlet*," [30] which discovers the clue neither in the nature of the times nor in the shift of sources, but in the very logic of Shakespeare's craft and experience as a dramatist. In *Henry V*, so the argument goes, Shakespeare went as far as a dramatist

can in the presentation of the successful man of action, but what we feel lacking in this play nonetheless is some spiritually significant idea, some deeper dimensionality in the character himself. And so, when he turned to *Julius Caesar* with the whole politics of the crucial turning point of the Roman world before him, he chose for his chief concern not Caesar, the triumphant though doomed man of action, but Brutus, the man of conscience, the philosopher of politics whose acts are nevertheless almost invariably wrong. Shakespeare is not really interested in what Brutus does, but in what he is, and this is what makes the figure of Brutus the transitional link between *Henry V* and *Hamlet*. The very popular success of *Henry V* had made it "the danger point" in Shakespeare's dramatic career, but by resisting the temptation to continue in the same vein, *Julius Caesar* (1599) was Shakespeare's turning point. In passing from the active but shallow hero of Agincourt to the stoic Brutus with his spiritual struggle and intellectual capacity, Shakespeare was halfway on the road to *Hamlet* (1601). For *Hamlet,* that "triumph of dramatic idea over dramatic action and of character over plot," is not only Shakespeare's greatest achievement, but also registers his commitment to a dramatic method which is henceforth to produce *Othello, Macbeth,* and *King Lear* within the space of a mere five years.

I do not know if the change in the nature of Shakespeare's concern with politics after *Henry V* is due to the fact that he suddenly lost interest in the direct presentation of the political meaning of history, or that he was the slavish follower of his newest source, Plutarch, or that, as a dramatic author, the portrayal of the powerful man of action had reached for him the point of diminishing returns. Whatever the reason, the subsequent plays, whether the Roman plays based on Plutarch or the great tragedies, if they are political, are so in a very different sense from that of the great historical sequence beginning with *Richard II* and ending with *Richard III.*

Let me say a word first about the Roman plays *Julius Caesar* and *Coriolanus.*[32] That these plays have a political subject matter in the usual sense is clear. *Julius Caesar* examines the Roman state at the very moment in which it is passing from a republic to an empire, shows the "treason" of private violence even against the threat of tyranny and the consequences in civil discord until the imperium finally falls into the hands of the triumvirate Antony, Lepidus, and Octavius. Its very center is the problematic but decisive act of political assassination. I say

"problematic" because the political moral of the play is exceed-
ingly ambiguous, and this is something quite different from the
opposition of the habitual medieval condemnation of Brutus
and Cassius, as in Dante, and the equally habitual Renaissance
condemnation of Caesar, as in Machiavelli and Montaigne.
Rather, it is something inherent in the play itself, as if Shake-
speare wishes to preserve this political ambiguity in all its
perplexity by creating in the two chief protagonists of the play,
Brutus and Caesar, enigmatic figures. On the one hand, Cae-
sar's ambition makes him a dangerous threat to the state, but,
on the other, his military accomplishment makes him the first
man of the Roman world. Whether we see him as an arrogant
usurper or as the benevolent shepherd of the Roman people
depends on whether we look through the eyes of Cassius or of
Antony. Brutus is in one sense less ambiguous, for his nobility
and high-mindedness in a world of petty corruption are con-
stant throughout the play. But since Caesar *is* so unclear, so is
the meaning of his assassination, and it remains correspond-
ingly doubtful whether Brutus' act is a righteous countermove
to the threat of tyranny or a cruel and useless murder by a
noble spirit misled by the self-interested persuasion of baser
and lesser men. Cassius and Antony are more simply portrayed;
they are both opportunistic politicians, men who place personal
considerations above the public good and who use an elaborate
rhetoric of persuasion to achieve their ends. But it is notewor-
thy that Shakespeare has placed them on opposite sides of the
political struggle, as if to say no political faction enjoys a
monopoly of political virtue, and to make even more difficult
an unambiguous political interpretation of the play.

As the political center of *Julius Caesar* is the act of political
assassination, so the political center of *Coriolanus* is the brutal-
ity of the class struggle in ancient Rome. There is much in this
which makes it appealing to the Marxist mentality. Brecht,
who begins "Die Dialektik auf dem Theater" [33] with an ex-
tended analysis of *Coriolanus*, is enthusiastic about it as about
no other Shakespearan play. He finds here Shakespeare's "real-
ism" at its most superb: its protrayal of the shrewd demagog-
uery of the patricians, the difficulties which lie in the way of a
unified proletariat, the naked hunger which compels the op-
pressed people to fight against their exploiters, the extreme
class consciousness of all strata within the state. It is not unnat-
ural that he conceived the work as the drama of the Roman
populace betrayed by their Fascist leader. Jan Kott too, al-

though infinitely less orthodox and doctrinaire than Brecht, calls *Coriolanus* a drama of class hatred.[34]

But if Brecht sees the moral of *Coriolanus* in its realistic and objective portrayal of proletarian exploitation, it has also been read in a fashion precisely the reverse. A. C. Bradley, in his famous British Academy Lecture of 1912,[35] sees it as the tragic apotheosis of a noble nature. Coriolanus is not a "tyrant" but an "aristocrat." "The patricians are his fellows in a community of virtue—of a courage, fidelity, and honour which cannot fail them because they are 'true-bred' . . . But the plebeians, in his eyes, are destitute of this virtue, and therefore have no place in this community. . . . To give them a real share in citizenship is treason to Rome; for Rome means these virtues. They are not Romans, they are the rats of Rome." [36] And A. L. Rowse, in his recent biography of Shakespeare, in the few pages which he devotes to *Coriolanus,* sympathizes to such an extent with Coriolanus' scorn of the ignorance and inferiority of the common people that he is led fatuously to remark: "Here is the conservative Shakespeare speaking, as percipient as Burke of the true facts of politics. What could be more prophetic of the last state of democracy, the Welfare State?" [37]

In the diametrically opposed enthusiasm of Brecht on the one hand and Bradley and Rowse on the other is to be found the proof that *Coriolanus* is no less politically ambiguous than *Julius Caesar* and for precisely the same reason. Jan Kott has seen this with extraordinary clarity:

Coriolanus, as written by Shakespeare, could not wholly satisfy either aristocrats, or republicans; friends of the people, or their enemies. The play annoyed those who believed in the masses, and those who despised them; those who recognized the purpose and didactics of history, and those who laughed at it; those who saw mankind as a mound of termites, and those who saw only lone individual termites painfully experiencing the tragedy of existence. *Coriolanus* did not fit in with any historical or philosophical conception current in the eighteenth and nineteenth centuries.[38]

Coleridge once spoke of "the wonderful philosophic impartiality in Shakespeare's politics," but this is obviously true of the Roman plays in a very different sense from that of the histories. There is no doubt as to whether Shakespeare prefers Richmond to Richard III, Henry V to Richard II, or the loyal and thoughtful soldiers of the eve of Agincourt to the stupid craftsmen of Jack Cade's rebellion. But that we are never com-

pletely sure whether Shakespeare's heart is with Caesar or Brutus, with Coriolanus' nobility or the hunger of the plebs of Rome is, I think, no accident. It is the mark of a dramatic mentality which has lost interest in the didactic certainties of politics for the more paradoxical middle reaches of man's political estate. Shakespeare's Roman plays *Julius Caesar* and *Coriolanus* are, as I have said, with respect to their political standpoint profoundly ambiguous. If anything of political relevance has been added, it is only what Shakespeare has gleaned from Plutarch or through him from republican Rome—a new emphasis (expressed in both Brutus and Coriolanus) on the old Renaissance concern with "nobility"—that and certain vestiges of the old Stoic ethics which were soon to seep into the greater Shakespearean tragedies as it had a century before into the treatises of Machiavelli and the essays of Montaigne.

There remains only a word to be said about the later great tragedies like *Hamlet* and *Macbeth* for, although in a sense even more remote than in the case of *Julius Caesar* or *Coriolanus,* they too can be seen as plays with a political center. Once again Brecht in his "Kleines Organon für das Theater" [39] reads *Hamlet* as primarily a political play. The times, explains Brecht, are parlous. Wars of aggression have been fought and even now threaten to devastate the country. Denmark is in the hands of the criminal ruling classes. Man's very reason is in doubt. But in this morass of domestic usurpation and foreign aggression, Brecht is blind to the purely personal misfortunes of Hamlet and Ophelia, the displaced son, the rejected girl gone mad with grief. Thus his mode of perception, though interesting and Marxist, is yet a partisan falsification of what is totally there. In the same way one could say that *Macbeth* is political. In its portrayal of immoderate, almost demonic, political ambition and the chain of political murder which follows in its wake, its course exactly parallels that of *Richard III.* Yet how enormous is the difference between the modes of perception which they celebrate! Richard meets his end on Bosworth Field with a bravado which never goes beyond the surface of the human possibility (V, 3) :

> Conscience is but a word that cowards use,
> Devised at first to keep the strong in awe:
> Our strong arms be our conscience, swords our law!
> March on, join bravely, let us to it pell-mell,
> If not to heaven, then hand in hand to hell.

But Macbeth goes to meet his death sick at heart (V, 3) :

> I have lived long enough. My way of life
> Is fall'n into the sear, the yellow leaf . . .

and when later, at the news of his wife's death, he utters the famous lines:

> To-morrow, and to-morrow, and to-morrow
> Creeps in this petty pace from day to day
> To the last syllable of recorded time,
> And all our yesterdays have lighted fools
> The way to dusty death. Out, out, brief candle!
> Life's but a walking shadow, a poor player
> That struts and frets his hour upon the stage
> And then is heard no more. It is a tale
> Told by an idiot, full of sound and fury,
> Signifying nothing

it is clear that the prosaic world of politics has been left far behind. All of Shakespeare's later tragedies take their point of departure from political situations, but their depth makes a travesty of the quotidian political standpoint. It is true that the confrontation of a wider sphere of reality than the political from time to time faintly touches the earlier history plays also as, for example, Warwick's dying speech in Part III of *Henry VI* or Henry's pathetic meditation at the battle of Towton. But this is simply a fleeting foretaste of the perception which is to flower in the later tragedies of Shakespeare's mature genius. For these tragedies possess a sense of the human horizon stretching far beyond the narrow margins of usurpation or civil disorder or ideal kingship. In this sense their humanism may be said to lie "beyond politics."

Four / The Great Refusal:

The German Withdrawal

from Goethe to Thomas Mann

THE CONTRAST between the type of politics expressed in the life and work of Erasmus and that of Montaigne may be taken as symbolic of one of the great dilemmas which besets the life of culture. For the ambiguous historical commerce between politics and art produces a constant ballet of advocacy and retreat, an eternal dialectic of political involvement and political withdrawal. The "lure" of politics is constant, for it is the atmosphere within which culture breathes, the matrix of order or disorder in which philosophy thrives and works of literature and fine art are produced. But theories of the *relationship* between the humanities and social life vary according to the optimism or pessimism which they express. In the organic theory art and literature *depend on,* are, indeed, *nourished by* the political and social matrix within which they occur, and, in the extreme Marxist position (which is only the modern continuation of the organicism of Hegel) they are an almost mirrorlike reflection of the social contradictions and the class antagonisms out of which they arise. In this theory political involvement and political expressiveness are a fate from which, try as they may, the humanities cannot escape.

But there is an alternative doctrine which sees the matter more as one of active choice, where the artist or thinker chooses or refuses to choose political themes for his treatment, rejects or embraces the values to which his nation is committed, advances into the political arena as a spokesman for its tenets, or withdraws into a private world where art is autonomous and self-

contained. This theory too does not deny the lure of the political, but it often sees it as an overwhelmingly destructive force to be resisted—the moth of culture and the flame of politics. For it is precisely the *primacy of politics* which mobilizes its discontent and engenders its dismay. What right has the political world to press its claims with such peremptoriness? Is its loud voice any more than a mere interpretation? How firm is *its* grasp on reality? Has it any special insight into our human truth? And what if, on the contrary, the truth about the political world is really quite different from what the political world claims it to be? What if its assertions of value are the product of an empty rhetoric? What if the private sphere is where men truly meet, if our bedrock certainties lie outside the political altogether? These are the claims of a Pater or a Berenson, a Wallace Stevens or a T. S. Eliot, and they represent an extreme variant—a pushing to its limits—of a position already implicit in Erasmus.

These are largely the claims of Goethe also, and it is perhaps he, above all modern artists and poets, who has represented the Erasmian position of cultural autonomy and political withdrawal for the contemporary world. Both Stefan Zweig and Thomas Mann have pointed out the similarity of these two men of learning—the cosmopolitanism, the political disengagement, the commitment to the ideals of "peaceful culture." It was his love of this latter, says Mann, "his constitutional quietism and anti-vulcanism" that linked Goethe with Erasmus.[1] He sees Goethe reacting to the French Revolution much as Erasmus did to the Lutheran explosion. In both are to be found the same neutrality, the same evasion of the demands of both sides of the partisan conflict. In each of these celebrities of two different eras it is possible to note a fundamental reserve toward politics and thus a basic similarity in their attitude toward their times. Mann is particularly qualified to see in Goethe this apolitical reserve: it is, as we shall see, an attitude which he was at one crucial period of his life to share. This mutual participation in the stance of "the unpolitical man" is no accident, no purely personal act of identification of the contemporary figure with the earlier man of the Enlightenment, but rather an enduring German cultural characteristic. There has always been a persistent German conception that politics and culture are antithetical, and that the humanity of the writer and the artist should express itself in extrapolitical territory. It is typical of the German intelligentsia of the nine-

teenth and twentieth centuries (figures like Schopenhauer and
George, Hofmannsthal and Rilke) that it should have with-
drawn from the political arena out of a contempt for its debase-
ment of values, and isolated itself from political conflict in
order to maintain the aesthetic purity of literature and the arts.
And it has been the archetypal and almost ritual figure of
Goethe which has sustained them in this withdrawal.

It is possible to find some explanation of this attitude in the
very backwardness of German history—in the failure of the
German nation to come to unified national consciousness as
early as either England or France—and therefore in isolationist
responses expressive of this failure as early as the eighteenth
century.[2] Hobbes, Locke, Fielding, Gibbon, Hume, and Swift
wrote in a political milieu where compromise was a fact, and
where, therefore, the burgeoisie had considerable power. There
was no incentive here to turn one's back on politics. Analo-
gously, French literature has always been psychological, realis-
tic, and skeptical: rooted in history and society, wishing to
dissect, analyze, and understand man as he is. But Goethe,
Herder, Kleist, and Hölderlin give the impression of being
deprived of the sustaining soil of a politically negotiable com-
munity. In consequence they turn to the realm of the ideal,
they return to the contemplation of ancient Greece, they pose
the problem of general and abstract values. Their "humanism"
is of a very different variety from the earthy realism of Molière
or Defoe, or the skepticism of Montaigne, Descartes, Voltaire,
or Hume. For all their skeptical questioning these men are the
perfect expression of their time and of their epoch—they are
close to their public and to the problems of their nation. But in
Germany it is the precise opposite. The extreme retardation of
social and economic development in the face of remorseless
Kleinstaaterei and petty absolutism, as well as the absence of a
powerful and representative bourgeoisie, meant that artists,
writers, and philosophers had no real contact with their public
and with society. Solitude is an enduring theme with Lessing,
Kant, Hölderlin, Kleist, and Schopenhauer. There is, even, a
fatal harvest of broken lives: Hölderlin, Nietzsche, and Lenau
go mad. Kleist is a suicide. Klopstock, Winkelmann, Heine,
and Nietzsche live in practically voluntary exile. Kant leads the
life of a recluse in the very center of Königsberg, and Schopen-
hauer lives out his life in a boardinghouse in Frankfurt, having
for his sole friend and companion a dog. Even a man with the
strength and inner resources of Goethe turns to the idealizing

propensities of lyric verse and to the impersonal dependability of an organic Nature!

Goethe himself, particularly in his later years, was constantly lamenting the lack of a national cultural center like London or Paris, where

the best minds of a great nation are assembled in one place, teaching and stimulating each other in daily intercourse, contention and rivalry, where the best products of nature and art from every corner of the earth are always there for them to see with their own eyes, where they are reminded whenever they cross a bridge or a square of a great past and where every street corner has seen history in the making.[3]

And even that humanitarian cosmopolitanism—the primary creation of Lessing, Herder, and Goethe, and the glory of the German eighteenth century—is, nevertheless, purchased at the cost of a local feeling which might have stabilized and nourished German literature even as it narrowed and provincialized its concerns. Lessing, the youthful Goethe, and Schiller all look down on national patriotism at the very moment when they are engaged in the creation of the ideal cultural community. But the irony is that this expansion of perspective is itself vague and abstract—the literary consequence of the life lived by "isolated ministers and officials in the country, or of members of small groups in provincial towns." Goethe toward the end of his life explained to Eckermann why it had been impossible for him to write patriotic verse during the German struggle for survival against the Napoleonic conquest:

How could I have written songs of hate without hating? And, between ourselves, I did not hate the French, although I thanked God when we were rid of them. And how could I, for whom the only thing that matters is whether people are civilized or barbarous, hate a nation which is among the most cultivated on earth and to which I owe so large a part of my own culture! National hatred is anyhow a peculiar thing. You will always find it strongest and most violent in the lowest stages of civilization. But there is a stage at which it entirely disappears and at which one stands in a sense above the nations, and feels the good or evil fortune of a neighboring nation as if it had happened to one's own. This stage was congenial to my nature, and I had long been confirmed in these views before I reached my sixtieth year.[4]

The sentiment is admirable, and it is symptomatic of the cosmopolitanism and broad intellectual culture which the German eighteenth century has bequeathed to the Western world, but there is a reverse side to this cultural advance. It is the contempt for the tedious political process of negotiation and compromise through which political liberties are won, the turning away from democracy as a mode of general education in its own right, the withdrawal from politics as a debasing factor in the fabric of cultural development and a possible source of contamination for the purity of dramatic creativity and the lyric impulse. It is Goethe, above all, who is destined to turn this contempt, aristocratic isolationism, and withdrawal into an enduring model for German literary, aesthetic, and intellectual life.

Goethe's basic relationship to the political events of his own times is not nonexistent, but it is tenuous. Although we now recognize that Gervinus' idea that he deliberately turned away from the great historical actions of his age in order to immerse himself in art, literature, and science is an extreme oversimplification, the exact nature of his reaction to the French Revolution and to the rise and fall of Napoleon is less clear than we should like.[5] The case is complex and there are more nuances in the evidence than in the cases, say, of Wieland, Herder, and Schiller. Explicit statements are not numerous. The correspondence reveals little. And those literary works which, for example, deal directly with the French Revolution are diverse, ambiguous, and fragmentary. It is almost as if the very magnitude of the upheaval in politics and social relations which dominated the age inhibited the literary creativity and revealed in Goethe a mind torn and uncertain. At times he shows indifference, at times a quiet hostility, but there is also hesitation and reserve, as if to hide a certain embarrassment and annoyance at the crude enormity of historical changes never completely mastered and understood. Goethe was temperamentally more at home with nature than with history, but in both areas the temper of his mind was more sympathetic to the evidences of slow and majestic changes than of cataclysmic irruptions. He was, as Mann and others have recalled, a "Neptunist" and not a "Vulcanist," and the volcanic intensity of the events in France must have stimulated a latent resentment, not simply because their meaning was hostile to his persistent elitism, but because they presented a permanent challenge to a mind devoted to "the understanding of phenomena"—even

those which he would instinctively have preferred to ridicule and condemn.

Goethe was forty when the French Revolution broke out and his own most active political services for the Duke of Weimar were in the past. For these services he had already sacrificed a decade of brilliant literary possibility to the prosaic tasks of small-time political administration. But this administration was in the service of a benevolent if autocratic prince—one who, in general, secured and continued to elicit Goethe's admiration—and the omnipresent reality of these personal political experiences conditioned all of Goethe's attitudes toward the political upheavals which were disrupting life beyond the borders of Germany and, through their impact, disturbing it within. Goethe's literary imagination was boundless, but his political imagination was provincial—meshed into the presuppositions of local paternalism of the benevolent variety—and although he knew too much of the realities of political life to be content with the petty German principalities as they were, yet he was stubbornly persuaded that reforms must originate from above—from the prince—that changes must come gradually, and that their orderly achievement was much more ultimately desirable than any passionate but lawless upsurge of "liberty." Thus, as he wrote to Jacobi at its outbreak, the revolution in France was also a "revolution" for him personally. The first clear expression of his views appears in the "Venezianische Epigramme," written during his visit to Venice in 1790:

Alle Freiheitsapostel, sie waren mir immer zuwider;
 Willkür suchte doch nur jeder am Ende für sich.
Willst du Viele befrein, so wag es, Vielen zu dienen.
 Wie gefährlich das sei, willst du es wissen? Versuchs!

Frankreichs traurig Geschick, die Grossen mögens bedenken;
 Aber bedenken fürwahr sollen es Kleine noch mehr.
Grosse gingen zugrunde: doch wer beschützte die Menge
 Gegen die Menge? Da war Menge der Menge Tyrann.

Jene Menschen sind toll, so sagt ihr von heftigen Sprechern,
 Die wir in Frankreich laut hören auf Strassen und Markt.
Mir auch scheinen sie toll; doch redet ein Toller in Freiheit
 Weise Sprüche, wenn ach! Weisheit im Sklaven verstummt.[6]

(All freedom-mongers were always offensive to me,
 For each sought power only for himself.

If you wish to liberate the multitude, try to serve it first.
 If you want to know how dangerous that is, try it!

The powerful should think on France's tragic history,
 But the lowly should take warning even more.
The powerful are destroyed, yet who protects the people
 Against themselves? They are their own tyrant!

These men are mad!—you say of the demagogues
 Now loudly holding forth on every street and square of
 France.
They seem mad to me too. But still a madman is free to talk wisely.
 While even wisdom, if enslaved, unfortunately must be
 dumb.)

In these quatrains are already discernible the major outlines
of Goethe's unwavering political beliefs. Revolution is the in-
strument of demagogues, and it is inevitable that the masses
should be deceived. But to serve and protect their subjects is the
solemn obligation of princes, and they should take warning
from the events in France of what they reveal of aristocratic
despotism and incompetence. The mob is a savage and destruc-
tive force, and its leaders unleash a madness not to be con-
trolled. Political wisdom lies, therefore, somewhere between the
inaction of princes and the wild sovereignty of the people.[7]
 It seems clear that the French Revolution made a profound
impression on Goethe, as it did on every artist and thinker of
his age, and that he attempted without complete success to
incorporate it and its political meaning into a large segment of
his work at this time. The year after the "Venezianische Epi-
gramme" he produced *Der Grosscophta*, the story of the charla-
tan Cagliostro, who had powerfully impressed noble French
society and was implicated in the scandal of the diamond neck-
lace which had done so much to discredit the nobility and
particularly Marie Antoinette in the eyes of the French masses.
Goethe's prose comedy is a powerful study of a corrupt and
credulous society, and from it one can see clearly that he was no
apologist for the *ancien régime*. Overtly it is not a political
play, but in presenting some of the most glaring symptoms of
French social and moral decay, it embodies its author's convic-
tion that France was sick and in need of political and social
therapy.
 Der Bürgergeneral of 1793 is a light comedy which is perhaps
the most successful of Goethe's attempts to portray the revolu-

tion on the stage. Its theme is the seduction of the placid German peasantry by the ideas of the French Revolution—the influence of the Jacobin fever on the further side of the Rhine. Its satire is light, but its rejection of the revolutionary ideal is conclusive. Revolutions, it is suggested, are not always avoidable, but wise rulers and tactful landlords may render them unnecessary, and the transformation of society has its best promise in the transformation of each individual. Let each consider the problem of his own reform and not only will he be fully occupied, but he will incidentally promote the general welfare. The unfinished drama *Die Aufgeregten* of the same year is a more ambitious, a more serious attempt to deal with the theme of *Der Bürgergeneral*—to portray the effect of seditious propaganda on the ignorant German masses. It admits the existence of upper class fraud and cruelty, and it shows how the outbreak of the revolution in France brings smouldering discontent to a head. Imcomplete as it is, it presents the ruling countess as kindly and moderate, impulsively interested in righting previous injustices voluntarily. She is perhaps Goethe's best portrayal of the enlightened ruler in action. And even the agitator, the country doctor Breme, organizes revolt but mildly and with more talk of principle than violence of behavior. The play is serious, it breathes a balanced conservatism, and even in its incompleteness presents Goethe's positive political views with a persuasiveness never surpassed. Its quiet moderation is in ironic contrast with the Terror raging in Paris at the very moment it was written, and it suggests the same calm and dispassionate seriousness with which Erasmus sent forth his humane letters from Cambridge and Louvain at the height of the madness of the Lutheran revolution.

No German poet has made so many attempts to embody the French Revolution in his literary work as Goethe. And yet the final effect is one of incompleteness and rejection. As late as 1802 he projected a dramatic trilogy, of which only the first play, *Die natürliche Tochter*, was ever written. Freely based on the *Mémoires historiques de Stephanie Louise de Bourbon-Conti*, it presents a view of diseased monarchy turning anarchic, but the later plays which would have portrayed the wild confusion of the revolution itself and the final emergence of republican order are needed to make it in any sense a statement of political principle. Its possible impact is thus lost, and so, finally, the most characteristic impression which we possess of the reaction of the Goethean aristocratic reserve comes from the long and

very successful poem *Hermann und Dorothea* of 1797. This poem is set in the atmosphere created by the political refugees from the revolution in France. It portrays the initial glory of the concept of the rights of man, followed by the darkness which descends when all social restraints are gone. And with the true conservative passion for order, it expresses a certain indignation at the collapse of fundamental law before the political holocaust which annihilates property rights, breaks the bonds of human friendship, and transforms a part of the commonwealth into the hunted and proscribed. It is a poem saturated with politics, and yet its end result, no less than that of *Torquato Tasso,* published three years earlier, is the denial of political claims against the primacy of the personal life. To develop the qualities of individuality, to build solid foundations for the personal life, it implies, serves mankind better than all talk of political reformation and the rights of man. Thus the French Revolution is not the *subject* of the poem as it is, for example, in Büchner's drama *Danton's Death* written a generation later, but simply its *setting,* and the role of the two protagonists, Hermann and Dorothea, becomes, therefore, that of enacting an independent idyll within a wild surge of revolutionary chaos. The poem portrays a political world in ruins against which arises a bastion of work, hope, love, and responsibility in the personal life. It is the pastoral tradition embedded in, but yielding no advantage to, the epic of history, and in this confrontation expressing, perhaps symbolically, the quintessential flavor of Goethe's lifelong political detachment.

For in the end, despite the excitements of the political setting within which Goethe's own middle life was lived, this is the impression which it makes.[8] He too lives within earshot of a political world in ruins, and, although he uses it for his literary purposes, even hovers on the outskirts of its actual events (as when he accompanies his duke on the French campaign and witnesses the bombardment of Valmy in 1792, or meets with Napoleon himself at the Congress of Erfurt in 1808), his private life of personal cultivation and scientific detachment is itself an idyll played out against the catastrophe of the times.

The campaign in France can be said to have marked a turning point in history. It decided the fate of the French Revolution, and it was the first great modern war of intervention undertaken for primarily ideological reasons. Goethe felt obligated to be with his duke at the front, yet in the midst of battlefields and bombardments, his own *Farbenlehre* always

seems more important to him than the war itself. On the retreat from Valmy he sits in the duke's comfortable kitchen wagon drawn by six horses, reading the third volume of Gehler's *Dictionary of Physics.*[9] At the siege of Mainz he is reading Marat, the most violent of the Parisian revolutionaries, but he is reading him not for his opposition to Louis XVI, but to Sir Isaac Newton! Some years earlier Marat had published a tract, *Discoveries in Light,* and two days before Marat is stabbed in his bath by Charlotte Corday, Goethe is reading it to discover if Marat is also on his side against Newton. As he leaves the ruined city on his way to Mannheim, he prepares to draft an appeal for the creation of a great academy or institute of scientists which will carry on his work on the theory of colors. Finally, at the end of the year, at the very height of the Terror in Paris, he goes to Jena, where he lives alone not far from the botanical garden newly established at the university. Since the world of men is chaotic and unprofitable, he will return to the quiet, grateful world of plants. "As Goethe summarizes it later, a single day at headquarters in Champagne and a single day in ravaged Mainz are for him symbols of contemporary history, and of the terrible collapse of all institutions. An active and productive mind will be forgiven if it devotes itself to quiet study and clings to it 'as to a plank of wood after a shipwreck'." [10]

In *Dichtung und Wahrheit* Goethe relates how indifferent he and his friends were to the new events of 1789. "I myself and my narrow circle did not concern ourselves with news and newspapers; our object was to know Man; as for men in general, we gladly left them to their own devices." [11] It is symbolic of the Platonic interest in the universal and the indifference to the particular (and therefore to historicity) which explains the disjunction between Goethe's personal life and the concrete political events by which it is surrounded—the curious aloofness which marks his relationship to the French Revolution and the Napoleonic Wars. His *Campagne in Frankreich* is written with all of the distance which one might expect in a man from another planet—that is, in a scientist or a poet on the Goethean model. Somewhere in that impersonal diary he wrote: "In all grave political questions, those spectators who take sides are best off, for they joyfully seize what favors their opinion and ignore the rest. The poet, however, must by his nature be impartial." It is not a description which would fit Dante inveighing against ungrateful Florence and a corrupt papacy, or

Ezra Pound castigating Franz Joseph, the English, or the unnat-
uralness of a usurious modern society, but it describes a situa-
tion in which poetic responsibility to reality is patterned on the
objective impersonality of science. Goethe's political presuppo-
sitions are not scientific, for he simply shared the ruling politi-
cal prejudices of the mid-eighteenth century—benevolent au-
tocracy and cultural individualism—but the aloofness and aris-
tocratic reserve of his nature were exquisitely in harmony with
the objectivity which science demands. Napoleon's invasion of
Germany finds him still principally preoccupied with his *Far-
benlehre*. Even Jena and Auerstädt leave him curiously un-
moved, and when he goes to Jena to unpack and catalogue the
specimens of minerals he has collected in Karlsbad, the Prus-
sian staff officers quartered there are amazed by his political
incuriousity and sangfroid.

It is almost as if some ingredient of fierce political feeling has
been left out of his nature at birth, as in color blindness, so that
political passion is always as unintelligible to him as religious
fanaticism, leaving him isolated in a world of growing political
passions, but free to assert his ideal of the formation of inde-
pendent personalities of wide and liberal culture. He was privi-
leged in that in his favored circumstances of birth and fortune
it exacted of him no particular price. Less than a hundred years
later, Thomas Mann and Stefan Zweig, writers formed on his
own mold of apolitical and cosmopolitan culture, reaped the
harvest; exile for the one, despair and suicide for the other.
The French Revolution should have been a warning of the
permanent threat of violence and irrationality. Happy is he
who in its face can turn unmolested to Gehler's *Dictionary of
Physics* and the perfection of his theory of colors!

It is obvious that Goethe is by nature apolitical, and the
contradiction between this fact and his ten years of devoted
administrative service to his duke—Karl August of Weimar—is
in need of some clarification. The facts are undeniable. Arriv-
ing in Weimar as a young man of twenty-six at the invitation of
the duke, he became successively councillor of legation in 1776,
privy councillor in 1779, president of the duke's council in
1782. And he engaged in various administrative duties until his
trip to Italy in 1786, being relieved from governmental respon-
sibilities (although not from all local posts) two years later.
Throughout his tenure he was actively engaged in promoting
the development of agriculture, industry, and mining in the
duchy as well as in the reformation of the local systems of

education, finance, and poor relief. Many of these activities find
their reflection in the second part of *Faust*. Toward the end of
this period—during the last four years when as *Kammerpräsi-
dent* his financial duties were particularly heavy—he com-
plained constantly of the impingement of politics on his cul-
tural activities. To his friends he wrote that he had completely
shut off his political and social life from his moral and poetical
activities, and that politics was now demanding so much of his
time that there was hardly any room for the things which he
really wished to do.[12] And in a famous letter of June 4, 1782 to
Charlotte von Stein he wrote: "Wieviel wohler wäre mir's,
wenn ich von dem Streit der politischen Elemente abgesondert
. . . den Wissenschafften and Künsten, wozu ich geboren bin,
meinen Geist zuwenden könnte." (How much better off I
would be if I could leave the strife of politics and devote myself
exclusively to the arts and sciences for which I was born.) [13]
And he continued: "Properly speaking, I was made for private
life and do not understand how fate has contrived to thrust me
into government administration and a princely family." It is
almost as if, born with the temperament of Erasmus, Goethe
was forced to follow the political métier of Montaigne, and it is
not surprising that when the first opportunity came, he extri-
cated himself from his involvement and never really entered
the world of government again.

But how did he view the politics in which he was immersed?
Unfortunately, we do not have from Goethe the leisurely medi-
tations on the political life which Montaigne provided in his
essays "Of the Useful and the Honorable," "Of Vanity," and
"Of Husbanding Your Will." Instead we have that problematic
and cynical scene in the Emperor's throne room in the second
part of *Faust,* where the Chancellor comments:

> Doch ach! was hilft dem Menschengeist Verstand,
> Dem Herzen Güte, Willigkeit der Hand,
> Wenns fieberhaft durchaus im Staate wütet
> Und Uebel sich in Uebeln überbrütet?
> Wer schaut hinab von diesem hohen Raum
> Ins weite Reich, ihm scheints ein schwerer Traum,
> Wo Missgestalt in Missgestalten schaltet,
> Das Ungesetz gesetzlich überwaltet
> Und eine Welt des Irrtums sich entfaltet.
>
> So will sich alle Welt zerstückeln,
> Vernichtigen, was sich gebührt;

Wie soll sich da der Sinn entwickeln,
Der einzig uns zum Rechten führt?

Entschlüsse sind nicht zu vermeiden;
Wenn alle schädigen, all leiden,
Geht selbst die Majestät zu Raub.[14]

(Yet what help does understanding give the mind,
Goodness the heart, or willingness the hand
When feverish disquiet rages through the state
And evils breed worse evils all the time?
To him who looks down from this lofty place
Upon the far-flung state, it seems a nightmare
Where deformity breeds more deformity
Where lawlessness has all the power and
A world of error envelops everything.

So the whole world is going astray
All that is proper is being destroyed.
How can that spirit be developed
Which alone leads us to what is right?

Decisions cannot be avoided.
If all men act unjustly and all suffer,
Sovereignty itself becomes the victim.)

And the Field Marshal underwrites his strictures:

Wie tobts in diesen wilden Tagen!
Ein jeder schlägt und wird erschlagen,
Und fürs Kommando bleibt man taub.

Das Reich, das sie beschützen sollten;
Es liegt geplündert und verheert.
Man lässt ihr Tobem wütend hausen,
Schon ist die halbe Welt vertan;

(What wildness in these riotious days.
Everyone strikes and is then stricken.
And to the call to order all are deaf.

The empire that was supposed to be defended
Lies plundered, prostrate, overrun
The savage rioting continues daily
And half the world is thrown away.)

It is a scene in which Chancellor and Field Marshal, Steward and Treasurer are all agreed. The state is torn by lawlessness and chaos. Strife is rampant, and obedience is nonexistent. The nobles are selfish, the soldiers restive. The clergy and the nobles together possess the goods of the kingdom only for themselves, while in the masses is brewing a spirit of revolt. Surprisingly, it seems to be the same judgment of the monstrousness of the age which pervades Montaigne's essay "Of Vanity," and it raises the question whether Goethe senses in the placid and benevolent Weimar forces which are a reflection of the vices of the *ancien régime* in France, and of the Revolution which so bloodily sought their rectification. Montaigne was writing of a France torn by religious hatred and civil war, Goethe of a modest and nontyrannical commonwealth, but in the end their criticism comes to much the same conclusion. But in Goethe the criticism has no thrust beyond the uses of poetry, and since it is not further elaborated and developed, there is always the possibility that it is meant somewhat less than seriously—as a product perhaps of that natural irritability with which the unpolitical man reacts to certain spiritual tendencies of his age, and to the temporary experiences of a momentary political fate.

It is not only this scene from *Faust,* of course, in which we find political criticism. In *Die Aufgeregten* and *Die natürliche Tochter,* as we have seen, the revolutionary situation is also portrayed as a demonstration that the times are out of joint. But it is never clear even here that the primary concern is political. For despite the seemingly historical preoccupations of *Götz* and *Egmont,* Goethe, unlike Schiller, lacks the participative sense of history, and is fundamentally lacking in any depth of political and social interest. It is not that he is without the most conservative, even reactionary political opinions. Thomas Mann in his later years, ironically mindful of his own similarity to Goethe, and especially impatient perhaps with the very conservatism which, as the author of the *Betrachtungen eines Unpolitischen,* he had shared and then passed beyond, singled out for particular mention Goethe's reactionary character, noting especially "his enormous power of obstruction, his indifference to politics, the weight with which he opposed because of his very nature, the passion of his age for the ideal of democratic nationalism. He was against freedom of the press, against a voice for the masses of the people, against democracy and constitutions. He was convinced that all good sense lies with the minority." [15]

But even the militantly aristocratic bias and antidemocracy can also be seen as the irritability of the unpolitical nature against those tendencies of the age which were asserting the primacy of the political life and demanding for it an increasing interest and participation. For some poets and dramatists (like Schiller, Büchner, Brecht, or Sartre) the political preoccupation is the very heart of their literary imagination. For others (like Wordsworth or Lucretius, Donne or Eliot, Keats or Rilke) it is the domain of nature, or of the metaphysical and religious, or of the lyric and the personal which engages their deepest creativity. Goethe belongs to the second group rather than the first. He not only was indifferent to the political, he defended himself against it with all the resources at his disposal. The living witness to this defense and counterassertion is his classic play, published in 1790 after a long period of germination, *Torquato Tasso*. It is, as has been said, "the first notable treatment in European literature of the private or anti-social conception of the artist." [16]

Set in Belriguardo, a summer palace of Alfonso the Duke of Ferrara in 1577, influenced in the details of its setting and characterization by the new biography of Tasso published by Pierantonio Serassi in 1785, it is yet a basic document in Goethe's spiritual autobiography, for its theme is the momentary disintegration of the poet in his circle of affectionate admirers by the impingement of the political. Tasso feels the poetic nourishment of the intimate society:

> Wer nicht die Welt in seinen Freunden sieht,
> Verdient nicht, dass die Welt von ihm erfahre.
> Hier ist mein Vaterland, hier ist der Kreis,
> In dem sich meine Seele gern verweilt.
> Hier horch ich auf, hier acht ich jeden Wink.
> Hier spricht Erfahrung, Wissenschaft, Geschmack;
> Ja, Welt und Nachwelt seh ich vor mir stehn.
> Die Menge macht den Künstler irr und scheu:
> Nur wer euch ähnlich ist, versteht und fühlt,
> Nur der allein soll richten und belohnen! [17]

> (Who does not see the world in his own friends
> Does not deserve the world to know of him.
> Here is my fatherland, here is the group,
> In which my soul is glad to dwell.
> Here I attend to every sign and listen carefully.
> Here speaks experience, erudition, taste;

Yes, world and future world before me stands.
The masses make an artist confused and shy:
Only those like you feel and understand,
They alone are capable of judgment and reward.)

"Die Menge macht den Künstler irr und scheu" (The masses make an artist confused and shy) —this is the heart of the matter, and Tasso is mistakenly secure under the protection of the discriminating few until the appearance of the strong and able secretary of state, Antonio Montecatino. An experienced and able diplomat and court negotiator, in speaking admiringly of the papel court, he enunciates the political ideal which is Goethe's own, and which he perhaps originally hoped for in the atmosphere of Weimar:

Es ist kein schönrer Anblick in der Welt
Als einen Fürsten sehn, der klug regiert;
Das Reich zu sehn, wo jeder stolz gehorcht,
Wo jeder sich nur selbst zu dienen glaubt.
Weil ihm das Rechte nur befohlen wird.[18]

(There is no finer sight in the entire world,
Than to behold a prince who wisely rules;
To see a realm where all obey with pride,
Where each man thinks to serve himself alone,
Since each is only ordered to be just.)

But Tasso in the play is far from being concerned with social structures or the conditions of the ideal commonwealth. His solitary egoism and inner inventiveness are part of the same personal core, but they are seen by a friend and opponent alike as dangerous temptations toward isolation in a social world. The princess exclaims:

Dieser Pfad
Verleitet uns, durch einsames Gebüsch,
Durch stille Täler fortzuwandern; mehr
Und mehr verwöhnt sich das Gemüt und strebt,
Die goldne Zeit, die ihm von aussen mangelt,
In seinem Innern wieder herzustellen,
So wenig der Versuch gelingen will.[19]

(This path
Leads us astray, and causes us to wander
Through solitary thickets and silent valleys, alone;

More and more the natural self is spoiled and seeks
To reconstruct in its own inner being
The golden age which is not found outside,
However little the attempt succeeds.)

And later in the play Antonio echoes her judgment:

Ich kenn ihn lang, er ist so leicht zu kennen,
Und ist zu stolz, sich zu verbergen. Bald
Versinkt er in sich selbst, als wäre ganz
Die Welt in seinem Busen, er sich ganz
In seiner Welt genug, und alles rings
Umher verschwindet ihm. Er lässt es gehn,
Lässts fallen, stössts hinweg und ruht in sich—[20]

(I've known him long; easy to know he is,
And too proud to conceal himself. At once
He sinks into himself as if the whole world
Were all inside his breast, and he were
Entirely complete in his own world, and everything
Surrounding disappears for him. He drops it,
Lets it go, and thrusts it from him,
And rests within himself.)

 The center of the play is the conflict between Antonio Mon-
tecatimo and Tasso—the political man and the poetic—two
sides of a single human being, but Goethe in his resolution
makes no real step toward their integration. Nor does he exalt
the poetic life over the political through a false and partisan
rhetoric. Antonio is both sophisticated and honorable; his
quarrel with Tasso represents less a moral criticism than a
repugnance instinctively rooted. And Tasso, too, the spoiled
and moody genius, admits his antagonism to the politican not
on grounds of right but of natural antipathy—through an ob-
scure knowledge that the claims to superiority of the political
are death to art. He will acknowledge that power only which
feeds his art, and he will deny a world of action which is in any
sense a limitation of his intellectual and creative freedom.

Verdriesslich fiel mir stets die steife Klugheit,
Und dass er immer nur den Meister spielt.
Anstatt zu forschen, ob des Hörers Geist
Nicht schon fur sich auf guten Spuren wandle,
Belehrt er dich von manchem, das du besser
Und tiefer fühltest, und vernimmt kein Wort,

Das du ihm sagst, und wird dich stets verkennen.
Verkannt zu sein, verkannt von einem Stolzen,
Der lächelnd dich zu übersehen glaubt!

Früh oder spat, es konnte sich nicht halten,
Wir mussten brechen; später wär es nur
Um desto schlimmer worden. Einen Herrn
Erkenn ich nur, den Herrn, der mich ernährt,
Dem folg ich gern, sonst will ich keinen Meister.
Frei will ich sein im Denken und im Dichten;
Im Handelm schränkt die Welt genug uns ein.[21]

(His stiff-necked cleverness is very annoying,
And that he must always play the master.
Instead of searching if his hearer's mind
Is not already on the proper track,
He lectures you on things which you
Feel better and more profoundly, and does not hear
A word you say to him, but will misjudge you.
To be misunderstood by a proud man,
Who, smiling, thinks himself above you!

Sooner or later, it could not go on,
We had to break; later it would have been
But that much worse. I only recognize
One man, the man who feeds me,
I follow him gladly, but will have no other master.
Free must I be in thought and in creation;
In action the world confines us quite enough.)

It is not merely Tasso, but Goethe himself speaking. The action of the world of politics was seen as a threat, as an impingement on the interior life of the artist through which his freedom might be compromised. The eighteenth century was the last age of Western man in which the security of an isolated pastoral existence could be presupposed. But the events of 1789 and 1806 had already brought into being forces which were to have consequences which no one then living could possibly foresee. The fact that a figure of the commanding stature of Goethe should make the great refusal of politics, should establish with force and authority the stereotype of the productive and self-sufficient artist withdrawn from the political arena as from a plague, was to dominate the cultural life of Germany for one hundred and fifty years, and to foreshadow in ways yet unforeseen the tragedy of the Third Reich.

Goethe's *Torquato Tasso* appeared in 1790 and is approximately contemporary with the French Revolution. Thomas Mann's *Betrachtungen eines Unpolitischen* (Reflections of an Unpolitical Man) was published in 1918 toward the conclusion of the First World War and is in a sense the fruit of the intense personal disturbance which that event caused in the spirit of its author. Over a hundred years separate the two works and yet, although *Tasso* is a tightly constructed play in Goethe's best classical manner, while Mann's *Reflections* is a loose, rambling, even pedantic essay of almost six hundred pages, there is an absolute continuity between them. *Reflections of an Unpolitical Man* celebrates art as man's highest vocation, but in the process it attacks democracy and liberalism as false and exalts the German monarchy over parliamentarianism. All this is in the best Weimar tradition. Goethe, too, professed a disinterest in politics while holding to political opinions of an extremely conservative nature. He confessed that he preferred injustice to disorder, but the order which he sought was of the personal rather than of the political kind. His reverence for creative achievement, and for the perfection of one's own talents, his aversion to politics and to the various revolutionary strategies for social reform, have come down unbroken, carried by the German intelligentsia of the nineteenth century, into the possession of Thomas Mann. What Goethe shows artistically and implicitly and with an economy of means in *Tasso,* Mann shows polemically and explicitly and with incessant rhetorical flourishes in the *Reflections of an Unpolitical Man.* The second epigraph of *Reflections of an Unpolitical Man* is taken from Goethe's *Tasso* (Vergleiche dich! Erkenne, was du bist!) and the reference is not accidental, but symbolic.

There are many features of the *Reflections of an Unpolitical Man* which make it an equivocal and a problematic performance, indeed, suggest that its ideology is but a transitory phase in the intellectual history of its author. *Für Kultur und Humanität—gegen Politik* it surely is, but the motivations, both personal and social, which have joined hands in its construction are, even to its author, somewhat suspect. In his Preface, Mann calls it "variations on a theme," but hardly a book. "A book? There can be no question of that. This searching, struggling, groping toward the roots of a discomfort, this dialectical fencing in the middle of a fog against such origins, this, naturally does not amount to a book." [22] But this "searching, struggling, groping toward the roots of a discomfort—this dialectical fenc-

ing in the middle of a fog"—expresses likewise a certain personal uneasiness that the times are out of joint. It is also, as Mann admits, "the product of a certain indescribable irritation against the spiritual tendencies of the time." These are the most difficult years of Mann's life, the period in which his basic principles come into question, in which the foundations of his life as an artist are threatened, in which his personal serenity and literary creativity are shattered.[23] *Death in Venice* (1912) closed one epoch in Mann's life, and *The Magic Mountain* (1924) opened another. Between them lie the three years 1915–18, war years in which the German bourgeoisie lies *in extremis,* fights with its back to the wall, sees its entire Goethean heritage at stake in a conflict which Goethe would have found it difficult either to condone or to condemn. In such a situation Mann finds it impossible to write stories or novels. The three years in which he lies fallow are devoted to the feverish composition of *Reflections of an Unpolitical Man.*

At least two events are responsible for this spiritual crisis. One is the implied personal criticism of his older brother Heinrich Mann, the hated "Zivilisationsliterat" of the *Reflections,* whose attempt to "politicize" the literary vocation [24] was a frontal attack on the most sincere conviction which Mann held as to the meaning of the artistic life. The other is the war itself, calling into question all of the conservative bourgeois values to which Mann, like Goethe, had been deeply, if only implicitly (and even unconsciously), committed. Mann's first real success, his great novel *Buddenbrooks* (1900), was written, as Georg Lukacs has pointed out,[25] when Mann and a large section of the German bourgeoisie looked to Schopenhauer as their chief philosophical spokesman. It raised with all its crucial and imperative concern the question of the problematic consequences of a dying bourgeois culture; it propounded the eternal dialectic of art and the bourgeois way of life. But at the same time in *Buddenbrooks* Mann symbolizes all that is best in the German bourgeoisie—he expresses with gentle irony his own profound sympathy for the familial environment out of which he himself has sprung. And equally, his two great short stories, the "Tonio Kröger" of 1903 and the *Death in Venice* of 1912, both put forward Mann's own conception of the artist as a moody, withdrawn, isolated individual, a devotee of romanticism, irony, music, and perhaps disease, but far removed from social commitment and political responsibility. These two themes—those of *Bürgerlichkeit* and *Künstlertum*—of the middle class man

and of the artist—were the very center of Mann's creativity
before 1914. The war itself was a bitter critique of the first; the
critical polemic of Heinrich Mann constituted an unrelenting
attack upon the second. *Reflections of an Unpolitical Man* is the
obsessive mobilization of Mann's defenses. It is his counterat-
tack against both his brother and the enemies of the German
bourgeois ideal. But important as it is as a document of the
time, important even as a turning point in the history of
Mann's literary and ideological development, this is not its
significance for us here. In what follows I shall be concerned
with it neither as personal testimony nor as sociological evi-
dence, but as a classic statement of the polemical case for the
inalienable rights of "the unpolitical man."

It is already clear from his Preface that the dialectical strat-
egy of Mann's argument hinges on a cultural and historical
appeal—to his sense of the profound opposition, on the one
hand, of the nineteenth and twentieth centuries, and, on the
other, of the German and the French senses of the meaning of
civilization. In each case he associates himself with the first item
of the antinomy. "I am in intellectual esentials" says Mann, "a
true child of the nineteenth century, in which fall the first
twenty-five years of my life,"[26] and he proceeds to spell out the
cultural characteristics of this nineteenth century with which
he feels so deeply identified. From it he has derived a sense of
identity with the peculiar narrative craft exemplified by an
Adalbert Stifter or a Theodor Storm, as well as the romanti-
cism, nationalism, music, pessimism, humor, and middle class
values which he also finds ingredient in the deepest layers of his
cultural being. He looks back with nostalgia to Schopenhauer's
philosophy of the will—a will without any social or political
involvement whatsoever—to the resolute aestheticism of Flau-
bert, to Nietzsche's isolation and sharply critical spirit, from
which he has himself learned the secret and the value of irony.
And with a mild bitterness he contrasts this placid century with
the more arrogant and unpalatable twentieth and its spirit of
social humanitarianism, its activism, meliorism, and politicali-
zation of all aspects of life—where even art itself must forge
propaganda for the reform of political and social and economic
conditions. "Nichts mehr," he cries out with exasperation, "von
Goethes persönlichem Bildungsethos: Gesellschaft vielmehr!
Politik! Politik!" ("No longer Goethe's ethics of personal culti-
vation: Instead everywhere the societal! And politics! Always
politics!")

Moreover this favorable reference to Goethe is at once countered with an unfavorable reference to Rousseau, the real father of the pan-political, the doctrinaire advocate of total politics, the intolerant proponent of democracy, the aggressive theorist of the primacy of the social contract. And here at once the individualistic humanism of the German eighteenth century is placed in sharpest opposition to the political fanaticism of the French Enlightenment. The dogma of progress drowns out the gentle reliance on tradition with all the malignity of a typically French rhetoric! "For almost two hundred years, all that one understands by politics stems from Jean Jacques Rousseau who is the father of democracy insofar as he is the father of the political spirit itself and of a political humanity." The consequence of the influence of Rousseau is the transformation of every ethics into a politics, of every spiritual endeavor into a manipulation of power, of every literary craft into a socially committed art or a rhetoric enlisted in the service of the socially desirable. But Mann is convinced that democracy, even politics itself, is strange and unnatural to the German spirit. "I confess to being deeply convinced that the German people will never be able to love political democracy, for the simple reason that it will never be able to love politics as such." The reason is not that Germany lacks spirituality, but that she refuses to have her spirituality compromised by political necessities in any narrowly defined sense. The bourgeoisie is the backbone of German nationality, but it is, following Goethe, "cosmopolitan." Geographically, socially, spiritually, it holds not to the extremes, but to the middle way. And this suggests a serenity which allies the German bourgeois not with politics but with art. Mann knew this not experimentally, but intuitively. Indeed, it was the demonstration he himself had produced in Hanno Buddenbrooks, Tonio Kröger, and Gustav von Aschenbach.

At the beginning of his chapter "Bürgerlichkeit" in the *Reflections* Mann cites with approval a passage from the new book of the young Hungarian essayist Georg von Lukacs, entitled *Die Seele und die Formen*. Mann is delighted that Lukacs distinguishes between the strange and hermetic aestheticism of a Gustave Flaubert and the true and open bourgeois artistry of a Storm, Keller, or Mörike. In the latter the vocation of the artist is married to the artistic responsibility of the middle class professional, so that to this aesthetics without politics is conjoined a distinctly ethical element. "The bourgeois calling as a way of life," Lukacs had written, "means in the first instance

the primacy of the ethical in life," and Mann appropriates this insight for the enlargement of his ideal presentation of the bourgeois artist. But Mann, in addition, goes far beyond the limits which either Lukacs or, for that matter, Goethe had set for the significance of the artistically productive life.

Lukacs' distinction between a Flaubert and a Theodor Storm was only to assert the superiority of order over mood, of the enduring over the momentary, of quiet labor over raw sensation in the very process of artistic creativity itself. And Goethe's Tasso hugs his own aesthetic idiosyncrasy without doubting for a moment that the political capability of an Antonio Montecatino also has its rightful claim in the Machiavellian atmosphere of the Renaissance world. But Mann converts the artistic vocation into a national stereotype. Aestheticism *and* bourgeois nature!—this conjunction is not only a possible form of life, it is a *German* form of life, and its legitimation lies therefore not merely in the limited utilities of specific vocation, but in the deepest recesses of a cultural tradition—in the German *Weltbild* which the cosmopolitan eighteenth century had bequeathed to Schopenhauer, Wagner, and Nietzsche, and which they in turn had entrusted to the modern exemplars of the unpolitical man.

The dialectical heart of the *Reflections of an Unpolitical Man* lies in the very long central chapter entitled "Politik." Here Mann presents his basic notion that aesthetics, which Heinrich Mann had seen as always properly qualified by political responsibility, is, indeed, the very dialectical opposite of politics. He states this dogmatically and unreservedly at the outset. "Politics is the very opposite of aestheticism. Or, politics is salvation from the threat of aestheticism. Or, quite strictly speaking, to be a politician is the only way not to be an aesthete." [27] What follows is the empirical justification of this definition by an appeal to the works and specific citations of a series of famous artists: Schiller (a curious choice, and supported by only one quotation from the *Braut von Messina*), Flaubert, Schopenhauer, Tolstoy (another curious choice, and supported chiefly by a quotation from his story "Lucerne"), and finally Strindberg. It is not, of course, that a work of art may not contain political ideas—it may, but they must be presented "aesthetically" and not emphatically—they must represent not the insistence and commitment of the author, but an internal, nonextrinsic requirement of the work of art itself. The reason for this is that the very essence of the aesthetic

attitude is skepticism and reserve, doubt and playful presentation.

It is clear that the "politics" with which Mann is here concerned is not that of the practical politician, but of the literary man, the "Zivilisationsliterat," the radical spirit in words, the "belles-lettres politician" who proposes actions without himself being under the necessity of engaging in them, and Mann's irony is sufficiently broad to cover the weaknesses of his brother as later in *The Magic Mountain* it covers both the weaknesses of Naphta and Settembrini. But it is also clear that there is a general relationship between the two political possibilities, that of the practical politician by profession and his "literary" analogue. Almost as if he had been reading Jacob Burckhardt's *Weltgeschichtliche Betrachtungen* instead of writing his own, Mann distinguishes between "ein Kulturzeitalter" (a cultural epoch) and "ein politisches Zeitalter" (a political epoch), or, as Burckhardt would have said, a period in which culture determines the state (der Staat in seiner Bedingtheit durch die Kultur) as opposed to a period in which the state determines culture (die Kultur in ihrer Bedingtheit durch den Staat). The tragedy of the contemporary age is precisely that it is a political age and that it produces a "kulturlose Staatlichkeit" at the very moment in which a "staatlose Kultur" is infinitely to be preferred. Mann sees this opposition already prefigured in the nineteenth century—in the confrontation between the values for which Nietzsche stands and those represented by Bismarck. The very meaning of Nietzsche's cultural criticism is that it is "a protest against politics in the name of philosophy," and Mann sees this pedagogical and philosophical leadership as the genius of Germany, its "ideal nationalism," its mission and its vocation with respect to the rest of Europe. But it is just this philosophical and aesthetic mission which has been overturned by the heavy hand of Bismarck. For Bismarck "condemned the German people to politics." [28] He set the German nation, so to speak, "in the saddle," and they must now either ride boldly or be thrown, and the consequences of this obsessive politicization are to be seen in all of the perversions of art and education to the service of an exclusively political use. But the ultimate ill consequence is this: when the concept of "the state" has passed from the tutelage of Hegel to that of Bismarck, when it becomes a concrete and a sociological rather than a spiritual, a cultural, and a metaphysical entity, then it loses the rightful allegiance of the artist.

At this point—having proved that the modern German sense of value has gone astray—Mann returns to the example of Goethe, and here we have precise documentation of the extent to which the ideas and example of Goethe have molded the German spirit. For the historical tradition of the German people, Mann asserts, the true sources of its spiritual development, stems from that specifically German antithesis between "Macht" and "Geist" (power and spirit) which is found in Goethe. The human question hangs not on social and political, but on metaphysical and moral considerations, and its solution is not a matter of politics, but of the soul of man and its inwardness (*Innerlichkeit*). The life of politics is the life of compromise and necessity. This was obvious to the unpolitical Goethe, and it is why he had no confidence in liberty, equality, and democracy. Mann's own rejection of democracy is thus at once bound up with the reliance on "inwardness" and an appeal to Goethe:

Democracy as a fact is nothing but the ever-increasing public character of modern life, and it will only be possible to avert the psychological dangers of this progressive democratization and the complete levelling, journalistic vulgarity, and stupidity which goes with it, by means of an education whose guiding idea is that of *respect*. This is what Goethe demanded in the field of education; Goethe, this natural pedagogue and passionate teacher, who knew so well that education in the spirit of *respect* would be the urgently needed and only possible corrective for a rising democracy. And why should this be so? Because the question of education puts social and political questions back where they belong, inside the self, and returns them to the area they never should have left—the sphere of the moral intelligence and the human.[29]

Politics is rawness, vulgarity, presumption, and the invariable element of intellectual and moral dishonesty which it contains is a far cry from that cosmopolitan humanism which is the heritage of the great age of German literature. Mann sees the contemporary politicization of life and of the spirit as a constant temptation, almost as a kind of cultural "original sin" against which the great German cultural guardians of the spirit have fought a series of delaying actions: Goethe in 1813, Schopenhauer in 1848, Nietzsche after 1871. But the prime symbol of the German spirit in this respect is Kant.

To separate and clearly distinguish the national spiritual life from
the political, is a truly German, in fact a Kantian, form of separat-
ing and distinguishing. The difference between intellect and politics
is the same as that between pure and practical reason. . . . There is
an excellent symbol for the German separation of intellect and poli-
tics, of radical theory and life, of "pure" and "practical" thought: it
is the two separate but adjacent volumes of Kant's "critical"
labors.[30]

It is, of course, true that the Kantian dualism of the theoreti-
cal and the practical was not permitted to stand. Kant himself
in the end adhered to the primacy of the practical over the
theoretical, and Germany has perhaps learned an unfortunate
lesson from this fact. For in men like Fichte and Treitschke
(Mann might have noted) the categorical imperative became
infected with a narrowly nationalistic political quality which
services the worst in the German mentality. Therefore the
appeal to Goethe will always need to be renewed. Of this Mann
was well aware.

Our legacy from Kant is the belief in the sovereignty of "practical
reason," of ethics; from him we have received the social imperative.
But Goethe's whole existence was a new confirmation of the legiti-
macy of the individual life, the great German artistic experience fol-
lowing the metaphysical and religious experience which was the leg-
acy of Luther: an experience of cultivation and sensuality, com-
pletely human, foreign to all abstraction, against every ideology, the
patriotic one first, and in general against any one which is
political.[31]

What Mann takes here as the basic moral of the German
consciousness, a culture and a sensibility free of all abstrac-
tions, hostile to every ideology, to politics in general, and to a
chauvinistic politics most of all, sets the quality of the literary
experience he would endorse. Such an experience produces a
literature quite unlike that demanded by the "Zivilisa-
tionsliterat." For it would be totally "uncommitted" in the
political sense, "national" perhaps in stamp, but having no
other aims than those of truthfulness and beauty, without polit-
ical will, egoistic in the sense of its aesthetic self-concentration,
and alien to any demand which would claim that it was not
simply an end in itself. Mann is indignant with the political
rhetoric which tries to distinguish between "private art" and

"responsible art," a distinction which Heinrich Mann had put forward, and which in our own time has been given increased emphasis by the Marxist theory of literature and even by the Sartrean demand for literary *engagement*. This is not to make an ethical, but a political claim. The former is not one which Mann himself would oppose despite his rigorous adherence to what seems to be the theory of *l'art pour l'art*. Any work of art must have moral consequences, although to directly demand of the artist that he consciously serve a moral purpose is to spoil the work itself. For, although it is a form of morality, art is not a moral instrument. This is the lesson which Mann admits he has learned from Schopenhauer, Wagner, and Nietzsche—precisely the three who, after Goethe, have been the formative influences on his aesthetic notions and general philosophy of culture.

Art as a resounding ethics, as fugue and counterpoint, as cheerful but at the same time serious piety, as an edifice characterized by nothing profane, where reason and sensibility interlock, joined without mortar, and held "in the hand of god"—this "art for art's sake" is truly my ideal for art.[32]

This is not merely aestheticism, it is also, as could be expected of one whose view of art had been molded by Schopenhauer and Wagner, *musical*, and this assimilation of art and literature to music serves as a protection against any threat of politics. Music, as both Schopenhauer and Nietzsche had shown, is essentially "metaphysical"—somehow bound up with tragedy, human destiny, and the powers lying close to the governance of the universe, and this metaphysical timelessness is a bulwark against any merely political claim. For politics is always "of this time and of that place," that is, "historical," and no artist whose enterprise is metaphysically grounded can feel any special tenderness for "the arbitrary fluctuations of the social dispute." The difficulty, as Mann sees it, with the "Zivilisationsliterat" and with all those who propound a radical politics is that they are still historically fixated in the French provinces of 1789, in that same "sansculottism" which established the Revolutionary Tribunal and the wild justice of the guillotine. The hated literary liberal-democrat of 1917 is as drunk with Michelet's account of the French Revolution as was Don Quixote with the lurid books of medieval chivalry,[33] and with consequences no less tragicomic for a rightful assessment of

culture and the arts. Radicalism is the consequence (or the cause) of the politicizing of culture, and to understand it so is to lead to the last antinomy which confronts the literary imagination—that of "Ironie und Radikalismus."

"Irony and Radicalism"—this is the title of the last chapter of the *Reflections of an Unpolitical Man,* and it serves to introduce the final tactics of the unpolitical man in the arts against the claims of the political. It is, of course, less an argument than a predilection. For Mann at this stage, political radicalism in the artist means the ultimate annihilation of his art. On the other hand the ironist is by this very fact conservative. The formula is oversimple, but clear: "Radikalismus ist Nihilismus. Der Ironiker ist konservativ." [34] In asserting that art is by its very nature unpolitical, Mann is far from denying at the same time that it constitutes a criticism of life. It does, but not in the sense that it proposes ameliorative action. The very nature of art is that it realizes both the claim of "Leben" and of "Geist." It perceives life as it is, it appreciates the constitution of the realm of ideal values, and the perception of their dialectical opposition provides it with an ironic method. Irony, as I have said elsewhere, is a kind of wry muscularity in the intellect. As an active cognition of disparity and incongruity between things as they are and as they ought to be, it is a critical commentary on the nature of the world. But this form of cognition, as Mann quite rightly asserts, may produce in the artist a certain modesty and melancholy. Modesty because his task is not political reform. Melancholy because of the native disparity between the actual and the ideal in experience. It is irony which permits the artist to be at once critical and detached, appreciative of flaws which lie within the nature of existence, but without active responsibility for their radical reformation.

Irony as modesty, as skepticism turned inside out, is a kind of morality, is personal ethics, is "interior" politics. But all politics in the bourgeois sense, whether taken in the intellectual or the activist form is "exterior" politics. One ought to consider everything which can make an artist not only unpolitical, but impossible as a politician.[35]

It is a stance which suits Mann's own temperament very well —in fact, one which is close to the center of his creative imagination—and it is not, therefore, beyond comprehension that he should appeal to its claims in the last pages of the *Reflections.*

For, from a certain point of view, this entire work, for all its piling up of literary reference and feverish dialectic, constitutes a very personal statement of values and literary method which, despite their intimacy, seemed to require the apparatus of an impersonal and polemical defense. The entire presentation of the philosophy of the unpolitical man, its bourgeois sources, skepticism, aesthetic self-reference, inwardness, and irony, becomes the form of justification by which the anxious, harassed, and frantic artist defends the very meaning of his creative existence.

Of the *Reflections* I have presented only what I think is the core of its rational argument for the self-concern of the artist, for the right of the literary man to focus on merely aesthetic concerns and to avoid the arena of politics. And in doing so I have avoided some of the other aspects of Mann's treatise which made it both to him and to his friends a source of subsequent embarrassment: his underwriting of the righteousness of the German national cause in the First World War, the hints of approval of reactionary economic and social policies, the icy aristocratic withdrawal, the almost ill-natured diatribe against "das Volk"—the common people. Some of the ideas which Mann seemed to espouse entered, in the next three decades, on an extremely compromising career, and the rise of Hitlerian power and his own consequent exile brought to Mann himself the apologetic afterthoughts of one who has seen too late that political withdrawal carries with it a certain guilty responsibility for the triumph of any inhumane politics, and that democracy means certain positive virtues of tolerance and humanity as well as the threat of decadence and vulgarity.

In an essay, "Culture and Politics," first published in 1939, two decades after the appearance of the *Reflections,* Mann presents the uneasy meditations which led to the forthright repudiation of the central thesis of his former book.

My personal allegiance to democracy rests upon a conviction which I was obliged to acquire, since it was basically foreign to my bourgeois-intellectual origins and upbringing. I mean the conviction that the political and the social are parts of the human; that they belong to the totality of human problems and must be assimilated to the whole. Otherwise we leave a dangerous gap in our cultural life.

Perhaps it sounds strange that I should so simply equate democracy with politics and define it, without more ado, as the political aspect

of the intellect, the readiness of the intellect to be political. But indeed I did that twenty years ago, in a large and laborious work called *The Reflections of an Unpolitical Man*. And therein my definition was not only negative, but even belligerently so. I defined democracy as the political functioning of the intellect, and I opposed it with all my power, in the name of culture—and even in the name of freedom. . . . Of the connection between moral freedom and social freedom I understood little and cared less. . . . Culture for me meant music, metaphysics, psychology; meant a pessimistic ethic and an individualistic idealism in the cultural field. From it I contemptuously excluded everything political.[36]

The bitter course of political events proved to Mann once and for all that the antidemocratic cultural pride of the German spirit had had no little hand in the triumph of National Socialism, and that the refusal of politics can result in political frightfulness, enslavement to power, even the totalitarian state. The ironic consciousness here reaps its bitter fruit in the recognition that the ultimate consequence of aesthetic bourgeois culture is barbarism, that "politics itself is nothing but intellectual morality, without which the spirit perishes."

I came to see that there is no clear dividing line between the intellectual and the political: that the German bourgeoisie had erred in thinking that a man of culture could remain unpolitical; that our culture itself stood in the greatest danger wherever and whenever it lacked interest and aptitude for the political. . . . The unhappy course of German history, which has issued in the cultural catastrophe of National Socialism, is in truth very much bound up with that unpolitical cast of the bourgeois mind, and with its anti-democratic habit of looking down with contempt from its intellectual and cultural height upon the sphere of political and social action.[37]

But this is not all. The essay proceeds to a sharp attack on the philosopher Schopenhauer, the intellectual hero of the *Reflections,* and one of the grand triumvirate by whom Mann's cultural outlook had been fixed. Here Mann finds his ironic disclaimer of any ambition to mix in politics sinister, his reactionary attitude to the aspirations of the Revolution of 1848 "shabby and grim," his petty, small-capitalist existence shoddy and philistine. And he sees in the life and ideas of Schopenhauer the very prototype of the old German bourgeois against which, in its intellectual conservatism, its passivity and remoteness from politics, and its profound and foolhardy indifference

to freedom, time has taken so frightful a revenge. Mann's violence against Schopenhauer is angry and guilt-ridden; for in Schopenhauer he is attacking only an image of his former self. And, in general, the split which runs down the very center of Mann's political life can be gauged by the changing estimate of his three former mentors. He never quite finds the heart to scold Goethe, and even for Wagner he always retains a certain passionate if guilty affection; but for the philosophers Schopenhauer and Nietzsche he has only the relentless rancor of a man who feels he has been led astray. The later essays always display Schopenhauer not simply as the man from whom he has discovered the metaphysical power of music but as a bourgeois philistine, and Nietzsche not as the man from whom he has learned the secret of ironic detachment, but as the mad syphilitic whose disease has produced paranoid delusions of totalitarian power.[38]

The case of Mann is fascinating—not only because of his intellectual and artistic stature, but because it presents so dramatic a shift from the philosophy of political withdrawal to the philosophy of political engagement, and offers, therefore, such an extraordinary opportunity for contemplation and criticism. It is natural that this criticism should be a function of the ideology of the critic, and this is the reason that the politics of Mann provides such contrary judgments in literary critics as insightful as Georg Lukacs and Erich Heller. Heller, who is himself socially conservative, if not reactionary, finds that the *Reflections* states a valid and an artistically legitimate point of view.[39] He holds that a creative writer's politics cannot be detached from the nature of his imagination and that Mann's creative imagination is itself essentially ironical, tragic, and aristocratic. All this he tacitly approves, with the consequence that for the later Mann of the democratic manifestos and passionate political calls to action he feels a faint embarrassment, as if they were blatant, but superficial, just the sort of "hectic trivialities" one would do better to ignore. And in his excellent book *Thomas Mann the Ironic German* this is precisely what he does.

The case of Lukacs is the exact opposite. For him, as for Mann himself, the *Reflections* is an unmitigated disaster. He had early called it "a political aberration" and characterized it as "a war book, which defends a Germany waging war as well as its decadence, the sympathy for disease and decay, for night and death . . . an unnatural attempt to learn to live with the

justification of German decadence." [40] "In Search of Bour-
geois Man," written for Mann in honor of his seventieth birth-
day, softens the rhetoric, but not the judgment. Citing a passage
from the 1933 essay on Richard Wagner in which Mann speaks
of Wagner's political withdrawal after 1848 in these terms: "He
went the way of the German bourgeoisie: from the revolution
to disillusionment, to pessimism, and a resigned power-pro-
tected inwardness," Lukacs abstracts the phrase "power-pro-
tected inwardness" as the clue to the poverty of Germany's
political development and to Mann himself in his relationship
to the German middle class.[41] In fact, according to Lukacs,
apart from exceptional figures like Lessing, the whole of Ger-
man classical literature and philosophy operated in an atmos-
phere of "power-protected inwardness." The consequence is the
great German withdrawal which he treats in detail in a subse-
quent essay "The Tragedy of Modern Art."

The tragedy of the "small world," its art and culture here reaches a
climax. The retreat into the study had been forced on the best intel-
lectuals. Bourgeois humanism foundered because those democratic
ideals which from Rabelais to Robespierre had been the public con-
cern of all progressive men in every field—political, social, cultural,
artistic—no longer played their vanguard role, but had been pressed
into the service of conservatism and hypocrisy. The cultural intelli-
gentsia fled from this situation into the "small world" of the
study.[42]

This "tragedy of the small world" is at once the history of
Germany from Luther to Goethe, and from Goethe directly to
Mann and the modern world. The "humanism" which, under
Voltaire and Locke, consolidated into a steady progress toward
freedom and emancipation became in Germany an ideological
drama of the disintegrating bourgeoisie under the force of
monopolistic capitalism.

Germany's humanism from the sixteenth to the eighteenth century
has never been anything more than an ideology in a backward coun-
try. At most it was a purely intellectual preparation for a demo-
cratic revolution which never materialized, which never trans-
formed the social structure as in France and England. . . . For this
reason both the ideological disintegration of bourgeois humanism as
well as the, at first subterranean, then rapid and conscious drive to
decadence and reaction occurs in a purer and more complete form
in Germany than in any other country. It is no accident that the

leaders of the muses of modern reaction, Schopenhauer and Wag-
ner, Nietzsche and Freud, Heidegger and Klages are without excep-
tion Germans, international leaders in a much larger sense than the
reactionary ideologists of other nations.[43]

From this "ideological disintegration of bourgeois human-
ism" Mann himself is, of course, exempted. But this is precisely
because of his conversion—of his later engagement in the polit-
ical polemics which Heller deplored. Mann after 1933 has be-
come for Lukacs the great anti-Fascist whose main concern is
once more the defense of humanism against barbarism. It is
only unfortunate, says Lukacs, that Mann did not go all the
way, that he did not finally see the inseparable connection
between bourgeois humanism and proletarian revolution—in
short, that he did not become a convert to Karl Marx! As
Lukacs and Stefan Zweig disputed the meaning and the stature
of Erasmus, so Erich Heller and Lukacs dispute the meaning, if
not the stature, of Thomas Mann. Heller's estimate grows out
of his conservative sympathies, Lukacs' out of his Marxist creed.
Heller judges Mann on the basis of a theory of the literary
imagination, Lukacs on a theory of the historical meaning of
the whole German literary experience. The very future of Ger-
many, Lukacs holds, is dependent on how far German workers
and the German bourgeoisie will succeed in their intellectual
life in replacing the tradition which runs: Goethe—Schopen-
hauer—Wagner—Nietzsche with another reading of tradition
which runs: Lessing—Goethe—Hölderlin—Büchner—Heine
—Marx. There is some hope that this regeneration may be
accomplished, for it is precisely this shift which marks the
weltanschauung of the later and chastened Mann of the "Cul-
ture and Politics" as compared to the earlier and unregenerate
Mann of the *Reflections of an Unpolitical Man.*

Mann has repented, but the great refusal, the conscious with-
drawal of the artist and the intellectual from politics continues
as a permanent possibility. Nor is the example of Goethe, the
German intellegentsia of the nineteenth century, and the early
Mann a merely German phenomenon. In his diatribe against
his brother Heinrich, the hated "Zivilisationsliterat" of the
Reflections, Mann had suggested that the inspiration for this
political activism was primarily French. Heinrich Mann's fa-
mous essay in praise of Zola had occasioned the accusation, and,
indeed, the French cultural tradition which runs from Voltaire

to Zola, and from Zola to Anatole France (and from Anatole France to Sartre and Camus in our own time) does give color to the contention of an unbroken line of radicalism in the course of French literary development. But Frenchmen may be political quietists as well as Germans, and in fact the mantle of spokesman for political withdrawal which *Reflections of an Unpolitical Man* placed on Mann's shoulders passed after the mid-1920's to a Frenchman. For in 1927, Julien Benda published in Paris his immediately famous book *La Trahison des Clercs* (The Betrayal of the Intellectuals).[44]

The separation of literature and politics on narrowly aesthetic grounds had been, as Mann suggested, one of the commonplaces of the German writers of the nineteenth century. One case which Mann does not cite makes the point perfectly. In a letter to his friend Heckenast, Adalbert Stifter wrote:

I am absolutely opposed to the indiscriminate mixing of questions of the day and daily sentiments with belles lettres. On the contrary, I believe that the beautiful has no other object than to be itself, and that politics is not made in verse and declamation, but by studying political science.[45]

It is natural that the attack on politics mounted by Stifter and by Mann should be on aesthetic grounds. For they are literary men, and their concern is to protect the autonomy of the literary life against politics' raucous claims. But Benda's aims are at once broader and more generally defined.

His concern is not merely literature, but the whole of the intellectual life, and his thrust is essentially an absolute demand for its "purity" against the lesser requirements of class, race, or nationality. Central to his argument are the distinctions between the contemplative and the active, between the purity of the ethical demand and the tainted opportunism of politics, between the cosmopolitan universality of the intellectual and the narrower passions which it is sometimes mistakenly required to serve. Benda's general theme then is corruption in the modern world—the corruption of the intellect when it falls away from its ancient ideals of order, clarity, precision, objectivity, impersonality, and universality, to ally itself with the subversive passions of contemporary life: political rancor, obsessive nationalism, racial intolerance, and class hatred.

All this is a function of two novel events: the descent of the intellectuals from the ivory tower of their former critical aloof-

ness into an atmosphere of participation, and the rampant politicization of the modern world. Today political passions have attained a universality never before known. Hatreds formerly scattered and intermittent have in the formation of impenetrable "ideologies" acquired a coherence and an obstinacy formerly inconceivable. "The condensation of political passions into a small number of very simple hatreds, springing from the deepest roots of the human heart, is a conquest of modern times." [46] The idea, for example, that any single race is too inhuman to be judged by the standard of a civilized ethic, or the notion that political warfare involves a war of cultures, is entirely an invention of the period subsequent to the eighteenth century Enlightenment.

Our age has introduced two novelties into the theorizing of political passions, by which they have been remarkably intensified. The first is that everyone today claims that his movement is in line with the development of evolution and the profound unrolling of history. All these passions of today, whether they derive from Marx, from M. Maurras, or from Houston Chamberlain, have discovered a historical law, according to which their movement is merely carrying out the spirit of history and must therefore necessarily triumph, while the opposing party is running counter to this spirit and can enjoy only a transitory triumph. That is merely the old desire to have Fate on one's side, but it is put forth in a scientific shape. And this brings us to the second novelty: Today all political ideologies claim to be founded on science, to be the result of a precise observation of facts.[47]

This is largely true whether one is speaking of the highly articulated ideology of Marxism, or the less structured, but equally messianic doctrines of the "Free World," but what is so devastating to the purity of the intellectual life is the way in which the intelligentsia of both parties identifies itself with the structure of ideas under whose domination it lives. And this is what constitutes "the great betrayal"—"the treason of the clerks" (intellectuals) whose very definition in a former age was men who pursued speculative rather than practical aims, not material advantages but the freedom of the critical intelligence.

Indeed, throughout history, for more than two thousand years until modern times, I see an uninterrupted series of philosophers, men of religion, men of literature, artists, men of learning, whose influence,

whose life, were in direct opposition to the realism of the multitudes. To come down specifically to the political passions—the "clerks" were in opposition to them in two ways. They were either entirely indifferent to these passions, and, like Leonardo da Vinci, Malebranche, Goethe, set an example of attachment to the purely disinterested activity of the mind and created a belief in the supreme value of this form of existence; or, gazing as moralists upon the conflict of human egotisms, like Erasmus, Kant, Renan, they preached, in the name of humanity or justice, the adoption of an abstract principle superior to and directly opposed to these passions.[48]

Within the last hundred years the situation has become completely different. One has only to mention Mommsen, Treitschke, Brunetière, Barrès, Péguy, Maurras, D'Annunzio, and Kipling (to say nothing of Heinrich Mann, John Steinbeck, John Dos Passos, Ezra Pound, Adam Schaff, Georg Lukacs, Jean-Paul Sartre, Herbert Marcuse, Erich Fromm, Stuart Hughes, and Arthur Schlesinger Jr.) to note the impatience for action, the thirst for immediate results, the political hatred (sometimes cleverly disguised as rational judgment) and the dogmatic commitment to an ideological stance. The modern "clerk" has, as Benda says, "entirely ceased to let the layman alone descend to the marketplace. The modern clerk is determined to have the soul of a citizen and to make vigorous use of it; he is proud of that soul; his literature is filled with his contempt for the man who shuts himself up with art or science and takes no interest in the passions of the State. He is violently on the side of Michaelangelo crying shame upon Leonardo da Vinci for his indifference to the misfortunes of Florence, and against the master of the Last Supper when he replied that indeed the study of beauty occupied his whole heart."[49]

It is not simply that Benda is defending professionalism or aestheticism against any contamination from the outside world. He does show himself willing to acknowledge the descent of the intelligence from its ivory tower of quietistic contemplation; but when the occasion arises, it must be one which mobilizes his action not in a political, but in a moral cause.

When Gerson entered the pulpit of Notre Dame to denounce the murderers of Louis d'Orléans; when Spinoza, at the peril of his life, went and wrote the words "Ultimi barbarorum" on the gate of those who had murdered the de Witts; when Voltaire fought for the Calas family; when Zola and Duclaux came forward to take part in a cele-

brated lawsuit [the Dreyfus affair]; all these "clerks" were carrying out their function as "clerks" in the fullest and noblest manner. They were the officiants of abstract justice and were sullied with no passion for a worldly object.[50]

It is not a prejudice against action as such, but an unwilling-ness to see those who ought to be the mirror of disinterested intelligence delivered over to the abject slavery of the political passions. And this holds not for any one class of intellectuals, but the whole spectrum of humanistic competences: for the poets like Aragon and Eluard who use their literary produc-tions in the service of an ideology, for historians like Treitschke or Mommsen whose works project not the disinterested activity of the mind, but a thesis in the national service, for critics like Zhdanov and even Lukacs whose pen is simply a Marxist voice, and for those philosophers like Fichte and Sartre whose ulti-mate metaphysics is unintelligible without a pre-knowledge of the political party to which they belong.

One of the theoretical roots of Benda's criticism is the triumph of pragmatism, the desire to abase the values of knowl-edge before the values of action, that peculiarly modern meta-physics which deserts Aristotle's contemplative intellect to honor the feeling, willing, active part of the self above all else. But if it is no longer possible to look on national quarrels with the noble serenity of a Goethe or a Descartes, this is largely because of the political and social conditions imposed on the intellectual by the organization of modern politics itself. One of the gravest indictments of the modern state is that it hardly permits intellectual impartiality—that it has made no con-certed effort to maintain a class of men exempt from civic duties, valued for their objectivity alone, whose sole function should be to maintain those rational and cosmopolitan values which are above the claims of political partisanship. The "sys-tematic nationalization of the mind" is undoubtedly one of the most sinister inventions of the contemporary world.

Benda's concept of the intelligentsia as the part of any nation which aspires to independent thinking, and which must there-fore be isolated, rootless, and unattached, rings with a certain old-fashioned and otherworldly innocence in modern ears. For the possibility of a group which is "uncommitted," free to question the existing hierarchy of values and to replace it with new values at which it has arrived through an abstract process of rational criticism. seems to belong to the quaint mythology

of a bygone age. Nationalistic politics has invented its own labels of "treason" and "subversion" for conclusions of this kind which contravene "the national interest," and both Marxism and the sociology of knowledge which it has produced have habituated us to a skepticism as to whether ideas can be independent creations rather than the unconscious and unacknowledged products of class interests in the universal political struggle of our time. But this raises the crucial question of the possibility of intellectual sincerity in the modern world. In any society, whether Marxist or liberal-democratic, individual sincerity is fortunate if it receives only condemnation for its subjectivism, capriciousness, and vanity. Usually the epithets are worse. Something the reverse of what Benda meant by "the treason of the intellectuals" has been suggested by Oscar Gass's concept of this intellectual sincerity.

To be sincere: to form thought effortfully in my mind accepting only the discipline of the object, not following *Pravda* or the *Wall Street Journal;* to experience and welcome emotion not included in the model of a Lenin hero or the American way of life; to see and imagine as I can, not according to the official imagery of Picasso's dove or Constitution Avenue; to refuse to shut out a reality because Marx or Christ or the Founding Fathers did not know it; to acknowledge the incomplete and unattained, the image worked on but not made, the idea reached for but not conceived. This is our non-conformist sincerity.[5]

This is, as Gass rightly remarks, not yet "politics," since such sincerity is at first "a relatively solitary contest" while politics remains an external and alien struggle. But the sincerity of the private being may lead to a sincerity in public exchange. It is this hope which underlies the strategy of those who strive (perhaps fruitlessly) to bridge the gap between the hypocrisy and corruption of the public routines and the personal intellectual integrity of an Erasmus, a Goethe, and a Thomas Mann.

Five / Friedrich Schiller:

The Playwright as Politician

WHAT I have called "the great refusal"—the conscious withdrawal of the German literary and artistic intelligentsia from the political arena—had its origins in Goethe and its most curious modern embodiment in Thomas Mann, but it is not characteristic of every German artist and poet. Almost as if to show the dialectical and oppositional character of the German past there stands the figure of Friedrich Schiller. My purpose in this chapter will be to indicate how perhaps the greatest national dramatist of the German-speaking world explored the political universe, showing in his plays how the great figures of history are caught in the political machinery of their age, but at the same time clothing the humanistic message of the Enlightenment in political terms.

Goethe and Schiller are twin ornaments of the German eighteenth century, and despite their differences in temperament they shared many attitudes toward the world. The reader of their decade-long exchange of letters (1794–1804) will find many instances of essential agreement in matters of poetics and dramaturgy, in their judgments of epic and dramatic poetry, their enthusiasm for the antique world, and he will find important comments throwing light on their own creativity and works in progress, but for one thing he will look in vain—any sense of the political ferment of the time—of the day-to-day "historicity" of the crucial period through which they are living. These are the last days of the terror in Paris, the final liquidation of the French Revolution, the rise of Bonaparte's fortunes, but they write to one another of Aeschylus and iambics and the day-to-day progress of *Wallenstein,* as if the prog-

ress of literary art in the German *Kleinstaat* were the sole preoccupation of the world.

The evidence is deceptive. It holds for Goethe. It does not for Schiller, and the fact that the correspondence has this apolitical tenor is perhaps because of his recognition that its existence is somehow subtly due to a tacit acceptance of the older poet's temperamental limitations and guiding whims. Goethe's avoidance of politics is no less well known than his avoidance of tragedy, but the dilemmas of politics are the very stuff out of which Schiller's great tragic dramas are constructed. There is a fundamental difference between the two poets in this respect, due partly to Goethe's "Olympian" temperament and partly, I think, to his more "metaphysical" and "objective" interests. Apart from poetry, Goethe's great interest lies in natural science—in the domain of "Nature." Here, as he himself said, all the responses are "pure." The botany of Linnaeus is clean and tidy. Vertebrate anatomy is distinct and clear. Even the organicism of Plato and Aristotle feeds Goethe's classic need. But Schiller has a deeper feeling for ambiguity, and this leads him in the direction of the human condition and makes him less a dramatist of natural law or aesthetic impulse than of the moral sense. Goethe fancied himself (often tediously) as an original nature scientist. Schiller found himself in mid-career as a professor of history at the University of Jena. The difference is essential for the contrast between the two poets. Despite *Götz von Berlichingen,* despite *Egmont,* Goethe has a nonhistorical dramatic mind. But in Schiller's deep concern for history lies his relevance for the topic of humanism and politics. In *Don Carlos* no less than in *Wallenstein,* and in *Maria Stuart* as well as in *Die Jungfrau von Orleans* and *Wilhelm Tell,* the materials of modern European history are dramatically exploited to express the ideal of freedom in the language of the German baroque.

Is it without significance that, beginning with *Don Carlos* in 1787, Schiller used decisive moments in Western European history as the temporal background and often the dramatic center of his plays? *Don Carlos* is haunted by the revolt of the Netherlands; it is that peripheral event's implications projected at the tightly controlled court of Philip II in Spain. *Wallenstein* is set at Pilsen and at Eger in Bohemia, those locales where the crucial events of the middle stages of the Thirty Years War occurred. *Maria Stuart* takes place at London and Fotheringay Castle in February, 1587, but its precondition is

the rise of Elizabethan England as a world power, and if the atmosphere is one of insularity, the invasive presence of intriguing Paris, conspiratorial Madrid, and the long arm of the Spanish Inquisition is always felt. *Die Jungfrau von Orleans* is staged at Chinon, Chalons, Rheims, and on the battlefields of northern France, where during the Hundred Years War the French won their liberation from English domination. And *Wilhelm Tell* uses the wild Alpine landscape of the Swiss cantons to detail the early foundation and triumph of Swiss democracy according to a romantic legend of the thirteenth century.

It has always been maintained that throughout the eighteenth century the scope of historical studies as such rapidly expanded.[1] Not only an augmentation in the collection of materials which in the end produced the polished narrative of Hume and the flowing periods of Gibbon, but also the bold advance in the philosophical interpretation of the course of European civilization in such men as Turgot and Condorcet, Lessing and Herder aided the historiographic profession. But what is truly remarkable is how in Schiller "the historical sense" has come to dominate the poetic feeling and the dramatic enterprise. Such an intrusion of historicity into the drama has not been known since the great chronicle series of Shakespeare, and it is perhaps right that we should turn for a moment to ascertain the meaning of these events for the development of European literature.

One of the insights which we owe to Marx and his school is that the conditions operative within any social order have repercussions on the state of its arts. And it follows that this historic growth of social antagonisms in life produces the tragic drama as that art form peculiarly suited to the expression and portrayal of conflict among archetypical social figures.[2] That both Shakespeare and a certain number of his contemporaries produced a great flowering of the historical drama is not unrelated to crises in the breakup of the feudal system only slowly making themselves felt in the rising mercantilism of the late sixteenth century. This is not to say that the Shakespearean drama is predicated on a conscious knowledge of the actual historical causality responsible for the decline of feudalism, but merely that the great chronicle series from the reign of Richard II to the ascension of the throne by Henry Tudor permitted Shakespeare to contrast governing types who perfectly exemplified these themes of feudal crisis. With Richard II (as we have seen) Shakespeare takes regretful leave of the colorful medieval

past, and with Henry IV he enters on the age of the pragmatic and prudential future. The whole series of contrasts between Gloucester and Somerset, Henry VI and Warwick, or Prince Hal and Harry Hotspur depicts with brilliant clarity the welter of contradictions which had filled the feudal past of England for centuries, and which the Tudor myth attempted to rationalize in the service of order and an expanding national economy. Shakespeare's cycle of chronicle plays is imbued with that brilliant historical sense which portrays the slow supplanting of "the old" by "the new" in a tapestry too rich for the triumph of a single socioeconomic moral posture, but too direct not to point the line of development of the emerging social order. However much Shakespeare feels a pang for the old ambience of aimless nobility and gorgeous pageantry, he foretells the triumph of a humanism not unrelated to practical wisdom of a high administrative order. For the old, inner-directed, unproblematic, and uncorrupted nobility Shakespeare may feel a keen, nostalgic, personal sympathy, but as a clear-sighted Elizabethan poet he regards the destruction of this particular social stratum as inevitable. The very profundity with which he experiences the paradoxes of his own age permits Shakespeare to create chronicle plays and tragedies of great historical authenticity even though he has no distinct consciousness of that *historical fate as such* which is to emerge with Hegel and the romanticism of the nineteenth century.

Schiller's great cycle of historical tragedies from *Don Carlos* to *Die Jungfrau von Orleans* is the heir of Shakespeare's *Henry V* and *Richard III*. They represent the second great wave of European historical drama which sets in with the German Enlightenment. As Shakespeare's history plays are the outcome of the dissolution of the feudal epoch, so Schiller's are the unconscious preparation for the age of the democratic revolutions. For it is one of the fascinating paradoxes of Schiller's dramatic genius that characters in *Don Carlos* should speak with the accents of some idealistic Danton or Robespierre, and that the courtiers supporting the English queen in *Maria Stuart* should give advice such as that which came to the rising Napoleon from the prudent and opportunistic generals by whom he was surrounded. It is in this sense that the plays of Schiller are brilliantly and significantly anachronistic. For by his representation of the crisis of freedom which led to the revolt of the Netherlands that forms the background of *Don Carlos* and the crisis of individual authority which caused the Thirty Years

War and the downfall of the problematic general in *Wallen-stein,* Schiller shows a much more marked consciousness of the mechanisms of history as such than any exhibited by Shakespeare. And this is not merely to say that while Shakespeare was simply a successful London man of the theater and a property-owner in Stratford, Schiller was an actual lecturer in history at the University of Jena, but that *the historical sense* in the concluding years of the sixteenth century in England was something profoundly different from what it was in the concluding years of the eighteenth century in Germany.

Historical fate in Elizabethan England is inseparable from a doctrine of divine providence which exists in unbroken continuity from the early Church Fathers to the Puritan divines of the seventeenth century. Historical fate in the Weimar of Goethe and Schiller has that actual historical palpability which the career of Napolean exemplified and the writings of Hegel are to distill with all the philosophical resources of a romantic idealism. For Shakespeare "history" means the pageant of kingship fulfilled or violated, *the concrete event* in all the immediacy of its happening. But for Schiller history is *the emerging idea,* the abstract meaning, the spiritual force which lies back of the phenomenal occurrence and constitutes its value and significance.

There is, of course, a real problem in the matter of the origin of the historical consciousness in eighteenth century Germany. From one point of view all of the history writing of the Enlightenment (like the political philosophy of Rousseau) was simply an ideological preparation for the French Revolution. For it drew the attention of writers and thinkers to the immediate significance of time, place, and social conditions, and so created the realistic literary means of expression for any contrast between outmoded traditions and contemporary values. Only when this sense of contrast between past and present becomes acute does the problem of the artistic reflection of past ages become a central preoccupation of drama and imaginative literature as it did in the Germany of Goethe and Schiller. If, as can be persuasively argued, it was the French Revolution, the various revolutionary wars, and the rise and fall of Napoleon which for the first time made history *a mass experience* for the population of Europe, it was in the nationalistically backward and petty principalities of the German-speaking center that a genuine historical consciousness came to determine the university curriculum and the aristocratic drama of court circles. For

here it had become implicitly clear that the *evaluation* of the present depends on a *recognition* of the past. History had (as in Rousseau and Robespierre) become the handmaiden of the moral sense! In the very year of the storming and destruction of the Bastille in Paris (1789), Schiller in delivering his inaugural lecture as professor of history at Jena on "The Meaning and Purpose of Studying Universal History" began his discourse thus: "Fruchtbar und weit umfassend ist das Gebiet der Geschichte; in ihrem Kreise liegt die ganze moralische Welt." [3] (Fruitful and all-encompassing is the domain of history; within its circle lies the entire moral world.) This is not only the historical sense which dominated the eighteenth century and the emerging philosophy of romanticism; it is the historical consciousness which created *Wallenstein, Maria Stuart,* and *Wilhelm Tell.*

Two other aspects of the historical sense are illustrated in this inaugural lecture of Schiller's. The first is the insight that the attempt to weave together the past and the present is not simply an effort to overcome "the blind rule of necessity," but represents a teleological exercise in which the mind projects a principle of harmony which it discovers in itself into the chaotic course of external events. And the second is that the abstract ideas of "freedom" and "humanity" which underlie the course of history as humanly discerned are not merely the evidence of one period and one historic segment, but a consequence of the historical process as a whole. "Der Mensch verwandelt sich und flieht von der Bühne; seine Meinungen fliehen und verwandeln sich mit ihm: die Geschichte allein bleibt unausgesetzt auf dem Schauplatz, eine unsterbliche Bürgerin aller Nationen und Zeiten" (Man changes continually and disappears from the stage: his opinions alter and disappear with him: history alone remains perpetually upon the boards, an eternal citizen of all nations and all times.) [4] It is precisely this consciousness of the "ideas" discernible in history which distinguishes the implicit historicity of Shakespeare and the Elizabethans from the explicit and consciously articulated morality of Schiller's political dramas, and it is a difference which has been neatly observed and described by Stephen Spender.[5]

Spender wonders whether there was something about the period in which Shakespeare wrote which made it possible to create royal and powerful figures as *people,* and which was lacking in Schiller's time. Shakespeare's Richard II or Henry V or Richard III are far from "mindless," but they are completely

absorbed in the situations in which they appear—acting imme-
diately, almost like forces of nature in their powers and weak-
nesses. History, in short, is precisely what they do or do not do.
They *are* history. But Schiller has a more modern, even an
Hegelian or Marxist view in which men are somehow *in* history
which surrounds them like a viscous and recalcitrant medium
and which they must test and be conscious of in order to gain
such freedom of movement as its properties permit them. Here
the reality of history—greater than the personalities of the
historic characters—is the force of "ideas," whether of idealism
or of power, and thus Schiller's chief characters in his historical
dramas must be "men of ideas" not simply because they are
idealistic, but because history itself is a dialectical struggle of
powers or forces which are available to mind and can be
grasped as ideas.

In Shakespeare the problem of the ruler is to exercise per-
sonal authority according to a principle of legitimacy in the
pursuance of social order. And here all of the crucial terms are
not external conventions, but allied with the structure of the
universe. Personal authority is a natural quality. Royal legiti-
macy is a divine gift. Social order is as implicit in the nature of
things as orderly organic growth or planetary movement. With
Shakespeare the problem of the ruler is not to betray or pervert
the vocation thrust on him by nature.

But with figures like Turgot and Condorcet, Rousseau and
Montesquieu, the eighteenth century had reestablished the an-
cient Sophistic distinction between "nomos" and "physis," be-
tween "nature" and "convention," so that the exercise of politi-
cal power is no longer identical with a doctrine of natural
right, and political rulership is cut adrift from instinctive be-
havior and set tossing on the infinite waters of deliberation and
calculation. Thus for Schiller, monarchs like Philip II or Eliza-
beth, or powerful figures like Alba or Wallenstein, exist in a
special relationship to forces which, by taking thought, they
may control, but which are, nonetheless, *outside* them. In this
view of the world the powers of history are *massive, inexorable,*
and *external.* This is precisely what is responsible in Schiller's
dramas for the ambience of conspiracy and the atmosphere of
intrigue. It is not only the rulers who are confronted with the
intellectual problem of interpreting historical forces. Figures
like those of Domingo and Posa in *Don Carlos,* Burleigh and
Leicester in *Maria Stuart,* Octavio Piccolomini, Illo, and Iso-
lani in *Wallenstein* are and must be constantly preoccupied

with relating themselves to the sources of power; calculating the evidence, reading the signs, interpreting the situation. And Wallenstein himself is only the most quintessential and archetypical historical figure whose relation to historic destiny becomes so self-consciously dependent on omens, hesitations, alternatives, the right moment, the proper confluence of the planets, as to produce an ultimate irony which can compare with anything to be found in Sophocles. So in the end Spender is profoundly right in saying that "Schiller reflects in his historic dramas the change from the feudalistic idea of human power as analogous with the order of nature arranged by the deity, to the modern idea of power as comprehension, organization, and control of material forces through abstract ideas which was characteristic of the eighteenth century." [6]

It is true, of course, that the difference between Shakespeare's view of history and that of Schiller is the result of profound changes in history itself between the sixteenth and eighteenth centuries. Although enormous differences distinguish the politics of Hobbes from that of Rousseau, what is at stake here is not merely a matter of theory. In Shakespeare's time, in the epoch of the Tudor myth, kings are divine; their power is infinite, their deposition creates a vacuum, and their murder is a crime. But since those days Charles I and Louis XVI have had their heads struck off like common criminals, in response to the judgment and with the consent of the majority of their own subjects. Royal survival is no longer the gift of divine protection but of cleverness and sagacity, of the ability to manipulate public opinion through prudence and calculation. It is no wonder, therefore, that the typical ruler of Schiller's political drama is, above all, a realist.

But the picture is more complicated than this. For if in his historical plays Schiller is in fact inventing the modern world where power corrupts and absolute power corrupts absolutely, he is, at the same time, propounding values which a romantic legacy has bequeathed to the nineteenth century. Freedom remains the final teleology of history, and values, too, perpetuate their motivating power as ideals in the hearts of men. Thus there is, in effect, an ultimate moral Manicheanism which invades Schiller's dramaturgy—a split sometimes discernible in the dramatic opposition of diverse characters, sometimes within the psyche of a single dominant figure. This reflects a division within Schiller's own philosophical thinking as a dramatist between the power of political accommodation and the power

of moral goodness, and it explains the tendency of his charac-
ters to split between the poles of realism and idealism. It is
what, for example, distinguishes the Grand Inquisitor from
Don Carlos, Shrewsbury from Burleigh in *Maria Stuart*, Max
from Octavio Piccolomini in *Wallenstein*. And it is what makes
the characters of Wallenstein himself and the Marquis of Posa
such complex, divided, and fascinating spectacles. Wallenstein
is a realist within whom nevertheless twinges of love, virtue,
and loyalty still struggle, and who, in spite of his purely selfish
ambition, toys with the dream of peace and a harmoniously
united central Europe. Posa is an idealist, a passionate defender
of political self-determination and the civil liberties, born two
centuries before his time, who yet dares to betray the deepest
ties of friendship and the loyalty of a subject for his king, and
to play the most Machiavellian political game to ensure the
triumph of his moral values. That Posa fails as an idealist in
the same way that Wallenstein fails as a realist indicates two
types of tragedy which stem from the predicaments of moral
aspiration in a world of power. Schiller's sense of history has
none of the simplicity, none of the cosmological naïvete which
characterizes that of Shakespeare, but his political drama deals
no more superficially with problems which for the modern
world are particularly acute. The essence of his work as a
dramatist is the study of man in a world of power where politics
has become disconnected from nature, and where values seek
their realization in a society bewitched by the lure of naked
force.

If, as I believe, "the historical sense" which underlies the
chronicle plays of Shakespeare is essentially different from that
which produced Schiller's plays from *Don Carlos* to *Wilhelm
Tell,* this is not merely a matter of its form, but equally of its
substantive expression. If history for Shakespeare is the destiny
of kings, and for Schiller the emerging quality of historical life
which is external to the more political acts of men of power,
then it is not difficult to understand also how Shakespeare's is a
"conservative" and Schiller's a "revolutionary" politics. For the
very meaning of successful Shakespearean kingship is the *estab-
lishment of order,* and the very emerging quality of historical
life which in the end determines the fate of Schiller's figures of
power is the *developing ideal of freedom.* The ultimate preoc-
cupation of Shakespearean politics is the preservation of the

inalienable ordering of feudal hierarchy. The zeitgeist within which Schiller's dramatic imagination operates is that of the French Revolution and the Rights of Man.

It is a zeitgeist which expresses itself most perfectly in the last pages of Hegel's *Philosophy of History*—in the dictum that "the History of the World is nothing but the development of the Idea of Freedom"—and, after all, Schiller and Hegel are of a single intellectual generation; both are the heirs of Herder and of Kant. The spirit of freedom emerging in the course of universal history is the faith which energizes what happens in *Wilhelm Tell* set in the thirteenth century, *Die Jungfrau von Orleans* set in the fifteenth, *Don Carlos* and *Maria Stuart* in the sixteenth, and *Wallenstein* in the seventeenth. And it lies back of the burning indignation implicit in *Kabale und Liebe,* set in the eighteenth. This does not mean (as is so often mistakenly asserted) that Schiller had a burning interest in the immediate politics of his own day, that, in fact, he was initially as passionately for the French Revolution as Danton or Robespierre or Saint-Just, but it does mean that the same mode of perception, crudely pragmatic, even brutal in the case of French politics, expressed itself refined and essentialized, energetically but with intellectual thrust and poetic idealism in the philosophy of Hegel and in Schiller's historical plays.

Of all the latter, it is perhaps *Don Carlos* in which the passion for political freedom is most nobly expressed. The much later *Wilhelm Tell* is probably more stirring and certainly more uncomplicated because it shows the actual triumph of freedom on the stage and because it paints a glowingly romantic picture of the congruence between the wild surge of freedom in the human heart and the wild unpredictability of nature itself, which saves the rebel through its sheltering storms and forbidding rocky passes. But *Don Carlos* is more brilliant because in it the forces of repression are not simply constructed as counterforces of heroic rebellion, but plumbed as the coldly functional mechanisms in the service of an idea, and although that idea triumphs in the play, there is throughout the anachronistic sense of historicity—the consciousness projected back into the sixteenth century that fanatical and repressive Catholicism and the absolutism of despotic kingly rule are both in the end doomed. Thus the Marquis of Posa, the libertarian of the play, speaks with the same sense of ultimate historical vindication which Rousseau thirty years before the French Revolution infused into his *Social Contract.* "Das Jahrhundert ist meinem

Ideal nicht reif," (The times are not yet ripe for my ideals)
says Posa, and later with the light of secure prophecy:

> Sanftere
> Jahrhunderte verdrängen Philipps Zeiten;
> Die bringen mildre Weisheit! Bürgerglück
> Wird dann versöhnt mit Fürstengrösse wandeln,
> Der karge Staat mit seinen Kindern geizen,
> Und die Notwendigkeit wird menschlich sein.

> (Milder
> Times will push aside the present
> And bring a milder wisdom. The common man
> Will walk reconciled with high nobility,
> The state will set its children free,
> And then necessity will be a human thing.)

In Domingo and Alba in the purest of distillations are exempli-
fied the repressive forces of church and state, but Philip II,
although narrow and implacable, is vulnerable to feeling and
to rational discourse. And it is this above all which makes the
great scene between him and Posa (Act III, Scene 10) both the
climax of the play and a breathtaking forerunner of the ideol-
ogy of the French Revolution.[7] It is Posa who not merely asks of
the king that Flanders be granted a peace other than that of the
graveyard of repression, and who sees that the Protestant revo-
lution is not to be contained, but whose vision includes the
emerging idea of a freedom which history is, in the nature of
things, bound to realize.

> Geben Sie
> Die unnatürliche Vergöttrung auf,
> Die uns vernichtet! Werden Sie uns Muster
> Des Ewigen und Wahren! Niemals—niemals
> Besass ein Sterblicher so viel, so göttlich
> Es zu gebrauchen. Alle Könige
> Europens huldigen des spanschen Namen.
> Gehn Sie Europens Königen voran.
> Ein Federzug von dieser Hand, und neu
> Erschaffen wird die Erde. Geben Sie
> Gedankenfreiheit!—

> (Give up
> The unnatural idolatry
> Which destroys us! Become a model

Of the eternal and the true! Never,
Did a mortal man possess so much,
Such godly power to create.
All the kings of Europe
Respect the name of Spain.
Be first among the European kings.
A pen-stroke from your hand
Creates the earth anew. Oh give us
Freedom of thought.)

This is the very center of Schiller's romantic libertarianism, and the moving effect which it has is in no small part due to the very anachronism of its occurrence. An impossible dialogue in the age of Philip II, it is the very presupposition of all dialogue in the age of Danton and Robespierre. The plausibility of the encounter between Philip and Posa in the play rests on the tragic personal involvements of the monarch and the romantic bravado of his noble subject, but the abstract meaning which Schiller intends is not foreign to the professional interests of the future historian of Jena. It is to display the warped absolutism of the sixteenth century confronted by the fanatical libertarianism of the eighteenth—in fact, a dialogue across the centuries although set in the royal palace in Madrid at the very height of Spanish power.

Schiller produced *Don Carlos* in 1787. One year later appeared his incomplete, but nonetheless substantial, historical work *Geschichte des Abfalls der vereinigten Niederlande von der spanischen Regierung (The Revolt of the Netherlands)*.[8] It is therefore clear not only that they deal with the same historical subject matter, but that they spring from an identical preoccupation with the emergence of freedom in history, and also that the historical work, no less than the *Briefe über Don Carlos* of the same year, constitutes an extended commentary to the play itself. In his later Kantian period Schiller makes much of the Kantian concept of freedom which he derived from his reading of *Die Kritik der praktischen Vernunft*—where freedom is metaphysically grounded and individually expressed—and traces of this more individualized application are surely to be found both in *Maria Stuart* and in *Wallenstein*, but the more strictly political concern of the dramatist with the problem of the emerging freedom of an entire oppressed people is perhaps the more constant preoccupation of the poet-historian, and underlies the permanent popularity of both the early *Don*

Carlos and the much later *Wilhelm Tell.* In his preface to *The Revolt of the Netherlands,* Schiller admits to a belief in the enormous simillarity of the historical and the dramatic enterprise (not unlike the similar closeness of the philosophical and the dramatic enterprise in the existentialist writers Sartre and Camus today). When, he says, he first read Watson's *History of the Revolution in the Lowlands,* he was seized with an enthusiasm which political events but rarely excited in him at that time, and he wondered if the enormous excitement which the book seemed to stimulate had not arisen less from the work itself than from the ardent working of his own imagination. At any rate, it was to fix, multiply, and strengthen this very exercise of the historical imagination and to communicate "these exalted sentiments" to others which was his principal motive in attempting his own historical work.[9] Schiller does not claim to be an archivist, to have perused recondite materials, or to have unearthed new sources. Rather he sees his task to be that of sifting the sources already abundantly available and to make interesting to the intelligent reading public a portion of the historical truth. This presupposes that it is possible to enrich history by utilizing the resources of the poetic imagination without at the same time degrading it to the level of fiction or romance.

It remains true, however, that Schiller as practicing historian is an historian of freedom,[10] and that, as he says in the opening words of his introduction to *The Revolt of the Netherlands,* he sees this memorial of a successful political struggle as a paradigmatic case, inspiring men of his own day and showing them what in the way of freedom remains possible to energy, enthusiasm, and the cooperative will:

Of those important political events which make the sixteenth century take rank among the brightest of the world's epochs, the foundation of the freedom of the Netherlands appears to me one of the most remarkable. If the glittering exploits of ambition and the pernicious lust of power claim our admiration, how much more so should an event in which oppressed humanity struggled for its noblest rights, where unwonted powers were united with the good cause, and the resources of resolute despair triumphed in unequal contest over the terrible arts of tyranny.

Great and encouraging is the reflection that there is a resource left us against the arrogant usurpations of despotic power; that its best contrived plans against the liberty of mankind may be frustrated; that resolute opposition can weaken even the outstretched arm of

tyranny; and that heroic perseverance can eventually exhaust its fearful resources. Never did this truth affect me so sensibly as in tracing the history of that memorable rebellion which forever severed the United Netherlands from the Spanish Crown. Therefore I thought it not unworth the effort to attempt to exhibit to the world this grand memorial of social union in the hope that it may awaken in the breast of my reader a spirit-stirring consciousness of his own powers, and give a new and irrefragable example of what in a good cause men may both dare and venture, and what by uniting they may accomplish.[11]

These words were written one year before the fall of the Bastille, five years before the Reign of Terror, and it is impossible not to sense in them (no less than in the libertarian sentiments of *Don Carlos*) the ideas—in fact, the very rhetoric and language—of the French Revolution. "Oppressed humanity" (*die bedrängte Menschheit*), "The terrible arts of tyranny" (*die furchtbaren Künste der Tyrannei*), "the liberty of Mankind" (*menschlichen Freiheit*), "the arrogant usurpations of despotic power" (*die trotzigen Anmassungen der Fürstengewalt*) —these are almost the common stock of language of the Tennis Court Oath, the Declaration of the Rights of Man, and the Jacobin debating societies. And if they refer to events two hundred years in the European past, it seems no less true that one tyrannical act may serve as a paradigm of every tyranny, one successful liberation as a symbol for every aspiration toward freedom. And does not Schiller himself refer to the practical and activist aim of his theoretical enterprise—to awaken in the reader "a spirit-stirring consciousness of his own powers"? From these words in *The Revolt of the Netherlands* it is easy to infer Schiller's sympathy with the coming age of the democratic revolutions, but the facts of the matter are far less simple.

The story of Schiller's relationship to the French Revolution is at once more complicated and more surprising than one would expect from the sentiments expressed in *Don Carlos* and *The Revolt of the Netherlands*.[12] It would be comforting and very tidy if one could say that Schiller was at first hopeful, even enthusiastic about the French Revolution from the period of the fall of the Bastille to the death of Mirabeau and the unsuccessful flight of the royal family to Varennes two years later (1789–91), and had only become thoroughly disillusioned by the desperate events of the year 1793—the establishment of the Revolutionary Tribunal, the execution of the king, and finally

the bloody massacres of September and October in which the queen and the Girondists perished. But there is no evidence from Schiller's own writings that he was ever deeply sympathetic with any of the specific acts of the revolutionists.[13] Schiller, as Benno von Wiese has contended, belonged not to the party of revolutionary force, but to that of humane liberalism, and his repugnance toward every form of social violence would have made him even less in sympathy with the events of 1789–91 than was the case with Wieland, Klopstock, and Herder. The author of *Die Räuber* and *Don Carlos* may have seemed to be a friend of violence used as a corrective to bitter social injustices, but in actuality he was not. It is a fact of profound irony that in 1792 he, among a handful of other illustrious and presumably sympathetic persons, was made an "honorary citizen of France." A diploma to this effect, signed by Danton and accompanied by a letter from Roland dated October 10, 1792, was sent to him from Paris, but it remained at Strasbourg, not finding its destination until March 1, 1798. But by this time Schiller himself remarked of it that it seemed to have come "from the kingdom of the dead."

One fact is, however, beyond question. It is Schiller's profound shock at the bloody events of the year 1793, culminating in the execution of Louis XVI and the Reign of Terror. For a while toward the end of 1792, he formed the idea of personally intervening in French politics—of exercising the right of "a French citizen" and his "duty to humanity" to intercede in behalf of the imprisoned monarch. He hoped, as he wrote his friend Körner, that the voice of reason might be heard even by the disaffected and disoriented French people, who would, perhaps, not consider either hopelessly partisan or reactionary the pleas of a libertarian dramatist. But Körner did not encourage him, and although the *mémoire* was written and even translated into French, Schiller was not in good health, and the good deed was too slow for the bloody march of events in France. The execution of the king took place and with it Schiller's profound disenchantment with the practical politics of the French Revolution.

How is this disenchantment to be interpreted? One school, noting that the end of the French Revolution finds Schiller engaged with his famous letters *Ueber die aesthetische Erziehung des Menschen,* holds that, partly because of his disillusionment with French politics, partly because of his new interest in the aesthetic doctrines of Kant, his interest shifts from

"political" freedom to "philosophic," and that he turns from a critique of politics to formulate a doctrine about art. The theory is plausible and attractive, partly because such shifts occur so frequently throughout the tradition of Western culture, particularly in the nineteenth century. Both Jacob Burckhardt and Thomas Mann at one point of their careers represent the classic transformation—aesthetic preoccupation blotting out the traces of political disgust. But it will not work for Schiller because it implies a theory of politics which is too narrow to represent his idealistic and comprehensive sense of the political world. There is a politics of moral idealism as well as a politics of institutional reform, and when Schiller turned away from the latter it was not to drown himself in purely aesthetic considerations, but to utilize the aesthetic itself in the service of the politics of moral idealism. This is implicit in the very content of the letters *On the Aesthetic Education of Man* and should be clear to anyone who reads them attentively, but if there were any doubt on this score it would be dispelled by the remarkable letter which Schiller addressed to their future recipient—Duke Friedrich Christian of Augustenburg—on July 13, 1793,[14] two years before the work itself was completed and published.

This letter was written at the height of Schiller's disillusionment with the French Revolution—midway between the execution of Louis XVI and the great massacres of the revolutionary tribunal—on the very day, in fact, on which Marat was assassinated by Charlotte Corday—but despite its expression of his distaste for French political extremism, Schiller makes it clear that his choice of an aesthetic subject matter is by no means completely irrelevant to the momentous questions of the hour —in fact, he shows how the use of aesthetic means for moral education has as its ultimate aim the creation of a humane politics.

The purpose of this communication to the duke is to explain and justify the work *On the Aesthetic Education of Man* which he proposes to send to him, but, not unnaturally, obsessed by the political events of the hour, his justification takes the form of putting in place "the aesthetic" against the more urgent demands of "the political." Is it not untimely (ausser der Zeit), asks Schiller, to concern oneself with the needs of the aesthetic when the concerns of the political present so much more immediate an interest? This would perhaps be the case, he implies, either if politics were pursuing an ideal course, or if there were

a more intimately established rapport between political direction and literary concern. But neither of these holds for the present age. "Der Lauf der Begebenheiten im Politischen, und der Gang des menschlichen Geistes im Literarischen hat dem Genius der Zeit eine solche Richtung gegeben, die ihn je mehr und mehr von der idealisierenden Kunst entfernt." (The course of events in the political realm and the path of the human spirit in the literary has given such a direction to the genius of the time as to separate it ever more and more from an idealizing art.) [15] It is, however, the contemporary degradation of the political by which Schiller is most affected. I am, he says, so far from believing in the commencement of a political regeneration, that the events of the time rather take from me all hopes for it in centuries to come. The reference is, of course, to the French Revolution:

> This effort of the French people to establish their sacred rights of humanity and to gain political freedom has only brought to light their unworthiness and impotence; and, not this ill-fated nation alone, but with it a considerable part of Europe, and a whole century, have been hurled back into barbarism and servitude. Of moments, this was the most propitious; but it came to a corrupt generation, unworthy to seize it, unworthy to profit by it. The use which this generation makes and has made of so great a gift of chance, incontestably shows that the human race cannot yet dispense with the guardianship of might; that reason steps in too soon where the bondage of brute force has hardly been shaken off; and that he is not yet ripe for *civil* liberty, from the attainment of whose *human* liberty so much is still missing.[16]

It is a passage worthy of our attention for its mode of perception is pure Schiller. Here is the same sense of the *externality* of history (so alien to the mind of Shakespeare) which pervades such plays as *Maria Stuart* and *Don Carlos,* the same faith in "the propitious moment" in history which haunts the pages of *Wallenstein.* But the crucial point is the insight of the last line, the distinction between "civil" liberty (bürgerliche Freiheit) and "human" (menschliche) on which the entire politics of the later Schiller is founded—the idea that the internal culture of the individual is a prerequisite to the establishment of a humane politics, and that institutional reform waits on the realization of a high general level of discriminating moral perception. It is not, I think (as has often been supposed), that Schiller has fallen under the spell of Kant's insistent "meta-

physics of the will," but rather that in Kant he finds the speculative materials with which to support his own essentially moral thrust, and that through the Kantian architectonic he has discovered a strategy by means of which the moral, the aesthetic, and the political can be brought into the accord of some higher Platonic harmony. The brutal failure of the French Revolution is that of a task at once too directly and too superficially pursued. The English moralists Hutcheson and Shaftesbury (and, following them, Kant) were more nearly right. There is a sense in which moral value is established through the niceties of aesthetic perception and both express themselves in qualities of human character which are a presupposition of all enduring political reforms. It is in this sense that the efficacious "liberty" of the individual human self is the prerequisite for the "liberty" enjoyed in any body politic. That Schiller turns to his new work *On the Aesthetic Education of Man* is *not* therefore evidence of his abdication of the political realm and his immersion in the less tempestuous waters of the aesthetic, and if there were any doubts on this score they should have been dispelled by the subsequent passage in the Augustenburg letter, which is, in my opinion, the most important thing to be found there, and, indeed, one of the most important passages to be found in the whole spectrum of Schiller's prose. For it fixes once and for all the political values of the poet, and shows clearly how for him the internal quality of human character is the rock on which all political achievement is to be built.

Freedom, political and civil, remains ever and always the holiest of all possessions, the worthiest goal of all striving, the great rallying-point of all culture; but this glorious structure can only be raised upon the firm basis of an ennobled character; and before a citizen can be given a constitution, one must see that the citizen be himself soundly constituted.[17]

It is no part of my purpose to pursue to its conclusion the argument of *The Aesthetic Education of Man*. It is enough to recognize in it the program cited by Schiller in the passage above. Freedom, political and civil, remains for him the ultimate aim of the cultural enterprise, but its instrument is the honorably developed character of the individual man. And while the French Revolution pursued its bloody course to provide a liberal constitution for the citizens of France, *The Aesthetic Education of Man* sketches those considerations which

are relevant in order that citizens of every nation may them-
selves be "soundly constituted." The letter to Augustenburg
shows us what we may expect in that it locates the moral
limitations inherent in a politics which is shallow and narrowly
conceived. "But so long," says Schiller, "as the chief presuppos-
tion of states is an overweening egotism and so long as the aim
of the citizen is limited only to physical well-being, just so long,
I am afraid, will that political regeneration which one believed
so near, remain but a lovely philosophical dream." [18] It is pre-
cisely this nationalistic madness and personal materialism
against which both the dramas and the educational theory of
Schiller are directed. And we shall therefore see that his ex-
treme (and perhaps overoptimistic) confidence in the effica-
ciousness of an "aesthetic culture" is that as an instrument of
character education it remains somehow independent of the
fanatical demands of any immediate political situation, main-
tained by its internal persuasiveness and momentum and not
by the grace and equivocal favor of a supporting political state.
It is perhaps after all what we might expect of a cosmopolitan
poet of the German eighteenth century, living in the petty
German principalities which are immune to the French disease
of national pride and among artists and writers for whom
German literature has not yet provided a "national" subject.

The letters which constitute *The Aesthetic Education of
Man* of 1795 dare to state publicly what Schiller has already
indicated in the private letter to Augustenburg. In Letter II, he
defends himself against the "unseasonableness" of turning to go
in search of a code for the aesthetic world at the very moment
when the spirit of philosophical inquiry is so narrowly chal-
lenged "to occupy itself with the most perfect of all works of art
—the establishment and structure of a true political free-
dom." [19] He admits that at this moment the eyes of all are "anx-
iously turned to the theater of political events where it is pre-
sumed that the great destiny of man is to be played out," but his
purpose is to show not only that art is relevant to politics, but
that the political problem is insoluble without reference to
aesthetic considerations. "I hope that I shall succeed in con-
vincing you that this matter of art is less foreign to the needs
than to the tastes of our age; nay, that to arrive at a solution
even for the political problem, the road of aesthetics must be
pursued, because it is through beauty that we arrive at free-
dom." [20] But it is in Letters IV and V that Schiller makes that
kind of self-reference which throws new light on the political

character of his own dramatic enterprise. He has been discussing the conditions under which political revolution in a state according to moral principles can be free from injurious consequences. But he turns from this to consider the difference between artists of matter and artists with human materials. The former need not "respect" the matter on which he seeks to impose form—he may even do violence to it. Not so the latter.

The *political and educating artist* (der pädagogische und politische Künstler) follows a very different course, while making man at once his material and his end. In this case the aim or end meets in the material, and it is only because the whole serves the parts that the parts adapt themselves to the end. The *political artist* (der Staatskünstler) has to treat his material—man—with a very different kind of respect from that shown by the artist of fine art to his work. He must spare man's peculiarity and personality, not to produce a deceptive effect on the senses, but objectively and out of consideration for his inner being.[21]

I do not mean to suggest that the self-reference here is intentional. Schiller has been speaking about the problem of political administration and his reference to the political artist is in the same spirit as that in which Burckhardt in *The Civilization of the Renaissance in Italy,* in referring to the institutions of the Italian fourteenth and fifteenth centuries, speaks of "the state as a work of art"—that is, as a work of reflection, calculation, and conscious design. Schiller's revolutionary or constitutional artist is a practical statesman—a kind of "social engineer"—but it is surely not entirely accidental that the term seems so well to characterize the work of the poet himself. Schiller's view of the function of the drama, and therefore his own practice in *Don Carlos* or *Wallenstein* or *Wilhelm Tell,* shows him in his own person to be *the political and educating artist* whose materials (character) and whose end (the audience) are both men, and whose dramaturgy requires that he treat these materials objectively, but out of profound consideration for man's "inner being." And it is in precisely this sense that it is possible to characterize him as "the playwright as politician."

It is of the greatest interest to note that Schiller's rhetoric employs the constant passage from the realm of art to the realm of politics and that, like Burckhardt, his most effective tools of political analysis are metaphors taken from the fine arts. In

Letter V, the same strategy is employed to present Schiller's essential criticism of the politics and class structure of his own day. "Man *paints* himself in his actions and what is the form depicted in the *drama* of the present time? On the one hand he is seen running wild, on the other in a state of lethargy: the two most extreme stages of human degeneracy and both united in the same epoch." [22] The first extreme is the spectacle of prole-tarian disorder—the bloody anarchy of the French Revolution: "In the lower class masses (den niedern und zahlreichern Klas-sen) coarse, lawless impulses come into view, breaking loose when the bonds of civil order are burst asunder, and hastening with unbridled fury to satisfy their savage instincts." But the second is the spectacle of upper class corruption— the very same which Schiller himself had portrayed in 1784 in the dar-ing and revolutionary *Kabale und Liebe:* "On the other hand the civilized classes give us the still more repulsive sight of lethargy, and of a depravity of character which is the more revolting because culture itself is its source."

It is clear that those political liberals who expect Schiller's passion for liberty to place him on the side of the French Revolution are in error, as well as those Marxists who interpret his attacks on the upper classes as an indication of his prole-tarian sympathies. But it is equally clear that those who see in Schiller's portrayal of noble upper class figures like Posa and Mary Stuart and Max Piccolomini the same aristocratic bias which they discern in Shakespeare are also profoundly mis-taken. In his quest for that soundness of character on which the hopes of an improved politics must rest, he finds no trace either in the crude violence of the lower classes or the lethargic decad-ence of the upper. The French Revolution had demonstrated the bankruptcy of the first, the very everyday experience of the petty German principalities in which he lived demonstrated the unworthiness of the second. It was precisely a disillusionment with the actual class structure of his time *at every level* which turned Schiller from faith in any purely political solution what-soever to the realm of an ideal morality and to the concrete tasks of "the political and educating artist."

In this concluding section I wish to ask one very simple question: If in the end Schiller began to see himself as "the political and educating artist," and if his dramaturgy as a whole is meant to be an exercise in the political education of

those who read or witness his plays, then what exactly is the nature of the "political education" which one receives from them? Do they contain political principles or prescriptions or policies or grounds for the formation of political attitudes? If so, what is the nature of these principles, prescriptions, or policies?

It is clear from the letter to Augustenburg that Schiller believes that "only the character of the citizen makes and supports the state and makes political and civil liberty possible," and, from Letter IX of *The Aesthetic Education of Man,* that he holds it to be the case that all improvement in the political sphere must proceed from the ennobling of character. But how is character to be ennobled? One instrument certainly is the art of the beautiful—for in its materials lie open to us immortal models. Are there such models to be found in *Don Carlos* and in *Wilhelm Tell,* in *Maria Stuart* and in *Wallenstein?*

The answer to this question is not so simple as it might seem, but it is at least a question which we have a right to ask on the basis of Schiller's own theory of the drama. It should not be forgotten that in 1785—ten years before the publication of *The Aesthetic Education of Man*—Schiller had produced his article "Die Schaubühne als eine moralische Anstalt betrachtet" (The Stage Considered as a Moral Institution), and that there he had insisted the theater was primarily an instrument for the moral education of mankind in that the moral effect which it produced on even the limited number of playgoers would broaden and communicate itself to others within the wider area of the political commonwealth. "The stage," Schiller had said, "is, more than any other public institution of the state, a school of practical wisdom, a guide through the pitfalls of civil life, an infallible key to the most sacred avenues of the human soul," [23] and thus there is a continuity in his thought from the period before the French Revolution to the period just after it—a continuity characterized by a sense of the intimate relationship between political, moral, and aesthetic considerations in the life of man. Politics is the coping stone and the summit, "the worthiest goal of all striving, the great rallying point of all culture," as Schiller had said in the letter to Augustenburg, but its bulwark and support is the moral nature of man, the deepest bedrock of his character, and it is this which is reachable through the pedagogical function of the aesthetic, through those models of perfection afforded by the arts and literature, and particularly through the agency of the tragic drama. Schill-

er's entire dramaturgy of twenty years—from the *Kabale und Liebe* of 1784 to the *Wilhelm Tell* of 1804—lay under the influence of this conviction, and it is therefore not inappropriate that we should ask in what sense it can be said to serve the ends of our political education.[24]

If Schiller's plays are a means of political education, it is not in any simple or immediate way. An older view was that Schiller's romanticism consisted in the creation of romantic models, that in Wilhelm Tell or the Maid of Orleans or even in the Marquis of Posa are to be found romantic and heroic characters, "larger than life," but somehow embodying the ideal of political and social freedom which is the heart of Schiller's political message. But the tide has turned. No less a critic than Thomas Mann has insisted that "the nimbus of sky-blue idealism which has ringed him with a conventional halo has been of too pale a shade, that the color should be stronger, tinged with a dash of realism. For realism is an essential part of his greatness; and realism is quite simply a matter of the vitality, the energy, the tenacity, the willingness and competence to confront life without which he should not have become what he was and remains."[25] Mann contrasts Schiller's strength and ambitious nature wth Hölderlin's delicate and vulnerable spirit—a contrast wich shows itself in the attempt of the one to recreate all the poignancy of Greek aestheticism and of the other to produce a politics fitting for a violent but aspiring age. With respect to this latter, Mann says: "For all his libertarian sentiments, there is a startling absence of sentimentality in Schiller's statements on politics and social problems. He did not limit himself to the celebrated pronouncement in which he flung the gauntlet into the face of democracy: 'The Majority is nonsense.' He carried this further . . ."[26]

We may agree with Mann as to Schiller's political realism, without following him to the excess of equating this with Schiller's antidemocracy, or in holding that Goethe was correct in saying that Schiller had been far more of an aristocrat than he himself, but there is indeed a problem to be faced in the matter of the quality of the class-consciousness displayed in Schiller's political plays. This may be rendered a little clearer by a return to the comparison with Shakespeare. Of Shakespeare's aristocratic bias there can be no doubt, but is there not something astonishingly like it in the mind which created *Don Carlos* and *Maria Stuart, Wallenstein,* and *Die Jungfrau von Orleans?* Schiller's attentiveness to Shakespearean models has often been

remarked, but did this go further than the mode of dramaturgy or the theory of tragedy into the very social presuppositions which underlay the Elizabethan drama? At first and superficial glance this seems plausible. Which of Schiller's "political" plays would it have been socially impossible for Shakespeare to have written? *Kabale und Liebe* certainly; perhaps *Wilhelm Tell;* probably also sections of *Wallensteins Lager,* although even here have not certain grossly proletarian aspects been anticipated in the low company of Part II of *Henry IV?* But the mind which conceived nobility in the actions of Mary Stuart and Philip II, and to a more limited extent in Charles VII and Agnes Sorel and Wallentein, cannot be too far from the aristocratic interests of Shakespeare and the entire sixteenth century.

The suggestion is deceptive, for it fails to distinguish between historical preoccupation and political bias. To an unusual degree Schiller's political plays have an historical setting —from the late thirteenth to the mid-seventeenth century, a period of European history dominated by the aristocratic principle—but this use of history, for all Schiller's political realism, reflects not a political bias, but the influence of a romantic historiography. It is precisely the point of view which also dominates Schiller's great contemporary, Hegel.

In the introduction to his *Lectures on the Philosophy of History* Hegel makes much of the great figures of history— those "World-Historical Individuals" as he calls them—who are the heroes of historical narrative precisely because they express in their purposes, their actions, and their vocations (although quite unconsciously) the will of the World-Spirit which they serve.[27] Although they appear to draw the impulse of their life from themselves, they are in fact the clear-sighted ones who have an insight into the requirements of their time. They express all in their age which was ripe for development, they are its heroes—its epoch-making figures—and they are also the heroes of the romantic historiography which takes them as its center. But Hegel is too realistic to stop here. For World-Historical Individuals are not isolated and alone. They are the leaders of a society. They arise from and direct the life of a broad base of what Hegel calls "Maintaining-Individuals"— the masses, the middle classes, the proletariat—call them what you will—they are the men who make up the body of any "civil society." Not only is this contrast between "World-Historical Figures" and "Maintaining-Individuals" the nerve of Hegelian history, but when the terms are used as categories of Marxist

literary criticism, the emphasis on the respective poles defines
the very meaning of realism and romanticism in literature.[28]
And it is somewhat in this latter sense that we may explore
their relevance to Schiller.

Philip II, Joan of Arc, Elizabeth of England, Wallenstein—
these are indeed in Hegel's sense "World-Historical Individu-
als," and Schiller's preoccupation with them not only reflects
the influence of a romantic and pre-Marxist historiography, but
the conviction that political instruction in the drama may well
choose such figures to illustrate a moral of political freedom
itself alien to the times in which they lived. But in *Wallensteins
Lager, Wilhelm Tell* and particularly in *Kabale und Liebe*
(and this means in every period of his dramatic productivity,
early as well as late) Schiller would satisfy the most demanding
Marxist in his attention to the "Maintaining-Individuals" and
the ordinary fabric of society whose elements they constitute.
This is, of course, true especially of *Kabale und Liebe,* Schill-
er's earliest masterpiece and the most outspokenly revolution-
ary of all of his dramatic works, and it is why Mann's complaint
about his libertarianism is so clearly beside the point. "How
curious it is, though," says Mann, "that this poet always trans-
posed his enthusiasm for liberty and liberation to other na-
tions: to the Netherlands in *Don Carlos,* to France in *The
Maid of Orleans,* to Switzerland in *William Tell.* This great
German did not write a national drama of liberation for his
own people; he deemed the Germans incapable of forming a
nation and assigned to them, in place of nationalism, the task
of educating themselves to be human beings pure and
simple." [29] It is true that the fragmented Germany of the cor-
rupt and petty principalities in which Goethe and Schiller lived
was not sufficiently a national entity even to suggest to Schiller
the concept of national liberation in the sense in which it was
meaningful to think of it retrospectively for Switzerland, for
France, and for the Netherlands. But Mann is completely
wrong in holding that Schiller had no political message for the
Germans of his time and that his hopes for them lay exclusively
in abstract aesthetic education. No one would be so foolish as to
say of the Marxists that they are unpolitical because they
preach not the liberation of nations, but of classes. Schiller's
message, too, at least in *Kabale und Liebe,* is a political mes-
sage not of national, but of class liberation. And in this he was
but following the example of these other *Sturm und Drang*
writers who were his contemporaries.[30]

They were all more or less steeped in the writings of the French critics of society, particularly Rousseau, and they therefore present the contemporary conflict between classes in such fashion as to take the side of the middle or lower middle classes to which they themselves belonged. They may never criticize the ruling prince directly—even in so bold a piece of social criticism as *Kabale und Liebe* Schiller seems to make the prince's agents and advisers primarily to blame or puts the most damning criticism in the mouth of the prince's mistress, who, although noble in spirit, is at least socially discreditable—but the corruption in high places is never in doubt and the unhappy suffering of the virtuous common people is revealed in so moving a way as to record an unmistakable revolutionary comment even if it is something less than an incitement to political revolt.

It is precisely this political thrust of late eighteenth century realism, this essentially revolutionary impact of Schiller's "middle class tragedy" of 1783, to which Erich Auerbach calls attention in Chapter 17 of his famous *Mimesis*.[31] The whole atmosphere of *Kabale und Liebe* is petty-bourgeois—the decency of the Miller home, the righteous humility of the father, the stupidity of the mother, and Luisa's sentimental virtue—but the characters are presented in such a way as to gain unwavering sympathy against the higher class with which they come in conflict. In the circles of these petty courts everything is permissible—not in the honorable sense of *Don Carlos,* where even Philip II and his Grand Inquisitor act repressively and cruelly, but according to an almost objective notion of *raison d'état*— but in a narrower and purely arbitrary ambience of personal impudence, hypocrisy, and corruption. Thus in the early Schiller even the extravagance of romantic love becomes a point of departure for the revolutionary in politics: purely personal and humane sympathy in the audience becomes a lever to exhibit the public enemy—the autocratic and unnatural class structure of eighteenth century German society. Auerbach is surely right: *Kabale und Liebe* is much more a political, even a demagogic, play than a mere exercise in realism, and Lukacs himself could not fail to be satisfied both with its central treatment of the "Maintaining-Individuals" and its revolutionary message. Although Schiller nowhere in the play displays the formal sentiments of Rousseau or of the French Revolution, although the idea of political and social freedom is nowhere explicitly formulated as ideology or doctrine, this play is, never-

theless, perhaps more than Schiller's other dramas (with the
possible exception of *Wilhelm Tell*), "a dagger thrust to the
heart of absolutism." It places in a stark and revealing light the
criminal procedures of the tyrannical princely governments,
and shows unflinchingly the price which they exact of their
docile subjects in inner bondage and physical suffering. With-
out any further underlining of the libertarian moral, simply as
it stands, the play could not but exert a significant political
influence. Its piercing if unsubtle appeal for class justice is one
very important side of the total endeavor of "the political and
educating artist."

Kabale und Liebe and *Wilhelm Tell* are the two most dra-
matic of Schiller's comments on the need for human freedom
and the two most enduringly popular of his plays performed on
the German stage. Perhaps there is a relation between these two
facts. For in each of these plays there is a certain simplicity of
moral statement. In part it is that characteristic moral Mani-
cheanism which runs through Schiller and divides his major
political figures into cold-blooded realists and warm-hearted
idealists. In part it is the single-mindedness of the moral drama-
tization which makes each of these plays less a drama than a
melodrama of the moral life. For the dynamic of passionate
sympathy aroused in each of these plays for the cause of social
and political freedom works through the creation of the venom-
ous figures of despotism, cruelty, and repression. The characters
of President von Walter and Wurm in *Kabale und Liebe* and
of Hermann Gessler in *Wilhelm Tell* are figures of such Ma-
chiavellian vindictiveness, of such palpable evil, that the need
for freedom is inherent in the very loathsomeness of the con-
trary symbols of oppression. And in each case, the class for
whose freedom our sympathy is enlisted is the lower—the hum-
ble petty-bourgeois Miller and the simple fishermen, herds-
men, and hunters of the cantons of Uri, Unterwald, and
Schweitz.

Thus, despite the fact that *Don Carlos*, *Maria Stuart*, and
Wallenstein are concerned with the making of political deci-
sions in high places, Schiller's portrayal of the world of princes
is not Shakespeare's, and if he too from time to time is preoccu-
pied with the decisive actions of World-Historical Individuals,
it is not without some clear and realistic acknowledgment of
the way in which these actions are sustained by the quotidian
lives of the classes far below. Schiller was perhaps too much an
historian, too much a man of the revolutionary atmosphere of

the eighteenth century not to understand that any total histori-
cal or dramatic picture must depend on a rich and graded
interaction between different levels of social response to any
major political disturbances of life. Only in the universal class
response to chaos in *Henry VI,* only in that unique scene with
the disguised king on the eve of Agincourt in *Henry V* is such
an interaction hinted at by Shakespeare. But the function of
Wallensteins Lager is to make it as artistically manifest as in a
sociological treatise—a sociological treatise, however, painted
by Brueghel.

When in the prologue to *Wallensteins Lager* (delivered at
the reopening of Goethe's theater in Weimar on October 12,
1798) Schiller announces the intent of the entire *Wallenstein*
trilogy, it is:

> . . . die alte Bahn verlassend,
> Euch aus des Bürgerlebens engem Kreis
> Auf einen höhern Schauplatz zu versetzen . . .
> Denn nur der grosse Gegenstand vermag
> Den tiefen Grund der Menschheit aufzuregen,
> Im engen Kreis verengert sich der Sinn,
> Es wächst der Mensch mit seinen grössern Zwecken.
> Und jetzt an des Jahrhunderts ernstem Ende,
> Wo selbst die Wirklichkeit zur Dichtung wird,
> Wo wir den Kampf gewaltiger Naturen
> Um ein bedeutend Ziel vor Augen sehn
> Und um der Menschheit grosse Gegenstände,
> Um Herrschaft und um Freiheit wird gerungen,
> Jetzt darf die Kunst auf ihrer Schattenbühne
> Auch höhern Flug versuchen, ja sie muss,
> Soll nicht des Lebens Bühne sie beschämen.[32]

> (. . . To leave old ways
> And from the narrow mold of bourgeois life
> Advance to a more exalted stage.
> For only subjects of great consequence
> Can stir man to his very depths.
> The mind grows narrow in a narrow place,
> And only great aims service human growth.
> And now at the century's impressive end
> Where reality itself is matter for poetry
> Where we see the struggle of mighty powers
> For an important end before our eyes,
> And round about humanity great struggles take place
> For mastery and for freedom,

Now can art too attempt a higher flight
Upon its stage. Indeed, it must
Not be shamed by life's own stage.)

Here is the essence of the program announced in theory three
years before in *The Aesthetic Education of Man:* to move the
individual from the narrow bonds of middle class existence, to
stir the moral nature of man by the representation of high
purpose on the stage, to render dramatic art worthy of contem-
porary history's own actual struggles for sovereignty and free-
dom.

In what follows the mind is prepared for the histrionics of
Don Carlos. How stunning and at the same time how brilliant
when it is then confronted with the confused proletarian scram-
ble of *Wallensteins Lager.* But in truth the confusion is only
apparent—a reflection of the bustling seventeenth century mili-
tary subject, not the intent of the poet, which, on the contrary,
paints with brilliant brush strokes the sly peasant and his son,
the bluff sutler-woman, and Gustel, the barmaid from Blase-
witz, in characteristics which we are not to rediscover in the
European drama until Bertolt Brecht. Every jeer and jest of the
commonest of the soldiers, Saxon or Croat, Walloon or Bohe-
mian, every transient political quarrel between the First Ar-
quebusier and the Sergeant or the Trumpeter, reflects the inter-
necine jealousies and suspicions of the polyglot generals Illo,
Isolani, Octavio Piccolomini, Buttler, Caraffa, and Kolalto,
and the central unresolvable conflict between Wallenstein and
the Emperor. In *Kabale und Liebe* and *Wilhelm Tell,* Schill-
er's plea for freedom is made in the name of the common
masses of the people, but in *Wallensteins Lager* the mode of
perception is almost Marxist, for it exhibits the most demonic
acts of princes and generals, acts that decide the destiny of
central Europe for a hundred years, as grounded in social
trends and historical forces already clearly apparent in the rude
interaction of the common military rabble.

I have dwelt on the positive libertarian message of *Kabale
und Liebe* and *Wilhelm Tell* and the quasi-Marxist view of
social action implicit in *Wallensteins Lager* in order to justify
our conception of Schiller as "the playwright as politician"—
the poet who speaks directly to our political emotions and turns
the stage—moral institution as he conceived it to be—into a
pulpit from which we are delivered a sermon on the nature and
the advisability of freedom. And this both registers one of his

appeals to us today and suggests the function of his dramaturgy for the age in which he lived. In the fragmented Germany of his time, without either a free press or an acknowledged political tribunal, Schiller's theater not only represented the artist's right of free speech, but the revolutionary message which such an exercise might embody. Perhaps it was not so inappropriate after all that the French Revolution made him an honorary citizen of France, for in a certain sense his dramaturgy was to the Germany of the dying eighteenth century the same courageous vehicle which the freedom of the press was to France.[33]

But there is also another sense—less insistent on the value of freedom perhaps, less assertive—in which Schiller enlists our political interest. It is the sense in which he recognized, and presented more sharply and perhaps more clear-sightedly than any other poet of that time or this, man's fateful and inescapable involvement in politics. No one who reads *Don Carlos* or *Maria Stuart* or *Wallenstein* can fail to make the connection with our own time, can fail to receive some brilliant light on our own current questions: How are the highest political decisions made? What is man's place in the life of politics? How does he master it, or it him? How are conscience, responsibility, reasons of state, private fears, resentments, and hatreds woven into the fabric of political decision? What is the relation of the private individual with his emotions and moral beliefs to the public arena? What is the fate of moral idealism in a political world? It was precisely this side of Schiller's accomplishment which caused Oskar Seidlin to say of him: "Though he was not a political poet, he was perhaps the greatest poet *of* politics." [34]

I believe that Seidlin is mistaken in his exclusiveness; that Schiller was *both* a political poet *and* a poet of politics, but even in this latter role I think he conforms to the conception which he has presented of "the political and educating artist." This side of Schiller's political achievement will not provide us with any political principles, prescriptions, or policies. But it will develop our political insight immeasurably, and it will prepare us in the formation of our own political attitudes. Schiller seems to me to be a dramatist of politics in much the same way as our contemporary C. P. Snow is a novelist of the political life. Both are obsessed by the personal concomitants and the social implications of political decision-making. Both are fascinated by "the corridors of power." And this, just as much as the influence of a romantic historiography, is surely what drew Schiller to his dramatic studies of Philip II, Eliza-

beth of England, and Wallenstein. *Maria Stuart* no less than *The Masters* exhibits the agonies and ironies which go into the preparation of the final political decision. *Wallenstein* no less than *The Affair* shows the ethical ambiguities which arise when men must preserve their freedom of choice until the last moment. *Don Carlos* no less than *The New Men* indicates the havoc which idealism can work in the realm of the practical, the moral dubiety into which the uncompromising idealist is forced in pursuit of his dream.

Like Snow, too, Schiller has a great sense of the political complexity of those surrounding figures which power draws in its wake, and of the varieties of motivation which they display. The generals who surround Wallenstein, Illo and Buttler, Isolani and Octavio Piccolomini, represent every psychological possibility from personal and civic loyalty to pride and greed. Philip II has as courtiers the colorless Duke of Feria, the upright Count Lerma, the cruel and sinister Duke of Alba. But it is perhaps in the advisers of Elizabeth of England that the political spectrum is most interestingly distinguished: in Leicester, the personal opportunist, unprincipled, hypocritical, chameleonlike in his desire to preserve his influence with the queen; Burleigh, the staunch support of the crown, shrewd, Machiavellian, ready with every argument of state security for the preservation of state power, but dependable and selfless in the queen's service; Talbot, the loyal old courtier, blunt, honorable, firm in his belief that no reasons of state can contravene the principles of morality and human justice. The interplay of these qualities at the English court and the way in which, through advice, they enter into the determination of royal decision is one of the most fascinating of Schiller's realistic political studies.

It was the presupposition of Renaissance statesmanship that man gains nobility through politics—that the pursuit of power is, or can be, a means of human fulfillment. This is the message alike of Machiavelli's *The Prince,* of Erasmus' *The Education of a Christian Prince,* of Shakespeare's *Henry V.* But Schiller's political drama presents a more complicated and at the same time a darker picture. In *Don Carlos* the Marquis of Posa is the great humanitarian, the lover of human freedom swept up in the political game. But as he begins to play this game, his moral identity becomes ambiguous, compromised, problematic. In *Maria Stuart* Queen Elizabeth, by making the decision which will gain everything in political security, loses everything which

is personally significant. For it is a security won at the price of morality, and there can be no doubt that the execution of Mary Stuart is an act of gross injustice which the public welfare unequivocally requires at this historic moment. In *Wallenstein* Schiller represents political man at his last extremity, where he is himself aware of his fateful involvement in history, and where the dialectical interplay of historical necessity and personal freedom becomes so ambiguous as to lead inevitably to tragic destruction.

Once again, in each of these cases, it is a matter of the expression of Schiller's sense of the "externality" of historical forces—so alien to Shakespeare—which causes him to share with Hegel an awareness of the element of necessity in historical destiny. For in spite of the proud voluntarism of *Die Jungfrau von Orleans* and *Wilhelm Tell,* the conclusion of Schiller's political thought is shot through with the sense of historical inevitability. If, on the one hand, Don Carlos can do nothing against this moment of Spanish absolutism, Philip II cannot in the end hold back the Protestant Reformation either. Mary Stuart has no chance to live in this instant of British political consolidation; Wallenstein cannot survive this moment of treason to the cause of the Emperor in Vienna. Despite all his romantic interest in World-Historical Figures, perhaps there is implicit in Schiller's political drama some profound eighteenth century sense that the centers of power are shifting, that the concerted action of the masses is supplanting the personal whim of the all-powerful ruler. Perhaps the individual can only operate effectively as historic agent within the context of the city or the nation or the society. But this would be only another reason why he should be educated by the great models of the political theater.

Six / History and Politics:

Ranke, Treitschke, and Burckhardt

THE NINETEENTH century was the golden age of European historiography. On the one hand, historians like Guizot and Thiers, Sybel and Mommsen, Macaulay and Bancroft were trusted as custodians of what their societies needed to remember, and, on the other, the eighteenth century association of history with belles lettres and the leisure of the amateur had given way to the example of scholarship in the sciences: history had become an academic discipline grounded within the universities.

It was perhaps Thucydides who first provided a model of the intimacy between history and politics. He was a political and military leader of the Athenian community who turned to write a narrative account of the very wars in which he had participated—but with distance and detachment, correcting the Athenian recollections by reference to Spartan purposes and intentions—"scientific" (if that word can be permitted in a context so ancient) in that his ideal was to heal the wounds of memory not through empty rhetoric but by writing a history of the internecine warfare of the Greeks in a fashion acceptable to both sides.

I do not mean to say that Thucydides became the model of nineteenth century historiography (although it is significant that Leopold von Ranke received his Ph.D. in 1817 with a dissertation on Thucydides' political doctrines), but the intimacy between history and politics which he symbolized was a problem of particular urgency for the age in which scientific history was born.

This becomes clear when one consults the great professional journals of history which were founded at this time: the German *Historische Zeitschrift* in 1859, the French *Revue historique* in 1867, and the *English Historical Review* in 1886. Each contains a programmatic statement in its initial issue, and these prefactory intentions show a decided concern for the conflict between political commitment and professional objectivity.[1] The editor of the *Historische Zeitschrift* rejects the discussion of the unresolved questions of current politics, and he declines to commit the review to any one political party, but he admits that historians exercise political judgment and he clearly states that the writing of history has a peculiar relevance to the national life of the Germany of his day. The editor of the *Revue historique* asks his contributors to avoid contemporary political controversy and to treat the subjects of their concern with that "methodological rigidity and absence of partisanship which science demands," but he admits that the study of France's past will be his principal task, since the historian, by revealing her historical traditions, can give to his country the unity and the moral strength she needs.

The editor of the *English Historical Review* hopes to avoid the suspicion of partisanship in political and ecclesiastical matters by refusing contributions which argue such questions with reference to contemporary controversy, since the object of history is to discover and set forth facts, and only this properly expresses the scientific spirit. But by this time not only the influence of Niebuhr and Ranke, but also that of Burckhardt has been felt in England, and the problem of the relation of history to politics has become not merely that of treatment, but also that of content. Therefore the editor of the review cites Freeman's celebrated definition—only to reject it.

Two views prevail concerning the scope of history. One regards it, to use the expression of an eminent living writer, as being concerned solely with states, so that (in the words of another distinguished contemporary) "history is past politics, and politics is present history." The other, which has found illustrious exponents from Herodotus downwards, conceives it to be a picture of the whole past, including everything that man has either thought or wrought. Of these views the former appears to us narrow, and therefore misleading; the latter so wide as to become vague, fixing no definite limit to the province of history as bordering on other fields of learning.

States and politics will therefore remain the chief subject of history, but since religious and philosophical beliefs have bearing on the acts of man, since language presents evidence of the relations of peoples to one another, and since literature and art are expressions of, and in turn determinants of, national life, these elements of culture are likewise deserving of historical attention. Thus by 1866 problems of the interrelationship of politics and culture have already become a concern of European historiography, and the various solutions which occur throughout the nineteenth century constitute a further chapter in the continuing dialectic of humanism and politics.

The heart of this dialectical interplay lies, as we have seen, in the relationship which cultural values bear to the exercise of political power, and some symptomatic expression of this relationship occurs in the way the historians of the nineteenth century visualize their task. The problem is twofold. What is the historian's subject matter? And can he retain his objectivity with respect to it? Is Freeman correct in defining history as no more than past politics, and if so, can the historian retain that absence of partisanship which the notion of history as a science demands? That the first great historians of the century had lived through the passionate days of the French Revolution and the Napoleonic dictatorship only pointed up the difficulty, and that those who lived closer to its end were witnesses of the nationalistic confrontations of Strasbourg and Sedan did nothing to make it less. The role of the historian as custodian of the national memory may not be completely congruent with his role as the dispassionate creator of an objective narrative, and the more narrow interest in politics as such may restrict the historian of culture from dealing with those very aspects of literature, philosophy, and art which suggest the universal values uniting the European nations in one cosmopolitan civilization. Here the discipline of history becomes the bloody arena of competing and incompatible values.

It will be my purpose in this chapter to indicate in a somewhat restricted fashion the continuum of historical possibility, and I want to do this by taking my examples from one language and from one historical continuity which spans the nineteenth century. I shall begin with Leopold von Ranke (1795–1886), treat next the case of Heinrich von Treitschke (1834–1896), and consider finally the work of Jacob Burckhardt (1818–1897). Ranke was twenty-three years older than Burckhardt, and Burckhardt was sixteen years older than Treitschke. Ranke

was born during the last days of the French Revolution. Burck-hardt and Treitschke died in the last golden days of the Victorian age, and between these limits lie the great days of European historiography. It will do to keep these facts in mind although my purpose in mentioning them is not historical. What I wish to show is how a quite moderate resolution of the problem of politics and culture in Ranke by a slight twist of emphasis turns into the rather extreme and opposite historical tendencies of Treitschke and Burckhardt. For in these latter the claims of politics and culture find their deepest and their sharpest opposition.

In a sense the problem is set by the very ambiguity of Ranke's moderation. Despite his intrinsic political conserva-tism, and the not inconsiderable part which he (like Niebuhr, Dahlmann, Droysen, and others) played in the growth of Ger-man unity through his preference for a Germany under Prus-sian hegemony, Ranke was not an apostle of Prussianism as was Treitschke who turned his chair at the University of Berlin into an obvious political rostrum. Unlike those "noisy, bluster-ing national historians" [3] whose historical judgments were a function of their political passions, he never lost his critical approach to history, which suggested to him that even the contradictions in the historical source materials could be ex-plained by partisanship arising from great political and social conflicts.[4] He was truth-loving and fair to the end; the qualities of the judicious historian shine out on every page and place his effort far from that of the controversialist or conscious political apologist.

One example will make this abundantly clear. Ranke was always aware that the course of the Protestant Reformation was shaped by the interplay of religious experience and political considerations. And with his instinct for dramatic relevance this gave him a particular concern for ambiguous and contro-versial figures like Savonarola, Philip II, and Wallenstein. The same was of course true of a romantic dramatist like Schiller, but whereas in a play like *Don Carlos* Schiller could treat the historical materials not impartially, but in order to create an implicit moral argument for human freedom as against the tradition of political despotism, Ranke deals with the same materials not only in a fashion which is scrupulously fair to the human actors involved, but also with a shrewd awareness of the

way in which the nearly contemporary historical sources distort
reality in the service of political partisanship. After a succinct
account of the "History of Don Carlos" [5] he turns to his "Kri-
tische Abhandlung," and here, noting how the opposition of
Don Carlos and his father became a *cause célèbre* for the
Catholic and the Protestant parties in the seventeenth century,
he finally presents his own summational judgment. Which of
the two shall we blame, the father with his initial harshness, or
the son who could never learn the obligations of a natural
obedience? Accusation and excuse, says Ranke, are here equally
out of the question. One fault calls out another—at neither
therefore can one cast the first stone. And he concludes with the
mellow wisdom of one who stands serene above the battle: "To
understand these events it is not necessary to make a devil of
the one and to find the other immaculate. Good and evil, the
healthy and the corrupt, genuine praise and well deserved
blame are not so distant from one another as mankind would
like to believe." [6] It is a far cry indeed from Schiller's fiery and
accusing verse!

This moderation and impartiality give to Ranke's historical
work a certain many-sidedness which often makes it difficult to
find its specific center of gravity. An archivist whose researches
in Vienna and in the private collections of the great families in
Rome (whose ancestors had controlled the papal administra-
tion during the Counter-Reformation) gave him the materials
for his great *History of the Papacy,* he is at the same time a
conservative critic of the French Revolution, whose bloodshed
impressed him more than its acts of liberation. His discovery of
the official reports of the German Diets of the sixteenth century
in the library of Frankfurt am Main was the origin of his
German History in the Age of the Reformation and coincided
with his explorations of the role which historical studies might
play in the drama of contemporary politics. In every case there
is the implicit contrast between the humanist and the politi-
cally alert historian, the cultural idealist and the staunch politi-
cal conservative.

This contrast reaches its apogee between the years 1828 and
1836. From 1828 to 1831 Ranke traveled and pursued his re-
searches in Italy. He had arrived in Venice in October to study
the *Relazioni*—the foreign reports of the Venetian ambassadors
housed in their original archives—and it is fair to say that his
purpose was humanistic and religious. He was always tempted
to read history as the expression of a divine intent,[7] and there-

fore in terms of those "ideas" or "ideal forces" or "moral and spiritual tendencies" which are at the heart of every historical epoch and every great social institution. Hence his views of the Italian Renaissance and of the heritage which it left for the great European powers of the sixteenth and seventeenth centuries are dominated by the faith that all human situations reflect a certain valuable and creative equipoise of tensions, and that these function to further the expression of the inner forces of a living historical spirit. The precise nature of this spirit has never been clear. Ranke probably derived both his idealism and his romanticism with respect to it from Hegel. But for those who hold to its reality a somewhat paradoxical consequence emerges—the conviction that political power is itself a moral force.

As an historian of the Renaissance and Reformation, Ranke had to give special attention to the political state and its power, the wars between great states, and the forms of intrigue, conspiracy, and treason against them in periods where religious fervor stood in particular dialectical opposition to the imperial glories and the secular temptations of this world. It is therefore not entirely surprising that his conclusions should repeat, in historically sublimated form, some of the insights of Machiavelli. The very *Relazioni* of the Venetian ambassadors with which Ranke was engaged pointed in this direction. Their subject matter was not only politics as it expressed itself in war and the anticipations of war, but also advice, hints for negotiations, and suggested diplomacy on an extremely subtle and sophisticated level. The more intricate byways of *Realpolitik* and *raison d'état* are developed here no less than in the admonitions of Hobbes and the darker pages of *Il principe*. Confrontation with these materials surely did not convert the Hegelian idealist into a crude advocate of power politics, but it may well have tempted Ranke, if not to assume an active political role himself, at least to get closer to the centers of political power, surely to observe, but also partly to influence.

Only some such hypothesis will explain his activity of the next three years. In 1831 Ranke returned to Berlin, where he was at once asked by Count Bernstorff, the Prussian minister of foreign affairs, to serve as editor of a semiofficial journal whose purpose was to present and rationalize the enlightened policy of the Prussian state. The first issue of the new *Historisch-Politische Zeitschrift* appeared in 1832 under Ranke's editorship. In 1836 the journal ceased publication and Ranke returned to

his great *History of the Papacy*. But between these two dates he contributed to the *Zeitschrift* several articles which are perhaps the best expression of his own views on politics and, implicitly, the political role of the active historian.

The most important of these is the "Politisches Gespräch" (Dialogue on Politics) of 1833.[8] Carl, the political sophisticate and man of the world, comes one evening to visit the more meditative Friedrich in his isolated study, and there ensues a conversation between them on the nature of political events and state power. It is Friedrich (undoubtedly the exponent of Ranke's own opinions) who insists that power is a mere instrument, its utility depending ultimately on the uses to which it is put. Carl is less sure. Seeing any state as composed of masses and elite, the rulers and the ruled, he sees the function of government almost according to the liberal model which became current thirty years later—as the mediator between clashing parties with incommensurable values, as the impersonal "point of indifference." But Friedrich will not have it so. As if in the very person of Hegel answering Mill across the decades, he insists that parties in conflict are not merely competing interests, but represent spiritual forces, and that government, in order to discipline them to stability and control, must itself be a stronger spiritual power with an active essence and a positive content of its own, a natural innate tendency which it must realize like any other "self."

Carl now asks for a more detailed description of this positive spiritual content of the state and Friedrich responds that in this matter national differences are of considerable importance. Identical institutions resting on common historical foundations assume the most divergent forms in different countries. Church, political state, the level of civilization are always prime factors to be reckoned with, so that external forms, whether educational, military, or administrative, even when copied or transplanted, assume new guises in the soil of their second home. This leads to a further distinction between the merely formal and the real aspects of any specific state. Constitutional forms which define personal powers and class relationships may be necessary in all states but, like Edmund Burke answering Bentham and the legal rationalism of the eighteenth century, Friedrich holds that no state is a mere expression of legal or administrative categories, but is a living thing, an historical individual, a unique self. This distinction between constitutional forms and inner spirit is similar to the difference be-

tween the grammar of a language and its accent and timbre. Grammatical forms always have a certain general applicability, but the modes in which they recur in different languages create separate and unique individualities. In precisely the same way different societies and civil constitutions possess different spiritual essences.

But this matter of the individual uniqueness of political states raises the whole problem of historical methodology. Does its acceptance not make all possibility of general laws of politics an idle dream? In essence Friedrich answers yes to this question, and thus demonstrates Ranke's eternal suspicion of the formal presupposition of "a logic of history" and his permanent commitment to pure empiricism in historical investigation. Professional historical inquiry alone services our aspiration to receive "a divining perception of the deeply hidden, all-embracing spiritual laws" of national states. No empty concept of the state alone will guarantee success. This is however quite different from saying that historical inquiry has nothing to do with the determinate activities of the statesman. "I am of the opinion," says Friedrich, "that the mastery of politics must be based on history; it must be founded on the study of the powerful states that have reached a high degree of inner development." [9]

Ranke's faith in the centrality of "the powerful states" is partly a result of his preference for particularity, and of the good sense which led him to see that while from the particular you can perhaps ascend with careful boldness to the general, there is no way leading from general theory to an automatic perception of particulars. But methodological considerations aside, it turned him toward a nationalism which has been the paradoxical consequence of every Hegelian concern with political forces as living essences. For the nation here becomes the all-embracing matrix from which we never escape. "Our mother country," says Friedrich, "is not where we find happiness at last. Our mother country, on the contrary, is with us, in us. Germany is alive in us, we represent it, willy-nilly, in every country to which we go, in each climate. We are rooted in it from the beginning, and we can never emancipate ourselves from it. This mysterious something that animates the lowliest as well as the greatest, this spiritual atmosphere in which we breathe precedes every constitution. It invigorates and swells all its forms." [10]

Ranke does not identify nationality with the state, nor does he agree that its power of brute force is all that matters. In the

growth of states the "nature of things," opportunity, genius, and good fortune all conspire to produce greatness, and even victory in warfare, he believes (as did von Clausewitz, who belongs to his same near-Hegelian generation), is not achieved without the ingredient of genuine moral energy. Still, a state's position in the world depends on the degree of independence it has attained, and it is therefore obliged to organize all its internal resources for the maintainance of its self-identity. This is the supreme law of states. If Ranke had stopped here, there would have been little to choose between his political theory and the most extreme expression of the so-called Machiavellian power politics, and indeed it is just this stance which is fervently adopted by Ranke's fanatical successor Heinrich von Treitschke. But if there is undoubtedly something of Hobbes in Ranke, there is even more of Aristotle. He is no more guided by hopes of making a state great and powerful than by those of making its citizens wise and good, and this is expressed in his Hegelian interest not merely in power, but in "the spiritual idea."

Everything depends on the supreme idea. That is the meaning when we say that states too derive their origin from God. For the idea is of divine origin. Each independent state has its own original life, which may have different stages and may perish like all living matter. But while it lives it penetrates and dominates its entire environment, identical only with itself. . . . Instead of the passing conglomerations which the contractual theory of the state creates like cloud formations, I perceive spiritual substances, original creations of the human mind—I might say, thoughts of God.[11]

Ranke's firm Hegelian belief that the state is a "spiritual substance" cannot help but elevate the concept of the political in the work of the empirical historian. And while it would be excessive to find in Ranke exclusive commitment to Freeman's later dictum that all history is merely past politics, even his interest in the great historical individuals follows largely from the role which he sees them playing in the development of the nations which they represent. Charles V, Henry VIII, Louis XIV only express on a more dramatic scale the claims which the state makes on the individual citizen, in their time no less than in Ranke's own. For the "spiritualizing" of state power means that for the meanest proletarian as for the most exalted monarch "autonomous private life no longer exists. Our activities naturally belong primarily to our community." When

asked by Carl what the private citizen receives for all his partic-
ipation, Friedrich answers with the conventional response of
nineteenth century organic nationalism: In the good state it is
its own reward. No citizen thinks of withdrawing from it since
he recognizes above all that for him there is no purely private
existence. He would not be himself if he did not belong to this
particular spiritual fatherland.

For Ranke, as for Aristotle, man is primarily a political
being; his very personality depends on the sincerity of his inter-
est in the common good, and since his faith in the development
of the state toward perfection was absolute, there seems to be
little to save him from an absolutist doctrine of political power
in which there is no formal counterbalance to the despotism of
irresponsible government. But for all its temptations this is a
doctrine to which he never adhered. He was saved by his con-
cept of religious universalism, and by a feeling for European
culture as a whole which, if not as strong as the cosmopolitan-
ism of Erasmus, was yet sufficiently powerful to keep him from
the xenophobic excesses of his successor Treitschke. When
Treitschke, in his *History of Germany in the Nineteenth Cen-
tury*, speaks of the French, it is with venom and resentment.
They are a nation of stupid policemen, corrupt courts, empty
rhetoric, drunken peasants, and religious fanaticism. But when
Ranke after 1850 begins to publish his *French History*, the tone
of the book, if not altogether sympathetic, is free from invective
and disparagement, and admiring of those elements of clarity
and rationality which made France the fountainhead of eight-
eenth century Enlightenment.[12] Every nation has not only its
characteristic national ambitions, but also virtues which, if
uniquely its own, it exports for emulation and adds to the fund
of European civilization.

Ranke cannot subscribe to a doctrine of political absolutism
for two reasons. The first lies in his religiosity; the second in his
essential pluralism. Although for him church and state are
eternally separate, the church unites man in the higher commu-
nity. Its rule of morality is absolute and the claims of its
spiritual power are universal, whereas the state is always
unique and partial and even its idea would be destroyed if it,
like the Roman imperium, were held to embrace the entire
world. Ranke's "Dialogue on Politics," no less than his essay on
"The Great Powers" which followed it closely in the *Histo-
risch-Politische Zeitschrift*, not only expresses, but accepts, the
postulate of political pluralism. Moral strength and a sense of

nationality are crucial necessities for every great power, but no single one dominates the course of European history. World history presents us with the spectacle of spiritual forces and moral energies unfolding, capturing the world, and appearing in manifold expressions, disputing with, checking, and over-powering one another. And in this interaction and succession the great national states play the role of bearers, advocates, and antagonists. Different peoples with their national ways and different states with their unique individualities compete and oppose one another as the bearers of great ideas, and this strife is not chaotic tumult or planless succession, but the significant development of the panorama of European history.[13] The claim for secular unification is, in Ranke's view, misguided. He uses the analogy of literature. No one expects or wants a single "world-literature" at the expense of the national languages. There would only be a disagreeable monotony if the different literatures should let their individual characters be blended and melted together. "It is the same with states and nations. Decided, positive prevalence of one would bring ruin to the others. A mixture of them all would destroy the essence of each one. Out of separate and independent development will emerge the true harmony."[14]

Ranke is never really explicit about the nature of this "true harmony," and in general his optimism about the course of the historical process led him to minimize the forces of disruptive conflict and the possibility of a transvaluation of civilized values. This is due partly to his sheltered life in the early days of the post-Napoleonic nineteenth century, partly to his quiet commitment to a doctrine of divine providence, never spelled out in an Augustinian eschatology, but reposing silently in the background of the historiographic mentality. Thus he per-ceived even such figures as Napoleon, Frederick the Great, and Richelieu as components of the divine plan and power politics as an agency through which civilized values receive their reality and social translation. Croce has criticized Ranke's historical empiricism and "lack of contact with ideas." This may be true in the sense that Ranke refused to permit himself a philosophy of history articulated in advance, but the theory of a divine providence, never abandoned, provided a constant if unexam-ined presupposition for the construction of his historical narra-tives. Many of Ranke's social beliefs have an air of simplicity, almost of naïvete, when read against the darker vision of a later day—Burckhardt's trenchant pessimism as expressed in his per-

sonal letters and the documented saga of decay presented in Spengler's *The Decline of the West.* Thus there is something provincial, almost shallow, in his belief in the permanent success of Bismarck's policy, his conviction that the war of 1870 stabilized Europe and guaranteed the unbroken continuity of Western civilization, his antagonism to the reforming spirit of the French Revolution, and his mistrust of the egalitarian emphasis of the Socialist party as destructive of the traditional values of morality and religion.[15] But this is partly because the man whose greatest scholarly strength lay in an examination of the English, French, and German records of the sixteenth and seventeenth centuries was more convinced of the continuity guaranteed by a divine concern than of the radical discontinuities introduced by the French Revolution and its political aftermath.

This is perhaps a strange conclusion for a man like Ranke, convinced as he was of the intimate relationship between politics and the historian's task. And it was precisely this relationship which he explored in his Inaugural Lecture at Berlin in 1836: "Ueber die Verwandtschaft und den Unterschied der Historie und der Politik." [16] (On the Connection and the Dissimilarity of History and Politics). What, he asks, have history (through which one derives knowledge of former times) and politics (which aims at the improvement of presently existing states) in common? First it is clear that both rest on the same foundation, for there is no contemporary politics which does not depend on an historical knowledge of earlier times. The past and the present form one seamless web. History and politics are at the same time both science and art. As science, they are narrowly bound together in the continuity of time. As art, they are more widely separated. History bases itself entirely on literature—on written records; politics is engaged in actions. Thus the distinction between history and politics is essentially the same as that between theoretical and practical philosophy, and, as in the case of these two, the lawlike character of the generalizations of the first does not imply that a mechanistic determinism holds for the second. One function of knowledge is to enlighten practice, the mission of the historian is "to fortify political judgment," and he may have some confidence that his implicit "advice" may really alter the state of political affairs. Naturally the task of the historian is to concern himself with facts, with things as they are—*die Natur und Notwendigkeit der Dinge selbst.* But he can be confident too that human

affairs do not hinge on a blind unavoidable destiny, but that
their successful prosecution depends on virtue, understanding,
and wisdom.[17]

Once again, Ranke's optimism has a naïve ring in the ears of
a generation which has experienced Auschwitz and Hiroshima,
and there is even something quaint in the religious faith on
which this optimism was founded—as if the course of Western
civilization is brooded over and offered divine protection. And
yet what is significant is that there are concepts like that of
"world history" or "the course of Western civilization" which
underlie all that Ranke has written. For the fact is that he was
essentially a political historian, extremely conservative in his
contemporary biases, a firm adherent of the ideas and the
unifying ambitions of the state of Prussia, and it would have
been very easy for him, as it was for Treitschke, to view the
entire course of Renaissance and Reformation development as
leading to the expansionist claims of Prussian power. From this
he was saved (as was Hegel himself) by the cosmopolitan
influences of the German eighteenth century—of that tradition
founded by Lessing, Herder, von Humboldt, and Goethe which
placed the claims of a European "Kultur" above those of a
merely limited and local patriotism. This tradition is not often
explicitly appealed to by Ranke, but it underlies his historical
work almost as strongly as his doctrine of divine providence.
And it means that he always writes not as a German nationalist
but as a good European, less as a narrow partisan of the Hohen-
zollern dynasty than as one who has followed in detail the
cosmopolitan influences of the Roman Catholic Church and
the Protestant Reformation.

As an exemplar of the problem of the relationship between
history and politics Ranke presents a paradoxical and a deli-
cately balanced case. Beginning as an autonomous historian, he
soon discovered the political art. Returning from the archives
of the Venetian republic, he allies himself with the German
political power of the new century and affords an interesting if
brief spectacle of the historian as political journalist. Despite
the intellectualism of his love of truth, he has a deep sympathy
for the political passions. Although his concept of history is
almost purely political, he is deeply interested in "civilization,"
and, in fact, the optimism of his last unfinished work, the
Universal History, is due to its portrayal of the continuity of a
cultural heritage which Ranke, perhaps mistakenly, believed
would remain the permanent basis of European civilization. In

his thinking the characteristic concepts of "the great powers" and of "universal history" contain an unstable blending of the ingredients of "political state," "universal churches," and "levels of civilization." I call it unstable because a slight alteration of the component emphases produces a dramatic shift in the center of gravity of the historiographic enterprise. When this alteration moves toward an accentuation of "state power," we have the fanatical and intemperate Prussianism of Heinrich von Treitschke. And when it moves toward an accentuation of "the level of civilization," we have the aesthetically motivated and deeply pessimistic *Kulturgeschichte* of Jacob Burckhardt. Each of these later historians also presents a variation on the theme of history and politics, and the irony is that, in equal although opposite fashions, both Treitschke and Burckhardt must be denominated as Ranke's heirs.

One academic event links these three historians. When in 1872 Ranke, now an old man of seventy-seven, retired from the University of Berlin, a search was at once instituted for his successor. His chair was first offered to Jacob Burckhardt, who quietly refused. At fifty-four he preferred the tranquil routine of his native Basel to the fever of Berlin.[18] Finally, in February, 1873 the Prussian government issued the invitation to Treitschke. Treitschke was then only thirty-eight and although he loudly professed that he preferred the peace of Heidelberg (where he was then teaching) to the excitement of the Prussian capital, he nevertheless lost little time in accepting the chair which would establish his reputation and make him a colleague at once of the physicists Helmholtz and Kirchoff, the economist Schmoller, and Edward Zeller, the great historian of Greek philosophy.[19] It is true that the elderly and well-known historian Droysen was already lecturing at Berlin on historical subjects in which Treitschke was much interested, but in order that their lectures should not overlap, Droysen proposed that his new colleague should offer courses primarily in "politics" and in "political theory." The suggestion could not have been more apropos. Treitschke was more than willing that his chair in history should become a platform of political advocacy. For to him the profession of history was but an occupation in the patriotic service of the fatherland; all meaningful history was "political" through and through; in fact the demarcation which separated "politics" as the implementation of present

policy from "history" as the prelude to contemporary Prussian grandeur could not in his mind or in his behavior be maintained. With Treitschke at Berlin, Ranke's judicious consideration of "the Great Powers" turns into the intemperate rhetoric of a raging nationalistic fever.

In this respect there is a consistency in Treitschke's career which is almost redundant. He was born in Dresden, the son of a Saxon army officer. His historical studies were carried on at Leipzig and at Bonn, where he came under the influence of Dahlmann, first of the German "political historians." From Dahlmann he learned at an early and impressionable age the folly of social revolutions, the role which the historian ought to play in the determination of his country's policies, and, indeed, the permanent rapprochement between the "lessons of history" and the ideal of contemporary statesmanship. And from Dahlmann he learned too (in the latter's course in the history of Germany since Charles V) that the much sought-after German national unity was intrinsically dependent on Prussian leadership. Henceforth the Saxon-born historical neophyte was to outdo any native Prussian in his loyalty to the Hohenzollern dynasty of that state, and that his final resting place became the University of Berlin was thus a fate of exquisite appropriateness.

Treitschke's was an exceedingly emotional nature. As a young man he had expressed decided poetic interests and published two collections of verse, the *Vaterländische Gedichte* of 1856 and the *Studien* of 1859, but these only expressed in the language of poetry that same rampant nationalism which his sociological treatise of the same year, the *Gesellschaftswissenschaft* (1859), was to embody in a more scholarly, but no less emotional, prose: that the theory of nationalism is only the rightful exemplification of the biological nature of peoples, and that Prussia, "the only state of purely German character," should therefore with absolute right be the sole claimant for the leadership of a united Germany.

For twenty years Treitschke lectured at Berlin, his fiery delivery and intemperate language drawing to his course in politics the largest audience at the university: not only students, but also a loyal following of younger army officers, civil servants, and Prussian bureaucrats. Because, moreover, since 1866 he had been editor of the *Preussische Jahrbücher,* since 1871 a member of the Reichstag, and, since Sybel's death, editor of the *Historische Zeitschrift* as well, his influence was enormous.

This influence he used not only in the service of a rampant German nationalism, but against every vestige of cosmopolitanism, social criticism, and liberal democracy. He admired the Prussian Junkers, allied himself with the anti-Semitic crusade of the 1880's, and declared that socialists should be forcefully suppressed, not merely argued with. Alfred von Tirpitz was his student, William I appointed him historiographer of the Prussian state (as Ranke's successor), and Bismarck was his friend. On the other hand, his academic enemies, even within the university, were legion. He clashed with Theodore Mommsen on the issue of anti-Semitism; Gustave Schmoller took umbrage at his hostility to the German Social Democratic movement, and even Wilhelm Dilthey severely criticized his identification of history with politics.

As Treitschke grew older, his excesses of language and position became ever more marked. A bitter sectarian with a fighting temperament, he had always been a zealot of nationalism, but now his rhetoric overstepped all bounds. His lectures on politics, published in two volumes after his death, and perhaps the best repository of his ideas, were repeated for twenty years every winter semester at the university. Their present text has been purified and expurgated so that they give no hint of the crudity, the grossness, the hysterical frenzy of the lectures themselves. Naturally they evoked a mixed reaction. Gooch, although not insensible to his fanaticism, yet attests to his magnetic quality:

As Fichte had reflected the change from the individualistic humanitarianism of the eighteenth century to the idealistic nationalism of the Wars of Liberation, so Treitschke spans the transition from the aspirations of 1848 to the era of blood and iron. His magnetic personality, his passionate conviction, and his incomparable eloquence, of which I was one of the last hearers, made him an educative force of the first magnitude. Though in history he founded no school, his flamboyant patriotism exerted enormous influence in Prussia for half a century.[20]

But Friedrich Paulsen, the famous ethicist of the late nineteenth century, and his countryman, registers a more negative judgment:

At Heidelberg I saw and heard Zeller and Treitschke for the first time, with both of whom I was to come in almost daily contact later, at Berlin . . . Treitschke carried his hearers away by the pompous

force of his words. Hearing his monotonous and hollow voice for the first time, one could not help wondering why or how. I heard him lecture only once more, several years later, at Berlin. Unfortunately he was just speaking about England, and the invectives he poured out in his blind hatred of English philosophy and the whole English mode of thinking became so intolerable to me that I walked out of the lecture room. His ungovernable temperament rendered him peculiarly insusceptible to historical justice. He knew only two categories: for or against the good cause; and in order to put down anything that warred against the latter, he regarded any means as justified—the good cause being the cause of Prussia. I wonder how England had really managed to incur his undying hatred—a hatred that knew no bounds. I can still hear his voice in the professors' room at Berlin when, on hearing of the fall of Khartoum and Gordon's death, he gave vent to his feelings in loud jubilation. "Just what ought to have happened!" he exclaimed, "every one of them ought to meet with the same fate!" His deafness made it impossible to reply; his own voice was the only voice he ever heard, and that increased the intemperance of his emotions.[21]

With a figure like Treitschke it is easy to stress the pedagogic and the rhetorical side. But the reputation of Treitschke the historian lies in three essential publications: first, his great unfinished *History of Germany in the Nineteenth Century* in five volumes,[22] treating of the history of Germany from the Peace of Westphalia to the Revolution of 1848, the volumes appearing over the period from 1879 to Treitschke's death in 1896; second, the four-volume collection of his *Historical and Political Essays,* containing also many of his meditations on German literature and German culture;[23] and finally his *Politics* in two volumes, which contains the essence of his doctrine of state power and of the nature of history as a politically oriented enterprise.[24] It is to this last that I shall devote my chief attention, although the first two works are worth a few brief comments. For they too repeat the intemperate rhetoric of the lectures and demonstrate clearly the historical mentality which can find no uses for historical narrative or literary criticism except those of nationalistic zeal and political partisanship.

By Treitschke's own profession his *History of Germany in the Nineteenth Century* was written not primarily for students or specialists, but "for the German nation." Unlike Thucydides, who might have said, "I write for both Athenians *and* Spartans," or Ranke, who asserts his canon of impartiality in

the attempt to narrate his story "as it actually happened," Treitschke dissents proudly. "I write for Germans," he says, and his history, which is little more than the romantic story of the growth of the Prussian state, had as its *raison d'être* the assertion of the rightful claims of the German nation and the justification of Prussia's historical right to lead Germany. Treitschke's dedicatory preface of 1879 states this without excuse: "The narrator of German history only half achieves his task if he merely indicates the causality of events and speaks his mind with courage. He should in addition feel himself, and create in the hearts of his readers, *joy in the fatherland*." [25] Here is an unambiguous stand on the issue in the minds of the founders of the *Historische Zeitschrift*, the *Revue historique*, and the *English Historical Review*, whether the historian should be primarily a seeker after truth or the custodian of the national memory. Treitschke's *History of Germany in the Nineteenth Century* was clearly devoted to the re-creation of the drama of the national existence, not to the restatement of the facts as such. Nor did he shrink from the consequences which this entailed in the matter of detachment and objectivity. In the preface to the fifth volume he asserts that history should be written "ruthlessly, with anger and with passion," and this no more than codifies his own constant procedure. Detachment and objectivity were for him impossible—his history is a clarion call to national consciousness and an inspiration to national devotion.

One of the most interesting features of his partisanship is the distortion of Germany's cultural past. Even in his treatment of literature and culture, Treitschke is chauvinistic. In the first volume, outlining events in Germany after the Peace of Westphalia, Treitschke turns to the literature of the German eighteenth century:

We know, indeed, from Goethe's memoirs how the heroic episodes of the Seven Years' War exercised upon German culture a fertilizing and liberating influence, how in those years of renown in arms a sense of national existence, an enlarging sentiment of vital energy, came to animate the exhausted field of poetry . . . It was within sound of the drums of the Prussian war camp that the first German comedy, *Minna von Barnhelm*, was written. In this wonderful spiritual awakening the people of Prussia took an extensive share, providing for the literary movement several of its pioneer figures from Winckelmann to Hamann and Herder.[26]

The spirit of Treitschke's remarks could not be further from the truth. No one was more uninterested in politics and political warfare than Goethe. And Lessing, the great cosmopolitan of a fragmented Germany, was interested not in the German spirit, but in a universal humanity. Goethe, the first proponent of the modern conception of a "world literature," and Lessing, the famous "universalist," are here presented not as the cosmopolitan representatives of the classic European Enlightenment, but as narrow nationalists inspired by a consciousness of the unique originality of the German nature and animated by the passionate desire to restore unity to the German nation.

This cultural bias to which the *History of Germany in the Nineteenth Century* attests is consistent throughout Treitschke's work. The two volumes of his *Selected Writings* [27] contain such essays as "Freedom," "Prussia," "Luther and the German Nation," "Gustavus Adolphus and German Freedom," "Fichte and the National Idea," and "In Memory of the Great Wars." But they also contain specifically literary studies of Lessing, Uhland, Hebbel, and Kleist. Once again Lessing is treated not as a European phenomenon but as "the founder of German literature" and "the savior of German literature from the French." And Kleist, whom Treitschke practically discovers for the modern consciousness, is seen in his work and in his suicide as motivated throughout by "patriotic despair of the German people." Treitschke concentrates all of his enthusiasm on the *Prince of Homburg* and sees it as "pointing the way to German victory." It is at the end of this astonishing essay that Treitschke quotes with enthusiasm and approval: "In Staub mit allen Feinden Brandenburgs!" (In the dust with all the enemies of Brandenburg.)

Treitschke's reputation as a historian in the more narrow sense must rest on his *History of Germany in the Nineteenth Century,* and his claims as an interpreter of the culture of the German people on the essays to be found in the *Selected Writings.* But the heart of what he stands for as the most extreme of nationalistic historians is only to be found in his two-volume *Politics,* the residue of twenty years of lecturing on a subject which was always his major concern and which he found it impossible to separate from the profession of the historian. His formal subject here is the state, its nature, social foundations, constitution, and administrative structure, but his treatment is rambling and unsystematic, and in the course of his discussion he provides what we are chiefly interested in—a clear and

dogmatic insistence on the essentially political nature of historiography.

The task of politics as a discipline, according to Treitschke, is threefold. It should first seek, by turning its attention to actual political states, to discover what is the "idea" or "essence" of the state. It should then consider historically what in the course of their political life states have desired and what they have accomplished. Finally, it should formulate "certain historical laws" and "set forth some moral imperatives." [28] In this program Treitschke assumes that "politics" and "applied history" are identical, and if, as he thinks, the subject of politics is in a backward condition, it is, on the one hand, because narrative historians are little interested in extracting a theory from their facts, and, on the other, because "the historical sense" has penetrated so slowly into the minds of philosophers and jurists. Treitschke seems to want to turn mere descriptive history into a systematic social science, and he wishes to check social theory at all points against the criteria of historical factuality. With these intentions it would seem that he is committed to both politics and history in the best positivistic tradition, but the briefest attention to his practice shows the hollowness of such a claim. The very association in his final aim of politics as the cognate activities of "discovering historic laws" and "setting forth moral imperatives" should have aroused our deepest suspicions. Treitschke's "historical laws" are the intuitions of a romantic patriot, and his thundered "moral imperatives" are the sound and fury of blind German nationalism. This becomes very clear as he abandons the objectivity of determinate causal laws in history for a mystique of the great man which is virtually Hegelian:

If history were an exact science, the future of governments might stand revealed. But this can never be, for the riddle of personality always remains unsolved. It is individual men who make history, such men as Luther, Frederick the Great, or Bismarck. This great heroic truth will endure for ever, and how it happens that the right man appears at his appointed time will always be a mystery to our mortal minds.[29]

Treitschke's choice of examples is not fortuitous, for Luther, Frederick the Great, and Bismarck are not only decisive European figures, but giants within the German pantheon. They indicate that it is of the very essence of political genius to be *national*. For Treitschke, a figure like Wallenstein could never

achieve historical fame precisely because he was not a true German but only "a Czech who played the German for the sake of expediency," and even Napoleon, the Corsican, appeared only "a splendid adventurer of history." The truly great maker of history always stands on a national basis because the state is itself inseparable from the consciousness of nationality and its historical genesis. Every state is simply a national people, legally united, primordial in its necessary being, as enduring as history, and as essential to mankind as speech. A man thinks of himself primarily as a German or a Frenchman and only secondarily and derivatively as a man in the wider sense. That cosmopolitan consciousness which was the presupposition of the German Enlightenment—of Herder and Lessing and Goethe —has here been inverted to fit the requirements of Prussian political expediency. And indeed, if Treitschke's theory of the great man in history is one which he derives from Hegel and shares with Ranke, his doctrine of the state is rather witness to his kinship with Fichte. The evolution of any state is simply the necessary outward form in which the inner life of a people clothes itself. Peoples attain to that form of government which their moral capacity enables them to reach and thus genuine patriotism is only the consciousness of cooperation with the body politic, the assuming of one's historical continuity with the generations, of being rooted in ancestral achievements and of transmitting them to descendants. And Treitschke quotes Fichte with enthusiasm and approval: "Individual man sees in his country the realization of his earthly immortality." [30]

To visualize the state in this way involves certain consequences. Every state is both a legal person and a center of moral responsibility. But if national states are essentially sovereign, acknowledging no arbiter above themselves and ultimately submitting their legal obligations only to their own verdict, naked force becomes the determinant in those conflicts which a pluralism of inalienable sovereignties makes inevitable. It is not a consequence from which Treitschke shrinks:

The features of history are virile, unsuited to sentimental or feminine natures. Brave peoples alone have an existence, an evolution or a future; the weak and cowardly perish, and perish justly. The grandeur of history lies in the perpetual conflict of nations, and it is simply foolish to desire the suppression of their rivalry.[31]

Moreover the absolute requirement of state sovereignty suggests a reading of the course of world history which is not

merely quasi-Darwinian but antihumanistic—which places the servicing of human culture far below the brutal maintainance of political power.

> The ruling nations are not so much the races rich in mental endowment but rather those whose peculiar gift is force of character. In this the thoughtful student of the world's history perceives the awful nature of justice. The sentimentalist may bewail the overthrow of cultured Athens by Sparta, or of Hellas by Rome, but the serious thinker must recognize its necessity and understand why Florence for all her refinement could not withstand the rivalry of Venice. All these cases took their inevitable course. . . . The State is not an Academy of Arts. If it neglects its strength in order to promote the idealistic aspirations of man, it repudiates its own nature and perishes.[32]

It is not that Treitschke is uninterested in culture as such, or that he sees no relationship between cultural preeminence and political power. Quite the contrary. It is his opinion that the arts flourish when the state is strong, and his instances come, paradoxically enough, from the literary history of England. He finds it no accident that Chaucer is contemporary with the Black Prince, Shakespeare with Elizabeth, and Milton with Cromwell. And even the lesser struggle against the French Revolution produced Walter Scott and Byron as well as Lord Nelson. Also, as he says later, it savors of barbarism to regard the state's fostering of art as a mere luxury. Art is as indispensable to men as their daily bread. Only, it should function in the service of power rather than against it—its great task is not the glorification of the individuality of the artist but the creation of a nation's monuments.

It is typical of Treitschke's mentality that he should subordinate all of the legitimate concerns of men to the demands of politics, and it is a corollary of this subordination that he should define the task of the historian in exclusively political terms. This brings him not only into critical opposition to Macaulay and the growing interest in the *history of civilization,* but also (and this is of the greatest interest for our purposes) to Jacob Burckhardt and the newly born *Kultergeschichte* of which he was the most brilliant practitioner.

> Macaulay was the first to assert that the era of political history was ended, and its place taken by the history of civilization, but he refrained from acting up to his own principles. Whoever recognizes

that continuity is the very essence of history will also understand
that all history is primarily political. The further we stray from the
State the more we lose sight of that true historic life. . . . No histo-
rian who lacks the political mind can penetrate to the heart of his-
tory, for all his philological learning cannot give him the political
insight to perceive how the ideas of the age influenced the State for
good or evil. There is always an incompleteness in those historical
works which treat only of the mere study of national character and
ignore the State and the world of action. Jacob Burckhardt's splen-
did book, *The Civilization of the Renaissance in Italy* is one of the
finest historical works existing, but nevertheless everyone feels the
want of something in it, and that something is living personalities.
To understand the Italian Renaissance at all it is first necessary to
understand the blossoming of the Italian States.[33]

It is clear that if Treitschke had written on the Italian
Renaissance he would have concentrated on the quest for
naked power of the Sforzas and Viscontis of Milan and said
little or nothing about the courtesies and culture of the court of
Urbino, and that he might have devoted considerable space to
the careers of the condottieri Colleoni and Gattamelata, with-
out finding it necessary to mention the artistic merits of Verro-
chio's equestrian statue of the former at Venice and Donatello's
of the latter at Padua. For if history is only a record of political
acts and of those powerful figures through whose willpower,
strong ambition, and passionate desire for success they are ac-
complished, then any attempt to explain historical events
through the dominance of economic factors or to find the true
spirit of historical change registered in its effect on literature
and the other arts would be to weaken, attenuate, and deflect
its central thrust. Without mentioning specifically either the
artistic preoccupations of Burckhardt or the economic concerns
of Marx, Treitschke rejects both the aestheticism and the mate-
rialism which are in his time coming more and more to influ-
ence the outlook of the professional historian.

At the present time there are two tendencies which work against this
political conception of history. One is the over-subtle, artistic, liter-
ary trend of thought, introduced by Hermann Grimm. He finds the
real inwardness of history in art and literature and forgets that mil-
lions of men are left untouched thereby. But a far greater danger
than this aesthetic one-sidedness lies in the modern suburban view
of life which prizes money-grubbing above the productivity of art or
even of the effective will.[34]

Treitschke's strictures against "the modern suburban view of life" with its emphasis on money and creature comforts serve another function also. They bring back to the foreground the basic role of the state in the conduct of war. In this view of middle class decadence as opposed to martial virtue Treitschke only echoes the fears of Clausewitz, who in a previous generation deplored civilian softness, and Treitschke cites Clausewitz as proof of how effeminate the science of government has become in civilian hands. But he is even more concerned about the "one-sided materialism" of the Manchester school of economists, which posed a more contemporary threat in seeing the profit-seeking motive as the essence of human striving. Such a doctrine is obviously incompatible with a glorification of war, and it is precisely that to which Treitschke's theory of the state inevitably leads.

Without war no State could be. All those we know of arose through war, and the protection of their members by armed force remains their primary and essential task. War, therefore, will endure to the end of history as long as there is multiplicity of States. The laws of human thought and of human nature forbid any alternative, neither is one to be wished for. . . . The grandeur of war lies in the utter annihilation of puny man in the great conception of the State, and it brings out the full magnificance of the sacrifice of fellow-countrymen for one another. In war the chaff is winnowed from the wheat.[35]

This is not only Treitschke's theory of politics; it is also the basis of one of those imperatives which he sets for the practice and interpretation of the professional historian. The historian, he says, who moves in the world of reality must surely see that any demand for eternal peace is purely reactionary. For if it were successful all movement, all growth, all progress would disappear from the life history of national states. Therefore, as he reads the history of modern Europe, only the exhausted, the spiritless, the "degenerate" periods have toyed with the idea of universal peace. This was the case after the Peace of Utrecht and the death of Louis XIV, after the downfall of Napoleon and the Congress of Vienna, and finally after the Franco-Prussian war of 1870, which in Treitschke's opinion destroyed German idealism. Any historical judgment about the health or the decadence of historical epochs must rest largely on an estimate of the role which warfare has played.

If Treitschke appeals to Clausewitz to second his glorification

of warfare, he is even more enthusiastic about Machiavelli, whom (with Luther) he takes to be the fountainhead of ideas working for the liberation of the state. "The brilliant Florentine was the first to infuse into politics the great idea that the State is power. The consequences of this thought are far-reaching. It is the truth, and those who dare not face it had better leave politics alone." [36] It was Machiavelli, says Treitschke, who laid down the maxim that when the salvation of the state is at stake there must be no inquiry into the purity of the means employed. And he was right, for in politics not injustice but weakness must always be condemned as the most disastrous and despicable of crimes, the unforgivable sin! The maxim of Machiavellian thought is the suspension of the ordinary canons of moral judgment in political evaluation, and it is precisely this maxim which Treitschke would also turn into an imperative for the working historian.

Every moral judgement of the historian must be based on the hypothesis of the State as power, constrained to maintain itself as such within and without, and of man's highest, noblest destiny being cooperation in this duty. Ethics must become more political if Politics are to become more ethical; that is to say that moralists must first recognize that the State is not to be judged by the standards which apply to individuals, but by those which are set for it by its own nature and ultimate aims. Political life will then appear to them infinitely more moral and more human than heretofore.[37]

It is clear that, by way of Machiavelli, Treitschke has arrived at the political position of Fichte—that the true historian must always maintain the principle that the state is in itself an ethical force, indeed, the highest moral good—and it is probable that Ranke himself, for all his Prussian conservatism, would have been appalled at this extremity to which his doctrine of "the Great Powers" had finally led. For to him the diplomacy and violence of power politics were always subject to the constraints of the moral principles of universal churches and of the civilized good sense of cultured men outside the orbit of political government. The effect of Treitschke's work was to absorb these two independent influences into an explicit imperialism of the political state. Ethics is now the state's pronouncements and culture is but an agency in its service. No man could go further in contracting the awareness of the professional historian and focusing it exclusively on the political aspects of human life.

In 1948, already a very old man, the famous historian of ideas Friedrich Meinecke delivered a celebrated lecture to the German Academy of Science in Berlin on "Ranke and Burckhardt." [38] Characterizing them as the greatest historical thinkers of the nineteenth century within the ambience of German culture, he proceeded to show how they polarized two points of view at the heart of German thought of the time represented symbolically by the two cities in which they lived —Berlin and Basel. Berlin was the center of the Prussian imperial idea to which both Ranke and Treitschke adhered. Basel, and Burckhardt with it, looked on this idea with criticism, anxiety, and mistrust. Ranke, says Meinecke, was a political reactionary who clearly saw the opposition between the principles of monarchy and of popular sovereignty but whose historiographic procedures strongly influenced all German historians who came after him. Burckhardt was less influential in Germany proper, but looked more deeply into the historical essence of his own time and into the precarious course of the future. Burckhardt, too, was essentially conservative, but it was a conservatism fed by a deeply pessimistic view of the sources and consequences of the political process. Ranke sympathizes with the rising forces which are to culminate in Bismarck; Burckhardt has the deepest antipathy toward the man and all that he stands for, and in the end this means that Ranke is, like Treitschke, an admirer of the state and of political power, while Burckhardt not only mistrusts the expanding state but, like Lord Acton later, believes that power itself is intrinsically evil.

In a word, Meinecke, in constrasting the meaning of Basel with that of Berlin, in reality symbolizes above all the opposition of the historiography of Burckhardt to that of Treitschke and thus the eternal dialectic of the forces of politics and the forces of culture. And this casts a new and metaphorical light on Burckhardt's rejection and Treitschke's acceptance of Ranke's chair at the University of Berlin. Basel, like the cities of ancient Greece, was a small, conservative, aristocratic *Kulturstaat*. Berlin was the bureaucratic center of a rising empire. However much Buckhardt's choice was conditioned by the comfort and familiarity of his native city, unconsciously perhaps it expressed his repugnance for magnitude and the glittering facade of power. It is as if some Stoic philosopher of the early Hellenistic age had chosen to remain in his native Athens and to reject the call of Rome.

Burckhardt's "rejection of the call of Rome" is thoroughly
consistent with his lifelong devotion to art and his commitment
to a mode of perception which is aesthetic even where it is
examining the structure of civilization and the foundations of
political power. This commitment is expressed in the duality of
his entire career. When in 1839, as a young man of twenty-
three, Burckhardt arrived to study history at the University of
Berlin,[39] he at once began to attend the lectures of Ranke, whose
presentation of historical method aroused his astonished admi-
ration even as the man himself struck him as somewhat less
than admirable. But even in Ranke's lectures he sensed the
somewhat dry appeal of the mere intellect, and it was to Franz
Kugler, Professor of the History of Art at the University of
Berlin, to whom he turned to provide the personal friendship
and the aesthetic warmth which were lacking in the more
famous political historian. Ranke and Kugler were undoubt-
edly the most profound influences of his student days. From
Ranke he derived historical method, from Kugler the encour-
agement to combine his love of the arts with his love of history,
and in the end to view history itself as a fine art—even as a
species of cosmic poetry. When five years later he began teach-
ing at his home university in Basel, it was as instructor in both
history and the history of art. Such archival studies as Burck-
hardt undertook in Paris and in Basel as well as in Italy and
the Netherlands were as much for the sake of art history as for
history proper. His posthumously published works, the *Welt-
geschichtliche Betrachtungen* (*Reflections on History*) and the
Kulturgeschichtliche Vorträge (*Lectures on Cultural History*)
combine in the first, theoretical treatments of the state with
reflections on culture and, in the second, essays dealing with
Byzantium in the tenth century, Rome under Gregory the
Great, and Napoleon, with essays concerned with genre paint-
ing in the Netherlands, Rembrandt, and Van Dyck. It is the
testament of a mind equally engaged by the threats of an
advancing industrialization and the consolations of the world
of classical sculpture, a mind which in fact discovers in the
latter those very norms which are to provide the basis of a
negative judgment on the former. And the upshot is that even
at the level of historical methodology itself, whereas Treitschke
cannot distinguish the provinces of history and politics, Burck-
hardt finds it increasingly difficult to distinguish the provinces
of history and of art.

Even in his student days Burckhardt sketched and wrote

poetry, but by the spring of his first year in Berlin he was transferring his allegiance to history without abandoning his poetic concerns. From Berlin he writes to Friedrich von Tschudi (March 16, 1840) : "My poetry, for which you prophesied fair weather, is in great danger of being sent packing now that I have found the height of poetry in history itself." [40] And two years later, writing to Willibald Beyschlag (June 14, 1842) and Karl Fresenius (June 19, 1842), he asserts not only the equivalence of poetry and history, but the dependence of the latter on imagination, and the lure of both for him in their appeals to his contemplative nature.

What I build up historically is not the result of criticism and speculation, but on the contrary, of imagination, which fills up the lacunae of contemplation. History, to me, is always poetry for the greater part; a series of the most beautiful artistic compositions. . . . My entire historical work, like my passion for travel, my mania for natural scenery and my interest in art, springs from an enormous thirst for contemplation. . . .

You would not believe how, little by little, as a result of this possibly one-sided effort, the *facta* of history, works of art, the monuments of all ages gradually acquire significance as witnesses to a past stage in the development of the spirit. Believe me, when I see the present lying quite clearly in the past, I feel moved by a shudder of profound respect. The highest conception of the history of mankind: the development of the spirit to freedom, has become my leading conviction, and consequently my studies cannot be untrue to me, cannot let me down, and must remain my good genius all through my life.

To me history is poetry on the grandest scale; don't misunderstand me, I do not regard it romantically or fantastically, all of which is quite worthless, but as a wonderful process of chrysalis-like transformations, of ever new disclosures and revelations of the spirit. This is where I stand on the shore of the world—stretching out my arms toward the *fons et origo* of all things, and that is why history to me is sheer poetry, that can be mastered through contemplation. You philosophers go further, your system penetrates into the depths of the secrets of the world, and to you history is a source of knowledge, a science, because you see, or think you see, the *primum agens* where I only see mystery and poetry. [41]

In these perceptions of the twenty-four-year-old Burckhardt are to be found the clue to his historical methodology—the

intellectual procedure which is to produce both his *Cicerone*
and his *Age of Constantine the Great,* both the *History of
Greek Culture* and *The Civilization of the Renaissance in
Italy.* It is clear how he has amalgamated the teachings of
Ranke and Kugler. From Ranke comes the Hegelian theorem
of history as the development of the spirit toward perfect free-
dom, but already this is diluted by the appeal to works of art
and monuments of the imagination as the primary data of the
historian's finished product. Thus even the dynamic move-
ments of the actors in the world-historical drama (which is the
very stuff of Rankean history) are being transmuted into a
series of "artistic compositions," paintings actually, or Apollo-
nian images (as Nietzsche, Burckhardt's younger colleague at
Basel, would have called them) which are to crystallize as
outgrowths of the historian's "contemplation."

The spirit of political narrative history is the same as that
which informs any dramatic actor, but the spirit of the *Kultur-
geschichte* which Burckhardt has made famous is that of the
tranquil portrait painter turning his attention to the construc-
tion of the portrait of an age. When Treitschke (in a passage
which I have quoted from his *Politics*) complained that Burck-
hardt's *Civilization of the Renaissance in Italy,* despite its
many excellences, was lacking in any portrayal of "living per-
sonalities," his criticism though partisan was quite in the spirit
of Rankean historiography. For not only are Ranke and
Treitschke both "political" historians, but methodologically
they are "Aristotelian" historians. Their subject matter is com-
posed of "actions" and "changes" of historical individuals
which can be *narrated.* Burckhardt, on the other hand, is not
simply a "cultural" historian, but is in method a "Platonic"
historian. His concern is with those qualities or aspects of an
age or an epoch which can be *characterized.* There is a vast
difference between the historical enterprise which narrates the
careers of those historic figures who are the bearers of the
destinies of the great European powers and that which seeks to
characterize the organic unity of those fateful and memorable
phases in the development of European civilization which we
denominate "the Hellenistic age" or "medieval culture" or
"the age of Romanticism." This is what gives to the historical
works of Burckhardt a character at once aesthetic and static, for
in producing a "history" of Greek culture or of Renaissance
civilization he must perforce neglect to infuse life into the
mechanisms of political and social dynamics while painstak-

ingly precipitating or isolating the static essence or *Zusammenhang* of the whole.

This is Platonism with a vengeance—the search for the characterizing universal rather than the significant particular hero—and it shows how essentially pointless is Treitscke's criticism of Burckhardt. For what we have here is not a *defect* in historiography but *another kind* of historiography. It cannot even be said that Burckhardt is uninterested in personality, but only that he searches for the culturally typical in personality—the "ideal type" as Max Weber would say—and if, unlike Treitschke, he is basically uninterested in a Pericles or an Aristides, a Roberto Malatesta or a Galeazzo Maria Sforza *as such,* it is because these are only the empirical data, the working particulars, as it were, from which can be extracted or superimposed "the Greek of the Heroic Age" or "the individualist of the Italian Renaissance."

It is neither unusual nor surprising that the youthful Burckhardt should have identified poetry and history, or that he should have, through the aid of Kugler, modified Ranke's narrative interest in the development of the Great Powers into an aesthetic concern with the presentation of historical epochs as a series of "beautiful artistic compositions." But what is unique and wholly unexpected is the natural congruence—one might almost say the preestablished harmony—between Burckhardt's artistic temperament and the method of cultural history which he was so successfully to utilize in his greatest work, *The Civilization of the Renaissance in Italy.* For here the aesthetic mode of perception dominates the Platonic historian at every turn. This can be concretely illustrated in two aspects of method: in the constant appeal to works of art and literature as *prime data* for the cultural historian, and to the metaphor of "the work of art" as the *prime symbol* through which all social and institutional phenomena are to be interpreted. The method here is striking insofar as it is the perfect inverse of what we have previously found in Treitschke. In Treitschke, all culture was interpreted and judged politically. In Burckhardt, all social and political institutions are to be interpreted and judged aesthetically. To the evidence for this in *The Civilization of the Renaissance in Italy* I should now like to turn briefly.[42]

The title of Part I of *The Civilization of the Renaissance in Italy* is "The State as a Work of Art." It is true that there is an ambiguity in the use of the phrase. Burckhardt does not merely

mean that the state must be an object of admiration like, say, the "David" of Donatello or Raphael's mural "The School of Athens." The analogical use here wants to suggest that the state was not "accidental" or "natural" but the result of creation and deliberate planning. Nevertheless this does not exhaust Burckhardt's meaning. Wherever there is art, there is the imposition of form on inchoate matter, and wherever there is form to be admired for its own sake, we are moving into the field of the aesthetic. Burckhardt's Platonism may not here have reached the stage where he means that the Italian Renaissance state would delight the spectator merely by its appeal to his detached love of pure form, but the connotations of the phrase and its context of usage do not, after all, differ too profoundly from just such vague and penumbral implications. For the meaning here is not confined solely to the expediential concept of the adaptation of means to ends—the application of the techniques of social engineering. There is equally an appeal to those purely aesthetic qualities of "beauty," "perfection," and "grandeur" within whose ambience all aesthetic analysis moves. This becomes clear as we begin Burckhardt's seventh chapter on "The Foreign Policy of the Italian States."

As the majority of the Italian States were in their internal constitution works of art—that is, the fruit of reflection and careful adaptation—so was their relation to one another and to foreign countries also a work of art . . . Thus Italy became the scene of a "foreign policy" which gradually, as in other countries also, acquired the position of a recognized system of public law. The purely objective treatment of international affairs, as free from prejudice as from moral scruples, attained a perfection which sometimes is not without a certain beauty and grandeur of its own.[43]

What this passage discloses is not merely that Burckhardt uses the image of "the work of art" in a sense intimately related to the aesthetic, but that this image is extended throughout the book in a manner almost obsessive. From the initial datum that the state is a work of art it follows that its diplomacy and foreign relations were works of art, that war is a work of art, that the battle plans of the condottieri are works of infernal artistry,[44] and Machiavelli, the originator of a naturalistic statecraft, becomes a "constitutional artist."[45] Finally, the Italian Renaissance's emphasis on the outward refinements of life, the graces of social intercourse, the exquisite protocol reflected

alike in the treatise of Castiglione and in the court of Urbino leads Burckhardt to say, "The demeanor of individuals and all the higher forms of social intercourse become ends pursued with a deliberate and artistic purpose." [46] He finds that "This society, at all events at the beginning of the sixteenth century, was a matter of art, and had and rested on tacit or avowed rules of good sense and propriety which are the exact reverse of all mere etiquette." [47]

The Italian Renaissance lends itself admirably to this type of aesthetic treatment. Burckhardt's book is a masterpiece less because of his scholarship than because here for once there is a perfect congruence between the subject matter itself and the mode of perception of its author. No historian whose center was moral righteousness or religious passion could look on the Italian Renaissance with either friendliness or affection. Its moral corruption was too profound, its religious sentiment too shallow. But to one acutely tuned to those perfections of form which constitute the deepest measure of aesthetic value, the Italian Renaissance could not be other than a constant joy. It was not that Burckhardt was morally blind or religiously unaware. He was eminently conscious that Alexander VI was an insult to the Papacy, that Sigismundo Malatesta under the verdict of history stood convicted of rape, murder, adultery, incest, perjury, and treason; but the age in which they lived blazed forth an aesthetic radiance which was overwhelming— and to Burckhardt irresistible. At the end of this chapter on Renaissance morality Burckhardt places a remarkable passage. It tell us, I think, as much about the author as it does about his subject matter:

But the Italian of the Renaissance had to bear the first mighty surging of a new age. Through his gifts and his passions he has become the most characteristic representative of all the heights and all the depths of his time. By the side of profound corruption appeared human personalities of the noblest harmony and an artistic splendor which shed upon the life of man a luster which neither antiquity nor mediaevalism either could or would bestow upon it.[48]

If one evidence of Burckhardt's aesthetic concern is the ubiquity of the metaphor of "the work of art" in his political and social analysis, another is his constant preoccupation with how art and culture are woven into the texture of Renaissance life. His judgment of Louis XI depends less on how his political

policy is superior to that of Francesco Sforza and the other
Italian princes than on how his culture and refinement are less
than theirs. Even as he underscores the ferocity and bloodthirst-
iness of the Baglioni of Perugia, he notes how Raphael used
one of them as the central figure of "The Expulsion of Heliodo-
rus from the Temple." Julius II interests him less because of his
soldiership than because under him the Vatican acquired the
"Laocoön" and the "Venus." His admiration for Federigo da
Montefeltro is based more on his collection of classical manu-
scripts, his patronage of Vittorino and Piero della Francesca,
and his mastery of the Greek historians than on his discreet and
humane administration. And even his repugnance for the cor-
ruption of Sigismundo Malatesta (who, with Frederick II of
Sicily, is one of his recurrent historical villains) is tempered by
a reluctant admiration for the man who held court with a host
of humanistic scholars (for whom he provided liberally), who
initiated the rebuilding of the famous San Francesco of Rimini,
and who even as a moral monster felt that learning and the
friendship of cultivated men were necessities of life.

In his reading of history as the destiny of art and culture,
Burckhardt is merely expressing something profoundly charac-
teristic of his own nature, and this holds also for the other side
of the coin—his political pessimism and his deep disillusion-
ment with the course of European political and social history in
the nineteenth century. In fact, in his work as in his most
intimate reflections these two aspects of his thought almost
always appear together. At twenty-eight, in a letter to Hermann
Schauenburg (February 27, 1847), he records, on the one hand,
his devotion to "beauty" and its "golden age," and, on the
other, expresses his repugnance for the course of European
politics since 1830.

Whether or not you manage in the end, after unspeakable drudgery
and toil, to achieve something in your profession really means very
little. How much better to be loved by one's beloved, and to have
followed one's fancy. But my "fancy" is beauty, and it stirs me pro-
foundly in all its forms more and more. I can do nothing about it.
Italy opened my eyes, and since then my whole being is consumed
by a great longing for the golden age, for the harmony of things,
and the *soi-disant* "battles" of the present seem to me pretty comic.
. . . The *Kölnische Zeitung* and other *carrés de papier*, as Alphons
Karr calls them, deduce that politics are at last entering a great new
phase, and have become "the people's politics," etc., but I can only
assure you as a sober historian that there has never been such a com-

mon, unattractive period in the history of the world as that since 1830. I feel justified in turning where my soul finds nourish-ment . . .[49]

Political disgust drowned in aesthetic indulgence—the syn-drome is almost classic for one sort of humanism which per-vades the Western tradition, but in Burckhardt there is less of a temporary romanticism than of a temperamental trait which lasts a lifetime. Twenty years later the situation has not changed—if anything it has become more acute—and now the horrors of 1870 confirm him in the belief that for the discipline of history itself the memory of political events can be dispensed with in favor of the memory of cultural events. In a letter to von Preen (New Year's Eve, 1870) he writes:

The worst of all this is not the present war, but the era of wars upon which we have entered, and to this the new mentality will have to adapt itself. O, how much the cultured will have to throw over-board as a spiritual luxury that they have come to love! . . . To me, as a teacher of history, a very curious phenomenon has become clear: the sudden devaluation of all mere "events" in the past. From now on in my lectures, I shall only emphasize cultural history, and retain nothing but the quite indispensable external scaffolding . . .[50]

The pursuit of history as cultural memory, the rejection of politics and the political way of life—these characteristics are constant throughout Burckhardt's life, and they are expressed both in the nature of his historiography and in his later philo-sophical meditations on history, first drafted in 1868 but pub-lished only after his death. Thus the concrete practice of *The Civilization of the Renaissance in Italy* is given its theoretical justification in the *Reflections On History*,[51] and to this latter work, at once sociological and eloquent, I should finally like to turn.

Burckhardt's *Reflections On History* is unimaginable with-out the historiography of Ranke. For, as we have seen, Ranke's central concern for the Great Powers in European history hinged upon the complicated interrelationships between politi-cal states, religious organizations, and the levels of civilization to which the diverse peoples of Europe had arrived throughout the course of their historical development. These dimensions of Ranke's historiography now become the "elements" of Burck-hardt's philosophy of history. He too identifies *der Staat, die Religion, die Kultur* as the three "powers" (*die drei Potenzen*)

whose interrelationships constitute the warp and woof of history. It is interesting and even paradoxical that Burckhardt, in speaking of the three great powers as state, religion, and culture, should call the first two "constants" and the third a "variable," for the chief thrust of his aesthetic mode of perception is to find an essential link between "culture" and "the beautiful." Yet, when a few pages later he comes to treat of "the true, the good, and the beautiful" it is the former two (science and moral achievement) which are above all the slaves of temporality and change, and only the latter attains to the eternal. Nowhere does Burckhardt's aesthetic Platonism more clearly express itself than when he asserts: "The beautiful may certainly be exalted above time and its changes, and in any case *forms a world of its own.* Homer and Phidias are still beautiful, while the good and the true of their time are no longer in all respects ours." [52]

Burckhardt is particularly aware of the limitations and prejudices of time and place, for they constitute for him the chief pitfalls of the historian. Provincialism of this kind is the worst enemy of historical knowledge, and it is most likely to occur, he thinks, in those nationalistic historians who in the guise of patriotism, read the historical record through the optical illusions of partisan and narrow political values. "Our imagined patriotism," he says, "is often mere pride towards other peoples, and just for that reason lies outside of the path of truth. Even worse, it may be no more than a kind of partisanship within our own national circle; indeed, it often consists simply in causing pain to others. History of that kind is journalism." [53] Here, without even mentioning his name, Burckhardt has laid waste the entire historiography of Treitschke!

But he does so on more theoretical grounds also. Although he recognizes a certain relativity in the actual influence and power of his three elements (at times they seem to function alternatively: there are primarily political and primarily religious epochs, and finally epochs like the Italian Renaissance which seem to live for the great purposes of culture), his personal judgment of values is never in doubt. Even the great states exist in history only for the maintenance and protection of culture, although the very extent of their centralized might makes it unlikely that they will follow their rightful aim rather than one of senseless conquest in the attempt to satisfy an unbridled lust for wealth and power. For "the truth is—we have only to think of Louis XIV, Napoleon and the revolutionary popular govern-

ments—that power is in itself evil." [54] If this is the case, only the small states guarantee that there may be a spot on earth where the largest possible proportion of the inhabitants are citizens in the fullest sense of the word and where art may flourish as the indigenous expression of a free people. Athens and Florence seemed to say as much, and perhaps Burckhardt is even thinking wistfully of his own native Basel, which Erasmus also valued for the minute but exquisite cosmopolitanism of its culture. As for the state at the level of imperial power, to assert with Hegel (and Treitschke) that it is "the realization of ethical values on earth" is sheer hubris. The forum of morality lies quite outside the state, and it will be most likely to remain healthy when it is aware of its own limited nature as a mere expedient.

Burckhardt's theory of the state is the precise opposite of Treitschke's—it is the profound mistrust of political power and the effort of the liberal humanist to limit its role to that of mere means in the achievement of cultural values. Treitschke would have laughed the idea to scorn. "The state," he had said ironically, "is not an academy of arts." But Burckhardt's profound mysticism about the role of the arts in human life shows him not essentially too far removed from even this excess. For him culture is always the final critic of both religion and the state— the clock which tells the hour at which their form and substance no longer coincide—and the arts, enclosed by the protective wrappings of religious and political forms, embody a "higher life" which would not exist without them:

From the world, from time and nature, art and poetry draw images, eternally valid and universally intelligible, the only perdurable things on earth, a second, ideal creation, exempt from the limitations of individual temporality, an earthly immortality, a language for all the nations. Hence they are, no less than philosophy, great exponents of their epochs. [55]

Burckhardt's theory of the proper relationship between art and politics, between the state and culture, follows from this evaluation. For "culture determined by the state" (*die Kultur in ihrer Bedingtheit durch den Staat*) he has only the most profound mistrust. He sees the dawn of the modern, centralized power state in the empire of Frederick II of Sicily, "based on the practice of Norman tyranny and on Mohammedan models, exercising terrible dominion over culture too, especially by its

trade monopolies," although the first *perfected* example of the modern state with supreme coercive power exercised on nearly all branches of culture is to be seen in the France of Louis XIV and in his imitators. "Literature and even philosophy became servile in their glorification of the State, and art monumentally servile; they created only what was acceptable at Court. Intellect put itself out to board in every direction and cringed before convention." [56]

On the other hand "the state determined by culture" (*der Staat in seiner Bedingtheit durch die Kultur*) represents for him the highest point in the development of Western civilization. The primary example is, of course, the Athenian city-state, where "the triumph of democracy might be regarded as the conquest of the State by culture, which is here equivalent to thought," and where the interest of subsequent ages is naturally less in the political life of the Athenians as such than in the quality of their state as a focus of culture. This whole section of Burckhardt's *Reflections* is a paean to Athens—its originality, its freedom as a center of intellectual exchange, its cultural citizenship through which eloquence, art, poetry, and philosophy all radiate from the life of the city.

Thus a general understanding was created. Orators and dramatists could reckon with an audience such as had never before existed. People had time and taste for the highest and best because mind was not drowned in money-making, social distinctions and false decencies. There was comprehension for the sublime, sensitiveness for the subtlest allusions and appreciation of the crassest wit. Everything we know about Athens shows us even the most practical details of life on an intellectual background, and in intellectual form. Athens has no tedious pages.[57]

Then, step by step, there came into being the modern centralized state "dominating and determining culture, worshipped as a god and ruling like a sultan." Even as the idea of popular sovereignty emerged, the epoch of profit and commercial traffic set in, and these interests came to regard themselves entirely as the governing principles of the world. Political thought now claims for the state an ever-increasing and more comprehensive power of coercion, and this in turn is utilized in the service of money-making and bureaucratic self-preservation —the chief forces of present-day political incentive.

Burckhardt's *Reflections on History* are trenchant—and

deeply pessimistic, for they are based on an aesthetic mode of perception which sees a steady threat of decadence in the passage from states determined by culture to the situation where culture is determined by the state. And it becomes now eminently clear where the more derivative Oswald Spengler received major inspiration for his flamboyant and disquieting *Decline of the West*. The historiography of Ranke had been dominated by an optimism—partly temperamental, partly due to the social situation in which he lived—which could contemplate the Great Powers of Europe, guided by divine providence and competing fruitfully for political rewards, but in the end never violating a final equilibrium which was the guarantee of European order. For Burckhardt such optimism was but the foolishness of a learned and pedantic child. Burckhardt's life was lived quietly and serenely within the shadow of the cathedral where Erasmus lies buried, but his mind and the reflections which are its product lead directly to the ambiguity, the decadence, and the horrors of our own contemporary life.

Seven / The Drama and Politics:

Büchner, Brecht, and Hochhuth

THE ASSOCIATION of the drama with politics is as old as playwriting in the Western world. The *Antigone* of Sophocles, *The Trojan Women* of Euripides, *The Acharnians, The Knights,* and *Lysistrata* of Aristophanes are, each in its own way, political plays written out of Greek political experience or reflecting the Athenian political dilemmas which served as motive or material for the greatest playwrights of the Periclean Age. Between the *Antigone* of 441 B.C. and the *Lysistrata* of 411 B.C. lay thirty of the most crucial years of Greek political existence. The first play is roughly of the period of the revolt and subjugation of Samos; the second was produced in the same year which saw the oligarchical *coup d'état* which overthrew the democratic constitution, and between them lay the strong administration of Pericles and the dark days of the Peloponnesian War which were to see Athens turn from the *Kulturstaat* which the world has never forgotten into the despotic imperialist power which was to engineer her own downfall. This peripeteia in Athenian fortune is witnessed by the crisis of conscience of her leading dramatic figures. But the play of Sophocles is political in a very different sense from that of Euripides, and both in turn are quite unlike those of Aristophanes. It may be useful to look at each in a little more detail so as to note some of the possibilities which lay open, even from the earliest times, for the political theater.

There is no question that *Antigone* is, in any reasonable sense of the term, a political play. For it deals with that intricate and perennial problem of political life—the revolt of the individual against constituted authority, the rights which con-

science has even against the seemingly inviolable law of the political constitution. Creon represents the authority of the positive state, Antigone the unwritten moral law of individual conscientiousness, and the bitter conflict between them is bound, as Sophocles sees, to have tragic consequences for them both. Many historians of the ancient world have tried to find in this play traces of Sophocles' own judgments on contemporary Athenian politics. Is Creon, for example, perhaps Sophocles' portrait of Pericles, or of some other political leader of the time? Prima facie, it seems not impossible. Sophocles was not only a dramatist, but a political figure in his own right, twice elected military general, once treasurer of the tribute, and on several occasions acting ambassador.[1] But despite his connection with public affairs, there is, as Haigh says, little trace of the statesman in Sophocles' plays, and the serene idealism of his tragedy is never compromised by the intrusion of contemporary politics. If he had controversial political opinions, they do not appear in *Antigone,* and it is impossible to discover from it whether he approved or regretted the great movements of his time—the growth of Athenian democracy and the imperial policy of Pericles. *Antigone* is political not because it is timely, but because its type of conflict is recurrent, and its espousal of the doctrine of a higher law of individual protest a principle eternally valid in the circumstances of political life.

Chapter XVII of Thucydides' *History* details a dreadful incident in the sixteenth year of the Peloponnesian War—the destruction of the little island of Melos through a wanton exercise of Athenian power. The Melians were a small colony of Spartan origin who would not submit to the Athenians, like the other Aegean islands, and at first remained neutral, but afterward, when Athens used violence and plundered their territory, became more hostile. Thereupon the Athenians invaded the island with a large force and the famous "Melian Conference" took place. Thucydides presents it in dialogue with a beautiful rhetorical flourish. The Athenians ask for submission. The Melians plead their weakness, their right to be neutral, the privilege of the weak against the strong. The Athenians speak a language of *Realpolitik* and naked power; they are unmoved by weakness and ethical argument. Standing stubbornly by their decision to defend themselves against hopeless odds, the Melians are finally forced to surrender, whereupon, as Thucydides says, "the Athenians put to death all the grown men of the colony, sold the women and children into slavery and subse-

quently sent out five hundred colonists and took over the place themselves."

It was this event of the year 416 B.C. which shook Euripides out of any thoughts of romantic or ironic dramatic composition.[2] For all that he could see in this massacre and enslavement of the weak was a revelation of the moral bankruptcy of a great political idea, the self-condemnation of Athens to the role of international tyrant, the monstrous extreme to which the bloody fanaticism of the Athenian war party must inevitably lead. Throughout that autumn and winter Euripides must have been brooding on the crime of Melos, for in the spring, just as the Athenian fleet was about to sail on the fatal Sicilian expedition, he produced a new and remarkable play, *The Trojan Women,* a masterpiece if ever there was one but the seed of a discord which was henceforth to separate him forever from his people and his city. *The Trojan Women* tells the story of the proudest conquest of the Greek people. But it tells the old story of the days just after the destruction of the city of Troy in such a way that at last one sees this consequence of military triumph not as glory, but as misery, shame, and wanton murder. *The Trojan Women,* with quiet determination and unbearable pathos, shows the other side of the coin of conquest— the brutality suffered by the defeated, the weak, and the helpless. It was a mirror held up before the Athenian cruelty at Melos—a play of political indictment and moral outrage—and therefore a profoundly different contribution to the political theater from the *Antigone* of Sophocles.

The comedies of Aristophanes—*The Knights,* which is a vitriolic attack on the Athenian demagogue Cleon, and the three widely separated plays of peace propaganda, *The Acharnians, The Peace,* and *Lysistrata*—are political plays in still a third sense, for their satirical immediacy brings the whole ambience of contemporary Athens on the stage, and their aim is directly propagandistic—partly to further the cause of aristocratic conservatism, but above all to plead for an end of the disastrous war with Sparta.[3] Aristophanes' very early play, *The Babylonians,* of which only fragments survive, seems to have been a thoroughgoing attack on Athens and the entire foreign policy of this "tyrant city" toward its allies and dependents. Its writing was an act of idealism and of extreme courage—of the same sort that prompted Thucydides to write the Melian Dialogue and drove Euripides into exile after *The Trojan Women* —and it is a wonder that Aristophanes escaped with his life. He

was prosecuted, but the charge of treason apparently broke down and he was left to pursue the same satirical path in *The Acharnians* and *The Knights,* both of which are also daring plays, and in *Lysistrata,* which was his final half-farcical, half-tragic appeal against the Peloponnesian War. *The Acharnians* was a bold demand for peace made at the very moment when the war fever was at its height. *The Knights* was an uncompromising attack on the spirit of a war policy still triumphant. *Lysistrata,* presented two years after the catastrophic end of the Sicilian campaign when Athens was growing weary of the sufferings of war, was a final plea for Athenians and Spartans alike to forget the errors of the past and join in peaceful reconciliation. The politics here is clear and undisguised, the reference to the contemporary is unmistakable. Both Sophocles and Euripides cloaked their political message (general in the first case, specific in the second) in the garments of the ancient mythology as was appropriate for the distanciation required in a tragic theme, but the comedy of Aristophanes is set in the atmosphere of yesterday's news from the theater of war and today's news from the Agora and the Prytaneum. And the thrust of its insistence—its demand for remedial action—is grounded on just this sense of political urgency and social immediacy.

Here then are at least three different possibilities of political theater suggested by the practice of the ancient world. *Antigone* is a play of political principle. *The Trojan Women* is a play of political outrage. *The Acharnians* and *Lysistrata* are plays of political insistence. Sophocles has utilized a method of family tragedy to present the elements of a *political philosophy*. Euripides has used an obvious mythical parallel to register the indignation of a *political protest*. Aristophanes has employed the satrical presentation of the commonplaces of contemporary Athens to mount a barrage of *political propaganda*. The devices and the intentions of the modern theater are hardly ever new. And I think that we shall therefore find in the political theater of Büchner a certain analogue to that of Sophocles, in the political theater of Brecht an obvious analogue to that of Aristophanes, in the political theater of Hochhuth an intention similar to that of Euripides. The problems and the settings change, but the defects of social living and the critical necessities which require the existence of the political theater are a constant throughout the course of Western culture.

Beginning with Shakespeare, as we have seen, the political

theater takes on a specifically historical character. For this there
are several reasons. In the first place the association is natural.
Since, as Freeman said, "History is past politics, and politics is
present history," any dramatic concern with political problems
always has the infinite past at its disposal to draw on in its
choice of instances. Secondly, authoritarian censorship and sen-
sitivity almost preclude the directness of a contemporary setting
for the purposes of criticism. Tudor absolutism was wont to
limit topicality and contemporary reference in its fear of "trai-
torous and fellonous stratagems," and even if only the most
conservative of political statements was Shakespeare's inten-
tion, the historical or legendary ambience had become the
standard convention of protection. Finally, the dramatic "mas-
tering" of the political past can be one of the most pressing
problems of the political present. Shakespeare's Yorkist and
Lancastrian tetralogies, original and independent as drama, as
"idea" do little more than to service the Tudor myth, and the
need for such current ideology attests to deep underlying colli-
sions between the feudal past and the monarchical present. The
social crisis of the English sixteenth century is indirectly repre-
sented in the cycle of Shakespeare's history plays, not simply for
the high argument for ideal kingship which they present, and
for their portrayal of the mad chaos of political disorder, but in
the realistic presentation of the whole spectrum of "feudal
types" which were still both fascinating and problematic in
their appeal to current Elizabethan memory.

The heart of Shakespeare's political drama lies in those plays
of England's historical past which occupied him almost contin-
uously from 1592 to 1599. But the Roman plays also—particu-
larly *Julius Caesar* and *Coriolanus*—provide another approach
to political theater, and one quite different from the treatment
of the Houses of York and Lancaster. Boris Pasternak, the late
poet and translator of Shakespeare into modern Russian,
thought that this difference of approach was simply one of
objectivity; that since the chronicle plays of English history had
their analogues in the circumstances of his own time, his atti-
tude toward the past could not be sober and dispassionate.[4]
Rather, the adoption of Roman themes, the setting in a remote
Roman antiquity, permitted Shakespeare, Pasternak said, "to
call things by their names"—to use the vehicle of temporal
remoteness in the service of a realism which enabled him to
make his own statements about ethics, politics, and the rela-
tionship between them. Pasternak's distinction is initially very

plausible, but in the end, I think, not quite accurate. There are certainly flourishes of the heroic and the histrionic in *Richard II* and *Henry V* which make the Roman plays seem quite "realistic" by contrast, but the chief difficulty is that if the Roman setting permitted Shakespeare "to call things by their names," it is not possible for us to discover from the plays themselves what names he called them! To a Marxist translator (which, to be sure, Pasternak was in only a very qualified sense) it would be a great comfort to be able to say that *Julius Caesar* was an argument in favor of the political assassination of despots, and that *Coriolanus* provided sympathetic documentation of the miseries of the Roman proletariat, exploited by its "Fascist" rulers, but such interpretations are not in accordance with the facts. The Roman plays of Shakespeare provide still another model of the political theater precisely because of the very ambiguity of the politics which they represent. In this sense they, perhaps even more than the history plays, lead to the political drama of Schiller.

It is true that the politics of Shakespeare's plays expresses the search for social order as two hundred years later the politics of Schiller's plays is to express the search for social freedom. It is also true that the historical sense exhibited in *Maria Stuart* and *Wallenstein* is completely different from that mirrored in *Henry V* and *Richard III*. But the fact that political problems are set for both Shakespeare and Schiller in historical terms indicates the role which historical consciousness in general plays in relating politics and drama in the West. It would perhaps be extreme to assert the Marxist claim that between any political drama and the specific structure of the capitalistic society in which it originates there is a determining relation. But it is difficult to deny that the drama of an age somehow paints the great historical explosions of its social crises. Elizabethan drama reflects the residual malaise of the feudal dissolution, as the eighteenth century drama of the German Enlightenment reflects the forms of social unrest which are to culminate in the French Revolution. Thus the drama of Schiller, while based on the repudiation of the violence of that revolution in detail, asks for political freedom and social justice in accents no less passionate than those of Danton and Robespierre, and sees the complexities of political action with a sensitivity no less than that of Montesquieu and Rousseau. There is a "realism" in Schiller which notes the equivocal and the problematic in all political life, but there is a romanticism

too which believes in the redeeming consequences of a moral education and expresses political hope in an expansive, sometimes even an extravagant, rhetoric. The modern political theater likewise, although it may completely repudiate both Shakespeare's aristocratic ideology and Schiller's rhetorical flourishes, has its own historical sense and its own criterion of political relevance. To the complexity of this modern political theater and to the variants on the political theme expressed, respectively, in the works of Büchner, Brecht, and Hochhuth I should now like to turn.

Perhaps one brief note on method should be added. In speaking of political theater and the "political" play, I have assumed that the adjective is made meaningful through the range of instances cited. I have taken for granted that there is some common "political" quality in, say, *The Acharnians* and *Lysistrata* of Aristophanes, *Richard III* and *Coriolanus* of Shakespeare, and Schiller's *Don Carlos* and *Wilhelm Tell*. But, except perhaps in distinguishing the play of political philosophy, of political protest and of political propaganda in the drama of the Greeks, I have done little to unpack the extreme complexity and variety in the meaning of the term "political" as it applies to the field of literature. It is of course always possible to make some rather general statement about this and then get on with the serious business of the analysis of specific examples of the novel or drama. This is what Eric Bentley does in his essay "The Theater of Commitment," [5] and what Irving Howe does in his book *Politics and the Novel*.[6] Bentley is primarily interested in politics as *attitude*. He deals with modern plays of political commitment, and he means by this quite simply those cases where (1) the author has political views, and (2) his political views enter into his art. Howe understands that the relationship between literature and politics is considerably more complicated. By a political novel he means one in which political ideas play a dominant role, or in which the political milieu is the dominant setting, or where the "idea" of society as distinct from the mere unquestioned workings of society has penetrated the consciousness of the characters in all of its profoundly problematic aspects. Here the distinction between the political *subject* and the political *setting* is already clearly recognized. To the three aspects distinguished by Bentley and Howe I should like to add a fourth. It is the role within the literary work of explicit political statement. *Setting, subject, attitude, statement:* these are the dimensions of the political

theater expressible in the four relevant questions which I think
we may ask about any literary work in whose political quality
we have an interest. Does it have a political setting? Does it
treat of political subject matter? Does it reflect or attempt to
create a political attitude? Does it make a political statement?
With these questions in mind I wish to approach the subject of
the modern political theater, of which I shall consider three
German plays as exemplary: *Dantons Tod* by Georg Büchner,
Mutter Courage und ihre Kinder by Bertolt Brecht, and *Der
Stellvertreter* by Rolf Hochhuth.

Danton's Death by Georg Büchner is surely one of the most
remarkable first plays in the entire history of Western theater.
Written in January and February of 1835, when the author was
only twenty-one, and when only two more years remained of his
brilliant but pitifully short life, it is as ambiguous and paradox-
ical a contribution to the political theater as it is a precocious
act of dramatic creation. Set in the center of revolutionary
Paris at the time of the Terror, it deals with that period in
which the French Revolution, like Saturn, is in process of
devouring its own children. Its time span is the thirteen days
from March 24 to April 6, 1794, from the condemnation and
execution of the radically revolutionary "Hébertists" to that
day less than two weeks later when the "Cordeliers"—Danton,
Camille Desmoulins, Lacroix, Hérault de Séchelles, Philip-
peau, and Fabre d' Eglantine—mount the scaffold. And its
"subject" may be viewed at will as "Paris in the grip of the
Terror," or "the Jacobin triumph," or "the life and fate of the
Dantonists," or "the victory of Robespierre and Saint-Just," or
simply, as the title states, "Danton's Death." The setting and
the subject are of the clearest: it is only the political attitude of
the playwright and of the play itself, as well as the political
statement which the play either does or does not make, which
are in doubt. And here, for all of our minute knowledge of
Büchner's life and political ideas, his personal revolutionary
activity, and revealing letters,[7] we remain in the area of the
intensely problematic. How does one mate the details of the
author's political life with the independent life of his creation?
How does one marry the egalitarianism of Büchner, the pas-
sionate social revolutionary, to the dispraise of, and disillusion-
ment with, the most striking instance of a passionate social
revolution in the whole of Western history?

Perhaps we can learn something from the analogy with Schiller. In the fifth letter of *The Aesthetic Education of Man,* the author of *Don Carlos,* without mentioning names, but with unmistakable reference to the French Revolution only just past, lays the foundation for the attitude toward this cataclysm of history which some are all too willing to attribute to *Danton's Death,* and which its content certainly suggests:

In the lower and larger masses, raw, lawless impulses appear, breaking loose when the bonds of civil order are burst asunder, and hastening with unbridled fury to their savage satisfaction. It may be that objective humanity has had cause to complain of the state, yet subjective man must honor its institutions . . . For its destruction contains its justification. Society set free, instead of hastening upwards into organic life, collapses into its elements.[8]

The phase of the French Revolution which Büchner chooses for the setting of his play is not the early period when the monarchy is joyfully abolished and the French citizens rush enthusiastically to the defense of their country against foreign invaders. It is, on the contrary, that later period when "society set free, instead of hastening upwards into organic life, collapses into its elements." "How long," asks Philippeau early in *Danton's Death,* "will we go on being as messy and bloody as newborn babes, with coffins for cradles, playing with human heads?" "The people," says Lacroix a little later, "is a Minotaur which must have its weekly supply of corpses if you don't want to be eaten yourself." Toward the end a prisoner in the Conciergerie draws the conclusion: "Hasn't the rolling of the tumbrels told you that Paris is a slaughterhouse?"[9] These three metaphors sum up the situation within the play, and perhaps Büchner's own view of the later days of the French Revolution. *The leaders are bloody babies playing ball with the severed heads. The populace is a Minotaur raging for corpses. The whole of Paris is a slaughterhouse.* It is as Schiller said—"the raw lawless impulses of the masses, breaking loose when the bonds of civil order are burst asunder, and hastening with unbridled fury to their savage satisfaction." But Schiller was a humane libertarian who hated violence, while Büchner at twenty was a revolutionary wanted by the police of Hesse, a refugee forced to flee his native state to escape a prison sentence for having written a pamphlet no less an incitement to violence than was the journalism of Danton and Camille Desmoulins. Perhaps the analogy with Schiller is not so useful after all.

Almost from his adolescence we sense in Büchner the senti-
ments of the far-leftist social revolutionary. At nineteen he
writes an indiscreet letter to his family from Strasbourg.[10] No
voluntary reforms can be expected from the German princes.
Whatever they concede comes only through compulsion. Thus
the only social resort of the time is naked force. Yet he sees the
relative hopelessness of the situation. In a letter from Giessen
in the same year he vows his eternal enmity to the aristocratic
class,[11] and in a letter to Gutzkow, his publisher, the following
year he exhibits all of the characteristics of a cynical Marxist
fifteen years before the writing of *The Communist Manifesto*.[12]
The relations between the rich and the poor constitute the only
revolutionary element in the world. Hunger alone can be the
goddess of liberty, and only a Moses bringing the seven plagues
against the ruling Pharaohs is capable of being a Messiah. But
feed the lower classes and the revolution would die of apoplexy!
From what sources do these ideas originate?

It is true that Büchner studied at Strasbourg between 1831
and 1833, and that in those days Strasbourg was one of the most
radical and politically active cities in France.[13] It is also true
that for a year—between the end of October, 1833 and the
autumn of 1834—he returned to the Hessian state university at
Giessen, where he was involved in active political agitation. He
was burning with a sense of social injustice, and he either
joined, or indeed perhaps founded, a genuinely revolutionary
student club, "die Gesellschaft der Menschenrechte"—the So-
ciety for the Rights of Man. All of this has a distinctly French
revolutionary flavor, and this impression is fully substantiated
by a perusal of the incendiary manifesto which he composed
(probably with a friend) at Giessen in June or July, 1834—
The Hessian Courier.[14] This call to violent action begins with
the heading FREEDOM FOR THE HOVELS! WAR FOR THE PALACES!
—the very slogan coined by the French deputy Merlin de
Thionville at the time of the Revolution.

"The life of the aristocrats," begins this revolutionary tract,"
is one long Sunday. They live in fine houses, they wear elegant
clothes, they have bloated faces and speak a language of their
own. But the common people lie at their feet like manure on
the fields. . . . The life of the farmer is an eternal day of labor.
Strangers eat up his fields before his very eyes, his body is one
great callus, his sweat lies on the table of the aristocrats like
salt." The pamphlet continues with an analysis of the finances
of the Duchy of Hesse, claiming that the enormous taxes are

extorted by the state as a blood levy drawn from the body of the people and because of which they groan, sweat, and starve. It attacks the government as a set of wastrels, secret police, and pimps. The prince is a leech and the officials are the bleeding-vessels which he has set to drain the country's blood. The nobility hide their running sores with ribbons and decorations, and cover their scabby bodies with rich brocades. The daughters of the people are their maidservants and whores; the sons of the people their lackeys and soldiers. The nation as a whole is one mass of exploitation and corruption.

The more attentively one reads this virulent revolutionary pamphlet, the more one becomes aware that it sounds less like something written after 1795 than like something written before 1789. The conditions it details make it seem as if the French Revolution had never occurred. And with this the situation and the attitude of Büchner become quite clear. For in the central Europe of 1834, as far as practical aims and permanent effects are concerned, it is as if it never had! For Büchner the ideals of the French Revolution are just as valid as they ever were—it is only that in fact this was a revolution which failed, and the sense of this failure haunts *The Hessian Courier* as it is to haunt *Danton's Death,* and provides the curious mixture of revolutionary fervor and personal despair which is to characterize the recesses of Büchner's mind as it is to infuse the atmosphere of his great play.

That this interpretation is correct is evidenced by *The Hessian Courier* itself, for it contains a two-page analysis of the French Revolution which begins with enthusiasm and ends with despair. In 1789 the people of France revolted against rotten institutions, defined the Rights of Man, and killed their king. But later the French themselves sold their freedom for the empty glory of Napoleon, and finally, with his defeat, took back the fat-paunched Bourbons for their kings. But when once again, in the insurrection of July 1830, brave men drove the perjured Charles X from the country, this bid to reclaim the revolution failed also, and France once again, giving itself to the dishonest Louis Philippe, reassumed the bondage which it had tried in vain to cast off for four decades. In this account there is no word of the Terror or of Danton's death—only the profound disillusionment of one who lives after 1830 and begins to realize that the fate of Europe is the eternal recurrence of revolutions which fail.

Büchner was too well endowed with the histrionic sense not

to recognize with the greatest clarity the intimate connection between the dramatic facts of life and the revolutionary crises of society. In a famous letter of November, 1833 to his fiancée, Büchner assets that he has been studying the history of the French Revolution. Six months later at Giessen he produces *The Hessian Courier*. By the end of the summer the pamphlet is proscribed and two of Büchner's friends and companions are arrested and imprisoned. Deeply suspect, Büchner himself returns to the parental home in Darmstadt where, in the greatest anxiety and secrecy in the first weeks of 1835, *Danton's Death* is written. The next month (March) he flees to Strasbourg with his manuscript—one step ahead of the police. Both *The Hessian Courier* and *Danton's Death* are in some sense the fruit of Büchner's preoccupation with the French Revolution as a repository of ideals and as a lesson of failure. To understand the intricate mixture of these two strands in Büchner's consciousness is a necessary preliminary to the understanding of the nature of his political drama.

The letter of 1833 which Büchner wrote to his fiancée Minna Jaeglé, states the mood of *Danton's Death* almost two years before its composition:

For several days now at every opportunity I have taken pen in hand, but it was impossible for me to write a single word. I have been studying the history of the Revolution. I have felt as if crushed beneath the monstrous fatalism of history. I find in human nature a terrifying sameness, and in human relations an inexorable force given to all and to none. The individual is but foam on the wave, greatness mere chance, the mastery of genius a puppet show, a ludicrous struggle against an iron law, which to recognize is the highest achievement, to control impossible. I no longer intend to bow down before the parade horses and the bystanders of history. My eyes have grown accustomed to blood. But I am no guillotine knife. "Necessity" is one of the most damning words with which human kind is saddled. The saying: "It must be that offenses come, but woe to him by whom they come" is frightful. What is it in us that lies, murders, steals? I don't feel like pursuing this idea further. . . .[15]

Despite the fact that Büchner in a later letter expressed great admiration for Shakespeare and very little for Schiller, that he was drawn to the Shakespearean "realism" and repelled by Schiller's idealistic rhetoric, it is clear that his historical consciousness is closer to that of Schiller than to Shakespeare's. For Shakespeare's English kings and Roman heroes are the makers

of history as well as its victims, and history is not the external compulsion brought to bear on their conduct, but the very principle of their acts. For Schiller, as we have seen, the externality of historical necessity is a factor constantly acknowledged, but he is still far more idealistic in his philosophy of history than is Büchner. Like Hegel, Schiller locates the meaning of history in the emerging quality of freedom—a point of view stemming from the eighteenth century and teleological through and through. In Büchner the "externality" and the "necessity" remain, but the rich purposiveness has vanished, leaving the operations of a fatalism which is as meaningless as it is inexorable.

If Büchner has a philosophical mentor, it is Schopenhauer, and not Hegel, or perhaps even that Democritus who is to serve as inspiration for the mid-nineteenth century materialism which moved both Marx and German natural science. In the light of this "materialistic pessimism" Büchner feels crushed beneath the fatalism of history, senses that the individual is but foam on the crest of the historical wave, finds frightful the iron law of social necessity. But being, too, a humane and compassionate man, the blood-letting ferocity of the French Revolution and the calculated inhumanity of its more fanatical leaders present a problem in moral value which is as perplexing to him as it is unanswerable. No wonder that "with eyes grown accustomed to blood," he is yet not comfortable with revolution's murderous necessity. No wonder that, like Schiller, contemplating the spectacle of those "raw, lawless impulses breaking loose when the bonds of civil order are burst asunder and hastening with unbridled fury to their savage satisfaction," he should ask: "What is it in us that lies, murders, steals?" without having the strength or courage to pursue the matter further.

Büchner is, I think, in some sense a revelatory and a prophetic figure. Passionately moved by politics, he is, at the same time, infected with that pessimism which renders problematic the very historical direction in which politics moves. Disillusioned by the failed revolutions of 1789 and 1830 into a kind of materialistic fatalism, he is still too committed to the values of the heart and the Rights of Man to succumb to a stoic acceptance. Thus the insistent claim of moral values in a world of materialistic necessity sets the dialectic of his mind and of his dramaturgy. Such a dialectic has enormous contemporary appeal. This, as well as his particular cynicism of response and toughness of language, is why he seems to us a man born out of

season and a preview of that most modern of political attitudes that came to maturity in the 1920's when George Grosz and Bertolt Brecht established the mode of perception of public events and personages which has become our own.

Danton's Death is a contribution to political theater which, although written in 1835, prepared the way for renewed attention to politics on the contemporary stage. Three strands dominate the play: (1) the dramatic confrontation of a hedonistic and compassionate moderation in politics as opposed to a puritanical and legalistic pursuit of purity through bloodshed; (2) a universal revelation of the coexistence of internal emptiness and external compulsion in the political man; (3) the pathos of the innocent bystander in history.

The dialectical structure of the play is given in the central opposition of the corrupt and profligate Danton, who, despite all protestation to the contrary, deeply loves life, and the incorruptible Robespierre, who metes out death—the unbridgable human gap between the voluptuary who tries to drown out remorse for his complicity in the September massacres in physical pleasure, and the ascetic leader of the Revolutionary Tribunal who has never stolen, drunk, or slept with a woman. Danton is coarse and lecherous and touched with human pity. Robespierre is "repulsively moral" in extending the Terror as a weapon of power and political solidarity. In addition the cynicism, boredom, and intermittent fatigue of Danton are contrasted with the conspiratorial activism and fanaticism of Robespierre and Saint-Just.

The beginning of the play presents the opposition as a matter of party rather than personality—the Cordeliers as a whole against the Jacobins represented by Robespierre and Saint-Just. Philippeau asks for an end of bloodshed and a commission of amnesty for the political prisoners. Hérault says it is time to end the Revolution and begin the Republic, substitute simple contentment for virtue, and human justice for the rigid notion of civic duty. "Every man must matter as an individual and be able to express his nature. And whether he's sensible or foolish, educated or not, good or bad—that's no concern of the state. We are all fools anyhow, and no one has the right to impose his own particular foolishness on anyone else. Each must enjoy himself in his own way, so long as others are not harmed by it, or their pleasures interfered with." [16] Camille says that the Constitution is only a thin covering over the body of the people through which every pulse and muscle and blemish should

show itself as it is. Its purpose is not to throw a concealing veil
of virtue over the bare shoulders of their sinful, beloved France.
She has a right to be the thing she is. What we need is more
naked gods, orgies, unbridled love. It is Epicurus and Venus
who should guard the portals of the Republic—not Marat and
Chalier.[17] The suggestion is attractive. Here is the voice of
moderation, common sense, and liberal humanism in politics
—tinged with a raciness which has forgotten neither the plea-
sure principle nor the body's persistent need.

But shortly afterward, in the scene at the Jacobins' Club,
comes the rigid antithesis. Robespierre's great obsessive
speech [18] assets that the weapon of the people is *fear* and the
great strength of the Republic is *morality*. ("Die Waffe der
Republik ist der Schrecken, die Kraft der Republik ist die
Tugend.") Fear is itself a part of virtue—it is simply the severe
and implacable force of *righteousness*. If one uses fear to smash
the enemies of the state, one is only exercising his privilege as a
founder of the Republic, for the Revolutionary Tribunal is in
fact simply the despotism of *freedom* against *tyranny*. ("Die
Revolutionsregierung ist der Despotismus der Freiheit gegen
die Tyrannei.") To punish the oppressors of mankind—that is
mercy. To pardon them is *barbarism*. But at the same time it is
necessary to see that there are those who are trying to infect the
people with their libertinism. Moral laxness is the filthy vice
which these people share with the corrupt aristocracy. But in a
republic, this is not merely a moral misdemeanor—it is a politi-
cal crime. For it is the *libertine* who is the political enemy of
true *liberty*.

The rhythm of the words is as obsessive as the sentiment is
narrow and puritanical. To the Cordeliers' politics of human
acceptance we have opposed a politics of moral fanaticism, and
a mere glance at the language of Hérault or Camille Desmou-
lins in contrast to that of Robespierre shows that Büchner the
artist has supplied the political philosophy in each case with its
proper linguistic counterpart. To the free and loose phrasing of
the first he has opposed the tight, hermetically sealed rhetoric
of the second, for the language of the Cordeliers is rich in
metaphor and sensuous images, while the language of Robes-
pierre is a controlled dialectic of bloodless concepts and of
political and moral abstractions.

It is tempting to read into this opposition Büchner's own
preference for a humane liberalism as opposed to political
fanaticism, political permissiveness against a politics of rigid

control, but the complicated nuances of the play will not, I think, permit so facile an interpretation. Büchner's association of liberalism and hedonism against the juncture of morality and political repression already anticipates the contrast between the politics of liberal democracy (inspired in part, surely, by Jeremy Bentham and John Stuart Mill) and Marxist virtue (as well as some of the political insights of the contemporary followers of Freud), but its originality as pure theater is shown by the fact that Peter Weiss has stolen this basic insight as the central structure of his *Persecution and Assassination of Jean-Paul Marat as Performed by the Inmates of the Asylum of Charenton under the Direction of the Marquis de Sade.*[19] This play, too, revolves around the issue of political fanaticism versus personal pleasure with the confrontation of Marat's mad passion for revolution with Sade's hedonistic commitment to personal experience. Here Weiss' Marat has much in him of Büchner's Robespierre, and Büchner's Danton has undergone a slight personal and social transformation to reappear in Weiss' Marquis de Sade.

There are two reasons why we are unable to assert unequivocally that *Danton's Death* shows Büchner's preference for a humane politics over political fanaticism. The first is his presentation of Saint-Just. The central opposition of character in the play is certainly that between Danton and Robespierre, and here the matter of the author's sympathy is clear. But the revolutionary message is compromised by certain internal weaknesses in each of these characters. Saint-Just, on the other hand, on the few occasions in which he appears, is strong, and argues with a compelling rhetoric. Robespierre, as Barère says later in the play, sees the Revolution as a moral lecture, and uses the guillotine as a pulpit. Moral puritanism is an unsympathetic motivation for social reform, but Saint-Just justifies the Revolution by a "necessity" which is as inexorable as that of Nature herself. His "moralizing" of bloodshed is drawn from the analogy of the operation of natural processes.

I now ask: Should the moral universe be more timid about its revolutions than the physical? Has an idea any less right to destroy what stands in its way than a law of nature? Can, indeed, an event which has altered the whole form of man's nature and of the world hesitate if bloodshed is its price? The world-spirit makes use of us in the moral domain just as much as it uses volcanoes and floods in the physical. What difference whether one dies of an epidemic or a revolution?[20]

Humanity, says Saint-Just, advances slowly, and every advance is marked by the graves of whole generations. And now, at the moment when social change is accelerated, can we count the cost?

Is it then so surprising that the great flood of revolution should need to cast up its corpses at every bend and halting place? We still have a few conclusions to be drawn from our propositions. Shall we be held back by a few hundred more corpses?

And he concludes:

The Revolution is like the daughter of Pelias; she dismembers mankind that it may be rejuvenated. Mankind is going to rise up out of the cauldron of blood as the earth once did from the waters of sin, with mighty strength in its limbs as if created anew.

It is the vision of every drastic revolution, and it is the proposition widely debated in our own time apropos of the heritage of Lenin and Stalin: in Arthur Koestler's *Darkness at Noon*,[21] Simone de Beauvoir's *Ethics of Ambiguity*, Merleau-Ponty's *Humanism and Terror*, and the political writings of Sartre. Is the price of blood too high to pay for the rejuvenation of mankind? Büchner does not answer our questions directly. True, he said in his letter: "My eyes have grown accustomed to blood. But I am no guillotine knife," but even the message of these words is ultimately unclear. To the liberal mind, committed in advance, the ideas of Saint-Just are a travesty on the humanitarian ideal. But within the context of the play, the unvarying energy with which they are presented and the strong rhetoric by which they are supported show that they are not to be dismissed lightly. Rather, they seem to be one strand in the political dialectic which Büchner has chosen for serious presentation.

The second reason why we are unable to infer Büchner's political preference from the play itself is because of his mingling of personal and political considerations. Danton's political leadership is compromised by his cynicism, world-weariness, and fatigue, Robespierre's by his envy and self-mistrust. And this constitutes the second pervasive strand in *Danton's Death* —the universal revelation of internal emptiness and external compulsion in the political man. Danton's melancholy is pathological and his death-wish close to the surface even in those

moments (as in the scene in the open fields in Act II) when he thinks he is merely "flirting with death and making advances to her at a safe distance." Both the melancholy and the death-wish are Büchner's own and we can recognize this without difficulty, for the very language of his letter to his fiancée becomes a speech in Danton's mouth although here dressed up in the classic images of cosmic powerlessness and distress. "We are puppets," cries Danton," swung on the string by unknown powers." (Puppen sind wir, von unbekannten Gewalten am Draht gezogen.) [22] Partly perhaps it is guilt for complicity in the September massacres, as if the very merchants of death are finally succumbing to the lure of their own merchandise. Philippeau in the Luxembourg prison, waiting to die, sums it up for the entire political leadership of the Revolution: "We are like priests who have prayed with dying men, have caught their disease, and now we are dying of it too." (Wir sind Priester, die mit Sterbenden gebetet haben; wir sind angesteckt worden und sterben an der nämlichen Seuche.) [23] Death hangs over Büchner's perverse and tragic play. It is the fate of those who have chosen the way of politics, expressed in their inner emptiness as well as the destiny played out on the scaffold, and it suggests at once a critique of politics and an insistence on considerations of cosmic culpability which lie far beyond the merely political sphere. And this is why, although *Danton's Death* has a political setting and a political subject, it contains no political statement and insists on no political message.

As I have said, the atmosphere of death rules the play. It is the fate of those world-historical figures who dominate the Revolution. It is also the fate of the innocent bystanders of history. Danton's wife, Julie, and Lucille, the wife of Camille Desmoulins (with the addition of Marion the prostitute, who is herself a victim in another sense), are perhaps the only humanly sympathetic characters in *Danton's Death*. They are womanly and full of feeling, pathetic and powerless, and yet they are the only ones who consciously seek death when death has claimed those they love and who mediate their tenuous and quite accidental relations to history. Once again, it is as if Büchner were struggling with Schiller's problem in *Wallenstein*—to humanize in some sense the monstrous fatalism of history. Schiller's subject, the dramatic relevance of a military episode in the Thirty Years War, has a kind of coldness and dryness which made it unpliable for poetry. But this, in general, is just the weakness of historical fact as a basis for dra-

matic creation; hence the introduction of Theckla and Max and the motif of love—the chief nonhistorical or purely invented elements in Schiller's play—to create a space, as it were, in the interstices of history where the reality of human passion could have full freedom for its development. Lukacs, who deals with this point in interesting detail, says that although this interpolation is characteristic of Schiller, such themes are not to be found in the later drama of Büchner.[24] I think he is clearly mistaken. Lucile and Julie are figures whose presentation by Büchner departs radically from documentary history, whose fate in no sense approximates that of historical fact. Danton's second wife, a girl scarcely sixteen when he married her less than a year before his execution, was named Louise, not Julie. Not only did she not take poison on his death, but, widowed at the age of seventeen, she married another man (Dupin, who rose to be a prefect and a baron under Napoleon) three years later. Camille Desmoulins' wife was indeed named Lucile, but her end was not the pathetic suicide with which Büchner ends the play: she was executed soon after Camille on a charge of having treasonously plotted to effect her husband's escape from the Conciergerie. So far as the records show, she was calm and intrepid as she faced her judges, and died like a Roman matron. The pathos of Julie and Lucile in *Danton's Death* is like that of Theckla and Max in *Wallenstein*. It stems from the impingement of the political on the innocent bystander in history, and its efficacy derives from a similar source—the counterpoint of honest emotion to a political atmosphere clogged with duplicity and choked with a rhetoric which both history and politics may demand, but which is ultimately irrelevant to the profoundest values of human life.

The problem of the historicity of Julie and Lucile may seem trivial, but it is not. For what is relevant here is the curious view of history and the dramatist's responsibility to it by which Büchner defined his art. A few months after the composition of *Danton's Death*, when his work had been published in a somewhat mutilated version, writing to his parents from Strasbourg (May 5, 1835), Büchner warned: "In case it gets into your hands, I beg you, before judging it, to remember that *I was compelled to be true to history* and to present the men of the revolution as they were; bloodthirsty, dissolute, vigorous, and cynical. *I regard my play as an historical painting which must be like its original . . .*"[26] Three months later, in the remarkable letter of July 28. he amplified this same dramatic theory:

The dramatic poet is in my eyes nothing but a writer of history, although he stands above the latter in that he creates history for the second time, and transports us immediately into the life of another age instead of giving us a dry account of it. Instead of characteristics, he gives us characters; instead of descriptions, actual figures. *His greatest task is to come as close as possible to history as it actually happened.* His book may be neither more nor less moral than history itself, but history was not created by the good Lord as reading matter for young ladies, and I too ought not to be blamed if my drama is equally unsuited for that purpose. I can hardly be expected to make virtuous heroes out of Danton and the bandits of the revolution! One could still complain that I have chosen such a subject matter, but that objection has long since been discredited. If it were taken seriously, it would be necessary to repudiate the greatest masterpieces of literature. *The poet is no teacher of morals;* he invents and creates characters, he makes past times live again, and from this people may learn as if from the study of history itself and from its consideration what happens in the human life around them.[26]

The entire passage reminds one of Leopold von Ranke and of his insistence that the task of the historian is to narrate history as it actually happened—"wie es eigentlich gewesen ist" —but it has a curiously naturalistic and nonmoral emphasis for a political dramatist who is himself a social revolutionary. Nonetheless we are to take it seriously, for it does largely represent Büchner's actual practice in *Danton's Death.* Büchner's play follows with extreme literalness the texts of the accounts of the French Revolution he had been reading: Thiers' *Histoire de la révolution française,* Mignet's *Histoire de la révolution française depuis 1789 jusqu'en 1814,* and Karl Strahlheim's *Die Geschichte unserer Zeit.*[28] From these he derived knowledge of the Cordeliers district covered by that part of Paris situated between the Luxembourg, St. Sulpice, and the ancient buildings of the Sorbonne, and of his characters themselves: Desmoulins who lived across from the Odéon, Fabre d'Eglantine the poet, the unsuccessful actor Collot d'Herbois, Legendre the ferocious pork butcher, and even the cobbler Simon, a coarse man, embittered by his poverty and perpetually spewing forth his bile. But above all he derived the actual words of Danton and Robespierre literally transcribed into the speeches of the play, and the traits of his characters, even to the morbid pun which Danton makes to Fabre the poet in the Conciergerie and his sardonic comment to the executioner in his last moment of life,

To have taken his sources so seriously, to have transcribed, cut, transposed, and copied is no qualification of Büchner's originality. It is merely the practice prescribed by his dramatic theory, from a position which holds that the dramatic poet is nothing but a more creative writer of history and that his greatest task is to come as close as possible to history as it actually happened. And it indicates how the political drama can conform to criteria of historical accuracy and moral neutrality and avoid the paths of political statement and political insistence.

In addition it shows just how mistaken a partisan interpretation can be, like the Marxist one which assumes that because its subject is the French Revolution and because on extrinsic grounds we know Büchner to have been a revolutionary, therefore somewhere beneath the surface cynicism is concealed a revolutionary message. This is the mistake of Lukacs. To be sure it is stated plausibly and with some subtlety.[29] For a Marxist, too, the French Revolution is a *failed* revolution, and he would like to trace the events from the fall of the Bastille through the fall of the Gironde, the Dantonists, and Robespierre right through to the rise of Napoleon as a "chain of collapse." Mistakes engender tragic consequences and this sequence can even be assimilated to the general model of tragic perception as the arrival of "the day of reckoning." For, since it is characteristic of drama not to portray the slow and gradual building up of consequences, but to deal with a relatively brief and decisive period of time, the dramatic moment becomes that of life itself in which the accumulation of consequences is transformed into a tragic conclusion. All this is simply to assimilate the dramatic movement of *Danton's Death* to the movement of Greek tragedy—but with a distinctly Marxist message.

Neither the powerful tactician of revolutionary victory nor the vacillating bourgeois politician who turns away from the continuation of the revolution stands at the center of the drama. All this has long since taken place in Büchner's play. What he portrays with unique dramatic power is how Danton, the great revolutionary, having estranged himself from both the people and his mission, is "called to account" for thus turning his back upon history.

Interesting as is this interpretation, it is hardly true to the substance of the play. It is at once too specific and too doctrinaire. The subject of the play is not how a great revolutionary,

having abandoned the people and his mission, faces the day of reckoning for his betrayal of history. It is how revolution itself engenders its own unresolvable dialectic, how the political man experiences the compulsion of external forces and his own internal emptiness, how the innocent bystander suffers as the victim of an historical process never completely understood. In *Danton's Death,* Büchner does not present Danton for our condemnation. He presents the revolution for our contemplation. And in this he is true not to Marxian ideology but to his own theory of the drama.

Mother Courage and Her Children is probably Bertolt Brecht's masterpiece. Written in 1938–39 while Brecht was in Denmark, an exile from his native Germany, but at the height of his creative powers (during this Scandanavian period he also wrote the first version of *Galileo* and *The Good Woman of Setzuan*), it had its premiere at the Zurich Schauspielhaus in April, 1941, and its definitive performance under Brecht's own direction and with Helene Weigel as Mother Courage at the Deutsches Theater in East Berlin in January, 1949.[30]

There is a certain interesting relationship between Büchner and Brecht. Büchner too had been a medical student and a lifelong "revolutionary," and his "flat" and intensely modern approach to theater was extremely sympathetic to Brecht, who reflected his influence from his first play *Baal* (which is modeled on Büchner's *Woyzeck*) to the quite late *The Days of the Commune* (which in some respects recalls *Danton's Death*). But between *Danton's Death* and *Mother Courage and Her Children* there is all the difference between a painting by David and one by Brueghel.[31] In Büchner's play, set in the French Revolution, there is an atmosphere of despair, world-weariness, and satiety, and the cynicism is bitter—as if in the presence of death. In Brecht's play, set during the brutalities of the Thirty Years War, the atmosphere is one of vivid life, of the desire to endure and come through, of strong peasant craftiness. There is cynicism here too, but it is humorous and healthy, the fruit of cunning, not of death-consciousness. Both plays exploit critical periods in Western history for essentially political purposes, and both use techniques of abrupt and shifting locales in the tradition of the chronicle play made available by Shakespeare (in his history plays and, above all, in *Antony and Cleopatra*) and adopted by the early Goethe in his *Götz von*

Berlichingen. But even here the effect is profoundly different. In *Danton's Death* the time span within the play is twelve days; in *Mother Courage and her Children,* it is twelve years, and in Büchner this produces the effect of classic organicity and inevitability which caused Lukacs (however mistakenly) to view the play according to the model of Greek tragedy. But in Brecht, the "chronicle" effect is truly realized, each scene has its own, rather than a merely cumulative, validity, and this extended narrative—this "epic" quality—is precisely one of the cornerstones of Brecht's own doctrine of what modern theater ought to be.

Both *Danton's Death* and *Mother Courage* are profoundly ambiguous and problematic plays, for diametrically opposed reasons, but in each case out of a common necessity—that of relating them to the life and dramatic theory of their authors. *Danton's Death,* as we have seen, seems incongruous because of the contrast between its seeming dispraise of, and disillusionment with, the French Revolution and the revolutionary life of social protest which Büchner led; but attention to the necessarily brief and attenuated theory of drama which Büchner presents in his letters shows that the play in its "contemplative" and "presentational" vein is in perfect harmony with the effort to be true to history, to regard a play as "an historical painting which must be like its original."

In the case of Brecht we have not too little theory but too much. Throughout his entire life as playwright, play director, and theater manager, he was interested in all aspects of the theater: its verse forms, its techniques of acting, its experimental character, its use of music, its aesthetic function, and its social effects, and he thus produced a considerable quantity of dramatic theory. But, on the one hand, his ideas develop and his attitudes change, and so the parts of his theorizing are not entirely mutually consistent. On the other hand, as a persistent and doctrinaire Marxist, the theory of the drama which he constructs is sometimes too rigid and unyielding to cover the intuitive dramatic "rightness" of most of his truly great plays. Thus the problematic character of *Mother Courage* lies not in the question of whether it succeeds or fails as drama, but whether it succeeds or fails according to the canons which Brecht himself set for the political theater of his time, whether, in fact, it manages to fit snugly enough into Brecht's dogmatic formulation of the nature of "epic theater." [32] To this question I shall subsequently turn.

Between Büchner and Brecht has fallen the shadow of Karl Marx. This is not to say that Büchner would not have been a Marxist had he been born three decades later, but only that since there was no rigidly formulated doctrine of the function of drama in the life of society, he was free to explore this relationship for himself. What he had to work against or incorporate was Schiller's idea that the theater should be considered as a "moral" institution. As we have seen, his modification was that drama should be not "moral" but naturalistic and historically "true." Marxism constitutes a massive assault on both these doctrines, not because it denies their modest usefulness, but because it subordinates them to considerations of quite a different character. Its cornerstone is that the theater must in the end be considered as a *political institution*.

Dialectical materialism assumes that the "lower" or material factors in any social order sustain the "higher" or nonmaterial factors. Men's conceptions, philosophies, views of the world change with the transformations of their material conditions and social relations. The ideas which rule each age are the ideas of its ruling class. But this means that ideas are not to be judged primarily according to their theoretical truth or artistic validity, but according to their social role. That ideas have roots is a commonplace, and that they have consequences is a cliché, but that *ideas are weapons* is the peculiar contribution of Marxism to the intellectual history of the modern world, and it follows that in the Marxian system the role of the arts in a capitalist society should not be to express the personality of the artist, but to forge the weapons of the proletariat. The theater is not, therefore, independent and autonomous; it must be in harmony with the interests of the proletariat—and it must be an instrument in the service of the revolution. The spiritual ending of every Marxist play ought not to be an enhancement of the bourgeois sense of tragedy, but a summary message which should be the symbolic equivalent of the ending of the *Communist Manifesto:* "Workers of the World, Unite!"

It was to this set of ideas that Brecht became committed soon after his arrival in Berlin as a young man of twenty-six. He began to study Marx almost at once, although it was not until about 1927 that he began systematically to take private lessons in Marxism. Throughout 1928 and 1929 he attended consecutively lectures at the Marxist Worker's College (Marxistische Arbeiter Schule) .[33] He was apparently particularly fascinated by the Marxist problem of the subordination of the individual fate

to the requirements of the Party, and his play *The Measures Taken* (Die Massnahme) of 1930 was the product of this interest. According to some accounts, changes were made in this play at the suggestion of the Communist Party of Berlin after its first performance.

Naturally Brecht was not primarily a Marxist philosopher, but a man of the theater. Finding that the Berlin playhouses of the time were dominated by three great producers—Max Reinhardt, Leopold Jessner, and Erwin Piscator—he turned to the latter as director of the radical left-wing Agitprop Theater—a dedicated Marxist who agreed that the stage was principally an instrument for the mobilization of the masses. Piscator assigned to the playwright himself a relatively minor role: he often constructed his productions out of newspaper reports, posters, or other documentary materials. He used charts, graphs, explanatory captions, lantern slides of photographs or documents, newsreels, and documentary film sequences to indicate the political and sociological background of the play, while at the same time the propaganda moral was stated by choruses who spoke or sang, sometimes on the stage, sometimes from the orchestra. Piscator's intention was to make the theater wholly political, using every technological means, so that the play would become a kind of living newspaper or an acted and illustrated lecture on contemporary society, Marxianly interpreted. It was he who first used the phrases "documentary drama" and "epic theater." [34] Brecht collaborated closely with Piscator, worked on many adaptations of the plays for his theater. And it was he who became the great formulator and popularizer of the principles of a new Marxist-inspired dramaturgy, derived undoubtedly from the practice which Piscator had established. [35]

So much has been written about Brecht's dramatic theory that one more complete exposition would be out of place here, but I should like to summarize its tenets briefly so that we shall be able to consider *Mother Courage* against the requirements which Brecht himself has established. Brecht's theory of political ends is surely Marxist, but his treatment of theatrical means is far more sophisticated and knowing than the usual Marxist aesthetics of the theater. But apart from his general theory of dramatic narrative, of distanciated acting, of those alienation effects which are necessary to achieve the sort of audience response which he wishes to elicit, lies the central concept which is back of his entire dramaturgy—the unwavering conviction as

to *the rationalistic, dialectical, forensic character of the whole theater experience.*

The theater as he found it was a theater of escape, drawing no social conclusions; its lack of any worthwhile content was a sign of decadence, its inaccurate representation of social life a scandal, its "aesthetics" an heirloom of a depraved and parasitic class, its playhouses simple entertainment emporiums (Verkaufsstätten für Abendunterhaltung) which had degenerated into a mere branch of the bourgeois "narcotics traffic" (zu einen Zweig des bourgeoisen Rauschgifthandels) .[36] Such a theater has designs on the spectator's emotions which prevent his cool, rational, and *critical* consideration of what he finds on the stage, and thus not only permits but encourages a falsified representation of contemporary reality. It presents the classics of the Western theater as so many declamatory "fancy dress performances" and turns the audience into a cowed, credulous mass of playgoers. This theater is not even, as Schiller demanded, a theater of enlightenment, but one of hypnosis. The eyes of the audience are open, but they stare, rather than see. They look at the stage as if in a trance, they exist in a detached state where they seem to be given over to vague but "profound" sensations.[37] How then can they be concerned with the solution of social problems, sympathize with the underdog, learn that respect for humanity which is a presupposition of all valid social action?

This is moral criticism, and if it finds the theater of entertainment and escape intellectually degrading and politically contemptible, it is only the kind of criticism to which we have grown accustomed in the tradition of Schiller's "The Theater Considered as a Moral Institution." But to this moral attitude Brecht appends a technical counterpart. It is in the form of a two-column comparison of the old "Aristotelian" or *dramatic theater* which he is attacking, and the new *epic theater* which he wishes to assert. The first concentrates on "plot"; the second on "narrative." The first implicates the spectator in a stage situation, but wears down his capacity for action; the second turns the spectator into an observer, but arouses his capacity for action. The first provides him with sensations; the second forces him to make decisions. In the first the human individual is taken for granted; in the second he is an object of inquiry. The first concentrates on the conclusion of the play; the second values each scene for itself. The first follows the idealist deviation that "thought determines being"; the second follows the

materialist principle that "social being determines thought."
And, finally, the first or dramatic theater is the theater of
feeling, while the second or epic theater is the theater of *reason.*[38]

Brecht's extreme rationalism underlies his sense of theater,
his hope that through a shift in the emphasis of the technical
means, the playhouse may develop from a mere locale of enter-
tainment into an object of instruction, from a simple place of
amusement into an important organ of public communication.
But it must be admitted that his sense of "instruction" and of
"public communication" is far more radical and open-ended
than any purely propagandistic commitment to the resources of
the Marxian dialectic. This is interestingly shown by the poem
which he addressed to Danish working-class actors on the na-
ture of their art:

> Here you have come to play in the
> theater, but first
> It must be asked: why?
>
> For here, on the lower benches,
> A quarrel has broken out in your audi-
> ence: Pigheadedly
> Some are demanding that you should
> By no means exhibit only yourselves but
> The world . . .
>
> You play before us only victims, and
> do it as if
> You yourselves were helpless victims of
> outside powers
> And your own impulses.
>
> No, we say from the lower benches,
> dissatisfied.
> Enough! That won't do! Have you
> then really
> Not heard what is getting around?
> That this fish-net was knotted and thrown
> by men?
> Everywhere, even from the hundred-
> storied cities
> Over the seas, crisscrossed by crowded
> ships
> To the remotest villages, the news
> has spread
> That man alone is his own fate.[39]

The implication of this poem is not only that the function of the actor is to reveal meaning, and that the world is changeable by human effort, but that it is to be expected that the front rows may start disputing obstinately, with the actors or among themselves, crying their discontent, questioning the play, carrying out of the theater those disputations which its problematic presentations have engendered. Thought, discussion, the active consideration of the engaged mind—these are meant to be the forensic consequences of the Brechtian theater.

This is foreshadowed already in his earliest Marxist plays, *The Measures Taken* (Die Massnahme), produced in the Grosses Schauspielhaus in Berlin in 1930, and *The Exception and the Rule* (Die Ausnahme und die Regel) written in the same year. The situation which each details is "problematic" in the simplest and most elementary sense of the word. The "plot" of *The Measures Taken* may be summarized as follows:

Four political agitators from Moscow relate to a commenting chorus of their superiors why they had to kill a young Communist who went with them into China. They act out his mistakes in a few short scenes. From sympathy he spoke too freely to the coolies; during a strike he interfered with the police; on a mission to gain bourgeois support, he alienated the bourgeois; sensing that the city was restless, he emerged too soon and tried to lead a revolution bound to fail. In these ways he compromised their work. Since they cannot smuggle him out, they decide to kill him, and he himself agrees to this. They shoot him and return to their work. The chorus agrees that they were right. (Were they?) [40]

Here is the situation in *The Exception and the Rule:*

A merchant goes on a business trip. His guide is too friendly with the coolie who carries the baggage and he dismisses him. They lose their way in the desert and they run dangerously short of water, but when the coolie approaches to give him a drink from a water-bottle, thinking he is really going to attack him, the merchant shoots him. A court, judging the case, decides it was self-defense. The rule is that any slave would want to attack his master, and the merchant could not be expected to believe that this was an exception. (Was the court right?)

The later masterpiece, *The Good Woman of Setzuan,* concludes with the speaker turning to the audience and posing the question himself:

Ladies and Gentlemen:
In your opinion, then, what's to be done?
Change human nature or—the world? Well: which?
Believe in bigger, better gods or—none?
How can we mortals be both good and rich?
The right way out of the calamity
You must find for yourselves. Ponder, my friends,
How man with man may live in amity
And good men—women also—reach good ends.
There must, there must, be *some* end that would fit.
Ladies and Gentlemen, help us look for it.[41]

The Brechtian theater is, above all, a theater of discussion in which the attitude of the audience is critical and disputatious, and in which the problems under consideration in the play itself, and the technique of the actors in presenting its images, "will leave the spectator's intellect free and highly mobile." This is ultimately the meaning of the "Alienation Effect," so central in Brecht's conception, which is, after all, simply a technique for creating detachment in the spectator and mobilizing his critical intelligence—as Brecht himself says in the *Kleines Organon für das Theater*—"to transform him from general passive acceptance to a corresponding state of *suspicious inquiry*." This is precisely the meaning of those many Brechtian devices: the songs which interrupt the action and the almost irrelevant ballads, the players commenting coolly on the action even as they act it out, the chorus haranguing the audience at the very moment that pandemonium breaks out on stage, those distracting "emblems" which hang from the flies and the magic-lantern comments projected against the backdrop of the stage. Their purpose too is to keep the audience in a state of active awareness, of "suspicious inquiry" which in the end makes the Brechtian play so indeterminate and so dangerous—above all for the dogmatic and narrow Marxism of the Party itself. And it explains why Brecht has received so few performances and such dark suspicions in Russia and the other satellite countries. Naturally he found it impossible to follow the naïve recipe for the right-thinking socialist artist which Zhdanov, Stalin's lieutenant, laid down in 1934: the cult of optimism, socialist enthusiasm, the glorification of the simple folk hero.[42] And it is clear too why even so generally perspicacious a critic as Lukacs should attack Brecht for his "formalism," for his "brand new means of expression," and should argue that his theoretical writings, no less than his plays, "pass

over social content and turn the proposed social rebirth of literature into an interesting formal experiment." [43] Nor is it difficult to understand why Brecht in turn should question Lukacs' outmoded literary models and regret "the tendency to restrict realistic writing by imposing limits on the formal side." [44] The dogmatic requirements of "Soviet realism" have little in common with that "state of suspicious inquiry" which is the truly revolutionary innovation of the Brechtian theater.

How does *Mother Courage* conform to the Brechtian pattern? Is it, indeed, to be considered as exemplary of Brecht's formulation of the nature of epic theater? Just what is it in the play which has made it so ambiguous and problematic to customary criticism? Its plot and its "moral" seem simple enough. Brecht calls it "eine Chronik aus dem dreissigjährigen Krieg" —a chronicle from the Thirty Years War [45]— and it is the "chronicle" character of the events and the way in which they fit into the dragging duration of historical time as felt by the poor and the powerless that signifies Brecht's intention. The action is scattered and episodic. Mother Courage, who owns a traveling canteen wagon and makes her living from the soldiers, loses her three children, one by one. The play opens in 1624 in Dalarna, Sweden. A recruiting sergeant makes off with her son Eilif as she bargains over the sale of a belt behind her wagon. The next year she meets Eilif again while traveling with the Protestant army in Poland. Three years later she is overrun by the Catholics, and adapts to the new situation, but her youngest son "Swiss Cheese" is shot as a result of his honesty. In 1631 she is on the fringes of Tilly's victory at Magdeburg (it costs her four shirts) and a year later she attends his funeral at Ingolstadt in Bavaria and philosophizes with the chaplain about war. In 1632 peace threatens her with economic ruin and Eilif is shot for performing an act in truce-time for which he was applauded during the war. By 1634, as we learn from the explanatory remarks flashed on the curtain before the episode begins, "The holy war has lasted sixteen years and Germany has lost half its inhabitants. Those who are spared in battle die by plague. Over once blooming countryside hunger rages. Towns are burned down. Wolves prowl the empty streets." Mother Courage is in the Fichtelgebirge, near the road the Swedish army is taking. Winter is hard and business is bad. Two years later (1636) Catholic troops threaten Halle, and Mother Courage's mute daughter Kattrin loses her life—shot by Catholic soldiers as she frantically beats the drum on a roof

to warn the sleeping inhabitants and save their little children. Mother Courage sits by her dead daughter, then gets up to pull her wagon further. Throughout the loss of each of her children (which she feels deeply) Mother Courage's chief concern is to keep her business going. Against the background of great historical events she holds to her commercial, ironic, matter-of-fact point of view. At the end she is left alone with her wagon, old and miserable, but still obsessed with the only thing she knows —to make a profit. From all her sorrows she has learned nothing!

The subject of this political play seems clear: the effect of war on the little people of lower class society. Its setting is the European heartland between 1624 and 1636. Even its political statement has been explicitly dealt with by its author. In his "Remarks," appended to the great performance of 1949 under the heading "The World Needs Peace," Brecht wrote: *"Mother Courage and Her Children* shows that the little people (in contrast to the powerful) have nothing to hope from war. The little people pay for both defeat and victory." [46] And a little later under the caption "What a performance of *Mother Courage and Her Children* is primarily meant to show": "That in wartime big business is not made by small people. That war is a continuation of business by other means, making the human virtues fatal even to those who possess them. That for the struggle against war no sacrifice is too great." And finally and most explicitly:

Of the Peasants' War, which was the greatest misfortune of German history, one may say that socially considered, it drew the teeth of the Reformation. Its legacy was cynicism and business as usual. Mother Courage (let it be said to help performances in the theater) recognizes, as do her friends and guests and nearly everyone, the purely commercial character of the war: this is precisely what attracts her. She believes in the war to the end. It never occurs to her that one must have a big pair of scissors to take one's cut out of a war. The spectators at catastrophes wrongly expect those involved to learn something. So long as the masses are the object of politics they cannot regard what happens to them as an experiment but only as a fate: they learn as little from a catastrophe as an experimental scientist's rabbit learns about biology. It is not the responsibility of the playwright to give Mother Courage insight at the end—she sees something at about the middle of the play, at the close of Scene 6, then loses again what she has seen—his concern is that the spectator should see.

The denunciation of war, the ironic paraphrase of von Clau-
sewitz connecting war and the profit motive, and the equally
ironic reference to the masses as the *objects* and not the subjects
of politics, as little in command of their fate as an experimental
rabbit, all show clearly the message which Brecht wishes the
audience to receive. But despite this clarity there is something
in the play which stubbornly resists this lesson, which gives to
the characters of Mother Courage and her daughter Kattrin a
tragic stature not completely in harmony with Brecht's ex-
pressed intention.[47] And it suggests that if the political setting,
subject, and statement of the play are clear and open, there is
something in the nature of the attitude it communicates which
is less so.

Four strands dominate the play: (1) the basic contrast be-
tween "monumental" and "proletarian" history; (2) the cata-
clysmic consequences of war; (3) the exploitative character of
public conceptions of morality; and (4) the symbiotic relation-
ship between war and the profit motive. The last three are
explicit in the play as Brecht has written it; the first is its ironic
presupposition.

Schiller, too, as we have seen, used the first play of the
Wallenstein trilogy (*Wallenstein's Camp*) to show the lower
class composition of the army on which Wallenstein's power
depended, and thus the inevitable dependence of "World-His-
torical Figures" on the "sustaining individuals" who constitute
their factual social support. But for Brecht this relationship is
not an axiom of class stratification, but an ironic contrast used
in the service of social criticism. Brecht exposes the pretensions
of monumental history, for its inflated conceptions of glory, for
its indifference to the individual human detail in history, for its
irrelevance in the face of the suffering of those whose fate it is
to experience the whole burden of political, social, and eco-
nomic reality. That in 1624, in Dalarna, King Gustavus Adol-
phus is recruiting for the campaign in Poland means that
Mother Courage loses a son. That in 1631 Field Marshal Tilly
wins the battle of Magdeburg means that Mother Courage
sacrifices four officers' shirts to bind the wounds of massacred
townspeople. That in 1636 the Catholic army threatens Halle
means the death of the compassionate daughter Kattrin. War
itself means fame and glory for the commanders in the history
books; to the people it means homes burned to the ground,
daughters raped, babies murdered.

The exploitative character of public conceptions of morality

is mirrored in the fact that the collapse of all virtue forms the background of the play. This is made explicit in the ironic ballad "The Song of the Wise and the Good" in Scene 9 when Mother Courage and the cook sing how Caesar is brought low by his bravery, Socrates by his honesty, St. Martin by his unselfish compassion. And it is precisely these virtues which take her children one by one. Eilif dies through his bravery, Swiss Cheese through his honesty, Kattrin through her unselfish compassion.

The symbiotic relationship between war and the profit motive is symbolized by the character of Mother Courage herself. Brecht paints her as committed to trade and the profit motive, realistically hard as she tirelessly haggles, bargains, and reckons, and loses her youngest son because she haggles and bargains just a trifle too long. She is not deficient in mother love; on the contrary, she has it in abundant measure. But the corrupted state of the society in which she (and we) live is haunted by this contradiction between economic incentive and natural feeling. For the Göttingen performance of 1956 Brecht wrote: "Now that Germany's economic prosperity and her politics of violence are advancing arm in arm so threateningly, it is especially important to present Mother Courage here as a merchant who wants to get her 'cut' out of war. She thinks her sharp trading practice is for her children's sake, but it destroys them one after another." [48] He had been even more explicit earlier. "A profit-seeking mother would be an enormous living contradiction. . . . To the audience the deeply felt tragedy of Mother Courage and her life consists in this frightful contradiction which completely destroys a human being, *a contradiction which could be resolved, but only by society itself and after a long and terrible struggle.*" [49]

It is not certain that a capitalist society views this contradiction as fatal, or even that for it there is a contradiction at all, and it may be this which suggests to Western critics that *Mother Courage* is a universal, rather than a merely Marxist, tragedy. But at the same time there is something profoundly uncomfortable about the play even to Western audiences. They may be completely cold toward the social revolution which its author underwrites, but the strong realism of the presentation, the ironic materialism of the point of view, the sustained misery of the lower classes in wartime, and the mirror image of a world where all sentiment is compromised by poverty and the

weak and the innocent are in constant danger are powerful solvents even for bourgeois complacency. Brecht's play remains political in its implications whatever the ideological presuppositions of the audience before whom it is performed.

It is likely, however, that Brecht conceived *Mother Courage* as a dialectical endeavor which would lend itself particularly to minds steeped in the dialectical method. The play is shot through with studied contradictions.[50] Mother Courage has eager expectations of war even as she fears it. She lives off the army and flees before it. She hopes fervently for prosperity: she will go bankrupt. She values her economic cunning: her children will die of it. War, the greatest of disorders, begins with order. It is ideal for making profits: it massacres the population. It has attractions even when it is ruinous. It is not likely that these and other problematic aspects of the play would resist ardent discussion and argument after the audience has left the theater. In this regard, however suggestive the play is of Aristotelian tragedy, it is in the end congruent with Brecht's requirements for the epic theater. Its ultimate subject is the relationship between war, the profit motive, and the reorganization of society, and it invites the "suspicious inquiry" of the critical and disputatious patron of the theater. As Büchner in *Danton's Death* presents revolution for our *contemplation,* so Brecht in *Mother Courage* presents the relationship between war and the profit motive for our *discussion.* Each reflects an alternative possiblity for political theater in the modern world.

The Deputy by Rolf Hochhuth is perhaps the most controversial—the most publicized, talked about, criticized—first play ever written. Begun in Rome in the fall of 1959 by the young West German editor and publicist when he was only twenty-eight, it was completed in the next three years and given its first production by Brecht's famous, but now aging, mentor Erwin Piscator at the Freie Volksbühne in West Berlin on February 23, 1963. In the next two years it was performed in Stockholm, Basel, London, Paris, Frankfurt, Vienna, Hamburg, Munich, Athens, Düsseldorf, and Rotterdam. It aroused demonstrations in Stuttgart. It almost caused a riot in Zurich. It was picketed in New York. For two seasons the public press of two continents was full of notices, judgments, controversial articles about it. The storm over *The Deputy,* wrote Eric Bentley, *"is almost*

*certainly the largest storm ever raised by a play in the whole
history of the drama.*"[51] What is the nature of its argument and
controversial character?

The best clue to this is provided by Piscator, its first producer
and himself the author of *Das politische Theater*. "Hochhuth's
play," he said, "is one of the few substantive contributions
toward mastering the past. Relentlessly, it calls things by their
names; it shows that no tale written with the blood of innocent
millions can ever be out of date; it apportions to the guilty
their measure of guilt; it reminds all the participants that they
could have made their decision, and that they in fact did make
it even when they did not. *The Deputy* makes liars of all those
who assert that a historical drama as a drama of decision is no
longer possible." [52] It was certainly the kind of play for which
Piscator must have been waiting his entire life. For unlike
Danton's Death, which had been produced by his rival Max
Reinhardt in Berlin in 1916–17, and *Mother Courage* by
Brecht (on whose early works he had practically collaborated),
this was a play exhibiting an historical sense not unlike that of
Schiller, yet whose immediate relevance was obvious and clear.
Danton's Death and *Mother Courage* were also historical plays,
in some sense devoted to "mastering the past" and indicating its
relationship to their authors' present, but Büchner was writing
of events set forty years before his time and in another country,
and Brecht employed an historical setting three centuries old.
Hochhuth's "history" goes back only twenty years, to Hitler
and his extermination of the Jews. It utters a condemnation. It
fixes responsibility and guilt inexorably. Like all history it
effects a restoration of memory, but in this case in the most
problematic, the most bitter, the most dangerous sense. For it
recalls to the self-righteousness of the German people and the
Roman Catholic Church memories which they would prefer to
have forgotten. It is a blistering attack. And the storm which it
has produced is a storm of defense—of outraged virtue at the
charge of criminal negligence.

The Deputy opens in Berlin in the reception room of the
Papal Legation on the Rauchstrasse on a late afternoon in
August, 1942.[53] The Papal Nuncio Cesare Orsenigo (a figure
from actual history) is deep in conversation with a young
Italian priest, Riccardo Fontana, the fictional hero of Hoch-
huth's play, an idealistic figure out of *Maria Stuart* or *Don
Carlos,* whose solidarity with the victims of persecution, Hoch-
huth tells us in his stage directions, and whose voluntary mar-

tyrdom for the Church "are freely drawn after the acts and aims of Provost Bernhard Lichtenberg of Berlin Cathedral who prayed publicly for the Jews, was sent to jail, and asked Hitler's henchmen to let him share the fate of the Jews in the East." Riccardo is shocked at the concordat signed by Hitler and the Pope, and at the Church's policy of peace at any price in the face of the wholesale extermination of the Jews. The Nuncio also deplores the slaughter, but he defends the policy of Vatican nonintervention.

The second scene shifts to a small hotel in Falkensee near Berlin on the evening of the same day. It has been requisitioned as a recreation center for Himmler's SS, and here in a long, rambling series of dialogues Hochhuth presents the ambience of the Nazi mentality: Adolph Eichmann, the amiable bureaucrat who does his ghastly job with as little dramatic flair as the simplest civil servant; coarse Professor August Hirt of Strasbourg, the anthropologist and collector of non-Aryan skulls, who pursues his science to justify Hitler's racial theory; the sinister doctor from Auschwitz who smiles charmingly as he sends women and children to the gas chamber; Baron von Rutta, a distinguished industrialist of the Ruhr aristocracy, who is privy to all the supporting advantages of the capitulation to Hitler—the use by Krupp von Bohlen of imported Russian forced labor, the I.G. Farben branch at Auschwitz, the establishment of armament cartel plants on the newly conquered Russian territories. Eichmann talks about the efficiency of the Auschwitz ovens and the respective advantages of prussic acid, carbon monoxide, and Cyclon B as he munches cold cuts and drinks his beer. Hirt mingles his interest in the details of the Nazi sterilization program with his enthusiasm for Goethe, Kleist, and the B-Minor Mass. The entire atmosphere is of the routinization of outrage and the domestication of monstrosity, and when the scene ends with an air raid and a power blackout, we know with a Dantesque certainty that we have been in one of the antechambers of hell.

The next three acts of the play take place in Rome, and this shift in locale indicates the true focus of Hochhuth's concern. Act II, "The Bells of St. Peters," a crucial confrontation at Riccardo's own home in Rome with his father and a high churchman, the Cardinal, is but the repetition at a higher level of the argument with the Papal Nuncio in Berlin. Riccardo asks that the Pope, as a man largely responsible for the moral climate of the world, speak out against the German outrages,

and says bluntly that a deputy of Christ who sees these things
and yet permits "reasons of state" to seal his lips is—a criminal.
One by one the shocked Cardinal marshals the counterargu-
ments. The concordat is used to protect the German Catholics;
realism dictates compromise with even evil forces actually in
power; the Jews, long unpopular, have largely themselves to
blame for Hitler's reactions; what would the Church be if it did
not permit the mob its faggots and its burning of heretics?
Riccardo listens, horrified, and the scene ends on an uneasy
note as the Cardinal departs.

Act III, also in Rome, shows the evidences of Hitlerian
power in the very shadow of the Vatican. A Jewish family living
within sight of St. Peters is rounded up for deportation by the
SS, and a brutal scene at the headquarters of the Gestapo in
Rome indicates that only the active protest of the Pope can save
the Roman Jews from slaughter at Auschwitz. This leads to Act
IV, the climactic interview with Pope Pius XII himself, entitled
(with its reference to *The Divine Comedy*) "Il Gran Rifiuto."
Hochhuth's presentation of the historical figure of the Pope is,
again, clearly indicated by the stage directions: "The actor who
plays Pacelli should consider that His Holiness is much less a
person than an institution: grand gestures, lively movements of
his extraordinarily beautiful hands, and smiling, aristocratic
coldness, together with the icy glint of his eyes behind the
gold-rimmed glasses—these should suffice." Riccardo's father,
Count Fontana, in all humility asks the Pope to warn Hitler
that 500 million Catholics will make Christian protest if he
continues the mass killings. Pius is embarrassed and vexed. It is
impossible! Hitler alone is now defending Europe from the
hordes of Russian Communism. The West must grant him
pardon as long as he is useful in the East. Reasons of state
forbid him to be considered a common outlaw. As to the matter
of taking a stand on the deportation of the Jews from Rome,
that too is impossible. It would be to take a position on what
are really "military" events. And the Holy See must continue to
shelter the spirit of *neutrality*. At this, Riccardo loses complete
control of his emotions. He takes from a pocket the yellow Star
of David and pins it on the front of his cassock. The Pope is so
agitated that he smears ink over his hand from the pen he has
been holding. As Riccardo makes an abrupt exit, an attendant
brings Pius a basin of water and, in the manner of Pontius
Pilate, he sits down and begins to wash his hands. Pained at
having been so misunderstood, he cries out "Summa injuria.

. . . We are—God knows it—blameless of the blood now being spilled." [54] And he raises his voice and begins to declaim:

> As the flowers
> in the countryside wait beneath winter's mantle of snow
> for the warm breezes of spring,
> so the *Jews* must wait, praying and trusting
> that the hour of heavenly comfort will come.

The scene is powerful—so much so that it almost makes the last act (set in Auschwitz, where Riccardo has been sent at his own request, and where he meets his death) amateurish and unpersuasive. The actual horror of the extermination camp is, as Hochhuth recognizes, impossible to portray adequately. Documentary naturalism cannot succeed here any more than Weimar expressionism. The alienation effects of Brecht would be as grotesque as realistic portrayal! The difficulty is that the human imagination itself fails, and therefore so do Hochhuth's efforts with speech, gesture, and action. But actually these were not really necessary. Hochhuth's indictment ends with the Pope washing his hands at the conclusion of Act IV. And as valid political drama this is where the play ends too.

Compared with *Danton's Death* and *Mother Courage,* as a political play *The Deputy* has a certain doctrinal simplicity. Four strands dominate the play: (1) the pathos of the Jewish victims of Hitler, (2) the brutal inhumanity of those entrusted with the Nazi extermination plans at every level, (3) the moral culpability of Pope Pius XII in remaining silent in the face of mass exterminations, and (4) the consequent indictment of the Roman Catholic Church as an institution more concerned with the tactics of survival than the moral leadership of the secular world. But the first two set the stage for the third, and the third also is the dramatic demonstration of the fourth. It is not, therefore, surprising that the heart of the indignant response to Hochhuth's play has centered on the matter of the justice and the historicity of his portrayal of Pius XII.

From official sources the reaction was as pained as was to be expected. Writing in *The New York Herald Tribune,* Cardinal Spellman spoke of this "slanderous and divisive drama." "Only six years after his death," he said, "our Holy Father is being tried and condemned on the stage. This is an outrageous desecration of the honor of a great and good man, and an affront to those who know his record as a humanitarian, who love him

and revere his memory." On March 7, 1964, *America* (the national Catholic weekly review), editorialized: "The basic Hochhuth thesis is an atrocious calumny against the memory of a good and courageous world leader occupying the venerable Chair of Peter during one of the great crises of humanity . . . perhaps never before in history have so many vicious, tendentious and mean imputations of motives been based on such flimsy, distorted and falsified historical arguments. *The Deputy* is character assassination." A year earlier Cardinal Montini of Milan, himself destined soon to occupy the throne of St. Peter as Paul VI, had given the definitive official response:

For my part I conceive it my duty to contribute to the task of clarifying and purifying men's judgment on the historical reality in question—so distorted in the representational pseudo-reality of Hochhuth's play—by pointing out that the character given to Pius XII in this play . . . does not represent the man as he really was; in fact it entirely misrepresents him.

It would be well if the creative imagination of playwrights insufficiently endowed with historical discernment (and possibly, though please God it is not so, with ordinary human integrity) would forbear from trifling with subjects of this kind and with historical personages whom some of us have known.

Let some men say what they will, Pius XII's reputation as a true Vicar of Christ, as one who tried, so far as he could, fully and courageously to carry out the mission entrusted to him, will not be affected. But what is the gain to art and culture when the theater lends itself to injustice of this sort? [55]

This last plaintive question seems to me to raise the crucial issue, for it is the first to consider the play in terms of "art" and "culture," in short in terms of the possible autonomy of the literary and aesthetic domain. For Spellman and *America*, as well as Montini himself in the first part of his statement, only raise charges of "slander," of the "falsification" of historical evidence, of the injustice which is done through a "distortion" of historical reality. But should we be concerned here with the question of "historicity" or with the freedom of the creative imagination of the playwright? Why should not an historical dramatist have complete freedom to shape his characters in accordance with his political thesis and his sense of dramatic appropriateness? Who seriously complains about Schiller that in fact his Elizabeth of England and Mary Stuart never met in the park at Fotheringay as he has them do in *Maria Stuart*, or

that his Joan of Arc died at the stake and not of battle wounds as he presents her in *Die Jungfrau von Orleans?* Or, more similar to our present case, on what grounds could one sensibly criticize Shakespeare because, according to all that we now know, his *Richard III* has more drastically blackened the character of Richard of Gloucester, is, in fact, a more insidious distortion of historical reality and thus a more insidious case of "character assassination" than anything which Hochhuth has accomplished for Pius XII?

Nor can we reasonably argue that the two cases are different —that a pope has prerogatives not open to a king—some divine status or right of papal press-agentry which makes him immune to adverse moral judgment. Dante himself, in Canto XIX, of the *Inferno* places three of his contemporaries, Nicolas III, Boniface VIII, and Clement V in a most uncomfortable position in the eighth circle of his hell—as Simonists suffering the tortures of the fraudulent—upside down in round holes, the soles of their feet on fire. And Erasmus, in one of his Colloquies (the "Julius Exclusus") , has shown the brutal warrior Julius II, whom he hated, swaggering outside the gates of heaven, amazed and outraged that Peter will not let him in. Surely in the moral universe popes have no special immunity, and there is perhaps a valid question as to whether official Catholic indignation is a consequence of concern that justice be done to the actual personality of Pius XII or of a more institutional concern for the preservation of the integrity of the papal "image." [56]

But let us consider seriously for a moment the validity of the criterion of historical faithfulness as a test of dramatic art. Since the time of Lessing we have had reason to question whether it is relevant or proper to apply to works for the theater canons of factual accuracy and virtual historicity. Lessing lived in an age which was just beginning to exploit the appeal of World-Historical Figures for dramatic purposes, and knew from his own experiences that the requirements of dramatic form often demand a radical transformation of the given historical materials; the theoretical question naturally arose as to the extent of the playwright's freedom of adaptation and metamorphosis—how, far, that is, a play may be warped out of its literal factuality without destroying its "historical" character. Lessing is perhaps the first of the moderns to consider the dialectical connections between history and tragedy as an aesthetic problem. And his solution (entirely in the spirit of Aristotle) is the absolute rejection of any appeal to merely histori-

cal authenticity in the assessment of a historical play. "For the dramatic poet," he says, "is no historian, he does not relate to us what was once believed to have happened, but he really produces it again before our eyes, and produces it again not on account of mere historical truth, but for a totally different and a nobler aim. Historical accuracy is not his aim, but only the means by which he hopes to attain his aim; he wishes to delude us and touch our hearts through this delusion." [57] Lessing thus defends the freedom of the dramatist against any demand of merely factual correctness in the name of the claims of the dramatic whole, and he underwrites the freedom to diverge from concrete fact in the name of intrinsic dramatic effectiveness. Does not this principle alone protect Hochhuth against the charges of historical falsification and factual distortion?

At first glance, it might seem so. But I am afraid we shall finally have to admit that in Hochhuth's case the defense cannot hold, and for reasons intrinsic to the very nature and intention of his play. Lessing's argument invokes an aesthetic criterion: it is an argument against literary "truth" and in favor of literary "verisimilitude," but the very grounds of the argument lie in canons of vividness and organic unity. But Hochhuth's basic thrust and fundamental intention is not aesthetic, but moral. And in the matter of the relationship between historicity and the exercise of moral judgment, Lessing has little or nothing to say.

The peculiarly new character of Hochhuth's work is that *it insists on the relevance of the historical documents.* For example, his stage directions are always expressly and self-consciously documentary. He cannot present the Nuncio Orsenigo without alluding to Baron von Weizsäcker's written comments about him. He cannot introduce the satanic doctor without referring to Frau Salus' description of his Auschwitz behavior. Even the fictional character Baron von Rutta cannot be introduced without quoting from a note of Ulrich von Hassell of 1941, describing the Ruhr milieu of which he is to be representative. Even more than Büchner, Hochhuth seems to be obsessed with the responsibility of narrating it as Ranke asked, "wie es eigentlich gewesen ist."

The crucial evidence here is the long essay "Sidelights on History" (Historische Streiflichter) which Hochhuth has appended to his play. In beginning this essay, he says:

It is rather unusual to burden a drama with an historical appendix, and I would willingly have omitted doing so. As a stage play the

work requires no commentary. But the action does not follow the historical course of events in a step-by-step manner, like a journalist's account. Condensation has been necessary in the interests of drama. Consequently, the historical persons mentioned in the play, and those of their relations who are still living, are entitled to know what sources—often obscure ones—have led me to view a given person or episode in this or that light. . . . Naturally I examined those memoirs, biographies, diaries, letters, records of conversations and minutes of court proceedings which bear on the subject and which have already been made available. No bibliography of these well-known sources is needed. If I submit the following notes on controversial events and testimony, it is to demonstrate that as far as possible I adhered to the facts. I allowed my imagination free play only to the extent that I had to transform the existing raw material of history into drama. Reality was respected throughout, but much of its slag had to be removed.

It is indeed unusual to burden a drama with an historical appendix, but it is incredible that Hochhuth would have omitted it, and to state that "as a stage play the work requires no commentary" is disingenuous to say the least. Shaw's philosophical prefaces were an essential part of his drama and Hochhuth's historical postscript is no less indispensable to the meaning of *The Deputy*. The very seriousness of the moral condemnation which is the essence of the play demands the citation of evidence, and the author's revelation of the sources on the basis of which he has imputed motives and apportioned guilt is crucial for the moral validation of the play. Factual evidence (as every courtroom demonstrates) is the presupposition of moral condemnation which is to be taken seriously, and the courtroom metaphor is here very much to the point. In this, indeed, Cardinal Spellman was correct: in *The Deputy*, Pius XII is certainly "being tried and condemned on the stage." It is therefore not only appropriate but absolutely indispensable that Hochhuth should "submit notes on controversial events and testimony . . . to demonstrate that as far as possible he has adhered to the facts." Without such supporting materials *The Deputy* could indeed be construed as merely character assassination and dramatic slander. Hochhuth's experiment with outrage can be supported only on the ground that "reality was respected throughout."

It should now be eminently clear that what we are confronted with in *The Deputy* is something completely new and unique in the history of theater—a novel type of "documentary" play whose function is to elicit moral condemnation to-

ward events which are still close enough in the consciousness of the spectators so that whatever transpires on the stage has direct relevance to their own sense of responsibility and thus reinforces attitudes that, through the very sharpness of the criticism by which they have been recalled, have contemporary implications. The precise phrases one uses are perhaps unimportant. One can say with Bentley that the purpose of the play is "to react back upon life," or with Piscator that it is a contribution "toward mastering the past"; but the crucial thing is that it is propelled by indignation and that it stimulates in the spectators that same mode of indignant perception which has clearly animated its author. The murder of 6 million European Jews within living memory is not only one of the supreme tragedies of modern history, it is an event which in its monstrousness still eludes our complete understanding. And while we are still trying through all of the resources of our sociological insight, political acumen, and psychological theorizing to lay bare its etiology, the theater serves contemporaneously as a public forum for the *mobilization* and *perpetuation* of that moral indignation with which in their "value-freeness" the social sciences dare not traffic! Thus the theater remains for Hochhuth, in Schiller's most obvious sense, a moral institution.

It is certainly not the eliciting of moral condemnation as such which makes *The Deputy* unique. *The Trojan Women* of Euripides was also intended to mobilize guilt and moral repugnance for acts previously considered as mere military expediency. The massacre at Melos is as much a part of the context of Euripides' play as the massacre at Auschwitz is of Hochhuth's, but the reference to current events in Euripides is oblique, and set within the established conventions of the tragic form, while in Hochhuth the reference is direct—with the authenticity of the latest historical research. It is clear that this is already having its effect on the contemporary theater. Günter Grass's *Die Plebejer proben den Aufstand* (The Plebeians Rehearse the Uprising) is not only a thinly disguised treatment of the problem of the political and moral sincerity of Bertolt Brecht, but handles it in terms of the context of recent West German indignation for the brutal putting down of the uprising of June 17, 1953, in East Berlin. The English edition of the play [58] not only contains a "Prehistory and Posthistory of the Tragedy of Coriolanus from Livy and Plutarch via Shakespeare down to Brecht and Myself," but also a "Documentary Report" by Uta Gerhardt on the East German uprising which is the

analogue to Hochhuth's historical postscript in *The Deputy*. And Peter Weiss has not only appropriated Hochhuth's basic theme, but has extended the method as far as it can be pushed. His *Die Ermittlung* (The Investigation), which was produced simultaneously in sixteen German cities late in 1965, is not merely based on the trial in a Frankfurt courtroom of twenty-one persons accused of complicity in the murder of 4 million prisoners at Auschwitz from 1941 to 1945, but in fact uses *only* the actual interrogation and testimony of the courtroom as its content, merely condensed and reordered for dramatic presentation. That the play fails is not the point. The point is that it pretends to be "a documentation of the outstanding negative achievement of our civilization," and that "from the testimony comes a literal and sickening account of the procedure at Auschwitz, the gas chambers, the mass cremations, the starvation, the brutality, the medical experimentation." For here what might be called *the documentary mobilization of moral indignation* can be seen in its stolen form as the very essence of the method which Hochhuth has contributed to the modern theater.

The Deputy, as drama, renounces both the neutrality which makes academic historiography one of the social sciences, and the objectivity through which political science and sociology gain their scientific reputability. Its roots are a pre-existing sense of outrage which it attempts to enlarge. Its presupposition is the innate capacity for moral judgment to which it directs its appeal. There is not one scene, as Rolf Zimmermann has pointed out,[59] which does not aim at provoking the reader's or spectator's indignation, and this means that as political theater, it has an immediacy which is not to be found in either Büchner or Brecht. Büchner's own appeal to a correspondence theory of truth in the relationship of drama to history suggests that very neutrality and detachment which makes history "scientific" and drama "presentational," and Brecht's plays, as we have seen, are held together not by organic unity, but by a concept of discussion set in motion during the progress of the play and continued in the streets and in the coffeehouses long after the curtain has fallen. On the surface it might seem that Hochhuth's play does the same. It has provoked a storm—it has been one of the most widely discussed plays of all time. But this is an accident of publicity, not an intention of the playwright. Brecht's themes are ambiguous and problematic, and they invoke subtleties and profound paradoxes which are the very stuff of dialectical

consideration and of endless discussion. But the theme of *The Deputy* is simple, and it is written in such a way as to preempt the single response for which it cares—that of indignant anger and moral condemnation. Hochhuth presents Eichmann and the cardinal, the doctor and Pius XII in such a way that there can be only one judgment on them, and this is the product less of a prolonged intellectual consideration than of immediate moral response. Factual documentation plays its part here not in the service of a new weighing of the evidence and thus an "openness" in the verdict, but in fact to foreclose any other alternative, and to make the conclusion of the playwright "un-challengeable." This is the strategy of Hochhuth's historical postscript.

Hochhuth's drama, like Brecht's, is a breaching of the customary framework of the tragic play, but in this case not because, as in Brecht, its alienation effects make for a greater impersonality and distancing, but because in fact it has precisely the opposite effect: It robs the dramatic experience of whatever distance it has; it invites an immediacy of participation in the service of a moral claim. The public, as in Brecht, is not to be appealed to in its aesthetic capacity, but as a political and a moral force. And it now, finally, becomes perfectly clear how, although the setting and the subject of the three political dramas which I have chosen for consideration are analogous, their political statements, and above all their political attitudes, are profoundly different. In *Danton's Death, Mother Courage,* and *The Deputy,* we are presented with three distinct approaches to the political theater. Büchner's approach, despite its modernity of tone, remains meditative and aesthetic. Brecht introduces a new dialectical factor—the appeal to discussion. And Hochhuth's play, despite its novel documentary means, remains within the ethical and evaluative tradition. Büchner presents revolution for our *contemplation.* Brecht presents war for our *discussion.* Hochhuth presents passivity in the face of racial extermination for our *condemnation.*

The contemporary persuasiveness of Brecht and Hochhuth represent a certain progress beyond the precocious modernity of *Danton's Death.* It utilizes Büchner's preoccupation with the concrete and the documentable, but in the service of moral judgment and political action. The whole art of drama must now increasingly tend to stretch the aesthetic implications of theater so as to embrace the entire spectrum of social inadequacy and political injustice. This is new, and it is heartening,

for it expresses a certain "humanism" which the contemporary theater has long been in danger of forgetting. Probably the most significant and influential developments in recent theater prior to Hochhuth have been those dramas of personal alienation and cosmic absurdity represented in the theater of Beckett, Genet, and Ionesco. But despite their unique originality, these plays often produce an effect of isolation and triviality. The success of *The Deputy,* even though it is in some respects an awkward and ill-made play, has already pushed the dramatic center of gravity closer to the documentary realism of *Danton's Death* and the passionate Marxism of Brecht. Despite its journalistic language, *Newsweek* magazine has admirably summed up the political significance of Hochhuth's play:

What is significant for the playgoer is that the conduct of the world's highest spiritual authority toward the world's most staggering crime is a question of the most stupendous moral weight. That this question should be raised in the theater by a drama which—for all its faults—makes that weight felt is a thing to make the theater proud. A 2,500-year machine for stirring the passions of men, the theater is again stirring passions that matter.[60]

Eight / Humanism and Warfare:

Machiavelli, von Clausewitz,

and Herman Kahn

The Personalization of Conflict:
Niccolo Machiavelli

THE LAST chapter of Niccolo Machiavelli's *The Prince* is a passionate "Exhortation to Liberate Italy from the Barbarians," addressed to the son of Piero di Medici and to his illustrious house. Its shrillness and its outrage match almost anything that Dante has written against Florence, and its vision of the unification of Italy, like his, is predicated on a desperate sense of present misery. In order that the need for a powerful savior should be recognized, says Machiavelli, "it was necessary that Italy should be reduced to her present condition, and that she should be more enslaved than the Hebrews, more oppressed than the Persians, and more scattered than the Athenians; without a head, without order, beaten, despoiled, lacerated, and overrun, and that she should have suffered ruin of every kind . . . so that now, almost lifeless, she awaits one who may heal her wounds and put a stop to the pillaging of Lombardy, to the rapacity and extortion in the Kingdom of Naples and in Tuscany, and cure her of those sores which have long been festering. Behold how she prays God to send some one to redeem her from this barbarous cruelty and insolence. Behold her ready and willing to follow any standard if only there be some one to raise it . . ."[1]

This chapter alone does much to dispel the fiction of Machiavelli's "coldness," of the frigid analyst, the clinical dissector of political facts, and to remind us that *The Prince* was written at

white heat in a few months of 1513, and that the sarcasm, the indignation, the grief, and the hope which appear here are but the emblems of a humanism which is a far cry from the tranquil neutrality of empirical science.

It is largely to Villari and De Sanctis that we owe the image of Machiavelli the positivist, the founder of modern scientific politics, who is preoccupied with facts at the expense of values, and whose assessments and interpretations are predictive because they hinge on a solid structure of cause and effect. De Sanctis, of course, had an ax to grind and he used Machiavelli to exploit his usual distinction between "the Age of Dante" and the Renaissance, between the culture of the head, that is, and the culture of the heart. "The God of Dante," he says, "is love . . . and the result was Wisdom. The God of Machiavelli is the intellect . . . and the result is Science." [2] This interpretation of the Renaissance and Middle Ages has much in common with that of Etienne Gilson, and it is equally ecclesiastical and partisan, but the crucial point is the creation of the basic image which has ruled the climate of opinion of all modern perception about Machiavelli. Sir Frederick Pollock, too, found in him "the pure passionless curiosity of the man of science," and Ernst Cassirer, comparing his enterprise to that of Galileo, sees him as "the founder of a new type of science of political statics and political dynamics."

The interpretation is one-sided if not absolutely false, and it does much to obscure the object of my present concern—Machiavelli's approach to the subject of warfare and the way in which it illustrates one of the enduring dilemmas of that region where power and value, that is, humanism and politics, enter into temporary and uneasy alliance. In speaking thus of the Renaissance I do not wish to associate myself with the confusion which has arisen out of the work of Burckhardt. For it does not by any means follow that because the princes of Renaissance Italy—Filippo Visconti, Francesco Sforza, Federigo da Montefeltre, or Lorenzo di Medici—were collectors of contemporary art or patrons of humanist learning, this substantially softened or humanized the brutal politics which they had inherited and which they gave no sign of modifying. Perhaps Burckhardt has not uttered so crude a *non-sequitur* explicitly, but his famous metaphor of the Italian states and their foreign policies as "works of art" (not merely in the sense that they were the fruit of reflection and of skill, but also in their "perfection," their "beauty," and their "grandeur") [3] has furthered the as-

sumption of a Renaissance "high culture" which in its organi-
city infused no less the siege of Naples, the Battle of Ravenna,
and the murder of the *condottieri* by Caesare Borgia than the
inventiveness of Leonardo and Fra Angelico's chromatic har-
monies!

The Renaissance princes saw no incongruity between an art
of spiritual enrichment and a daily politics of conquest by force
and fraud (as in a comparable area the ferocious Pope Julius II
saw no incongruity in decorating his private apartments in the
Vatican with Raphael's "The School of Athens"). This was the
anomaly, and it is the peculiar genius of Machiavelli that he
speaks for the Renaissance at that point where it becomes
distressingly aware of politics as an affront to culture. For as
Whitfield has so admirably said, he does not represent the
double degeneracy of both politics and culture. "He represents
instead the culture that is born of humanism becoming aware
of political problems because they are at a crisis. It is because of
this that he seeks to solve them from the elements with which
humanism had endowed the western mind." [4] Among these
were a feeling for the immediacy and the drama of contempo-
rary historical experience as lively as that of Thucydides, a
concern for the understanding of human motives as subtle as
that of Montaigne, and a passionate devotion to the Roman
world as the forerunner of a humane politics.

For all the maxims of ruthlessness, treachery, and deception
which grace the Machiavellian canon (and which have alone
provided the features of the distorted portrait which Marlowe
supplied in the Prologue to *The Jew of Malta* and Shakespeare
to Richard, Duke of Gloucester, in Part III of *King Henry the
Sixth*), the last chapter of *The Prince* states without equivoca-
tion the ultimate aim of Machiavelli's statesmanship: a great
prince for Italy—"*an opportunity to a prudent and capable
man to introduce a new system that would do honor to himself
and good to the mass of the people.*" Yet it is undeniable that
when these qualities of "prudence" and "capability" are
spelled out, it is within a context and according to a mode of
political perception which enthrones the equivocal and ques-
tionable categories of "warfare," of "force," and of "necessity."
Here, says Machiavelli, is a *just cause,* but the Roman maxim
which he has chosen to explicate this justice—*iustum enim est
bellum quibus necessarium, et pia arma ubi nulla nisi in armis
spes est* (that war is just which is necessary, and arms are
hallowed when there is no other hope but in them) —reveals the

desperation and the extremity of the Renaissance predicament. For, by an association of ideas so remarkable as to seem wantonly malignant, Renaissance experience suggested an almost definitive relation between the imposition of order and the exercise of violence. Therefore, when Machiavelli develops his theme in the few remaining paragraphs of Chapter 26, it is with an important backward reference to Chapters 12, 13, and 14: "The Different Kinds of Militia and Mercenary Soldiers," "Of Auxiliary, Mixed, and Native Troops," "The Duties of a Prince with Regard to the Militia." The topic seems at first sight thin within the dense texture of *The Prince,* but it is not. Indeed, it is the very nerve of his "political imagination." [5]

The degradation of Italy is due to the circumstance that military capacity seems extinct. The ancient methods are outmoded, and no one has arisen to discover new ones. And although Italians as individuals are not wanting in strength, dexterity, and intelligence (as witness their behavior in duels and single combat), when it comes to armies they make a poor show. Machiavelli sees the solution clearly. It is to abandon mercenaries and to institute a civilian army—one which moreover will develop an infantry with neither the defect of the Spaniards (who cannot sustain the attack of cavalry) nor the Swiss (who wilt before an infantry which meets them with a resolution equal to their own). It is a curiously provincial and prosaic note on which to end a treatise world-renowned as a universal analysis of statesmanship and power. But it is, in fact, as we shall see, the very heart of the Machiavellian enterprise.

The dramatic maxims of treachery and deceit, almost all drawn from *The Prince,* have largely determined Machiavelli's subsequent reputation, so that the more humane side of his attachment to political power has remained obscure. But the man who said, "It cannot be called virtue to kill one's fellow-citizens, betray one's friends, be without faith, without pity, and without religion; by these methods one may indeed gain power, but not glory," and "The prince must be cautious in believing and acting, and must not be afraid of his own shadow, and must proceed in a temperate manner with prudence and humanity," and, finally, "A prince must also show himself a lover of merit, give preferment to the able, and honor those who excel in every art" [6] cannot be accused of lacking respect for nobility, for excellence, and for order. It remains true, however, that the agency of order for a Renaissance mind (as for many another before and since) consisted in the institu-

tionalized legitimacy of force. "The chief foundations of all states," says Machiavelli (*The Prince,* Chap. 12), "whether new, old, or mixed, are good laws and good arms. And as there cannot be good laws where there are not good arms, and where there are good arms there must be good laws, I will not now discuss the laws, but will speak of the arms."

This is the heart of what *The Prince* has to tell us, and it is to be found clarified and essentialized in the chapter entitled "The Duties of a Prince with Regard to the Militia." "A Prince," says Machiavelli in this chapter, "should therefore have no other aim or thought, nor take up any other thing for his study, but war and its organization and discipline, for that is the only art that is necessary to one who commands. . . . He ought, therefore, never to let his thoughts stray from the exercise of war; and in peace he ought to practise it more than in war, which he can do in two ways: by action and by study." By action Machiavelli means discipline and exercise, hunting, and the exploration of the local topography. And by study he means the reading of history and biography, reviewing the behavior of eminent statesmen and generals, noting how they acted in warfare, and paying particular attention to the causes of their victories and defeats. At this point he only repeats one of the principles which he has previously suggested in Chapter 6: that "a prudent man should always follow in the path trodden by great men and imitate those who are most excellent . . ." It is a humanistic maxim worthy of Plutarch or Tacitus, and does much to suggest the unusual temper of mind of one who habitually brings to bear the resources of classical literature and humane letters on the strategic problems of the most ruthless of the *condottieri.*

Between 1506 and 1512 Machiavelli was a trusted member of the Florentine civil service, on diplomatic missions to the Emperor Maximilian and to Cesare Borgia, provisioning the army operating against Pisa, and recruiting the Tuscan militia to be trained according to his proposed plan. But in 1512 his fortunes abruptly changed. A Spanish army moved into Tuscany. Florence capitulated, Soderini, Gonfalonier, and Machiavelli's patron, went into exile, and the Medici once more became masters of the city. Machiavelli was dismissed from his secretaryship, imprisoned, probably tortured, and only released in March, 1513 on the day that Giovanni di Medici (as Leo X) was elevated to the papal throne. Retiring to his tiny estate of Sant' Andrea six miles from Florence, Machiavelli fell into the

life which he has described in his famous letter of December 10,
1513 written to his friend Francesco Vettori, Florentine ambas-
sador to Rome.

I will tell you what my life is now. I get up in the morning with the
sun, and go into a wood of mine I am having cut down. I spend an
hour or two there looking over the work done on the previous day
and passing the time with the woodcutters.
When I leave the wood I go to a spring and on from there with a
book under my arm, Dante or Petrarch, or one of the minor poets,
Tibullus, Ovid or someone like that to an aviary which I have. I
read of their amorous passions and their loves; I remember my own
—and for a while these reflections make me happy. Then I move on
along the road to the inn, talking to passers-by, asking news of the
places they come from, hearing about this and that, and observing
the various tastes and fancies of mankind. This brings me to lunch
time, when I and my brood eat such food as this poor farm and my
slender patrimony provides. When I have eaten, I go back to the
inn, where I usually find the landlord, a butcher, a miller and a cou-
ple of bakers. With these I act the rustic for the rest of the day. . . .
When evening comes, I return home and go into my study. On the
threshold I strip off my muddy, sweaty, workday clothes, and put on
the robes of court and palace, and in this graver dress I enter the an-
tique courts of the ancients and am welcomed by them, and there I
taste the food that alone is mine, and for which I was born. And
there I make bold to speak to them and ask the motives of their ac-
tions, and they, in their humanity reply to me. And for the space of
four hours I forget the world, remember no vexation, fear poverty
no more, tremble no more at death: I pass indeed into their world.
And as Dante says that there can be no understanding without the
memory retaining what it has heard, I have written down what I
gave gained from their conversation and composed a small work
The Prince, where I dive as deep as I can into ideas about this sub-
ject, discussing the nature of princely rule, what forms it takes, how
these are acquired, how they are maintained, why they are lost.[7]

I have quoted this fascinating letter of Machiavelli to Vettori
neither to specify the conditions under which *The Prince* was
composed, nor to suggest that the Machiavelli who is devoted to
the love lyrics of Dante and Petrarch, Ovid and Tibullus must
of necessity share in the possession of a humanistic view of life
and warfare. Surely enforced association with artisans and rus-
tics has only a limited pathos in the present day, and an amo-
rous sentimentality, however grounded in good literature, is
not incompatible with ignoble moral principles. Rather it is

because in the self-provided account of the nighttime Machia-
velli in his study is revealed a most important humanistic
component in "the Machiavelli method"—the interrogation of
ancient instances to throw light on human motives with the
hope that they *in their humanity* will reply.

It must not be thought that Machiavelli in the seclusion of
Sant'Andrea turned to the classics for recreation as some elderly
British gentleman, retired from the civil service in India or
Ceylon, turns to consider the meaning of blood sacrifice in
Aeschylus or to translate the works of Pliny anew. Machiavelli
was only forty-three, burningly impatient to resume his active
career, and the letters which he wrote to Vettori between Janu-
ary and August of 1513 show him to be almost feverishly con-
cerned with the situation of contemporary Italian politics. But
it is the letter of August 26 which captures once and for all the
essence of his mode of political perception and the literary form
which it instinctively takes.

In one mordant paragraph bristling with characterizing
adjectives, he sums up the prospects of contemporary peace:

And as to the state of things in the world, I draw this conclusion
about them: that we are ruled by princes of such a sort that they
have, either by nature or by accident, these qualities: we have a
Pope who is wise, and therefore serious and cautious; an Emperor
unstable and fickle; a King of France inclined to anger and timid; a
King of Spain stingy and avaricious; a King of England rich, fiery,
eager for glory; the Swiss brutal, victorious, and arrogant; we in
Italy poor, ambitious, cowardly; the rest of the kings I do not know
about. Hence, considering these qualities in connection with what is
going on at present, I believe the friar who said: "Peace, peace, and
there will be no peace." [8]

It is an interesting passage in two respects. In the first place it
shows the extraordinary degree to which politics in the six-
teenth century could be *personalized;* how universally political
power was individually concentrated, and therefore to what
extent political events were a function of individual decisive-
ness. From the age Machiavelli learned this lesson of "personal-
ization," and his treatment of an ideal warfare is permeated
with it. In the second place it shows Machiavelli's weakness for
the attribution of characterological qualities (not always con-
sistent) on whose shrewdness he thought the predicting of the
logic of events and the forecast of political outcomes depended.
These qualities are never exclusively descriptive or normative,

but oscillate between the two, so that, despite a general belief to the contrary, Machiavelli's thought always hovers ambiguously in a no-man's-land between ethics at one extreme and psychology at the other.

From this point on in the letter Machiavelli takes issue with his correspondent's own assessment of the contemporary situation, holding that Vettori underestimates the King of France as he overestimates the King of England, and, above all, that he does not sufficiently fear the Swiss. And this point leads him from the particular to the general: from the strength of the Swiss to the strength of *any* state made up of "detached pieces," and from the Swiss desire for conquest to the desire for conquest in general, on which questions he cites the instances of the Aetolians and Achaeans, Macedon and Rome, as well as those of the present Pope and Duke of Milan. Finally, in considering how the Swiss may best be dealt with, he returns once again to his favorite topic—the need for a "people's militia," and in support of his position contrasts on the one hand the Romans and the Spartans (as well as Ninus the Assyrian, Cyrus the Persian, and Alexander of Macedon), who used such militias, with the counterinstances of Hannibal and Pyrrhus, who did not. And from this he returns to the problem of the King of France and his wars with the English and the Swiss.

The details are not important. What counts is the method. And this involves not only the constant mutual reference of particularity and generality, but also *the illuminating juxtaposition of ancient and contemporary instances.* Readers of *The Prince* will only find the same strategy writ large: the case of Messer Annibale Bentevogli, Prince of Bologna, compared to that of the Emperors Commodus and Caracalla; the struggles of Louis XII of France and Ludovico il Moro over Milan to that of Roman policy in conquered Macedon and Aetolia; the brutal arrogance of the tyrant Agathocles of Sicily found similar to that of Oliverotto da Fermo.

Machiavelli's humanism is not merely that of a patriot [9] brooding over the facts of civic deterioration; it lies even more strongly in the utilization of a method which considers the fortunes of Florence in the light of the classics. Machiavelli looked to Roman history to illuminate the complexities of Renaissance actuality, for the politics of his time was not only *violent,* but also *confused.* And if there seems something strange to us in the spectacle of a Florentine who turns to Livy in order to understand the Borgias and the Sforzas, it is only

because, obsessed by our historical relativism, we have lost the sense that all ages house a common humanity and therefore share a common relevance. There is a well-known passage in Burckhardt, in which he sums up the work of the great Florentine historians of the beginning of the sixteenth century: Machiavelli; Guicciardini, Varchi. Although, says Burckhardt, they were of another breed than the professional Greek and Latin classicists, they wrote in Italian not merely because they could not compete with the Ciceronian elegance of the philologists, but also (and especially in the case of Machiavelli) because only in a living tongue could they record their impressions of contemporary actuality. And he concludes: "And yet, with all that is characteristic in their language and style, they were powerfully affected by antiquity, and without its influence would be inconceivable. They were not humanists, but they had passed through the school of humanism, and they have in them more of the spirit of the ancient historians than most of the imitators of Livy. Like the ancients, they were citizens who wrote for citizens." [10]

The warriors with their pikes and armor who appear in the canvases of Vittore Carpaccio, and even the mounted spearmen of Paolo Uccello, have about them an air of pageantry which is festive and almost light. But what the Italians learned from the Battle of Fornovo (July 6, 1495) was no joke. When Charles VIII of France met, defeated, and massacred the joint forces of Venice and Milan under the leadership of Giovanni Franscesco Gonzaga, prince and *condottiere* of Mantua, it was clear that the pattern of warfare had changed, and that the bloodless chess games of the *condottieri* (where checkmate was accepted with some of the courtesy of the medieval tournament) had been transformed by northern ruthlessness into the serious brutality of the more traditional forms of war. The wars of the local *condottieri* were very scientific and, at the same time, almost playful affairs in which the colorful strategy of a gallant cavalry caused even the aim of victory to pale into insignificance. But Fornovo unsettled this preponderance of the means over the end. It demonstrated beyond refutation that battles of chessboard maneuvers were a thing of the past, and that henceforth no army was complete without a high-grade infantry.[11] It is in the light of this drastic lesson to Italian statesmanship (as well as in that of the traditional medieval "mirror-of-princes"

literature) that the political writings of Machiavelli are to be understood. For they lie stretched on that continuum which contains prescriptions for the noble ruler at one end and man-enslaving violence at the other. It is the peculiar genius of Machiavelli that he has changed this disjunction into a polarity.

Machiavelli's chief political writings illustrate this continuum of his inventiveness, although in time their composition was compressed. *The Prince,* begun in 1513, was completed before the end of the same year; *The Discourses on the First Decade of Titus Livy,*[12] also begun in 1513, was probably completed five years later; *The Art of War,* begun in 1518 or even earlier, was completed in 1520 and published in Florence in 1521. It is as if the preoccupations of Machiavelli's mind followed a path of descending generality. *The Prince* was hastily written but taut in its argument, and although that argument explores both the highroad and the byways of power, its treatment of warfare is restrained and largely implicit. *The Discourses* are more meditative, more leisurely, more bland. This is partly due to the format, which is a commentary, diffuse and unanchored, on the first ten books of Livy's history of Rome. But the wider scope at Machiavelli's disposal mitigated the astringency of *The Prince* in two respects: it showed that behind the bare maxims of power lay an intent humanistically relying on those republican values potentially realizable in any commonwealth, and it developed this ethos within the context of a humanist enthusiasm, neither for despotism nor empire but for the actual history of republican Rome. Nor was the choice of Livy a mere cultural accident. Even more than Greece, Rome was the political exemplar of the Renaissance. Dante and Petrarch had both seen the Roman empire as the culminating achievement of human reason operating without grace—that is, in its exclusively secular embodiment, and if the taste of humanism was rather for the Roman republic than for the empire, in Livy, above all, were the virtues of the republic accepted and admired. For Italy in the fifteenth century Livy was *the* Roman historian, and his influence far outweighs that of Polybius, Sallust, or Tacitus.

Not unnaturally *The Discourses* reflects the preoccupations of Livy himself—with Rome's constitution, with her military organization, with the virtues of her outstanding men—but it is a series of interests which is tailor-made for a Renaissance statecraft which oscillates between a passion for the elucidation

of the constitutional structures of power and inordinate con-
cern for the inner workings of the machinery of violence in its
culminating expression—warfare. Machiavelli selects incidents
from Livy's narrative (almost always in chronological order)
and then uses them to formulate just those theorems of the
political life which experience had suggested to him, so that
here again is found the essential expression of the Machia-
vellian method—the rich mutual reference of terse political
maxims and generalizations drawn from history, given exem-
plary expression through the trenchant citation of ancient and
modern instances. And like almost all of the great classics of
political theory, from Plato's *Republic* to *The Communist
Manifesto,* it intermingles the theoretical and the practical to a
degree which renders their major thrust problematic. Any work
which bases political imperatives on descriptive generalizations
from history will suffer from this ambiguity, and *The Dis-
courses* with its mixed intention of discovering "historical laws"
and proffering political "advice" is no exception. But what is
primarily significant for our purposes is that *The Discourses*
shows Machiavelli's increasing preoccupation with the artistry
of violence—with the sinews of war. Warfare, as we have seen,
is a topic only implicit in *The Prince.* But, congruent with Livy
himself, something over a third of *The Discourses* is specifically
devoted to the tactics and the strategy of war. *The Discourses* is,
therefore, a kind of halfway house which leads from the mor-
dant political maxims of *The Prince* to the no less professional
considerations of *The Art of War.*

Machiavelli was perhaps the greatest military writer of his
day. But he was far from being the only one to take a passionate
interest in the warlike operations of the time. The very format
of *The Discourses* was, however, a perfect illustration of the
curious new alliance between humanism and warfare. Those
changes which took place in the waging of war between the
Middle Ages and the Renaissance were, in fact, largely due to
the revival of interest in ancient history and literature.[13] Wars
were carried on in an atmosphere of eager intellectual activity,
and since almost all of the important campaigns were fought in
Italy, the finest minds of the day witnessed, recorded, and com-
mented on the exploits of the leading captains and the most
famous troops of Europe. The exploits of "the Great Captain"
Gonsalvo de Cordova, and of the famous *condottieri* Gian
Paolo Vitelli and Prospero Colonna, were avidly followed and
discussed. The Italian *condottieri* themselves to a large extent

originated the theoretical study of war.[14] They founded military schools, they analyzed tactical and strategic problems, and they fortified their arguments by citations from the Greek and Latin classics. Captain Fluellen in Shakespeare's *Henry V*, with his constant allusions to "the true disciplines of the wars, look you, of the Roman disciplines," and to "the ceremonies of the wars, and the cares of it, and the forms of it, and the sobriety of it, and the modesty of it," [15] is but the humorous Elizabethan trace a hundred years later of a decorum, now degraded into pedantry, established by the *condottieri* of Machiavelli's age.

Even the form of Machiavelli's military treatise established the ambience of discourse—the courtly gathering for learned and gracious dialogue, the new enthusiasm for abstract discussion. At the precise moment when Baldassare Castiglione is writing *The Book of the Courtier* and setting its discussions of love and nobility within the refined atmosphere of the court of Urbino, Machiavelli is writing his treatise *The Art of War* and setting its discussions of warfare and soldierly virtue in the gracious garden of Cosimo Rucellai in Florence where, refreshing himself, the famous *condottiere* Fabrizio Colonna enters into conversation with the handsome young men Zanobi Buondelmonti, Battista dalla Palla, and Luigi Alamanni. It is a small detail, this literary setting, and of little intrinsic significance, but the very atmosphere which it establishes makes Machiavelli's *L'arte della guerra* a far cry indeed from either Carl von Clausewitz's *Vom Kriege* or Herman Kahn's *On Thermonuclear War!*

The first English translation of *The Art of War* was published by Peter Whitehorne in 1588 (the year of the Armada) and dedicated to Queen Elizabeth out of a sense of extreme urgency; as he himself says, "because considering the ambition of the World, it is impossible for any Realm or Dominion long to continue free in quietness and safeguard where the defense of the Sword is not always in readiness." [16] It is a sentiment of extreme modernity, but it also looks back to the spirit which animated Machiavelli himself almost a hundred years before. Whitehorne borrows from Machiavelli two concepts: the stoic virtuousness of the military life and the pragmatic necessities of self-defense. Cognizant of the Spanish threat, he thinks it well to have Elizabeth's people interested in the art of war "the better to resist the malignitie of the enemie who otherwise would seeke paradventure to invade this noble realme or kingdome." And he warns "that when the ancients through long

and continual peace began to be given altogether to pleasures and delicacys, they sodainly fell into decay and utter ruine."

Still, Machiavelli's chief preoccupation is neither stoic virtue nor mere self-defense. The *condottieri* had believed that wars were won by industry and cunning rather than by the clash of arms, and their comparatively bloodless campaigns were the artistic demonstrations of professors—a kind of *Kriegsspiel*. The paradoxical consequence of this attitude was that it gave to Italian Renaissance warfare at the same time an aura of professionalism and of artificiality—a kind of *depersonalization* cut off from both civic involvement and human concern. Machiavelli, for the first time, begins to take seriously the relations between warfare and politics, and his philosophical survey of the art of war is an attempt to assess the possibilities and the limitations of armed force within a context of passionate civic patriotism. His outlook is political rather than military, but he sees no basic opposition between the two. The civilian and the soldier are but one man in two guises. Soldiering is a branch of citizenship as warfare is of politics. This is a new gospel for the Renaissance, and it is the heart of Machiavelli's dedication of *The Art of War* to Lorenzo Strozzi, Nobleman of Florence:

Many are of opinion that no two ways are more discordant than the civil and the military life. But if we consider the nature of government and the institutions of the Ancients, we shall find a very strict and intimate relation between these two conditions. . . . For all the arts and sciences which have been introduced into society for the common benefit of mankind, and all the ordinances that have been established to make them live in the fear of God and obedience to human laws, would be vain and insignificant if not supported and defended by a military force.[17]

But if force of arms is the foundation both of the laws of states and of the cultural superstructure which these laws make possible, the decadence of the times has worked havoc with the military virtues which are the legacy of the golden age of the Romans. Formerly the life of a soldier was edifying and served as a pattern for others. "But since our discipline is now depraved to such a degree, that what it is is totally different from what it anciently was, it is no wonder that other men have so bad an opinion of a military life." It is within this ambience that Machiavelli writes, as he himself declares: "To revive the discipline of our ancestors and in some measure to retrieve the

reputation of our soldiery, I have written the following treatise concerning the Art of War."

The political utility of armed force is surely the heart of Machiavelli's interest in the art of war, but the deep humanistic commitment to the twin values of discipline and tradition provides for it a secondary ethical center. The Roman virtues constitute a permanent ethos, and in the light of their strength and purity, conduct in the Italian *quattrocento* seems to Machiavelli but the reflection of an age which has lost its sense of continuity and of value. It is surprising how regularly in *The Discourses,* but even more constantly in *The Art of War,* appear the evaluative adjectives "corrotto," "depravato," "degenerato," applied to the customs and the policies and the human material of Machiavelli's own times. And it is a disconcerting counterevidence for a reputation which has been traditionally patterned on the image of Iago and Richard III.

Speaking for Machiavelli himself at the beginning of *The Art of War,* Fabrizio Colonna says: "If we consider the practices and institutions observed by the old Romans (whose example I am always fond of recommending) we shall find many things worthy of imitation, which may easily be transplanted into any other state, if it has not become totally corrupt." [18] Certain things follow at once. No honest man ought to make war his only profession. One should have a militia, of course, composed of one's own citizens or subjects, but in peacetime they should return to other occupations. Soldiers should be drafted, not volunteers, led by citizens, not professionals, drawn from the country rather than the city. (The Venetians, Colonna remarks, use their own citizens at sea, and win; they use hired mercenaries on land, and lose.) Even the arms of the Romans were best. They were right to prefer heavy defensive armor rather then the light armor of the modern Germans, short swords rather than the pikes of the contemporary Swiss, infantry rather than the cavalry of the present-day *condottieri.* Realizing that a field war is the most effectual and honorable, the Romans used cavalry to harry and pursue, to reconnoiter and raid, but never in the field. On the other hand the legendary discipline of their legions in the field was the fruit both of their rules for the formation of battalions and of their placing of captains, as well as their peacetime engagement in constant military exercise.

How about artillery? asks Luigi Alamanni. And Colonna replies, not useful! Artillerymen blind with their smoke, and

they do little damage to mobile troops. Even gunpowder in the hands of foot soldiers is of limited utility, and musketeers are less for service than to frighten country people in battle! And he concludes: "The invention of Artillery therefore is no reason, in my opinion, why we should not imitate the Ancients in their military discipline and Institutions, as well as their courage." [19] Machiavelli treats a great diversity of other subjects, among them: how to reduce an army to battle order, in what formation the Romans marched, how a general is to gain intelligence, how to press for or avoid an engagement, military justice, how to suppress mutiny and discord, how fortresses are to be built, sieges, mines, and military discipline. He quotes the texts of Livy, Plutarch, and Josephus. He cites the historical instances of Hannibal and Caesar, of Philip of Macedon, of Fabius Maximus, of Scipio. But the ultimate outcome in every case is the same—a recall to discipline and personalization.

BATISTA: Did the Romans ever suffer women or gaming in their Camp as we do at present?
FABRIZIO: They prohibited both: nor was the restraint very grievous; for their soldiers were so constantly employed either in one sort of duty or other, that they had no time to think either of women or gaming, or any other of those vile avocations which commonly make soldiers idle and seditious.[20]

And the virtues of Caesar and Alexander were not merely their mastery of strategy and command, but their personal authority and moral presence. They fought at the head of their men, marched with them on foot, carried their own arms. They were neither effeminate nor enervate. If our princes were to read and deeply consider *their* lives and fortunes, says Fabrizio, it is impossible that they would not alter their conduct.

In almost every sense Machiavelli proceeds by *personalization*. It is the prince rather than the state that counts, the citizen army, patriotic and ego-involved, rather than the "imperial" and "professional" mercenary; and even the battle must be engaged at close range. Thus Machiavelli has denigrated artillery at the expense of infantry, and believes that the pike should be abandoned for short weapons for close combat like the sword of the ancient Romans. But the ultimate appeal is not to the swords, but to the military virtue and the moral hardihood of Rome.

There is one long passage from the last pages of *The Art of*

War which is worthy of quotation almost in full, for it is an interesting clue to our interpretation of *The Prince,* and it sums up, I think, the moral implications of the political enterprise of which *The Prince, The Discourses,* and *The Art of War* constitute successive moments.

Before our Italian Princes had been scourged by the Ultramontanes, they thought it sufficient for a Prince to write a handsome letter; to excel in drollery and repartee, to undermine and deceive one another, and to set themselves off with jewels and lace; to eat and sleep in greater magnificence and luxury than their neighbors; to spend their time in wanton dalliance and lascivious pleasures; to keep up a haughty kind of State, and grind the faces of their Subjects; to indulge themselves in indolence and inactivity; to dispose of their military honors and preferments to Pimps and Parasites; to neglect and despise merit of every kind. . . . To this were owing the dreadful alarms and disgraceful defeats and the astonishing losses they sustained in the year 1494. . . . But it is still more deplorable to see that those Princes who are yet left in possession of any dominions are so far from taking warning from the downfall of others, that they pursue the same course and live in the same sort of misrule and fatal security.[21]

It is, as I say, an interesting commentary on the proper interpretation of Machiavelli's ideal prince, and it indicates how far astray the Elizabethans had gone by being ignorant of, or, at least, uninterested in the original Machiavellian texts. For if the typical Machiavellian prince is assumed to be Richard III, he is in reality none other than Henry V. And if it is indeed the case that this play, perhaps better than any other of Shakespeare's history plays, mirrors Elizabethan ideas about the ruler, the state, and warfare in the national interest, then the irony revealed by the above quotation from *The Art of War* is that the Machiavellian political message is almost identical with that revealed by the moral contrast implicitly stated between Shakespeare's Richard II and his Henry V. In their pursuance of the themes of humanism and warfare Machiavelli and Shakespeare are not in opposition, but alike.

The Instrumentation of Policy: Carl von Clausewitz

In 1897, almost twenty years before the First World War, Paul Valéry wrote a searching essay on modern Germany. He called it "A Conquest by Method," and in it he professed an

ironic admiration for the German spirit, which had trans-
formed disciplined intelligence into an instrument of military
accomplishment. If, he said,[22] we turn our attention to the
military history of Prussia from Frederick the Great to Field
Marshal von Moltke, we cannot escape the impression of a
system dominated by the concept of a *method* comprising per-
fect preparation, generally adequate execution, and always—
results. The Prussian military system is, of course, characterized
by its preoccupation with strategy, but the meaning of this
preoccupation is *an attempt to rationalize the future.* "The
study of the future, carrying foresight as far as possible, care-
fully weighing the probabilities, everything that tends to re-
duce chance, to eliminate blind action—these are the remarka-
ble qualities of the military method marked 'Made in Ger-
many'." On the field of battle, whether economic or military,
one general theorem dominates methodical action—the
achievement of preponderance. The planning of military pre-
ponderance is the work of the general staff with its division of
intellectual labor, its specialized minds fixing their constant
attention on the details of tactics and strategy, and its research
extended even to subjects that at first seem unsuited to techni-
cal study. Its various famous headquarters are therefore in
reality so many "factories for turning out victory."

For Valéry, Field Marshal von Moltke personifies the system.
He was its director and exemplar. The elements of his success,
says Valéry, were to be found in Frederick the Great and in
Napoleon, but the battlefield was not his base of operations.
"He should be pictured in a room, in a small occupied town,
working with his faithful staff. He is diligently repairing the
accidents and the disruptions caused by the sufferings of
others." This one man's life is a complete lesson, and it corre-
sponds exactly to what we know of contemporary Germany.
And for this icy hero the true enemy is neither England nor
France, *it is the accidental!*

In all this elaboration of the German "conquest by method,"
Valéry does not mention the spirit which lies behind von
Moltke, that of Carl von Clausewitz and his justly famous
treatise *On War.* For it is Clausewitz above all, the spokesman
of the previous generation, the contemporary of Goethe, who
makes available to military practice the spirit of Kant and of
the Enlightenment (*Aufklärung*), who attempts to rationalize
the future by embedding in the most unhistorical of formats

the lessons implicit in the experience of Frederick the Great and Napoleon.

It must be admitted that Valéry's implicit dispraise of German system, discipline, and method is a trifle disingenuous. For Valéry himself is at heart a Cartesian,[23] and surely Descartes is the father of Kant and the Enlightenment. I do not mean to imply that von Clausewitz is entirely a Kantian, for his dedication to the rationale and the forms of warfare seems in opposition to the author who wrote *Zum ewigen Frieden* (On Perpetual Peace), but his effort to treat war as a "thing-in-itself" and as an object lying at the center of its own "system of pure reason" shows the influence of modes of eighteenth century thought of which Kant is the pristine exemplar.[24]

It is in this sense above all that we experience the profound differences between the works on warfare by Machiavelli and those by von Clausewitz—not merely in their principles, but in their entire texture and flavor. It might seem at first glance as if only the historical setting of warfare had changed, as would be inevitable as we move from Renaissance Italy to the Napoleonic Wars. But this is not because Machiavelli cites the exploits of *condottieri* like Gian Paolo Vitelli or Gonsalvo de Cordova, while from time to time von Clausewitz makes tacit reference to the campaigns of Frederick the Great and Napoleon's generals. The fact is that we have also an opposition between the basic intellectual outlook of the two periods, humanism and the Enlightenment. Humanism *remembers,* and it is committed to *the method of history* as Machiavelli is committed to the military virtue of ancient Rome. The Enlightenment *projects,* and it is committed to *the method of logic* as von Clausewitz is committed to that systematic analysis which Valéry associates with the military method "Made in Germany." We today, in more senses than one, are closer to Clausewitz than to Machiavelli, and if we now turn briefly to the chief principles and the informing spirit of his great treatise *Vom Kriege,* we will be in a better position to see how Western man has been able to pass from the quaint antiquarianism of *L'arte della guerra* to the spectacular and frightening rationality of Herman Kahn's *On Thermonuclear War.*

In pressing the contrast between Machiavelli and von Clausewitz, I do not mean to deny the obvious continuities between them. For if we today are closer to Clausewitz than to Machiavelli, Clausewitz himself is closer to Machiavelli than to us.

And in setting up the opposition between humanism and the Enlightenment as that of an age committed to the method of history as opposed to one committed to the method of logic, it is important to see that the disjunction is not absolute. For the Enlightenment itself, to which Clausewitz so clearly belongs, is predicated hardly more on faith in rationality than on faith in human values. And here, above all, one will recognize the similarity between Clausewitz and Kant. Despite the fact that Kant wrote a small but notable treatise *Zum ewigen Frieden* (Perpetual Peace), his attitude toward warfare was, I think, ambivalent, and this for reasons which show him to be a true son of the Enlightenment. In the first place his entire mode of perception is teleological. And in the second, like the Enlightenment as a whole, he was beginning to sense that the rise of a bourgeois and commercial culture (exemplified to perfection in the prosperous Königsberg of his own day) was not an unmixed moral blessing even when contrasted with the darkness of the Middle Ages, and that feudal "honor" and "nobility" had certain elements of moral elevation even if allied with the brutalities of warfare. Kant's ambivalence is shown not in his treatise *On Perpetual Peace* but by two remarks which he makes, almost in passing, in that apotheosis of his teleology: *The Critique of Judgment.* The first passage, written in the context of a treatment of beauty and the sublime, constitutes his moral and cultural criticism:

War itself, if it is carried on with order and with a sacred respect for the rights of citizens, has something sublime in it, and makes the disposition of the people who carry it on thus, only the more sublime, the more numerous are the dangers to which they are exposed, and in respect of which they behave with courage. On the other hand, a long peace generally brings about a predominant commercial spirit, and along with it, low selfishness, cowardice, and effeminacy, and debases the deposition of the people.[25]

Kant's association of warfare with "the sublime" strikes a discordant note in modern ears, but to an eighteenth century sensibility, used to applying the concept of sublimity to any event of sufficient magnitude to cause awe and wonder (and perhaps also pity and terror) the cataclysmic aspect of warfare would fit it well for such an association. And yet in Kant the twist is slightly different. For here it is, I think, *the morally sublime* which he has in mind; that martial steadfastness in the

face of extreme danger which gives whatever "ethos" there is to heroic gallantry from Homer's *Iliad* to Tolstoy's *War and Peace,* and which stands in such ironic contrast to the predominantly selfish and prudential virtues which characterize a commercial civilization. Here in Kant there is a sympathy, not unlike that of Machiavelli himself, for the martial virtue of the Roman republic, and we shall see it reappear with a strong but quiet fervor in the writings of Carl von Clausewitz.

Kant's second passage, written in the context of his treatment of the teleological judgment, contains likewise an insight into his philosophy of culture:

Though war is an undesigned enterprise of men (stirred up by their unbridled passions), yet it is perhaps a deep-hidden and designed enterprise of supreme wisdom for preparing, if not for establishing, conformity to law amid the freedom of states, and with this a unity of a morally grounded system of those states. In spite of the dreadful afflictions with which it visits the human race, and the perhaps greater afflictions with which the constant preparation for it in time of peace oppresses them, yet it is (although the hope for a restful state of popular happiness is ever further off) a motive for developing all talents serviceable for culture, to the highest possible pitch.[26]

Certainly von Clausewitz does not have Kant's passion for parliamentarianism and for that federalism (expressed in both *On Perpetual Peace* and *The Idea of A Universal History*) which sees the formation of a world federation based on law as the aim and final end of all political history, but in two important respects he shares with him the mentality of the eighteenth century. First, in his sense that war must be carried on with *order,* that it is not chaotic activity, but an enterprise with a form, a *rationale,* and, indeed, its own set of *rules* and *principles.* And second, in his sense that war is not an isolated experience, but an expression of *culture,* and that its formation and prosecution must be always within a context provided by the demands of culture as an expression of the nature of man. *Rule-orientation* and *a sense of cultural base* are important presuppositions of the Enlightenment, and they appear no less in von Clausewitz than they do in Kant.

For this there is abundant reason. The life of Carl von Clausewitz (1780–1831) lies within that crucial half century between the death of Voltaire and the death of Goethe.[27] Thus he experienced revolutionary violence, the imperialism of the Napoleonic Wars, and the restoration of the French monarchy.

He was also a contemporary of Hegel, whose sources also lie deep in the Kantian philosophy, and this is of no little significance, for the presuppositions of Clausewitz' life work are intimately bound up with the politics and the weltanschauung of German idealism.[28] The period in which he lived was a transition period in more senses than one, for, if he never forgot the lessons of the Kantian Enlightenment, he used them in the service of that same passionate nationalism which characterizes the works of Fichte and Hegel. Despite Kant's mild republicanism, the humanist preoccupations of the German Enlightenment—of Lessing and von Humboldt, of Herder and Goethe—were largely apolitical, and in this respect, as we have seen, they present a paradoxical contrast between the intellectual climate of the time and its social reality. For in the Prussia of Frederick the Great, the army had already become the central instrument of national politics, and it was notoriously Frederick's dream that the structure of his administrative system should be "as coherent as a system of philosophy." It is precisely this which von Clausewitz accomplishes for the science of warfare. Here, too, there was need for rationalization and coherence. Clausewitz appropriates the rule-orientation of Kant in the service of a patriotism exemplified by Fichte and Hegel.

But if von Clausewitz' aims are in some sense akin to those of Frederick the Great and the Prussian state, there are factors of ancestry and education which ally him strongly to the culture of the apolitical Enlightenment. His grandfather was a professor of theology in Halle. His student years between 1801 and 1804 found him digging deep into the roots of German culture, and between the last days of the French Revolution (1795) and the outbreak of the Napoleonic Wars (1806) he was busying himself with an attempt to relate the theory of warfare, philosophy, and art.[29] Above all he prized the dramatic poetry of Schiller: *William Tell, The Maid of Orleans, Wallenstein.* At the same time as he was studying deeply the great battles of modern Europe from Gustavus Adolphus to Napoleon, he was also busying himself with Kant's logic and with Herder's philosophy of history. He was acquainted with both August Wilhelm and Friedrich Schlegel, and he knew the culture of the Italian Renaissance. In a letter of this period he writes: "In Raphael I marvel at the beauty of the human form, and in Rubens at the beauty of composition." (Have we such letters from General Eisenhower or General MacArthur?)

So much for the education in humanism. But Clausewitz was,

of course, first and foremost a soldier. His father had served as a lieutenant under Frederick the Great, and von Clausewitz entered the army at thirteen. Here he remained, serving in the wars of the Napoleonic era until 1815. He was in the Rhine campaign of 1793, receiving his commission at the seige of Mainz. Later he experienced the transformation of French revolutionary vigor into Napoleonic imperialism. He was in the Jena campaign of 1806, which saw the collapse of the Prussian army and during which he himself was taken prisoner. After Jena and Auerstadt, Napoleon entered Berlin. He "desecrated" the tomb of Frederick the Great at Potsdam, sent the latter's sword to the *Invalides,* and removed the figure of Victory from the Brandenburg Gate to Paris. From 1808 on Germany is humiliated, and Napoleon is the master of Prussia.

Earlier in the campaign von Clausewitz had attracted the attention of the great general and theoretician Scharnhorst, and after 1808 these two, together with Gneisenau, Boyen, and Grolmann, began the movement for the reform of the Prussian army. This period of reform (1809), during which the *Kriegsakademie* was founded in Berlin, is of great importance for Clausewitz' intellectual development. He participated in wide-ranging discussion about domestic, foreign, and military policy, and began to philosophize about war as an abstract phenomenon, as a separate domain worthy of its own contemplation and examination. Meanwhile he was writing his partial history of the Thirty Years War, *Gustav Adolphs' Felzuge 1630–1632.*

The conclusion of the Franco-Prussian treaty of 1812 was the despair of the reform group around Scharnhorst and Gneisenau. It humbled the Prussian military caste, and made its army subservient to France. The chief officers (among them Boyen and von Clausewitz) resigned in disgust, and Clausewitz wrote his brief but moving war credo, *I Believe and Profess.* I should like to quote its opening lines, because they betray not only the feudal presuppositions of a Prussian patriot, but the dedication to the concept of honor which underlies much of the later treatise *Vom Kriege:*

I believe and profess that a people must never value anything higher than the dignity and freedom of its existence; that it must defend these with the last drop of its blood; that it has no duty more sacred and can obey no law that is higher; that the shame of a cowardly submission can never be wiped out; that the poison of submission in the bloodstream of a people will be transmitted to its chil-

dren and paralyze and undermine the strength of later generations; that honor can be lost only once; that, under most circumstances, a people is unconquerable if it fights a spirited struggle for its liberty; that a bloody and honorable fight assures the rebirth of the people even if freedom were lost; and that such a struggle is the seed of life from which a new tree inevitably will blossom.[30]

It is an interesting passage, and it indicates something more than Prussian pride in the face of Napoleonic defeat. For a moment later it becomes clear that the dialectic of values is involved, and that we are in the presence of the same spirit invoked by Kant in the *Critique of Judgment* in contrasting the sublimity of courage with the selfishness and cowardice of a commercial civilization. "Boldness," says von Clausewitz, "is the outstanding military quality . . .

the genuine steel which gives to arms their luster and sharpness. It must imbue the force from camp follower and private to the com- mander-in-chief.

In our times, struggle and, specifically, an audacious conduct of war are practically the only means to develop a people's spirit of daring. Only courageous leadership can counter the softness of spirit and the love of comfort which pull down commercial peoples enjoy- ing rising living standards . . .[31]

After his resignation from the Prussian army, von Clausewitz defected to Russia to further carry on the war against Napo- leon. He witnessed Napoleon's disastrous Russian campaign of 1812, and many of the principles which appear later in the *Vom Kriege* (particularly those concerning defensive warfare) are a product of his experience of the war in Russia and of Napoleon's fatal retreat. For a brief period immediately after the Congress of Vienna, von Clausewitz (like Gneisenau) was considered to be so radical as to be almost a revolutionary, but in 1818 he was made director of the *Kriegsakademie* in Berlin, and from then until 1830 he was engaged in writing his massive treatise *Vom Kriege*. Von Clausewitz died of cholera in 1831, only a short time after Gneisenau himself, leaving the manu- script to be published posthumously by his wife.

The further one reads in Clausewitz' enormous treatise, the more one is forced to the conclusion that this is not simply a manual of arms, but a philosophical adventure, not merely a textbook of strategy and tactics fit for the general staff of a bureaucratized army, but a sober contemplation of the nature

of the war experience, written by one who is, to be sure, a philosopher of absolute war but who ponders the image of war as an essentially human enterprise, with an interesting mistrust of logical theory as such, as profound a sense of the role which fortune and fate play in the affairs of men as Plutarch or Machiavelli, and a strong bias in favor of the role which moral considerations play in the prosecution of absolute warfare. In the very brief treatment which I can afford of this massive and extremely rich work, I shall therefore stress those three themes which seem to me to be very close to Clausewitz' philosophical center: (1) the conception of war as an expression of *will*, rather than mechanical necessity, (2) the conception of military virtue as a positive factor in the fabric of civilzation, and (3) the already famous notion that war and politics form one seamless web, so that as a phenomenon in the life of nations and of peoples the function of warfare is to serve as an instrumentation of policy.

In the very first metaphor by which Clausewitz seeks to define war, one sees the aristocratic and personalized presuppositions of his thinking: War is nothing but a duel on a larger scale (*Der Krieg ist nichts als ein erweiterter Zweikampf*),[32] and if one would envisage as a totality the countless duels of which it consists, one might imagine two wrestlers, each seeking through physical violence to force the other to do his will, to throw him, to render him powerless for further combat. Physical violence is the means; the destruction of the power of the enemy is the end, and Clausewitz makes no effort to minimize the elements of passion and brutality involved. For although international law and custom impose trivial restrictions, the use of violence as an instrument of war is theoretically without limit, and indeed the ruthless combatant who shrinks from no enormity in its employment may gain a real advantage over a more reluctant opponent. It is, says Clausewitz, a mistake to ignore the element of brutality because of its moral repugnance, and if the wars of civilized nations are essentially less cruel and destructive than those of the uncivilized, this lies in social conditions accidental to the nature of warfare itself. To see warfare among modern civilized states, therefore, as the purely rational acts of governments would be to miss the point, for the elements of hatred and unbridled passion are always with us. Military theory, says Clausewitz, was in its new-found rationalism beginning to forget this fact. But the wars with Napoleon have recalled it to the truth!

War is always a collision of two opposing concentrations of force, but this force when further analyzed consists of two parts: the extent of the *physical means* at one's disposal, and the strength of one's *will*. An extreme rationalism, dealing only with the opposition of mechanical means, could itself be seduced by the mechanistic analogy and transform the foundations of strategy into a mere calculus of probabilities, but this is a temptation to which Clausewitz not only does not succumb, but against which he warns. The element of will is the crucial imponderable, and a recognition of this fact brings the thinking of von Clausewitz into harmony with that of Plutarch's *Moralia* and the famous Chapter XXV of Machiavelli's *The Prince.*[33]

If we now cast a glance at the subjective nature of war—that is, those personal qualities with which it must be carried on—it must strike us even more as a gamble. The activity of war moves in the element of danger. What is the highest of all moral qualities in the fact of danger? Courage certainly. Now courage is indeed quite compatible with prudent calculation, but calculation and courage are nevertheless profoundly different in kind and belong to different faculties of the mind. On the other hand, daring, reliance upon good fortune, boldness and foolhardiness are only the expressions of courage, and all these manifestations of the spirit seek the accidental because it is their proper element.
We see thus that the absolute, the so-called *mathematical* element nowhere finds a sure foundation in the calculations of the art of war, and that from the very beginning there is a play of possibilities and probabilities, of good luck and bad which permeates every aspect of war, great or small, and makes war of all branches of human activity the most like a game of cards.

For Clausewitz it is no metaphysical necessity lying within the nature of the universe, but the very human element itself which allies the activity of warfare with the concepts of "fortune" and "fate," and this is why, although Valéry is right that for von Moltke perhaps the great enemy was "the accidental," for von Clausewitz it is of the very essence of warfare, and the notion that the German mentality as applied to combat proceeded to the construction of "factories for turning out victory" must be qualified by the humanistic recognition by von Clausewitz of the extreme variability, spontaneity, and, occasionally, nobility of the human material engaged.
The art of war has to do with living moral forces (*Die*

Kriegskunst hat es mit lebendigen und mit moralischen Kräften zu tun), and it therefore follows that the attainment of absolute certainty in its domain is an impossibility, and that the margin of the accidental is precisely that defined by the variant possibilities of human courage and self-confidence. Herein, as Clausewitz so well knew (and, as we shall see Herman Kahn has so conveniently forgotten), consists the limitation of pure theory: *that it can only lay down such rules as allow free scope for the expression of the essential and the most noble of the military virtues in all their degrees and variations.*

But to say this is at the same time *not* to succumb to the temptations of romanticism—as Friedrich Schiller might have done if he had turned his talents to a treatise on war. For war is no pastime—no mere passion for daring and winning, no enterprise for an uninhibited enthusiasm. It is serious business, and all that it displays of the glamour of fortune, the thrills of passion, and a courage grounded in enthusiasm are but properties of a means devoted to a sober end. In this respect the thought of von Clausewitz is in essence (like Hegel's) dialectical, for it is constantly aware of the paradoxes of opposition which haunt the concept of war: deep national hatreds versus cool political necessities; prudent calculation in the general staff versus the charismatic leadership of the captain on the battlefield; the intellectual foundations of all acts of military judgment versus the emotional grounding of all acts of military bravery. This led him to his most profound insight—that of war as a process, a movement, a mixture—or, as he put it—a chameleon.

War is therefore a chameleon because in each concrete case it changes somewhat its nature, but it is not only that. It is also, when regarded as a totality consisting of all the leading tendencies which compose it, a most strange and remarkable trinity. It is composed of the original violence of its essence, the hate and enmity which are to be regarded as blind, natural impulses; the play of probability and chance which makes it a free activity of the emotions; of the subordinate character of a political instrument through which it belongs to the domain of pure intelligence.

The first of these three sides is more particularly the concern of the people, the second that of the commander and his army, while the third belongs to the government.[34]

The dominance of the concept of "personality" is to be seen in every aspect of Clausewitz' theory of war: in the original

definition of war as an act of violence to compel the enemy to
do our *will,* and that it, as a hostile tension of hostile agencies,
cannot be regarded as concluded until the *will* of the enemy is
subdued, as well as in a recognition of the dominating import-
ance of the attitude of the common soldier in the field and the
moral quality of his commander. And from this "dominance of
the personal" follows the more generalized and philosophical
consideration of war as a factor in civilization itself. Military
genius is a function of the mental and moral development of a
people, and a high degree of civilization, writes von Clause-
witz,[35] will always provide the most brilliant examples of mili-
tary achievement. As Machiavelli looked back to the Roman re-
public, so Clausewitz looks back not only to Rome, but to the
great French generals from the time of Louis XIV to Napoleon.
War is the province of danger, and therefore courage, that is,
moral courage or *courage in the presence of responsibility,* is
the first quality of a warrior. Boldness and firmness are requis-
ite, but intellectual qualifications are no less so, for, since war is
so completely the province of ambiguity and chance, a fine and
penetrating intellect is required to feel out the truth with in-
stinctive judgment in the fog of uncertainty. The genius of
war demands not only strength of character, but searching and
comprehensive minds. It is in the exploration of these ideas
that von Clausewitz as a writer projects some of his most strik-
ing (if hardly completely original) metaphorical images.[36]
"Like an obelisk toward which the principal streets of a town
converge, the strong will of a proud spirit stands prominent and
commanding in the middle of the art of war." "Just as a man
immersed in water is unable to perform with ease and regular-
ity the simplest and most natural of movements, that of walk-
ing, so in war, with ordinary powers one cannot keep even the
line of mediocrity. That is why the correct theorist is like a
swimming master, who teaches on dry land movements which
are required in water, which must appear ludicrous to those
who forget about the water." "Every war is rich in individual
phenomena. It is therefore an unexplored sea, full of rocks
which the general may suspect but which he has never seen and
round which he must steer in the night."

Clausewitz' metaphors of the theorist as a swimming teacher
on dry land and the general [sic] steering by night through an
unknown sea point up his mistrust of any real possibility of a
"science of war," and he belittles the previous attempts to
create such a science on the ground that its concern was only

with "material things"—weapons, fortifications, the mechanical disposition of an army's movements—and that, excluding the free activity of the mind, it reduced the army to an automaton. His attitude here is therefore much like that which Tolstoy in *War and Peace* gives to the rough but sympathetic Russian general Kutusov—the sense that with the best of chessboard tactics worked out beforehand, the actual battle will be a chaos of ruling cross-purposes and widely divergent individual intentions. For a science of war strives after determinate quantities, whereas in actual warfare all is undetermined, and the calculation must be made with riddling variables.[37] Courage is such a variable, as is hatred and also fear, and in fact all of those emotional forces which are excited by hostility and danger: envy and nobility of mind, pride and humility, brutality and tenderness, and last, and above all, that "soldierly simplicity of character" (*soldatischen Einfachheit des Charakters*) which is perhaps the most characteristic quality of the military profession. The certainties of rational calculation may be an enormous satisfaction to the insecure mind, but the military commander of discrimination knows that in the end it is personal talent and the favor of fortune on which, for lack of objective knowledge, he must depend.

The necessary knowledge for a high military position is therefore distinguished by the fact that by observation, study, it can be gained only by a special talent, an intellectual instinct which extracts from the experiences of life only their essences, as bees do the honey from the flower. This instinct can be gained by experience of life as well as by study and reflection. Life with its rich teachings will never produce a Newton or an Euler, but it may well produce the higher powers of calculation for war possessed by a Condé or a Frederick the Great.[38]

Special talent, intellectual instinct—these are the qualities on which the successful prosecution of warfare depend, and this is why in the proper sense war is neither a mechanical art nor a science, but a form of human intercourse in which the conflict of great interests is settled by bloodshed with all the attendant uncertainties of human life. War is an activity of the will—a question of living and reacting forces—not, like the mechanical arts and sciences, an operation on inert matter. And this is why the attempted application of the methodology of science to warfare—the constant seeking and striving after laws like those

obtainable in chemistry or physics—cannot but lead to constant error.

This does not imply, however, that war is the domain of the amateur. War, as von Clausewitz constantly maintains, is a special profession (*ein bestimmtes Geschäft*) and, as if personally answering Machiavelli across the centuries, he denies the demand of the latter for a simple citizen-soldiery.[39] No matter how carefully we seek to combine the citizen and the soldier in the same individual, no matter how much we may regard war as a concern of the entire nation, and no matter how passionately we may deplore the mercenary armies of the Italian *condottieri*, it will never be possible to dispense with the special nature of a professional routine. And so those who belong to the profession will always look on themselves as a kind of guild or brotherhood, bound by vows and regulations in which the spirit of war is predominantly expressed. Indeed, it would be a profound mistake to deprecate this corporate spirit—this *esprit de corps*—for its center is that conception of pride and self-respect, that feeling for "the honor of its arms" through which military virtue appears as a definite moral power.

Surely one of the most interesting sections in Clausewitz's great work is the early chapters of Book VIII (*Kriegsplan*), in which, under such titles as "Internal Coherence of the Parts of War" and "Magnitude of the Aims of War and of Its Efforts," he sketches his own history of the art of warfare.[40] Beginning with the half-civilized Tartars and the ancient republics, passing through the monarchies and duchies of the Middle Ages as well as the commercial warfare of the *condottieri* and the early Renaissance to the conquests of Charles V and Louis XIV, he arrives at last, at the end of the seventeenth and the middle of the eighteenth centuries, at the appearance of "three new Alexanders," Gustavus Adolphus, Charles XII, and Frederick the Great. But what is interesting is his point of view, for he regards all of these simply as "the precursors of Napoleon Bonaparte." For it is clear that from the point of view of a philosophy of war, he takes the French Revolution as the decisive moment. Before 1789 war is "a regular game in which time and chance shuffled the cards"—it is a somewhat intensified diplomacy, a more forceful way of negotiating in which battles and sieges meant the registering of political intentions. But with the French Revolution war suddenly becomes total, "an affair of the whole people," a desperate enterprise in which entire nations wager their destinies. And this concept of *abso-*

lute war—based on the strength of the entire population, ruthless, where all of war's most violent elements, freed from all conventional restrictions, break loose with the concentrated pressure of their natural force—is the perfected achievement of Napoleon.

There is in Clausewitz' tracing of the art of warfare a certain relativism—a certain recognition that each historical period has its own peculiar forms of war, perhaps also its own particular theory of warfare—but he attempts to surmount this relativism by his insistence that above and beyond the peculiar temporal relations of states and the momentary balance of military power there is always something quite general with which theory must be concerned. And it is both ironic and paradoxical that the element which he stresses is not the post-Napoleonic conception of total war, but the pre-Napoleonic conception of warfare as an intensified diplomacy, as an instrument of political aims which lie outside the sphere of war's intrinsic determination. Already extremely early in his treatise he had insisted that war originates in a political motive and that this motive remains the first and highest consideration in its conduct. Here for the first time appears the formula which has made von Clausewitz famous: *"War is merely a continuation of politics by other means. . . .* It is not merely a political act, but a true political instrument, a continuation of political intercourse, a carrying through of the same with other means." [41] This is the conception to which he finally returns in the renowned Chapter 6 of Book VIII: "Der Krieg ist ein Instrument der Politik." [42]

It may seem paradoxical to find some tincture of humanism in the mentality which created the conception of war as an instrument of politics, and yet I think that there is some claim to an appreciation of value in any enterprise which attempts the just distinction between means and ends. It may be that by granting politics the importance which he does, Clausewitz is himself unwittingly turning into an absolute what a more observant humanism would call only a means, but within the intrinsic limits of his subject matter, he performed an important service. By making war only a fraction of political intercourse, he destroyed once and for all the notion that it was an *independent* thing-in-itself. And he pointed the way to the modern (if equally dangerous) conception that in their political involvement the stages of war and peace are not absolute contraries, but stages within a political continuum which is the matrix for them both. As the cessation of diplomatic inter-

course does not really stop the political relations between hostile states, so war itself is but a symbolic manifestation—a kind of "writing and language" for their thought. And this means that if Clausewitz is actually able to codify the methods of warfare, this is because it has its own grammar, but not its own logic. Its logic is a political logic; therefore in the long run war cannot follow its own laws but must be subservient to those of policy.

Thus politics makes out of the all-overpowering element of war a mere instrument: it changes the frightful battle sword, which should be lifted with both hands and with the whole power of the body to strike once and no more, into a light, flexible weapon which is sometimes no more than a rapier which it uses for thrusts, feints, and parries.[43]

That the political point of view should end when war begins would make sense only in that primitive situation where war was a question of complete annihilation—a struggle of life or death engaged in out of pure hatred. But short of this, politics is the intelligent faculty, war only the instrument, and this entails of course the subordination of the military point of view to the political. Von Clausewitz is a professional soldier and a Prussian patriot whose entire life is dedicated to the understanding and the prosecution of war, but he would be the first to say that it is impermissible and even harmful to leave a great military event or the plan for such an event to military judgment alone.

Of all the conceptions of von Clausewitz, it is surely that of the "politicizing" of warfare which has had the most far-reaching and lasting effect. The correspondence of Marx and Engels of 1857–58 shows that both have read Clausewitz and found him relevant to problems of social revolution. Between 1913 and 1916 Lenin also read *Vom Kriege* (particularly Books I and VIII) with the greatest care, and his notebook (No. 18674 of the Archives of the Lenin Institute in Moscow) contains texts from Clausewitz carefully chosen and annotated. Lenin, of course, concentrates his attention on Clausewitz' doctrine of the relation of war to politics and to Clausewitz' dialectical treatment of the problem of war as a social phenomenon. As is to be expected, he appreciates particularly in Clausewitz those thoughts which had been fertilized by Hegel. Lenin, after reading "War is the continuation of politics," asks "Of what sort of

politics is any actual war the continuation?" thus widening the debate, and showing that Clausewitz himself is but the ante-chamber of politics—not the conference room of politics itself. But in general his marginal notations express enthusiasm and agreement. *Vom Kriege* was one of the two books that he took with him to the July insurrection of 1917.[44]

But if Clausewitz deserves a place in any consideration of the problem of "humanism and warfare" it is not because of his influence on Marxist theory. Rather it is because, although he registered the future, his mode of perception was molded on the past. Living at a period when the advances of scientific technology and industrial production were just beginning to make possible the creation of real mass armies with a greatly accelerated lethal potential, he yet looked back to a more gracious age. Feudal wars were governed by rules of courtesy, by the concept of "knightly combat." And it is not simply by accident that Clausewitz' first metaphorical reference to warfare is to the duel—the model for aristocratic equals. It is a curious image for an age of military democracy in which Napoleon, by recruiting an army of French peasants, can defeat the most highly trained professionals of the Prussian army, but it shows the bias of a mind still under the spell of the concept of "nobility." Clausewitz never attempted to minimize the brutality of warfare—its stark violence and frequent cruelty—but behind it all shines some ray of Enlightenment optimism and confidence in the nature of man. For warfare is still not a matter of machines, but of *persons*. It is grounded not in mechanical necessity but in human *will*. For all its terror, it is a factor in the definition of human civilization, and in the utmost reach of its demand on human resources, it can call out some of the noblest virtues of which humanity is capable.

The Quantification of Tragedy: Herman Kahn

The three figures whom I have chosen to illuminate the theme of "humanism and warfare" can be taken as representative of important moments in the development of Western culture, and they are separated by crucial events in that development which give them individual importance and define their relationship to one another. Between Machiavelli and von Clausewitz lie the French Revolution and the battle strategy of

Napoleon. Between von Clausewitz and Herman Kahn lie the triumph of modern industrial technology and Hiroshima.

It is a fateful divide, and it ushers in the moral agony of the modern world. And it is of particular importance if we would understand the curiously repellent point of view and extraordinary content of Herman Kahn's large and extremely influential work, *On Thermonuclear War*.[45] For the presupposition of that work is the massive change which technology has wrought in the very concept of warfare itself.

It was von Clausewitz' point (and one which would be in accord with the point of view of many living today) that "fighting"—the conflict in which men and nations risk their lives in the pitting of violence against violence for determinate ends— is a primordial phenomenon of human life, grounded in ineradicable passions of the human psyche, issuing in multiple manifestations of the fierce fighting spirit, but subject, for all that, to principles of civilization and rules of honor. It is this subjection which produces "soldiership," for the fierce fighting spirit becomes "soldierly" if curbed for orderly commitment, disciplined by routines of comradeship and loyalty, and placed under the guardianship of personal qualities of courage and self-control.[46] It is almost as if from Thermopylae to Philippi and from Pavia to Waterloo some special moral sense (amplified perhaps by a consciousness of specific masculinity) produced a soldier's ethos for dealing not only with the "enemy," but also with the "defeated," the "innocent," and the "helpless." In ages infected by the cult of pomp this was expressed as conscious "chivalry," but even in less ceremonious times, martial instinct has been subject to regulation by some underlying sense that battles are fought by men, not by beasts, that there are certain contests which are ignoble, certain weapons too barbarous to be permitted, certain acts too inhumane to fall within the scope of civilized behavior. Today, after Auschwitz and Hiroshima, all this sounds like a fairy tale—a myth forever displaced by the events of our immediate past and by the military outlook for the immediate future.

After the First World War, despite the tank, the aeroplane, and the long-range howitzer, there were still novels and treatises which claimed to perceive something like the spirit of medieval chivalry still dimly apparent in the inhuman battle of machines. After the second, after Rotterdam, Dresden and Coventry, Hiroshima and Nagasaki, even this fiction had become bankrupt. The development of weapons technology which pro-

duced dive bombers and fire rockets, and finally atom bombs, nuclear submarines, and the unpublished horrors of a possible biological warfare has worked an irreversible revolution in the concepts of war and soldiership. An intensified mechanization has made obsolete not only the conventional infantry, cavalry, and artillery, but also the publication of warlike intentions (the formal declaration of war) and a compassionate discrimination between civilians and combatants. Combat is no longer combat when one presses a button to launch an infernal engine of death, against which there is no defense, on anonymous victims of all ages and degrees of innocence. In such a universe war has changed from the human contest of combat to the businesslike calculations of technological extermination. And it is within this ambience, cognizant of its presuppositions and keyed to its spirit, that Herman Kahn has written *On Thermonuclear War*.

The point is not simply the contemporary existence of a new strategy of terror, a new and unprecedented distribution of danger. It is rather the corollaries implicit in the idea of mechanization itself which contain the notions of depersonalization and human anonymity. War has always been terrible. And from the wrath of Achilles and the remorseless combats of the *Iliad* until today, violent killing has always been pitiless and inhumane. But the new inhumanity lies rather in this, that once combat is replaced by machinery operating at long range, the killer kills mechanically, the victim is executed anonymously, and the basic fact of moral responsibility becomes obscured in the sheer factuality of mechanical slaughter divorced from its tragic *and experienced* coefficients of suffering, agony, and death. It is this sense of sheer factuality also which Kahn exploits in the three lectures, long, involved, and often repetitious, which make up *On Thermonuclear War*.

He does this however not without some necessary apology and contempt. For to establish the tone from which *On Thermonuclear War* derives its resonance, it is first requisite by an act of sheer will to reject the natural reticences of human feeling. Actually, says Kahn,

when one examines the possible effects of thermonuclear war carefully, one notices that there are indeed many postwar states that should be distinguished. If most people do not or cannot distinguish among these states it is because the gradations occur as a result of a totally bizarre circumstance—a thermonuclear war. The mind re-

coils from thinking hard about that; one prefers to believe it will never happen. If asked, "How does a country look on the day of the war?" the only answer a reasonable person can give is "awful." It takes an act of iron will or an unpleasant degree of detachment or callousness to go about the task of distinguishing among the possible degrees of awfulness.[47]

This "act of iron will" or, alternatively, if you will, "unpleasant degree of detachment or callousness" Kahn proceeds to employ as he distinguishes "tragic but distinguishable postwar states," beginning with 2 million dead and one year required for economic recuperation to the last figure of 160 million dead and one hundred years required for economic recuperation. The chart is little more than an exercise in stoicism, for the numerals chosen are arbitrary; they are based on no research, and at the last moment Kahn himself seems to succumb to an involuntary weakness. For he asks: "Will the survivors envy the dead?" It is a poignant, but (for him) irrelevant question, for in the Kahn universe such forms of feeling must be forever out of bounds. It is not that human consequences are not a part of the calculations of war strategy. They are—and in a new and diabolical form, indeed. For, as he so clearly says, "those waging a modern war are going to be as much concerned with bone cancer, leukemia, and genetic malformations as they are with the range of a B-52 or the accuracy of an Atlas missile."[48] Only the twist of human feeling must be sublimated into the impersonal curiosity of science. "Unfortunately," he tells us, "in order to make some necessary distinctions I will now have to treat some aspects of human tragedy in an objective and quantitative fashion even though some readers will find such treatment objectionable."[49]

Here is the paradoxical crux of the new and contemporary theory of war—the curious intersection of the mathematical mentality and the facts of human suffering, the bizarre meeting of concepts springing, respectively, from the scientific chain of meaning and the humanistic imagination. And the mind rears back as if in the presence of some irrational construction—like the luminous darkness of the mystic or the round square of medieval disputation. For Niccolo Machiavelli the theory of warfare implied the *personalization of conflict,* for Carl von Clausewitz *the instrumentation of policy.* For Herman Kahn it means *the quantification of tragedy.*

Such quantification requires acts of decision-making from which the mind instinctively recoils. So long as Kahn's tables deal with mere scientific probability, there is no problem. It is interesting if terrible to know the predictable consequences of atomic radiation: that from an exposure of 200–300 roentgens we could expect 5 per cent of the population to die, between 350–600 about 50 per cent, and almost everybody at some dose between 600–1000. But the political problems of limited atomic warfare raise issues about the martyrdom of the innocent which reduce the entire mode of perception to a dangerous absurdity. "It might well turn out, for example," writes Kahn with an assurance bordering on smugness, "that U. S. decision makers would be willing, among other things, to accept the high risk of an additional 1 per cent of our children being born deformed *if that meant not giving up Europe to Soviet Russia.*" [50] But *by what right* and according to what principles of judgment could (by "U. S. decision makers," or indeed by any others) such a decision be made? So long as Kahn restricts himself to the vocabulary of strategy (no matter how new and strange that may be) the mind functions according to rules to which the chessboard imperatives of Machiavelli and the more massive formulations of von Clausewitz also conform. To speak of "Finite Deterrence" (whose only strategic objective is to annihilate or punish the enemy reliably) or "Counter-force as Insurance" or "Pre-attack Mobilization Base" or "Credible First Strike Capability" [51] is only to modernize for an atomic and air age what is already implicit in the standard Clausewitz vocabulary of "attack" and "defense." But when this brilliant cerebral play suddenly turns to concrete application, the heart stops and the blood freezes.

Kahn has been playing with the curious notion of a "Doomsday Machine"—a Homicide Pact Machine, whose only function is to destroy all human life on earth including our own, which we might use as a threat against Soviet power, and which Kahn conjectures could actually be built by 1970 at a cost of 10–100 billion dollars. But he brings this dream to a close almost wistfully: "It is most improbable that either the Soviet or U. S. governments would ever authorize procuring such a machine. The project is expensive enough so it would be subject to a searching budgetary and operational scrutiny—a scrutiny which would raise questions it could never survive." [52] And then he turns to the astonishing consequence.

The unacceptability of the Doomsday Machine raises awkward, un-
pleasant, and complicated questions that must be considered by
both policy maker and technician. If it is not acceptable to risk the
lives of the three billion inhabitants of the earth in order to protect
ourselves from surprise attack, then *how many people would we be
willing to risk?* I believe that both the United States and NATO
would reluctantly be willing to envisage the *possibility* of one or
two hundred million people dying from the immediate effects . . .
if an all-out thermonuclear war results from a failure of Type I De-
terrence.[53]

But what of the mentality which is "willing to envisage" the
possibility of 100 or 200 million people dying from the immedi-
ate effects of a thermonuclear war, and on what moral premises
can such a calculus of death and destruction be based? At last
one is forced to the conclusion that such strategic reckoning is
representative of the logical faculty gone insane, and of an
ethical consciousness paralyzed before the forgetfulness of a
merely technical rationality.
 Wallace Stevens begins one of the stanzas of "Esthétique du
Mal" with these interesting verses:

> Victor Serge said, "I followed his argument
> With the blank uneasiness which one might feel
> In the presence of a logical lunatic."
> He said it of Konstantinov. Revolution
> Is the affair of logical lunatics.
> The politics of emotion must appear
> To be an intellectual structure. The cause
> Creates a logic not to be distinguished
> From lunacy. . . .[54]

It is a passage which passes a judgment on the nature of
political revolution. But it is with even greater force applica-
ble, I think, to the kind of intellectual architecture to be found
supporting the conclusions of *On Thermonuclear War*. Kahn's
plea for a discussion of the problems of modern war and peace
on a factual rather than an emotional level has a certain initial
plausibility. But as one "follows the argument" which is to
reconcile us to 100 or 200 million people dying from the imme-
diate effects of thermonuclear war, and of an additional count-
less number of our children being born deformed or doomed to
die early of leukemia or bone cancer, and notes not merely the
unemotionality, but also the total lack of appeal to the canons
of moral value, then one indeed experiences that "blank uneas-

iness which one might feel in the presence of a logical lunatic."
For Stevens is surely right. Though the "politics of emotion"
can be given an intellectual structure, still no politics can
rightfully be separated from human emotion, and to banish the
humane feelings of compassion, sympathy with suffering, and
outrage at innocent deaths in the name of strategic rationality,
is, indeed, to "create a logic not to be distinguished from lu-
nacy."

It is almost as if Kahn's massive retreat before emotionality
were a defense against human problems too deep-seated, too
frightening to solve, for there is little doubt that he takes great
pleasure in a solution which reduces decision as much as possi-
ble to the technical level. If the requirements of an authentic
humanism are too threatening and too problematic, the war
theorist of our time can always take refuge in the mechanical.
"Analytic treatments of war," writes Kahn, "during the last five
or ten years have a real possibility of being more reliable than
the same kind of attempt made in preceding decades. The
reason for this is partly because we have new tools and tech-
niques available, but mainly because in a nuclear war many of
the problems that arise really are problems in physics and
engineering." [55] It is the precise opposite of von Clausewitz'
mistrust of mechanical certainty, but it is clear also that this is
not merely a necessity of the scientific age, but the satisfying
conclusion of one who has *the most serious doubts about the
reliability of the human materials involved.* Kahn's whole elab-
orate picture of the mechanism of strategic defense hangs on
the possibility of complete mechanization and split-second,
computer-controlled decision. After having dwelt on this at
some length he says:

All the above assumes that there is some kind of information-gather-
ing network and data-processing centers that can receive and evalu-
ate information, make decisions, and transmit orders—all in a mat-
ter of minutes or even seconds. It seems to be feasible to build sys-
tems that will do this even under enemy attack.[56]

He then goes on to speculate on the human decision material
with considerable pessimism. Shall we let the President make
the crucial decision? Shall we hold a whole series of Vice-Presi-
dents in readiness? Or is it perhaps too dangerous to leave such
matters in civilian hands at all, and ought not the military to
have the final decision? But such questions Kahn does not

resolve, and it is for a reason which goes to the very heart of the mentality here involved. Though he is apparently completely at home in the mythical realm of engineering projection, Kahn's *psychology* when called on seems to be both crude and totally without scientific support.

This applies with particular force to his constant tendency to underestimate the psychic damage incidental to survival in a serious nuclear war. He is, of course, aware of the potential of physical damage. Megaton weapons may even surpass the gross forces of nature at their utmost—the most powerful hurricane, the most lethal earthquakes imaginable—and this means that for the first time in the history of warfare there exists the special problem of "the post-attack environment." But Kahn's optimism (unsupported by all that we know of the nature of massive human demoralization and the "disaster research" on which it is founded) exhibits both the incredible crudity of his sense of values and the almost manic certainty that nuclear catastrophe cannot destroy the psychological supports of "business as usual." "If," he says, "we assume that people could survive the long-term effects of radiation, what would the standard of living in their postwar world be like? Would the survivors live as Americans are accustomed to living—with automobiles, television, ranch houses, freezers, and so on? No one can say but . . . I believe . . . the country would recover rather rapidly and effectively . . ." [57]

But this unbelievable attempt to reassure us of the eternity of the American way of conspicuous consumption is matched only by the grossness of his psychological optimism. Much of the first part of *On Thermonuclear War* is an attempt to extrapolate the characteristics of the post-nuclear war environment, and some of the more spectacular "tables" which punctuate this section and give it its speciously scientific character deal with such matters as "Radioactive Environment Three Months Later," "Radioactive Environment 100 Years Later," "The Strontium-90 Problem," "The Carbon-14 Problem," "Morbidity of Acute Total Body Radiation," and, finally, "Estimated Production Capacity Surviving Destruction of 53 Standard Metropolitan Areas" (our fifty largest cities, from New York with its 13 million to Newark and Erie with their 200–220,000; these 53 containing one-third of our total population, one-half of our wealth, one-half of our manufacturing capacity, and almost three-fourths of our capacity to manufacture war goods). But the show of mechanical exactitude in the tables

cannot disguise the completely unsupported final summary generalizations. Would not the shock of a nuclear catastrophe so derange people that every man's hand would be against every other man's? "This seems entirely wrong. *Man never lives in a Hobbesian state of nature. There is always a society of some type.*" In either Russia or the United States would not nuclear war with great population destruction end in complete demoralization? "We believe that if either nation suffered large casualties, even of the order of a quarter or *a half of the population,* the survivors would not just lie down and die. *Nor would they necessarily suffer a disastrous social disorganization.* Life would go on and *the necessary readjustments would be made.*" [58]

It is of course true that there is little previous experience on which to base judgments of the nature of thermonuclear destruction and its psychological consequences, but the little we have to learn from the survivors of Hiroshima and Nagasaki hardly supports Kahn's blithe assumptions. His optimism is meant to be reassuring—to slowly condition the mind so that it can contemplate nuclear warfare with equanimity rather than horror—but just this is one of the most frightening features of many to be found in *On Thermonuclear War.*

It is perhaps trivial in considering a treatise on warfare to turn from principles of content to matters of mere style, and yet attention to the idiom in which this book is written reveals an interesting and, I think, significant paradox—one which characterizes much of the material produced by the social sciences of our time. It is *the paradoxical contrast between the austerely "scientific" character of the subject matter and the crude, "folksy" garment of its literary style.* It is perhaps unfair to criticize Kahn too strongly for this, because the company of war theorists in which he has unwittingly been placed is "fast" company indeed! Machiavelli, the Florentine humanist, is one of the great masters of Italian prose style, and von Clausewitz, while certainly no Lessing or no Goethe, is yet the child of the German Enlightenment, and his prose style expresses a straightforwardness and simplicity often bordering on elegance. In contrast, the images which Kahn employs are those which originate at the Saturday night poker game or in street-corner fighting, and this incredible "folk language" as the instrument of a supposedly "technical" treatise of the highest specialization and complication only reinforces that impression of "technological barbarism" which one so often derives from writing in the

social sciences, particularly in contemporary America. One
brief example from Kahn will have to serve, and it not only
illustrates the latent "animism," the crude personification of
complicated entities, so characteristic of the popular mind, but
also the grossness in the type of political "reductionism" im-
plicit in this mentality. Kahn has been using the image of the
poker game—of that serially intermixed "bluffing" and "threat-
ening" in the "game" of international relations and power
politics played between the Russians and ourselves. And he
continues: "In actual fact we do have some very strong cards to
play, but if we do not know what these cards are we may be
tricked out of playing them. If we refuse to accept a facesaving
defeat and the Russians persist in rubbing our noses in the dirt,
then it would be clear to all in NATO that unless we did
something spectacular. . . . etc." [59]

Kahn's world is paradoxical. It has all of the psychological
motivations of the folk society (threatening, bluffing, face-sav-
ing, etc.) dressed up in the machinery of high-speed computer
systems, intricate ballistic calculations, and glossy IBM
efficiency. But just who is this "we" to whom Kahn refers? The
President? The Congress? The General Staff? And just who are
"the Russians"? Kahn's actual political universe is of the most
primitive, where the convenient fiction is maintained that Rus-
sia and the United States are *persons* with every crude element
of personal motivation coming into play. It is a point of view
appropriate to the social science of the age of Sumner, Albion
Small, and Le Bon, but hardly to that of Freud, Max Weber,
and George Herbert Mead!

Card playing and card trickery, saving faces and rubbing
noses in the dirt, may belong in a vocabulary relevant to the
gambler and the juvenile delinquent, but hardly in one rele-
vant to the concerns of the serious diplomat and political policy
maker, and this fact serves, I think, to raise the interesting
question: To what audience is *On Thermonuclear War* ad-
dressed? The answer is not immediately obvious. Delivered
originally as three lectures at Princeton, the materials on which
it is based are those assembled by the RAND Corporation, the
research organization doing technical and policy studies for the
U.S. Air Force.[60] Although therefore purportedly of general
concern to social scientists and policy makers, its content makes
a special appeal to military experts and military personnel.
And this may be responsible for that peculiar flavor of "dou-
ble-talk" and "double-think," of manipulation and insincerity,

of "budgets" and of "persuasion" which is embarrassingly apparent not only between the lines, but almost on every crucial page.

Machiavelli dedicated *L'arte della guerra* to the Florentine patriot Lorenzo Strozzi, and it was written for him and for those other noblemen in whose hands lay the political future of the Florentine state. Von Clausewitz never actually completed *Vom Kriege* and it thus contains no dedication, but according to the foreword written by his wife after his death, it was a work meant for men of the caliber of Scharnhorst and Gneisenau. A part of it had actually been used for the instruction of the Crown Prince of Prussia, and was to find its final utility in the curriculum of the *Kriegsakademie* in Berlin, which was the training school for the flower of the higher officers of the Prussian army. *On Thermonuclear War* is predicated neither on the foundations of Florentine aristocratic patriotism nor on those of Prussian military *esprit de corps,* but on the smoke-filled antechambers of congressional appropriation committees and the internecine rivalries of the corridors of the Pentagon. It therefore contains not only "axioms" and "principles" of a theory of nuclear deterrence, but also practical advice which military men might well heed if they wish to retain their power and the congressional appropriations on which it is based. Kahn has been devoting his attention to one of the persistent nightmares of the nuclear age—the fear of mechanical accident or human rashness, the well-founded anxiety lest any technical failure or unforeseen human weakness unleash the catastrophe. And he then says:

To repeat: On all these questions of accident, miscalculation, unauthorized behavior, trigger-happy postures, and excessive destructiveness, we must satisfy ourselves and our allies, the neutrals, and, strangely important, our potential enemies. Since it is almost inevitable that the future will see more discussion of these questions, it will be important for us not only to have made satisfactory preparations, but also to have prepared a satisfactory story. Unless everybody concerned, both laymen and experts, develops a satisfactory image of U. S. strategic forces as contributing more to security than insecurity, it is most improbable that the required budgets, alliances, and intellectual efforts will have the necessary support. To the extent that people worry about our strategic forces as themselves exacerbating or creating security problems, or confuse symptoms with the disease, we may anticipate a growing rejection of military preparedness as an essential element in the solution to our security

problem and a turning to other approaches as an alternative. In particular, we are likely to suffer from the same movement toward "responsible" budgets, pacifism, and unilateral disarmament that swept through England in the 1920's and 1930's.[61]

Here is not only a point of view to which all efforts toward pacifism and disarmament must seem like weakness if not treason, but also where "public relations" loom large; where it is important "to have prepared a satisfactory story," to have "developed a satisfactory image" of our armed forces, lest budgets, alliances, and efforts be no longer forthcoming, and lest men turn to other alternatives than an escalating arms race—to dreams of peace, and perhaps (horror of horrors!) even universal disarmament. It is in passages like this that Kahn unwittingly "gives the whole show away" and testifies conclusively that what purports to be impersonal social science is, in fact, but the propagandist tool of essentially militaristic interests. But it is interesting for another reason also—not merely because it compromises the reliability of what pretends to be "the conclusions of science," but because it uncovers *the mechanisms of the manipulative mind at work*. Between the man of science and the man of power the gap is unbridgeable. No one has expressed this better than Walter Lippmann:

It is only [he tells us] knowledge freely acquired that is disinterested. When, therefore, men whose profession is to teach and to investigate become the makers of policy, become members of an administration in power, become politicians and leaders of causes, they are committed. Nothing they say can be relied upon as disinterested. Nothing they teach can be trusted as scientific. It is impossible to mix the pursuit of knowledge and the exercise of political power and those who have tried it turn out to be very bad politicians or they cease to be scholars.[62]

It is important to stress this fact because Kahn so relentlessly insists on the scientific nature of his investigations, and so ostentatiously presents the full paraphernalia of graphs, charts, and tables which customarily grace the laboratory reports of physicists and the scholarly publications of the social scientists. The stance which he assumes—that of presenting a scientifically coherent body of doctrine in support of a theory of nuclear deterrence—is that of a whole new class of "social scientists" on the American scene (Henry Kissinger, Thomas Schell-

ing, Oskar Morgenstern, and Albert Wohlstetter among them)
who pretend that *the conclusions of science* support a particu-
lar alternative in the spectrum of national strategy. It is a
hollow pretension, indeed, to believe that science can analyze
and prescribe a proper course of political and military behav-
ior, and it is an error of which von Clausewitz, with all of his
mistrust of the logical, the necessary, and the mechanical in a
theory of warfare, would never have been guilty; but it follows
inevitably from that fantastic overestimation of human ration-
ality and contempt for feeling which lies at the heart of Kahn's
intellectual method.

The assumptions which underlie *On Thermonuclear War*
are simple to identify. They are the following: (1) that modern
warfare is a perfected science—indeed, a "social science,"
(2) that decision-making is a completely rational process or, at
least, that with a little care it can be made so, (3) that the
assemblage of the data of decision-making, the grounding of
decision, as it were, can be turned over completely to machines,
and (4) that the "tragedy" implict in the effects of thermonu-
clear war may be so quantified that it need have no emotional
impact. These are assumptions which are in contradiction to
every basic tenet of the classical tradition in the theory of
warfare, whether expressed in the Roman theorists, the treatises
of the *condottieri,* in Machiavelli or von Clausewitz, and the
fact that they are currently powerful and persuasive indicates a
"humanistic" crisis in the very theory of warfare itself. For the
paradoxical consequence of the separation of "rationality"
from "value" and, on the other hand, of the confusion of "sci-
ence" and "policy" is to enthrone the manipulative point of
view in the center of the human psychology, and to redouble
the rationalistic effort at the very moment when one has con-
veniently forgotten its humanistic aim.

It is very clear that Herman Kahn does not agree with the
assessment of Walter Lippmann presented above; that for him
there is indeed no serious problem of conflict between the
disinterested acquisition of scientific knowledge and the practi-
cal presentation of a single policy alternative. It would be false
to say that for him there is no problem. There is. But the
practice of his peculiar form of intellectual diplomacy in these
matters glosses over the difficulty in such a way that the prob-
lem is taken out of the realm of the ethically problematic and
placed simply in the domain of "timing" and of "tact." There
is, admits Kahn,

a serious and only partially reconcilable conflict between the "politi-cian" and the "educator." There are many occasions when the first is trying to diffuse issues . . . so that diverse groups will find it possi-ble to support him. On these same occasions the second may be trying to make the issue sharper so that people will understand in-tellectually what the choices are. It is clear that both things have to be done; often the only question is emphasis, timing, and place. With care it is not difficult or unethical for responsible people to practice this form of double-think without doing any harm.[63]

The curiously self-defeating consequence of this espousal of "the manipulative point of view," this failure to see a crucial and unbridgeable gap between the educator and the politician, is that it operates reflexively, that it makes us wonder whether Kahn himself in *On Thermonuclear War* is operating as "edu-cator" or as "politician," or, since the roles are in his opinion so interchangeable, when he is undeniably one rather than the other. What if his exhortations to the military are really "edu-cation"? What if the whole elaborate apparatus of his charts and figures is only "politics"? The questions are not rhetorical, for there is evidence of this dangerously manipulative point of view in every crucial issue of modern thermonuclear politics which Kahn treats. Arms control? Go along with it, Kahn tells the military,[64] for in the end it will not mean disarmament or a neglect of the armed forces. In fact, intelligent interest in it is likely to increase their influence. Fear of war? Finite deterrence advocates believe (rightly enough) that there is a "residual fear of war" even in a "reliable balance-of-terror situation". Good enough, says Kahn, "We may want to manipulate this fear of war—to have more or less of it." [65]

Every human hope, every human fear becomes a lever of command, a possible pawn in a power struggle to achieve ends never subjected to the light of moral criticism. Indeed, the most striking feature of *On Thermonuclear War* is that nowhere in its entire six hundred pages is the question raised of the "moral-ity" of total war, of the technology of extermination, of a concept of massive retaliation which makes no distinctions of guilt between decision-makers and decision-followers, the weak and the powerful, the combatant and the innocent.[66] Although there is already a considerable literature on "the morality of obliteration bombing" and "the ethics of extermination",[67] *On Thermonuclear War* has been written as if this did not exist, with the tacit assumption rather that what is "rational" is

therefore *ipso facto* "ethical." The conclusion is even more astonishing than Hegel's famous equation of the rational and the real, and with consequences no less serious for a humanistic theory of ethics. That a treatise which pretends to be not merely "social science," in the old-fashioned theoretical sense, but also a model of "policy science" can treat the most problematic question of moral value in the modern world as if it did not exist, is itself implict indictment of the pass to which the theory of warfare has finally arrived in our time.

Machiavelli did not minimize the sufferings of warfare, but he gave it explicit justification as a means for the unification of Italy and the restoration of the Roman virtues. Von Clausewitz did not deny the role which cruelty and hate played in war's primitive foundations, but he hoped that courage in the presence of responsibility would elevate the inevitable at last to a plane of moral grandeur. Herman Kahn is the final and frightening consequence not only of a technology gone mad, but of a "rationality" which has reached the stage where it prefers a logic to an ethics, machines to persons, and the operations of mechanical necessity to the freedom and responsibility of the human will.

The three figures whom I have chosen to illuminate the theme of "humanism and warfare" do, as I have said, form an interesting continuum in the expression of attitudes toward violence which has characterized the tradition of western culture. But I am aware too that there is a certain paradoxical contradiction in the very phrase "humanism and warfare," which I have chosen for the title of this chapter. Are not the very concepts of "humanism" and of "warfare" so opposed to one another that they cannot rightfully be combined? And is not the characteristic attitude of an earlier humanism the correct one—that of Montaigne who viewed the civil wars of religion in France with horror, or of Erasmus, that passionless, cool-headed, and fair-minded man who yet reserved all the resources of his satire and invective for the warlike violence he abhorred?

In the light of a purely philosophical consideration, this must indeed be granted, and the proper point of view in these matters is surely that of the intellectual and moral purity of Simone Weil, who, in her fascinating essay "The Iliad, or The Poem of Force," [68] has said the last word on the subject. Between "hu-

manism" and "force" there is irreconcilable contradiction because force is that very "x" which turns anybody who is subjected to it into a *thing*. "Exercised to the limit it turns man into a thing in the most literal sense: it makes a corpse out of him. Somebody was here, and the next moment there is nobody here at all. . ." And from this first property of force (the ability to turn a human being into a thing by the simple method of killing him) flows another—quite prodigious, quite lethal in its own way, too—the ability to turn a human being into a thing while he is still alive. This is the consequence of force as fear and servitude. It is this "force" with which the *Iliad* deals—force that kills, force that enslaves, force before which human flesh shrinks away. Such is the nature of force, and its power of converting a man into a thing is a double one, and in its application double-edged. To the same degree, although in different fashions, those who use it and those who endure it are turned to stone. It engenders bitterness—the only justifiable bitterness—for it means the ultimate subjection of the human spirit to matter and necessity.

To think in this way is right, and it exhibits a purity from which we have all fallen. Perhaps someday we shall learn not to admire force, not to hate the enemy, not to scorn and mistreat the innocent and the unfortunate. But this is not the morally ambiguous and materially corrupt world in which we live, not the world of Machiavelli or von Clausewitz or Herman Kahn, and in dealing with these, I have chosen to explore not the possibilities of "humanism" in its spiritual purity, but humanism as it may condition actual practice, as it impinges on the most inhumane of all human activities—the act of war. For even here, as I have tried to show in the case of Machiavelli and von Clausewitz, there is a *residual* humanism—an attempt to humanize by moral purpose and ethical enlightenment an act which otherwise would be one of sheer brutality.

But I have shown too, I think, a certain progressive deterioration in the relevance of humanism to warfare in the modern world, as if the very conditions of technology had worked for the dehumanization of man. War is human as it is personal, as men struggle face to face, kill, and see the agony of their antagonists, as they feel both the responsibility and guilt which are the indubitable marks of the human condition. There is then a profound difference between "fighting at arm's length" and "fighting at earth's length," between combat and extermination, and the physical question: "At what distance does one

engage the enemy?" has a curious degree of moral relevance. And it is not therefore without significance that the war treatise of Machiavelli is written in the age of the short sword and the pike, that of von Clausewitz in the age ushering in the intermediate range rifle and the field howitzer, that of Herman Kahn in the age of the long-range bomber and the intercontinental ballistic missile!

Today we are living in an Alexandrian age, one in which science rather than the humanistic imagination stands triumphant, and the consequences in political insecurity and nuclear terror are plain for all to see. The heritage of Prometheus and Faust seems all too apparent, and the only vital question is whether our scientific hubris is to usher in a new age—or the end. Almost exactly one hundred years ago, on April 7, 1869, the brothers Goncourt made an extraordinarily interesting entry in their *Journal.*

At the Magny dinner they were saying that Berthelot had predicted that a hundred years from now, thanks to physical and chemical science, men would know of what the atom is constituted and would be able, at will, to moderate, extinguish, and light up again the sun as if it were a gas lamp . . .
To all this we raised no objection, but we have the feeling that when this time comes in science, God with His white beard will come down to earth, swinging a bunch of keys, and will say to humanity, the way they say five o'clock at the Salon, "Closing time, gentlemen." [69]

The hundred years is up, and the utterance, while not completely exact, has turned out to be prophetic. The nuclear avalanche is upon us, and once again science has triumphed. The only question is, will Mars with his black beard and swinging his sharp sword come down to earth, saying to humanity, the way they say five o'clock at the Salon, "Closing time, gentlemen"?

Nine / Art and Politics:

The Continuum of Artistic Involvement:

Picasso, Brecht, and Pasternak

IN THE latest published volume of her "Memoires," *La Force des choses,* Simone de Beauvoir speaks of her visit to Yugoslavia in 1954, and of her meeting with Yugoslavian intellectuals in Beograd:

Socialism and literature, art and commitment, we talked about the classic problems, but the writers of Beograd had a special one of their own—most of them, influenced recently, in fact, almost branded by surrealism, asked if and how it could be integrated with popular culture. "Now that with us socialism is accomplished," observed a novelist, "each is free to write according to his own phantasy." The others protested. For it was impossible to hide from us that the country was even now experiencing great difficulties. Collectivization had run aground—the peasants had practically committed murder to prevent it.[1]

The passage is extremely interesting, but I am less concerned with its specific reference to Yugoslavia than with the more general issue which it raises. "Socialism and literature, art and commitment"—truly these *are* the classic problems of the artist of our time, but to ask how so esoteric a movement as surrealism is to be integrated with popular culture in a socialist state is to presuppose an entire theory of "mass" and "intellectual elite" which is by no means restricted to the socialist economies. Furthermore, the last remark which she quotes has singular connotations. The implication is that, with socialism accomplished, the freedom of the artist is assured, while, with the

issue in doubt, restrictive measures of a rather severe kind are justified and in order. Just as one often says of a capitalist entrepreneur who has become a paragon of respectibility: "He has reached that stage of success where ethics has finally become feasible," one can now say of socialist society: "It has finally reached that stage of success where the civil liberties (and particularly the freedom of the artist) have become feasible." In either case the position is, I think, contradictory and indefensible. The civil liberties and the liberty of the artist with them are inalienable rights of *man as man* and not of citizen as citizen, and this follows neither from a traditional eighteenth century doctrine of "natural rights" nor from a nineteenth century theory of "social utility," but from a doctrine of cosmopolitan "humanism" which must, I believe, in the twentieth century supplant them both.

The chief issue—the classic issue—is, of course, that of the relation between art and politics; whether they are independent and autonomous, or whether they are not rather related, respectively, as means to ends, as intrinsic to instrumental value, and in this case, what is the proper construal of their subordination and dependence. But before we leave Mlle de Beauvoir, it will be instructive to remember that she herself (vastly inflenced by Sartre, to be sure) has taken a stand on these matters, and perhaps to see in her more recent despair the bankruptcy not only of the particular existentialist stance which she has learned from Sartre, but, in addition, of that theory of literary "engagement" which denies autonomy to the arts and makes of them mere handmaidens to the higher art of politics.

During the French Algerian crisis, Mlle de Beauvoir tells us, her political disappointment reached epic proportions, but curiously her disgust vents itself equally on literature and art. She is sick with hatred of those who follow de Gaulle and his North African policy, but since this means most of France, she turns bitter against the French and with them the entire domain of the arts.

I detested the neighborhood where I lived, and it sometimes happened that I went three whole days without going outside. I no longer listened to music: I was too exasperated. I read, but scarcely any fiction. Literature, what I had written as well as that of others, disgusted me with its insignificance. So many things have happened since 1945 and of this it has expressed almost nothing. Later genera-

tions who would understand our time must consult works in sociology, statistics, even simply the newspapers.[2]

The crucial point here is Mlle de Beauvoir's criterion of literary "significance," and it is clear from the context that this is narrowly political. For, with an explicit reference to Sartre's distinction between "the literature of production" (*litterature engagée*) and "the literature of consumption" (*littérature de la consommation*), she proceeds to excoriate "the New Novel" in France and the efforts of its authors, Robbe-Grillet, Sarraute, and Butor, because, as she asserts, for this school "the Revolution has fallen through, the future is shunned, the country founders in the apolitical, and man comes to a standstill." Behind it all is that fanatical faith in historicity which Camus has identified so well—the fear that when the arts are shorn of their political instrumentalism, life is deprived of its historic dimension, and they themselves return to the isolation of their ivory tower. As her horrible example Mlle de Beauvoir repeats a sentence which she heard Nathalie Sarraute utter in Moscow. "When I am seated at my desk," said Mlle Sarraute, "I leave politics at the door, as well as the world and its events: I become another person." Here is the precise opposite of the identification of literature with politics, and it constitutes, says Mlle de Beauvoir dogmatically, a mutilation of both writing and the self; it symbolizes the defeat of France in the modern world—her impotence, her passivity, her degradation!

I do not wish to dispute with Mlle de Beauvoir either her evaluation of the New French Novel or of the current status of France as a world power, but only to demonstrate how the identification of literature with politics lays the foundation for an unnecessary disillusionment with the arts, growing perhaps out of the megalomania sometimes exhibited by Sartre himself, namely the belief that the artist single-handedly may change the course of history. Too much ambition in this regard leads not unnaturally to the bitterness and disgust of failure, and one may wonder if the current disillusionment of both Sartre and de Beauvoir is not less the fatigue of age than the consequence of a mistaken constellation of values. For in the end politics is nothing in itself. It is a collection of techniques for the achievement of the good society, and the very meaning of the good society is that in which the expressions of man's best nature may have free rein. But the arts are one of the chief agencies of this expressiveness, and the humanities—*litterae humaniores*—

are one of the chief consummations of society, not simply its instrumentality. It is not surprising that Mlle de Beauvoir should, like so many of us, have experienced that perverse dialectic of art and politics, fact and fiction, of exquisite hopes and cruel realities, of beauty and suffering, but it is indicative of her own bankruptcy of values that in the end she should have so little faith in the very arts to which she has devoted her life. Her epilogue to *La Force des Choses* is one of the saddest documents of our age, but no passage is more revealing than that in which she speaks about art.

Often also I detest it. The evening of a massacre I listened to an andante of Beethoven and I stopped the record in anger; it contained all the misery of the world but mastered, and sublimated so magnificently that it seemed merely justified. Almost all works of beauty have been created for the privileged, by those privileged who, even if they suffered, have had the possibility of giving meaning to their suffering: but they have disguised and hidden the scandal of naked suffering itself. Another evening, I have wished to destroy all these lying things of beauty. Today the horror is far away. I can listen to Beethoven. But neither he nor anyone else ever gives me any more this impression that I used to have of touching something absolute.[3]

It is a pity that Mlle de Beauvoir reads into art a justification of the misery of the world and sees it as a mere disguise for "the scandal of naked suffering." For, in truth, it is neither. The requirement of giving meaning to suffering is by no means a monopoly of the privileged classes, if one means this word in its economic sense. But it *is* the case that the formalization and distanciation achieved in all great literature, and particularly tragic literature, is one of the gifts of art, and it is a mark of the sublimity of Beethoven and Racine and Shakespeare that they can perform this function through their very mastery of experience. It is a sign of Mlle de Beauvoir's superficiality that she cannot realize that since metaphysical evil is inescapable, tragedy is written into the very structure of the world. Things fade, alternatives exclude, potentialities remain unrealized. And the consequence is that there is an unalterable bias toward suffering, inhumanity, and destruction implicit in the nature of human life. But art and life are singularly different, and it is a curious misunderstanding to demand of the former always an immediate rather than a distanced view of the latter. There is a profound difference between "the tragic evil" and "the gross evil," and if in Mlle de Beauvoir's case the immediacy of the

latter blinds her to the beauties of the former, it is because she is a victim of that shallow optimism which believes that all human evil can be remedied by politics, and that literature fulfills its only function when it serves the cause of political transformation. It is a mistake to forget that the arts also serve the cause of purely human as opposed to exclusively political values, and one will always lose in art "the impression of touching something absolute" when one is reduced to considering it as an ideological weapon and not an end in itself.

I have appealed to Simone de Beauvoir and her *Mémoires* to raise the problem of literature and politics, not to solve it, for, in truth, the issue is far more complicated than it appears in her consciousness. For it constitutes a permanent dilemma present not only in the internal behavior of political states, but in the internal consciousness of the writer. Thirty years ago someone put the question to Paul Valéry and his answer ("Réponse à une enquête sur la chose littéraire et la chose pratique") is still a classic formulation of the perplexing alternatives:

If, for example, we see in *literature* an opportunity to explore something in ourselves that is entirely our own and can be dealt with by no one else, a peculiar need to develop in oneself the relations of thought and sensibility with language, a "sport" (sometimes strenuous) that requires the exercise of almost all the powers of the mind; and if, on the other hand, *politics* seems to us a practice amounting necessarily and wretchedly to nothing but expedients, obliging us to say emphatically what we could not possibly think, to promise the impossible, to speculate on credulity, enthusiasms, instincts, and all the human weaknesses or illusions, constraining us to reckon with fools, to flatter people who repel us, to depreciate the man we esteem, and to be party to a "party," which means consummating every day the *sacrifice of the intellect* . . . and all this for the sake of winning or keeping "power" whose possession in every imaginable case will be but the *experience of helplessness* . . . then we shall find that a man caring for true value will have nothing to do with events, and must shut himself up in his Ivory Tower.

But if we consider literature to be a means of influencing great numbers of unknown people, an enterprise aiming at advantages that depend entirely on public opinion at the moment, then it is very close to politics as represented below. On the other hand, a certain way of considering the latter so as to embellish and ennoble it would be sufficient to lift it above pure literature. One would invoke the public weal, justice, the good order of the city, etc., etc., and one's duty not to lose interest in these great things.

In short, there is no solution applying to everyone, but rather individual decisions that depend on one's character and circumstances, for here reason can decide nothing.[4]

Valéry is, I believe, right that there is no universal solution, that objective reason can decide nothing, that the decision can only be individual. For at almost the same moment that M. Julien Benda is excoriating the "treason of the intellectuals" for taking sides in matters of political involvement and using their writings to "stimulate political passions," Lenin is arguing that all literature must be "Party literature" geared to the cause of the proletariat, striving to overcome its ancient heritage of "bourgeois individualism" and "aristocratic anarchy." Benda's rhetoric of "treason" and Lenin's of "anarchy" are equally intemperate, and their vehemence only underlines Valéry's insistence on the powerlessness of reason to adjudicate the quarrel. For indeed underlying the dispute is a profound difference in meaning which one gives to the concept of "the political."

The relations which politics may bear to literature are at least threefold. They may consist (1) in the motivation which animates the writer, (2) in the nature of the themes which he chooses for development, and (3) in the social consequences, proximate or ultimate, which his writings may have. As to the first, there is no necessary impingement of the political. In fact, it is probable that the origins of the literary impulse are closer to private than to public wellsprings. A truly creative writer draws on sources which lie far below the level of merely rational thought. Therefore, even for those writers like Gorki or Aragon or Brecht, who join a political party to which they acknowledge a deep spiritual commitment, that commitment, while it may provide incentives to write and may even determine the choice of theme and subject matter, is still largely irrelevant to the originality of their creative impulse. All art conveys a sense of life and a vision of the world which imaginatively renders facts of nature and society into a representation rich in color and vitality. But this vividness of the imagination feeds on freedom. So long as a political ideology frees and stimulates the creative imagination it will be a brilliant matrix for the production of literature and art. But unfortunately it is the fate of most political ideologies to be narrow, to misrepresent and oversimplify the complexities of the world, to insist on the rightness of but a single way, to fanatically constrict those

operations of the imagination on which art feeds. And when this is the case (with either Marxist dogma or any other narrow ideology), then what demands for its health the infinite freedom of fantasy is forced into the rigid framework of an intellectual creed which nullifies its power. This is why there is so seldom a fruitful symbiosis between political insistence and creativity in the arts. Art and literature thrive on "subjectivity."

In Valéry's phraseology, few writers are directly concerned "to promote the public good"—rather, they find in the literary experience "an opportunity to explore something in themselves that is entirely their own." This, I think, is true of Mann and Hemingway, Yeats and Ezra Pound no less than of Joyce and Proust, Rilke and T.S. Eliot, where the subjectivity is obvious and essential. It may well be that we have at this level the eternal opposition in social life of solid institutionalism to the lyricism of the purest privacy. Writing will always be an act close to the purely private sense of authority—the individual imagination and its conscience—and writers will always object to the attempts of public authority, either legally constituted or informal, to coerce the direction of their creativity.

In this resentment they are, I think, solidly based in the humanist tradition, which has generally asserted the principle of laissez-faire—not primarily as an economic, but as an intellectual and a cultural prerogative. Philosophy and the arts both breathe the air of freedom, and this means a reliance on that elbowroom of the spirit where political intervention and social imperatives are at a minimum. Justice Brandeis spoke of "the right to be let alone—the most comprehensive of rights and the right most valued by civilized man." It is a right particularly valued by writers and artists—in capitalist and in socialist countries alike—and it springs from the heart of every humanist conception of civil liberty: not the demand for private property, but the demand for proper privacy!

As for the themes which the writer chooses for development, these may or may not be political. Shakespeare's history and Roman plays, as we have seen, show a decided interest in problems of the royal succession, of political legitimacy, and of political treason and usurpation in its manifold and sinister occasions, but his sonnets are as personal, as preoccupied with the crises of the private life as the most romantic of lyric poets. Goethe in his drama occasionally adopts a political theme (as in *Egmont*) but somehow manages to sink the political possibil-

ities in private preoccupations, whereas Schiller's work is suf-
fused with the sense of the political, and however the passionate
confusions of the private life pervade *Don Carlos, Wallenstein,*
or *Maria Stuart,* it is their political ambience and implication
which haunt the consciousness of the spectator. Brecht can no
more write an apolitical play than Anouilh or Pirandello can
write one with a truly political center. With respect to theme,
therefore, there is no generalization which either explains the
relationship of literature and politics in the past or is adequae
to legislate for the writer of the future.

When we come to the matter of the political and social
consequences of literature, we are in the most problematic area
of all. Presumably consequences should be intimately related to
literary intention. Brecht and Piscator and Meyerhold postu-
lated a "political theater" where all the devices of modern
dramaturgy were to be used to overcome the bourgeois limita-
tions of the so-called Aristotelian "theater of illusion." And
Brecht, as we have also seen, is the author of an elaborate (and
not always consistent) theory of non-Aristotelian drama or
"epic theater" where the aim is not to purge the spectators of
emotion, which leads to quiescence, but rather to turn the stage
into a forum of political discussion, mobilizing social judg-
ment, arousing indignation at the facts of human injustice and
class oppression, and, in the end, preparing for concrete social
action. Brecht once described the old theater of illusion as
Marx described religion—as "a branch of the bourgeois drug
traffic"—and it is clear that his dramatic theory exemplified a
new rationalism: to extirpate illusion, emotionalism, and
magic from the proscenium arch, and to supplant it with indig-
nation, dissatisfaction, and a realization of the contradictions
in social life. And yet, as has often been pointed out, the factual
consequences of Brechtian theater have been paradoxical in-
deed. Brecht's intention was that epic theater, by appealing to
the critical faculty of the audience, would turn the theater into
a laboratory of revolutionary enlightenment, and that the in-
dignation of the audience would automatically lead it to em-
brace the Marxist alternative. In fact it has been otherwise.
The plays of Brecht have never been popular within the Soviet
Union, while those in the bourgeois world who have seen *The
Caucasian Chalk Circle* or *Galileo* have never dreamed that the
first was other than a folk fable and the second a rather tame
defense of freedom of thought. And as for East Berlin, Brecht's
final home, as Martin Esslin the Brecht critic has so wittily

said: "The East Berlin audience who followed the adventures of Mother Courage and saw poor dumb Kattrin raped by the brutal soldiery, knowingly compared what they had seen in the theater with their experiences with the Russian soldiers, and concluded that in fact human nature had *not* changed . . ." [5]

Brecht's distinction between a theater which will by catharsis syphon off emotion and one which by stimulating it will prepare for political action is oversimple. But even if the nonpolitical dramatist writes to make people *meditate* or *imagine,* and the political dramatist to make them *act,* there seems to be no true causal relation between intention and consequence. The writer who intends a specific influence may have one directly contrary to his intentions, while even the pure thinker or creator may unintentionally produce profound changes. "It sometimes happens," said Valéry, "that the Ivory Tower unknowingly sends out powerful waves. Nothing is more remarkable than to see that ideas, separated from the intellect that conceived them, isolated from the complex conditions of their birth . . . can become *political agents, signals, weapons, stimulants*—that products of reflection may be used purely for their value as provocation." [6] And he cites the examples of Fichte, Hegel, Nietzsche, Gobineau, and Darwin to substantiate his case.

The problem of the relation between art and politics is one which haunts the history of Western culture. It is implicit in the story of Euripides' exile from Athens after the writing of the *Trojan Women,* in the troubled relations between Leonardo da Vinci and his royal patrons from the Duke of Milan to Francis I, in the curious destiny of the painting of Gérard and David during the dictatorship of Napoleon, and in the latter's efforts to control the writing of French history after the battle of Jena. But this problem, which arose in scattered and sporadic form before the nineteenth century, has reappeared with concentrated and dramatic urgency in the Marxism of our time. For this there are several reasons.

First of all, for Marxism, art is an unconscious witness to the "truth" of all former social relations. The plays of Shakespeare reveal the contradictions in the feudal past, as those of Racine and Molière indicate the rise of the bourgeois spirit in an atmosphere of absolute royal authority. The paintings of Hieronymous Bosch reveal the underlying social malaise of the late Renaissance as those of Pieter Brueghel exhibit the latent power of the northern proletariat in the sixteenth century. But

this Marxian insight into the way in which literature and works of art "bear social witness' is itself the consequence of a new sociological awareness, of a new seriousness toward temporality and history which results in viewing all particular cultural objects as being rooted in time and conditioned by economic and social circumstance. This holds no less for contemporary works than for the masterpieces of former times.

But there is another reason: It is that whereas in former ages (and even today in some capitalist nations of the "free world") art is viewed either as peripheral entertainment or mere cultural decoration, for the Marxist nations it is taken with the most desperate seriousness. One recalls the sentence of Voznesenzki that Simone de Beauvoir heard at a literary mass meeting in Moscow: "La poésie, c'est la forme que prend la prière dans les pays socialistes." (Poetry is the form which prayer takes in socialist countries).[7] And George Steiner has emphasized the other side of the same coin: "In a communist society the poet is regarded as a figure central to the health of the body politic. Such regard is cruelly manifest in the very urgency with which the heretical artist is silenced or hounded to destruction."[8] Thus, because Marxism is serious about the arts, and also because in the course of its history it has actually found it necessary to develop a theory concerning the relationship between art and politics, any treatment of this problem in our time must draw heavily in its documentation on the Marxist experience.

If we turn to the classic Marxist texts for light on the relationship between literature and politics, we shall find a multicolored and by no means consistent body of theory. And if we then compare this theory with the historic practice of a socialist state—for example, that of the Soviet Union—we shall be even more bewildered by the enormous role which seemingly arbitrary factors play in the interpretation of the place and function of literature and the arts. But as a rough summary this can be said. The attitude of Marx and Engels toward literary freedom is not significantly different from that of classical liberalism. With Lenin it grows increasingly circumscribed and authoritarian as socialist theory comes closer to the immediate problems of the seizure of power. Soviet practice begins in the more doctrinaire atmosphere of Lenin; with Stalin it becomes arbitrary, tight, and totalitarian, and only after Stalin's death does it loosen as writers themselves demand that freedom without which their creativity is stultified and enslaved. I think it can

be said therefore that the combination of the provisional character of early Leninist theory with the despotism of the Stalin era has bequeathed to socialism in general a theoretical problem with respect to the relationship of literature and politics which independent socialist nations like Yugoslavia—and even those more tightly bound within the Soviet orbit, like Poland and Czechoslovakia—are currently trying to solve. But even these attempts are, I think, wavering and ambivalent, and as an example of this, I will turn finally to the case of Adam Schaff.

The early Marxist texts are full of explanations of the way in which philosophy can be serviceable to the proletariat, of the relation which ideas bear to class structure, and of the economic basis of the ideological superstructure. There is, however, almost nothing about the condition of the writer as such. It was only the institution of a new Prussian press censorship in 1841 and the threat of a similar one by the Rhenish Diet in 1842 that moved Marx to some trenchant, and extremely important, observations on the freedom of literary creation.[9] Quoting with enthusiasm a text of Buffon, *"Le style, c'est l'homme"* (part of an address delivered to the French Academy in 1753), Marx asserts that the writer's mode of perception and expression is *his private property*—that which constitutes his spiritual individuality—and he then proceeds to excoriate a law which permits one to write, but only on condition that one assumes a style other than one's own. It is, says Marx, a violation of the spirit that it should be allowed only one mode of existence, as it would be a violation of nature to decree that it should express only one color—"the official color." "Grey upon grey"—that is, the color decreed by the official press censor! On the contrary, what the spirit needs are light and diversity, for truth is always of its essence and multifarious is its message.

The idea here is clear and, although uttered by Marx in 1842, it expresses perfectly a classic liberal doctrine which humanism has always put forward in the eternal struggle of the individual against the constrictive uses of state power. In the same year, in a series of articles for the *Rheinische Zeitung* (also directed against the threatened press censorship) Marx further asserted that literature itself is intrinsically valuable. "The writer does not consider his works in any sense as a mere means. They are *ends in themselves,* so little a means either for himself or for others that he will sacrifice his existence for theirs should it be necessary." [10] It is certainly true that the context in which this passage occurs shows Marx to be defending literature

against commercial debasement, and asserting the right of the litterateur to freely follow his own way and his ideal rather than to sell his talent against his will, but the *principle* is not different in its application to either economic *or political* exploitation. If works of literature have intrinsic value, then they are not primarily means in the service of either economic success or ideological purity, and they should no more be subject to the whims and caprices of party functionaries than of capitalistic editors. Marx's first insights about the nature of literature are the purest, and in not following these principles where they lead, subsequent Marxism has made a travesty of the humanistic imperative.

It seems clear that in his consideration of literature, Marx is guided by the same model which controls his thoughts about productivity in general. If the relationship between the agricultural or industrial worker and the product of his labor is intimate, how much more intimate is that of the writer and his literary creation, where the product is not merely the fruit of a manual dexterity, but of the very spirit itself? And if (as was the burden of the argument of Marx's *Economic-Philosophic Manuscripts*) alienation can corrupt the intimacy of worker and artifact, how much more sinister is that which corrupts the intimacy of the creative spirit of the writer and his output? In an early work on surplus value, apropos of the distinction between productive and unproductive labor, Marx has uttered a fascinating aside about the great English poet John Milton. "Milton," says Marx, "produced *Paradise Lost* as a silk worm produces silk. It was a manifestation of his very nature. Only later did he sell his product for five pounds sterling. But the proletarian writer from Leipzig who, at the orders of his editor, fabricates books (for example, manuals of political economy) is a productive worker, since his production is, from the beginning, subordinated to capital and only undertaken for profit." [11] There is much here to be read between the lines. But Marx's respect for true genius and his contempt for hack work are unmistakable. Great literature is a manifestation of its author's nature: it cannot be produced on order and according to specifications by any editor, capitalist or socialist!

More than sixty years separate Marx's reflections on Prussian censorship and Lenin's celebrated article of November 13, 1905, "Party Organization and Party Literature." In this article Lenin outlines the party responsibility of the writer as journalist, but he also reflects on the problem of literary crea-

tion in general.[12] But a world of difference separates the concerns of Lenin from those of Marx sixty years earlier. Marx was writing as a minority of one and as a theoretician, but utilizing in his service all of the humanistic resources of Western culture which were at his fingertips. But Lenin was writing with the Revolution in sight, as a practical politician, above all as a devoted partisan for whom the strategies which bring about political success outweigh any merely theoretical appeals to humanist principle. Lenin's remarks are the more rigidly conceived, the more fanatical, and it has been their import, rather than that of Marx, which has influenced the practice of the Soviet world.

Literature, says Lenin, must be "party literature." In opposition to bourgeois custom, literary opportunism, bourgeois individualism, and aristocratic anarchy, it must put itself at the disposal of the proletarian cause; it must be an organ of social democracy. Publishing houses, editors, writers, lecture halls, libraries, *all must be Party enterprises and subject to Party control.* To the objections that literary creation is a matter too delicate to submit to collective decision, that problems of science, philosophy, and aesthetics are too elevated and specialized to be resolved by majority vote of the working class, Lenin replies quite disingenuously. "Be reassured! I am only speaking of party literature. To be sure, all must be free to write and speak as they wish without the least restriction. Only, the party has a perfect right to purge itself of those members who propagate ideas contrary to its principles."

I say that Lenin speaks disingenuously, because in a pluralistic society the party would be only one insitution among many. But in a monolithic society, completely coordinated and with the party in control, Lenin's conception leads to a bureaucratization of censorship control and a party monopoly in the matter of literary judgment. Lenin, I think, foresaw this possibility and welcomed it. Yet even he was sufficiently cultured to recognize also the possibility of a separation between the literary and the political spheres of life. Lenin admired Maxim Gorki enormously, and in one of his letters (Zurich, March 12, 1917) [13] he recalls a meeting with Gorki on the isle of Capri in which he reproached Gorki for his "political errors." Gorki, reports Lenin, "met these reproaches with a smile full of his inimitable charm and said completely without artifice: 'I know that I am a bad Marxist. But then . . . we artists . . . we are all a little irresponsible, you know'." To which, says Lenin dryly, it

was difficult to complain further. And he adds: "It is beyond question that Gorki possesses an immense artistic talent and that he has been extremely useful to the international proletarian movement. But still, why should Gorki concern himself with politics?" Exactly! And we might ask precisely the same question about any first-rate literary talent.

It would be unprofitable to trace in detail all the effects of Lenin's ideas on the actual practice of the Soviet Union. From the earliest days of the new regime there were attempts to completely regiment literary activity and to subordinate it to the political strategy of the Communist Party.[14] The idea of literature as independent and apolitical had been officially outlawed as "bourgeois-liberal" and "utopian." Henceforth it was to be judged no longer by criteria of intrinsic merit, but purely and simply by its political and propagandistic usefulness. This lasted until well after the end of the Second World War. August 14, 1946, especially, was a fatal day for Soviet literature— for on this day, by a rabid attack on two Leningrad journals, *Zvezda* and *Leningrad,* the Central Committee of the Communist Party laid down a decree which was to determine the direction of postwar Soviet literature for a decade. The attack, reinforced by a report of Zhdanov, singled out two writers in particular; Zoshchenko, a satirist, and Akhmatova, a poetess, claiming that the latter reflected "moods of loneliness and hopelessness alien to Soviet literature" and that the former "exploited the seamy side of Soviet life in order to paint an anti-Soviet picture and ridicule the Russian people." Zhdanov called on Soviet writers to show the fine qualities of the Soviet populace and to depict them not merely in terms of the hard times of the present, but in the light of the Party's hopes for the future. It was clear that from now on critics were to base their judgments not on literary merit alone, but on ideological content, and that the orders now were that this content should be ruthlessly optimistic. One is reminded of Marx's ironic comments on the nature of the Prussian censorship. It seems that the more things change, the more they remain exactly the same. There is still to be "an official color." There in the Rhineland it was "grey upon grey." Now in the Soviet Union it is to be "rose upon rose"!

But even in those days there were limits to the ideological control of literature—to the stultification produced by decreeing that literature should deal only with political tasks and technical problems. By 1952 *Pravda* was complaining that writ-

ers were sacrificing the human essence to mechanical considerations, and demanding a fuller and more personal characterization of Soviet life. Criticism began to expose the ridiculousness of the usual themes of Soviet literature. In one play, for example, the conflict centers on the question of what crop shall be sown on a collective farm. The husband, the collective farm chairman, favors a "backward" crop. His wife favors an "advanced" crop, and leaves her husband because of his stubbornness. In the end the proper crop is sown, the husband sees the error of his ways, his wife returns to him, all is forgiven, and the play ends happily. But, as the *Pravda* critic pointed out, this does not exactly paint an admirable picture of Soviet life either. If a wife packs her bags every time she disagrees with her husband over a production problem, what price Soviet marriage? And what confidence can the poor husband have when sowing time comes around the next year? [15] If one compares this example of domestic discord with that of Kitty and Stephan Arkadievitch with which Tolstoy begins *Anna Karenina*—one of the most bourgeois and yet universally human of all domestic situations—then one has some measure of the gap between the literature of political contrivance and the literature of genius.

With the death of Stalin, of course, a new era of greater freedom began for Soviet literature. Olga Berggolts, Twardovsky, Ilya Ehrenburg—these are the voices of new demands: for a freer expression of the poet's subjective personality, for an end of bureaucratic regimentation in the arts, for a greater psychological depth in the portrayal of character, unfettered by purely political requirements. Underlying these demands is a new skepticism regarding the relationship of literature and politics; a new viewpoint challenging the qualifications of the Party, or of Party-inspired critics, to be adequate judges of literary merit. The new era is heralded by Pomerantsev in his 1953 article "On Sincerity in Literature," and, in general, this term used by Pomerantsev became the symbol of a new criterion in the Soviet critical vocabulary. For when "sincerity" rather than "ideological purity" becomes the battleground of literary criticism, the mold of judgment has been sufficiently loosened to challenge the validity of Lenin's principle of the strict Party control of the arts.

The Second Writers Congress of 1954 gave formal expression to the reservations of Pomerantsev. It expressed dissatisfaction with the high-handed, bureaucratic methods of the top leader-

ship of the Writers Union, emphasized the desirability of de-
centralization, stressed the need for greater attention to prob-
lems of form and technique, insisted on that individuality and
pluralism which had hitherto been considered to be the essence
of bourgeois anarchy. I will quote one passage from the Con-
gress Report, not only to show the new direction in Soviet
thinking but also because the passage itself might have been
lifted bodily out of John Stuart Mill's essay *On Liberty*. "The
method of socialist realism presupposes among writers a wealth
of individualities and styles, a rivalry between different creative
tendencies. Tireless searchings are needed for ever-new meth-
ods for the very best expression of the great truth of our ideas,
the richness and many-sidedness of our life." [16]

The newer emphasis on individuality and pluralism as well
as the requirement of literary sincerity represents the thrust
toward greater autonomy for literature. And it can, I think, be
said, that from the end of the war, through the Second Writers
Congress and the stormy years of 1956 and 1957, the trend of
Soviet experience is away from the restrictive requirements of
Lenin's approach to literature. Strochkov had in 1956 at-
tempted to place Lenin's demands in some sort of historical
perspective, emphasizing the difference in situation between a
minority party and a party in power. And he asserted that when
the latter is achieved, the responsibility of the party for the
activities of the nation becomes not narrower, but broader.
The concerns of successful socialism are therefore as broad as
life itself, and it is no longer reasonable to demand that the
writer express in each work a narrowly political party message.

Of course the path toward liberalization is not uniformly
progressive. Lenin's ghost haunts the consciousness of Soviet
officials, and therefore within the Soviet mentality itself there is
a permanent temptation to revert to the restrictive demands of
the Stalinist era. Even as late as 1963 Khrushchev initiated a
return to the principles of Lenin. "The press and radio, litera-
ture, painting, music, the cinema and the theater," he said, "are
sharp ideological weapons of our party. In all questions of
creative art, the Central Committee demands from everybody
unswerving obedience to the party line." [17] It was on this as-
sumption that a Picasso exhibition was canceled, a Léger collec-
tion shipped back to Paris, a Shostakovitch choral symphony
censored, and the poet Evtushenko forced to cancel a visit to
Princeton until he had become "ideologically mature." The
issue involved was less one of "style" than of "intention." The

old critical cliché of the Soviet arsenal which opposed "formal-
ism" to the approved "socialist realism" was supplanted by a
new offensive against literary and artistic "subjectivism."
"Sometimes," said Leonid Ilyichev at a Moscow literary lunch-
eon, "men of letters say, 'Let us create as we wish; do not
restrict us.' This is swollen subjectivist arbitrariness." [18]

Despite this temporary set-back, this equation of subjectivism
with artistic freedom, the over-all situation in Russia is not
unpromising. The experience of the last two decades in the
Soviet Union has demonstrated in the very stronghold of nar-
rowness and restriction an increasing power of aesthetic over
merely ideological considerations, and argues powerfully for
the autonomy of the literary experience. It is, of course, less an
ideal totally achieved than the objective of a permanent strug-
gle. But surely this much can be said: Wherever there is
agitation for the diminution of ideology and the elevation of
the individuality of the artist, there is a significant move away
from the totalitarian dominance of politics.

Since we are in part concerned here not merely with a theory
of the relations of literature and art to politics within the
environment of socialism, but also with the actualities of the
literary and artistic life in the Marxist ambience, it may be of
some interest to ask: Under what concrete conditions is artistic
freedom most likely to be achieved? And here we have a series of
case studies—of actual life experiences—to which we may turn
for the light they throw on our problem. Of the many possible
candidates I wish to choose three, and to consider them not so
much as isolated instances as for their comparative significance.
My theme is, therefore, *the continuum of artistic involvement,*
and my instances are those of Pablo Picasso, Bertolt Brecht, and
Boris Pasternak.

Six weeks after the liberation of France, Pablo Picasso joined
the French Communist Party.[19] It was a human rather than a
political act, an effort to obtain a cultural solidarity and cele-
brate the heroic resistance, rather than to commit himself to a
specific political platform or to become subordinate to an or-
ganization. He had long been sympathetic to the Party; many
of his good friends were among its members; he considered it
the bravest and the solidest bulwark against Fascism, and
among the Communists he found all those whom he most es-

teemed; as he said, "the greatest scientists, the greatest poets, and all the beautiful faces of the Paris insurgents" of the August fighting.

Naturally much has been written about his motivation and the causes of his "political conversion." Picasso's own statements are the most revealing. In 1944 he explained his motives to Pol Gaillard in an interview first cabled to the *New Masses* and published in condensed form on October 24, then appearing in its complete form in *L'Humanité* a few days later. Picasso said:

My adherence to the Communist Party is the logical outcome of my whole life and work. For I am pleased to say that I have never considered painting as simply entertainment or distraction. I have wished through line and color (since these were my weapons) always to penetrate further into the consciousness of the world and of men in order that this consciousness may liberate us more each day. Of course I am aware that I have always fought through my painting as a true revolutionary. But I now see that this is not enough; these last years of fearful oppression have shown me that I must fight not only with my art, but with my whole being. And of course I have turned to the Communist Party without the slightest hesitation, for basically, I was always on its side. Aragon, Eluard, Cassou, Fougeron: all my friends know it well; and if I have not previously adhered officially, it was through a sort of naiveté since I believed that my work and my heartfelt sympathy was enough, but even then it was my Party. Is it not the Party that works the hardest to know and reconstruct the world, to make the men of today and tomorrow freer, happier, more rational? Is it not the Communists who have been the most courageous in France, in the Soviet Union and in my own Spain? How could I hesitate? Fear of committing myself? But I have never felt more free or more self-sufficient. And then again, I was so anxious to find a homeland once more. I have always been an exile; now I am one no longer. Until finally Spain can welcome me back, the French Communist Party has opened its arms to me. I have found there all whom I esteem the most, the greatest scientists, the greatest poets, and all the beautiful faces of the Paris insurgents which I saw during those August days. I am once again among my brothers.[20]

What is interesting here, I think, is not simply that the Communist Party offered Picasso the solidarity of friendship, infinitely welcome to a man whose avant-garde achievement had often led in the direction of personal isolation. It is much more the natural affinity (as Picasso conceived it) between the

political and the artistic enterprise when both are not simply creative and conventional, but rebellious and estranged. French painting since the time of "Les Fauves" has generally been not merely "against" society, but in a very important sense "outside" its presuppositions and its *raison d'être*. Picasso's sense of "exile" placed him squarely in the center of this tradition, only, if anything, even more strongly supported by a resentment against all that is settled, conventional, and bourgeois. And this is why he could have become a Communist only where Communism was a struggling, subversive, *minority* party, not, as in the U.S.S.R., the very Establishment itself.

Two things determined Picasso's attitude. The first was his sense of *the total involvement of the act of painting*. The second was his conviction of *the subversiveness of art*. Early in the spring of 1945 a French correspondent Simone Téry interviewed Picasso. She told him that in the United States his Communism was considered a mere whim, and that he was reported to have said that art and politics have nothing in common. Picasso was scandalized, denied having made such a remark, and then impetuously wrote down a statement "about which no one could have any doubts." Picasso's statement read:

What do you think an artist is? An imbecile who has only his eyes if he's a painter, or ears if he's a musician, or a lyre at every level of his heart if he's a poet, or even, if he's a boxer, just his muscles? On the contrary, he's at the same time a political being, constantly alive to the heart-rending, fiery, or happy events, to which he responds in every way. How would it be possible to feel no interest in other people and by virtue of an ivory indifference to detach yourself from the life which they so copiously bring you? No. Painting is not done to decorate apartments. It is an instrument of war for attack and defense against the enemy.[21]

Even here nothing is said of ideology or political principle. Benda's theory of the treason of the intellectuals is implicitly denied; art as mere sensory perception is repudiated; painting as a "weapon" in the service of political warfare is asserted in the best Leninist tradition. Only, the politics here is an emotional rather than a rationally formulated perception—a spiritual sympathy and not a calculation of the content and consequences of policy. Deeply associated with this "emotionality" is Picasso's sense of the subversiveness of art. About three years after the Gaillard interview, Picasso received a cable from the Museum of Modern Art in New York. American congressmen

were fulminating against modern art as politically dangerous. The Museum was holding a meeting in protest and wished Picasso to cable a statement in support of their position. Kahnweiler, to whom the cable had been addressed, and who had forwarded it to Picasso, was contemptuous. The established people, wrote Kahnweiler, were not worth bothering about. On the other hand perhaps he was wrong and Picasso would think it necessary to reply. Françoise Gilot has recorded Picasso's response:

Pablo shook his head. "Kahnweiler's right," he said. "The point is, art *is* something subversive. It's something that should *not* be free. Art and liberty, like the fire of Prometheus, are things one must steal, to be used against the established order. Once art becomes official and open to everyone, then it becomes the new academicism." He tossed the cablegram down onto the table. "How can I support an idea like that? If art is ever given the keys to the city, it will be because it's been so watered down, rendered so impotent, that it's not worth fighting for." [22]

The very idea apparently excited Picasso's indignation. Every artist, he shouted, is an antisocial being by nature. He can't be anything else. Thus the business about defending and freeing culture is absurd. The right to free expression is something one seizes, not something of which one is made a gift. And he continued:

The only principle involved is that if it does exist, it exists to be used *against* the established order. Only the Russians are naive enough to think that an artist can fit into society. That's because they don't know what an artist is. What can the state do with the real artists, the seers? Rimbaud in Russia is unthinkable. Even Mayakovsky committed suicide. There is absolute opposition between the creator and the state. So there's only one tactic for the state—kill the seers. [23]

It should be eminently clear from this passage in exactly what sense Picasso's "Communism" is to be taken, and why he could only have joined the Party in France, never in Russia. His joining the Party under any circumstances had aroused the greatest interest—controversial interest naturally—in what the outcome would be. Soviet ideology had long been at one with Hitler in condemning the modern movement in painting and with it, of course, Picasso, its greatest leader. Leningrad's great

Hermitage Museum had long held many great Picassos, chiefly from his cubist and pre-cubist periods, but they were incompatible with the official line on painting, and had been relegated to basement storage. The question now was whether Picasso would retain his right to paint as he wished, or whether he would find himself obliged to change his style to that of the socialist realim, which was in ideological command of the Marxist artistic world. Who would win?

The question need not have been asked. The answer was never in doubt. The Communist Party is no match for Picasso. He continued to paint exactly as he always had. Unruffled by any impingement of official doctrine, he devoted himself as usual to the distortions and the chromatic experiments which interested him. If anything, his painting became more private and personal than it had been before. If the place had been Russia, as the case of Pasternak will show, the outcome might have been quite different, but the French Communist Party was forced by the very traditions of French art and culture to a more permissive stance. Moreover, it was one party among many, it enjoyed no monopolistic position, and Picasso was a world-figure who shed his luster on it rather than the reverse. International Communism did, indeed, open its arms to Picasso, but it greeted his art with very mixed feelings, especially abroad where the ideological strictures of Moscow were more enforcable.

Picasso cooperated with Communism politically. Between 1947 and 1950 he attended peace congresses in Paris, Rome, Warsaw, and Sheffield, not always happily or comfortably. One incident which he reports from the Warsaw Congress may be taken as typical.

There was just one incident, an embassy dinner that was a catastrophe. The Poles have always been broad-minded and independent and it didn't occur to them that anyone would attempt to criticize my painting for political reasons. At the end of the dinner, when toasts were being proposed, one of the Russian delegation stood up and said he was pleased to see I had come to the Congress but he went right on to say it was unfortunate that I continued to paint in such a decadent manner representative of the worst in the bourgeois culture of the West. He referred to my "impressionist-surrealist style." As soon as he sat down I stood up and told them I didn't care to be talked to like that by some party hack and that in any case his description of me as an "impressionist-surrealist" painter was not very impressive. If he wanted to insult me, at least

he should get his terminology straight and damn me for being the inventor of Cubism. I told him that I had been reviled in Germany by the Nazis and in France during the German Occupation as a Judeo-Marxist painter, and that that kind of talk, whatever the exact terms, always cropped up at bad moments in history and came from people nobody had much respect for. Then everybody began to get excited and protest in one direction or the other. The Poles tried to calm down the Soviets by agreeing that perhaps *some* of my painting was decadent, but in any case, they said, the Russians couldn't be allowed to insult their guests.[24]

Despite his political cooperation with Communism and his critical reception at the hands of the Soviet Union, Picasso continued to paint as if painting had no relation to politics. The one exception is the *Massacre in Korea* of 1950. And even this had a curious history.

It seems that only twice has Picasso been deeply moved in his painting by external political events. The first time was registered in the *Guernica* of 1937, the world-famous painting in which Picasso represented all the cruelty and horror of the Spanish Civil War and his deep hatred of the Franco brutality which was its outcome. The second was expressed in the *Massacre in Korea,* in which he once again shows his hatred of military force used against defenseless human beings. Implicitly it is a critique of Western aggression against the Korean people, and as such it was freely used by the Communists when first exhibited in the Salon de Mai in 1951. But five years later, at the time of the brutal Soviet repression of the Hungarian uprising, a large reproduction of the *Massacre in Korea* was set up in the streets of Warsaw as a symbolic protest against the brutality with which the Russian army tanks had mowed down the Hungarian workers. The tables were now turned, but Picasso himself welcomed the use to which his painting had been put. Indeed, he was deeply disturbed by the events in central Europe in the autumn of 1956. Together with nine other intellectuals he signed a letter addressed to the central committee of the French Communist Party, expressing grave dissatisfaction with the Russian intervention and demanding the calling of a special Party congress.[25] The reply, published in *L'Humanité,* was not sympathetic. It gave a lengthy defense of the official party line and rejected the demands of the petitioners. Privately Picasso was visited and reassured by the highest ranking members of the central committee. He did not resign from the Party.

Several other embarrassing occasions have marked Picasso's relations with the French Communists. A portrait which he made of Maurice Thorez was severely criticized in Party journals on grounds of style, and his portrait of Stalin, made at the request of Aragon for his paper *Les Lettres Françaises* on Stalin's death in 1953 and called by Picasso himself "a bouquet of flowers," was severely criticized by the Communist rank and file; it also met with official coldness because the drawing was held to be insufficiently realistic. None of this has ever bothered Picasso in the slightest. Nor in fact, except for Aragon and Laurent Casanova, has he had much respect for the French Party functionaries as individuals. Visited by them constantly, his response has invariably been knowing and ironic. This much one can gather from one of Françoise Gilot's numerous reports:

We were martyrized, too, occasionally—every time the Communists came to eat with us. Each one ate enough for four. Even old Marcel Cachin, dean of the Party hierarchy, scrawny as he was, would put away all kinds of appetizers, a fish, steak, salad, cheeses, a fancy dessert, and coffee, washed down with plenty of good wine. Pablo and I ate little and never lingered over a meal, so those banquets, which, together with the conversation, lasted for hours, were always an ordeal for us. "What appetites those people have," Pablo said to me after one of their visits. "I suppose it's because they're materialists. But they're in more danger from their arteries than from the inequities inherent in the capitalistic system." [26]

In general those who approved of Picasso's painting were shocked by his politics, while those who approved of his politics were shocked by his painting. Meanwhile he has continued to be disturbed by neither, pursuing his intransigently individualistic way, speaking what he feels, painting as he likes; despite his emotional commitment to the Communist Party, a living exemplar of the basic separateness of politics and art.

It is perhaps no accident that Bertolt Brecht asked Picasso to design the curtain and the main poster for the Berliner Ensemble and that Picasso furnished him with designs of a highly "formalist" nature.[27] The relation of both Brecht and Picasso to the Party organization of Communism has certain similarities. But the case of Brecht is at once more interesting and more complicated, and the complication arises in the moral dilemma

which faces any writer of genius who finds himself working in a Marxist environment of a clearly restrictive nature. Picasso is so successful that he can afford to live and work in the West as his own master. Brecht, although he spent the Nazi years in Switzerland, Scandinavia, and the United States, was never successful enough to work as he pleased in complete freedom from financial worries. Brecht's acceptance in 1949 of the invitation to spend his final years in East Berlin was, therefore, a compromise full of uncertainty and equivocation.

There is no question whatsoever that Brecht's sympathies, his ideas, the very philosophy underlying his unique dramaturgy were Marxist. Although he baldly denied it to a U. S. Congressional investigating committee,[28] he is said to have been a member of the Communist Party since 1930. He loyally supported the Communist cause, and throughout his life he did all in his power to put his great talents at the service of its aims. And yet the Party seems to have accepted his adherence generally without enthusiasm, for his basic attitude was anarchic, radical, iconoclastic, against authority of any kind. As in the case of Picasso, the freely offered adherence to Communism of a dramatist of world renown was too great an asset to be cast aside lightly, but it is an asset which (as in the case of Gide or Sartre) can sometimes turn into a liability. Brecht never really caused the Party serious embarrassment. Yet, although he had no intention of leaving the advantages of the Deutsches Theater in East Berlin, he made cunning use of the threat of possible defection. Experienced, tired, cynical in human relations, Brecht with almost peasant canniness made a position of enormous convenience for himself in central Europe, providing himself with the advantages of Communist patronage, while at the same time, by maintaining certain crucial relations with the West, retaining a maximum of freedom of speech and of movement. Among his paradoxical assets during the last years of his life were a complete theater at his disposal in East Berlin, an Austrian passport in his pocket, a Swiss bank account, and the publishing rights of all his plays in the hands of a West German publisher. With such external protection Brecht was safe against even the most provincial and fanatical of Communist totalitarian regimes.

Despite the profundity of his Marxism, the story of Brecht's relations with the Party is one of friction and uneasiness. From the early days, when *Die Massnahme* (1930) shocked the orthodox by its revelation that the murder of one's colleagues might

be a legitimate necessity of Communist strategies of action, to the days toward the end of Brecht's life when *Mother Courage* was played in Moscow and offended a number of Soviet critics and *Das Verhör des Lukullus*, set to music by Paul Dessau for the East Berlin State Opera in 1951, provoked a storm in *Neues Deutschland*, the Party organ in East Berlin, there was constant condemnation and disapproval of a dramatic practice which was contemporary, highly original, and without precedent in the literary annals of Marxist orthodoxy. Contempt for bourgeois society and the burgeois way of life was surely at the heart of the Brechtian theater (as it was of Picasso's painting) and the quality of his drama drew much from its reliance on a dialectic both Marxist and Hegelian, but Brecht's skepticism— his constant insistence on doubt and free inquiry as the very meaning of an epic theater—sat uneasily on Marxist stomachs.

Even the meditative and intellectual side of Brecht's responsiveness affronts the Russian Marxists and suggests to them something Germanic, heavy, almost Kantian. Sergey Tretiakov, one of the most sympathetic of Brecht's Russian colleagues, a man liberal enough to die in the Stalinist purges of the late 1930's, begins his article on Brecht with heavy irony. He is describing a meeting with Brecht and his circle in Berlin in 1931:

The air is thick with cigar smoke. The only place where it gets any thicker is the smoker's car in the Berlin subway. People have drawn up their chairs and are sitting in a circle around a large ashtray. A telephone on a long cord is handed back and forth across the room as if it were a sugar bowl. . . .

The conversation proceeds in circular fashion (the way Georgians drink). Everyone speaks in an even tone, avoiding emphatic gestures or inflections. The craniums of the assembled intellectuals, economists, critics, men of politics, pamphleteers, and philosophers are like chemical retorts from which comments on the burning issues of the day dribble. No one interrupts: each waits his turn until the preceding speaker has squeezed out his last drop of utterance. . . .

Statements and aphorisms issue distilled, and perfectly bottled, from the human retorts. The most highly trained German minds discuss the situation. They hunt for formulas, formulas of cognition.

I am surprised. Formulas of cognition are all very well, but where are the formulas of action?

Climb out of your low armchair, Comrade Bert Brecht. Tell me why these people are here instead of in the Party units, or in the

demonstrations of the unemployed? Why does the present welter of smoke and words remind me of the expression *"Stammtisch-Politik"?*
Every beerhall has its habitués. And these habitués have their table —*"Stammtisch"*—where they will swill beer and talk politics. They acquire distended livers from the beer and a complete aversion to political action from the talk.[29]

But the charge of intellectual inactivism is not enough. He is also disappointed with Brecht's later stage adaptation of Gorki's novel *The Mother*. It is didactic. It is too German. It does not really exhibit acquaintance with the problems and the position of the proletariat. "Regardless of whether Brecht likes it or not, I must mention the vividness of the teacher, the houseowner, the shopwoman, and the policeman in the play. The workers are hard to distinguish from each other; this is a general shortcoming of all Brecht's plays, which shows that he does not know the proletarian milieu intimately (this is a warning to him that he must get to know it so)." [30] Is there a hint of menace that Brecht's mentality is still essentially petit-bourgeois, that his dramatic content betrays the *nouveau-arrivé* to the Communist cause?

There were, in addition, problems of form. Brecht's entire theory of theater, as we have noted, is against that of Stanislavsky, where the audience is supposed to identify itself with the characters. He had never, therefore, been trusted as a dramatist in the Soviet Union. There, where for so long there reigned an exceedingly narrow conception of "socialist realism," Brecht's experiments with casual newspaper effects and with a modernized expressionism which he had learned from Meyerhold were either judged as the gloom of "naturalism" or, even the more wicked opposite error, of "formalism"—for this latter is necessarily the fault of a theater that applies the devices of expressionism or conveys its political message in a highly stylized or abstractive form. As one East German Communist newspaper once summed up its whole artistic case against Brecht: "Why is it that in his theater the trees have no leaves?"

The objection is not as absurd as it seems on the surface, for underneath its literal stupidity is the burning issue of the adequate definition of "socialist realism" and the problem of its enforcement on the more talented and original in the cadre of Communist artists. And here it has not only been Zhadanov and the party hacks of *Pravda* who have been at fault, but even so brilliant and intuitive a critic as Lukacs himself. Lukacs had

raised the issue first in 1934 in the Moscow review *Interna-
tional Literature* and for the next four years the pages of *Das
Wort,* the monthly German-language review, also published in
Moscow with Brecht as one of its three editors, seethed with the
debate over realism and expressionism. In April, 1938 Lukacs
contributed a piece to *Das Wort* on the realistic novel, citing
Balzac and Tolstoy as model writers, praising the two Manns,
and singling out Gorki as the leading author in world litera-
ture of the day. Brecht's immediate reaction was to write two
articles himself, neither of which he published in *Das Wort.*
The most significant of the two, "Volkstümlichkeit und Realis-
mus" (The Popular and the Realistic) was published only
after Brecht's death (in *Sinn und Form,* Potsdam, 1958) and
illustrates the quiet defense which he makes of his own methods
and the intransigence with which he opposes all official con-
straints on artistic individuality.[31] Brecht does not mention
Lukacs by name, but the object of his remarks is unmistakable.
In his argument is to be discerned a protest against all standard-
ization of literary method, all explicit appeal to determinate
literary models, and a definition of "realism" sufficiently broad
to include all experiment and originality.

Literary works cannot be taken over like factories, or literary forms
of expression like industrial methods. Realist writing, of which his-
tory offers many varying examples, is likewise conditioned by the
question of how, when and for what class it is made use of: condi-
tioned down to the last small detail. As we have in mind a fighting
people that is changing the real world we must not cling to "well-
tried" rules for telling a story, worthy models set up by literary his-
tory, eternal aesthetic laws. We must not abstract the one and only
realism from certain given works, but shall make a lively use of all
means, old and new, tried and untried, deriving from art and deriv-
ing from other sources, in order to put living reality in the hands of
living people in such a way that it can be mastered. We shall take
care not to ascribe realism to a particular historical form of novel
belonging to a particular period, Balzac's or Tolstoy's, for instance,
so as to set up purely formal and literary criteria of realism. We
shall not restrict ourselves to speaking of realism in cases where one
can (e.g.) smell, look, feel whatever is depicted, where "atmos-
phere" is created and stories develop in such a way that the charac-
ters are psychologically stripped down. Our conception of realism
needs to be broad and political, free from aesthetic restrictions and
independent of convention. *Realist* means: laying bare society's cau-
sal network/ showing up the dominant viewpoint as the viewpoint
of the dominators/ writing from the standpoint of the class which

has prepared the broadest solutions for the most pressing problems afflicting human society/ emphasizing the dynamics of development/ concrete and so as to encourage abstraction.[32]

Brecht's counterattack on Lukacs is cunning, for it turns the tables against him in two crucial respects. In the first place it makes the insistence on models itself a species of "formalism."

By taking over the forms of Balzac and Tolstoy without a thorough inspection we might perhaps exhaust our readers, the people, just as these writers often do. Realism is not a pure question of form. Copying the methods of these realists, we should cease to be realists ourselves. . . . So the criteria for the popular and the realistic need to be chosen not only with great care but also with an open mind. They must not be deduced from existing realist works and existing popular works, as is often the case. Such an approach would lead to purely formalistic criteria, and questions of popularity and realism would be decided by form.

And in the second place, it appeals from the aesthetic elitism of the specialist to the innate good sense of the common proletariat.

I speak from experience when I say that one need never be frightened of putting bold and unaccustomed things before the proletariat, so long as they have to do with reality. There will always be educated persons, connoisseurs of the arts, who will step in with a "The people won't understand that." But the people impatiently shoves them aside and comes to terms directly with the artist. . . . The sharp eyes of the workers saw through naturalism's superficial representation of reality. . . . "The universally-applicable creative method": they didn't believe in that sort of thing. They knew that they needed many different methods in order to reach their objective. If you want an aesthetic, there you are.

This article, unpublished as it was, gives a certain insight into Brecht's problem as a creative dramatist and poet in a restrictive Marxist environment and into his strategy of survival. Never seriously questioning the authority of the dominant regime, but twisting its terminology to his own purposes, and appealing always in his shrewd way to its own ultimate values to support his personal artistic practice, he survived and flourished—perhaps the only artist in the Communist realm who was unaffected by Zhadanov's demands and by the repressive ukases of the Stalinist and the Ulbricht bureaucracies.

After Stalin's death the cultural situation became somewhat better in East Germany. A new permissiveness seemed to be in the air, and the Berliner Ensemble moved into its new home— the rebuilt *Theater am Schiffbauerdamm.* But the temporary respite proved to be illusory. A deep restiveness was apparent in the East German masses and the party authorities, demoralized by Stalin's death and the lack of clear directives from Moscow, were unable to stem the rising tide by peaceful diplomatic measures. On June 17, 1953 the people of East Germany broke out in open rebellion. The regime briefly lost control of the situation and then quickly—as was to happen in Hungary three years later—Soviet tanks rushed in to put down the revolt and restore order. Brecht's reaction to this event has been clouded in ambiguity. On June 21 *Neues Deutschland* published a brief and relevant news item:

National Prize Laureate Bertolt Brecht has sent the General Secretary of the Central Committee of the Socialist Unity Party, Walter Ulbricht, a letter, in which he declared: "I feel the need to express to you at this moment my attachment to the Socialist Unity Party. Yours, Bertolt Brecht." [33]

From that time to the present Brecht has been the object of a storm of indignation in West Germany, the latest manifestation of which is Günter Grass' ironic and accusing play of 1966, *Die Plebejer proben den Aufstand.* But there is evidence that Brecht was quoted completely out of context, and a poem of Brecht's, found only after his death, seems to indicate quite a different attitude:

> After the rising of the 17th June
> The Secretary of the Writer's Union
> Had leaflets distributed in the Stalinallee
> In which you could read that the People
> Had lost the Government's confidence
> Which it could only regain
> By redoubled efforts. Would it in that case
> Not be simpler if the Government
> Dissolved the People
> And elected another? [34]

The June uprising had revealed the precariousness of the Ulbricht regime and the unpopularity of its politics. And in the new atmosphere of stock-taking and reappraisal, Brecht found

the opportunity to express long suppressed criticism against the cultural policy of the regime. The chief target of his attack was the East German State Commission for the Arts, which had so ruthlessly attacked the procedures and the philosophy of Brecht's theater. On August 12 the party's own official organ, *Neues Deutschland,* published an article by Brecht, "Kultur-politik and Akademie der Künste," which contains his sharpest criticism of bureaucratic direction of the arts and states as clearly as possible the case of the dedicated Marxist artist against the intrusion of official bigotry and aesthetic ignorance. As an indication of the kind of critical freedom irregularly available to the Marxist intellectual even in a system of ex-treme rigidity and repression, it merits our careful attention. It cannot be denied, says Brecht,

> that the attitude of many of our artists towards a major part of our cultural policy is one of rejection and incomprehension; and to me the reason seems to be that the politicians did not take this great store of ideas and make it available to the artists, but forced it on them like so much bad beer. It was the Commissions, with their un-fortunate measures, their policy of dictation-cum-argument, their unaesthetic administrative methods, their cheap Marxist jargon, that alienated the artists (Marxists included) and stopped the Academy from taking up a sensible position in the aesthetic ques-tion. It was particularly those artists who are realists that felt certain demands of Commissions and critics to be more like presumptions. No new state can be built up without confidence; it is surplus en-ergy that builds a new society. But superficial optimism can lead it into danger. Those features of our social life must be stressed that are full of implications for the future. But prettification and im-provement are the deadliest enemies not just of beauty but of politi-cal good sense.[35]

The burden of Brecht's appeal is not unlike the thrust of any liberal-democratic approach to the arts—to be free of adminis-trative shackles, that artists be permitted simply to be them-selves; it is in the end an appeal to qualitative excellence against standardization.

> The state is primarily interested in the workers; our best artists are primarily interested in them too. But at the same time there are other classes' tastes and needs that must be taken account of. All this can only be accomplished by a highly qualified, highly differen-tiated art. For a truly socialist art the question of quality is politi-cally decisive.

It is clearly not that Brecht asks for freedom beyond the tasks of a Marxist reconstruction, for to these tasks he is committed with all the ardor of a profound political passion. But within this commitment he holds to a clear separation between political and aesthetic authority. A series of his late unpublished notes reinforces the ideas of the "Kulturpolitik und Akademie der Künste." I cite a few of the most relevant.

No painter can paint with hands that tremble for fear of the verdict of some official who may be well-trained politically and very conscious of his political responsibilities yet be badly trained aesthetically and unconscious of his responsibility to the artist.

It's not the job of the Marxist-Leninist party to organize production of poems as on a poultry farm. If it did the poems would resemble one another like so many eggs.

Art has no competence to make works of art out of the artistic notions of some official department. *It is only boots that can be made to measure.* In any case many politically well-educated people have mal-educated and therefore unreliable taste.[36]

In spite of his unhappy history with the Party bureaucrats, Brecht remained convinced that at least in theory there was no essential contradiction between artistic freedom and the dictatorship of the proletariat. When, after the Korean War, West Germany began to rearm, Brecht worked tirelessly against it, sending appeal after appeal to the West. Shortly after this activity (and perhaps because of it) he was, toward the end of 1954, awarded the Stalin Peace Prize, and traveled to Moscow to receive it in the Kremlin. But ambiguity and equivocation followed him to the end. Returning home, he deposited most of his 160,000 rubles of prize money in his Swiss bank account, much to the anger and vexation of the leaders of the East German Communist Party.

Brecht's ultimate dilemma, as Esslin has said, was the same as that of the Hungarian artists, the Polish intellectuals, the Yugoslavian philosophers, and all the other "liberal" elements within the Marxist world—how to preserve artistic freedom and intellectual autonomy within the often oppressive mold of the only politics which seemed to offer hope for the future. But his case is unique in the delicacy of the balance he maintained between personal liberty and party allegiance. One false move and, like so many others, he might have been destroyed. Picasso in the West faced no such peril. Both the depth of his commit-

ment to Marxism and the price which he had to pay were lighter. But Brecht, in the very seriousness of his Marxism and his decision to live in a Marxist country, walked at all times the narrow path beside an abyss. His weapon was the strategy of cunning and insinuation, of knowing when to speak and when to remain silent, when to stand before a light breeze and when to bend low before the hurricane, and this gives to his life that curious blend of political opportunism and aesthetic intransigence which is almost unique in the Communist world. Also it makes the artist's relation to the political state one of wiliness and mutual exploitation. To gain value from Brecht's presence, the Party in East Germany had to provide him with a wealth of resources to do his artistic work. By accepting the Party's lavish support while adhering stubbornly to his own dramatic ideas, Brecht perhaps felt that he was getting the best of the bargain after all. It was a curious arrangement, but it represented a kind of equality. In France the Communist Party is no match for Picasso. In Russia Boris Pasternak was no match for the Communist Party. But in East Germany the hesitant state and the world-famous artist engaged in a perpetual duel between political insistence and artistic independence.

When Gerd Ruge interviewed Boris Pasternak at Peredelkino in the last years of his life, Pasternak spoke of Goethe and Shakespeare as if they were his contemporaries.[37] He also said that Bertolt Brecht had asked him to put into Russian the speech of thanks which Brecht had made when he came to Moscow in 1954 to receive the Stalin Peace Prize. "He had done so without pleasure, and without pleasure had read the volume of Brecht's poetry which the German dramatist had in gratitude sent him. He had little affinity with poets who were above all else political." It was only somewhat later, said Pasternak, when Helene Weigel brought her theater troupe to Moscow, that he realized that he had translated the speech of a great poet and that, because of the selection in the East German anthology which Brecht sent him, he had almost missed recognizing him as such. It is typical that Pasternak should have been ambivalent about any case of "the poet as politician," that he should have embraced the poet and been repelled by the politician, for this is the very essence of his own poetic nature, and in the end, in the fanatical environment of even the post-Stalinist era in the Soviet Union, he was destroyed by it.

When Pasternak died on May 30, 1960 Soviet officialdom ignored his funeral and not one member of the Writers Union was present. Nonetheless fifteen hundred Russians went, and Sviatoslov Richter, the greatest interpreter of Scriabin whom Pasternak so loved, played the funeral marches of Chopin and Beethoven on an old upright piano until the sweat ran down his face and neck. Pasternak's burial called on the courage of the Russian intelligentsia, for his was a special and at the same time an important case—the official excommunication of a poet of the first order, the tragedy of an artist who was by no means anti-Communist but simply antipolitical, whose love of Russia was never in doubt, but who was constitutionally unable to do other than to present his own uncensored vision of the world.

Reared in the best tradition of nineteenth century enlightenment by an artist father and a musician mother, influenced by Tolstoy, Scriabin, and Rilke, and having studied with Hermann Cohen in Marburg, he early became a member of that brilliant circle of poets which included Blok, Yessenin, Mayakovsky, and Akhmatova.[38] Anyone who has read his poetry as well as *Doctor Zhivago* knows of his lyric feeling for and attachment to nature, and at the same time his disinterest in, and essential innocence of, all that has to do with politics. He knew about as much about political science and revolutionary strategy as Keats or Swinburne. But he did know the poet's need for freedom and self-expression. In 1931 Pasternak said at the All-Union Association of Proletarian Writers: "They are always shouting at the poets: 'Do this! Do that!' But first of all it is necessary to speak of what the poet himself needs. The times exist for man, not man for the times."[39] Five years later he spoke to the full assembly of the Writers Union: "They speak of poetry as of some continually functioning machine with an output directly proportional to the work put in . . . Some speakers here very confidently divide poems into the good and the bad as if the latter were correct or faulty machine parts . . . Writers must not be given orders . . . There are some dirty hands meddling with art, but I see no love of art." From which it can be seen that from the very beginning Pasternak was outspoken and individualistic; a perfect exemplification of what Premier Khrushchev has called "a bourgeois-anarchist, individualistic conception of the creative liberty of the artist directed against the Party supervision of art," and that the later Soviet indignation at the publication of *Doctor Zhivago* was not merely rage at a particular work, but also the expression of

a long-standing judgment of disapproval against the whole course and meaning of Pasternak's creative life.

In this sense Pasternak's whole mode of perception and way of life *was* counterrevolutionary, if that means implicit affirmation of the values of the culture of old Europe for which Burckhardt was willing to die and by which Karl Marx himself, ironically enough, always lived. Mozart and Goethe, Shakespeare and Pushkin, Chopin and Tolstoy dominated his consciousness, as the fading mementoes of the nineteenth century dominated the walls of his home at Peredelkino. Olga Carlisle, who visited him four months before his death,[40] was struck by the similarity of his house to Tolstoy's in Moscow, which she had visited the day before, and noted the combined austerity and hospitality which she thought "must have been characteristic of a Russian intellectual's home in the nineteenth century," and the charcoal studies of Tolstoy, Gorki, Scriabin, and Rachmaninov by Pasternak's father which hung in the dining room. And Ruge, noticing the complete works of Kafka in German and of Proust in French in his study, concluded: "This man lives in Peredelkino, in a spiritual world which embraces everything that can be called Western civilization. This is the world in which he lives, the enclave of freedom that he has carved for himself. It is a world in which no ideological positions are manned. He has said himself that he is not a social realist. He is not a Marxist, nor a Communist. But which party, after all, could claim as one of its members a man who regards the Russian revolution and the developments determined by it as merely a transitional phase of world history, as prelude to the birth of something new?" [41]

That Pasternak should have manned no ideological position, that he should have carved for himself an enclave of freedom, that he could not in any enthusiastic or committed sense be called Marxist, Communist, or even social realist, was itself in the Russia of 1935–1960 sufficient cause for suspicion, excommunication, and martyrdom. For what was at stake here was the same conflict which we have already found in the cases of Pablo Picasso and Bertolt Brecht—the fundamental opposition between the perspective of the Communist artist and the cultural bureaucrat. Even after the beginning of the period of liberalization in Russia, there were other and insistent voices. As late as 1957 an article in *Literaturnaya Gazeta* (June 22) proclaimed: "We heard voices which gave mistaken interpretations of 'freedom of thought' and literary freedom. But we are

not partisans of any kind of freedom . . . We Soviet writers do not support a freedom in literature which stands in contrast to the principles of Party-mindedness and Communist ideological content." [42] Three years later Premier Khrushchev was also restating the ancient Leninist line: "In the great historical movement toward Communism one should put into motion all the levers and transmission belts, all the kinds of spiritual weapons, and use them in such a way that they should operate without fail as a single mechanism . . . The development of literature and art in a socialist society proceeds not in an elemental, not in an anarchic way, but planwise as directed by the Party, and is considered as an important component of the all-national effort." [43] Against this official requirement stand not only Pasternak's lifelong practice, but the simple rights of every artist whose themes derive from self-exploration and the nonpolitical consideration of the world, and it is within the context of this atmosphere of conflict that the publication of Pasternak's celebrated classic *Doctor Zhivago* must be considered.

Doctor Zhivago is the product of ten years of interrupted work. Begun after the Second World War (probably in 1945) and broken off in 1950 to be begun again after Stalin's death in 1953, it was completed in 1955. Some of the poems which appear at the book's end were published in April, 1954 with a note by Pasternak announcing its imminent completion. These poems are the only part of the original to be published in the Soviet Union. Having submitted the novel to several Moscow publishing houses and to the editors of some Russian periodicals, Pasternak, having no idea that the book would not be published in the Soviet Union (perhaps in an abridged form) , sent a copy also to Feltrinelli, a Communist publisher in Milan, to whom he granted all foreign rights. Meanwhile no word came from the Moscow publishers, and Feltrinelli was asked to postpone Italian publication. He agreed to delay for six months but, despite a later reluctantly sent telegram from Pasternak asking for still further postponement, Feltrinelli (perhaps divining the author's true sentiments) published his Italian translation in 1957, which began the further translation and finally worldwide dissemination of the novel.

On October 23, 1958 it was officially announced that the Nobel Prize for literature for 1958 had been awarded to Pasternak. This event was greeted with undisguised rage by the Soviet press. For it turned out that the book had indeed been rejected

by the Moscow publishers. Only on October 25 did *Literatur-naya Gazeta,* in the course of an angry diatribe against the award, make public the fact that two years before Pasternak's novel had been turned down as "counterrevolutionary and slanderous," and publish *Novy Mir's* 1956 letter to Pasternak rejecting his novel. *Literaturnaya Gazeta's* intemperate response is perhaps a measure of official Russian indignation and of how it interpreted the event:

The Swedish Academy of Literature and Philosophy has awarded the Nobel Prize for literature for 1958 to the decadent poet B. Pasternak for, as the decree puts it, "an important contribution both to modern lyricism, and to the great traditions of the Russian prose writers." This sensational decision which is penetrated with lies and hypocrisy has been received by the reactionary bourgeois press with a roar of enthusiasm. Furthermore, the press of the capitalist monopolies makes no attempt to hide the fact that this dirty trick on the part of the Swedish literary conservatives arises from one thing —the publication in some capitalist countries of B. Pasternak's novel *Doctor Zhivago,* since all his other works are practically unknown in the West. The presentation of the award for an artistically poverty-stricken and malicious work, which is full of hatred of socialism, is an inimical political act, directed against the Soviet Union. It was not the "refined" abstruse lyricism of Pasternak, nor the great traditions of Russian prose writers (which are deeply foreign to him), that inspired the perpetrators of this deed. The bourgeois "experts" and "connoisserurs" of literature have behaved in this instance as a tool for international reaction. Their decision is directed toward an intensification of the cold war against the Soviet Union, against the Soviet system, and against the idea of all-conquering socialism.[44]

But it is the long twenty-five-page letter from *Novy Mir* to Pasternak which is worthy of the greatest attention. It is impossible to reproduce in its entirety,[45] but a few sections from its running argument will make evident the conviction of the editors of *Novy Mir* that the book is "a libel on the October Revolution, the people who made the Revolution and the building of socialism in the Soviet Union":

Boris Leonidovich,
We have read the manuscript of your novel *Doctor Zhivago* which you submitted to our magazine, and we would like to tell you, in all frankness, what we thought after reading it. We were both alarmed and distressed. . . . The thing that has disturbed us about your

novel is something that neither the editors nor the author can change by cuts or alterations. We are referring to the spirit of the novel, its general tenor, the author's view on life, the real view or, at any rate, the one formed by the reader. . . . The spirit of your novel is that of nonacceptance of the socialist revolution. The general tenor of your novel is that the October Revolution, the civil war and the social transformations involved did not give the people anything but suffering, and destroyed the Russian intelligentsia either physically or morally. . . .

The first third of the novel is, primarily, a chronicle of several gifted individuals, living a many-sided intellectual life and concentrating on the problem of their own spiritual lives. One of these gifted individuals, Nikolai Nikolaievich, says at the very beginning of the novel that "the herd instinct is the refuge of mediocre people, whether it is loyalty to Solovyev, or Kant, or Marx. Truth is sought after only by isolated individuals, and they break with all who do not love it enough. Is there anything on earth that deserves loyalty? Such things are very few." This idea is presented in the novel within the context of Nikolai Nikolaievich's God-seeking. But beginning with the second third of the novel it gradually becomes a condensed expression of the author's attitude to the people and to the revolutionary movement. . . . Your heroes, and, in the first place, Doctor Zhivago himself, have spent the years of revolution and civil war in search of comparative well-being and tranquillity, and they do this amid the vicissitudes of the struggle, in the middle of the general devastation and ruin. . . . It becomes clear in those hard years of civil war that he [Dr. Zhivago] does not admit that such a thing as a people exists. He recognizes only himself as an individual whose interests and suffering he rates higher than anything else, as an individual who in no way feels himself a part of a people, who feels no responsibility toward the people. . . .

"Marxism and science?" Doctor Zhivago asks at the beginning of Part Two of the book. "It is imprudent, to say the least, to discuss that with a stranger. And come what may, Marxism is too poor a master of itself to be a science. A science is balanced. Marxism and objectivity? I know of no teaching that is more isolated in itself and more divorced from reality than Marxism." . . . Doctor Zhivago, in your opinion, is the acme of the spirit of the Russian intelligentsia. In our opinion, he is its slough . . .

However painful it is to us, we have had to call a spade a spade in this letter. It seems to us that your novel is profoundly unjust and historically prejudiced in its description of the revolution, the civil war and the years after the revolution, that it is profoundly anti-democratic and that any conception of the interests of the people is alien to it. All this, taken as a whole, stems from your standpoint as

a man who tries in his novel to prove that, far from having had any
positive significance in the history of our people and mankind, the
October Socialist Revolution brought nothing but evil and hard-
ships. As people whose standpoint is diametrically opposed to yours,
we naturally believe that it is out of the question to publish your
novel in the columns of the magazine *Novy Mir*. . . . Enclosed is the
manuscript of your novel *Doctor Zhivago*.

In the light of the official rage of the Soviet press and of the
profound threat to Pasternak's good name, security, and mode
of life which followed it, it is of some importance to evaluate
the charges made by the editors of *Novy Mir* against Paster-
nak's novel. It is, of course, necessary to ignore the official
rhetoric of "slanderous" and "counterrevolutionary." These
are conventional and meaningless. It is another thing to ask if
it is in any serious sense "a libel on the October Revolution, the
people who made the Revolution, and the building of socialism
in the Soviet Union." And here, I think we are faced by a
profound irony. Although disagreeing on their estimate of its
ultimate value, both Soviet circles and the host of those who
hailed the book in the West agreed on the single fact that
Doctor Zhivago does indeed express the spirit of nonacceptance
of the socialist revolution. The irony is that a close reading of
the novel completely fails to support this universal contention.

That the October Revolution was experienced, deeply felt,
lived through, is clear. And that it brought exhilaration,
breathless excitement, high hopes is equally so. Pasternak's
language for the Revolution expresses it all:

The revolution broke out willy-nilly, like a sigh suppressed too
long. Everyone was revived, reborn, changed, transformed. You
might say that everyone has been through two revolutions—his own
personal revolution as well as the general one. It seems to me that
socialism is the sea, and all these separate streams, these private, in-
dividual revolutions, are flowing into it—the sea of life, the sea of
spontaneity. I said life, but I mean life as you see it in a great pic-
ture, transformed by genius, creatively enriched. Only now people
have decided to experience it not in books and pictures but in them-
selves, not as an abstraction but in practice.

What splendid surgery! You take a knife and with one masterful
stroke you cut out all the old stinking ulcers. Quite simply, without
any nonsense, you take the old monster of injustice, which has been
accustomed for centuries to being bowed and scraped and curtsied
to, and you sentence it to death. This fearlessness, this way of seeing

the thing through to the end, has a familiar national look about it.
It has something of Pushkin's uncompromising clarity and of Tol-
stoy's unwavering faithfulness to the facts.[46]

Nor is the historical evaluation of Marxism neglected, its
global significance, its meaning for the nineteenth century, its
force to remedy the great evils of materialism and inequality.

But what gave unity to the nineteenth century, what set it apart as
one historical period? It was the birth of socialist thought. Revolu-
tions, young men dying on the barricades, writers racking their
brains in an effort to curb the brute insolence of money, to save the
human dignity of the poor. Marxism arose, it uncovered the root of
the evil and it offered the remedy, it became the great force of the
century.[47]

This is not the language of an anti-Marxist, of a man for
whom the October Revolution brought only suffering and de-
stroyed the Russian intelligentsia. To be sure, there is another
side to the story. For to the narrow and fanatical Marxism
which uses all literature as propaganda, which considers any
somberness in a picture a sign of treachery, realism itself cannot
be a witness to the truth, but only the snide betrayal of a
transcendent ideal. Pasternak is a poet, and poetic sincerity
cannot permit any game-playing with the truth as experienced
and felt. The phenomenon of revolution presents a spotted
actuality. And it cannot be denied that *Doctor Zhivago* also
shows the Revolution in its confusion and contingency, its
wrenching and cataclysmic character, the mixture of the mo-
tives of those who were its movers and shakers, its coefficients of
suffering and dislocation. Only a narrow and utterly fanatical
Marxism could feel that loyalty to the Revolution and profound
admiration for its life-giving transformations might be compro-
mised by the realistic description of the price which it entailed
in bloodshed and implacability, in irony and pitiless solutions.
And alongside this realism in the matter of execution is a
comparable realism in the matter of consequences. Commissars
invested with dictatorial powers ("men of iron will in black
leather jackets") are not universally benevolent and just. Ide-
als retain their original purity only in the minds of those who
have conceived them, and the casuistry of an established poli-
tics can turn them inside out. The Leninist passion to proclaim
the *truth* of social injustice may turn with Stalin into "the
inhuman reign of the *lie*." Pasternak, as he remarked much

later to Gerd Ruge,[48] had the duty to "bear witness"—the witness not of a politician, but of an artist, to an age intimately known, experienced, lived through. Such "witnessing" can sometimes be an embarrassment, and it is undeniable that in a totalitarian state, paranoid in its defensiveness and oversensitive to criticism, the color of truth often seems to be the color of treason. "However painful it is to us," wrote the editors of *Novy Mir,* "we have had to call a spade a spade." Pasternak must have known exactly what they meant, for *Doctor Zhivago* is itself just such an exercise in political candor. The unswerving poetic intelligence focuses a searchlight whose piercing radiance illumines the dark corners of revolutionary upheaval. It may be an ungrateful task to cast reflections which indicate in detail how in some instances a lofty ideal degenerates into crude materialism or how from time to time the initiators of a needed social reform have become dehumanized by political conceit, but it is no proof of counterrevolutionary tendencies or of a bias against the building of socialism in the Soviet Union.

The second charge of the editors of *Novy Mir* is perhaps more just—the charge that Pasternak's novel is marked by an accentuated individualism, that the chief characters of *Doctor Zhivago* seek truth as isolated individuals, seek personal salvation without feelings of responsibility for the whole of the Russian people. It is a travesty to call this "anti-democratic," but "personalism" it surely is. Such a philosophy of man distrusts the pleasures of conformity and the rhetoric of social submission, values the uniqueness of the individual personality, refuses to remove the human problem from the larger context of its cosmic setting. Lara in the novel exhibits the first:

The main misfortune, the root of all the evil to come, was the loss of confidence in the value of one's own opinion. People imagined that it was out of date to follow their own moral sense, that they must all sing in chorus, and live by other people's notions, notions that were being crammed down everybody's throat. And then there arose the power of the glittering phrase, first the Tsarist, then the revolutionary.[49]

Zhivago exhibits the second:

Mourning for Lara, he also mourned that distant summer in Meliuzeievo when the revolution had been a god come down to earth from heaven, the god of the summer when everyone had gone crazy in his own way, and when everyone's life existed in its own right,

and not as an illustration for a thesis in support of the rightness of a superior policy.

Their life together represents the third:

Never were they unaware of a sublime joy in the total design of the universe, a feeling that they themselves were a part of that whole, an element in the beauty of the cosmos. This unity with the whole was the breath of life to them. And the elevation of man above the rest of nature, the modern coddling and worshipping of man, never appealed to them. A social system based on such a false premise, as well as its political application, struck them as pathetically amateurish and made no sense to them.

Doctor Zhivago is indeed suffused with the sense of the personal life lived out against the background of the times which, although they condition it, provide its possibilities, enter into it, yet do not supplant it as the focus of importance and novelistic concern. And it projects a sense of the cosmos which both permits it to emphasize the setting of man's life in the natural world and, without being religious in any orthodox or conventional sense, makes nevertheless a constant reference to values which transcend the strategy of the Party, or the latest ukases from Moscow. The narrowness of the Marxist ideology appears when, in insisting on the artificial distinction between the individual and society, it subordinates the former to the latter, and when it restricts the richness of the cosmos to the narrow thoroughfare of man's social development and political achievement. In doing this it expresses a humanism of sorts, but one of extreme narrowness and restriction. Pasternak is first of all a poet, with the poet's awareness that his individuality is his poetic capital, with a profound and lyrical sense of the natural world, and with a certain openness to the lure of transcendent values. It is this poetic openness to those modes of experience which are outside the political which suffuses Pasternak's novel, which makes it unacceptable to the fanatical puritans of the political conscience. It is precisely this which the editors of *Novy Mir* expressed when they admitted disturbance and alarm at something in the novel "which neither the editors nor the author can change by cuts or alterations"—the spirit of the novel, its general tenor, and its author's unacceptable sense of life.

But there is something more which follows from the philosophical individualism of *Doctor Zhivago*. Anti-Russian the

novel certainly is not: indeed its passion for Russian landscape and Russian speech expresses a deep mystical patriotism. And the acclaim which it has won in the West as a courageous condemnation of Soviet Communism strikes one as imperceptive and mistaken where not actually gross and dishonest. Nonetheless it may constitute an implicit threat to a politically obsessed regime. Pasternak's novel contrasts its central character, the self-concerned and essentially nonpolitical Zhivago, with another character, the proletarian Pavel Antipov, raised by a family of railway workers, a gifted and eccentric figure who turns up later in the novel as the dreaded Commissar Strelnikov, leader of the Red Army forces in the Urals. Strelnikov has been the husband of Zhivago's great love, Lara, and the contrast between Zhivago and Strelnikov is, as Max Hayward has pointed out,[50] perhaps the central ideological theme of the novel. It is the contrast between the poetic and private man and the fanatical political activist. Although the latter is generally described and spoken of in the highest terms in the novel, in the end there can be little doubt where Pasternak's sympathies lie in the dialectical opposition of these two characters.[51] Zhivago views Strelnikov and his type as doomed, as revolutionaries, horrifying less because of their bloodshed than because they are rootless and unanchored individuals, like machines that have got out of control, like runaway trains. "There are limits to everything." He says:

In all this time something definite should have been achieved. But it turns out that those who inspired the revolution aren't at home in anything except change and turmoil, they aren't happy with anything that's on less than a world scale. For them transitional periods, worlds in the making, are an end in themselves. They aren't trained for anything else, they don't know anything except that. And do you know why these never-ending preparations are so futile? It's because these men haven't any real capacities, they are incompetent. Man is born to live, not to prepare for life. Life itself, the phenomenon of life, the gift of life so breathtakingly serious! So why substitute this childish harlequinade. . . . ?[52]

The criticism here is pertinent to the footloose revolutionary, but it may also be extended to the postrevolutionary politician, the bureaucratic functionary so ubiquitous in the Soviet Union, and it might well have served to undermine that sense of superiority which they had so laboriously managed to build up. Who composes, we may ask, that public to whom Pasternak

thought he was addressing his novel, and which the powers that
be were so eager to prevent from receiving it? Surely neither
political activists nor counterrevolutionaries waiting for an op-
portunity to rise against the present regime as the followers of
Essex were ready to rise against Queen Elizabeth after the
performance of *Richard II* at the Globe. The very thought is
absurd. The audience to whom Pasternak wished to speak is
composed neither of members of the Party nor of its dedicated
opponents, but of the broad mass of those intellectuals and
small, unimportant people who in Russia are not the subjects,
but rather the objects of political decision. As Hayward says,

Such people, in fact the overwhelming majority of the population of
the U.S.S.R., have been taught to believe for the last forty years that
they are in every respect inferior to the selected active fighters for a
better society. In the official view, those who dare to fight for social
ideals may perish when they go wrong, but they have nevertheless
led a conscious, purposeful life and they are far above any loyal and
well-intentioned "ordinary, non-political man." The latter is des-
tined for ever to remain a mere object of political action and it is
his duty patiently to endure every discomfort and to acquiesce in
the praise with which the "activists" reward their own efforts for the
establishment of general happiness.[53]

And it is in this sense that the editors of *Novy Mir* perhaps
rightly perceived that the publication of *Doctor Zhivago* might
constitute a threat to established authoriy.

But, although in no vulgar sense subversive, the novel certainly con-
tains a most devastating criticism of the very foundations of official
Soviet enthusiasm. The real danger it presents to the regime is that
it destroys the position of moral superiority of the political "activ-
ists" and restores the confidence of those who are seeking nothing
more than their right to love nature and to follow in their actions
the inclinations of their heart. The compelling power of Pasternak's
argument is not based on any theoretical view, but on a direct poeti-
cal vision of Soviet society and of the mechanism by which its ideo-
logical foundations are maintained.

Whatever the true explanation, from the day in October,
1958 when it was announced that Pasternak had been awarded
the Nobel Prize, his official persecution began. On October 26
Pravda published an attack by David Zaslavsky, emphasizing
Pasternak's independence. "The writer Pasternak," he said,
"has turned out to be a superfluous man, a lonely individualist

in Soviet literature. . . . He could not find the words needed to become a truly Soviet writer for whom it is a sacred duty and foremost obligation to serve the people. . . . He arranged for himself of his own accord the semblance of an emigré existence. . . . He broke off living ties with the Soviet writer's collective." [54] The article was probably "inspired," since two days later *Tass* reprinted the Resolution of the Union of Soviet Writers of October 27 expelling him from their organization.

Pasternak's literary activity has long since exhausted itself in ego-centric seculsion, in self-isolation from the people and the times. . . . The Union of Soviet Writers, which has solicitude for the creative art of writers, has for a period of years tried to help Pasternak to understand his errors, to avoid a moral downfall. But Pasternak has severed the last links with his country and its people and transformed his name and his activity into a political weapon in the hands of reaction. . . . Therefore, bearing in mind Pasternak's political and moral downfall, his betrayal of the Soviet Union, socialism, peace and progress . . . the Union of Soviet Writers deprives Boris Pasternak of the title of Soviet Writer and expels him from membership in the USSR Union of Writers.[55]

For the next week the pressure on Pasternak became unbearable. Under the threat of expulsion from the country, he refused the Nobel Prize, and on November 2, *Tass* published the pathetic letter which Pasternak had sent to Khrushchev the day before: [56]

To Nikita Sergeyevich Krushchev.

Respected Nikita Sergeyevich: I am addressing myself to you personally, to the Central Committee of the Soviet Communist Party and to the Soviet Government. I have learned from the speech made by V. Semichastny that "the Government would not put any obstacle to my departure from the Soviet Union." For me this is impossible. I am linked with Russia by my birth, life, and work. I cannot imagine my fate separate from and outside Russia. Whatever my mistakes and errors, I could not imagine that I would be in the center of such a political campaign as started to be fanned around my name in the West. Having become conscious of that, I informed the Swedish Academy of my voluntary renunciation of the Nobel Prize. A departure beyond the borders of my country would for me be equivalent to death, and for that reason I request you not to take that extreme measure in relation to me. With my hand on my heart, I can say that I have done something for Soviet literature and I can still be useful to it.

B. Pasternak

With the refusal of the prize, the immediate campaign against Pasternak came to an end, and he was permitted to remain in Russia, although ostracized and alone. Eighteen months later (on May 30, 1960) he died in his sleep at his home in Peredelkino, a writer's colony twenty miles outside Moscow.

As a personal epilogue to the Pasternak case, and as evidence of the opinion of him in Russia even now, I should like to relate a brief conversation which took place in June, 1963 on a Yugoslavian boat as it was sailing up the Dalmatian coast and approaching Split about five o'clock in the afternoon. I had just come from a week's participation in a symposium on "Man Today" in Dubrovnik to which some forty philosophers, largely from the countries of Eastern Europe, and including a Russian delegation, had been invited to discuss matters of ideological and philosophical import. The Russians had also taken the boat from Dubrovnik to Split. I was sitting in a low deck chair by the rail, reading a paperback copy of *Doctor Zhivago* bound in red and with the title in giant letters on the cover, when one of the Russians, a professor of philosophy at the Academy of Sciences in Moscow, noticed what I was reading, approached, and, unsmilingly pointing to it, said dryly: "That is not a good book." "Have you read it?" I asked. He was careful not to answer my question directly. "We know all about that book," he replied. I said: "It is certainly not Tolstoy, and by itself probably not worth the Nobel Prize, but what a pity that it was not published in Russia!" The professor was joined by one of his colleagues from Moscow University and the two of them then explained to me that Pasternak was asked to make certain changes in the manuscript which he refused to do. "We think," said the professor, "that literature is political—a weapon in our struggle for freedom. It should reflect the people's consciousness." I said that in my opinion literature should lead, should point new directions of sensibility, not simply reflect and follow. It should be, I said, more a compass than a mirror. My Russian friends took up my words, but in a somewhat different sense from that in which I had meant them. "Not badly said," they replied, "but it must be a good compass. The writer must know the scientific laws of history and society." I thought of Lenin's comments about Gorki. "You ask too much of an artist," I said, "they are not political men." And I pointed out that after Tolstoy had become dogmatically interested in social reform and doctrinaire in his attitudes, he never wrote another

good novel. "But Pasternak," they insisted, "unlike Tolstoy, did not understand Russia." "But he loved it," I replied, "He begged not to be exiled." "Yes," they agreed dryly, "and that was his tragedy."

The shocking treatment which Pasternak received in the Soviet Union after being awarded the Nobel Prize aroused the indignation of fellow writers and artists throughout the world. Ignazio Silone, hardly a tool of reactionary bourgeois capitalism, wrote: "All of us knew, in discussing the Pasternak affair, that we were not arbitrarily interfering in the internal affairs of a foreign country. Pasternak is our colleague; he belongs to us as much as to the Russians; he is part of what Goethe called *Weltliteratur*. The boundaryless society of artists and free men has thus felt outraged and wounded by the ignoble behavior of the Soviet cultural bureaucracy. We had the right and the duty to intervene." [57]

If the freedom of art and literature is to be a reality, it must surely be in the name of what Silone so aptly calls "the boundaryless society of artists and free men." And I think it is plain here, as in so many other cases, that civilization and decency are not essentially matters of political ideology or of the attachment to one or another idea of the proper organization of the economic life of a society. The great divide in the area of political censorship of the arts, the fateful division, is less between socialists and nonsocialists than between humanists and bureaucrats, between fanaticism and cultivation.

It is true that Marxism because of its newness and its special history has been the chief offender in this respect, but totalitarian nations of all persuasions have not been far behind. And if I have taken the cases of Picasso, Brecht, and Pasternak to state the dilemma of art against politics, to exhibit the continuum of artistic involvement, it is for the symmetry of the demonstration, and not because parallel cases could not have been found in Hitler's Germany, Mussolini's Italy, and Franco's Spain.

The case for the freedom of the artist need not be argued again. For it is, I think, only a subheading of the general topic of the civil liberties. Freedom of speech and the freedom of creative expression are so close as to derive their validation from the same arguments and the same rhetorical models. If civil liberties are held to be essentially rights of *man as man*

and not of citizens as citizens (and that is precisely what Silone's comment on the Pasternak affair implies), then the case of art against politics falls back on the perception of the difference between values which are intrinsic and those which are instrumental. Artistic expression is both intrinsically valuable and a vehicle for the self-realization of the human person. The political state is an instrument of human organization whose acts and powers are perpetually relative to the human values which it is its function to serve. It is this which all totalitarian regimes refuse to admit.

The perpetual struggle of the arts against the state in the Marxist countries has produced a rhetoric which is singularly repetitive and standardized. It repeatedly asserts (1) that art is a means to political ends, and (2) that art is a species of "manufactured goods." The psychological presuppositions of the first need not detain us long, for they are commonplace: that art is to be judged in its crude effects, as a thought and action stimulator, as a propaganda tool. But the second sustains a kind of ironic interest. For it sees art as a *commodity* capable of production, distribution, and consumption, and whose "mass production" and wide distribution—*Volkstümlichkeit* or popularity—are therefore the goal. No conception could be more offensive to the artist. "Literary works cannot be taken over like factories," complained Brecht. "It's not the job of the Marxist-Leninist party to organize production of poems as on a poultry farm." "It is only boots that can be made to measure." And Pasternak in scorn: "They speak of poetry as of some continually functioning machine with an output directly proportional to the work put in," and (in his *I Remember*), "Mayakovsky was beginning to be propagated compulsorily like potatoes in the reign of Catherine the Great." But these are, in fact, only responses to the official language of an Ulbricht who says: "We must produce an art which can be widely distributed among our people," or of a Khrushchev who proclaims: "In the great historical movement toward Communism one should put into motion all the levers and transmission belts, all the kinds of spiritual weapons, and use them in such a way that they should operate without fail as a single mechanism." The supreme irony is that Marxism, in its essence and in its origins directed against a crude commodity orientation, has itself turned art into a commodity.

Earlier I said that the provisional character of early Leninist theory combined with the despotism of the Stalin era has be-

queathed to later socialism a theoretical problem with respect to the relationship of literature and politics. One evidence of the confusions and contradictions which this problem has engendered is the efforts of Adam Schaff, the well-known Polish Marxist philosopher, in the direction of its solution. In the third part of his *A Philosophy of Man* he tries to outline the position of the newer socialist humanism with respect to the freedom of the individual. "A humanist," he says, "defends freedom in all of its aspects. Freedom of discussion, the free clash of opposing views undoubtedly provides the best conditions for the development of science and of culture generally. If political authorities attempt to settle controversial problems in this field by toplevel decisions, they can only do harm." It is an admirable statement and, although somewhat general and trite, is so only because behind it are Milton, Locke, Mill, Dewey, and, in fact, all of the great names in the liberal-democratic tradition. But unfortunately on the next page, Schaff proceeds to take away with his left hand everything which he has given with his right.

The demand for creative freedom in science and art would be not only obvious but banal if it were not for its political repercussions. At least some fields of science and art are directly related to politics; they are expressions of progressive or retrogressive social tendencies, and may have a progressive or reactionary effect on society. Only a utopian can ignore this fact and demand absolute freedom of creation. Nor can we treat as absolute the right of scientists and artists themselves to solve scientific and artistic questions as the only people competent to judge such matters. . . . It is obvious that a controversy about atonality is a purely musical one. Only a very imprudent person would dare to interfere from outside in such a controversy; he would gain nothing but ridicule for his pains. But it is another matter with the ideological content of a novel or poem, which is closely connected with politics regardless of its artistic merits. It is shaped under the influence of politics and reacts on politics.[58]

These qualifications ruin the liberalism, and, indeed, the humanism of the argument. And I believe that Schaff is profoundly wrong both in thinking that the content of literature is a political problem in the sense in which he intends it, and that adjudication calls for the intervention of public officials in the name of social defense. For it becomes clear that this ambivalence leads him to the enunciation of two further principles which are question-begging and opportunistic in the extreme.

The first of these is that political intervention in matters of artistic creation should be "exceptional"—limited to cases of clear political implication. He admits that a certain amount of "subjectivism" in choice and evaluation enters here, and that there is no escape from it, but on the crucial question which at once follows he is silent. Who, then, is to tell us which case is "exceptional"? And who is to be the judge as to which works of art have clear political implications? If the right of artists themselves to judge is denied, then certainly it must be the politicians. But this only opens the way once more to the worst and most arbitrary abuses of the Stalinist era.

The second principle is no less pernicious. Of course, says Schaff, we must distinguish the ideal future from the spotted actuality which is the present. The goal of Communism is, of course, full and unhindered freedom, but for the moment, in the contemporary world where socialism is fighting for its life, some limitations on artistic freedom are required, demanded by "unfortunate political necessity." We have heard this type of argument before, and the phrase "unfortunate political necessity" can be used to justify every cruelty and injustice in the arsenal of history.

In the end every attempt to place literature under the aegis of politics is a mistake. For the freedom of the writer and the artist is a civil liberty like any other, ultimately based on the classical humanist claims for pluralism and individuality. As the human intellect must be free to come to such conclusions as it logically must, so the human imagination must be free to shape and present its fantasies in artistic form. To paraphrase the famous statement of Mill, it is the proper condition of an artist arrived at the maturity of his faculties to use and interpret experience in his own way. For in the last analysis it is politics which is the mere means, and it is the self-realization of men which is the end. Adam Schaff is wrong, and the martyred Pasternak was right. Man is born to live, not to prepare for life. The times exist for man, not man for the times.

Ten / The Existentialist Dilemma:

Camus, Sartre, and Merleau-Ponty

IF JOHN Stuart Mill and John Dewey were alive today, they would note with astonishment that current Anglo-American philosophy has little interest in, or relevance for, the problems of politics. Analytic philosophy in its two branches, logical empiricism and linguistic analysis, which dominate the present British and American scene, is essentially apolitical. Logical empiricism takes as its task the analysis of the methods and the procedures of the sciences, and, although this includes by tolerance the fields of history and political science, such interest as it shows in them is technical and methodological: how they operate as sciences, their ability to isolate causal laws, the validation of their conclusions. Linguistic analysis is even more restricted. It may from time to time examine the linguistic usage exhibited in the texts of political discussion, or construct rhetorical models for procedures illustrating "the language of politics," but it too is withdrawn and disengaged from the making of political decisions and the assertion of political values.

Unlike these other philosophies of the recent past, existentialism has arisen as a direct consequence of, and as a specific effort to redirect, the fate of man in the modern world. It is therefore inevitable that in an age when politics has begun to dominate both the personal life and the possibilities for its future, the existentialist stance should require a political commitment. Both Karl Jaspers and Gabriel Marcel have contributed sharply critical accounts of the tendencies in modern mass society,[1] although the metaphysical isolationism of Martin Heidegger since his Nazi days has placed him in almost the same

position of objective disengagement as Carnap or Wittgenstein or G. E. Moore. But it is Sartre for whom the political engagement of the philosopher is axiomatic, and it is his political position and its dialectical interplay with that of his French contemporaries Camus and Merleau-Ponty that I wish to take as central in what I think may be fairly called "the existentialist dilemma."

In speaking thus, I am well aware of the rather loose and general sense in which the word "existentialist" is being used. Camus was surely no existentialist. A writer, and in the narrow technical sense no philosopher at all, one in fact who expressly repudiated the conclusions of existential philosophy,[2] he nevertheless wrote philosophically about politics, and his famous and important quarrel with Sartre was over issues which, if seemingly narrowly political, do, in fact, touch on matters central to existentialist thought. And the same can be said of Merleau-Ponty. He would have called himself a phenomenologist rather than an existentialist, and, unlike Sartre, his debt to Husserl is surely greater than his debt to Heidegger. But in the generation after Husserl, phenomenology and existentialism have been sometimes bewilderingly intermingled, and the product has been bound up with man's concrete human experiences and with his political destiny in a fashion diametrically opposed to the narrowness, objectivity, and reserve of Anglo-American philosophizing in the last twenty years.

In fact the specific relation between philosophy and politics to which I wish to call attention is quite characteristically French. Sartre, like Camus, is no "mere philosopher," but a writer-novelist, dramatist, and literary critic as well—and Merleau-Ponty, although he held a chair of philosophy at the Sorbonne and later at the Collège de France, concerned himself with Cézanne and impressionism, Machiavelli and Montaigne, as well as with the immediate political situation: the Korean War, Indo-China, and Algeria. All three, despite their individual differences, are men of broad culture in whom the literary experience is inseparably bound up with philosophical presuppositions and political concern. Politics dominates the French literary tradition which runs from Voltaire to Zola and Anatole France, and from Zola and Anatole France to Sartre, Merleau-Ponty, and Camus. It is possible that Goethe, contemplating the writings of Rousseau, or the early Thomas Mann, noting the effect of Zola on his brother Heinrich, would have called

politics "die französische Krankheit" rather than what Germans generally refer to by that name.

But there is something more. Not merely since Marx, but since the French Revolution itself, there has existed in France an unbroken tradition of strong political radicalism. In England this was overshadowed by the relative stability of the Victorian era and in central Europe by the bureaucratic stringency of the Hapsburg and the Hohenzollern dynasties, but it has been supported in France by the political bankruptcy of Napoleon III, which led to the defeat of 1870, the devastation of France in the First World War, and the defeat and German occupation during the Second World War. Fourier, Proudhon, Louis Blanc represent an uninterrupted continuity of radical thought stretching from the Terror to Sedan, and since the end of the nineteenth century every French intellectual has had to make his peace one way or another with the thought of Karl Marx. Political radicalism feeds on moral uncertainty. The tradition of the French *moraliste,* stretching at least as far back as Montaigne, and of which Camus himself was perhaps the last famous representative, flourishes in its pure state only in an atmosphere of classical certainties or Christian belief. But with the dissolution of the traditional patterns of belief and the rise of a kind of *fin de siècle* nihilism (represented for example by Schopenhauer, Nietzsche, and finally Spengler) the certainties of the *moralistes* are supplanted by the reexamination of all social institutions and a commitment to philosophies of action. Politics, particularly radical politics, became the inescapable challenge of the French intellectual. The vigorous role of the French Communists in the Resistance of 1939–44 only added a tinge of nationalistic loyalty (and hence of prestige) to doctrines which were intellectually challenging in their own right. It is thus no accident that Camus was once briefly a member of the Communist Party, that Sartre is a perennial Marxist whose own failure to create a non-Party political left in France has led him even closer in his rapprochement with "official" Marxism, and that Merleau-Ponty has never failed to test his own political humanism against the insurgent challenges of both Arthur Koestler and Leon Trotsky, of both Bukharin and the authority of the Moscow Trials.

For Sartre, Camus, and Merleau-Ponty the claims of Marxism have been philosophically pertinent in a sense undreamed of by Husserl or Whitehead, Carnap or G. E. Moore, Wittgen-

stein or Gilbert Ryle, and it is because some of the most crucial problems of political humanism are to be found illumined in their mutual relations that I have sought to treat them under the literally not completely accurate rubric "the existentialist dilemma." Nor have I forgotten that although the problems are universal, what we have here is an ambience and a flavor particularly French. Thus, in the more traditional and elliptical sense, the basic problem of the existentialist dilemma, illustrated in the opposition of Sartre, Camus, and Merleau-Ponty, may be simply stated: La Bruyère or Rousseau? Montaigne or Louis Blanc? Sismondi or Robespierre?

Albert Camus's *L'Homme révolté* (The Rebel), his chief contribution to a philosophical politics, appeared under the Gallimard imprint in 1951. It at once became a cause célèbre, attacked on the left, supported by the liberal middle. In May of the following year it was reviewed in *Les Temps Modernes* by Francis Jeanson, Sartre's chief lieutenant and colleague on the periodical. Simone de Beauvoir laconically remarks: "Two things marked the beginning of that summer: Sartre quarreled with Camus and effected a reconciliation with the Communists." [3] The two events are certainly not unrelated. Why Jeanson rather than Sartre himself reviewed the book is not clear, but Sartre, although concerned with Jeanson's tone, was surely in complete sympathy with his ideological position. De Beauvoir describes the situation in a paragraph.

I saw Camus, for the last time, with Sartre in a little café on the Place Saint-Sulpice in April. He made fun of a lot of the criticisms of his book; he just took it for granted that we liked it, and Sartre had great difficulty in knowing what to say to him. A little later, Sartre met him in the Pont-Royal and warned him that the review in *Les Temps Modernes* would be fairly cool, if not harsh. Camus seemed disagreeably surprised. In the end, Francis Jeanson had accepted the task of doing the piece on *The Rebel;* he had promised to do it circumspectly; as it turned out, he got carried away. Sartre persuaded him to soften some of his strictures, but there was no censorship on the magazine. Camus, affecting to ignore Jeanson's existence, sent Sartre an open letter in which he addressed him as "Monsieur le directeur." Sartre replied in the next issue. And everything was over between them.[4]

Jeanson's review is by no means crudely ill-natured. It is perhaps a little patronizing when it asks Camus to forsake his

abstractions and return to the personal idiom which his friends all know and admire, but its ideological opposition is clearly set forth.[5] There is, says Jeanson, a certain inconsistency in Camus's thought which renders it indefinably plastic and malleable, a certain "vague humanism" which expresses itself in the rather excessive reliance on an elevated and pretentious style. It is a style striving after perfection and purity—a "transcendental" style unsoiled by the grime of everyday existence. Jeanson uses the matter of style only as a symbol, to point up what he takes to be the basic contradiction underlying Camus's whole approach to the world—that of "a Mediterranean soul," addicted to intellectual clarity as to the pure light of the *Midi*, but knocking his head against the real world of contradiction, irrationality, and human suffering.

Jeanson's chief target in the book is Camus's concept of "metaphysical" revolt, and he accuses Camus of viewing revolutions as an abstract metaphysician, leaving absolutely out of the picture their "vulgar causes," historical or economic. "A vrai dire, il s'agit d'éliminer toute situation concrète pour obtenir un pure dialogue d'idées." At this elevated level of thought, says Jeanson ironically, revolution may seem a concept worthy of theological dispute, but it has surely lost sight of the actual existence of men who happen to be hungry, and who attempt, following their very inferior logic no doubt, to rise against those responsible for their hunger. The impatience grows into a crescendo of polite abuse as Jeanson parades one by one the errors which a dedicated Marxist can discern in the discourse of a liberal political humanist. Camus has too low an opinion of the accomplishments of the French Revolution. He fails to do justice to the insights of Karl Marx, and by this failure, he condemns the revolutionary enterprise in advance. Camus only sees revolution (the Russian or any which preceded it) as "the passage to terror," but he passes over in silence the essentials of revolutionary phenomena—its causes, its effective moves, the human behavior which it comprises. Thus his treatment of revolution and his rejection of its efficacy neglects as if negligible the massive phenomena of man's injustice to man.

But even this misjudgment of revolution can be reduced to a more pervasive theoretical error—Camus's attempt to create a political logic outside the impingement of time, his treatment of the political problem as if there were no such thing as the living course of history! Camus, says Jeanson, will have no truck with history because it is not pure enough for him, and

thus *The Rebel* deals with history only to show that it does not exist. It is true that Camus sees a radical evil in things, a pure metaphysical evil such as might have been asserted by Kant or Hegel, but the evil within history itself he seeks to avoid. The charge here against Camus—although the term is never expressly used—is of a kind of Platonism. It looks, Jeanson insinuates, as if Camus in his retreat from history is looking for a refuge, a disconnection from a plane of political being which he identifies as a domain of cynicism, destruction, servitude without limit; a series of convulsions, a great collective agony. But does Camus, asks Jeanson, really hope to suppress the course of history by refusing the obligation of social action? He is against militant revolutionaries and Communist leaders, Stalinists and terrorists of every variety, but is he any less the "prisoner of history" than they themselves? The course of history, says Jeanson, is at once our prison and our work—never wholly the one or the other—and we must do our work within it precisely that it may become less a prison of inequality and injustice. Perhaps capitalism offers "a less convulsed face" than Stalinism, but what does it offer the tortured and oppressed of Madagascar, Vietnam, Tunisia? One does not, says Jeanson, voluntarily imagine a voice like Camus's indifferent to the constant occurrence of monstrous crimes. And even under the literary pose, beautiful phrases, inconsistent thinking, there must be a genuine human voice charged with real torment. But in *The Rebel* that voice has sacrificed its own reality to a pseudophilosophy and a pseudohistory of revolutions. The ultimate failure of the book is its abstractness, and Jeanson's last appeal is directed away from that. "On implore ici Camus de ne point céder à la fascination et de retrouver en soi cet accent personnel—par où son oeuvre nous demeure, malgré tout, irremplaçable."

Camus, as de Beauvoir said, knew and was disagreeably surprised that an unfavorable review would appear, probably because he attributed the sentiments expressed less to Jeanson than to Sartre himself. Some evidence for this is to be found in the fact that in his reply he ignored Jeanson completely and addressed himself directly to Sartre. In the next issue of *Les Temps Modernes* (August, 1952) appeared a twenty-page "Lettre au Directeur des Temps Modernes," followed immediately by a reply of the same length by Sartre himself.[6] In these two documents, if one reads between the lines of deep impa-

tience and personal pique, are to be found the seeds of a political issue of considerable importance.

In some respects, except to deny them, Camus's letter does not really come to grips with Jeanson's two charges of antirevolutionism and Platonism. But it frankly transforms a philosophical argument into a political one. Its strategy is to countercharge that the partisan Marxism of Sartre and *Les Temps Modernes* gives to its critique a built-in quality of dogmatism and distortion. Jeanson, says Camus, has made a travesty of his position. That *The Rebel* has been praised in "rightist" circles is not to the point. The truth of an idea is not decided by whether it is "rightist" or leftist." By such a criterion Descartes himself would be a Stalinist and Péguy a reactionary. Jeanson's presupposition is that whatever is not frankly Marxist is reactionary, and this is to completely misunderstand Camus's position!

Camus says that he does admit economic factors among the causes of human action; only, he does not depend on them exclusively. And the charge of his avoidance of history is simply false. "My book does not deny history, *except as an absolute.*" This last, as we shall see, is crucial, for, as Camus goes on to maintain, it is the mark of the non-Marxist independent thinker. The *Temps Modernes* critique, says Camus, uses all of the techniques of Marxist controversy: it pushes to the right everything critical of Marxism, it affirms that all idealism is reactionary, it has only derision for any revolutionary tradition which is not Marxist. (It neglects, for example, the First International, Bakunin, the revolutionaries of 1905, etc., etc.) But in writing as if the Marxist theories were untouchable, it passes over in silence precisely what it ought to question. It says nothing about that Russian "totalitarian socialism" which is the principal revolutionary experience of our time. Nor does it come to grips with the concentration camps—"le fait concentrationnaire en Russie." Your editor, says Camus, would revolt against anything but the Communist Party and the Communist state, but this is a denial of liberty and "the existential adventure." By making no allusion to Stalinism and the questions of the hour he wants to have it both ways: he does not raise the crucial question of the compatibility of personal liberty and those forms of repression which Stalinist Marxists justify by "the necessities of history."

It is possible that Camus's stilted address to his old friend

Sartre as "Monsieur le Directeur des *Temps Modernes*" stung the latter into an instant response which, in contrast, uses all the devices of the insultingly personal.

Our friendship [begins Sartre] was never easy, but I shall be sorry to have lost it. We are in accord about many things, at odds about few, but these few are already too many. Friendship also tends toward the totalitarian. But I should have preferred our differences to be fundamental and not mingled with I don't know what odor of wounded vanity. I might have preferred to be silent, but cannot do so without losing face. I will answer then, without anger, but for the first time between us without delicacy or consideration. A combination of somber self-conceit and vulnerability has always prevented speaking to you the whole truth. The result is that you become the prey of an excessive gloom which masks your internal difficulties and which you call, I believe, Mediterranean decorum . . . You write like an anti-Communist. A dictatorship, violent and at the same time ceremonious, has taken up its abode in you which relies upon a veritable bureaucracy of abstractions while pretending that it is the moral law which is speaking. You take Jeanson's article and make it into a majestic lesson in pathology. I think I see Rembrandt's painting: you as the doctor, Jeanson as the corpse! You have come into *Les Temps* Modernes with your portable pedestal. . . .

I have included this unfortunate *ad hominem* opening diatribe of Sartre's not to emphasize the drama of a ruptured friendship, but because beneath its surface impatience lies a more politically relevant emotion—an abrupt irritation that Camus has assumed the mantle of an ethicist, that he has applied to the contingent realm of the political the necessary criterion of moral principle. And if, as I believe, the very center of humanism lies in its ethical content, then the issue of humanism and politics is a question of the degree to which moral considerations become decisive in political thought and behavior. It is precisely at this point that the existentialist dilemma becomes manifest.

Sartre continues with a series of more trivial attacks and defenses. Camus, despite his protests, is bourgeois in spirit. He is philosophically incompetent and the thought of his book is vague and banal. He seems to dislike the "difficulty" of philosophical thinking; neglecting sources, in his simple-minded strictures against Sartre's doctrine of freedom, not bothering to carefully consult *Being and Nothingness* in detail. For if he

had, he would have seen that Sartre's political doctrines are perfectly congruent with his theoretical philosophy. Liberty *is* absolute and without check. Man is both free *and* the being for whom other men can become mere objects. Indeed, it is precisely this which permits us to comprehend oppression. "Notre liberte aujourd'hui n'est rien d'autre que *le libre choix de lutter pour devenir libres. Et l'aspect paradoxal de cette formule exprime simplement le paradoxe de notre condition histo-rique.*" It is not necessary to put our contemporaries in a cage —that's where they are already—we must, on the contrary, unite with them to break the bars. This is the reason why all writers must be committed and why, if they wish to prevent any popular movement from degenerating into tyranny, they must not condemn it out of hand and withdraw. To win the right to influence those in the social struggle, one must join the struggle and necessarily accept many things at first if one wishes to reform some of them afterward. "History presents few situations more desperate than ours . . . but when a man can only see in the actual struggle an imbecile duel of two monsters equally abject, I hold that this man has already left us . . . How can you try to dominate like an arbiter an epoch on which you have already turned your back?"

Here is the true center of Sartre's quarrel with Camus: that he plays the role of political spectator rather than political partisan, and that he opposes the spotted requirements of political action with the philosophical reserve of moral judgment. And it is the point where, underwriting Jeanson's argument in almost every particular, he presents his brilliant and telling assessment of Camus the man.

As we saw you in 1945 you were a *personage,* of the greatest complexity and richness, the last and the most welcome of Chateaubriand's heirs, and the devoted defender of a social cause. You had every opportunity and every merit, for you united the sentiment of grandeur with the passionate taste for beauty, the joy of life with the sense of death . . . In short you are in our great classic tradition which, since Descartes, (and if one excepts Pascal) is entirely hostile to history. But you finally made a synthesis between aesthetic enjoyment, desire, fortune and heroism, between the fullest contemplation and duty, between the plenitude of Gide and the dissatisfaction of Baudelaire. You achieved the immoralism of Ménalque by an austere morality . . . The Resistance threw you into history. History for you was the war—the folly of others! You were for the old humanism, but revolt and despair intruded. The revolt against ab-

surdity. You revolted against "nature," but not enough perhaps against human injustice. A child dies. You accuse the absurdity of the world. But the child's father accuses men . . . he knows well that the absurdity of our condition is not the same thing in the luxurious neighborhoods and in the slums. In 1944 you represented the future: now in 1952 the past. You live in the ideal, in a language grown more and more abstract. You live on memories and have retired to a solitude. Terror is an abstract kind of violence. You have become a terrorist and violent now that history, which you reject, has in its turn rejected you as no more than an abstraction of revolt . . . Your ethics has first changed into moralism. Today it is no more than literature. Perhaps tomorrow it will be immorality.

This curious "reply" in which Sartre mingles the insults of a dueling opponent with an admiration for past accomplishment, the icy judgment of a stranger with the earnest admonition to an erring but familiar comrade is a dramatic rhetorical exercise, and the eruption of the quarrel between Camus and *Les Temps Modernes* seems in its terms to be the immediate product of Camus's publication of *The Rebel*. But the quarrel was, in truth, much older, and it is summarized rather matter-of-factly by de Beauvoir:

As a matter of fact, if this friendship exploded so violently, it was because for a long time not much of it had remained. The political and ideological differences which already existed between Sartre and Camus in 1945 had intensified from year to year. Camus was an idealist, a moralist and an anti-Communist; at one moment forced to yield to History, he attempted as soon as possible to secede from it; sensitive to men's suffering, he imputed it to Nature; Sartre had labored since 1940 to repudiate idealism, to wrench himself away from his original individualism, to live in History; his position was close to Marxism, and he desired an alliance with the Communists. Camus was fighting for great principles . . . usually he refused to participate in the particular and detailed political actions to which Sartre committed himself. While Sartre believed in the truth of socialism, Camus became a more and more resolute champion of bourgeois values; *The Rebel* was a statement of his solidarity with them.[7]

The summary is interesting because it suggests in capsule form how the opposition between Sartre and Camus can be simplified—how, in fact, it yields a dialectic which is significant far beyond the personal circumstances of the French intelligentsia of the late 1940's and early 1950's. Realism *or* idealism,

politics *or* morals, Communism *or* anti-Communism, history *or* nature, detailed political action *or* principles, socialism *or* bourgeois values, involvement *or* withdrawal; these present the clear-cut options which to a Sartre (or a de Beauvoir taking her cue from him) seem to exhaust the relevant political possibilities, and to some extent they do present the fashion in which Camus assessed the options also. Politics *or* morals, the fanatical totalitarian socialism of the Soviet Union *or* an egalitarian people's democracy, an acknowledgment of the eternal metaphysical setting which is the context of human life *or* a faith in brutal present action as justified by the clearly discerned Marxist goal of all history—these are oppositions which are surely basic to Camus's mode of political perception. But the charge that whereas Sartre believed in the truth of socialism, Camus became a more and more resolute champion of bourgeois values, and that *The Rebel* was his statement of his solidarity with them, is disingenuous to say the least. Any truth it contained would require a very Pickwickian sense of "bourgeois," and a brief look at *The Rebel* will hardly support this interpretation.

The dynamic core of Camus's motivation in *The Rebel* is an almost unmanageable sense of the political enormities of our time. He says that he is willing to "accept" the realities of today which are logically rationalized crimes, to examine meticulously the arguments by which they are sustained, and to attempt to understand the time in which he lives.[8] But in his heart to understand does not mean to accept, but only to supply the clarity for the foundation of a passionate protest. If all contemporary political action leads to murder—whether political assassination, state executions, murderous revolts, or organized warfare—then it is necessary to examine the charter of the right to kill. And to a deeply humane temperament, committed to the absurdity of existence, yet recognizing that human life is the single necessary good, such a charter is necessarily a contradiction in terms. To recognize this is an act of personal revolt, and such an act always signifies an awakening of conscience.

The "moral philosophy" of Sartre is deficient in the sense of conscience—not that it denies the fact of subjective determination, but that it admits no preexisting moral structure as a source of this determination, which is authoritatively shared by all men. This makes for opportunism, for moral "contingency," and it underlies the crucial point which Sartre made in his famous Sorbonne lecture, "Existentialism Is a Humanism," that man has no preexisting *essence,* but only an existence

which he creates for himself out of the whole cloth of pure possibility.

It is precisely this basic tenet of existentialism which Camus denies. His analysis of revolt leads to the conclusion that, contrary to the postulates of Sartre, a "human nature" does exist as the Greeks believed,[9] and that even the slave when he rebels does so in the name of something inside himself which has been outraged—something not unique to him, but shared with all other men, even his master and oppressor. This is to place Camus with the classical moralists, with those who hold that there is a pervasive structure of values in which all men participate. There are moments in Camus's philosophizing—moments when he confronts death or when the triumph of disvalue stimulates in him emotions of irony and of the world's absurdity—in which the more immediate confidence in the ultimate triumph of value is muted or absent, but the presupposition of its necessary existence underlies like an invisible support his sharp critique of unprincipled Machiavellianism in the political left. It is this, above all, which Sartre has in mind when he scornfully speaks of Camus's resolute championship of bourgeois values.

There can be no doubt that Camus utilizes the appeal to moral principle to call into question the validity of Marxist violence, and that he finds this violence to be only the last link in a chain which begins with the Jacobin vindication of terror, with the coldly murderous calculations of Marat, Robespierre and Saint-Just:

Russian Communism, by its violent criticism of every kind of formal virtue, puts the finishing touches to the revolutionary work of the nineteenth century by denying any superior principle. The regicides of the nineteenth century are succeeded by the deicides of the twentieth century, who want to make the earth a kingdom where man is God. The reign of history begins and, identifying himself only with his history, man, unfaithful to his real rebellion, will henceforth devote himself to the nihilistic revolution of the twentieth century which denies all forms of morality and desperately attempts to achieve the unity of the human race through an exhausting series of crimes and wars.[10]

What appalls Camus here is not merely the denial of morality as a formal system, but the insensitivity to a stern judgment of political instruments, the inversion of means and ends which concludes with the ironic effort to achieve social utopia through

torture and extermination. Any sensitive Marxist must from
time to time feel an inevitable guilt as he realizes the incompat-
ibility between a present dedication to brutal means and the
concept of brotherhood and the human community in whose
service they are invoked. Brecht himself, one of the least senti-
mental of all artists dedicated to the Marxist cause, celebrates
this emotion with gentle ruefulness in his famous poem of 1938,
"An die Nachgeborenen" (To our Successors) :

> You who will emerge out of the flood
> In which we have gone under
> Think also
> When you speak of our weaknesses
> Of the dark time
> From which you have escaped.
> For we went, changing our country
> more often than our shoes,
> Through the war of the classes,
> despairing
> When there was injustice only and
> no rebellion.
>
> And yet we also know
> That hatred against debasement
> Distorts the features.
> And anger against injustice
> Makes the voice hoarse. Oh we
> Who wished to prepare the soil for
> friendliness
> Could not ourselves be friendly.
> But you, when it has gone so far
> That man helps man
> Think of us with
> Indulgence.[11]

This is at least a "conscientious" Marxism, but it is a far cry
from Lenin's glorification of expediency and deceit, a man who
never ceased to fight mercilessly against the sentimental forms
of revolutionary action and who believed that revolutionary
power could never be established if the Ten Commandments
were to be respected. "Completely impervious to anxiety, to
nostalgia, to ethics," says Camus, "he takes command and looks
for the best method of making the machine run." [12] From that
point on, traditional human relations in the Soviet Union have
been transformed. Rational terror has replaced free choice,

propaganda and polemic have replaced dialogue and personal relations, and the revolutionary himself has ended by becoming an oppressor. Camus in *The Rebel* is peculiarly aware of how power, even revolutionary power, corrupts, and therefore of how the absolute can never be attained or created through history. Revolution in the name of man's freedom ends in the tyranny which abolishes freedom. Violence exercised to extirpate injustice results in a multiplication of injustices. The lesson is almost monotonously the same. Early Christianity ends with the Spanish Inquisition. The Declaration of the Rights of Man ends with the Terror. The October Revolution ends with the Moscow Trials.

Toward the state terrorism in which the Marxist revolution eventuated, Camus is implacable, but to the individual terrorism which preceded it (as the experience of the amateur sometimes precedes that of the professional) he has a certain understandable softness. In the eighteenth century Saint-Just had remarked: "No one can rule innocently," and when Lenin professionalized revolution, and in his success finally seized power, the problems of administration and control required ruthlessness and realism—in short, an end of innocence. But the "children and adolescents" of Russian nihilism from 1865 to 1905—that "proletariat of undergraduates" as Dostoievsky called them—utilized the instruments of individual terror like the band of amateurs they were, as a matter of principle, and with an astonishing degree of innocence. Camus accords them his infinite respect:

Until the end of the nineteenth century these undergraduates never numbered more than a few thousand. However, entirely on their own, and in defiance of the most compact absolutism of the time, they claimed and actually did contribute to the liberation of forty million moujiks. Almost all of them paid for this liberation by suicide, execution, prison or madness. The entire history of Russian terrorism can be summed up in the struggle of a handful of intellectuals to abolish tyranny, against a background of a silent populace. Their attenuated victory was finally betrayed. But by their sacrifice and even by their most extreme negations they gave substance to a new standard of values or a new virtue, which, even today, has not ceased to oppose tyranny and to give aid to the cause of true liberation.[13]

No sympathizer with the partisans of Russian nihilistic terrorism can rightly be called "a resolute champion of bourgeois

values," but the complaint of Sartre and de Beauvoir against Camus is at bottom his insistence on the moral scruple, and it is true that it is precisely the moral sensitivity of these youthful terrorists—their conscientiousness—which appealed to the *moraliste* in Camus. A brief section in *The Rebel* entitled "The Fastidious Assassins" (Les meurtiers délicats), based in large part on Boris Savinkov's *Souvenirs d'un terrorist* (Paris: Payot, 1931), shows the extent to which they had seized on his imagination. This is the group which had plotted and carried out the murder of the Grand Duke Sergei in 1905, the young student Kaliayev who threw the bomb and his companions and accomplices Boris Savinkov, Dora Brilliant, Boris Voinarovski. "In the universe of total negation," says Camus,

these young disciples try, with bombs, revolvers and also with the courage with which they walk to the gallows, to escape from the contradiction and to create the values they lack . . . "How can we speak of terrorist activity without taking part in it?" exclaims the student Kaliayev. His companions, united ever since 1903, in the *Organization for Combat* of the revolutionary socialist party, under the direction of Azef and later of Boris Savinkov, all live up to the standard of this admirable statement. They are men of the highest principles: the last, in the history of rebellion, to refuse no part of their condition or their drama. . . . This little group of men and women, lost among the Russian masses, bound only to one another, chose the role of executioner to which they were in no way destined. They lived in the same paradox, combining in themselves respect for human life in general and contempt for their own lives—to the point of nostalgia for the supreme sacrifice . . . At the same time, these executioners who risked their own lives so completely, only made attempts on the lives of others after the most scrupulous examination of conscience. The first attempt on the Grand Duke Sergei failed because Kaliayev, with the full approval of his comrades, refused to kill the children who were riding in the Grand Duke's carriage . . . Such a degree of self-abnegation, accompanied by such profound consideration for the lives of others, allows the supposition that these fastidious assassins lived out the rebel destiny in its most contradictory form. It is possible to believe that they too, while recognizing the inevitability of violence, nevertheless admitted to themselves that it is unjustifiable. Necessary and inexcusable, that is how murder appeared to them . . . From their earliest days they were incapable of justifying what they nevertheless found necessary and conceived the idea of offering themselves as a justification and of replying by personal sacrifice to the question they asked themselves. For them, as for all rebels before them, murder was identified

with suicide. A life is paid for by another life, and from these two sacrifices springs the promise of a value.[14]

I have quoted Camus here with some fullness because in no other section of *The Rebel* is expressed so quintessentially the quality of his own moral perception—of a mind that does not shrink from the concept of revolutionary violence so long as it is coupled fast with the profoundest sentiment of personal moral responsibility. The coupling is paradoxical and problematic and one not immediately understandable to those unused to observing the utmost tact and restraint in dealing with the world of real politics. If Camus had been content to find all direct violence inexcusable except that exercised by military and police powers in the capitalist state for the perpetuation of its injustices, he could, indeed, have been accused of being "a resolute champion of bourgeois values"; if, on the contrary, he had consoled himself in the name of history with the thought that all proletarian violence is justified, wherever and however it occurs, he would have been one with the party of the radical Marxists and with Sartre and de Beauvoir. But he is neither, and thus, *between* the perpetuators of bourgeois injustice and a cynical revolutionary Machiavellianism, *he inserts the moral claim.*

"A creative writer's politics cannot be detached, without loss of authenticity, from the nature of his imagination." Camus and Sartre are both creative writers, and the nature of their imaginations expresses itself equally in their ideological polemics and in their literary works. Two years before the 1952 political debate in the pages of *Les Temps Modernes* had occurred a mute literary confrontation in which the entire dialectic of political and moral opposition could be already clearly discerned. On April 2, 1948 Sartre's play *Les Mains sales* (Dirty Hands) was presented for the first time at the Théâtre Antoine in Paris. And on December 15, 1949 Camus's play *Les Justes* (The Just Assassins) was given its premiere in Paris at the Théâtre Hébertot. In the respective statements and ambience of these two political dramas is prefigured the political rupture of the future.

Camus's play is an almost literal retelling of the successful murder of the Grand Duke Sergei, and its chief characters are therefore the same historical Kaliayev, Boris, and Dora treated in *The Rebel,* with a slight change of names (Boris Savinkov is Boris Annenkov; Dora Brilliant becomes Dora Dulebov).

Sartre's play is indefinite as to setting, but takes place presumably in revolution-torn Hungary toward the end of the Second World War. "The subject of the play," Simone de Beauvoir tells us, "had been suggested to him by the assassination of Trotsky. I had known one of Trotsky's ex-secretaries in New York; he told me how the murderer, having managed to get himself hired as Trotsky's secretary, had lived for a long time by his victim's side in a house fanatically well guarded. Sartre had pondered on this dead-end situation; he had imagined a young Communist, born into the middle classes, seeking to erase his origin by an act, but unable to tear himself away from his subjectivity, even at the price of an assassination; in opposition to him he had created a militant politican utterly devoted to his objectives. (Once again, the confrontation of morality and *praxis*.) As he said in his interviews, Sartre had no intention of writing a political play. It became one simply because he had chosen members of the Communist Party as its protagonists." [15]

We may, I think, take de Beauvoir's assertion that Sartre had no intention of writing a political play with a grain of salt. The episode which inspired it, Trotsky's murder, is political through and through. The play is political not only because members of the Communist Party are its protagonists (and why should de Beauvoir be so disingenuous? the very choice to make them so is deliberately political), but because, like *The Just Assassins*, its theme is the problem of political assassination, and because, whether consciously or not, Sartre's treatment of this theme, his central contrast of the weak and vacillating bourgeois Hugo with the strong, hard-bitten, purposeful Communist leader Hoederer conveys an attitude which constitutes practically a political statement. The assassination of a Trotsky-like figure by Communist order in a Hungary-like nation sometime around 1943–45 is as politically relevant as the assassination of the Grand Duke Sergei in the Russia of 1905. *Dirty Hands* is no less a clue to the political philosophy of Sartre than *The Just Assassins* is to that of Camus, and a brief comparison of their respective plots and treatments will substantiate in all respects the conclusions which can be drawn from the bitter polemic of *Les Temps Modernes*.

The plot of Camus's play and its historicity we already know —how the group of youthful terrorists planned to kill the Grand Duke and put an end to tyranny, how in the face of the populace's impassivity they hoped to demonstrate to the Impe-

rial Court that the reign of terror was to be a permanent fact of
life until the land was returned to its rightful owners, the
Russian people. But the play's center, as we might have in-
ferred from *The Rebel,* is the curious joining of terrorism and
innocence, of determined political murder and the moral scru-
ple which seems to have obsessed Camus in his concern with the
young revolutionaries of 1905. And it is this obsession which
causes Camus to place the climax so early—in Act II of this
five-act play—where the execution is put off because Kaliayev
finds himself unable to fling the bomb at the carriage in which,
by chance, innocent children are also riding. But the heart of
Camus's moral intention is revealed in Act I; through "that
achievement of dramatic tension through classical means," as
he says in his preface, "through an opposition of characters who
are equal in strength and reason." [16] Here is the play's original-
ity, for perhaps the single invented character is that of Stepan
Fedorov, the slightly twisted revolutionary fanatic for whom
the end justifies any means whatsoever, the stalwart believer in
party strength and party discipline whose prison humiliations
have brought him to the point of believing that love and pity
no longer have any place in the makeup of the dedicated man
of revolutionary action. It is the contrast between this cluster of
ideas and that of the humane and conscience-ridden Kaliayev
which transmits the message of the play.

Kaliayev is the play's paradoxical center, the Rousseauistic
man of feeling who joins the revolution for the ultimate extir-
pation of violence, who engages in the strategies of death be-
cause he loves life.

KALIAYEV: I'd want them to know that I'm not really so unusual.
They find me flighty . . . too impulsive, no doubt. Yet, like them, I
believe in our ideal. Like them, I am ready to give up my life for it.
I, too, can be cunning, silent, crafty, and efficient when necessary.
Only, life continues to seem a wonderful thing to me. I love beauty
and happiness! That's why I hate despotism. How can I explain it
to them? Revolution—of course! But revolution for the sake of life
—to give life a chance. You understand me?
DORA (impulsively): Of course! (After a short silence, in a lower
voice.) But meanwhile . . . we are going to bring death.
KALIAYEV: Who? Us? Oh, I see what you mean. But that's not the
same thing. Because when we kill, it's to build a world where no one
will kill again. We agree to be criminals in order that at last only
the innocent shall be on earth.[17]

Kaliayev has asked to be the one to throw the first bomb because, as he sees it, to die for an ideal is the only way of proving oneself worthy of it. For it is suicide which provides the only possible justification for murder. Herein lies the peculiar "delicacy" of these assassins.

KALIAYEV: Sometimes at night I toss and turn on my cheap straw mattress and I am tormented by the thought that they have turned us into murderers. But then at once I remember that I am going to die and I feel calm again. I smile to myself and go back to sleep like a child.[18]

This is touching, and it prepares us for the second-act climax where Kaliayev returns devastated from the first bombing attempt, having failed because of the children unexpectedly sitting beside the Grand Duke. His companions understand. Only Stepan Fedorov is furious that the attempt has failed, and that two solid months of shadowing and hairbreadth escapes, of harrowing suspense and sleepless nights, of plotting and scheming, have gone down the drain.

DORA: Open your eyes, Stepan, and try to understand that our Organization would lose all its power and influence if it tolerated even for a moment that children might be blown to pieces by our bombs.
STEPAN: I'm afraid my heart isn't tender enough for such stupidities. Only when the day comes when we stop shedding tears over children will we be masters of the world and the revolution triumph.
DORA: When that day comes the revolution will be hated by the whole human race.
STEPAN: Who cares, if we love it enough to force it on humanity and to save the human race from itself and from its bondage?
DORA: And suppose the whole human race rejects the revolution? What if the masses for whom you are struggling won't stand it that children should be killed? Will you then strike at them too?
STEPAN: Yes, if it were necessary, and I would go on striking at them until they understood. . . .[19]

The others protest one by one. Even in the experience of revolutionary violence it is false that "everything is permitted." Even for a just cause there are some things which must be ruled out. Even for the future of the proletariat *there are limits!*

STEPAN (vehemently): There are no limits! The truth is that
you don't believe in the revolution, any of you. (All, except Ka-
liayev, rise to their feet.) No, you don't believe in it. If you did be-
lieve—completely and without reservation—if you were convinced
that through our sacrifices and our victories, we would at last build
a new Russia free from despotism, a land of liberty that should fin-
ally spread over the entire world, and if you were sure that then,
freed from his oppressors and his superstitions, man would raise his
face toward heaven, a god in his own right, how then could you be
daunted by the death of two children? Surely you would claim the
right to do anything—anything at all. And if now you are stopped
by the death of these two children, it is simply that you are not sure
that you have the right. You simply do not really believe in the re-
volution! (A short silence, then Kaliayev also rises to his feet.)
KALIAYEV: Stepan, I am ashamed of myself and yet I cannot let
you continue. I am ready to kill to destroy despotism. But behind
what you say, I discern another despotism which, if it ever comes to
power, will make me a murderer even though what I try to be is a
bringer of justice.
STEPAN: So long as justice is brought about, even by murderers,
what does it matter what you are? You and I are not important.
KALIAYEV: We *are* important. And you know it too, since it's just
because of your pride that you talk the way you do now.
STEPAN: My pride is my own business. But men's pride, their re-
bellion, the injustice in which they live—these are the business of us
all.
KALIAYEV: Men do not live by justice alone!
STEPAN: When their bread is stolen, what else have they to live
by?
KALIAYEV: By justice and—by innocence.[20]

The issue here is one on which Camus himself is willing to
stake the revolutionary adventure. Men do not live by abstract
justice alone, but by honor and by innocence. One must not
strike his brothers in the face for the sake of some far-off city.
Killing children (and indeed any ruthless equivalent) is
against human honor, and when the revolution decides to
break with honor, its claims to legitimacy are laid waste. To
think that delicacy of concern—squeamishness, the other side
calls it—is out of place even in the matter of political assassina-
tion is to destroy the very moral claim which gives to ruthless-
ness its ultimate human support. To smash the framework of
moral order for the sake of a utopian future is the temptation
of every malignant form of proletarian blindness. Camus's
drama of *The Just Assassins* tries to place the political tempta-

tion of our age in a perspective at once contemporary and classically Greek, as Sophocles did in *Antigone* to show the human fate in a political guise, but, unlike Sophocles, with a contemporary reference which cannot but speak to the great political issues of our time. Marxism is the pivotal point on which the affirmation of every contemporary French intellectual can be made to rest, and *The Just Assassins* is addressed to a modern world implicated in the Stalinist purges, the Moscow Trials, and the assassination of Leon Trotsky. It is no accident that Merleau-Ponty's first extended essay on the problem of Communism was entitled *Humanisme et Terreur* and Camus's play is but another variant on this crucially important modern theme—how the humanizing solvents of innocence, honor, and responsibility alone legitimate the barbarism of terror, and how a world which does not take this sermon to its heart is the ironic breeding ground of a murderous injustice. If there were any doubt at all of Camus's intention, it would be resolved by a reading of *The Rebel,* and by the preface which precedes *The Just Assassins* itself.

My admiration for my heroes, Kaliayev and Dora, is complete. I merely wanted to show that action itself had limits. There is no good and just action but what recognizes these limits and, if it must go beyond them, at least accepts death. Our world of today seems loathsome to us for the very reason that it is made by men who grant themselves the right to go beyond those limits, and first of all to kill others without dying themselves. Thus it is that today justice serves as an alibi, throughout the world, for the assassins of all justice.[21]

The crucial political issue between Camus and Sartre is that of the relevance of the moral qualm, the question of "limits," the matter of whether "innocence" in the sense in which Saint-Just introduced the term has indeed any relationship to the necessities of a revolutionary politics. And as *The Just Assassins* argues one side of the case, so Sartre's *Dirty Hands* argues the other. As *The Just Assassins* presents the opposition between the relentless fanatic Stepan Fedorov and the scrupulous revolutionary Ivan Kaliayev in such a way as to underwrite the latter, so *Dirty Hands* presents a central opposition between the weak but principled petit-bourgeois convert to the Communist Party, Hugo Barine, and Hoederer, the strong, ruthless, and opportunistic Party leader, in such a way as to show that "the moral scruple" is the mask of political incompetence, and that

the way of Machiavelli and Thrasymachus constitutes the wave
of the future.

Hugo, considered even by the Party which accepted him as
an undisciplined, anarchistic individualist, a pose-striking in-
tellectual, is sent ostensibly to be Hoederer's secretary, but is
under secret Party orders to assassinate him. Hoederer has
proposed that the Party join with the reactionary Regent and
the Pentagon, the party of the liberal center, in a coalition
government to take power jointly and then wrest it from the
other two, but even this obvious accommodation is too much
for the lesser Party leadership. They consider Hoederer to be a
class traitor to be liquidated. Hugo is taken by Hoederer in
good faith as his secretary, lives with him in his closely guarded
enclave, and, Hamlet-like, awaits his opportunity. After Hoe-
derer has sealed the compact with the Regent's son, Prince
Paul, and Karsky, the representative of the liberal bourgeoisie,
in his office, Hugo's indignation knows no bounds. That night
in his own quarters the climactic confrontation with Hoederer
occurs. Hugo blurts out that he too finds Hoederer to be a
traitor to his class and to the Party, and Hoederer wants to
know why. Hugo explains that the Party is a revolutionary
organization, and that Hoederer is willing to let it become a
government party.

HUGO: The party has one program: the realization of a socialist
economy, and one method: to utilize the class struggle. You are
going to use it to pursue a policy of class collaboration in the frame-
work of a capitalist economy. For years you will have to lie, trick,
and maneuver; you will go from compromise to compromise and
you will have to defend the reactionary measures taken by a govern-
ment in which you participate before the eyes of our comrades. No
one will understand: the tough ones will leave us, the others will
lose whatever political capability they have acquired. We will be
contaminated, weakened, disoriented. We will become reformists
and nationalists and, finally, the bourgeois parties won't even have
to take the trouble to liquidate us. Hoederer! The party belongs to
you. You can't have forgotten the hardships you went through to
make it, the sacrifices required, the discipline it was necessary to im-
pose. I beg of you: don't sacrifice it with your own hands!
HOEDERER: What idiotic talk! If you don't want to take risks you
shouldn't be in politics.[22]

Hugo objects that the Party rank and file will never submit
to such subversion of their principles, and that only if they are

told lies will they acquiesce. Hoederer admits that this will probably be necessary, and to Hugo's horrified objection he retorts:

HOEDERER: I'll lie when I must, and I scorn no one. I didn't invent lying. It grew up in a society divided into classes and each of us has inherited it from birth. It is not by refusing to lie that we shall abolish it, but by using every means possible to abolish classes.
HUGO: All means are not good.
HOEDERER: All means are good when they're effective.[23]

And then, seeing Hugo overcome with despair and unbelief, he utters the climactic insight of the play:

HOEDERER: . . . How you cling to your purity, my boy! How afraid you are to soil your hands. Well, stay pure! What good will it do, and why did you join us? Purity is an idea for a yogi or a monk. You others, you intellectuals and bourgeois anarchists, use it as a pretext to do nothing. To do nothing, remain motionless, arms straight at your sides, carrying kid gloves. Well, I have dirty hands. Up to the elbows! I've plunged them in filth and in blood. So what? Do you think one can govern innocently? [24]

Sartre's repetition of the ancient words of Saint-Just has a peculiar resonance in the mouth of his hero Hoederer, and it is clear that he approves of the implied philosophy of politics. Purity is not a political category, and it is doubtful whether in his opinion principles are either. Almost as if anticipating the very language of Camus's play, Hoederer accuses Hugo of a cold and irrelevant virtue.

HOEDERER: You see! There you are! You don't love men, Hugo. You only love principles.
HUGO: Men? Why should I love them? Do they love me?
HOEDERER: Then why did you join us? If you don't love men, you can't fight for them.
HUGO: I joined the party because its cause is just, and I shall leave it when it is so no longer. As for men, it's not what they are that interests me, but what they can become.
HOEDERER: As for me, I love them for what they are. With all their beastliness and all their vices. I love their voices and their warm clutching hands, and their skin, the nudest skin of all, and their uneasy look, and the desperate struggle that each has to wage against anguish and against death. For me a man more or less in the world counts for something. Its something precious. You, my friend

—I know you now—you are a destroyer. You detest men because
you detest yourself. Your purity is like death, and the revolution of
which you dream is not ours. You don't want to change the world,
you want to blow it up! [25]

It is not simply that Sartre is anticipating Camus's play. He is
also anticipating the very reply which he is to make to Camus
in the pages of *Les Temps Modernes*. Camus is a kind of Hugo,
a petit-bourgeois, a man of principle whose purity resembles
death. And Sartre is a kind of Hoederer who reminds him of
this fact. The more one becomes involved in the histrionic
problems of the existentialist intellectuals, the less one knows
whether it is life which follows literature, or literature which
follows life!

Dirty Hands is susceptible of misunderstanding in the same
way as Brecht's *Die Massnahme* (The Measures Taken) and
for a similar reason: both show the extremes of duplicity or
violence to which the Party may resort (and, indeed, in
Brecht's and Sartre's opinion *must* resort) when the need arises.
To a liberal-democratic consciousness they therefore seem an
implicit condemnation, while for their authors they are only
realistic portrayals of Party problems and Party dilemmas in no
way condemnatory of a necessary political realism. Hoederer's
speech against "kid gloves," and his assertion that he has right-
fully plunged his hands into blood and filth "up to the elbows"
has its perfect analogue in *The Measures Taken:*

> Welche Niedrigkeit begingest du nicht, um
> Die Niedrigkeit auszutilgen?
> Könntest du die Welt endlich verändern, wofür
> Wärest du dir zu gut?
> Wer bist du?
> Versinke in Schmutz
> Umarme den Schlächter, aber
> Ändere die Welt: sie braucht es!

> (What baseness would you not commit to
> Wipe out baseness?
> If you could finally change the world, what
> Would you consider yourself too good for?
> Who are you?
> Sink into the filth
> Embrace the butcher, but
> Change the world: it needs it!) [26]

Despite the possible misinterpretation of Sartre's play (which caused him to refuse to let it be performed at the World Peace Congress in Vienna in 1948), his own attitude and intention seem clear from the statement of Simone de Beauvior.

The play didn't seem to me to be anti-Communist. The Communists were presented as the only valid force against the Regent and the bourgeoisie; if a leader, in the interests of the Resistance, of socialism, of the masses, had another leader suppressed, it seemed to me as it did to Sartre that he was exempt from all judgment of a moral order. It was war, he was fighting; this did not mean that the Communist Party was made up of assassins. And then . . . in *Dirty Hands* Sartre's sympathy went to Hoederer. Hugo decides to kill in order to prove that he is capable of doing so, without knowing if Louis is in the right against Hoederer. Afterwards he decides to take credit for this irresponsible act when his comrades order him to keep quiet. He is so fundamentally in the wrong that the play could be put on, during a period of thaw, in a Communist country; which is in fact what happened in Yugoslavia recently. Only, in the Paris of 1948, circumstances were different.[27]

It is thus clear that the mutual confrontation of *The Just Assassins* and *Dirty Hands* indicates a profound difference in moral assessment exhibited at even so gross a level as their titles. Camus elevates the "justice" and scrupulosity of the terroristic assassins. Sartre proclaims his admiration for and solidarity with "the dirty-handed" in the unconscionable struggle for social justice. It is the age-old controversy again of persons against principles, of opportunism against consistency, of the overriding character of ends and the impunity of political means. Any serious political concern which transcends the merely arbitrary fluctuations of the social dispute will always be forced to come to grips with this opposition. Camus and Sartre, in their dramatic thrust as in their polemical intent, only illustrate once again that permanent problem of humanism and politics which centers on the necessary or the contingent role of ethical considerations. After Camus was killed in a shocking motor accident in January, 1960, Sartre, on whose shoulders it has so often devolved to write the obituaries of his alienated but former friends, published his generous and honorable "Tribute to Albert Camus."

He represented in our time the latest example of that long line of *moralistes* whose work constitutes perhaps the most original ele-

ment in French letters. His obstinate humanism, narrow and pure, austere and sensual, waged an uncertain war against the massive and formless events of the time. But on the other hand through his dogged rejections he affirmed, at the heart of our epoch, against the Machiavellians and against the idol of realism, the existence of the moral issue . . . In a way, he *was* that resolute affirmation. Anyone who read or reflected encountered the human values he held in his fist; he questioned the political act. One had to avoid him or fight him—he was indispensable to that tension which makes intellectual life what it is. His very silence, these last few years, had something positive about it: This Descartes of the Absurd refused to leave the safe ground of morality and venture on the uncertain paths of practicality. We sensed this and we also sensed the conflicts he kept hidden, for ethics, taken alone, both requires and condemns revolt.[28]

It is perhaps an ambiguous and a problematic performance, but it states truly the moral impact of Camus's thought and personality on the political dilemma of the French existential intellectuals and, by extension, on the modern world.

There can be no doubt that the proposition which separated Sartre from Camus was "the existence of the moral issue," and that to a degree of which Sartre was not capable Camus "questioned the political act." Crucially at stake was the question of the primacy of morals *or* politics. And for the impartial observer who concerns himself with their quarrel, one fact stands out more and more—it is the intense mistrust, almost, one would say, bitter resentment which Sartre feels toward every customary ethics. Sartre's anti-ethical bias is more than an intellectual conclusion, it is an emotional blindspot, almost a political passion, and it explains much in Sartre's position which has been suspect to the liberal tendencies in the West.

Four strands in Sartre's thought and feeling seem to me to stand in intimate relationship to one another: (1) his scorn of customary morality, (2) his almost obsessive hatred for the bourgeois class, (3) his inability to produce the moral construction entailed by his metaphysical system as promised by the last pages of *Being and Nothingness,* and (4) his momentarily vacillating, but in the end constant support of the aims of the Soviet Union and of the French Communist Party. One could compress it all by saying simply: "Sartre is a Marxist," but this, while true, would be to oversimplify the peculiar complex of ideas which makes the texture of his thought at once so compel-

ling and so exasperating. For it is necessary to recognize the paradoxical co-presence of rational and irrational elements in Sartre's system: the construction of a social psychology (in *Being and Nothingness*) which makes impossible the very social solidarity of the proletariat which Sartre wants to assert; the assertion of a metaphysical freedom which is in total opposition to the repressive tendencies of that Soviet Union whose adventures (except for moments of brief bitterness like those at the Hungarian intervention) he has never ceased to underwrite; the dogged independence of the bourgeois intellectual which has prevented Sartre from ever joining the Communist Party while at the same time never ceasing to heap coals of scorn on the bourgeois complex of values which, for all its perversions, remains the source and support of his courageous intellectual individualism. The contradictions here are too deeply seated to be the product of a merely faulty logic, or a dialectic not sufficiently thoroughgoing to establish a strain toward consistency—they are the consequences of prejudices which for all Sartre's rationalism are "pre-logical," and which are sometimes overlooked in the rigid Cartesian garments in which they are clothed—a beautifully constructed chain of argument masking a turmoil of ambiguous passions.

The conclusion of *Being and Nothingness* already evinced an interest in "ethical implications" (*perspectives morales*). For, although Sartre indicated that he had absorbed the lesson of Hume, that he realized that ontology cannot formulate ethical precepts, that from its indicative mood, no imperatives are forthcoming, he yet voiced the hope that it (ontology) might permit us to "catch a glimpse of what sort of ethics will assume its responsibilities when confronted with a *human reality in situation*." [29] And he asserted that the various tasks of the human ego might be made the object of "an existential psychoanalysis" which would itself constitute a moral description as it "releases to us the ethical meaning of various human projects." He went on to speculate briefly on the mutual relationship of certain crucial ethical concepts—"freedom," "value," "situation"—without definitive solution. And the book ends with these words: "All these questions, which refer us to a pure and not an accessory reflection, can find their reply only on the ethical plane. We shall devote to them a future work." Now, over two decades later, no such volume has appeared, and it is of some interest and importance to ask why. Sartre's famous promise of an ethics has been no more fulfilled than Heidegger's

equally famous promise of a second part to *Sein und Zeit,* and in this obvious failure is to be found a clue to the obsessive Marxism which has dominated all of the subsequent writings of Sartre.

We have the authority of de Beauvoir that even in these early days (1943), Sartre's ethical ambitions were not independent of a Marxist commitment.

There were no reservations in our friendship for the U.S.S.R.; the sacrifices of the Russian people had proved that its leaders embodied its true wishes. It was therefore easy, on every level, to cooperate with the Communist Party. Sartre did not contemplate becoming a member. For one thing he was too independent; but above all, there were serious ideological divergences between him and the Marxists. The Marxist dialectic, as he understood it then, suppressed him as an individual; he believed in the phenomenological intuition which affords objects immediately "in flesh and blood." Although he adhered to the idea of *praxis,* he had not given up his old, persisting project of writing an *ethics.* He still aspired to *being;* to live morally was, according to him, to attain an absolutely meaningful mode of existence. He did not wish to abandon—and indeed, never has abandoned—the concepts of negativity, of interiority, of existence and of freedom elaborated in *Being and Nothingness.* In opposition to the brand of Marxism professed by the Communist Party, he was determined to preserve man's human dimension. He hoped that the Communists would grant existence to the values of humanism; and he was to try, with the tools they lent him, to tear humanism from the clutches of the bourgeoisie. Apprehending Marxism from the viewpoint of bourgeois culture, he was to place the latter, by an inverse process, in a Marxist perspective.[30]

In this passage, as in some witch's potion, are distilled all of the contradictory elements which are later to prove so upsetting in Sartre's position: the will to cooperate with the Communist Party without any desire to join its ranks; the recognition that the Party suppresses individuality in its members, combined with the assertion that it is the only authentic voice of the proletariat in France; a reluctance to forsake the "immediacy" of experience joined to a faith in the organizations of the left as a mediator of its message; a belief in the primacy of the act without the abandonment of the exercise of moral criticism; a persistent desire to write an ethics in the face of a social psychology which would make its conclusions irrelevant; a recognition that "humanism" was as yet a foreign importation into the Communist Party, and that values, like some material and

tangible substance—as, for example, the instruments of production—were to be "torn from the clutches of the bourgeoisie" and placed where they belong, in the hands of the proletariat, through some act of axiological violence. and the whole to be performed by that feat of dialectical legerdemain which would permit one to view Marxism as a bourgeois and bourgeois culture as a Marxist. What is chiefly interesting here is not the presupposition of the socially unanchored intellectual—so antagonistic in its thrust to the rigid Marxist insistence on class membership and the class determination of intellectual perspective—but rather the admission that "to live morally" means "to attain an absolutely meaningful mode of existence," since this would have been the only possible motivation for the persisting project of writing an ethics. For it was just this motivation that underwent progressive attenuation in the next decade of Sartre's life.

For this there are, I think, two quite different reasons, although they surely blended in their total effect. The first is that the account of individual constitution and motivation presented in *Being and Nothingness* is inconsistent with the promise of a future ethics registered in its last lines. And the second is the intense conflict in Sartre's own personality between theoretical and practical considerations—the incompatibility between the desire to be the first metaphysician of his age and to determine the political destiny of the modern world, or, at least, of modern France. In either case the desires may seem inordinate, but I do not think they overestimate Sartre's ambition.

It is not necessary to dwell on either of these reasons in any detail. For it is clear that in *Being and Nothingness* Sartre's theory of social relations is poisoned by his cynicism, and makes impossible that very fraternal rebellion against the strictures of bourgeois injustice which his later practical Marxism inconsistently and paradoxically invokes—I mean his treatment of "the look" and his concept of sociality as mutual aggression, appropriation, exploitation. The entire third part of *Being and Nothingness*, "Being-for-Others," with its insistence that the function of another's gaze is to transform one into a thing, that social striving is the quest for domination, and that love itself is but the appropriation of the alien body of the other—all this presents with infinite refinement a Hobbesian state of nature in psychological guise.[31] Alienation is here the rotten core of all social relations, and it cuts off Sartre's philosophy from the

primary values of an optimistic ethics (the felicities of genuine communal action or the behavior of a selfless love) more decisively than an act of deliberate moral cynicism. It is for this reason above all, I think, that Sartre's long-promised ethical system has never appeared, and, indeed, if I am not mistaken, can never appear. With such presuppositions one can produce a clinical psychology or a social pathology, but not a moral philosophy.

There were some who seemed to believe that Sartre's mammoth *Critique of Dialectical Reason* which appeared in 1960 would be his long-awaited moral treatise, but they have been doomed to disappointment.[32] For this immense, pedantic, repetitious, and essentially formless and unreadable production has only substituted the commonplaces of the sociology of the last thirty years for an absent assertion of moral principle. It is almost as if deep down Sartre realizes the impossible contradiction within his system: the incompatibility between a selfish, hermetically sealed ego of action and the idealistic collective—the "we" of a passionately felt social action—so that all of the elaborately built up sociological apparatus of the *Critique*, the passage from mere "seriality" to the genesis of "the group" and "the party," would be at last a redemption from the original sin of the isolated individual. The "demonstration" outdoes the prolixity of some medieval "summa," but no *quod erat demonstrandum* can be placed on its last page. For Sartre's idiosyncratic Marxism is in the end hamstrung by the initial limitations of his bourgeois individualism. The exclusive emphasis on the subject as supreme value excludes any apotheosis of a collective ideal. No group or totality gains ultimate sovereignty while the self is the atom of power; no totalizing Hegelian consciousness can overcome the limitations inherent in the original Cartesian "cogito" which is Sartre's starting point—his glory, and the inevitable ruin of his system.[33]

It is tempting here to cite the example of Kant, for, in truth, Sartre's *Being and Nothingness*, like Kant's *Critique of Pure Reason*, is "an essay in phenomenological ontology," and his *Critique of Dialectical Reason*, like Kant's *Critique of Practical Reason*, is an attempt to repair the ravages of his own first book. "I have therefore," said Kant, "found it necessary to deny metaphysics as knowledge in order to make room for moral faith." And Sartre analogously might have said: "I have found it necessary to leave the area of ontology for that of sociology in order to provide a validation for my cherished system of social

action." But Sartre might have done well to note the dualistic strategy which Kant employed and which guarantees the success of the Kantian enterprise. Kant's pure speculative reason and his pure practical reason exercise a dual sovereignty, but over philosophical realms which never truly intersect. Thus, nothing is posited in his first critique which vitiates the conclusions of his second. But Sartre's description of the human condition in the later sections of *Being and Nothingness* is invaded through and through by empiricism, contingency, and time, so that the "dialectical reason" of his "second critique" can never be given a free hand, but remains forever subject to limitations set for it by conditions prior to its birth. Or, to speak more literally, Sartre's "ontology" has already been given a certain sociological factuality which his later expressed sociology is reluctantly obliged to take into account. Thus Sartre's sociology can never establish those moral imperatives which his phenomonological ontology has so utterly compromised—and his ethics fails.

The conflict in Sartre's nature between theoretical and practical considerations has had a similar effect, no less drastic, no less confused. For the metaphysician famous for the theoretical constructions of *Being and Nothingness* is also the energetic editor of *Les Temps Modernes,* writing passionately on the political questions of the day, promoting a journalism of advocacy and insistence. In itself this split is well known and hardly unusual, but in Sartre's case it presents an intellectual contradiction of a rather severe kind, for it hinges on a point which has been seriously at issue between Marxism and existentialism —the proper interpretation of the meaning of "alienation." It is the issue of whether alienation is for man a permanent phenomenological structure (as with Hegel) or a contingent historical occurrence (as with Marx), whether it inheres in "the human condition" or qualifies "the condition of man under capitalism"; and its consequence for social criticism lies either in a deepening of the tragic sense of life (as in *Being and Nothingness*) or in an optimistic commitment to the principles of social meliorism (as in the political writings in *Les Temps Modernes*). Sartre's analysis of alienation in *Being and Nothingness* often suggests that it is situational, permanent, and ineradicable, while his political writings (somewhat journalistic in character and almost always published first in *Les Temps Modernes*) echo the orthodox Marxist line: that the proletariat is the heart of France, that the French Communist Party is its

authentic voice, and that unity under its banner will bring the
revolution and the end of alienation. One might say that the
strife in Sartre's mentality between Hegel and Marx is reflected
in his life in the dual roles of systematic philosopher and stri-
dent political journalist. This, too, has had its effect on the
attenuation of his purely ethical interests.

As the theoretical difficulties of *Being and Nothingness* have
slowly revealed themselves in Sartre's consciousness, and as the
prospects for the construction of an adequate and internally
consistent ethics grew ever more remote, Sartre progressively
lost the conviction that "to live morally was to attain an abso-
lutely meaningful mode of existence," and grew increasingly
concerned with the requirements of a merely political praxis.
This increasing concern has also brought with it immersion in
the philosophy of Marxism and the more unrestrained expres-
sion of his sympathies with the ultimate aspirations of the Soviet
Union and the French Communist Party. The year 1949 seems
to have been crucial in this respect. De Beauvoir says: "Sartre
abandoned his work on morals proper that year because he was
convinced that *the moral attitude appears when technical and
social conditions render positive forms of conduct impossible.
Ethics is a collection of idealistic tricks intended to enable us to
live the life imposed on us by the poverty of our resources and
the insufficiency of our techniques.*" [34]

"Ethics is a collection of idealistic tricks" (La morale, c'est
un ensemble de trucs idéalistes) —this is the heart of the mat-
ter, and it indicates the degree to which Sartre's conviction of
the ontological supremacy of the moral life has assumed the
Marxist guise of suspicion and mistrust. For it follows from the
Marxist doctrine of the dependence of ideologies on the eco-
nomic facts of life that the ruling ideas of each age must simply
be the ideas of its ruling class, and that the assertion of a system
of perennial values—whether Greek or Christian or humanist
—must in fact serve as a mask for a system of class exploitation
and oppression. "Values" in this constellation of beliefs serve as
a defense of the *status quo* and every system of ethics (save that
which the proletariat, once in power, will dictate to the classless
society) has about it an air of duplicity and insincerity. Sartre's
contempt for the bourgeois way of life goes back a long way—at
least to his early days in Le Havre and the period of the
composition of *La Nausée*—but the identification of this con-
tempt with the disinclination to produce an ethics only slowly
reveals itself in his development.

It is not accidental that in de Beauvoir's description of Sartre's beliefs around 1943 she should have coupled the ideas of morality and action, that she should have noted that *"although* he adhered to the ideal of *praxis,* he had not given up his project of writing an *ethics,"* for the fact is that as the last grew weaker, the former increased in strength. The issue of ethics *or* politics which was at the center of the quarrel with Camus had been prepared by the whole history of Sartre's changing opinions as to the relationship between theory and practice. As his faith in the theory of moral behavior diminished, his essentially irrational commitment to practice increased, so that at last, almost as for the orthodox Marxists themselves, the political element in human life became paramount. This new and nuanced, although specifically Sartrean, brand of Machiavellianism is expressed to perfection in the course of his tribute to the recently deceased Merleau-Ponty. "There is an ethics of politics—a difficult subject, never clearly treated—*and, when politics is forced to betray its moral principles, to choose the moral principles is to betray the politics."* [35] When Sartre finally committed himself to the politics of the Communist revolution and to the Soviet Union, its living embodiment in the actual world, his commitment was absolute. Blind faith replaced the search for political evidence. Even at the time of the bloody Soviet intervention in Hungary in 1956 Sartre—although he blasted a politics which, as he recognized, "was the criminal folly of a Stalinism *in extremis"*—ultimately supported it as perpetrated by a political entity which nonetheless remained man's final hope. In "Le Fantôme de Staline" he wrote: "Must we call this bloody monster that tears at its own flesh by the name of Socialism? My answer is, quite frankly, yes." [36] It is the *ipse dixit* of a mentality no longer fitted to be the rational guide of a generation seeking political clarity against a background of humanistic assumptions. The Soviet Union had chosen to betray its moral principles, but even in the face of this betrayal, Sartre preferred to reject the moral principles rather than to compromise the politics.

There is some evidence that the year 1952 represented for Sartre a kind of personal crisis, a moment of ultimate political decision, a point of no return for his commitment to the politics of the Soviet Union. For about ten years he had been reading the Marxist texts, following current events, growing ever more alienated from the bourgeois class in which he had his origins, even, if we can believe Simone de Beauvoir, becoming para-

noid in the contradictory struggle which was tearing him apart. She quotes from his unpublished notes: "I was a victim of, and an accomplice in, the class struggle: a victim because I was hated by an entire class, an accomplice because I felt both responsible and powerless . . . I discovered the class struggle in that slow dismemberment that tore us away from the workers more and more each day . . ." [37] It seems that the arrest of the Communist leader Duclos was the straw which broke the camel's back. Sartre himself tells the story in showing how, just as Merleau-Ponty was leaving the left in disgust, he was joining it forever.

The last strings were broken; my vision was transformed. An anti-communist is a swine, I hold to that and I will never cease holding to that. I was perhaps naive . . . but after ten years of meditation I had reached the breaking point and needed only the slightest push. In the language of the church, it was a conversion. Merleau had also been converted—in 1950. We were both conditioned—but in an opposite sense. Slowly accumulated, our disgusts moved us to discover in a single instant, in his case the horror of Stalinism, in mine that of my own social class. In the name of the principles it had inculcated in me, in the name of its humanism and its "humanities," in the name of liberty, equality, and fraternity, *I swore a hatred against the bourgeois that would last until my death.* When I returned abruptly to Paris, I had either to write or choke. I wrote day and night. It was the first part of *The Communists and the Peace.*[38]

This work, published in *Les Temps Modernes* in 1952, marked Sartre's irrevocable installation in the Marxist camp, and the point of view which it lucidly expresses will reward our brief attention.[39]

Sartre's first and most important assertion is that at the present moment the Communist Party is the only possible representative of the working class; it is their *necessary* expression, and as an expression it is *exact.* Of course this poses a problem, for it can be said with some justice that the Communist Party is also a representative of Soviet interests. But in practice the aims of the working class and of the Soviet Union are identical.[40] In theory (if capitalism is necessarily doomed) Russia's example is not absolutely requisite for the triumph of socialism. But in fact (through historical, if not specifically logical, considerations) the destiny of the Soviet Union is the fate of the proletariat as a whole. It may be offensive to some that the policy of the

Communist Party is to lead the workers down the road of illegality and violence, but behind this necessity lies the reality of the class struggle. Sartre's strategy in "tearing humanism from the clutches of the bourgeoisie" is to redefine it in a way to link it indissolubly with "terror," to reassert with Marx himself that since the law is but the expression of an exploitative bourgeois jurisprudence, therefore the first violence and illegality have been exercised against the workers, and that the workers' revolt against inhuman laws is itself a new humanism, a new justice. In fact, says Sartre, "humanism and violence are the two indissoluble aspects of the effort [of the working class] to overcome the condition of oppression." It is true that under the leadership of the Communist Party "the natural violence of the worker" has lost its immediacy; it has become mediated and self-conscious. But though here ordered and controlled, it has not been here created. It is the original seething cauldron of proletarian unrest in which it had its source and from which it stems." [41]

Sartre's curious identification of humanism and natural violence has a strangely Rousseauistic flavor—not that it finds all corruption springing from the imposition of social bonds, but that it looks to something natural which lies beneath the social surface as a guarantor of value, and that it in this case discovers "the noble savagery" not in the remote wildness of the undiscovered frontier, but in the suppressed nature of the urban proletariat. Thus the Communist Party has an authority which resembles that of a constituted government but, since it does not embody itself in institutions, its legitimation can come only from the masses themselves. Here again is to be found a kind of inverted Rousseauism: it is *in the streets* that the Communist Party measures its power. It is the size of the mass demonstrations which legitimizes its authority.[42] Surely, here is conjoined with the Sartrean cynicism and knowingness a naïveté—even a blindness—beyond belief, for street demonstrations can be rigged and even paid for, and to judge legitimacy in terms of numbers which may be the product of dishonesty and manipulation shows a political innocence almost criminal in its culpability. But it also follows from Sartre's populist romanticism, from the inexperience of the bourgeois intellectual—the *nouveau arrivé* at the platform of proletarian politics. What the bourgeoisie fears, and must fear, according to Sartre, is precisely this irrational and violent authority—the wild sovereignty of the people ("La souveraineté sauvage du peuple") .[43]

At other moments Sartre exhibits a realism reinforced by the underpinnings of his existentialism and by the insights of Marx which he has integrated with it. Those who wish the benefit of the working class, but seek to detach it from the Communist Party, are misguided, for only the Party truly organizes it. Without the Party the proletariat is nothing. For in the end class unity does not consist in a mere identity of condition (this concept is too mechanical), but in *a disposition to act*. The proletariat is not "a sum of despairs and solitudes," but an active group of active men. A worker is made into a proletarian just to the degree to which he rebels against his condition. ("L'ouvrier se fait prolétaire dans la mesure même ou il refuse son état.") [44] Here, as with Marx, it is clear that revolt contains within itself a principle of union. A class is a system *in movement. Directed toward practice,* it becomes an organization. It is striking that when Marx attempted a rudimentary phenomenology of the fighting proletarian, he found in him entirely new characteristics which arose out of the facts of struggle, and Sartre assimilates this insight to his own existential doctrine of the individual's freedom and his achievement of existence through the "project" which underlies and produces his acts. "For the worker politics is not a luxury; it is his unique defense, the unique means of integrating himself into the community. The bourgeois is integrated from the beginning, solitude is his coquetry. The worker is first alone, politics is his need. The bourgeois is a man who joins a party to exercise his civil rights; the worker is an inferior being who enters a party to become a man." [45] In action the worker becomes another man, through a sort of conversion, as it were. To be a bourgeois, says Sartre, comes naturally; but nothing is more difficult than to become a proletarian. This comes through action which surmounts fatigue, hunger, even the fear of death. And it follows that the worker needs a truth, a direction, a practical aim incarnated in an organization.

Sartre's emphasis on organization as against spontaneous individual behavior seems to conflict with the existentialist theory of the individual creative act, and, as we have seen, the basic purpose of the later *Critique of Dialectical Reason* was to repair this seeming inconsistency and to provide additions of theory in support of the definition of social class as "a system in movement directed toward practice." It is thus the theoretical construct, created *after the fact* to rationalize the essentially

irrational commitment to the Communist Party as such registered in "The Communists and the Peace." For here there is little doubt that for Sartre class reality is given through class struggle, and that without the Communist Party there would be no unity, no action, indeed, no proletarian class. This brings to a head the curious divide between *Being and Nothingness,* where "freedom" is a metaphysical absolute, too good to be true, and the excessive realism which follows in the wake of Sartre's radical revolutionary commitment. For here the universal metaphysical liberty of man has turned into something which is practically the exclusive possession of a single class which bears the message of history. The liberty of the worker is simply the power to surmount the given, to act, to manifest itself in the reality of Party organization. "One could say in a word," remarks Sartre of the worker, "that the Party *is* his freedom." [46] Can one help but be reminded of the humorously tortured logic of Shigalov in Dostoievsky's *The Possessed?* "I am perplexed by my own data and my conclusion is a direct contradiction of the original idea with which I start. Starting from unlimited freedom, I arrive at unlimited despotism. I will add, however, that there can be no solution of the social problem but mine." [47]

"The Communists and the Peace" of 1952, contemporary with Sartre's withering reply to Camus and symbolic of the same unhesitating commitment to the Communist Party, was a manifesto in which the object was concretely political and activist—to indicate a solidarity with the strategies of the Party and the Soviet Union, whose aspirations it shared. But this practical act entailed consequences of a more theoretical character. It forced Sartre to a reappraisal of the course of modern philosophy since Descartes, and in particular to an evaluation of Marxism within the spectrum of contemporary thought. And here, unlike his rather naïve acceptance of the institutions of Marxism at the political level, Sartre displays a critical aptitude completely congruent with the necessity of defending that type of libertarian and contingent existentialism with which his work has been associated. This reappraisal, which was to occupy him in the pages of *Les Temps Modernes* for the next five years, culminated in the lengthy "Marxism and Existentialism: Questions of Method," published in 1957. It is the transitional link between the theory of *Being and Nothingness* and the *Critique of Dialectical Reason,* and, indeed, is republished

as the introductory section of the latter work. To summarize its chief conclusions is to place Sartre's Marxism within the theoretical perspective which he has himself provided.

One year before, in "Le Réformisme et les fétiches," Sartre had clearly stated what is so often forgotten: the degree to which Marxism had become the chief problem of French intellectual life, the sense in which from either the assertion or denial of its premises one's own social weltanschauung took its point of departure. "For us," said Sartre, "Marxism is not only a philosophy: it is the climate of our ideas, the environment within which they are nourished, the true movement of what Hegel called Objective Spirit. We see it as a great cultural gift of the left, or better, since the demise of bourgeois thought, it is itself Culture, for it alone permits us to understand men, cultural objects, and events." [48] It is this sense of Marxism as the great solvent, not only for contemporary French culture but for the whole course of European intellectual history, which led Sartre in "Marxism and Existentialism" to define the form of existentialism for which he himself was responsible within the total context of the movement of Western thought since Descartes.

Sartre's very definition of philosophy is Marxist: it is the intellectual form which any rising class has of visualizing itself. It becomes for succeeding generations the summary of an age, almost a social movement in itself, which bites into and conditions the future. "All philosophy is practical, even that which at first seems the most theoretical; philosophic method itself is a social and political weapon." [49] Thus one can trace the fortunes of Cartesianism with its analytic and critical rationalism: first an instrument of the rising commercial class against the old regime, later a weapon of liberalism against the lower classes, and finally the inspiration of those antireligious and anti-aristocratic pamphlets which triggered the French Revolution.

There have been, says Sartre, three great movements in philosophy since the sixteenth century: (1) that of Descartes and Locke, (2) that of Kant and Hegel, and (3) that of Marx, and although each of these three has become the horizon of a total culture, it is the Marxist moment which Sartre takes as pivotal for Western man. Thus, an anti-Marxist argument is for him only the recourse to a pre-Marxist idea, a pretended outmoding of Marxism only the return to an antecedently discredited tradition. But even philosophical crises are the expressions of an underlying social malaise—of contradictions which tear the

society; therefore the oppositions in thought must be reduced for greater understanding to the class antagonisms whose battles they fight. But within the philosophical environment there is still a distinction to be made between those who originate the great seminal systems and those who only apply and make practical their conclusions. The first are the "founders," the second are the relative men, the "ideologues." And this supplies Sartre with the sufficient (and unaccustomed) modesty to place his own efforts in the latter rather than the former category. For, as he sees it, existentialism is an ideology, a parasitic system which lives on the margin of knowledge. As medieval philosophy was the handmaiden of theology, modern existentialism is the handmaiden of the Marxist revelation, and its role is to purify its applications and to save it from the continual heresies of its disciples.

Of course it is necessary to distinguish between "existentialisms." Sartre is not thinking of someone like Jaspers, whom he speaks of as a nostalgic, partly de-Christianized bourgeois, who regrets his own loss of faith, eschews practice, refuses as an individual to cooperate with the history which Marxists make, and as a typical European *Kulturmensch* seeks to justify his privileges by an appeal to "aristocrats of the spirit." [50] Sartre means instead his own brand of existentialism, which has developed in the shadow of Marxism rather than against it, which was affected less by the textual content of the sources than by the living reality which they represent—"the heavy presence on my horizon of the working class masses" who *lived* and *practiced* Marxism and who even at a distance exercised on the petit-bourgeois intellectual (which the youthful Sartre was) an irresistible fascination.

But the question remains: Why has existentialism retained its autonomy? Why has it not dissolved itself in Marxism as superfluous and unneeded? Lukacs once answered: Because the bourgeois conscience needed a third way between the stark options of idealism and materialism during its imperialist period. But Sartre in disagreeing calls to mind precisely what Lukacs was all too ready to overlook—the way in which the Marxist theorists in the Soviet Union, by their one-sided and dogmatic interpretations, froze Marxism into a ponderous and unwieldy mass which, imposed by a bureaucracy perpetually unwilling to acknowledge its errors, became a violence against reality itself. With the "official" Marxists, Marxist doctrine was no longer an empirical attempt to study concrete facts within a

general perspective; instead it neglected detail, forced interpretation to fit in with an immutable and fetishistic theory, and perpetuated " the intellectual terrorism of liquidating the particular."

In the face of this brazen-faced deformation, says Sartre, existentialism affirms the individual reality of men as Kierkegaard did against the system of Hegel. It seeks not for man in a system, but *where he is!* For "the scholasticism of justification" it substitutes Marxism's living truths. Marxism indeed remains *the* philosophy of our time; it is indispensable because the considerations in which it was engendered have not been outmoded. It is only that an existentialism founded on Marxism, but with a bias toward freedom, contingency, human effort, and the individual project, must serve as a corrective for the dogmatic tendencies of its high priests in the modern world. The explanatory system of orthodox Marxism is much too broad and rigid. Its economic emphasis is ultimately right, but it loses the juice of particularity in its abstract sieve when it refuses to see the family and social relations as mediating between the individual and his society. To the central core of Marxism must be added a concrete anthropology, a concrete sociology, even a concrete psychology. For unless the dialectical consciousness of man is grounded in the empirical experience which the social sciences codify, its abstractness will lead to error. Existentialism affirms the specificity of the individual event in community, in society, in history, and in thus redeeming Marxism from its Stalinist reifications—from its Platonic ideas of *"the* worker," *"the* bourgeois," *"the* intellectual"—it returns the Marxist philosophy to its privileged position as the only context adequate for a dialectical examination of the truth.

Les Temps Modernes was founded in 1945, immediately after the war, and on its initial editorial board were those who have become the most illustrious philosophers and social philosophers of France: Jean-Paul Sartre, Raymond Aron, Maurice Merleau-Ponty. Almost from the beginning the actual political color of the review (if not its announced ideology) was Marxist, but today of the original editorial board only Sartre remains. In some sense, therefore, this natural attrition can be considered to be a mirror of the progressive disaffection of the leading intellectuals of France with the Communist cause. The

quiet, undramatic resignation of Merleau-Ponty in 1953 (although it was the culmination of differences of opinion going back at least to 1950) registered an ideological quarrel with Sartre no less momentous than the earlier one between Sartre and Camus. That the friendship, even mutual admiration, of the two former schoolfellows at the *Ecole Normale* prevented the rancorous irritation of the other break cannot conceal the seriousness of the political issue at stake, and a rather cursory treatment of the Marxism of Merleau-Ponty will illustrate still another facet of the existentialist political dilemma.

From the beginning of his association with *Les Temps Modernes* Merleau-Ponty functioned both as editor in chief and as political director, and the numerous essays which he published here and in other periodicals during the years 1945–46 afford an excellent approach to the type of Marxism he embraced.[51] To anyone who reads these essays, it will at once be clear that we are dealing here with a philosophical mind and a political intelligence of the first rank, someone on the order of Montaigne or Machiavelli (the real Machiavelli we get to know from reading his works—not the fictional creation of the Elizabethans or Villari or De Sanctis)—for the Marxism of Merleau-Ponty is based on a foundation of essential realism. We know today, he says in his essay "Concerning Marxism,"

that formal equality of rights and political liberty mask rather than eliminate relationships based on force. And the political problem is then to institute social structures and real relationships among men such that liberty, equality and right become effective. The weakness of democratic thinking is that it is less political than moral, since it poses no problem of social structure and considers the conditions for the exercise of justice to be given with humanity. In opposition to that particular moralism we all rallied to realism, if by that one means a politics concerned with realizing the conditions of existence for its chosen values.[52]

The foundation of political realism is not essentially different from the foundation of metaphysics since both depend on a distinction between appearance and reality. In these terms, the political man is precisely "he who has recognized the price of existing things and defends them against private fantasy." This is the reason Merleau-Ponty found the greatness of Marxism not in its having treated economics as the principal or unique cause of history, but in its treating cultural history and economic history as two abstract aspects of a single process. Thus,

as is so often misunderstood, economic life is not a separate
order to which the other orders are to be reduced: it is simply
Marxism's way of registering the inertia of human life. Just as
our bodies maintain the basic habits of our behavior beneath
the surface of our changing moods, so economic life is "the
body of society" where its multiple expressions are registered
and achieve stability. For who can doubt that modes of work
and patterns of consumption more surely than books or moral
precepts hand on the previous generation's way of being to its
successors?

But this is not to say that the economic habits of a society are
permanent and immutable. On the contrary, class struggle is an
essential fact, class antagonism shatters the constituted forms of
culture, and step by step the economic decay of capitalism
corrupts all the ideas, all the values it had sanctioned. And it is
precisely this last which justifies our cynicism before its perva-
sive moralism. It is clear that in the quarrel between Camus
and Sartre, between the claims of ethics against politics, Mer-
leau-Ponty is all on the side of the latter, but since the source of
his thinking is cool consideration and not personal irritation,
he can deepen and make persuasive arguments which in
Sartre's mouth seem only imperious and insulting.

It is a fact that, in our present situation, there is not one term in the
moral vocabulary which has not become ambiguous, not one tradi-
tional value which has not been contaminated. If one is to be able
to speak favorably of work, family, or country some day, it will be
on the condition that these values have first been purified by the res-
olution of the ambiguities they served to foster. Which means that
there can be no question of saving them from proletarian violence,
since this violence is the only thing that can make them honorable
once more.[53]

If there were any doubt about Merleau-Ponty's position, it
would only be necessary to turn to "The War Has Taken
Place," where he not only takes a stance which opposes Camus,
but in so doing prophetically upholds the moral of Sartre's as
yet unwritten *Dirty Hands*.

We have unlearned "pure morality" and learned a kind of vulgar
immoralism, which is healthy. The moral man does not want to
dirty his hands. It is because he usually has enough time, talent, or
money to stand back from enterprises of which he disapproves and

to prepare a good conscience for himself. The common people do not have that freedom . . .[54]

And yet this is not exactly Sartre's position either, for while Sartre seems to stop at "realism," Merleau-Ponty goes beyond it to indicate that Marxism is itself value-saturated. Only, the values which it wishes to institute are real rather than merely verbal. And this is to place the entire debate on a more viable, if ultimately no less ambiguous a plane.

Marxism does not like talking about morality and distrusts values insofar as they are abstract and help mystify men by luring them away from their lives, their conflicts, and their necessary choices. But the dominant idea of Marxism is not, in the last analysis, the sacrifice of values to facts, of morality to realism. It is the idea of replacing the verbal morality which preceded the revolution with an effective morality, creating a society in which morality is truly moral, and destroying the morality that exists dream-like outside the world, by realizing it in effective human relationships.[55]

In addition to Merleau-Ponty's realism, there is another respect in which he is kin to Machiavelli: they are both profoundly aware of the ultimate contingency of history. In Machiavelli, this appears as a more than half-serious invocation to the metaphysical goddess of fortune: in Merleau-Ponty, as a Marxism whose rigidity has been softened by the existential doctrine of freedom. Marxism for Merleau-Ponty is not really an optimistic philosophy where the ultimate triumph of social good is guaranteed. Rather, it is the denial of the rule of fate—for good as for evil—and the recognition that happiness and the just society are not inevitable, but merely possible. Man's existence is "open-ended," and the most that one can expect is a resolute try for that future which no one in the world or out of it can certainly foretell.

Marxism, as we know, recognizes that nothing in history is absolutely contingent, that historical facts do not arise from a sum of mutually foreign circumstances but form an intelligible system and present a rational development. But the characteristic thing about Marxism—unlike theological philosophies or even Hegelian idealism—is its admission that humanity's return to order, the final synthesis, is not necessitated but depends upon a revolutionary act whose certainty is not guaranteed by any divine decree or by any metaphysical structure of the world.[56]

It is "the revolutionary act" which is crucial—the attempt to place possession of the economic apparatus in the hands of those furthest from the special interests of private benefit and national imperialisms, for, as the alternative of socialism or chaos becomes clearer, the class struggle may once again become the motivating force of history, and men will perhaps choose a proletarian socialism—not as a guaranty of happiness but as its most responsible hope. And this would be a Marxism "without illusions, completely experimental and voluntary" where one recognizes at last *both* the logic *and* the contingency of history. Merleau-Ponty has seen clearly, and before Sartre, that "the fetishism of science has always made its appearance where the revolutionary conscience was faltering," and thus that the conception of Marxism as "science" and history as the predestined, the fated, the inevitable, is a disease of Marxism, not its essential ideology. Thus Merleau-Ponty has anticipated by at least a year (and perhaps more) Sartre's famous essay "Materialism and Revolution." As when rereading Burckhardt one finds the originality of Spengler so much less than one had previously thought, so, in reading Merleau-Ponty, one finds the earlier and seminal insights which are to appear later dramatized and expanded in the better known and more famous works of Sartre.

The furthest and most radical reach of Merleau-Ponty's Marxism is celebrated in his *Humanisme et terreur: essai sur le problème communiste* of 1947. Treating the problem of terror —of Marxist violence—in its first half in terms of the ideas of Koestler, the behavior of Bukharin, and the ideas and behavior of Trotsky, it turned in its second half to the "humanism" of the proletariat and of the Party, whose repressive measures, particularly in the case of the Moscow Trials, were exercised in defense of the Revolution. Thus its curious strategy was to equate humanism and proletarian violence in a sense more subtle and more disturbing than any such subsequent equation by Sartre. For the thrust of Merleau-Ponty's argument was that to believe that violence could ever be extirpated from the structure of human social arrangements is utopian. History being contingent, social arrangements being the product of effort, and moral persuasion never being efficacious against the institutionalization of vested economic and social interests, violence is inevitable for either the maintenance or the overthrow of the *status quo*. Thus the problem of terror is not to destroy, but to legitimate it, not to ask how it can be eliminated

but for what end it is being used, and if that end is socially progressive or reactionary.

The two foci of the argument were: (1) the idea that even the violence of the Moscow Trials was legitimized by a socialist experiment fighting for its life, and (2) the notion of the essential hollowness of the ideology of bourgeois humanism. The first brought down on Merleau-Ponty all the wrath of the liberal left as well as the right. Sartre related that when Simone de Beauvoir visited New York, the editors of *Partisan Review* expressed their disgust that the hand of Moscow held the pen of this grey eminence of *Les Temps Modernes*. He also tells how one evening, at the home of Boris Vian, Camus took Merleau-Ponty aside and upbraided him for defending the Moscow Trials. Merleau-Ponty defended himself, and when Sartre took his side, Camus ran out into the street in a blind rage.[57]

But the second point is even more provocative than the first. For Merleau-Ponty distinguished between the empty humanism of capitalism, which abolishes neither unemployment, war, nor colonial exploitation, and which, as in the Greek city state, is the privilege of the few and not the many,[58] and the realistic humanism of Marxian socialism, which provides a generalized solution to the human problem, confronts ideas with social functioning, and shows to the West the incompatibility between its noble ethics and its ignoble politics.

There is no question that at this point Merleau-Ponty represents the most extreme, the most advanced Marxism of the entire circle around *Les Temps Modernes*. Of *Humanism and Terror* Sartre has said: "I read it, I was instructed by it, and I ended by becoming inflamed by my reading. It became my guide." [59] And Simone de Beauvoir comments: "He subordinated morality to history much more resolutely than any existentialist had ever done. We crossed this Rubicon with him, conscious that moralism—although we were not yet free of it ourselves—was the last bastion of bourgeois idealism. His essay diverged too far from orthodox Marxism to be well received by the Communists. The Right waxed indignant; he was accused of writing an apology for Stalinism." [60]

At this moment in 1947 it is Merleau-Ponty who is the leader in Marxist radicalism and Sartre who is the student. Two years later they are still of one mind. They agree on plans for the review, for the pursuance of a more active political line. And then, says Sartre, "Precisely at the moment when our accord at last seemed to me perfect, it began to crumble. It was that we

had begun to get wind of the Soviet labor camps." [61] From now on it is a story of Merleau-Ponty's progressive disillusionment, not with Marxism as such, but with its Soviet embodiment. The Korean War only confirmed his worst suspicions of Russian imperialism. Over the next three years his relations with Sartre became ever more strained. Without any open reproaches, he viewed Sartre's notorious essay "The Communists and the Peace" with disagreement and mistrust. In 1953 he quietly withdrew from all association with *Les Temps Modernes,* and in 1955 he produced his bombshell, *Les Aventures de la dialectique,* of which a good half was taken up with his explicit attack on Sartre, the lengthy concluding chapter "Sartre et l'ultra-Bolchevisme." At this point the political break between Merleau-Ponty and Sartre was just as sharp as that between Sartre and Camus in 1952, and brief attention to the argument of *Les Aventures de la dialectique* will indicate why.

For our purposes we can treat the first half of Merleau-Ponty's book as introductory to his attack on Sartre, as almost a statement of principles of procedure. As a matter of fact, he deals with the fate of the dialectical principle in the Marxist tradition, with Lukacs, Trotsky, and Lenin, and with Max Weber's remarks about politics. In the course of this treatment he indicates his sympathy with Weber's concept of political responsibility and Trotsky's notion of "the permanent revolution." But his chief thrust is in the direction of realism and tentativeness—in the loosening up of the tight dogmatism which from time to time infects the Marxist tradition. Marxist politics, he says, is indemonstrable. Its sources are pragmatic, not rationalistic. And for that reason, for Communism (as some recent theologians have insisted about theology) we need a new process of de-mythification, of de-poetization—even, perhaps, a generous dose of disenchantment. For in historical understanding, the chief problem is not the infusion of sense, but the elimination of non-sense and, in consequence, politics must accept the role of "supporting the irrationality of the world." Two problems (which are perhaps in the end the same) confront Marxism: (1) can it surmount relativism? and (2) can it provide an adequate account of the relationship between consciousness and history? Is consciousness a product of history, or is history a product of consciousness? [62] It is necessary to hold to both doctrines simultaneously, says Merleau-Ponty, and indeed Marx did. But this very doctrine provides a lever for the more

open consideration of the Marxist problem in the modern world.

The basic charge which Merleau-Ponty makes against Sartre in the second part of his book (and practically the whole of the chapter "Sartre and Ultra-Bolshevism" is directed against Sartre's long article "The Communists and the Peace") is his substitution of faith, absolute trust, and irrevocable commitment in his treatment of the Communist Party for the skepticism, careful critical judgment, and sharp empirical assessment of the conditions and consequences of its political decisions which Merleau-Ponty thinks should have been there. For Sartre, all debate about Communism is closed by a desperate justification which tolerates no type of condition or restriction. And the invalid assumption on which this rests is a form of "reification" no less inadmissible than that of which Lukacs accused the capitalist world. Sartre has converted the proletariat into a Kantian "class in itself" and the Party into a Whiteheadean "eternal object." If, as Sartre believes, the Party always represents the principle of "pure action," then by definition it becomes "the bearer of the spirit of the proletariat"—it possesses forever the global gift of being exclusively that without which there can be no proletariat.[63] Thus his absolute commitment makes such a mystique of the Party that when the proletarian resists the Party, indeed, *asserts his freedom against the Party,* he ceases to be a proletarian! The Sartrean romanticism of action thus leads to a doctrine (contradicted by all the facts of a realistic history) that the proletariat does not exist, it simply acts; when it ceases to act, it decomposes and passes out of existence.

What is chiefly at stake in Merleau-Ponty's criticism is Sartre's rigid conception of the Party, his notion that the Party is always an active force and the people is and must always be passively led. Sartre (as no critical Marxist should) gives the Party carte blanche as if it were an eternal exemplification of a democracy, representing somehow the democracy of the masses, although without minorities, without dissent, without even that deliberation which is the usual attempt to reconcile the divergent interests and opinions of any entity as complex as "the people." This is the substantive node of Merleau-Ponty's attack, but on the periphery are at once more personal and more theoretical issues. Sartre's avowed procedure: to assess the social order as the socially downtrodden see it—to "find truth

in the accusations which we read in the eyes of the poor"—is mystical and intuitionistic, hopelessly inadequate as social methodology. He himself, after counseling all others to join and submit themselves to the discipline and orders of the Party, obstinately retains a freedom which he is willing to grant to no one else. And, finally, there is the critical theoretical issue, insufficiently developed but, I think, absolutely valid, that Sartre is ultimately more of a Cartesian than a Marxist since in his philosophy there is a plurality of subjects, but no genuine intersubjectivity.[64]

The epilogue to *Les Aventures de la dialectique* leaves the discussion of Sartre, but reveals the presuppositions of Merleau-Ponty's attack on him, and shows the point at which his own critical and highly personal Marxism has arrived. And it expresses once again the interest in contingency and in development, in flux and in "the permanent revolution" which underlie all of Merleau-Ponty's political radicalism. For what he sees so clearly is that ironic transformation of social movements which turns them from radical beginnings into essentially conservative establishments. All revolutions are *true as movements* and *false as regimes*.[65] Wherever the Communist Party has come to power, it has shown how difficult it is to bridge the gap between social democracy and the tyrannical dictatorship of a Party bureaucracy. Nowhere better than in the Soviet Union is revealed the equivocation between the revolutionary myth and the quiescent and conservative meliorist actuality. Since Stalin, Soviet Russia has ceased to be the country of revolution, and within her boundaries direct democracy and proletarian power remain only as a genteel fiction of legitimacy. And the unhappy consequence is that decadence of Marxist culture which results, and which is there for all who look to see.

It is, I think, clear that the traumatic breaks which Jean-Paul Sartre experienced with his two former friends and colleagues Albert Camus and Maurice Merleau-Ponty, although they may have had suppressed personal roots, were, in effect, philosophical quarrels which hinge on basic differences in the interpretation of the meaning of politics. These quarrels, as I have tried to show, were fundamentally different in nature. Sartre's quarrel with Camus was over the relevance of ethical considerations in the face of political necessity. Sartre's quarrel with Merleau-Ponty was at bottom a difference of belief as to the absoluteness

or the tentativeness of one's political commitment. Sartre, passionate and irrational as one would never have expected, in his absolute espousal of the politics of the Communist Party and the Soviet Union, was only demonstrating in his own life what he meant by being *engagé*—to the extreme point where even in practice it meant the absolute impossibility of withdrawal. Merleau-Ponty in his coolness and objectivity was only illustrating his lifelong belief in contingency, in day-by-day assessment, in an approach to politics both realistic and empirically grounded. Both of these quarrels are essential examples of, and throw considerable light on, what I have called "the existentialist dilemma." For the problem of the status of ethical rules and ethical procedures has haunted the philosophy of existentialism from the beginning, and its concern with the general problem of human choice has made the issue of "commitment" one of the chief areas of its sustained attention. The interest in practical politics which so passionately engaged the French intelligentsia from the time of the Resistance to the Vietnam war, coupled with that obsessive flirtation with Marxism which Raymond Aron has called "the opium of the intellectuals," placed the existentialist problems themselves in a political setting, even to Sartre's redefinition of existentialism as the organon of a Marxist approach to the world. Two things in all this are paradoxical in the extreme: first, that Sartre's very choice of politics over ethics which alienated him from Camus (but in which Merleau-Ponty would have concurred), when pressed to the extreme of a romantic intuitionism about the Party, alienated him from Merleau-Ponty, who shared almost all his illusions save that. And the second is that existentialists (and phenomenologists) responsible in the last analysis for an ontology of consciousness and a phenomenology of perception should find the ultimate test of their metaphysics in the ambiguous marshes of practice.

In 1960, not long before his death, Merleau-Ponty himself turned his attention to this paradox. "Is it not an incredible misunderstanding," he asked, "that all, or almost all, philosophers have felt obliged to have a politics, whereas politics arises from the 'practice of life' and escapes understanding? The politics of philosophers is what no one *practices*. Then is it politics? Are there not many other things philosophers can talk about with greater assurance?" [66] (This from the author of *Humanism and Terror* and the political editor of *Les Temps Modernes!*) And he expands his point further: "One thing that is certain at

the outset is that there has been a political mania among philosophers which has not produced good politics or good philosophy . . . In the recent period, all forms of life and spirit were linked to a purely tactical politics, a discontinuous series of actions and episodes with no tomorrow. Instead of combining their virtues, philosophy and politics exchanged their vices: practice became tricky and thought superstitious." It is clear that Merleau-Ponty considered Sartre's political thinking to be "superstitious." But can the same be said of Merleau-Ponty himself? I think not, and if we ask what has been his preservative, we might say it has been precisely that quality of mind which made Machiavelli such a sympathetic figure for him. In his "A Note on Machiavelli," written a decade before his death, he said:

The reason why Machiavelli is not understood is that he combines the most acute feeling for the contingency or irrationality in the world with a taste for the consciousness of freedom in man. Considering this history in which there are so many disorders, so many oppressions, so many unexpected things and turnings-back, he sees nothing which predestines it for a final harmony. He evokes the idea of a fundamental element of chance in history, an adversity which hides it from the grasp of the strongest and the most intelligent of men. And if he finally exorcises this evil spirit, it is through no transcendent principle but simply through recourse to the givens of our condition.[67]

Merleau-Ponty too "combined the most accute feeling for the contingency or irrationality in the world with a taste for the consciousness of freedom in man." He sees no predestined harmony as the certain fate of the world, and so he likewise has constant recourse only "to the givens of our condition." In this realism he has avoided both the temptation of Camus toward moralism and of Sartre toward dogma. In him the dilemma of existentialism finds the faintest Ariadne thread in the direction of its resolution.

Eleven / Humanism and the Marxist

Tradition: The Young Marx, Lukacs,

the Yugoslavian School

WHATEVER ELSE it is, Marxism is at least a politi-
cal program, a mode of social criticism, and an ambience of
culture. Obsessed as we are in the West with the threat of the
first and the frequent embarrassment of the second, we have
conveniently forgotten the pervasive reality of the third. For
those who have experienced in their own lifetime the Stalinist
purges, the Moscow Trials, the existence of Russian labor
camps, the brutal crushing with Soviet tanks of the East-Ger-
man uprising of 1953 and the Hungarian revolt of 1956, the
title of Merleau-Ponty's book, *Humanism and Terror*, repre-
sents the joining of incompatibles, and while it has become a
cliché to identify Marxism with "terror," its "humanism" is one
of those inconvenient facts which we have chosen to ignore.
Thus Merleau-Ponty's early statement of the necessary aims of
the European left—to recall to the Marxists their humanistic
sources of inspiration, and to the democracies their basic hypoc-
risy—and Sartre's claim in "Le Reformisme et les fétiches"—
that for this group Marxism is not merely a philosophy, but the
very climate of their ideas, the environment within which they
nourish themselves, is, indeed, (since the death of bourgeois
thought) nothing less than culture itself—are to be interpreted
more in terms of French radical idiosyncrasy than in terms of
basic European truth. But Marxist humanism is a fact, and the
relationship of Marxism as a political program and Marxism as
an ambience of culture is a theme worthy of investigation in
any enterprise concerned with the variant possibilities of asso-
ciation between humanism and politics in the West.

Only—what is Marxism? We have seen already that there is a profound difference between Marx and Lenin in the matter of the role of art and literature as the bearers of political duties and obligations; and Merleau-Ponty and Sartre, while both affirming vehemently their Marxist affiliations, differ radically in their assessment of the politics of the Soviet Union and in their respective evaluations of the role of the Party as keeper of the conscience of the proletariat. The Marxist tradition is rich, and, above all, variable in its modes of emphasis. Marx, Engels, Plekhanov, Lenin, Trotsky, Lukacs, Bukharin, Stalin, Kardelj, Sartre, Adam Schaff, Mao Tse-tung—which are the authentic voices, which the deviant and the heretical accents? It is like asking the same question of the complex of medieval thought. Who speaks most truly for Christianity, the Augustinian ontologists, the nominalists, the Platonizing Aristotelians or the Aristotelianized Platonists, the rigid Thomists, an Abelard or a William of Champeaux, the passionate followers of Scotus, or the Ockhamites? To raise the question is but to underline the ambiguities of any tradition, and to suggest that successive variants on a basic theme are not so much elements which must be made compatible, as elements on which each newcomer must exercise choice and selectivity. Traditions are not as solid as the rock of ages; they are forged anew by each generation, and by each intellectual whose own integrity is at stake. No one has seen this better than Merleau-Ponty himself.

To remain faithful to what one was; to begin everything again from the beginning—each of these two tasks is immense. In order to state the precise respects in which one is still a Marxist, it would be necessary to show just what is essential in Marx and when it was lost. One would have to point out the fork at which he stood on the genealogical tree if he wanted to be a new offshoot or main branch, or if he thought of rejoining the trunk's axis of growth, or if finally he was reintegrating Marx as a whole to an older and more recent way of thought, of which Marxism was only a transitory form. In short, one would have to redefine the relationships of the young Marx to Marx, of both to Hegel, of that whole tradition to Lenin, of Lenin to Stalin and even to Khrushchev, and finally the relationships of Hegelo-Marxism to what had gone before and followed it. This Herculean task (of which all of Lukacs' works together constitute a very guarded outline) tempted Marxists when they were in the Party because it was the only way at that time of philosophizing without seeming too evidently to do so. Now that they have left the Party, the task must seem crushing and derisory to them.[1]

But the task is not only one for Marxists—whether they have left or are still affiliated with the Party. It is also the task of non-Marxist students of Marxism, whose interest it is to identify the undeniably humanistic elements in the Marxist tradition, and for them it is equally difficult. For as we discover the young Marx, and then (to use Merleau-Ponty's metaphor) travel laboriously further upstream to his Hegelian inspiration, and then finally drift down from there once again to Lenin and Trotsky, it is possible to find the ammunition not only for one, but for *several contrasting* Marxist positions. Where then lies the *authentic* humanism in the Marxist tradition? And here the issue is not simply: what is Marxism? but also: what is humanism? The question is difficult. No connotative or "intensive" definition will ever do justice to the richness of meaning required. The answer can, therefore, be plausibly suggested only by an accretion of denotations. "Humanism" lies in Michel de Montaigne's "Each man carries within himself the entire form of the human condition"; in Immanuel Kant's third formulation of the categorical imperative: "So act as to treat human beings (yourself or any other) always as intrinsically valuable, never as a means only"; in Karl Marx's "To be radical is to grasp things by the root. But for man the root is man himself"; and in John Stuart Mill's "Among the works of man which human life is rightly employed in perfecting and beautifying, the first in importance surely is man himself." And here we have recourse to a larger context of humanistic awareness within which the Marxist is only one illuminating strand.

This reference to Marxism as part of a larger context of awareness has one important consequence—it frees the Marxist question from the more superficial tasks of justification or attack. It is not simply a matter of transcending violent partisanship through an act of adjudication, but rather that when the entire inner history of Marxism is reexamined, and when its relationship to pre-Marxist modes of thought and post-Marxist philosophy is revealed, then the common platitudes—that Marxism is "essentially valid" or that it is "contradicted by the facts of modern economic life"—are seen to be shallow and inapplicable. No one has expressed this more clearly than Merleau-Ponty.

The history of thought does not summarily pronounce: This is true; that is false. Like all history, it has its veiled decisions. It dismantles or embalms certain doctrines, changing them into "messages" or

museum pieces. There are others, on the contrary, which it keeps active. These do not endure because there is some miraculous adequation or correspondence between them and an invariable "reality"—such an exact and fleshless truth is neither sufficient nor necessary for the greatness of a doctrine—but because, as obligatory steps for those who want to go further, they retain an expressive power which exceeds their statements and propositions. These doctrines are the *classics*. They are recognizable by the fact that no one takes them literally, and yet new facts are never absolutely outside their province but call forth new echoes from them and reveal new lusters in them. We are saying that a re-examination of Marx would be a meditation upon a classic, and that it could not possibly terminate in a *nihil obstat* or a listing on the Index. Are you or are you not a Cartesian? The question does not make much sense, since those who reject this or that in Descartes do so only in terms of reasons which owe a lot to Descartes. We say that Marx is in the process of becoming such a secondary truth.[2]

And if Marxism be adjudged neither a "museum piece" nor a "message," but a *classic*, then it follows, as Merleau-Ponty also sees, that the Marxian thesis "can remain true as the Pythagorean theorem is true: no longer in the sense it was true for the one who invented it—as an immutable truth and a property of space itself—but as a property of a certain model of space among other possible spaces." This is surely relativism—but it is a relativism based on the most absolute form of historical appreciation. Behind the literal statements of Marx and his followers there is always "Marxism" as a matrix of intellectual and historical experiences, a series of successes and failures in the real world of politics, a series of equally brilliant inspirations and errors in ontology, literary criticism, and the philosophy of culture, and the successes and failures, inspirations and errors have been too crucial in the intellectual and political history of the West in the last two centuries to strike out or dismiss. And they have played too large a role in the tradition of Western humanism to neglect or forget.

The distinction between Marxism as politics and Marxism as culture suggests a further distinction which is useful in dealing with the problem of Marxian humanism. For there are two different senses in which Marxism has contributed to the humanistic frame. One of them consists of its philosophical and anthropological *doctrines*, the other of its *procedures* and *practices* as a method of cultural consideration. The former finds its chief exemplification in the Marx of *The Economic and Philo-*

sophic Manuscripts, the latter one of its examples in Adorno's studies of the conditions and consequences of musical composition, performance, and appreciation in the modern world. The two strands unite in a figure like Lukacs, who produces both a *History and Class-Consciousness,* on the one hand, and *Studies in European Realism* and *The Historical Novel,* on the other.

That Marx's "philosophy of man" is one of the landmarks of Western humanism is not to be denied, but there is an entire group of Marxist scholars in western and in central Europe that constitutes a little-noticed band (so far as I know George Steiner is the only one who has called specific attention to it in popular form) [3] that in its various, and by no means unified or consistent, efforts testifies to the brilliant suggestiveness of Marxian inspiration in the interpretation of literature and culture. There is no question, of course, that Marx's own philosophy of man bears some relation to his having been steeped in the sources of Western humanistic culture. Quoting Aristotle in the original Greek, having deeply considered the work of Democritus and Lucretius, knowing Spinoza as well as Hegel, and, in general, owing an enormous debt to the Enlightenment weltanschauung from Diderot and Rousseau to Lessing and Goethe, it could be expected that he would feel the same passion for the freedom of man which inflamed Schiller and Büchner. "Marxism," as George Steiner has rightly said, "is a reading of history and a utopia of human conduct profoundly rooted in European civilization. Marx is as much an heir to Vico, Lessing, and Diderot as he is to Hegel. The impulse of rational doctrine and utopian idealism behind the Russian revolution is part of the genius and legacy of European enlightenment." [4] And the same world view which has produced a radical politics is also responsible for a revolution in method for the treatment of the major humanities. Theodore Adorno's sociology of music, Arnold Hauser's social history of art, Ernst Bloch's utopian poetics and philosophy of culture, Walter Benjamin's studies of the effect of technics on art, Henri Lefebvre's sociology of daily life, Lucien Goldmann's treatment of class and metaphysics in Racine and Pascal, Herbert Marcuse's critique of popular culture, all bear witness to the fruitfulness of the Marxist insights for the interpretation of the cultural situation. And of course, as I have noted, Lukacs is the archetypical figure in this mode of investigation and discovery.

In each of these philosophers, sociologists, and critics there is a common European cultural heritage: they are infinitely

aware of the vocabulary of thought from Kant to Marx, with
particular respect for the seminal insights of Hegel; they have
classical culture, as well as the European languages and litera-
tures, at their fingertips; they have been particularly nourished
on that fruitful moment of late nineteenth century German
awareness which produced Dilthey, Simmel, and Max Weber.
And, above all, they are students of Marx. No inventory of
Marxian humanism can neglect some recognition of their con-
tribution.

But it remains true, of course, that our chief interest lies in
Marxism as a *political* humanism, and here the doctrines are of
greater significance than the mere techniques of cultural analy-
sis. What I shall do therefore is to show how Marxian human-
ism finds its origin in the early Marx, builds up to a more
elaborate body of doctrine between the two World Wars in
Lukacs (who is particularly interesting, as I have remarked, in
the way in which he combines the political and the cultural
orientation), and then flowers into a kind of "second coming"
in certain Marxist environments following the Second World
War. It is the last which presents the greatest scholarly prob-
lem, for the widening stream of Marxism, as it proliferates,
grows increasingly multiple and complex. In treating of con-
temporary Marxist humanism, one could profitably choose to
focus either on the present school of Yugoslavian philosophers,
largely centered at Zagreb and Beograd and clustered around
the journal *Praxis,* or on the writings of the contemporary
Polish philosopher Leszek Kolokowski, or even the new "dia-
logue" which Roger Garaudy has been initiating between
Marxism and certain religious thinkers of the Roman Catholic
Church. Since I must be selective, I have chosen the first alter-
native. The young Marx, Lukacs, and the Yugoslavian school
of philosophers can then be considered as a series of paradigm
cases in the development of Western Marxism, three "mo-
ments," as it were, in the continuing dialectic of an authentic
Marxist humanism.

When, on March 17, 1883, Karl Marx was buried in High-
gate Cemetery in London, a funeral oration was delivered by
Friedrich Engels. A brief summary of the meaning of Marx's
life and work, it was, perhaps, the first formal characterization
of Marxism as "scientific," and of some of the paradoxes which
this entails.[5] Engels' major comparison of Marx was not with

Aristotle or Hegel, but with Darwin and Newton. As Darwin had discovered the law of evolution in organic nature, said Engels, so Marx had discovered the law of evolution in human history. And as Newton had discovered the special law of motion of the planetary bodies, so Marx had discovered the special law of motion proper to the contemporary capitalist method of production and to the bourgeois society which that method of production has brought into being. And then Engels continued: "I have pictured the man of science. But the man of science was still only half the man . . . For, before all else, Marx was a revolutionist. To collaborate in one way or another in the overthrow of capitalist society and of the State institutions created by that society; to collaborate in the freeing of the modern proletariat, which he was the first to inspire with a consciousness of its needs, with a knowledge of the conditions requisite for its emancipation—this was his true mission in life." Thus Engels expressed at once that faith in the efficacy of "the scientific" which was the crowning dogma of the nineteenth century, and the unwavering belief in the unity of theory and practice which has been a cornerstone of Marxist ideology from *The Communist Manifesto* until today. That there might be some incompatibility between the roles of "man of science" and "revolutionist" never seems to have occurred to Engels, and the characterization of Marx as a "humanist" does not appear in the eulogy at all. If the interment were to take place today, the funeral oration would, I think, be rather different.

What has intervened is the discovery and publication, first in an incomplete Russian translation in 1927, then in a practically complete German translation in 1932 [6] of Marx's *Economic and Philosophic Manuscripts* of 1844. These truly revolutionary writings (revolutionary, that is, for the interpretation of Marxism itself) have had an extraordinary history. They are the first systematic sketch of what later Marxism was finally to become, written by a young man of twenty-six, who had just turned away from the Hegelian philosophy by which he had been obsessed, and who, by means of a critique of that philosophy, had stumbled on his own quite original insights into the nature of man in modern economic society. Marx did not permit their publication during his lifetime,[7] since he apparently thought them compromising of his later and more dogmatic formulations after 1848, but there is one cryptic reference to them in the Preface to the second edition of *Capital* of 1873, where he

speaks of his own dialectical method as the very opposite of
Hegel's and continues: "The mystifying side of Hegelian di-
alectic I criticized nearly thirty years ago, at a time when it was
still the fashion." But he adds: "The mystification which dialec-
tic suffers at Hegel's hands, by no means prevents him from
being the first to present its general form of working in a
comprehensive manner." [8] This critique of "nearly thirty years
ago" is the *Economic and Philosophic Manuscripts* of
1844 (their last section is headed "Critique of Hegel's Dialectic
and General Philosophy"), and the half-admiring reference to
Hegel even in 1873 attests the origins of Marxism in the bril-
liant development of German post-Kantian philosophy.

But it is the practice of *nouveau arrivés* to deny their origins
out of embarrassment, and of mature thinkers to deny their
youthful indiscretions out of pride—not realizing that the in-
discretions often account for the maturity, and even attest the
particular form which the maturity is itself to take. The *Eco-
nomic and Philosophic Manuscripts* lay unpublished in Marx's
drawer during his lifetime, and Engels maintained the same
secretive attitude when the archives came into his possession
after Marx's death in 1883.

> Some years later he [Engels] made public the 'Theses on Feuerbach'
> as an appendix to a new edition of his own *Ludwig Feuerbach*. In
> 1893 a Russian visitor, Alexis Voden, suggested that Marx's other
> early philosophical writings also ought to be published. He reported
> afterwards that Engels showed embarrassment when this subject was
> raised, and answered that 'Marx had also written poetry in his stu-
> dent years, but it could hardly interest anybody.' Was not the frag-
> ment on Feuerbach 'sufficient'? And ought he not to continue work
> on Marx's unfinished economic writings rather than publish 'old
> manuscripts from publicistic works of the 1840's'? [9]

After Engels' death the Marx achives seem to have passed into
the possession of the German Social Democratic Party, and it
was presumably with its permission that the Russians, after the
October Revolution of 1917, published the entire corpus of
Marx's work, including the early philosophical writings.

It is obvious that both Marx and Engels felt that to make the
hidden documents public would cause more confusion than
enlightenment, and that, particularly in Engels' case, there was
fear of a possible danger in any confrontation of Marxism's
scientific and revolutionary thrust with its original humanist
inspiration. For a "scientific socialist" it might be profoundly

disturbing to learn that his rigorous doctrine had originated in anything as misty and metaphysical as Hegel's *Phenomenology of the Spirit*. For the Marxism of the 1880's and 1890's, the evolutionary socialism of Bernstein, and the "scientific" social- ism of Karl Kautsky and Lenin himself had little to do with "alienation" and "the realization of man's true nature." These ideas smack of Aristotle and of Hegel, not of the implacability of class warfare and the urgency of proletarian violence. And in the positivistic and materialistic climate of the late nineteenth century, it was generally thought that the validation of a deci- sive social theory should come from science and not from ethics.

This was, of course, not universally the case. Karl Kautsky, perhaps the leading theorist of German Marxism after Engels' death, wrote in the early years of this country a small work, *Ethics and the Materialist Conception of History,* with the express purpose of supplementing Marxism with the moral underpinnings which in his opinion a democratic workers' movement required, but which "scientific" socialism did not provide. It is unimportant that Kautsky turned for his ethical norm to the Darwinian theory of the social and altruistic in- stincts in animal behavior (and therefore unconsciously at- tested the very strength of the faith in scientific theory which was for him a source of weakness in Marxism as a social creed). For he saw Marxism more as social science than as the bearer of a moral purpose, as the strict demonstration of a specific chain of causal occurrences in history rather than as a revolutionary transformation of social structure grounded in the transcendent attractiveness of an ethical ideal.

The discovery and publication of Marx's *Economic and Phil- osophic Manuscripts* of 1844 had radically altered this inter- pretation of Marxism and has shifted the center of interest from the warranted assertability of a scientific generalization to the general validation of a humanistic imperative. For the new status of Marxism as the latest participant in the humanism of the Western tradition is intimately bound up with current skepticism as to its dogmatic claim to be the irrefutable social science of the twentieth century. It is precisely this which has stimulated the attitude of Merleau-Ponty to which I referred earlier—the idea that an insistence on the "verifiability" or "non-confirmability" of Marxist doctrine is shallow or invalid before its new classic status as a "secondary truth." "It is," Merleau-Ponty had insisted in his "Marxism and Philosophy" of 1946, "strictly everyone's right to adopt the philosophy of his

taste: for example, the scientism and mechanism which have for so long taken the place of thinking in radical-socialist milieus. But it should be known and stated that this type of ideology has nothing in common with Marxism." [10] And he continues in a vein which ridicules the scientific pretensions of Marxist doctrine; indeed, makes its scientific claims vary inversely with the vigor of its revolutionary thrust: "Throughout the history of Marxism, in fact, the fetishism of science has always made its appearance where the revolutionary conscience was faltering: the celebrated Bernstein exhorted Marxists to return to scientific objectivity. As Lukacs notes, scientism is a particular case of alienation or objectification (*Verdinglichung*) which deprives man of his human reality and makes him confuse himself with things." Needless to say, a position like Merleau-Ponty's would have been impossible before the discovery of the writings of the youthful Marx, and the work of Lukacs would have been unintelligible and scandalous to the generation of Bernstein, Kautsky, and Lenin.

The writings of the young Marx before 1845, particularly the *Economic and Philosophic Manuscripts,* are the cornerstone of Marxian humanism, but their interpretation has presented a new set of problems no less subtle and difficult than those of the older deterministic philosphy of history which could be inferred from the great chain of Marxist works from *The Communist Manifesto* to *Capital.* What is the relationship between the youthful and the mature Marx? Is the humanistic theory of the former an Hegelian indiscretion, separated from the scientific studies of the latter by an abyss as great as that between the idealism of Plato's *Republic* and the reactionary product of his old age, *The Laws?* Or does it represent that kind of continuity which holds for a philosopher like Aristotle or Descartes or Hume, where the later works depend on the earlier, represent, indeed, merely the continuity and development of a fundamental unity of intent? These questions, in turn, hinge on the prior question of the true nature of Marx's relation to Hegel, as well as the much more difficult question as to whether Marxism as a whole is to be interpreted primarily as a scientific theory of history, a moralized philosophy of man, or a secularized religion in which a transcendent God has been replaced by the ideal claims of the transcendent future. My own preference is for the second alternative, but I shall reserve my reasons for this, and my answer to the other questions which I have raised, until we have had a chance to examine briefly the evidence of Marx's early writings themselves.

An examination of Marx's early writings (before 1845) [11] will reveal the dominance of three themes, treated constantly, and often bewilderingly intermixed. They are: (1) a critique of religion, (2) a critique of Hegel's philosophy, and (3) a critique of the contemporary economic order. In the writings of 1843–44 which appeared in the *Deutsch-Französische Jahrbücher* (on "The Jewish Question" and the "Contribution to a Critique of Hegel's Philosophy of Right") the first two themes are uppermost, while the then unpublished *Economic and Philosophic Manuscripts* of 1844 are devoted to the last. But in all these early writings Marx continually emphasizes a series of ideas or concepts which are basic to his system: alienation, money, freedom, the "species-being" of man, labor, the proletariat.

The larger theme of all of Marx's early writing is the theme of *emancipation:* how man can slough off the crippling ideas of religion, economics, and politics, and their rock-like institutional embodiment, and realize himself and his true human qualities within the charmed circle of an harmonious community. The thrust here is always in the direction of human *immediacy* and the critique is always directed against those "intermediaries" which distort the human reality. Religion is simply the recognition of man in a roundabout fashion, that is, through an intermediary, while the state functions as the intermediary between man and his human liberty. "The perfected political state," says Marx, "is by its nature man's *species life* in *opposition* to his material life. All the presuppositions of this egoistic life remain in *civil society outside* the sphere of the state, but as qualities of civil society. Where the political state has achieved its full development, man leads, not only in thought or consciousness, but also in *reality* a double life, an earthly and a heavenly. In the *political community* he regards himself as a *communal being;* in *civil society* he acts as a private individual, treats other men as means, is himself degraded to the status of a means and becomes the plaything of alien forces." [12]

In this passage (as in these two essays as a whole), although critical, Marx shows himself deeply under the spell of Hegel. His treatment of alienation is essentially Hegelian, for he finds it to consist in the division, the separation, the *fragmentation* of man which Hegel had first described in *The Phenomenology of the Spirit.*[13] Religious alienation becomes a fact at that paradoxical moment when institutionalized religion has become separated from the state and become private, when, in fact, by

separating into competing sects and thus expressing all the
egotism, competition, and pluralism of civil society itself, it has
retreated from the universal community to become the very
spirit of differentiation. Thus it has become a symbol of man's
separation from the community, from himself, and from other
men. "What prevails in the so-called Christian state is not *man,*
but *alienation.*" (In dem sogenannten christlichen Staate gilt
zwar die *Entfremdung,* aber nicht der *Mensch.*[14])

It is clear that Marx's attack is directed both against religion
and against the state, against the Christian orientation of West-
ern culture and against the political organization of power
which appeals to that orientation for its ultimate validation.
For both are but expressions of the alienation of man. Al-
though political democracy can be said to be Christian in the
sense that every man counts as a value, the very concept of
"man" here presupposed is a debased concept, namely, that of
"man as he has been corrupted, lost to himself, alienated, sub-
jected to the rule of inhuman conditions and elements, spoiled
by the whole organization of our society—in a word, man who
is not yet a *real* species-being." [15] This is neither the language of
a political opportunist nor of a philosophical materialist, but of
a humanist whose vision of what man may become is founded
on an almost Rousseauistic faith in the existence of a kind of
natural goodness from which man has fallen through his
subjection to the essential inhumanities of institutionalized
living. "*Every* emancipation," says Marx, "is a restoration of
the human world and of human relationships to man
himself." [16] The abstract rights of the abstract citizen are mean-
ingless when in his everyday existence the individual has been
separated from those values which spring from his humanity,
when the political power to which he is subjected has no roots
in the elementary requirements of his human need. "Human
emancipation will only be complete when the real, individual
man has absorbed into himself the abstract citizen; when as an
individual man, in his everyday life, in his work, and in his
relationships, he has become a *species-being;* and when he has
recognized and organized his own powers as *social* powers so
that he no longer separates this social power from himself as
political power." [17]

Marx's "Contribution to the Critique of Hegel's Philosophy
of Right" is remarkable on two counts: it indicates how, out of
a criticism of religious and political institutions, a new concep-
tion of philosophy arises, and it celebrates Marx's discovery of

the proletariat. Marx's statement about religion in this essay has become universally known: that it is "the sigh of the oppressed creature, the sentiment of a heartless world, and the soul of soulless conditions. It is the *opium* of the people." Thus the abolition of religion as the *illusory* happiness of men is a demand for their *real* happiness. About every immoral social institution there is a web of illusory justification, and as this veil is removed from the domain of transcendent promises, so the veil must be torn away from the domain of institutional practices. Thus the task of history is to establish the truth about the bitter world of social actuality, and "the immediate *task of philosophy, which is in the service of history, is to unmask human self-alienation in its secular form* now that it has been unmasked in its *sacred form.*" [18] It is at this point that Marx begins the famous transvaluation of philosophy as speculative culture into philosophy as mainspring of the revolution. "Criticism," as he says, "is no longer an end in itself, but simply a means; *indignation* is its essential mode of feeling, and *denunciation* its principal task." But if one objects that the mode of indignant perception and denunciatory rhetoric do not do justice to the tradition of Plato and Aristotle and Descartes, Marx's reply will be based on what Hegel has accomplished. For his definitive negation of all the past forms of consciousness in German jurisprudence and politics has paved the way for a new conception of the function of theory.

To be sure the arm of criticism cannot replace the criticism of arms. Material force can only be overthrown by material force; but theory itself becomes a material force when it has seized the masses. Theory is capable of seizing the masses when it demonstrates *ad hominem,* and it demonstrates *ad hominem* as soon as it becomes radical. To be radical is to grasp things by the root. But for man the root is man himself. Clear proof of the radicalism of German theory, and thus its practical energy, is that it begins from the resolute *positive* abolition of religion. The criticism of religion ends with the doctrine that *man is the supreme being for man* and, therefore, with the *categorical imperative to overthrow all those conditions* in which man is an abased, enslaved, abandoned, contemptible being . . .[19]

The strategy of Marx's humanism is here made crystal-clear. The importance (and the danger) of religion is not only that it stands for all the illusions which retard the human condition, but that its supernatural claims distract attention from the centrality of man himself. Only when these claims are rejected

is the path open for the radical reconstitution of society. The Western tradition has long identified humanism with Christianity but, despite St. Augustine and St. Jerome, the cathedral schools of Orléans and Chartres, and the labors of Erasmus and Montaigne, there is no *necessary* argument for this identification. And since (as witnessed by each of the above exemplifications) there has been such an intimate association of Christian humanism with an upper class elite and the aristocratic ideal, there is even greater reason for suspicion by a social theory which is already beginning to take the matter of "class position" with the greatest seriousness. When Marx turns his attention to the current situation in Germany, to the "monstrous discrepancy" between "the questions" of German thought and "the answers" of German reality, then he sees without illusion the bankruptcy of the German middle classes and their virtual role as an "oppressing class." And his answer to the question of the real possibility of an emancipation in Germany is the discovery of the proletariat.

Where, then, is there the real possibility of emancipation for Germany?
Answer: In the creation of a class with *radical chains,* a class within civil society which is not a class *of* civil society, a class which is the dissolution of all classes, a social sphere which possesses a universal character because its sufferings are universal and can claim no special right of redress because the wrong which it suffers is not a *particular injustice* but *injustice in general,* which can challenge no more upon *historical,* but only upon *human* grounds, which stands in no partial opposition to specific consequences but in total opposition to the assumptions of the German political system; a sphere finally which cannot emancipate itself without emancipating itself from all other spheres of society and thus without emancipating them as well, and which is in a word a *total loss* of humanity only to be regained by the *total redemption* of humanity. This dissolution of society as a particular class is the *proletariat.*[20]

The proletariat becomes the embodiment of the new humanism, not because it is the bearer of "culture," but because it stands for "man," and its role in the social order is to attest not to natural poverty, but to poverty artificially produced, not to a population mechanically oppressed by the weight of society, but to a population resulting from the disintegration of society. As the symbol of the effective dissolution of the social order, the proletariat plays the same role as the new-born philosophy,

which, no longer merely speculative, has become a material force in the reconstitution of society. Just as philosophy finds its *material* weapons in the proletariat, so the proletariat finds its *intellectual* weapons in philosophy. In the thought of the youthful Marx, these two, philosophy and the proletariat, advance or retreat together.

The *Economic and Philosophic Manuscripts,* although they are incomplete, disjointed, and somewhat diffuse, are rendered coherent by the central idea which dominates them—the idea of alienation. This idea, derived from Hegel, but transformed and rendered more original and "Marxian" in the process, serves as the chief vehicle of Marx's "humanism," for its function is to insist on the distinction between man's essential nature and the various forms of transformation and debasement which this nature undergoes as the modes of capitalistic production and exploitation impinge on it. The meaning of alienation in the essays in the *Deutsch-Französische Jahrbücher* was Hegelian in the most literal sense—it referred to a "division," a "separation," a "fragmentation" in the life of man, but here we have a new dimension which is characteristically Marxist—the notion that the human individual under capitalism is progressively *treated as an object, depersonalized, transformed into a thing* in his economic relations and their social consequences. This follows equally from the conditions of labor, the logic of exchange, and the intrinsic nature of money.

In an economic society dominated by production for a profit, the worker is himself transformed into a commodity, and his labor, once dignified and "his own," has become "alienated" in the service of avarice. Although the division of labor intrinsic to an advanced capitalism increases the productive power of labor (and hence the wealth and refinement of society) it impoverishes the worker and transforms him into the solidity of a machine. And even the political economy of the time, the theory of capitalistic functioning, must define the proletarian not in terms of the humanity of his total existence (consumer, father, sportsman, citizen, concert-goer), but of the mechanical role which he plays in the process of industrial productivity. For Ricardo, as for the system itself, "men are nothing, the product is everything." And this *indifference toward men* becomes the chief target of what in the early Marx is an essentially "humanistic" protest against the capitalistic system. For what is central here is that the *devaluation* of the human world increases in direct relation with *the increase in value* of the

world of things.[21] The commodity produced by labor—its prod-
uct—now stands opposed to it as an alien thing, as a power
independent of him by whom it was made, and this *externality*
has become the proof that the worker is not fulfilled by his
work, but degraded thereby, does not develop freely his physi-
cal and mental energies, but is physically exhausted and men-
tally debased.

The point seems trite and cliché, but only because its expres-
sion by Marx in 1844 has been echoed by every social critique,
every indignant cry against the capitalistic system for the last
hundred years. But what is peculiarly Marxian in it is that it is
based on the presupposition that man in his essential nature is
a "species-being" who makes his own community, is an intrinsic
part of nature, yet differentiated from it, and whose characteris-
tic mode of being is *free, creative activity*. It is because alien-
ated labor is so inimical to human consciousness and to the
realization of human life that Marx opposes it, and because
private property functions less as an agent of self-realization
than as a symbol of the tension-ridden and anxiety-consumed
membership in economic society that it becomes the object of
his critique. The humanism of Marxism consists not in the
attack on the capitalist economic system, but in its *grounds*.
And the communism which it advocates is thus conceived
(however mistakenly) as *the reintegration of man, his return
to himself, the supersession of his self-alienation.*

Communism is the *positive* abolition of private property as human
self-alienation, and thus is the real *appropriation* of the *human*
through and for man, and thus the return of man to himself as a *so-
cial*, i.e., a truly human being—a complete and conscious return uti-
lizing the whole wealth of previous development. This communism
as a fully developed naturalism is humanism, and as a fully devel-
oped humanism is naturalism. It is the genuine resolution of the an-
tagonisms between man and nature, and between man and man, the
true resolution of the conflict between essence and existence, aliena-
tion and self-affirmation, freedom and necessity, individual and
species. It is the riddle of history solved and knows itself to be
such.[22]

The passage is truly Hegelian in several respects. It contem-
plates a return from alienation to the bedrock of human na-
ture. It visualizes a future which transcends, but at the same
time contains, all of the riches of the past. And it paints a
picture of human and societal *wholeness* in which all of the

antinomies of experience and nature have been finally over-
come. But it indicates also a new estimate of causal factors
which goes far beyond the abstractions of Hegel. The commodi-
ties of capitalist production show us in an alienated form the
essential human faculties transformed into objects. And even
natural science, although its first penetration into industry has
accentuated the dehumanization of man, represents a real his-
torical relationship of man to nature. The socialist perspective
turns attention to a new mode and a new objective of produc-
tivity—the manifestation of human powers and a new enrich-
ment of the human being. It seeks to supplant a commodity
orientation, where every new product is a new potentiality of
mutual deceit and robbery, and where the *quantity* of money
becomes increasingly the one important *quality* of life, with a
functional orientation which releases objects of enjoyment and
activity from their alienation, and whose reference is to "use"
and not to the mechanisms of exchange. Throughout Marx's
analysis, like the hoarse and indignant refrain of a Hebrew
prophet, appears the constant sense of the truly monstrous
effects of the power of money. "Money," he had said in an early
essay, "is the jealous god of Israel, beside which no other god
may exist. Money abases all the gods of mankind and changes
them into commodities. Money is the universal and self-suffi-
cient *value* of all things. It has, therefore, deprived the whole
world, both the human world and nature, of their own proper
value. Money is the alienated essence of man's work and exist-
ence; this essence dominates him and he worships it."

In the center of the *Economic and Philosophic Manuscripts,*
like an igneous intrusion coming up through layers of sedimen-
tary deposit, lies Marx's "Critique of Hegel's Dialectic and
General Philosophy." It is presented as a footnote within the
text, almost like an afterthought, but it is extremely revealing,
not only of Marx's relationship to his master, but also of the
deepest philosophical grounds on which his humanism rests. In
a word, this is a "naturalistic humanism" whose bête noire is
the constant tendency toward abstraction. Marx's vision of man
(exemplified so well in his recurrent strictures against money)
pictures him as vivid and feeling, living a rich sensory life of
qualitative immediacy in which the human senses as such pro-
vide a wealth of subjective sensibility ("a musical ear, an eye
which is sensitive to the beauty of form, in short, senses which
are capable of human satisfaction and which confirm them-
selves as human faculties") . As money transforms real human

and natural faculties into mere abstract representations, (and becomes thereby the universal *confusion* and *transposition* of all things, the inverted world, the inversion of all natural and human qualities), so the Hegelian philosophy has contented itself with an abstract, logical, and speculative expression of the historical process. The Hegelian *Encyclopaedia* is but an expression of the philosophical mind, an alienated world-mind conceiving itself as a bundle of abstractions, and, although Hegel in the *Phenomenology of the Spirit* grasps the self-creation of man as a process, and even the nature of human labor, his one-sidedness and limitation consist in his reducing all reality to the pale dimensions of *mind.*

No naturalistic humanism can countenance such a reduction. Man is directly a natural being endowed with natural powers and capacities for suffering. His sensuality is his reality, but the direct expressiveness of his nature has been compromised by the repressive character of the social and economic institutions with which this state of history confronts him. Hegel understood the mechanism of alienation, even the dialectical process through which a formal alienation is overcome, but his concessions to the power of religion, the state, and economic society indicate the essential bankruptcy of the Hegelian enterprise. Marx's atheism and communism mark his break with Hegel, since, in Marx's opinion, they are not only definitive of the humanist position, but they eschew Hegelian abstraction, and they take account of the first actual emergence, the genuine actualization of man's nature as something real.

Atheism as the annulment of God is the emergence of theoretical humanism, and communism as the annulment of private property is the vindication of genuine human life as man's own property. This is also the emergence of practical humanism since atheism is humanism mediated through the annulment of religion as communism is humanism mediated by the annulment of private property. Only by the annulment of this mediation (which is, however, a necessary first step) can the *positive* self-originating humanism appear.[23]

To Western ears, accustomed to associate humanism with the Christian imperative, and to define human self-realization through an identification with various forms of private property, the definition of humanism as a combination of atheism and communism has a curiously twisted, if not a grossly perverse, ring. But an examination of Marx's argument in his early writings does reveal, I think, a virtual humanism no less insist-

ent, no less valid than that which is to be discovered in the
writings of Erasmus, Shakespeare, and Montaigne. The ele-
ments of this humanism are indeed naturalistic, for they consist
in a critique of abstractions and the demand for a recovery of
human sensuality and enjoyment. But while they deny any
claims of supernaturalism, they do not reduce human life to the
merely naturalistic level. The emphasis on man as a species-
being, that is, not merely a social animal, but one who con-
ceives of himself as a member of the human community, with
all that this entails of morality and responsibility, gives to
human life the unique dimension which separates it equally
from the "higher" level of divine imperatives (fictive and the
embodiment of class exploitation in Marx's view) and the
merely animal level of natural functioning. And this produces
a social criticism aimed at the eradication of those social, eco-
nomic, and political institutions which maim and distort man's
true nature. Thus, however a later Marxist development has
seemed to emphasize a dynamic of social change dependent on
violence and terror, the origins in the early Marx are depend-
ent on a humanistic criterion of societal judgment. It is this,
above all, which entitles us to view Marxism in its essence as
neither a systematic social science nor a secularized religion,
but a practical and applied *ethics* founded on what the eight-
eenth century would have called an "anthropology"—a moral-
ized conception of man.

It is true that the preoccupations of the later Marx grew
increasingly technical, and that the format of *Capital* shows it
to be a work of "political economy" in the great tradition of
Adam Smith, Ricardo, and the two Mills, but the *impulse*
behind this systematization remains moral (just as John Stuart
Mill's *System of Logic* had as its impulse the desire to provide a
logic for the social and moral sciences, and thus make their
"knowledge" available to the process of social reform), and
from time to time (as in the treatment of the commodity, the
fetishism of commodities, and the perverse tendency of social
relations under the commodity orientation to assume "the fan-
tastic form of a relation between things") even the earlier
concern with "alienation" and "objectification" crops up again
to reveal the moral theory perpetually presupposed. It is under-
standable that Engels, to demonstrate the profound originality
of Marx's work, should have had to distinguish between a
"utopian" and a "scientific" socialism, and that Kautsky, Bern-
stein, and Lenin should consecrate this necessity in the form of

a positivistic dogma. But to argue that there are "two Marx-isms" rather than one, and that the mature system remains the truly serious and significant creation of Marx, while the early writings are an interesting youthful aberration—a momentary intoxication with an obscurantist Hegelianism in due time completely overcome [24]—is an extravagance which no complete reading of the Marxian corpus can possibly tolerate. If the interpretation of the Marxian writings must be assimilated to any paradigm, it is to that of Aristotle and Descartes and Whitehead rather than that of Plato and Carnap and Sartre—to the model of continuity and inclusive development, that is, rather than to that of dramatic internal disruption.

In the same way, Robert Tucker's brilliantly argued and persuasive thesis that Marx is essentially a religious thinker [25] (since, although he held strong moral views, he was not really a moral philosopher, but rather reflects a "religious conception of the world" which can be traced back to Feuerbach and Hegel and to their notion of man's divine self-realization) does not, I think, in the end hold up either. To say that Marx created a religious myth in a secular form is to describe the fashion in which Marx has frequently been used (or misused) rather than an intrinsic property of his writings taken as a whole. Tucker's analysis of Marxism as a religious system is based on a four-point analogy with Western Christianity: (1) it undertakes to provide an integrated, all-inclusive view of reality, an organiza-tion of all significant knowledge in an interconnected whole; (2) it views all existence under the aspect of history: it tells a story which has a beginning, a middle, and an end; (3) it has a master-theme of salvation in which the final revolution is to bring about a radical transformation of human nature, a change of heart, a true regeneration; and (4) Marxism, like Christianity, has both a world view and a set of prescriptions for action based on it—in this sense it too holds to the unity of theory and practice.[26] But if there is an analogy here, it is based not on an essential but an accidental property. Tucker's first two characteristics and his last in no way uniquely differentiate between a religious and a synoptic philosophical system. His first point would hold equally for the philosophical endeavors of Plato and Aristotle as his second would for those of Hegel or Spengler, while his third would serve for any metaphysics which entailed an ethics, like that of Plato or Spinoza, Kant or Brad-ley. The third point is the strongest, but even this is essentially weak, for any ethics of self-realization can require a moral

change of heart no less than a specifically religious conversion.

The crucial weakness in Tucker's argument lies in his assumption that *because Marx was not a moral philosopher in the classical sense, therefore his moral views cannot be taken as central.* Granted that Marx initiates no systematic inquiry into the nature of the supreme good like Plato, that he is no follower of Kant or Bentham or Mill, and that he worked out no canons of distributive justice like Aristotle or Sidgwick, it still remains true that his whole philosophical edifice rests neither on a scientific nor a religious, but on a *moral* base, and that the humanism detailed in his early writings, if carefully analyzed, will yield a self-realizational ethics not unlike that of Aristotle or that implicit in the later writings of John Stuart Mill. To deny that a system is ethically grounded because its author does not systematically engage in moral philosophizing is an egregious *non-sequitur.*

But of the two attempts to push Marxism in the directions of science and of religion, respectively, it is surely the former which is more compromising of its original humanistic intent. Karl Kautsky was clearly right: if socialism as a scientific theory has no ethical implications, then in the name of a program having a motive power and making a claim on human loyalty and commitment, it is surely necessary to provide it with some. To feel confident of the working out of historic destiny and of the triumph of the proletariat may provide a certain theoretical satisfaction, but no moral contentment. The weary hours which the aging Marx put in at the British Museum in the construction of his later system may have attested a theoretical passion matching anything to be found in Galileo or Newton, but *The Communist Manifesto* expresses a moral passion sufficiently strong to have lasted well into Marx's later years.

The early writings show this impulse at its freshest. The moral indignation is here at the full, but matched by a certain moral serenity too. For if Marx was on the point of abandoning Hegel and the great idealist tradition, he had learned much from their guidance. One small part of this debt was the legacy of an ethics of human self-realization. The early essays and the *Economic and Philosophic Manuscripts* exhibit this ethics as the core of the Marxian humanism and of the critique of capitalist society which was its consequence. To examine the nature of man (elliptically to be sure, but in the same spirit as Aristotle's *Nicomachean Ethics*) and in the light of this examination to visualize what it was in his power to become is no

mean moral venture, and if Marx went on to plot the social and economic strategy of this recovery without a further backward glance at the moral presuppositions as strongly entrenched as the *Economic and Philosophic Manuscripts* show them to be, this constitutes no abandonment of humanism, but a construction on its foundations. It was precisely in recognition of this fact that Lukacs urged on the regenerate Thomas Mann that at the heart of his intellectual and moral life he should replace the tradition which runs: Goethe—Schopenhauer—Wagner—Nietzsche with another which runs: Lessing—Goethe—Hölderlin—Büchner—Heine—Marx.

The case of Lukacs himself is one of profound ambiguity and contradiction. Born in Budapest in 1885, and from the very beginning of his education passionately interested in literature and the theater, he studied at Heidelberg and Berlin with Simmel and Max Weber, taking his doctorate with the former in Berlin in 1906. In 1911 he published his famous series of essays, *The Soul and the Forms*. The book made his reputation, attracted the favorable attention of Thomas Mann, and in its attack on "naturalism" in literature as destructive of the spiritual foundations of tragedy established the groundwork for a philosophy of literature from which he was never really to depart. Settled in Heidelberg in 1912, he became a member of the gifted circle around Max Weber, devoting himself to *Geistesgeschichte* in the manner of Simmel, Dilthey, Cassirer, and the other great neo-Kantians who dominated this fruitful period of German intellectual culture. Profoundly shaken by the outbreak of the First World War, he nonethelesss published his *Theory of the Novel* (1915–16) while coming ever more strongly under the influence of Hegel and Marx. At last, fully converted to the Marxist solution, he joined the Hungarian Communist Party in 1918, and a year later left his lectureship in aesthetics at Heidelberg and became, at thirty-four, Commissar of Culture during the brief dictatorship of Bela Kun in Hungary. From this time on his life was one of flight, exile, and precarious survival against Communist pressures and sharply critical strictures against his literary and ideological productions.

After the collapse of the dictatorship in Hungary, he fled to Vienna, where, often in prison, he wrote his famous *History and Class Consciousness*, published in 1923. He remained in

Vienna until the late 1920's. From 1930 to 1931 he lived in Moscow as Research Assistant at the Marx-Engels-Lenin Institute, but returned for two years to Berlin. In 1933, with the rise of National Socialism, he emigrated to Russia, where he worked as Research Associate at the Philosophical Institute of the Moscow Academy of Sciences. He remained there until 1945, despite continuous friction with his Soviet colleagues, pouring out his brilliant studies in literary history and criticism. In 1945, when a Communist regime had been set up in Hungary, he returned to Budapest as Professor of Aesthetics and the Philosophy of Culture. Here too his writings brought him in conflict with the Party and the government. Brought into the Nagy cabinet during the Hungarian uprising (as Minister of Education and Culture for the second time), he took asylum in the Yugoslavian embassy in Budapest when that short-lived regime was put down by Russian tanks in 1956. Briefly exiled to Roumania, in 1957 he was permitted to return to Budapest, where he still lives, in retirement and isolation, a very old man completing the *Aesthetics* which he hopes will crown his literary and cultural life work.[27]

In speaking of Lukacs' "precarious survival" against Communist pressures and the critical strictures against his work, there is no question of presenting him as an heroic figure in the pantheon of Marxist revisionism and nonconformity. Lukacs survived, but he was no Pasternak, remaining true to himself no matter what the cost; no Brecht, using all the wiles of a peasant canniness in order to preserve to the end his intellectual and artistic integrity. On the contrary, the very "two-sidedness" and opportunism of his actions and modes of survival are a source of considerable embarrassment to one wishing to present him as an authentic "humanist" in the Marxist tradition. In fact, the portrait which emerges is not unlike that which Mann patterned after him in his portrayal of Naphta in *The Magic Mountain*, the ferocious little Communist whose dogmatic brilliance and hysterical power-hunger make him at once so intellectually compelling and so personally suspect. Lukacs' abortive period as cultural Commissar under Bela Kun shows him wielding the most restrictive form of autocratic power against the artists and authors of Hungary, setting up "A National Council for the Products of the Mind" and a "Literary Register," categorizing writers not by their literary talents, but according to the warmth of their political allegiance. And when his own turn came, and the brilliant *History and Class Con-*

sciousness was attacked by Zinoviev himself at the Fifth Congress of the Communist International in 1924, Lukacs passively accepted official discipline. Later he even repudiated this most characteristic product of his ideological originality, and the rightful source of his Marxist reputation in the West. His abject, almost hysterical, recantation of his earlier views before the philosophical section of the Communist Academy in Moscow in 1934 makes painful reading.

The ambivalence of his behavior is embarrassing enough; that of his intellectual productivity is no less so. The *History and Class Consciousness* of 1923 is indeed a remarkable work, worthy of the tradition of the early Marx. *The Young Hegel* of 1948 is a work of brilliant scholarship, and a real addition to our knowledge of Hegel and of the debt which Marxism owes to him. *The Historical Novel* (1937), *Studies in European Realism* (1938), and *Goethe and His Time* (1947) are, despite occasional lapses in judgment and falling into cheap Marxist clichés, magnificent additions to the European heritage of literary and cultural criticism. On the other hand, *German Literature in the Period of Imperialism* (1950) uses terms like "reactionary" and "decadent" in a fashion both treasonable to the classics, and blind and imperceptive in the extreme in relation to all modernism in literature. *Existentialism or Marxism* (1948) simply cannot be taken seriously as a critique of existentialism and the phenomenology to which it owes its birth, while the bloated and hysterical (as well as critically second-rate) *The Destruction of Reason* (1954), in its unfairness to Schopenhauer and to Nietzsche, to Simmel and to Dilthey, to Scheler and to Jaspers, is a piece of Communist falsification which, as George Lichtheim indignantly wrote, "ranks among the intellectual crimes of the age." [28]

In this spotted, and by no means generally favorable, picture it may seem Pickwickian in the extreme to take Lukacs as the second great figure in the tradition of Marxian humanism, but I believe it is both legitimate and just. For, in a broader perspective, if his life is problematic and unadmirable, his mind is fertile and has wrestled with some of the most crucial problems in the cultural experience of Europe in the nineteenth and twentieth centuries. Any revolutionary experience seems to mark a profound cultural disruption—a break with the seamless web of the historical tradition. But through the concepts of "the dialectic" and of "totality," terms which he discovered in and reappropriated from Hegel, [29] Lukacs has

laboriously attempted to repair the Marxist rips and tears in the fabric of culture, without sacrificing the dramatic weapon which the concept of alienation became in the arsenal of the youthful Marx. Lukacs has sharpened the notion of alienation further, using the Marxian terminology, but in a fashion which never forgets its Hegelian derivation, so that, as the critique of an estranged bourgeois society becomes ever more radical and severe, the cultural accumulations of that society yet remain permanently available for reintegration into the utopia of the future. This, within the context of the Marxist presuppositions which it assumes, is a labor of profound constructiveness.

In a broader perspective, therefore, the work of Lukacs has accomplished two great humanistic tasks, one *theoretical,* the other *practical;* the first exemplified in the theory of *History and Class Consciousness,* the second in the profoundly fruitful works of literary criticism like *The Historical Novel* and *Studies in European Realism.* In the first he has taken the concept of alienation directly from its Hegelian matrix; developed it prophetically with its Marxist significance ten years before the discovery of the writings of the youthful Marx showed how intuitive and clairvoyant had been his theoretical perception; and, by applying this concept to the cultural world, *demonstrated* how the fragmentation of bourgeois man has produced the peculiar and problematic constructions of Western philosophy and aesthetics from Descartes to the nineteenth century. And in the second, the will-to-power of the real cultural Commissar of the Hungary of 1918 has been sublimated into the *obiter dicta* of the professor of aesthetics and the literary critic in the assertive act *of single-handedly forging* the culture of the proletarian revolution. As a kind of unofficial commissar of Marxist culture, despite neglect or scorn, or angry attacks from the real commissars, Lukacs in the vast series of his critical works has taken it upon himself *to define the literary tradition of socialist man.* All his great works of literary criticism—ostensibly merely theoretical or pedantic, as the case may be—have at bottom this latent, but infinitely powerful, practical intent.

To see it this way is to break up Lukacs' productive life into the tripartite structure which I think it yields. His writings before 1918 are dazzling in their originality, but they are non-Marxist, whereas in general the writings which he produced after his return to Hungary in 1945 show the results of a mind taking the easy road of hardened doctrine and expressive cliché —in short, the logic of fatigue. But between the flight to Aus-

tria of 1919 and the return to Hungary after the Second World War lies a quarter of a century of exile in which his Marxian brilliance reached its height. I shall turn briefly, therefore, first to a summary examination of the significance of the *History and Class Consciousness* of 1923 and secondly to a restricted overview of the sense of *The Historical Novel* and the *Studies in European Realism* of 1937 and 1938.

In the preface to *History and Class Consciousness* [30] Lukacs states the conceptual basis of his entire analysis, and in the two essays "What Is Orthodox Marxism?" and "Class Consciousness" he exhibits the methodology which achieves such profound fruitfulness in his hands. His essays have been written in an effort to understand the Marxian method and to apply it correctly, and they are based on the conviction that only Marxist method and doctrine make possible a true understanding of history, society, and "the present moment." The center of the Marxian method, says Lukacs,[31] is *the dialectic,* and it is impossible to understand this method without some attention to Hegel and his relationship to Marx. He quotes Lenin to the effect that all good Marxists constitute a kind of "society of materialist friends of the Hegelian dialectic." It is precisely this *Hegelianizing of the Marxist position* which has permitted Lukacs to arrive at the crowning insight of the entire work— the discovery of "reification" and its exemplifications in "the contraditions of bourgeois thought" as reflected in the classical philosophy of the West since Descartes.

It is possible, says Lukacs, to be an orthodox Marxist while rejecting all the specific theses of Marx so long as one embraces the method of the Marxian dialectic. For, in the end, it is primarily the materialistic dialectic which is revolutionary in its consequences, which is the only method of molding class consciousness on the truths of historical reality, which is basic for the forging of an authentic proletarian self-consciousness. The dialectic is a perpetual process of change, where opposites are constantly overcome, incorporated, and transcended, not merely in thought (the domain to which Hegel restricted them) but in social experience and in history. And it is here that the application of the dialectical method reveals the true evolution of capitalism—the progressively "fetishistic" forms of economic life, the reification of all human relationships, the crucial extension of a division of labor which atomizes ("abstractly" and "rationally" as Max Weber had taught) the processes of production without concern for the human beings who are affected.[32]

To speak of the true evolution of capitalism implies an understanding of the facts. All knowledge of reality, naturally, begins with "the facts," but for a Marxist it is important to recognize the "historical" character of facts—how, precisely, in the structure of their "objectivity" they are the products of a special historical epoch—that of capitalism. But further, it is possible to relate the various levels of fact in social life only by placing them in the *totality* which both includes them and is the key to their interpretation. For example, only by following this Hegelian insight of the concrete totality of social reality can one recognize in the contradictions which it reveals not symptoms of an imperfect scientific understanding, but a real and permanent feature of capitalist society. And only this methodological starting point provides the essential unity of theory and practice in the proletarian perspective, which follows from the proletarian's awareness that he is at once the subject and the object of the historical process. From Hegel, Lukacs derives not only the category of "totality," but also the central position of "consciousness" or "self-awareness." For in the end it is in terms of these ideas that orthodox Marxism is to be defined. The task of orthodox Marxism is the unceasing struggle against the perverse influence of bourgeois forms of thought on the consciousness of the proletariat.[33] And it fulfills this task not by setting itself up as the guardian of any revolutionary tradition as such, but in setting forth clearly what the present historical situation requires. Marxism is here visualized less as an agent of immediate violence than as the representative of historical truth struggling for the mind of man.

What in the Hegelian system was "self-consciousness in general" or "consciousness of absolute spirit" is here, following Marx, transformed into "class consciousness." Since the bourgeois and the proletarian are the only "pure" classes given in history, it is first of all requisite to know the function which self-identity or common consciousness plays in their constitution and behavior. Class consciousness is at bottom a consequence of productive role, of the position which the class holds in the concrete totality of the social situation, and for this very reason it implies an identity of theory and practice. *Class knowledge is class power.* Thus class struggle reduces to a conflict of perceptions of social role, and it is precisely here in the question of violent action (where classes confront one another in the effort to survive) that the matter of class consciousness is finally decisive.[34] The destiny of any class, its capacity for reso-

lute activity in any situation of crisis, depends entirely on the
adequacy of its social perception, on its ability to see clearly the
necessity which historical evolution has imposed on it.

But in this conflict, Lukacs believes—no matter how over-
whelming the obvious advantages of organization and power
which accrue to it—the ultimate position of the bourgeoisie is
untenable. For its point of departure must always be an apol-
ogy for the present order of things, an order which is histori-
cally doomed, and this conflict of ideology and historical inevit-
ability imposes on it an insoluble task. This constitutes for the
bourgeoisie a kind of "tragic doom" or fatality of class position
which has literary and philosophical no less than institutional
expression.[35] No sooner had the bourgeois class overcome its
predecessor, feudalism, when a new class enemy, the proletar-
iat, appeared. And all of the obvious yet uneasy contradictions
with which it is confronted are insurmountable since they are
at bottom contradictions inherent in the nature of capitalism
itself. There is the simple dislocation of the bourgeois individ-
ual before his personal destiny. There is the basic contradiction
between the principle of capitalistic self-interest and private
profit and the Christian ideal of charity and justice which
constitutes its sense of obligation. There is the insurmountable
opposition between the political ideology of democratic self-de-
termination and the hierarchical and exploitative character of
its fundamental economic conditions. For, in the end, the domi-
nation of the bourgeoisie is a domination in the interest of a
minority, but its public and ritual insistence on the organiza-
tion of force "for the common good," and on securing "an
impartial justice for all," etc., etc., shows the vital necessity for
a masking of the true essence of bourgeois society.

One of the major responsibilities of proletarian class con-
sciousness is the task of "unmasking," of annihilating the bour-
geois facade with its claim of eternal and immutable "higher"
values. And thus the rage and despair with which bourgeois
thought combats historical materialism is eminently under-
standable. For it dimly realizes that for the proletariat, truth
itself is the chief armament of victory. "When the final eco-
nomic crisis of capitalism begins, the destiny of the revolution
(and with it that of humanity) will depend on the ideological
maturity—on the class consciousness—of the proletariat."[36]
But the realization of the truth is not easy. The proletariat,
itself a product of capitalism, is necessarily subject to the forms
of existence of its producer. These forms of existence are aliena-

tion and inhumanity. And, although the proletariat is by its very existence a critic, a living negation of those forms of existence, the inhuman character of its situation in the ensemble of political, economic, and cultural circumstances presents itself as a state to be overcome. Insofar as its alienated consciousness remains imprisoned in either of the extremes of a crude empiricism (opportunism) or an abstract utopianism, it will be impotent. Its social effectiveness, therefore, is dependent on the achievement of an authentic, that is to say, on a truthfully based and actively disposed class consciousness.

The essays on orthodox Marxism and class consciousness reveal his methodology and his central concepts, but they are preliminary. It is the long middle essay, "Objectification and the Proletarian Consciousness" ("Verdinglichung und das Bewusstsein des Proletariats" in the original, or "La Réification et la conscience du prolétariat" in the French translation), which is the heart of Lukacs' thinking and the juncture at which his own humanism takes up at the point where the young Marx left off. Calling attention to the central role which the analysis of "the commodity" plays throughout the body of Marx's work, Lukacs appropriates it as the clue to an understanding of capitalist society—as the central structural problem of this society in all of its vital manifestations—so that in the commodity orientation is to be found "writ large" every form of alienation, every form of subjective escape which has become embedded in bourgeois culture.

The consequence of the commodity structure is, as Marx had pointed out, a process of increasing "thingification" in which the living relations between persons take on more and more the "impersonal" and "objective" relations between things, and in which the "fetishistic" character originally surrounding the commodity is slowly transferred to all of the elements of the social structure: its class cleavages, its economic forms, its laws, its philosophies, and the structure of its science. But this is not a universal quality of historical experience; it is the specific problem of our epoch and of modern capitalism.

The crucial area in which this alienation expresses itself is in that of thought, of human consciousness, and here the process at work is that of *abstraction*. A commodity is an object. An object is that which can be considered "objectively." Objective consideration of that which is not itself an object (i.e., vital human relations) requires abstraction. In this environment of impersonality and of modern science, as Lukacs said much

earlier in a somewhat different connection, there arises "an awareness that man's self-created environment is no longer his home, but his dungeon." The process of destruction is so slow as to be imperceptible, so complete as to seem inherent in the nature of things. The continual subordination of man to the machine in modern industrial production makes time itself no longer qualitative and fluid, but a quantitative continuum, exactly measurable and filled with "things" also exactly locatable and measurable. This is how "humanism" is replaced by "science" to form the space of physics.[37] And it shows how Marx provides a technological explanation of "the spatialization of time," noted by Bergson, and the "fallacy of simple location" criticized by Whitehead. What is important is that the universalization of the concept of the commodity marks not only the position of the worker, but the system of thought in general. What began as a radical change in the technique of industrial production becomes the general fate of the whole of capitalist society and the modes of thought which it employs.

Nowhere has this change been more apparent than in the evolution of modern social science. For the "commodity structure" of all entities means that their mutual relations take on the solidity of unchangeable "laws of nature," and the dream of an emerging sociology is that all of the functions of human intercourse can be assimilated to this "objective" model. Although Lukacs does not pursue this specific line of reasoning in detail, his theory seems to imply that the attempt to create a scientific sociology is a by-product of capitalism, and that it is perhaps no accident that Comte's positivistic dream originates as the methods of modern industrial production capture France. What more obvious evidence is needed that social science is the child of *Verdinglichung* (reification, objectification, thingification) than Durkheim's formulation of the method of observation of social facts: "La premiere règle et la plus fondamentale est de *considérer les faits sociaux comme des choses*"?[38]

But contemporary social science is only one specialized example. In fact, in the course of the evolution of capitalism, reification has thrust itself more and more deeply, fatally, constitutively, into human consciousness and social institutions. Bureaucracy is the inhuman and the objective in government. A faculty psychology, abstracting from the organic unity of the human being, turns functions into objects which man possesses, and can consider them "objectively," like all the other objects of the external world. Both modern science and modern philo-

sophy have lost the sense of totality. The first has abandoned concrete nature for a nonontological formulation of the functional correlation of variables. The second has restricted itself to specialized problems of grammar and linguistic use which it has found less in concrete experience than in the interstices of the sciences. The entire system of law has solidified capitalistic needs as eternal values, and has become hard as rock within the body politic. Wherever one turns, the alienated consequences of the commodity orientation meet the eye.

However keen Lukacs' perception of the consequences of reification on modern institutional structure may be, it is in the field of the history of ideas, or *Wissenssoziologie,* that his pursuit of dehumanization is most brilliantly carried out. For in his elaboration of "the antinomies of bourgeois thought" he has explored in depth how out of the reified structure of the modern consciousness has grown the whole of Western philosophy since Descartes. The task has been difficult, not simply because of the subtlety required in attaching the play of intellectual imagination to the anchor of social necessity, but also because of the long tradition which ascribes continuity to the course of philosophical thought. Thus Plato is read as a precursor of Kant, or Aristotle as a precursor of Aquinas, without recognizing that although there was an element of reification in ancient and medieval cultures, it was quite different qualitatively and without essential relationship to that which has held in the West since the Industrial Revolution.[39] That Descartes is "the father of modern philosophy" is no accident, nor is it fortuitous that his frank dualism and subjectivism have served as the classic statement for every subsequent philosophy to either embellish or overcome. For the central intuition that the object of our consciousness cannot be known by us except insofar as it is in some sense our own creation, and its cognate counterclaim that the mathematical or geometric method (the method of construction, of the apperception of the object as stemming from the formal conditions of objectivity in general) is the chief clue to the creation of philosophical generality, provide a dichotomy which haunts both the eighteenth and the nineteenth centuries. The conflicts of rationalism and empiricism, which seem to find their resolution in Kant only to give way to an even deeper split between the world of appearances and of things in themselves, between the *forms* and the *content* of the human understanding (to say nothing of the split between *knowing* and *doing,* between the *theoretical* and the *practical*

reason) delimit the fate of all modern philosophizing, since
they suggest an eternal dialectic of thought (the rationality of
forms against the sheer irrational immediacy of content; the
insurmountable *necessity* of external nature against the *inter-
nalizing* of the moral consciousness and its freedom) which is
rooted both in the nature of things and in the structure of the
human mind. It is Lukacs' peculiar originality that he finds
them rooted in neither, but rather in the social frame, so that
the separations and divisions of mind and nature are less onto-
logical presuppositions than the simple logical and methodol-
ogical correlates of the current state and the acute problems of
modern bourgeois society.

In this perspective Kant becomes the great philosopher of
capitalism, not because he was in any serious sense its apologist,
nor, indeed, even conscious of it as a philosophically productive
force, but because he made no attempt to disguise the fatal split
between appearance and reality or between liberty and neces-
sity, but asserted them and the insoluble character of the prob-
lems which they raise vigorously—even brutally—and in so
doing symbolizes perfectly the final dilemma of the bourgeois
consciousness. The position of bourgeois man in the process of
capitalist production shows him confronted with what he takes
to be a permanent and unalterable reality (which he, or his
whole class, has actually made) with an essence strange to him,
yet to whose laws he is delivered without possibility of resist-
ance. And since, as a result of this reification, he remains by the
very logic of his situation the *object* and not the *subject* of
historical change, the field of his proper activity is turned to-
tally inward—toward subjectivity.[40]

Out of this curious situation spring the antinomies of bour-
geois thought; the dualisms of man and nature, of reason and
sensibility, of form and matter, of subject and object, of liberty
and necessity, of individual and society, of theory and practice.
It is one of the tragic ironies that the bourgeois urge toward
totality in the face of these irrevocable dualisms should have
focused on *the aesthetic object,* and that, from the eighteenth
century to today, aesthetics and the theory of art became the
areas in which might be discovered an organic unity not to be
found either within a fragmented society or in the class division
which constitutes its underlying structure. Only a Kant, reflect-
ing unconsciously the social dualisms of the modern industrial
period, would have looked to art to overcome the fatal opposi-
tion of form and content; only a Schiller, obscurely conscious of

the divisiveness of human social functions, could have attempted to reconstitute "the whole man" not in the recombination of his serious social roles, but in the moment when he "plays."

The paradox is exquisite. For it so happens that the proposed resolutions of the dilemmas of the capitalist world since Descartes occur at levels which completely avoid the problem at its center (the level of work) to concentrate on the available modes of a superficial *escape*. Man, fragmented by the social system, is to be reintegrated either in *play* or in *thought*. And if Schiller represents the first possibility, Hegel represents the second. Lukacs, as if to convict the master out of his own mouth, quotes from the early Hegel: "When the power of unification disappears from the life of man, and when contradictions lose their relationship and living interaction, and become autonomous, then the need for philosophy is born." [41] Hegel's own philosophizing is the living exemplification of this insight. It is the search for wholeness and the attempt to overcome fragmentation. It is an effort to renew the momentum of the dialectic at the moment when it has been frozen into insoluble antinomies. Unfortunately it, too, only proposes salvation at the level of *thought*.

Lukacs, like Marx, takes up the problem of man's alienation in terms of "fragmentation" and "reification." Like Marx, he shows the crucial importance of Hegel in the liberation of his thought. But like Marx, too, his implicit criticism of Hegel is directed against the way in which he cuts off consciousness from its class embodiment. The humanism of both Marx and Lukacs seeks the *wholeness* of man in the face of his inescapable capitalistic fragmentation, and the agent in both cases is the aware, the enlightened, the embattled proletariat. But whereas Marx leaves the natural history of proletarian enlightenment as an unsolved problem, Lukacs, more under the spell of Hegel than he might like to admit, raises the problem of proletarian class consciousness, of the proletarian "point of view," as the veritable key to the revolution and the transformation of capitalist society. His "humanism" returns Marx to Hegel as the far-ranging prodigal son is at last returned to the paternal bosom.

Lukacs' second humanistic accomplishment is, as I have said, to have defined in his important works of literary criticism a literary tradition for the Marxist world which would neither uncritically praise those works produced in the socialist countries since the Russian Revolution of 1917, nor automatically

reject all works produced under bourgeois inspiration before that time, but rather, by finding a formula of definition and reconciliation, to show on what terms almost the entire tradition of Western letters can be assimilated to the Marxist point of view. This formula is *the theory of critical realism,* and it permits Lukacs at once to establish his own rapport with the classical founders of Marxism, and, at the same time, to extend their insights systematically far beyond their merely impressionistic beginnings. Both Marx and Engels had enormous respect for the realistic novels of Balzac (Marx proposed to do a study of *La Comédie humaine* after he had completed *Capital,* which, of course, illness and death prevented, while Engels in his letter to Margaret Harkness of April, 1888 spoke of "Balzac, whom I esteem a master of realism infinitely greater than Zola"), and Lenin wrote admiringly both of "Tolstoy, mirror of the Russian revolution" and of Gorki. Lukacs in his literary pantheon follows Marx, Engels, and Lenin in their enthusiasm, but through his critical formula he can point out in detail *why* Engels was correct in preferring Balzac to Zola, and he can further add to the acceptable Marxist slate works like Goethe's *Götz von Berlichingen* and the major novels of Stendhal and Thomas Mann. What is interesting however is less the specific tradition which is built up than the criteria for its selection, the critical method presupposed, and this is, I think, nowhere more fully presented than in Lukacs' 1948 Preface to his *Studies in European Realism,* itself actually written a decade before.

Lukacs' procedures never wander far from a single center— the search for the material roots of each phenomenon, its historical connection and movement, the laws of its development and decay—and he thus welds together in his aesthetics and literary criticism Marxian materialism and Hegelian concern with change and maturation. To examine the interaction between the economic and social development of a period and the ideas and artistic forms to which they give rise, to explore the social basis for "the divergence and convergence of genres," the rise and withering away of new elements of form within the complicated process of historical development and economic change, has always been the essence of his method, producing brilliant results within a limited field, but also paying a certain price in narrowness and selectivity for the insights achieved. Plekhanov once wrote: "The first task of a critic is to translate the idea of a given work of art from the language of art into the language of

sociology, to find what may be termed the social equivalent of the given literary phenomenon." But it is not merely that Lukacs' criticism is "sociological" (and thus scornful of those methods which emphasize purely "biographical" or "formal" elements in the literary work), but that it is finally "teleological"—grounded in a specific philosophy of history which has prejudged the course of European economic evolution so as to hold before its eyes the apocalyptic vision of the ultimately triumphant proletarian society. This means that his canons of judgment are firmly grounded in considerations of time and place, and that his estimates of literary value are always ultimately fixed by social considerations extrinsic to the literary work itself. This, for example, makes him essentially unappreciative of lyric form (whether in Verlaine or Keats, Hoelderlin or Rilke) and of any purely subjective or formalistic experiments with style (as in Kafka's stories, or the novels of Musil and Proust). On the other hand, it gives consistency, even "objectivity," to his mature judgments. He can assert with confidence that Balzac rather than Flaubert was the greatest novelist and the typical classical author of the nineteenth century, not as a matter of subjective taste, but because a novel of social appropriation must be by definition a greater accomplishment than a novel of social retreat, and because, since the novel is the predominant art form of modern bourgeois culture, and because that culture is declining, it can be judged with assurance to have reached its peak in Balzac, Stendhal, and Tolstoy rather than in Gide, Virginia Woolf, and Joyce.

When Lukacs in *The Historical Novel* makes the year 1848 a decisive one in the alteration of class groupings and of class attitudes to all important questions of social life, when he perceives that "here for the first time a decisive battle is carried out by force of arms between proletariat and bourgeoisie, here for the first time the proletariat enters upon the world-historical stage as an armed mass," [42] then it follows that whatever faint stirrings toward revolutionary democracy the bourgeoisie might have had before 1848 are now converted by fear into "compromising liberalism," and the descending spiral of decadence has been set in motion. Thus Balzac and Stendhal, writing between the Napoleonic era and the debacle of 1848, can record a level of accomplishment which is never to be resumed (although Thomas Mann is perhaps the one exception Lukacs permits) [43] and the Flaubert of *Salammbô,* out of hatred and

disgust for his own bourgeois age (and seeking passionately and paradoxically a world which in no way resembles it), begins the inhumanity of subject matter, where atrocity and brutality of presentation attempt to compensate for the lost greatness of real history. For others Flaubert may mean the flowering of an exquisite bourgeois sensibility. For Lukacs he signifies a new "darkening of horizon," a new dehumanization in modern literature.

This is in opposition to the trend of literary criticism of the last fifty years, and it may seem to impose a restrictiveness which contradicts what I have said of Lukacs' efforts toward the "enlargement" of the literary tradition for socialist man. But actually it does not. "Those who do not know Marxism at all," says Lukacs to this very point, "or know it only superficially or at second-hand, may be surprised by the respect for the classical heritage of mankind which one finds in the really great representatives of this doctrine and by their incessant references to that classical heritage." And he continues:

It is not by chance that the great Marxists were jealous guardians of our classical heritage in their aesthetics as well as in other spheres. But they do not regard this classical heritage as a reversion to the past; it is a necessary outcome of their philosophy of history that they should regard the past as irretrievably gone and not susceptible of renewal. Respect for the classical heritage of humanity in aesthetics means that the great Marxists look for the true highroad of history, the true direction of its development, the true course of the historical curve, the formula of which they know; and because they know the formula they do not fly off at a tangent at every hump in the graph, as modern thinkers often do because of their theoretical rejection of the idea that there is any such thing as an unchanged general line of development . . . For the sphere of aesthetics this classical heritage consists in the great arts which depict man as a whole in the whole of society. Again it is the general philosophy, (here proletarian humanism) which determines the central problems posed in aesthetics.[44]

It is a line of reasoning with which we are already familiar from *History and Class Consciousness,* and it indicates that Lukacs is the pupil of the Hegelian category of totality no less in his literary investigations than in his inquiry into the nature of proletarian class consciousness. For the Marxist philosophy of history seeks to unearth the hidden laws governing *all* human relationships, literary as well as those of class structure.

Thus the object of proletarian humanism is to reconstruct the complete human personality and free it from the distortion and dismemberment to which it has been subjected in class society. These theoretical and practical perspectives determine the criteria by means of which Marxist aesthetics establishes a bridge back to the classics and at the same time discovers new classics in the thick of the literary struggles of our own time. The ancient Greeks, Dante, Shakespeare, Goethe, Balzac, Tolstoy all give adequate pictures of great periods of human development and at the same time serve as signposts in the ideological battle fought for the restoration of the unbroken human personality.[45]

Except for the Marxist terminology, it might be Irving Babbitt or Paul Elmer More or T. S. Eliot speaking!

This concept of totality, applied to the human personality in literary terms, and derived from the whole of the classical tradition, shows the literature of the nineteenth century in a new light. It indicates the superiority of Balzac and Tolstoy over Flaubert and Zola; in terms of mere theory it argues for the superiority of *realism* over *naturalism*. The aesthetic distinction between realism and naturalism (as Lukacs was to make clear in his later *Realism in Our Time*) [46] depends on the presence or absence in a work of art of "a hierarchy of significance," of "a principle of choice" which exercises selectivity in terms of the meaningful relations of individuals to social situations. It thus permits a significant description of the French countryside in Balzac or of a menu in *Anna Karenina,* but not meaningless descriptive catalogues like Zola's list of cheeses in *Le Ventre de Paris* or the parade of agricultural, chemical, astronomical, geological, and archeological trivia which Faubert includes in *Bouvard et Pécuchet.* Flaubert and Zola wish to mirror experience with accuracy, but they are obsessed with a method of minute description, and art is lost as inventory takes over. Lukacs' permanent bias against literary naturalism is that he sees in it the mark of a literary talent which has redoubled its effort just as it has forgotten its aim.

The distinction between realism and naturalism is one of the standbys of Lukacs' critical apparatus, and he therefore invokes it no less in his judgment of the historical novel than in the literature of the nineteenth century as such. Any great historical novel must attempt a "total historical picture," [47] and this in turn depends on the fictional presentation of a rich and graded interaction between different levels of human response to any major disturbance of social life. "It must disclose artistically

the *connection* between the spontaneous reaction of the masses
and the historical consciousness of the leading personalities."
This is precisely what Tolstoy accomplishes in *War and Peace*
and what Flaubert fails to do in *Salammbô,* although the anti-
quarianism and pseudohistoricism of the latter may exhibit an
authenticity of individual fact which is not to be discovered in
the former's faithful artistic reproduction of one of the great
crises and turning points of modern history.

Lukacs has defined realism as a principle of selectivity faith-
ful to the reality of the literary whole. But there is another
mode of definition which renders an implicit negative judg-
ment against realism's two alternatives. Realism is also to be
understood, says Lukacs,[48] as the recognition that a work of
literature can rest neither on a lifeless average, as the natural-
ists suppose, nor on the mere individuality of immediate factual
experience. "The central category and criterion of realist litera-
ture is the *type,* a peculiar synthesis which organically binds
together the general and the particular both in characters and
in situations." In short, there are essences and there are gross
particulars, and the task of a critical realism is *to seek the
essential in the particular.* It is almost as if we had some mirac-
ulous contemporary transformation of the famous medieval
quarrel over universals set now in the rhetorical context of
literary method, and it is clear that in this analogy Lukacs'
position is that of "moderate realism" or "immanentism." The
quest for the essential alone is Platonism, and in literary terms
it yields the method of *symbolism* or *allegory.* The quest for
particulars alone is nominalism, and in literature it yields the
raw descriptive empiricism of *naturalistic* art. In consequence
Lukacs' critical realism is equally suspicious of both, and if it
leads him to choose the novels of Balzac and Tolstoy over those
of Zola and Flaubert, it leads him equally to choose the bour-
geois honesty of Thomas Mann over the decadent allegory of
Franz Kafka. If, indeed, Harry Levin is right in thinking that
Joyce's *Ulysses* joins together an epic symbolism and a natural-
istic atmosphere,[49] then this incongruous linkage of the two con-
trary vices of literary method would have confirmed Lukacs in
the belief that this must be the very arch-exercise of literary
depravity in the age of bourgeois imperialism!

But in the end Lukacs' humanism takes him far beyond a
mere critique of symbolism and naturalism as literary "errors."
What he is concerned with is the writer's *vision.* What does he
see and how does he see it? How deep is his thirst for truth?

How concentrated and probing is his striving for reality? These questions transfer issues of mere aesthetics to the plane of ethics, which is concerned with the writer's sincerity and probity, his fundamental outlook on the place of man in the universe and in society. Involvement and concern are here practical virtues with methodological implications; crucial differences of perspective and style arise out of the degree to which writers "are bound up with the life of the community, take part in the struggles going on around them or are merely passive observers of events."

In the end Lukacs' chief criteria of value are again derived from the Hegelian categories of *totality* and *interpenetration,* and these, translated into sociological terms, are the guarantee of his authentic humanism. True realism, as he sees it, depicts man and society as *complete entities,* instead of showing merely one or another of their aspects, and thus, measured by this criterion, either exclusive introspection or outward-looking equally impoverishes and distorts reality. Realism means a full dimensionality, a roundedness in the presentation of characters and life situations, and all it opposes is the distortion which results from any destruction of the completeness of the human personality. Seen in this way, Lukacs' view of literature, despite differences of terminology and basic social philosophy, is not essentially different from that of Ortega y Gasset. Both protest the "dehumanization" of art.

The central aesthetic problem of realism, says Lukacs, is the adequate presentation of the complete human personality, but this can be achieved only through attention to the media of social interaction; the inner life of man, its essential traits and essential conflicts, is truly displayed only in organic connection with social and historical factors. And here Lukacs' aesthetics can once more be seen as intimately related to the humanistic assertions of the young Marx: the search for the intrinsic wholeness of man in the face of his inevitable capitalistic fragmentation. "The point in question," says Lukacs, "is the organic, indissoluble connection between man as a private individual and man as a social being, as a member of a community. We know that this is the most difficult question of modern literature today and has been so ever since modern *bourgeois* society came into being." And he continues:

The true great realists not only realized and depicted this situation —they did more than that, they set it up as a demand to be made on

men. They knew that this distortion of objective reality (although, of course, due to social causes), this division of the complete human personality into a public and a private sector was a mutilation of the essence of man. Hence they protested not only as painters of reality, but also as humanists, against this fiction of capitalist society however unavoidable this spontaneously formed superficial appearance. If as writers, they delved deeper in order to uncover the true types of man, they had inevitably to unearth and expose to the eyes of modern society the great tragedy of the complete human personality.[50]

It is in this sense (as Matthew Arnold also saw) that literature is "a criticism of life." Lukacs' passion for literature, his deep concern with the forms of its expressiveness, his sharp strictures against naturalism's preoccupation with biological processes (both sexuality and the mechanisms of pain and death), against the luxury of symbolism's multiple escapes, against the self-indulgence of subjectivism in either its Proustian or its Rilkean form, can thus be seen as aspects of his intense moral and political seriousness. Writers like Balzac and Tolstoy enlist his enormous admiration for the skill with which they treat those most important, most burning problems of the social community which is their starting point, for the way in which their pathos as writers is always stimulated by human suffering and its social etiology. And this sets forth plainly *the criterion for the formulation of a living tradition in Western letters.* Judged by this criterion, the kind of appeal which Eliot makes to the tradition in *The Wasteland* seems merely whimsical, eclectic, and self-indulgent. And even the more consistent presentation of "The Representation of Reality in Western Literature," which Erich Auerbach gives in *Mimesis,* while "realistic" in the most obvious sense, yet hardly distinguishes the achievement of Homer or Cervantes from that of Rabelais or Schiller as social criticism. The tradition which the body of Lukacs' literary criticism seeks to establish is one in which Balzac's recognition of the torments which the transition to the capitalist system of production inflicted on every section of the people, Molière's humorous exposé of the residues of vice and depravity implicit in the dawning age of bourgeois respectability, and Lessing's and Schiller's presentation of the middle class tragedies growing out of the unnatural class structure of the eighteenth century join hands in one seamless web of humanistic insistence.

It is thus that great realism and popular humanism are merged into an organic unity. For if we regard the classics of the social development that determined the essence of our age, from Goethe and Walter Scott to Gorki and Thomas Mann, we find *mutatis mutandis* the same structure of the basic problem. Of course every great realist found a different solution for the basic problem in accordance with his time and his own artistic personality. But they all have in common that they penetrate deeply into the great universal problems of their time and inexorably depict the true essence of reality as they see it. From the French revolution onwards the development of society moved in a direction which rendered inevitable a conflict between such aspirations of men of letters and the literature and public of their time. In this whole age a writer could achieve greatness only in the struggle against the current of everyday life. And since Balzac the resistance of daily life to the deeper tendencies of literature, culture and art has grown ceaselessly stronger. Nevertheless there were always writers who in their lifework, despite all the resistance of the day, fulfilled the demand formulated by Hamlet: "to hold the mirror up to nature," and by means of such a reflected image aided the development of mankind and the triumph of humanist principles in a society so contradictory in its nature that it on the one hand gave birth to the ideal of the complete human personality and on the other hand destroyed it in practice.[51]

It may seem strange that Marxism, so often identified with a grossly materialistic view of man and history, and with a positivistic passion to describe the iron laws of inevitable social development, should eventuate in Lukacs in a literary apotheosis of "the complete human personality," for this is to make it (Marxism) a part of the mainstream of European thought and letters which includes Dante and Shakespeare, Erasmus and Montaigne, Lessing and Goethe, Matthew Arnold and John Stuart Mill. That Lukacs' Marxism does have this embracing and cosmopolitan character is beyond doubt. It is true that the critical realism which he so strongly urges has its real limitations of implication and perspective. It underestimates, as I have said, the lyric impulse. It denies essential value to some of the most brilliant examples of literary experimentation of our age—Joyce and Proust, for example, as well as Yeats and Pound. It tends to be suspicious of "modernism" in all of its multifarious richness, and in opposition provides paradigms of perfection which seem restrictive and oppressive to a brilliant innovator like Bertold Brecht. On the other hand, it shares with Brecht and the whole of the humanistic tradition its ele-

ment of *pedagogical faith.* "The great lesson," says Lukacs, "to be learnt from the Russian development is precisely the extent to which a great realist literature can *fructifyingly educate* the people and *transform* public opinion." [52] Lukacs' aesthetic does not neglect the purely formal aspects of literature, and in it, matters of style and expressive mode loom large. But in the end, literature is too important to him, as a mirror of man's present reality and as a guide post of his utopian future, to be left to the formalists and the grammarians. And this is the substance of his humanist dream: that his *revaluations* of figures like Goethe and Tolstoy, Balzac and Thomas Mann, should play some small part in the return of alienated and fragmented man to the path of his integration and fulfillment.

To anyone who has attended meetings of the Yugoslavian Association for Philosophy, the Croatian Philosophical Society (one of its six branches) , or the International Summer School of the University of Zagreb on Korcula, or has thumbed through *Praxis,* the philosophical review edited at the University of Zagreb, it must be clear that a new and intensely fruitful breeze is blowing through the Marxist world. Traces of it are to be found in Henri Lefebvre at Strasbourg, Lucien Goldmann in Paris, Karel Kosik and Milan Prucha in Prague, and Leszek Kolokowski and Marek Fritzhand in Warsaw. But while elsewhere it is expressed in voices crying out in the wilderness, in lonely thinkers, and in courageous minorities, in Yugoslavia it is so strong as to be the prevailing climate of philosophical and sociological opinion. This is not to say that in Yugoslavia belief is standardized and that all philosophers agree. Far from it! Philosophical positions vary a great deal. Disagreement is lively. The University of Beograd (through the overwhelming influence of Mihailo Marković) is largely oriented toward logic, philosophy of science, and the positivistic and analytic tradition in ethics and social theory (although even here the interest of Veljko Korać in Kant, Hegel, and the central European tradition also looms large) , while the University of Zagreb, through the teaching of Gajo Petrović, Pedrag Vranicki, and Rudi Supek, has strongly felt the influence of existentialist and ontological thinkers like Heidegger and Sartre.

The effects of Carnap and Ayer, of Heidegger and Sartre, even of Husserl and Nicholai Hartmann, on Yugoslavian philosophers are clearly to be discerned, but to overemphasize their importance is to neglect the really crucial factor—the basic

reinterpretation of the writings of Karl Marx. The characteristic situation of Marxist philosophy has always seemed to me to bear an important analogy to philosophizing in the medieval world. Both have taken a set of fundamental texts as central, but within the acknowledged authority of this canon, important plural interpretations and divergent positions slowly emerge in forms of intense dialectical opposition. These divergencies are frequently accompanied by the rhetorical claims of "orthodoxy" and "heresy," but always within a milieu of basic agreement which authorizes an ultimate arbitration where possible by the authority of the ambiguous canonical texts. What emerges in Yugoslavia, therefore, is not a forsaking of the Marxist texts (for appeal to them is constant, and the exegesis is subtle and the reading close), but *a new way of reading them,* freed from the positivistic assumptions of the generation of Engels, Kautsky, and Lenin, and profoundly transformed by the impact of the writings of the early Marx.

Here also the analogy with the formation of the medieval mind in the twelfth and thirteenth centuries is striking. The difference between the thinking of the generation of Marković and Petrović and that of Kautsky and Lenin is like the difference between the thinking of Abelard and that of Aquinas— and for a similar reason. During the thirteenth century the philosophical thought of Europe was transformed by the rediscovery of the chief logical treatises of Aristotle as well as his *Physics* and *Metaphysics,* and this incorporation of new material made possible for Aquinas a comprehensive synthetic effort denied to Abelard, who, brilliant dialectician though he was, knew only the minor works of the *Organon.* The rediscovery of the writings of the youthful Marx has had the same effect on Marxist revisionism as the discovery of Aristotle's *Metaphysics* had on the thirteenth century, and thus the renaissance of humanism in Yugoslavian philosophy is but the latest stage of an evolution predicated on the *Economic-Philosophic Manuscripts* and the intermediate work of Lukacs. There is, however, one profound difference. Whereas the influence of the rediscovered works of Aristotle on Aquinas was chiefly metaphysical, that of the rediscovered works of Marx on Marxism is almost entirely ethical and humanistic.

In a remarkable paper, "The Dialectic of Morals and the Morals of Dialectic," delivered at Korcula in 1964, Karel Kosik of Prague raised the issue of the notorious Marxist shyness at, if not actual distaste for, confrontation of the moral problem.[53] Is

the Marxian failure to treat ethics, its distrust of "moralism,"
he asked, a sign of its theoretical incapacity in a certain domain
of human reality? And he went on to show the severe disloca-
tion which occurs when historical reality is considered as a
domain of strict causality, when historic processes are deprived
of human significance and reified as "natural events" rather
than conceived as the immediate consequences of human judg-
ment and volition. This, he said, is the result of a too narrow
Marxist point of departure. It all goes back to the uneasy
question: What is man? And the theory of man is indispensable
for both moral theory and a mature Marxism.

But he need not have raised this issue in Yugoslavia, for the
entire course of its philosophizing since the Second World War
and its release from the rigid mold of an intellectual Stalinism
soon after was but a reinforcement of this very point. Meetings
of the Croatian Philosophical Society devoted to "Humanistic
Problems of Marxism" eventuated in 1963 in the publication
in Serbo-Croatian of a volume, *Humanism and Socialism*,[54]
which, among others, contained papers on "Marx's Concept of
Man," "Marxist Humanism and the Problem of Value," "The
Humaneness of Art," "Some Moral Aspects of the Yugoslavian
Way to Socialism," and "Worker's Self-management and the
Humanization of Work and Consumption." Serious specific
attention had earlier been devoted to the very problem which
Kosik had raised. In a rather extraordinary article on "Marxist
Humanism and Ethics" Marković had said:

Marxism is often claimed to be incompatible with any kind of ethi-
cal theory, because of its assumptions of economic determinism, of
the class structure of morals, and of the subordination of morality to
politics. But the author proposes that these assumptions can be in-
terpreted in such a flexible way as not to rule out the freedom of
choice and responsibility, the relative independence of morals from
economic conditions and political ends, and concepts of universal
human value and a specifically moral ideal. A humanist philosophy,
centered in Marx's analysis of alienation, provides a sufficiently rich
theoretical basis for the solution of both ethical and meta-ethical
problems.[55]

He refuted in detail the notion that there is no place for a
genuine ethical theory within the frame of Marxian historical
materialism, and denied the charge that Marx reduced "human
nature" to "class nature." "It is therefore quite compatible
with Marxism," he said, "to speak about a whole set of moral

norms which transcend limits of class and epoch and which, in various, sometimes disguised forms, reappear in all historical forms of morality." [56]

Much more significant for an insight into the humanistic transformation of the new Marxism, Marković pointed out how, in the present epoch of hot and cold wars, politics has been occupying an increasingly important position in relation to all other forms of cultural activity, so much so that moral demands as well as scientific objectivity and the freedom of artistic expression have often been sacrificed to immediate political goals. This, he said, *is true of both capitalist and socialist countries.* "And as a matter of fact some Marxists (although by no means only Marxists) have been behaving as though they accepted 'the end-justifies-the-means' principle." And he continues:

Marxist humanism rejects both this principle and the practice of permanent subordination of morals (and science, and law, and art) to politics. The struggle for political emancipation of the oppressed social groups is just one of the fields in which human emancipation takes place. Cultural and moral revolution in particular are certainly not less important than the political reconstruction of a society. Certainly, morality itself, as an expression of the interests of a particular class, is politically colored. But, on the other hand, any political party, which claims to speak in the name of the whole of humanity must follow moral values in its political struggle. And it certainly must not overlook how closely connected are the moral values of ends and means. Noble goals can be realized only by noble men. There is no doubt that the use of bad, degrading means morally degrades those who use them. [57]

It is a far cry from Adam Schaff's illiberal belief that the content of literature is a political problem whose adjudication calls for the intervention of public officials in the name of social defense, from Merleau-Ponty's quaint confession that "we have unlearned 'pure morality' and learned a kind of vulgar immoralism which is healthy," and from Sartre's cold-blooded assertion that when politics is forced to betray its moral principles, it is better to throw overboard the moral principles than to betray the politics. And it shows that the foundations of a Marxist humanism are not essentially different from the humanism which the Western tradition has learned from Socrates, from Epicurus, and from Kant.

I have said that the Marxist situation is not unlike the medie-

val in its reliance on a set of fundamental texts, and it is true that the new "liberalism" follows from a novel textual situation in which the *Economic and Philosophic Manuscripts* are interpreted not as a youthful Hegelian indiscretion, but as a laying of the moral foundation on which all the later technical innovations are based. But the very novelty of this textual situation has introduced a certain "loosening" of the textual mode of interpretation. "While it was shown rather convincingly," says Petrović in his recent collection of essays translated into English, "that it is impossible to oppose the young and the old Marx, that Marx's philosophical work is basically unified, it also became equally clear that Marx's philosophical views changed in many respects and in many other respects remained incomplete and unfinished. We cannot boast that we have exhaustively studied and determined all the stages of Marx's philosophical development, exactly reconstructed and analyzed all of Marx's solutions, difficulties and questions." [58] It has also become apparent that there are real differences between the philosophical views of Marx and Engels, of Engels and Plekhanov, and that the rigid materialism of the mature Lenin (*Materialism and Empirio-Criticism*) diverges considerably from the more sympathetic Hegelianism of the *Philosophical Notebooks*. In all these cases there are meanings to establish, relationships to explore, and this indeterminacy, admitted in honesty and good faith, gives to the Yugoslavian ambience an "openness" denied to more monolithic forms of intellectual interpretation which see in every possible ambiguity and disagreement a threat to the purity and strength of the "sacred" doctrines.

This breaking of the mold of doctrinal rigidity has had other beneficial effects. It has made it possible to explore the relationship of Marxism to other fruitful contemporary possibilities: existentialism, phenomenology, the newer logic and philosophy of science, often without formally retreating from the established Marxist vocabulary. The issue of the relationship of the youthful and the mature Marx raises most of the humanistic problems intrinsic to existentialism, while that of the relationship of formal logic to "the dialectic" permits a reference to the most modern contributions of Carnap and Reichenbach, Quine and Tarski. And this is why, although the philosophical atmosphere of Prague and Budapest often seems old-fashioned and provincial, that of Beograd and Zagreb is cosmopolitan and

contemporary—as is likely to come from a knowledge of the latest lecture of Heidegger or the last issue of the *Journal of Symbolic Logic*.

The revolutionary reinterpretation of Marxist doctrine has not only changed the rigid view of the Marxist canon, and permitted freer intercourse with the various strands of contemporary philosophy, but has also added new libertarian elements to the content of Marxian philosophy. "One of the basic achievements of our postwar philosophical development," says Petrović, is the discovery that man, who was excluded from the Stalinistic version of Marxist philosophy as an abstraction, is in the center of authentic Marxist philosophic thought." [59] And it follows from this that "man is praxis," which is not to say that he is always necessarily creating, but that "man is really a man when he does not become alienated from his creative essence, when he is open toward the future and when, in realizing his historically given human possibilities, he creates new and higher ones." Man is by definition a being whose essence lies in his "self-realization"—in the active efforts which he makes toward transforming himself and in creating a world in which the agencies of alienation and exploitation are progressively overcome. Thus Marx's definition of man contains "a criticism of alienated man who does not realize his human possibilities, and a humanistic program of struggle for humanness." [60] The *dominance of the economic,* which has so often been taken as the central insight of the Marxist position, is thus seen as a deformation of its true meaning, as one single strand of understanding perhaps, but infinitely less important than the humanistic vision of the nonalienated pure being of praxis who is the final cause of all revolutionary transformation and social struggle. And this inevitably adds to the Marxist insistence on equality and social justice a new emphasis on freedom, which has often been thought to be a liberal-democratic monopoly. *"There is no praxis without freedom,"* says Petrović, *"and there is no free Being that is not praxis.* The question of freedom is a constituent part of the question of praxis, and hence a constituent part of the question of man." [61] Nor do the problems which result characterize capitalist society only. "The escape from freedom makes its appearance in socialism too. Here too we encounter people who seek to avoid or be rid of freedom, who reduce or attempt to reduce themselves to blind executors of the directives of higher social or political forums, who are prepared to

be active to the limit even of physical exhaustion only in order not to have to carry the invisible but nevertheless difficult and unpleasant burden of freedom."

This is reminiscent of the words of Dostoievsky's Grand Inquisitor, and it is dangerous too, since it implies a criticism of those bureaucratic agencies of state power which, even in socialism, claim to govern "for the good of the people." But this is just one of the libertarian revaluations in Yugoslavia. Veljko Korać has asserted that "Marx's philosophy cannot be reconciled with bureaucratic decrees which announce that socialism or communism in a certain country is already an accomplished fact. On the contrary, what is necessary, according to Marx, is unconditional and uncompromising criticism of 'everything existing.' Only to the extent that such criticism exists can the principles of Marx's socialism be verified and affirmed. That is why such criticism increasingly assumes the characteristics of *a humanistic revolt against bureaucratic-technocratic pragmatism* and against all forms of dehumanization and alienation— whatever the society to which it is applied." [62]

At the Dubrovnik Congress of 1963 the Russians bitterly reproached their Yugoslavian hosts for raising questions about the bureaucratic practices of socialist states when they might far better have applied their criticism to the exploitative practices of capitalism. But one year later at the Korcula Summer School a hot debate again arose as to the meaning of socialist bureaucracy; whether it is a breakdown of communication between the people and the Party functionaries, or whether it is a pure form of politics, necessarily present when the will of the people must be technically implemented. Is it benign or a great danger? Is it merely "administration," or is it the essential alienation of treating men as mere things? The argument was loud and passionate; it was perhaps never conclusively settled, but that the issue was raised at all within a socialist state was convincing proof that the standards of philosophical humanism can underwrite a devastating critique of the actualities of political practice.

The new Communist polycentrism is a fact. And in the new expression of the democratic and libertarian elements, the influence of Yugoslavia and of her humanist philosophers is entirely disproportionate to her size. The dissent within the socialist ranks has brought into open view a new distrust of political authoritarianism, and of a dogmatically materialist interpretation of history. On the other hand, it has emphasized

the relevance of personal moral engagement and the necessity of personal freedom in the living of the authentically creative Marxist life. Above all, it has brought to its critique of social institutions in the modern world a new perception of bureaucratic absurdity and the requirement that these institutions measure up to standards of meaningfulness in terms of personal self-realization.

It is understandable that the older socialist despotisms should resent these shifts in the centers of intellectual power, and should attempt to minimize the value and effectiveness of their thrusts. The *Soviet Philosophical Encyclopedia* in its 1960 edition carries an article "Humanism," by L. Denisova, which, in part, says:

Social-democratic ideologists and modern revisionists have made the principles of bourgeois humanism into programmatic demands in the struggle with the Communist ideology . . . In a revival of the opportunism of the ethical socialism of the Austro-Marxists and Bernstein, modern revisionism upholds the individualist principles of humanism and demands that socialism effectuate them (H. Lefebvre in France, L. Kolakowski in Poland, I. Widmar in Yugoslavia, etc.) . . . The revisionists have turned to Marx's early writings where they have dug up various pre-Marxist propositions borrowed from German schools of philosophy constituting one of the sources of Marxism. In place of the Marxist-Leninist concepts of the socialist revolution . . . the revisionists advance as ideal the eternal principles of humanism and the problem of "overcoming alienation," understood, as in Hegel, in extremely abstract and distorted fashion . . . Marxist philosophers abroad and Soviet scholars . . . have provided a critique of the false revisionist evaluation of bourgeois humanism offered by the modern revisionists.[63]

The rhetoric is hollow and the assertions are false. With the writings of the youthful Marx, Marxism asserts a valid claim to membership in the great humanist tradition of Western culture. With the best of Lukacs' efforts this claim is deepened and enlarged. And with the spirit of the philosophy and sociology of contemporary Yugoslavia, it has reached that point where it offers valid hope for the slow humanist transformation of the entire Marxist world.

Twelve / Conclusion

THE STUDIES which compose this book are heterogeneous, and they cover a wide range of the European cultural experience. It seems a far cry from the delicate perceptions of Erasmus to the crude fantasies of Herman Kahn, from the imaginative plateau of Shakespeare's history plays to the strident moral insistence of Hochhuth's documentary drama. And yet it has been my hope to indicate that they are all variations on a single theme, demonstrations (negative or positive) of the relationship between the humanistic impulse and the fierce solicitations of politics.

It is true that to investigate the relationship of power and value in the Western cultural tradition is a complicated matter, and that this stems in part from the frequent separation in actuality of two realms of discourse, two areas of human experience which have a much closer affinity for one another in conceptual formulation—in idea. But if politics and culture do not seem immediately related, if, for example (as in the cases of Goethe or Jacob Burckhardt or Pasternak), there is a determined effort to maintain their separation, there is, nonetheless, a close affinity between them which cannot ultimately be denied. I have tried to indicate their inevitable and permanent linkage through an "intervening variable," or mediating idea. This notion is the idea of "history." The unity of the demonstrations attempted in this book is, therefore, at bottom a unity maintained through the awareness of the omnipresence of the historical process, and of the idea that politics is simply the demands of history at each particular moment of cultural experience.

The abstractionist dream that the work of Aristotle is only an attempt to answer Plato, that Descartes is merely underwrit-

ing St. Augustine across the ages, or that Kant in *The Critique of Pure Reason* simply sets right inadequacies in the texts of Descartes and Locke, Leibniz and Hume, is at best a convenient fiction making possible the rationalistic interpretation of the history of ideas. It is also well to remember that behind every text there is a man, that behind every man there is a family, and that behind every family there is a social matrix embedded in, and expressive of, an ongoing continuity of historical experience. It may be going too far to assert that philosophy is *only* the conceptual response to the fundamental human problems forced on a given society at a given epoch (as the corpus of literature and the arts is only the more concrete and sensory response to these same stimulating causes), but in large part this is precisely what it is, and if, therefore, we wish to understand the conceptual formulations and the attitudes from which they spring, it is necessary to comprehend the historical necessities in which they find their origins.

Behind *Humanism and Politics,* like an invisible scaffolding, lie the crises of western European history from the beginning of the sixteenth century to yesterday's newspaper. In presenting Erasmus and Montaigne as two models of a humanist politics, I have tried to show strikingly different responses occasioned by the first great trauma of the modern mind—the Protestant Reformation. In investigating the politics of Shakespeare's plays, I have not neglected the ethics of an aristocratic and monarchical conservatism, but I have been mindful of the peculiar problems presented to the dramatic intelligence by the residual traces of feudalism within the pragmatic and expansionist Elizabethan actuality. As the examples of Erasmus and Montaigne illustrate divergent responses to the religious crisis of the sixteenth century, so I have interpreted the examples of Goethe and Schiller as expressing diametrically opposed reactions to the most disturbing challenge of the eighteenth century —the practices and the ideology of the French Revolution, and if Thomas Mann is somehow joined to this dialectical encounter, it is only because his latent uneasiness at the radical socialist threat beginning to make its active appearance at the time of the First World War places him as an analogue to Goethe, and as his spiritual "contemporary."

The historical dependence does not grow less as we approach modern times. Büchner and von Clausewitz, although one would never associate them otherwise, are products of the Napoleonic restoration, while Ranke, von Treitschke, and Bur-

ckhardt, important as are their theoretical differences in the interpretation of the aims and the methodology of modern historiography, are curiously similar as symbols of the failed revolutions of 1789 and 1830. Brecht and Sartre, Lukacs and Merleau-Ponty are the disquieting precipitates of the two World Wars and the Marxist avalanche; disquieting because the brilliance of their perception and the inevitable persuasiveness of their ideological critiques express a mode of awareness intimately related to a contemporary crisis of the historical consciousness which the more conservative forces of the West have been trying to sleep through, or to combat with ideological weapons drawn from a bygone age. One does not need to take the side of Brecht against Pasternak, of Sartre against Camus, or of Lukacs against Flaubert to recognize the flamboyant and largely legitimate claims of history.

I have suggested that the examples dealt with in *Humanism and Politics* are haunted by the specter of "history" not to labor the commonplace, but to indicate that the humanist theme has a certain necessary anchorage in time. All of my figures from Erasmus to Goethe, from Goethe to Burckhardt, and from Burckhardt to Lukacs, Brecht, and Camus exhibit a certain intellectual restlessness and disquiet. This is because they have felt the pressures of their times. Whether they like it or not, they are infected by history. But this, if obvious, is only one side of the story. For if the theme of humanism and politics is embedded in a certain reliable substrate of historical consciousness since the sixteenth century, it is also unified by the perennial and recurring dilemma which it embodies. And, since the history of ideas is a philosophical as well as an historical subject matter, and since studies in the philosophy of culture are not merely orientative and descriptive, but interpretative and ultimately normative in character, I have made much of this recurring dilemma. The examples of Montaigne and Erasmus, of Goethe and Schiller, of Treitzschke and Burckhardt, Brecht and Pasternak, Camus and Sartre, are not only interesting in themselves, but illuminate a permanent feature of the human condition insofar as cultural values and political necessities are both parts of the social experience.

Perhaps the unifying thread of all our studies is the political dilemma of humanism, what I have called *the permanent dialectic of embracement and rejection,* the ceaseless ballet of advance and withdrawal before the political arena. For here

the battle lines are drawn. The tradition of determined, if delicate, rejection is that of Erasmus and Goethe, the early Mann and Benda, Burckhardt and Pasternak. The tradition of passionate embracement is formed by a galaxy equally illustrious: Montaigne and Schiller, Treitschke and Lukacs, Sartre and Brecht. The first illustrates the type of humanist mentality for which politics, with all that it entails of brutality and destruction, is an affront to culture. The second sees in politics not a necessary evil, but a mode of implementing the values of freedom, equality, security, and national greatness with which culture itself is allied. The split occurs in every epoch of European history. Without doubt it is alive today.

The issue antedates Erasmus and Montaigne. After Chaeronea, the philosophy of civic participation advocated by both Plato and Aristotle was countered in Greece by the Cynic advocates of withdrawal; during the period of the Roman Empire, Stoic espousal of an intensely personal ethics, of a universal *logos* and a cosmopolitan political outlook, made actual political involvement a matter of repugnance and distaste. The fourteenth century also witnessed the drawing conflict between Petrarch, who muffled his concern over the social issues of his time, insulated himself against the vulgar, and devoted himself to an assiduous program of personal cultivation, and Dante's idea of the poet's responsibility for the public moral health, and, although the Petrarchean sense of primary responsibility to the self remained the dominant strain of humanism throughout the Italian Renaissance, the Dantean emphasis on the duty of public responsibility never completely died out. That something of the former remained in Erasmus, and much of the latter in Montaigne, is only a proof of the eternal recurrence of an antithetic political bias in the history of Western culture.

Humanism has always functioned as an educational device for the creation of the human community through inculcation of ideals of common value and the reciprocal responsibilities of men. In Erasmus this took the form of a naïve faith in the power of the classics to mold character and educate the Prince —a faith largely shared even by political "realists" like Machiavelli and Montaigne. Some variant of this doctrine has pervaded the tradition even after the French Revolution, and has remained, as we have seen, in theories so paradoxically diverse as Schiller's faith in the political drama as a tool of "the political and educating artist," in Burckhardt's faith that acquaint-

ance with the classical heritage of the Greco-Roman and Renaissance past would provide a cultural foundation to compensate for the failures of bourgeois commercialism and materialism, and in Lukacs' faith that to substitute the influence of the great realists like Shakespeare, Molière, Balzac, and Tolstoy for that of their decadent adversaries, Flaubert, Rilke, Kafka and Proust would be to advance the proletarian revolution.

It would seem then that responsible political commitment should be an essential element in every truly humanistic conception of culture. The difficulty lies in the word "responsible." Unfortunate as it may be, the notion as to what constitutes political responsibility varies widely, as, for example, between Erasmus' epistolary persuasiveness and Montaigne's engagement in the actualities of political negotiation; between Ranke's moderate claim that the objective stance of the historian can produce results which can serve to enlighten practice and von Treitschke's fanatical belief that the historian must be hot and passionate and that he is an instrument for the achievement of the goals of the fatherland; between Camus's idea that the writer's political allegiance is to the truth of the universal human condition and Sartre's that an "engaged" literature can function only in the furthering of proletarian aims in the class struggle; between Büchner's idea that the political dramatist is obligated to a contemplative and absolutely accurate portrayal of historical truth and Hochhuth's that the political role of the dramatist is to concentrate on political iniquity and to subject it to an uncompromising moral condemnation.

Despite the belief on one side that responsible political commitment is an essential element in the humanist ideal, there is another branch of the humanist party which holds that the insertion of *any* political claims tends to compromise or destroy the purity of humanistic values. It finds science, philosophy, literature, and art to be autonomous products of a rationality (or "understanding") and an ordering of feeling (through imagination) which transcends politics, and it therefore resents any political interference with either the content of its conclusions or the form of its expression. Therefore, whether in the innocent and half-instinctive poetic practices of Boris Pasternak or in the articulate insistence registered in Thomas Mann's *Reflections of an Unpolitical Man,* it holds that abstention from politics is mandatory if the intellectual life is not to be compromised or the artistic life rendered corrupt. This imperative applies equally for the writing of novels, the creation of

drama, and the governing principles of an independent historiography.

That there is so sharp a split between those of humanist persuasion who incorporate politics in their system of values and those who reject it as incompatible with humanism itself is alone worthy of note, but that this split has been a permanent feature of Western culture surely requires some explanation. One temptation is to subjectivize it, to reduce it to factors in temperament which are general, and which appear in other areas also. Politics is the realm of the public, and there are those who are attracted to the public and the social, as there are those who are equally attracted to inward-looking, meditation, and the lyricism of the purest privacy. Perhaps the differences in political concern of Goethe and Schiller, of Erasmus and Montaigne, and of Treitschke and Burckhardt are reducible to just such mysterious temperamental factors.

But there is another possibility also, one obliquely suggested by Lukacs in his *History and Class Consciousness*. Could it be that the constant recurrence of just this split in the humanist tradition of the Western world is symbolic of a basic contradiction within the very nature of that society itself? It is not only the philosophy of the Greeks and the system of Kant which embody the permanent antinomies of the Western intellect. The dualism of the speculative and the practical functions of the mind and its embodiment in the contrasting ideals of the active and the contemplative life reappear constantly in Western thought and experience. A society whose system of ideal values was profoundly at variance with the actualities of its economic and social practice might produce individuals who either, on the one hand, avoided the practices to preserve the purity of the ideals, or, on the other, claimed that to attempt to transform the practices would be the only method of realizing the ideals. Humanism has at its foundation the ideal of the total human community. But it is obliged to recognize the reality of a world of force and brutal political conflicts. If an Erasmus, a Goethe, or a Thomas Mann retreats within the acknowledged safeties of the former, it is a Montaigne, a Schiller, or a Brecht who engages the latter in the utopian hope of its transformation. Von Treitschke, holding that the very justification of history is the service it can perform for the Prussian future, embraces every opportunity to participate in the making of that future. Burckhardt, holding that the very purpose of the political state is the development and enhance-

ment of a humanistic culture, withdraws into the privacy of a quiet provincial university to meditate on, and to recreate, the cultural past for himself.

In saying that humanism has at its foundation the ideal of the total human community, we encounter a problem. Much of this book has been taken up with humanism and politics in a neutral and descriptive way: in a comparison of famous war treatises, or an examination of how ideas condition the practices of dramatists and historians, or how artists fare in their confrontation with state power. Even here, of course, complete neutrality has been but a polite fiction. For my comparison of the war treatises of Machiavelli, von Clausewitz, and Herman Kahn suggests its own moral for a society given over to an obsession with strategies of terror and destruction; my comparison of the practices of dramatists cannot conceal my sympathy with a drama of political involvement and moral judgment; my examination of how artists fare in their confrontation with state power cannot resist the insistence on the freedom of the artist as grounded in the nature of man as man. But the moral presuppositions, if strong and omnipresent, are yet only latent. So it becomes necessary, if only with the greatest brevity, to make the latent manifest and to ask: What would be the politics of humanism if it were given explicit and constructive formulation? Underlying the attitudes of, say, Erasmus, Goethe, Burckhardt, the youthful Marx, and Camus, is there some common unifying frame of reference?

I think that there is, and that it consists of the use of moral and aesthetic criteria in the judgment of political acts. Humanism as a great historic tradition in Western culture shows itself most strongly in its moral guise—as a recall to moral order, and perhaps also as the employment of standards derivable from literature, history, and the arts in the assessment of any exercise of political power. This is what Gilbert Murray meant when he said that the politics of Aristophanes is the politics of a literary man "greatly moved by the *spirit* of a policy, its cruelty, its unfairness, its vulgarity, and not so much by its material results," and it is probably why in this book the cases of von Treitschke and Herman Kahn stand out so strikingly as negative examples. Herman Kahn forgot to ask the right questions, and if von Treitschke asked the right questions, he gave to them the wrong answers.

The concept of raw Machiavellianism, of *raison d'état*—as Friedrich Meinecke once showed—is precisely to fail to ask the

moral question, or, if it is asked, to answer it improperly, in terms of a fanatical nationalism which brooks no extrinsic moral evaluation. Recourse to the brutalizing agency of mere force always weakens the power of moral discrimination and converts men into something spiritually hard and cold. It reduces the human quality as it exalts the importance of mechanical agency; as the youthful Marx would have said, it converts humanity into "material" and is, thus, a primary factor in the alienation of man. It is for this reason that humanism has been eternally opposed to the demonic influence of mere political power, that it insists on judging it ethically, in terms of a humanitarian ideal, and that it opposes to "reasons of state" the more universally valid "reasons" of charity and justice. Humanism is, therefore, essentially antipolitical in this twofold and specific sense: that it always falls back on a humanitarian ideal, and that it maintains a permanent respect for cultural values which are neither founded on nor responsible to the political state.

The first pervasive characteristic of the tradition of Western humanism is its *cosmopolitan universalism,* and this is why so many of the epochs of Western history have cast a tragic shadow as vestiges of a radicalism that failed. The "world citizenship" of the ancient Stoics, "a common faith" which haunted the medieval world, "the infinite community of reasonable men" which was the Enlightenment's dream, "the rights of man" of the revolutionary eighteenth century are now just so many empty phrases (because unrealized possibilities) in the ample graveyard of the Western past. And yet it is this same universalism which constitutes a unifying spiritual bond between the figures dealt with in this book. The previous question of the common frame of reference underlying the attitudes of Erasmus, Goethe, Burckhardt, the youthful Marx, and Camus can then a second time be resolutely answered in the affirmative. Erasmus represents the cosmopolitan ideal of man as a citizen of the world. Goethe throughout his long life put forward the idea of a peaceful culture and a "world literature." Burckhardt tried to codify the Greco-Roman and the Renaissance traditions to produce the humane cultivation which might compensate for a corrupt politics. The youthful Marx called emphatic attention to man as a "species-being"—that is, one whose responsibilities and obligations spring from a human nature which he shares with all other men. And Camus fights passionately the particularities of politics and the brutal-

ity of political "terror" in the name of a universal condition of man which requires respect.

In the light of this emphasis on universal values, it is possible to see that the frequent humanist withdrawal from the political arena does not always represent a repugnance for politics as such, but rather the judgment against a politics which is too narrow, in which the stakes are petty and trivial when measured against the humanitarian ideal. This is certainly true of Erasmus, and it is probably true of Goethe, Burckhardt, and Camus as well. Erasmus, as we have seen, provides a perfect example of that kind of humanist who withdraws from political fanaticism in the name of a universal lucidity, and attempts to retain a permanent openness rather than to pledge himself unreservedly to any narrow ideology. And he, therefore, no less than Montaigne (although with considerably less success) functioned as one of those peacemakers, arbitrators, reconcilers, of which the turbulent days of the late Renaissance were so painfully in need. Friedrich Heer calls them *die dritte Kraft*—the third force—that little band of European humanists who tried in the crucial days of the sixteenth century to rescue Europe from the threatened split of the religious fanatics, and from the fratricidal consequences of the split after it became accomplished fact.

The conception of "the third force" is very relevant to the humanist intention in any age. For the universal criteria which humanism employs tend to make it acutely sensitive to the irrationality of partisans, and wherever possible it attempts to reconcile their claims. Its logic is less the logic of "either—or" than that of "both—and," it attempts to beget dialogue and communication, and, without any compromise of values, its general philosophy is that of tolerance and "coexistence." When, as in the case of Erasmus, this makes for mildness and "in-betweenness," this can seem to be a weakness. But in a universe of brutal conflict and irrationality, it can also be a strength. To build bridges is a greater service to the human community than to erect barriers.

The message of humanism and its constructive efforts are needed no less today than in the age of Erasmus. More so, for, as the metaphor from the Goncourt Journal suggests, our time is swiftly running out. Today the political dilemma of humanism is even sharper. Where impersonality rules (as it does now in all the powerful modern states) it is the humanistic task to seek out such possibilities of social action as remain *personal*.

And when the moral element of politics appears once again through the dense verbal fog of *raison d'état,* then there is a great urge even for persons little disposed toward politics to participate—persons perhaps like Aristophanes, who might be moved by the *spirit* of a policy, its cruelty, its arrogance, its vulgarity, even more than by its tragic material results. Then politics is no longer the implacable march of impersonal events; it can be turned into the confrontation of person with person. It is, as Merleau-Ponty once said, "a time of decisions rather than a time of institutions." At such a moment the writing of an intellectual history or a philosophy of culture might seem at best a marginal and dispensable pursuit. But I do not believe that this is the case. Even the present is fed by the moral supports of the past, and every effort toward the restoration of our humanistic memory can play its part in the resolution of the tragic dilemmas of our time.

Notes

1. Introduction

1. Paul Valéry, *History and Politics,* trans. Denise Folliot and Jackson Mathews (New York: Pantheon, 1962), p. 23. Copyright by Bollingen Foundation and reprinted by permission.

2. One instance of the contemporary revaluation of scientists may suffice. There are two versions of Bertolt Brecht's famous play *Galileo.* Brecht wrote the first in Denmark in 1938, the second in California in 1946 and the third during new rehearsals at the *Schiffbauerdamm* theater in Berlin almost ten years later. There is a basic difference between the first two versions; primarily in the judgment made on the figure of Galileo as a person and as the founder of modern science. In the first version Galileo is a scientific hero whose cleverness outwits the Inquisition, and whose scientific intelligence brings new light into an age of darkness. In the second version Galileo practices his science without a sense of social obligation, he retracts his doctrines out of cowardice, and his human failure delivers over his science into the hands of those who would misuse it. For this harsher second judgment there was clear reason. The first atomic bomb was dropped upon Hiroshima just before the writing of the second version, and it was impossible for Brecht to ignore the fact that the bomb was itself a product of the science founded by Galileo. It is not possible to doubt that the atomic bomb caused him to change profoundly his view of Galileo and of the historic significance of the scientific advance for which he was responsible!

3. Norman Mailer, *Advertisements for Myself* (New York: Putnam, 1956), pp. 338–9 (from "The White Negro").

4. Martin Heidegger, *Einführung in die Metaphysik* (Tübingen, 1953), pp. 28–9.

5. Thomas Mann, *Der Zauberberg* (Frankfurt: G. B. Fischer, 1963), p. 470.

6. Valéry, p. 233.

7. *The Last Essays of Georges Bernanos,* trans. Joan and Barry Ulanov (Chicago: Regnery, 1955), p. 27.

8. *Ibid.,* p. 44.

9. Mann, p. 146: "Denn die Literatur sei nichts anderes als eben dies: sie sei die Vereinigung von Humanismus und Politik, welche sich um so zwangloser vollziehe, als ja Humanismus selber schon Politik und Politik Humanismus sei . . ."

10. See, for example, Pieter Geyl's extremely revealing essay: "French

Historians for and against the Revolution" in his *Encounters in History* (New York: World-Meridian, 1961).

11. Valéry, p. 119.

12. "Sartre's Underground," *New Republic,* May 19, 1952.

13. I have treated this elsewhere. See Albert William Levi, *Literature, Philosophy and the Imagination* (Bloomington: Indiana Univ. Press, 1962), Chap. V.

14. For more on Jaspers, see Albert William Levi, *Philosophy and the Modern World* (Bloomington: Indiana Univ. Press, 1959), Chap. X.

15. Simone de Beauvoir, *La Force des choses* (Paris: Gallimard, 1963), p. 633.

16. Maurice Merleau-Ponty, *Humanisme et terreur* (Paris: Gallimard, 1947), p. 205.

17. Albert Camus, *The Rebel* (New York: Knopf, 1954), p. 11.

18. Oscar Gass, "Russia: Khrushchev and After," *Commentary,* Vol. 36, No. 5, Nov., 1963, p. 362.

19. Montaigne, *Essais* (Paris: Garnier, 1962), Vol. II, 222–3.

20. Aulus Gellius, *Noctes Atticae,* XIII, 16. This passage is constantly cited by authors as profoundly different in orientation as Richard McKeon ("The Nature and Teaching of the Humanities," *Journal of General Education,* Vol. III, No. 4, July, 1949, p. 292) and Julien Benda (*La Trahison des clercs,* trans. Richard Aldington as *The Betrayal of the Intellectuals,* Boston: Beacon, 1955, p. 177). I have used the translation given by Aldington for Benda.

21. Isidore Silver, "Humanism, the Conscience of the Renaissance," in *Studi Francesi* (Milan, 1962), No. 17, pp. 201–7.

22. As stated, for example, in his 1912 British Academy Lecture, "Coriolanus."

23. Levi, *Philosophy and the Modern World,* pp. 427–35. See also my "The Meaning of Existentialism for Contemporary International Relations," *Ethics,* Vol. LXXII, No. 4, July, 1962.

2. *Erasmus and Montaigne:*
Two Models of a Humanistic Politics

1. Stefan Zweig, *Triumph und Tragik des Erasmus von Rotterdam* (Vienna: H. Reichner, 1934); English ed., *Erasmus of Rotterdam* (New York: Viking, 1934). All references will be to the English edition.

2. Ibid, pp. 13, 14.

3. Georg Lukacs, *The Historical Novel,* trans. Hannah and Stanley Mitchell (Boston: Beacon, 1963), p. 267. The work was written in German but first published in Moscow in 1937. The first German edition was published in East Germany in 1955 and in West Germany in 1961.

4. Erasmus in *The Education of a Christian Prince* says that the Prince "must be fortified as by certain efficacious drugs against the poisoned opinions of the common people" and "removed from the sullied opinions and desires of the common folk." Montaigne is never quite so explicit, and mention of his suspicion of the common people may be unsupported by specific passages in the *Essais,* but his aristocratic preferences are every-

where clear as in his contempt for "vulgar and popular esteem" ("Of Vanity"), his amusement by those "who salute a whole people in a crowd and in a body" ("Of the Art of Discussion"), and of his expressed preference for the society of "talented gentlemen" and "beautiful and well-bred women" ("Of Three Kinds of Association"). Frame has pointed out (*Montaigne's Discovery of Man*, p. 152) that his words for the common people—*vulgaire, commun*—change from terms of disdain to terms of praise as he grows older. Before 1580 the people are a mob—stupid, base, ignorant, brutal. After 1580 *vulgaire* becomes more closely associated with *human*. "We are all of the common herd."

5. Literature on the life and work of Erasmus is without end. Most useful and accessible for an English-speaking audience are P. S. Allen, *The Age of Erasmus* (Oxford Univ. Press, 1914); Preserved Smith, *Erasmus* (New York: Harper, 1923); Johan Huizinga, *Erasmus and the Age of Reformation* (New York: Harper-Torchbooks, 1957). The German studies of L. K. Enthoven and P. Kalkoff are valuable. No student of Erasmus can do without the monumental compilation of P. S. Allen, *Opus Epistolarum des Erasmi Roterdami* (Oxford: Clarendon Press, 1906–1947).

6. See the article by Richard McKeon, "Renaissance and Method," in *Columbia Studies in the History of Ideas*, Vol. III, (New York: Columbia Univ. Press, 1935).

7. P. S. Allen, "Erasmus," in *Lectures and Wayfaring Sketches* (Oxford: Clarendon Press, 1934), p. 23.

8. "On Physiognomy."

9. It is perhaps good to have the chronology straight. Erasmus' dates are 1466–1536, Machiavelli's 1469–1527, Montaigne's 1533–1592. Erasmus and Machiavelli were contemporaries, while Montaigne belonged to the succeeding generation. Machiavelli's lifetime falls within that of Erasmus. He was three years younger and died nine years earlier. At Erasmus' death Montaigne was a child of three. There is a further irony. Machiavelli deals at some length both in *The Prince* and elsewhere with the warlike Pope Julius II (1503–1513). Erasmus had seen him in person entering Bologna in 1506 at the head of his troops and celebrating a bloody triumph. The peace-loving Erasmus never forgave him and in one of his Colloquies, "Julius Exclusus," just as Dante before him had put some medieval popes in hell, so Erasmus shows this pope swaggering outside the gates of heaven amazed to find that Peter will not let him in. Julius' successor was Leo X (1513–1521), the scholarly Medici patron of art. It is from his accession that Erasmus hopes so much in the quotation which follows. But it was his accession which symbolized the return of the Medici to Florence, turned Machiavelli out of office, and blasted his hopes of a further political career (see Chapter VIII).

10. Huizinga, p. 218 f. Huizinga's book concludes (pp. 197–253) with a brief selection from Erasmus' vast correspondence, translated into English by Barbara Flower. I have found it convenient to use it here and in what follows. These letters are reprinted by permission of Harper and Row, Publishers.

11. Ibid., p. 252.

12. Ibid., pp. 229–31.

13. Ibid., p. 241 f.

14. The first edition of the *Adagia* printed in Paris in 1500 contained

818 proverbs; the last in Erasmus's lifetime—the sixtieth—printed 36 years later contained 4,151. To augment and improve the book had been a lifelong labor and its influence in "democratizing" Renaissance learning was incalculable. The style and thought of Montaigne were nourished on it and both Bacon and Shakespeare seem to have known it, or at least to have used it secondhand.

15. There is a complete translation of the *Institutio principis christiani* in English by Lester K. Born, *The Education of a Christian Prince* by Desiderius Erasmus, (New York: Columbia Univ. Press, 1936); it will be cited in what follows.

16. *Institutio*, pp. 145, 150.

17. Ibid., p. 175.

18. Ibid., p. 211.

19. Ibid., p. 249.

20. *Erasmus's Querela Pacis,* The Complaint of Peace, (Chicago: Open Court Pub. Co., 1917), p. 33.

21. Ibid., p. 6.

22. *Erasmus Against War* (The *Dulce bellum inexpertis*), with an introd. by J. W. Mackail (Boston: Merrymount Press, 1907), p. 24. The *Dulce bellum inexpertis* was probably written in the winter of 1514–15. It was printed in 1515 in the enlarged and rewritten *Adagia* (see note 14) issued by Froben at Basel. It was probably addressed particularly to Pope Leo X, whose accession to the papal throne in 1513 marked the downfall of Machiavelli in Florence. Two years later it was withdrawn and issued by Froben as a separate quarto of 20 pages, entitled the *Bellum Erasmi* and as such spread like wildfire across the continent of Europe. It was reprinted by half of the scholarly presses of the time. Within 10 years it was reissued at Louvain, Strasbourg, Leipzig, Antwerp, Cologne, and Paris.

23. *Dulce bellum inexpertis*, p. 10.

24. The whole question of Erasmus' relation to Holland has been interestingly explored by Ludwig Enthoven, "Erasmus Weltburger oder Patriot," in *Neue Jahrbucher für klassische Altertum* (Leipzig: Teubner, 1912), Vol. XXIX, pp. 205–15.

25. Huizinga, p. 214.

26. T. S. Eliot in his essay "The Pensées of Pascal" has testified both to the "insidious" character of Montaigne's effect ("By the time a man knew Montaigne well enough to attack him, he would already be thoroughly infected by him.") and to his contribution to the French mentality: "Of all authors Montaigne is one of the least destructible. You could as well dissipate a fog by flinging handgrenades into it. For Montaigne is a fog, a gas, a fluid, insidious element. He does not reason, he insinuates, charms, and influences; or if he reasons, you must be prepared for his having some other design upon you than to convince you by his argument. It is hardly too much to say that Montaigne is the most essential author to know, if we would understand the course of French thought during the last 300 years."

27. This term has been popularized, and the similarities between the two men rather cursorily recognized by Friedrich Heer in his book *Die dritte Kraft: Der europaische Humanismus zwischen den Fronten des konfessionellen Zeitalters* (Frankfurt: S. Fischer, 1960). "Montaigne," says Heer, "ist einer der grossen Erzieher des Menschen aus dem Geblut des Erasmus" (p. 567).

28. An account of Montaigne's political activities will be found in all the standard biographies, among which Fortunat Strowski, *Montaigne* (Alcan, 1931) and *Montaigne, sa vie publique et privée* (Nouvelle Revue Critique, 1938) and Jean Plattard, *Montaigne et son temps* (Boivin, 1933) are among the most useful. But all accounts of Montaigne's political activities draw heavily on the basic work of 19th century scholarship: Alphonse Grün, *La Vie publique de Michel Montaigne* (Paris: Libraire d'Amyot, 1855) and it is my own chief source in what follows. The periodical literature on Montaigne's political opinions, his parliamentary experience, his ideas of justice, his conception of liberalism, democracy, and freedom, is enormous and the articles by Camille Aymonier, Pierre Barrière, Louis Cons, Jean David, Guy Desgranges, Pierre Gaxotte, and others, sprinkled through the volumes of *Bibliothèque d'humanisme et renaissance, Bulletin de la société des amis de Montaigne, The French Review, Modern Language Quarterly*, etc., provide sidelights on and new interpretations of facts relatively well established by the scholarship of an older generation.

29. Montaigne, *Essais*, 2 vols., ed. Maurice Rat (Paris: Garnier, 1962). The best English translation is by Donald Frame, *The Complete Essays of Montaigne*, 3 vols. (New York: Doubleday-Anchor, 1960), and it is this edition to which all subsequent references will be made. It was originally published by Stanford Univ. Press and quotations are by their permission.

30. *Essais*, II, 216, 217. There have been some interesting considerations of this topic. See, for example, Albert Cherel, *La Pensée de Machiavel en France* (L'Artisan du Livre, 1935) and Alexandre Nicholai, "Le machiavélisme de Montaigne," *Bull. Soc. de Montaigne* (Oct.–Dec., 1957, Jan.–June, 1958; July–Sept., 1958; Jan.–Mar., 1959).

31. Grün, p. x. Chap. III (pp. 63–120), "Montaigne Magistrat," deals with this subject in detail. Also useful is Jean Plattard, Chap. III (pp. 41–56) "Montaigne au Palais de Justice."

32. The original Latin inscription appears in Grün, p. 138. I use the translation in Donald M. Frame, *Montaigne's Discovery of Man* (New York: Columbia Univ. Press, 1955), pp. 35–36.

33. French text from Grün, p. 209; trans. Frame, p. 124. The matter is discussed in Alexandre Nicholai, *Les Belles amies de Montaigne* (Paris, 1950) pp. 135–45.

34. The details of Montaigne's mayoralty can be found in Grün, Chap. VIII, and more cursorily in Plattard, Chap. XIII.

35. *Essais*, II, 447–72.

36. There is surely some contradiction here in Montaigne's treatment of politics. He says that he has been accused of exerting himself too little for the public welfare and that it has been a source of reproach that his administration passed so unremarked. But he complains of being accused of inactivity at a moment when most administrators are accused of doing too much. And he does not explain how the "liveliness" of his way of acting is reconcilable with his abilities as a subtle negotiator. ("If anyone wants to use me according to my nature, let him give me tasks in which vigor and freedom are needed, tasks that require direct, brief, and even hazardous conduct; in those I can do something. If it has to be long, subtle, laborious, artificial, and tortuous, he will do better to apply to someone else" (Frame, pp. 260, 261).

37. *Essais*, II, 457, 458. I have used Frame's translation, III, 250.

38. Ibid., pp. 283, 284.

39. Ibid., p. 288.

40. Ibid., p. 188.

41. It is amazing to what extent Montaigne's biographers, blind to the admissions found throughout the *Essais,* hold him up as a figure of moral virtue even in the pure Erasmian sense. Thus Grün: "Entré dans les fonctions publique sous Henri II, magistrat sous Charles IX, il a vu de près la cour de ces rois et celle de leur successeur, les violences et les intrigues des partis et de leurs chefs; dans ses rapports avec les Guise, avec Catherine de Medicis, avec Henri III, il a vu fonctionner la politique de dissimula-tion et de mensonge dont les derniers Valois ont été les disciples et les victimes; il a eu sous les yeux les plus hideux exemples donnés par les personnages les plus élevés, et il a offert le beau spectacle de l'honnêteté conservée au milieu de la corruption générale" (pp. 15, 16).

42. Especially in "On Some Verses of Virgil," Frame, pp. 94–8.

43. His comments on travel are exemplary, Frame, pp. 220, 221.

44. Ibid., p. 234.

45. Ibid., p. 205.

46. The first comes from the essay "Of Repentence," the second from "On Vanity."

47. Frame, p. 260.

3. The Politics of Shakespeare's Plays

1. See *A Companion to Shakespeare Studies,* ed. H. Granville-Barker and G. B. Harrison (New York: Macmillan, 1934), p. 171. The entire article "The National Background," by G. B. Harrison (pp. 163–186), is of the greatest interest.

2. Ibid., p. 181.

3. A. C. Bradley, "Coriolanus," in *Studies in Shakespeare:* British Acad-emy Lectures, selected by Peter Alexander (London: Oxford Univ. Press, 1964), p. 223.

4. William Shakespeare, *The Life of King Henry the Fifth,* ed. Louis B. Wright and Virginia Freund (Penguin Books, 1957), p. 17.

5. E. M. W. Tillyard, *Shakespeare's History Plays* (New York: Collier Books, 1962), pp. 19–30.

6. I do not wish to press the similarity of Shakespeare and Hobbes too far, for there is a notable difference in the relationship between politics and nature in their respective bodies of work. Shakespeare, as the speech on degree from *Troilus and Cressida* makes clear, holds to faith in the orderliness of the cosmos which is then reflected in the body politic. This is a poetic version of the doctrine of natural law. But Hobbes is committed to the old Sophistic distinction between nature and convention. For him "the state of nature" is precisely what is brutal and anarchic, and it is "human convenant" which breaks its anarchy to bring order and justice into political existence.

7. Shakespeare wrote 10 history plays in approximately the following order: (1) *Henry VI,* Parts 1, 2, 3 (1592), (2) *Richard III* (1592), (3) *Richard II* (1595), (4) *King John* (1596), (5) *Henry IV,* Parts 1, 2 (1597–98), *Henry V* (1599), (7) *Henry VIII* (1613). The periods of

history to which the events covered in these histories belong are another matter: *Richard II* (1377–99), *Henry IV* (1399–1413), *Henry V* (1413–22), *Henry VI* (1422–80), *Richard III* (1480–85). The total pattern into which they fall is therefore a prologue, *King John;* eight plays divided into two tetralogies of *Richard II* to *Henry V* and *Henry VI* to *Richard III,* with an epilogue, *Henry VIII.* My treatment will exclude prologue and epilogue. *King John,* although interesting in many respects, is weak in political ideas, while *Henry VIII* is probably too little by Shakespeare's hand to constitute clear evidence. I will limit myself to the eight plays of the Yorkist and Lancastrian tetralogies and these I will treat not in the order of historical occurrence, but in the order in which Shakespeare wrote them. This yields a less symmetrical pattern, but one fairer to the Shakespearean intention.

8. Cf. the interesting treatment of L. C. Knights, "The Thought of Shakespeare" in *The Hidden Harmony: Essays in Honor of Philip Wheelwright* (New York: Olyssey, 1966). Knights has also been previously concerned with the problem of Shakespeare's politics. See his "Shakespeare's Politics," "Personality and Politics in Julius Caesar," and "Poetry, Politics and the English Tradition," all reprinted in *Further Explorations* (Stanford Univ. Press, 1965).

9. The literature on Shakespeare's history plays is very large. Most useful for investigating them in terms of "the Tudor myth" and Tudor historiography are: Lily B. Campbell, *Shakespeare's Histories: Mirrors of Elizabethan Policy* (San Marino: Huntington Library, 1963; first published 1947); E. M. W. Tillyard, first published 1944; M. M. Reese, *The Cease of Majesty: A Study of Shakespeare's History Plays* (New York: St. Martin's, 1961). Two other works, not orthodox, are of the greatest interest: A. P. Rossiter, *Angel with Horns* (New York: Theatre Arts Books, 1961) and Derek Traversi, *Shakespeare from Richard II to Henry V* (Stanford Univ. Press, 1957).

10. The extent to which Shakespeare's character departs from the historical figure both in physical description and in known behavior is made clear in the best contemporary biography: Paul Murray Kendall, *Richard the Third* (New York: Doubleday-Anchor, 1965). Particularly interesting is Appendix II, "Richard's Reputation," which traces the links in the transmission of the perjured legacy. The following facts seem established: that Richard, although small and slight of stature, was not physically deformed; that Richard did not personally murder either Henry VI or his son Edward; that he is not responsible for the murder of his brother George, Duke of Clarence; that his marriage to Anne Neville was happy and that he was deeply grieved at her early death, probably from tuberculosis.

11. Jan Kott, *Shakespeare—Our Contemporary* (New York: Doubleday-Anchor, 1966).

12. Ibid., p. 5.

13. Ibid., pp. 6–7.

14. Ibid., pp. 9–10.

15. Ibid., p. 30. Here Kott is not entirely persuasive. No age viewed less than sympathetically and from the outside would be subject to a like cynicism from those within. It is not farfetched to think that Shakespeare would be enthusiastic about Elizabeth's reign and sympathetic to the "official view" of Tudor destiny.

16. Ibid., p. 36.

17. There are in fact not two but three theories of history which are relevant here: (1) that history is meaningless, (2) that it is developmental, (3) that it is cyclical (i.e., repetitious). Kott assumes that (1) and (3) are the same, and this is not unnatural in one with Marxist presuppositions, but it is inaccurate. See, in this connection, Albert William Levi, *Philosophy and the Modern World* (Bloomington: Indiana Univ. Press, 1959), pp. 102–110, "The Philosophy of History."

18. This is in part done by Brents Stirling, *The Populace in Shakespeare* (New York: Columbia Univ. Press, 1949). "It is well known that Shakespeare confused the chronicle accounts of Cade's rebellion [of 1450] with those of the Peasants Revolt in 1381 and that this confusion probably arose from motives both of political emphasis and dramatic license" (p. 22). Wat Tyler was known to be against learning and literacy. As to Shakespeare's "hatred of the masses," noted by Georg Brandes in his remarks on *Coriolanus*, Stirling says (p. 66) : "As the facts are assembled, it is uncomfortably apparent that when Shakespeare's commoners gather, something occurs which with slight whimsicality could be called a collective halitosis of democracy in action. Anyone who has read in sequence the Cade scenes, *Julius Caesar,* and *Coriolanus* may have been uneasy at the motif of proletarian stench which occurs in all three plays, and in *Coriolanus* becomes a minor obsession. . . . In the end, at least one conclusion may be prominent: a conviction that the association in Shakespeare of stench with *demos* is hardly explainable as a mere dramatic device . . . or as a practice common in Elizabethan literature. Whatever personal impulses may have evoked this from Shakespeare, it falls clearly into the category of gratuitous accentuation which as biographical data cannot be glibly dismissed."

19. John Masefield, *William Shakespeare* (Home University Library, 1911), pp. 95–99.

20. Edward Dowden, *Shakespeare: A Critical Study of his Mind and Art* (New York: Putnam-Capricorn, 1962), pp. 180–190.

21. E. K. Chambers, *Shakespeare: A Survey* (New York: Hill & Wang, n.d.), pp. 12–19.

22. Tillyard, pp. 227–339.

23. Kott, pp. 33–48.

24. Rossiter, pp. 1–22.

25. Ernst Kantorowicz, *The King's Two Bodies: A Study in Mediaeval Political Theology* (Princeton Univ. Press, 1957). Chapter II of this work (pp. 24–41) deals specifically with Shakespeare's *Richard II.* Two other relatively recent works are to the point here, one dealing with the general medieval doctrine of the divine right of kings, and the other orienting it specifically to Shakespeare's history plays: P. Kern, *Gottesgnadentum und Widerstandsrecht im früheren Mittelalter* (Darmstadt, 1954) and Erich Braun, *Widerstandsrecht: das Legitimitätsprinzip in Shakespeare's Königsdramen* (Bonn, 1960).

26. Kantorowicz, p. 7.

27. Chambers, p. 92.

28. Alfred Harbage, *Shakespeare's Audience* (New York: Columbia Univ. Press, 1961) ; see Chapter III, "What Kind of People?"

29. It is so argued by Derek Traversi, *Shakespeare from Richard II to Henry V,* pp. 1–11.

30. There is internal evidence that even while he was writing *Henry V*

Shakespeare was reading Plutarch. In Act IV, Scene 7 of this play Fluellen contributes his well-known comparison of Alexander of Macedon and Henry of Monmouth—a parallel undreamed of by Plutarch but doubtless suggested by him.

31. Reprinted in *Studies In Shakespeare:* British Academy Lectures, selected and introduced by Peter Alexander (London: Oxford Univ. Press, 1964), pp. 71–102. I am here simply summarizing the central argument of that always interesting, but sometimes wandering essay.

32. I do not include *Antony and Cleopatra.* This play also in some sense deals with a political subject (the division of power of the triumvirate in the Roman empire), but the personal so overshadows the political that it is not relevant for my purposes. Shakespeare's Roman plays have received much attention. Classic is M. W. MacCallum, *Shakespeare's Roman Plays* (London: Macmillan, 1910). Dealing exclusively with imagery is Maurice Charney, *Shakespeare's Roman Plays* (Harvard Univ. Press, 1961). Most recent is Derek Traversi, *Shakespeare: The Roman Plays* (Stanford Univ. Press, 1963), which is so detailed as to constitute almost a commentary on the text. Also useful here is John Palmer, *Political Characters of Shakespeare* (London: Macmillan, 1948) which contains "portraits" of Brutus and Coriolanus.

33. Bertolt Brecht, *Schriften zum Theater* (Berlin: Suhrkamp, 1961), p. 174 ff.

34. Kott, p. 206.

35. Reprinted in *Studies In Shakespeare*, pp. 219–237.

36. Ibid., p. 227.

37. A. L. Rowse, *William Shakespeare: A Biography* (New York: Pocket Books, 1965), p. 413.

38. Kott, p. 181.

39. *Schriften zum Theater*, p. 167 f.

4. The Great Refusal:
The German Withdrawal from Goethe to Thomas Mann

1. Thomas Mann, *Last Essays* (New York: Knopf, 1959), p. 122.

2. This thesis has been put forward by Georg Lukacs in his *Goethe und seine Zeit* (Bern: Franke, 1947), *Deutsche Realisten das 19 Jahrhunderts* (Berlin: Aufbau, 1952), and in relevant sections of *The Historical Novel* (Boston: Beacon, 1963). Lucien Goldmann has appropriated Lukacs' point of view and reexpressed it interestingly in *La Communauté humaine et l'univers chez Kant* (Paris: Presses Universitaire de France, 1948). A brief but valuable presentation of the thesis is also to be found in W. H. Bruford, *Germany in the Eighteenth Century: The Social Background of the Literary Revival* (Cambridge Univ. Press, 1965), Part IV, Chap. II, "The Influence of Political, Economic and Social Factors on Literature."

3. Eckermann, *Gespräche,* under May 3, 1827, quoted in Bruford, p. 292.

4. Ibid., Mar. 10, 1830; quoted in Bruford, p. 305.

5. This has been a matter of endless treatment. Older but still illuminating are: Edward Dowden, *New Studies in Literature* (London: Kegan Paul, 1902), "Goethe and the French Revolution"; G. P. Gooch, *Studies in*

Modern History (London: Longmans, 1931), "The Political Background of Goethe's Life"; G. P. Gooch, *Germany and the French Revolution* (London: Longmans, 1927), Chap. VII. More recent and by non-German scholars are: Maurice Boucher, *La Revolution de 1789 vue par les ecrivains allemands ses contemporains* (Paris: Didier, 1954), pp. 129–170; Lucien Goldmann, *Recherches dialectiques* (Paris: Gallimard, 1959), "Goethe et la revolution française."

6. *Goethe: Gedichte und Dramen*, 2 vols. (Insel, 1953), I, 90–1.

7. Goethe's political ideas have also been the subject of endless consideration. The bibliography is enormous, but I have found the following useful: Franz Krennbauer, *Goethe und der Staat: Die Staatsidee des Unpolitischen* (Vienna: Springer, 1949); Wilhelm Mommsen, *Die politischen Anschauungen Goethes* (Stuttgart: Deutsche Verlags-Anstalt, 1948); Hans Tümmler, *Goethe in Staat und Politik* (Cologne: Böhlau, 1964).

8. For details of Goethe's life and works and the relationship between them it is no longer necessary to return to the older and more massive biographies and studies of Heinemann, Bielschowsky, and Gundolf. Two more recent works are accurate and stimulating, and I have used them with profit: Barker Fairley, *A Study of Goethe* (Oxford Univ. Press, 1961; first published 1947), and Richard Friedenthal, *Goethe: His Life and Times* (World, 1965); first published as *Goethe: Sein Leben und Zeit*, 1963).

9. Friedenthal, Chaps. 29, 30.

10. Ibid., p. 327.

11. Johann Wolfgang Goethe, *Aus meinem Leben: Dichtung und Wahrheit*, Parts 3 and 4 (Deutscher Taschenbuch, 1962), pp. 242–3.

12. Fairley, p. 74.

13. Ibid., p. 75.

14. *Goethe: Gedichte und Dramen*, I, 389–90.

15. *Last Essays*, p. 123.

16. Fairley, p. 77.

17. *Goethe: Gedichte und Dramen*, II, 446.

18. Ibid., II, 451.

19. Ibid., II, 460.

20. Ibid., II, 490.

21. Ibid., II, 495.

22. Thomas Mann, *Betrachtungen eines Unpolitischen* (Frankfurt: Fischer, 1956), p. 2. This volume will henceforth be referred to simply as *Reflections*.

23. *Reflections*, p. 4.

24. As, for example, his essays "Geist und Tat" dating from 1910 and his "Zola" published in 1915. Both of these essays appeared in Heinrich Mann's early collection *Macht und Mensch*. Both have been reprinted in the later *Geist und Tat* (Deutscher Taschenbücher, 1963) and it is in this edition that I have read them.

25. Georg Lukacs, *Essays on Thomas Mann*, trans. Stanley Mitchell (New York: Universal Library, 1965), pp. 9–26; from the essay "In Search of Bourgeois Man."

26. *Reflections*, p. 13. The contrast between the 19th and 20th centuries is developed on pp. 14–17, that between the French and German spirit on pp. 18–25.

27. *Reflections*, p. 214.

28. Ibid., p. 235.

29. Ibid., p. 251.

30. Ibid., pp. 262, 269.

31. Ibid., p. 271.

32. Ibid., p. 311.

33. Ibid., p. 325.

34. Ibid., p. 560.

35. Ibid., p. 568.

36. This essay has been reprinted in Thomas Mann, *Order of the Day: Political Essays and Speeches of Two Decades* (New York: Knopf, 1942), and all references to it are to this volume. Present quotation from pp. 228–9.

37. Ibid., pp. 229–30.

38. Unbelievable as it may seem, this is precisely the point which he makes in the essay "Nietzche's Philosophy in the Light of Recent History," which appears in the *Last Essays*.

39. Erich Heller, *Thomas Mann the Ironic German* (World-Meridian, 1961), Chap. IV, "The Conservative Imagination." Strangely enough with the exception of Heller and Lukacs few Mann scholars are interested in the problem which the *Reflections* presents. An exception is Martin Flinker's *Thomas Manns politische Betrachtungen im Lichte der heutigen Zeit* (The Hague: Mouton, 1959), but I have found the work disappointing.

40. Flinker, pp. 16, 17.

41. Lukacs, "In Search of Bourgeois Man," p. 27.

42. Ibid., p. 94.

43. Ibid., p. 95.

44. Julien Benda, *The Betrayal of the Intellectuals,* trans. Richard Aldington, Introd. by Herbert Read (Boston: Beacon, 1959). All references are to this edition.

45. *Sämmtliche Werke,* ed. Gustav Wilhelm (Prague, 1901–39), XVII, 286.

46. Benda, p. 5.

47. Ibid., p. 22.

48. Ibid., p. 30.

49. Ibid., p. 32, 33.

50. Ibid., p. 36.

51. Oscar Gass, "Russia: Kruschev and After," *Commentary*, Vol. 36, No. 5 (Nov., 1963) p. 361.

5. *Friederich Schiller: The Playwright as Politician*

1. See, for example, the chapter "From the Renaissance to the French Revolution," in G. P. Gooch, *History and Historians in the Nineteenth Century* (Boston: Beacon, 1959).

2. The following line of argument is suggested by, though not in every respect identical with that of Georg Lukacs. See his *The Historical Novel* (Boston: Beacon, 1963), Part II, Chap. 5: "A Sketch of the Development of Historicism in Drama and Dramaturgy," pp. 152–170.

3. *Schillers Werke in Zwei Bänden* (Knaur Klassiker, 1959), II, 956.

4. Ibid., II, 968.

5. Stephen Spender, "Schiller, Shakespeare, and the Theme of Power," in *A Schiller Symposium,* ed. A. Leslie Willson (Austin: Univ. Texas Press, 1960), pp. 51–61.

6. Ibid., p. 57.

7. Benno von Wiese, whose *Friedrich Schiller* (Stuttgart: Metzlersche, 1963) is perhaps the best and most encompassing recent treatment of Schiller's work, says: "War nicht eine Gestalt wie der zweiunddreissigjährige Lafayette, der der Nationalversammlung am 11. Juni 1789 nach dem Vorbilde amerikanischer Erklärungen den Entwurf zu den Menschenrechten vorlegte, geradezu eine Verkörperung des Schillerschen Posa? Könnte das Wort Targets in der Versammlung: 'Die Rechte des Menschen sind nicht hinreichend bekannt; man muss sie bekannt machen,' nicht fast ein Zitat aus Don Carlos sein?" (p. 450).

8. Friedrich Schiller, *Sämtliche Werke,* IV. Historische Schriften (Munich: Hanser, 1962), pp. 27–361.

9. Ibid., p. 29.

10. See, for example, Golo Mann, "Schiller als Historiker" in *Schiller: Reden im Gedankenjahr 1959* (Stuttgart: Klett, 1961), p. 106: "War Schiller Erzähler wie Plutarch, Moralist und Psychologe, so war er doch auch Historiker der Freiheit; jener Freiheit, die sich in unserer glücklichen Zeit, im achtzehnten Jahrhundert, endlich in Europa einbürgerte. Freiheit als Ziel des Menschen erscheint in seinen geschichtsphilosophischen, wesentlich an Kant sich anlehnenden Fragmenten. Um Freiheit geht es in den grossen Konflikten, von denen seine Bücher handeln. . ."

11. Schiller, *Sämtliche Werke,* IV, 33.

12. For this relationship, see especially Benno von Wiese, Chap. 19, "Politik und Aesthetik in Schillers Denken"; also the same author's "Schiller und die Französische Revolution" in *Der Mensch in der Dichtung* (Düsseldorf: Bagel, 1958); Maurice Boucher, *La Revolution de 1789 vue par les ecrivains allemands ses contemporains* (Paris, 1954), pp. 95-113, "Schiller."

13. Benno von Wiese says: "Zwar liest man immer wieder, dass Schiller die Revolution bei ihrem Beginn begeistert begrüsst habe. Aber Belege dafür blieben uns die Autoren schuldig." *Schiller,* p. 450.

14. *Schillers Briefe,* ed. Fritz Jonas (Stuttgart, 1892), III. 327–340.

15. Ibid., p. 330.

16. Ibid., p. 333.

17. Ibid., p. 336 (italics mine).

18. Ibid., p. 335.

19. *Schillers Werke,* II, 565.

20. Ibid., II, 566.

21. Ibid., II, 570 (italics mine).

22. Ibid., II, 571 (italics mine).

23. Ibid., II, 468.

24. Schiller's political ideas and their expression in his dramatic productions have come in for a certain amount of interesting if scattered treatment. In addition to the chapter of Benno von Wiese cited above, the following are typical of the sort of thing to be found in the literature, and

I have found them to be moderately illuminating: Wolfgang Greulich, *Recht und Staat in Schillers Werken* (Cologne, 1961); Paul Böckman, "Politik und Dichtung im Werk Friedrich Schillers," in *Schiller, Reden im Gedankenjahr 1955* (Stuttgart, 1955); Ernst von Hippel, "Schiller als politischer Denker," in *Kunder der Humanität* (Bonn, 1946); Dolf Sternberger, "Macht und Herz oder der politische Held bei Schiller," in *Schiller, Reden im Gedenkjahr 1959* (Stuttgart, 1959); Pierre-Paul Sagave, "La Pensée politique de Schiller," *Cahiers du Sud,* Vol. 43 (1956), No. 336.

25. Thomas Mann, *Last Essays* (New York: Knopf, 1959), p. 18.

26. Ibid.

27. G. W. F. Hegel, *Lectures on the Philosophy of History* (London: Bell, 1884), p. 30 ff.

28. Georg Lukacs in *The Historical Novel* (pp. 30–63) does precisely this. Not only does he explicitly appeal to the Hegelian distinction (p. 39), but he disputes Sir Walter Scott's reputation as a "romantic" on the grounds that his historical novels shift the focus of concern from "World-Historical Figures" to those historical unknowns from common life who play so dominating a role in his novels.

29. Mann, p. 64.

30. This point is made clearly by W. H. Bruford, *Germany in the Eighteenth Century: The Social Background of the Literary Revival* (Cambridge Univ. Press, 1965), pp. 317–319. In this Bruford follows, as he acknowledges, the well-documented study by Clara Stockmeyer, *Soziale Probleme im Drama des Sturmes und Dranges* (Frankfurt, 1922).

31. Erich Auerbach, *Mimesis: The Representation of Reality in Western Literature* (Doubleday-Anchor, 1957), pp. 382–399. My subsequent comments follow Auerbach.

32. *Schillers Werke,* I, 633.

33. Sagave, p. 262.

34. Oskar Seidlin, "Schiller: Poet of Politics," in *A Schiller Symposium,* p. 34.

6. *History and Politics:* *Ranke, Treitschke, and Burckhardt*

1. These prospectuses have been translated and reprinted in Fritz Stern, ed., *The Varieties of History from Voltaire to the Present* (New York: World-Meridian, 1956), pp. 170–7.

2. Ibid., p. 175.

3. Antoine Guilland, *Modern Germany and Her Historians* (London: Jerrold, 1915), p. 69.

4. Hans Liebeschütz, *Ranke* (The British Historical Assoc., 1954), p. 7.

5. Leopold von Ranke, *Gestalten der Geschichte: Savonarola, Don Carlos, Wallenstein* (Berlin: G. B. Fischer, 1954), pp. 119–95.

6. Ibid., p. 195.

7. In 1820 Ranke had written: "God dwells, lives, is recognized in all history. Every act testifies to him, every moment preaches his name, but most of all it seems to me, the context of history. Good cheer then. No matter how it goes, let us try to reveal for our part the sacred hieroglyph-

ics. In that, too, we serve God, in that too we are priests, in that too teachers"; quoted in Theodore H. Von Laue, *Leopold Ranke, The Formative Years* (Princeton Univ. Press, 1950), p. 42.

8. This important essay has been translated by Theodore H. Von Laue, pp. 152–80. All references will be to this translation.

9. Ibid., p. 165.

10. Ibid., pp. 165, 166.

11. Ibid., pp. 168, 169.

12. See, for example, G. P. Gooch, *History and Historians in the Nineteenth Century* (Boston: Beacon, 1959), pp. 86, 87.

13. Von Laue, p. 217.

14. Ibid., p. 218.

15. These beliefs of Ranke have been noted by the many secondary sources which have dealt with his life and work. A Ranke bibliography would be both valuable and voluminous. The works which I have found of greatest value are the following: Rudolph Vierhaus, *Ranke und die soziale Welt* (Munster: Aschendorffsche Verlagsbuchhandlung, 1957); Otto Diether, *Leopold von Ranke als Politiker* (Berlin: Inaugural Dissertation, 1910); Theodore H. Von Laue; Hans Liebeschütz. Also valuable, if brief, are the accounts in Antoine Guilland; G. P. Gooch; Friedrich Meinecke, *Machiavellianism* (New York: Praeger, 1965).

16. Leopold von Ranke, *Geschichte und Politik,* ed. Hans Hofman (Leipzig: Kröner, n.d.). Ranke's lecture and other articles are published in this useful volume and all references to it cite this edition.

17. Ranke's lecture ends: "Endlich erkennen wir, dass die menschlichen Dinge weder durch ein blindes unvermeidliches Geschick geleitet, noch durch Truggebilde gelenkt werden, sondern ihre glüekliche Durchführung nur von Tugund, Verstand und Weisheit abhänge." Ibid., p. 132.

18. In a letter of June 28, 1872 to von Preen, Burckhardt wrote: "I would not have gone to Berlin at any price; to have left Basle would have brought a malediction on me. Nor is my merit in the matter great; there would be no helping a man of fifty-four who did not know where his modest portion of good luck lay. Had I accepted I should be in a suicidal mood instead of which people here are really grateful to me and here and there quietly shake me by the hand. Officially nothing is known of the matter as I wanted to avoid all fuss. On the other hand, it is a great triumph for Treitschke——good luck to him!" Alexander Dru, ed. and trans., *The Letters of Jacob Burckhardt,* (New York: Pantheon, 1955), p. 152.

19. Andreas Dorpalen, *Heinrich von Treitschke* (New Haven: Yale Univ. Press, 1957), p. 192.

20. G. P. Gooch, *Studies in Modern History* (London: Longmans, 1931), p. 223.

21. Friedrich Paulsen, *An Autobiography,* trans. T. Lorenz (New York: Columbia Univ. Press, 1938), p. 194.

22. Heinrich von Treitschke, *Deutsche Geschichte im neunzehnten Jahrhundert* (Leipzig, Hendel, 1927); English trans. *History of Germany in the Nineteenth Century* (New York: McBride, 1915). All references will be to the latter edition.

23. Heinrich von Treitschke, *Historische und politische Aufsätze,* 4 vols. (Leipzig, 1897–1903). Many of the important literary and cultural articles

appear in the *Ausgewählte Schriften von Heinrich von Treitschke,* 2 vols. (Leipzig: S. Hirzel, 1907). My references will be to this edition.

24. Heinrich von Treitschke, *Politik:* ed. Max Cornicelius, Verlesungen gehalten an der Universität zu Berlin, (Leipzig, 1911). English trans.: *Politics,* 2 vols. (New York: Macmillan, 1916). My references will be to the English edition.

25. *History of Germany in the Nineteenth Century,* I, xv.

26. Ibid., I, 91.

27. *Ausgewählte Schriften* (Leipzig, 1907).

28. *Politics,* I xxxii ff.

29. Ibid., I, xxxvii.

30. Ibid., I, 15.

31. Ibid., I, 21.

32. Ibid., I, 24.

33. Ibid., I, 55–6.

34. Ibid., I, 61.

35. Ibid., I, 65–6.

36. Ibid., I, 85.

37. Ibid., I, 99.

38. Friedrich Meinecke, "Ranke und Burckhardt," *Deutsche Akademie der Wissenschaften zu Berlin: Vorträge und Schriften,* (Berlin: Akademie-Verlag, 1948), Vol. 27, pp. 1–35. The following exposition is based on this lecture.

39. The definitive biography of Burckhardt is Werner Kaegi, *Jacob Burckhardt: eine Biographie,* 3 vols. (Basel, 1947), and I have depended on it for all matters pertaining to Burckhardt's life. Two other books are also of value for an assessment of Burckhardt's thought: Werner Kaegi, *Europäische Horizonte im Denken J. Burckhardts* (Basel, 1962) and Karl Löwith, *Jacob Burckhardt, der Mensch in Mitten der Geschichte* (Stuttgart, 1966). The source of Burckhardt's own writing is the *Gesamtausgabe,* 15 vols. (Stuttgart, 1930–34).

40. Dru, p. 53.

41. Ibid., pp. 73–5.

42. Jacob Burckhardt, *The Civilization of the Renaissance in Italy* (New York: Harper-Torchbooks, 1958), 2 vols. All references are to this edition.

43. Ibid., p. 107.

44. Ibid., p. 115 ff.

45. Ibid., p. 104.

46. Ibid., p. 361.

47. Ibid., p. 377.

48. Ibid., p. 443.

49. Dru, p. 104.

50. Ibid., p. 145.

51. Jacob Burckhardt, *Weltgeschichtliche Betrachtungen: Historisch-kritische Gesamtausgabe.* Mit einer Einleitung und textkritischem Anhang von Rudolf Stadelmann (Neske, n.d.); English edition: *Force and Freedom: Reflections on History,* ed. James Hastings Nichols (Boston: Beacon, 1964). All quotations are from the English edition.

52. *Force and Freedom,* p. 87 (italics mine).

53. Ibid., p. 89.

54. Ibid., p. 115.

55. Ibid., p. 144.

56. Ibid., p. 181. The entire section "Culture Determined by the State" (pp. 169–184) is worthy of the closest attention.

57. Ibid., pp. 217–18. This entire section also, "The State Determined by Culture" (pp. 211–230), is as rewarding as its predecessor.

7. The Drama and Politics:
Büchner, Brecht, and Hochhuth

1. A. E. Haigh, *The Tragic Drama of the Greeks* (Oxford Univ. Press, 1946), p. 130.

2. See Gilbert Murray, *Euripides and His Age* (Home University Library, 1913), Chap. V.

3. For the details, see Gilbert Murray, *Aristophanes: A Study* (Oxford Univ. Press, 1933).

4. Boris Pasternak, *I Remember: Sketch For An Autobiography* (New York: World-Meridian, 1960), p. 138.

5. Eric Bentley, "The Theater of Commitment," *Commentary* (Dec., 1966).

6. Irving Howe, *Politics and the Novel* (New York: World-Meridian, 1960).

7. The letters and documents concerning the life as well as the complete writings are to be found in the "Gesamtausgabe": Georg Büchner, *Werke und Briefe,* ed. Fritz von Bergemann (Insel, 1953). All of my references to *Dantons Tod* as well as to the letters will be to this edition hereafter referred to as *WB.*

8. *Schillers Werke in Zwei Bänden* (Knaur Klassiker, 1959), II, 571: "In den niedern und zahlreichern Klassen stellen sich uns rohe gesetzlose Triebe dar, die sich nach aufgelöstem Band der bürgerlichen Ordnung entfesseln und mit unlenksamer Wut zu ihrer tierischen Befriedigung eilen. Es mag also sein, dass die objektive Menschheit Ursache gehabt hätte, sich über den Staat zu beklagen: die subjektive muss seine Anstalten ehren. . . . Seine Auflösung enthält seine Rechtfertigung. Die losgebundene Gesellschaft anstatt aufwärts in das organischen Leben zu eilen, fällt in das Elementarreich zurück.

9. (1) *WB,* p. 11: "Wie lange sollen wir noch schmutzig und blutig sein wie neugeborne Kinder, Särge zur Wiege haben und mit Köpfen spielen?" (2) *WB,* p. 21: "Das Volk is ein Minotaurus, der wöchentlich seine Leichen haben muss, wenn er sie nicht auffressen soll." (3) *WB,* p. 53: "Haben Ihnen die Guillotinenkarren nie gesagt, dass Paris eine Schlachtbank sei?"

10. Letter from Strasbourg, Apr. 5, 1833, *WB,* 204.

11. Letter from Giessen, Feb., 1834, *WB,* 213.

12. Letter from Strasbourg, 1835, *WB,* 229.

13. Accounts of Büchner's life and work have now become very numerous. I have relied most heavily on two: Karl Viëtor, *Georg Büchner: Politik-Dichtung-Wissenschaft* (Bern: Franke, 1949) and A. H. Knight, *Georg Büchner* (Oxford: Blackwell, 1951). Also valuable are the earlier

Karl Viëtor, *Georg Büchner als Politiker*, 2d ed. (Bern: Franke, 1950) ;
Ludwig Büttner, *Georg Büchner: Revolutionär und Pessimist* (Nürnberg,
1948) ; Max Zobel von Zabeltitz, *Georg Büchner, Sein Leben und Sein
Schaffen* (Berlin, 1915) ; Herbert Lindenberger, *Georg Büchner* (Carbon-
dale: Southern Illinois Univ. Press, 1964).

14. "Der Hessische Landbote," *WB*, pp. 171–183.

15. *WB*, p. 209.

16. *WB*, p. 11.

17. Camille's sentiments are very modern. The youthful critics of the
United States policy in Vietnam 1965–7 also wore buttons which pro-
claimed: "Make love, not war!" They too thought it was Epicurus and
Venus who should guard the portals of the Republic—not Lyndon John-
son and certainly not Dean Rusk!

18. *WB*, pp. 18–20 (italics mine).

19. Peter Weiss, *Die Verfolgung und Ermordung Jean Paul Marats
dargestellt durch die Schauspielgruppe des Hospizes zu Charenton unter
Anleitung des Herrn de Sade* (Frankfurt: Suhrkamp, 1964).

20. The quotations from Saint-Just are in *WB*, pp. 47–48.

21. Arthur Koestler, *Darkness at Noon* (New York: Modern Library,
1946) p. 43. It is not insignificant that Rubashov in Koestler's novel at one
point uses the rhetoric of Saint-Just even to the metaphor of the corpses
cast up by the revolutionary flood. Can he have learned this from Büchner?
"The Party is the embodiment of the revolutionary idea in history. History
knows no scruples and no hesitation. Inert and unerring, she flows toward
her goal. At every bend in her course she leaves the mud which she carries
and the corpses of the drowned."

22. *WB*, p. 43.

23. *WB*, p. 52.

24. Georg Lukacs, *The Historical Novel* (Boston: Beacon, 1963), p. 158.

25. Louis Madelin, *Danton* (New York: Knopf, 1926), p. 280.

26. *WB*, p. 227 (italics mine).

27. *WB*, pp. 232–3 (italics mine).

28. These sources have been identified and the passages drawn from
them compared with passages in the play itself in the very useful work of
Richard Thieberger, *Georges Büchner: La mort de Danton, publiée avec
le texte des sources et des corrections manuscrites de l'auteur* (Paris:
Presses Universitaires de France, 1953).

29. Lukacs, pp. 101–102. This brief discussion contains the passage
which I quote just below.

30. There are two excellent books on Brecht in English: Martin Esslin,
Brecht: The Man and His Work (New York: Doubleday-Anchor, 1961)
and John Willett, *The Theater of Bertolt Brecht* (London: Methuen,
1959). The first is the best for factual materials, biographical, social, and
political. The second concentrates on theater with many valuable illustra-
tions and bits of theater lore. The two supplement one another admirably
and will be drawn on jointly in what follows.

31. My reference to Brueghel here is inspired by the peasant mentality
which he so often portrays. But it is interesting that Brecht himself should
have singled him out as illustrating the same technique in painting which
he (Brecht) wished to use in drama. See his "Verfremdungseffekte in den
erzählenden Bildern des älteren Brueghel" (Alienation Effects in the

Narrative Pictures of Brueghel the Elder), in *Bildende Kunst* (Berlin and Dresden, 1957), No. 4.

32. The chief repositories of Brecht's theater theory which I shall use are the following: Bertolt Brecht, *Schriften zum Theater* (Berlin: Suhrkamp, 1961); *Materialien zu Brechts "Mutter Courage und ihre Kinder"* (Suhrkamp, 1964); and *Brecht on Theater* ed. and trans. John Willett (New York: Hill & Wang, 1964).

33. Esslin, p. 48; Willett, *The Theater of Bertolt Brecht,* p. 193.

34. Jürgen Rühle, *Theater und Revolution: Von Gorki bis Brecht* (Munich: Deutscher Taschenbuch, 1963), Chap. V, "Das Theater der deutschen Revolution: Piscator," and Chap. VI, "Brecht und die Dialektik des epischen Theaters."

35. Piscator also wrote a famous work: *Das politische Theater* (Berlin, 1929).

36. Foreword to "Kleines Organon für das Theater," *Schriften zum Theater,* p. 128.

37. Ibid., Sect. 26; pp. 142–43.

38. "Das moderne Theater ist das epische Theater," Ibid., pp. 19–20.

39. Ibid., p. 265 ff.

40. This and the following summary were suggested by similar ones in Willett, *The Theater of Bertolt Brecht,* pp. 37–38.

41. Trans. Eric Bentley and Maja Apelman, *Parables For the Theater: Two Plays* (New York, 1948), p. 106.

42. See Walter N. Vickery, *The Cult of Optimism: Political and Ideological Problems of Recent Soviet Literature* (Bloomington: Indiana Univ. Press, 1963).

43. Georg Lukacs, *Skizze einer Geschichte der neueren deutschen Literatur* (Berlin: Aufbau Verlag, 1955), pp. 141–2.

44. See Brecht's "Weite und Vielfalt der realistischen Schreibweise," in *Versuche,* Vol. 13.

45. Bertolt Brecht, *Mutter Courage und ihre Kinder: Eine Chronik aus dem Dreissigjährigen Krieg* (Suhrkamp, 1963). Any references will be to this edition.

46. Brecht's principal writings about *Mother Courage* as well as other useful comments and reactions concerning the play have been collected in a valuable little book: *Materialien zu Brechts 'Mutter Courage und ihre Kinder,'* (Suhrkamp, 1964). The three following Brecht passages are to be found, respectively, on pp. 9, 17, 93.

47. Many critics have pointed this out. Characteristic is Heinz Politzer ("How Epic Is Bertolt Brecht's Epic Theater?" *Modern Language Quarterly,* Vol. XXIII, No. 2) who asserts that Kattrin's death inspires in the audience just that "process of empathy or identification against which Brecht's theory of the epic theater is directed," and that Brecht was "obviously stunned by the tragic impact he had produced."

48. *Materialien,* p. 94.

49. Ibid., p. 123 (italics mine).

50. Ibid., pp. 7–9.

51. In his Foreword to *The Storm Over the Deputy,* ed. Eric Bentley (New York: Grove, 1964), p. 8. This collection of essays and articles, mostly, but not exclusively, American, contains important material which will be referred to later. It needs however to be supplemented with

broader European materials of which two collections are indispensable: *Der Streit um den Stellvertreter* (Basel: Basilius, 1963) and *Summa Iniuria oder Durfte der Papst Schweigen?: Hochhuth's "Stellvertreter" in der öffentlichen Kritik,* ed. Fritz J. von Raddatz (Hamburg: Rowohlt, 1963).

52. *The Storm over the Deputy,* p. 11.

53. Rolf Hochhuth, *Der Stellvertreter:* Schauspiel mit einem Vorwort von Erwin Piscator (Hamburg: Rowohlt, 1964). In English, *The Deputy,* trans. Richard and Clara Winston, Preface by Dr. Albert Schweitzer (New York: Grove, 1964). I shall use both of these editions.

54. It is this scene patterned on the behavior of Pontius Pilate as given in Matthew 27:24 which has aroused the greatest indignation in Roman Catholic circles. The symbolic reference is cynical indeed.

55. The sources of the two preceding and the following quotations are, respectively: *The Storm over the Deputy,* pp. 38, 39–40, 66–9.

56. I speak here of "official" Catholic indignation as expressed by the highest churchmen. But other Catholics have taken a more sympathetic position. *The Commonweal,* in its issue of Feb. 28, 1964, editorializes: "The fact that one can count on one hand the number of times that the Pope publicly referred even indirectly to the persecution of the Jews cannot wholly be explained away. . . . If one cannot flatly say that the Church demonstrably failed, neither can one say that the Church stood as a supreme exemplar of the Christian conscience. At a moment in history when the Church should have borne constant, unmistakable witness at every level that Nazi persecution of the Jews was a despicable crime, its voice was muted and erratic. . . . It is hard too to escape the conclusion that the persecution of the Jews did not occupy a notably high place in the Church's assessment of contemporary moral evils. The Church, in fact, risked very little in behalf of the Jews: it certainly did not risk its concordat with Germany or the maintenance of diplomatic relations. In sum, the Catholic record is a very mixed one; and that in itself should be grounds for self-reproach."

57. G. E. Lessing, *Hamburgishe Dramaturgie,* Introd. and Commentary by Otto Mann (Stuttgart: Kröner, 1965), pp. 46–7 (No. 11). This insight is expanded further in No. 19 which cites Aristotle especially and in the series No. 22–25 where Lessing treats of Thomas Corneille's play "The Earl of Essex" and Voltaire's strictures against it.

58. Günter Grass, *The Plebians Rehearse the Uprising: A German Tragedy* (Harcourt-Harvest, 1966).

59. In his "Drama or Pamphlet: Hochhuth's *The Deputy* and the Tradition of Polemical Literature"; republished in *The Storm over the Deputy,* pp. 123–148.

60. *Newsweek,* Mar. 9, 1964, p. 79.

8. *Humanism and Warfare:*
Machiavelli, von Clausewitz, and Herman Kahn

1. Nicollo Machiavelli, *The Prince,* trans. Luigi Ricci (New York: Mentor Books, 1952), p. 124 f.

2. Francesco De Sanctis, *History of Italian Literature* (New York: Basic Books, 1959), II, 559.

3. Jacob Burckhardt, *The Civilization of the Renaissance in Italy* (New York: Harper-Torchbooks, 1958) I, 107.

4. J. H. Whitfield, *Machiavelli* (Oxford: Blackwell, 1947), p. 18.

5. The phrase is Federico Chabod's. See his *Machiavelli and the Renaissance* (London: Bowes, 1958), p. 8. This is just one more instance of the host of contradictory impressions which Machiavelli's work has provoked. De Sanctis said specifically of Machiavelli: "He fights the imagination as the most dangerous of enemies." But Chabod is, I think, correct.

6. *The Prince*, Chaps. 8, 17, 21, respectively.

7. An excellent selection of Machiavelli's letters has been translated by Allan Gilbert, *The Letters of Machiavelli* (New York: Putnam-Capricorn, 1951). A smaller number appear in *The Literary Works of Machiavelli*, ed. and trans. J. R. Hale (London: Oxford Univ. Press, 1961). While I have made most use of Gilbert, the letter in the text (No. 137) follows the more graceful translation of Hale, and is reprinted by permission of Oxford University Press.

8. *The Letters of Machiavelli*, tr. Gilbert, p. 133 f.

9. In 1515 or 1516 Machiavelli wrote a brief *Dialogue on Language*. His purpose seems to have been to exalt the Florentine idiom and to controvert Dante's statement in the *De vulgare eloquentia* condemning the Italian vernaculars as a whole, and declaring that he did not write in Florentine Italian but in a courtly idiom. It contains two remarkable statements: the first illustrating Machiavelli's attitude directly (and containing arguments reminiscent of those of Socrates in Plato's *Crito*); the second, a part of the debate as to whether the language of the Florentine poets (Dante, Petrarch, Boccaccio) is "Florentine," "Tuscan," or "Italian," and taking Dante severely to task for his unpatriotic attacks on Florence. The entire treatise is translated in J. R. Hale, pp. 175, 178 ff. I append the two passages which are reprinted by permission. (1) "Whenever I have had an opportunity of honoring my country, even if this involved me in trouble and danger, I have done it willingly, for a man is under no greater obligation than to his country; he owes his very existence, and later, all the benefits that nature, and fortune, offer him, to her. And the nobler one's country, the greater one's obligation. In fact he who shows himself by thought and deed an enemy of his country deserves the name of parricide, even if he has legitimate grievance. For if it is an evil deed to strike one's father or mother for any reason, it necessarily follows that it is still more criminal to savage one's country. You owe her every advantage you have, and she can be guilty of no persecution that justifies your injuring her; indeed, if she disposes of some of her own citizens you should rather be thankful for those that remain than blame her for those she has banished. And if this is true (which is most true) I shall never fear to be mistaken in defending her and attacking those too presumptuous persons who seek to rob her of her just repute." (2) "I shall concentrate on Dante, who shows himself at every point to have excelled in genius, learning and judgment, except when he spoke of his native city, which he attacked with every sort of injury in a way unworthy of reason or charity itself. The affront of his banishment offended him so deeply and so much did he want to revenge himself that he was unable to stop defaming her; he accused her of every vice, condemned her inhabitants, criticised her situation, slandered her laws and customs, and all this not in a single part of his poem, but

throughout it . . . So it is no marvel if this man who heaped infamy in every way on the place of his birth, wished to rob her language of the reputation which he felt he had given it by his writings, and, so as not to pay it any honor, composed this work to show that the tongue he had written in was not that of Florence."

10. Burckhardt, p. 251.

11. The details appear in Sir Charles Oman, *A History of the Art of War in the Sixteenth Century* (New York: Dutton, n.d.) Chap. VIII.

12. The indispensable English edition is *The Discourses of Niccolo Machiavelli*, 2 vols., trans. from the Italian, with an introd. and notes by Leslie J. Walker (London: Routledge and Kegan Paul, 1950). Walker's notes, analyses, and critical apparatus are valuable, but I prefer the older translation of Christian E. Detmold in *The Prince and the Discourses* (New York: Modern Library, 1950).

13. The details have been interestingly treated in F. L. Taylor, *The Art of War in Italy, 1494-1529* (Cambridge Univ. Press, 1921).

14. The ancient world had, of course, produced manuals for the guidance of commanders like Frontinus' *De stratagematis* and Vegetius' *De re militari*, but these are pragmatic rather than scientific. In Italy at this time arose the first "scientific" treaties; see F. L. Taylor.

15. *Henry V*, especially III, 2 and IV, 1.

16. For *The Art of War* I have used two editions: in Italian, Francesco Flora and Carlo Cordie, *Tutte le opere di Niccolo Machiavelli* (Mondadori, 1949), Vol. I (*L'arte della guerra*, pp. 445-631); in English, *The Works of Nicolas Machiavelli, Newly Translated From the Originals,* by Ellis Farneworth, M.A. (London, 1762), Vol. II (*The Art of War* in seven books pp. 1-163). Farneworth contains the earlier preface to the Elizabethan edition by Peter Whitehorne, and it is from this source that I quote here.

17. Farneworth, II, ix.

18. Ibid., II, 5.

19. Ibid., II, 75. Of such quaint beliefs regarding warfare, Sir Charles Oman remarks (p. 93): "He backed the wrong horse in almost every instance; he thought that artillery was going to continue negligible, that the day of cavalry in battle was quite over, that infantry was going to continue in very huge units, like the legion, and that the pike was destined to be put out of action for close combat, like the sword of the ancient Romans or of the Spanish footmen of Gonsalvo de Cordova. In every case his forecast was hopelessly erroneous."

20. Ibid., II, 127.

21. Ibid., II, 161.

22. *The Collected Works of Paul Valéry*, Ed. Jackson Mathews, Vol. X, "History and Politics" (New York: Pantheon, 1962), pp. 46-66.

23. Cf. Maurice Bémol, *La Méthode critique de Paul Valéry* (Paris: Libraire Nizet, n.d.), Chap. IV.

24. As a young man Clausewitz studied with Kiefewetter, the student and popularizer of Kant, who wrote a book, *Foundations of the Kantian Philosophy*. Hans Rothfels has written: "Ja, man wird bemerken dass Clausewitz' theoretische Lebensarbeit von einem in der Tat an Kant gemahnenden Geist besonnener Grenzsetzung getragen ist" (*Carl von Clausewitz, Politik und Krieg: Eine ideengeschichtliche Studie,* Berlin, 1920, p. 23).

25. Immanuel Kant, *Critique of Judgment*, sec. 28, trans. Bernard) London: Macmillan, 1914), p. 127.

26. Ibid., p. 357 (sec. 83).

27. I have drawn the materials on Clausewitz' life from the useful little book by Werner Hahlweg, *Carl von Clausewitz: Soldat—Politiker—Denker* (Göttingen: Musterschmidt, 1957). But any student of Clausewitz will find very valuable the following, and I have consulted them also: K. Schwartz, *Leben des Generals Carl von Clausewitz und der Frau Marie von Clausewitz* (Berlin, 1878) 2 vols.; M. Hartl, *Carl von Clausewitz: Persönlichkeit und Stil* (Emden, 1956). For a use of Clausewitz for the history of ideas, see H. Rothfels; W. Hahlweg, "Lenin und Clausewitz, ein Beitrag zur politischen Ideengeschichte des 20 Jahrhunderts," *Archiv für Kulturgeschichte*, Vol. XXXVI (1954), and Berthold Friedl, *Les fondments théoriques de la guerre et de la paix en U.R.S.S. suivi du cahier de Lénine sur Clausewitz* (Paris: Editions Medicis, 1945).

28. Rothfels, p. viii.

29. "Philosophie, allgemeine Geschichte und Kriegsgeschichte, Staatswissenschaft und Politik, Militärwissenschaft und Truppenpraxis, Naturwissenschaft und Technik, schöngeistige Literatur und Kunstwissenschaft, Nationalökonomie—auf allen diesen Gebieten war Clausewitz . . . mehr oder weniger zu Hause." Hahlweg, pp. 69–70.

30. I have used the English translation of Edward M. Collins in *Karl von Clausewitz: War, Politics and Power,* (Chicago: Regenery-Gateway, 1962), p. 301.

31. Ibid., p. 303.

32. *Vom Kriege:* Hinterlassenes Werk des Generals Carl von Clausewitz, 16th ed. Complete edition of original text with a critical-historical evaluation by Dr. Werner Hahlweg; three parts in one vol., 1165 pp. (Bonn: Dümmler, 1952), p. 89. This is the definitive contemporary edition and all further references to the German text will be to it.

33. I have suggested the philosophical implications of this particular attitude, and its occurrence in both Plutarch and Machiavelli in Levi, *Literature, Philosophy and the Imagination* (Bloomington: Indiana Univ. Press, 1962), Chap. VII, "Destiny, Fortune, and Fate." The quotation which follows is from *Vom Kriege*, pp. 105–6.

34. Carl von Clausewitz, *Vom Kriege,* pp. 110–11.

35. Ibid., p. 130 ff.

36. Ibid., p. 160 ff.

37. Ibid., p. 181 ff.

38. Ibid., p. 196. See also Clausewitz on intuition and instinctive judgment, p. 859.

39. Ibid., p. 260.

40. Ibid., pp. 850–906.

41. Ibid., p. 108: "Der Krieg ist eine blosse Fortsetzung der Politik mit anderen Mitteln. So sehen wir also, dass der Krieg nicht bloss ein politischer Akt, sondern ein wahres politisches Instrument ist, eine Fortsetzung des politischen Verkehrs, ein Durchführen desselben mit anderen Mitteln."

42. Ibid., pp. 888–900.

43. Ibid., p. 890.

44. The facts about the relation of Clausewitz to Marxism have been briefly treated by W. Hahlweg, (pp. 97–100), who says: "Das Verständnis der Doktrin des revolutionären Marxismus ist ohne eine tiefgehende

Kenntnis von Clausewitz nicht denkbar." This is perhaps extreme, and Berthold Friedl, (p. 38), says it more moderately: "Engels et Lénine et les philosophes marxistes qui les suivirent admiraient et reprirent les théories stratégiques du général von Clausewitz." Friedl's book is particularly useful because it reprints in its entirety (pp. 48-78 the *Leninskaya Tetradka* from the Lenin Institute in Moscow containing Lenin's passages from Clausewitz and his marginal comments on them.

45. Herman Kahn, *On Thermonuclear War,* 2d ed. (Princeton Univ. Press, 1961). All subsequent references to Kahn's book will be to this edition.

46. This whole matter has been interestingly treated in Karl Jaspers, *Die Atombombe und die Zukunft des Menschen* (Munich: Piper Verlag, 1958), pp. 79-92; English ed. entitled *The Future of Mankind,* trans. E. B. Ashton (Univ. Chicago Press, 1961), pp. 45-56.

47. Kahn, p. 19. This passage occurs near the beginning of *On Thermonuclear War*. But its spirit is maintained to the very end. On p. 553 Kahn writes: "I believe the basic reason for this lack of study of many important problems is less irresponsibility or incompetence than the enormous psychological difficulty which everybody has of coming to grips with the concept of thermonuclear war as a disaster that may be experienced and recovered from. It seems to be much better to deter the event. Peace seems so desirable and war so ridiculous. Everybody prefers to spend his time thinking about the prevention of war by deterrence or negotiation." And now Kahn's ultimate purpose becomes clearer. It is to permit us to think about war itself and its prosecution rather than about "the prevention of war by deterrence or negotiation."

48. Ibid., p. 24.

49. Ibid., p. 41.

50. Ibid., p. 46 (italics in the original).

51. Ibid., pp. 303-4.

52. Ibid., p. 145.

53. Ibid., p. 149 (italics in the original).

54. Wallace Stevens, *Transport to Summer* (New York: Knopf, 1947), pp. 51-2. Reprinted by permission.

55. Kahn, p. 331.

56. Ibid., p. 187 f.

57. Ibid., p. 74. Kahn's concern for the American standard of living is in marked contrast to his airy dismissal earlier of the possibility of 1 per cent of our children being born deformed. Why worry about children so long as television, ranch houses, and freezers will be safe?

58. Ibid., pp. 89, 91 (italics mine).

59. Ibid., p. 222.

60. Soviet spokesmen and writers have called the RAND Corporation "the Academy of Death and Destruction" and this is perhaps not inappropriate since it was RAND strategists who invented the words "overkill" and "megadeath." Kissinger has said of them: "There is a fantastic intellectual arrogance for all traditional forms and all those facets of human beings and nations which are not rational."

61. Kahn, pp. 158-160.

62. Walter Lippmann, "The Deepest Issue of Our Time," *Vital Speeches,* July 1, 1936, quoted in Arthur M. Schlesinger, Jr., *The Politics of Hope* (Boston: Houghton, 1963), p. 147.

63. Kahn, p. 343.

64. Ibid., p. 232.

65. Ibid., p. 139.

66. This is a general feature of the theorists of nuclear deterrence and "massive retaliation" and it must come as a shock to all ethically sensitive minds. Thus, for example, J. Robert Offenheimer: (*Bull. of the Atomic Scientists,* Jan., 1960, p. 22) : "I find myself profoundly in anguish over the fact that no ethical discourse of any nobility or weight has been addressed to the problem of the atomic weapons . . . What are we to think of such a civilization, which has not been able to talk about the prospect of killing almost everybody, except in prudential and game-theoretic terms?"

67. See, for example, Walter Stein (ed.) , *Nuclear Weapons: A Catholic Response* (New York: Sheed, 1961) ; John C. Bennett (ed.) , *Nuclear Weapons and the Conflict of Conscience* (New York: Scribner, 1962) ; Paul Ramsey, *War and the Christian Conscience* (Durham, N.C.: Duke Univ. Press, 1960) ; Robert C. Tucker, *The Just War* (Johns Hopkins Press, 1960) ; Richard Falk, *Law, Morality and War in the Contemporary World* (New York: Praeger, 1963) ; John Ford, "The Morality of Obliteration Bombing," *Theological Studies,* Vol. V, No. 3 (1944) ; Robert M. Palter, "The Ethics of Extermination," *Ethics,* Vol. LXXIV, No. 3 (Apr., 1964) .

68. Simone Weil, "The Iliad or the Poem of Force," trans. Mary McCarthy, *Politics* (Nov., 1945) , pp. 321–331.

69. Edmond et Jules de Goncourt, *Journal: mémoires de la vie littéraire.*

9. *Art and Politics—the Continuum of Artistic Involvement: Picasso, Brecht, and Pasternak*

1. Simone de Beauvoir, *La Force des choses* (Paris: Gallimard, 1963) , p. 372–3.

2. Ibid., p. 648.

3. Ibid., p. 682.

4. *The Collected Works of Paul Valéry* (New York: Pantheon, 1962) , X, 273–4. Reprinted by permission.

5. Martin Esslin, *Brecht: The Man and His Work* (New York: Double-day-Anchor, 1961) , pp. 143–4.

6. Valéry, p. 275.

7. de Beauvoir, p. 655.

8. George Steiner, "Marxism and the Literary Critic," in *Language and Silence* (New York: Atheneum, 1967) , p. 323.

9. "Remarks on the Recent Prussian Instructions Relative to Censorship," in *Karl Marx, Friedrich Engels sur la littérature et l'art,* Text selected by Maurice Thorez (Paris: Editions Sociales, 1954) , p. 194.

10. Ibid., p. 195.

11. Ibid., p. 197.

12. This article, the contents of which I refer to in what follows, has been partially reprinted in *V.I. Lenine sur la littérature et l'art,* Text selected by Jean Fréville (Paris: Éditions Sociales, 1957) , pp. 85–91.

13. Ibid., p. 106.

14. An interesting and important account has been given in Walter N. Vickery, *The Cult of Optimism: Political and Ideological Problems of Recent Soviet Literature* (Bloomington: Indiana Univ. Press, 1963); I have drawn heavily on this for factual material in what follows.

15. Ibid., p. 30.

16. Ibid., p. 67.

17. Quoted in Eldon Griffiths, "Mr. Khrushchev's Turn toward Stalinism," *Saturday Evening Post,* June 1, 1963.

18. Ibid.

19. The facts about Picasso's relations with Communism and the French Communist Party may be found briefly treated in the following: Alfred H. Barr, Jr., *Picasso: Fifty Years of His Art* (New York: Museum of Modern Art, 1946) (particularly valuable for supplementary documents); Roland Penrose, *Portrait of Picasso* (New York: Museum of Modern Art, 1957); Roland Penrose, *Picasso: His Life and Work* (New York: Schocken Books, 1962) (perhaps the best single book on Picasso); and, most recently, Françoise Gilot and Carlton Lake, *Life with Picasso* (New York: New American Library, 1965) (a lively, perceptive, and revealing book by Picasso's companion of more than ten years).

20. Barr, p. 267, where the French text appears; I have translated it.

21. Ibid., p. 247.

22. *Life with Picasso,* p. 186.

23. Ibid., p. 187.

24. Ibid., p. 207.

25. *Portrait of Picasso,* p. 92; *Picasso: His Life and Work,* p. 364.

26. *Life with Picasso,* pp. 261–2.

27. Martin Esslin, *Brecht: The Man and His Work* (New York: Doubleday-Anchor, 1961), p. 221. Although I have consulted the books cited in Chap. VII for Brecht, Esslin's book, particularly Chaps. VII and VIII, is my chief source for the facts of his political involvement.

28. Brecht's testimony before the House Committee on Un-American Activities is reprinted in Peter Demetz, *Brecht: A Collection of Critical Essays* (New York: Prentice-Hall, 1962) pp. 30–42. It is a model of cunning, duplicity, and downright lying, but its net effect is to demonstrate less Brecht's bad faith than the stupidity of his interrogators. Hans Eisler, Brecht's friend, stated unequivocally that he joined the Party in 1930 (see Ruth Fischer, *Stalin and German Communism,* Harvard Univ. Press, 1948, p. 615).

29. Demetz, pp. 16–17.

30. Ibid., p. 26.

31. *Brecht on Theater,* Ed. and trans. John Willett (New York: Hill & Wang, 1964). Pages 112–115 describe the conditions of the writing of this essay. The essay appears on pp. 107–112. Citations from this work reprinted by permission.

32. Ibid., p. 109.

33. Esslin, p. 181.

34. Ibid., p. 183.

35. *Brecht on Theater,* pp. 266–7.

36. Ibid., pp. 269–70.

37. Gerd Ruge, "A Visit to Pasternak," *Encounter,* No. 54 (Mar., 1958).

38. He has related all this in his *I Remember: Sketch for an Autobiography* (New York: World-Meridian, 1960), pp. 31–101.

39. Robert Conquest, *The Pasternak Affair: A Documentary Report* (Philadelphia: Lippincott, 1962), pp. 40–41. This is the best account of Pasternak's difficulties with the authorities after the publication of *Doctor Zhivago* and I am heavily indebted to it. Not the least of its advantages is an appendix containing most of the important documents in the case. Those cited are reprinted by permission.

40. "Three Visits with Boris Pasternak," *Paris Review* No. 24 (Jan., 1961).

41. Ruge, p. 25.

42. Conquest, p. 78.

43. Ibid., p. 112.

44. Ibid., p. 131.

45. The entire letter is reproduced in Conquest, pp. 140–163.

46. Boris Pasternak, *Doctor Zhivago* (New York: New American Library, 1962), pp. 124, 164.

47. Ibid., p. 383.

48. Ruge, p. 23.

49. *Doctor Zhivago,* pp. 336, 378, 417.

50. Max Hayward, "Pasternak's *Doctor Zhivago,*" *Encounter,* No. 56 (May, 1958); this is an extremely interesting and perceptive article.

51. It is this, I think, which caused Lucien Goldmann (in a private conversation in Korcula in 1954) to describe *Doctor Zhivago* as a "Stalinist novel," and to insist, against my strong protest, that an application of Lukac's category of "totality" would prove it so. His error, in my opinion, was that he overestimated the role of Lara's praise for her former husband without taking account of the overwhelming human superiority which Pasternak accords the nonpolitical Zhivago.

52. *Doctor Zhivago,* p. 248.

53. Hayward, pp. 47–8.

54. Conquest, pp. 165, 166.

55. Ibid., pp. 172–4.

56. Ibid., p. 177.

57. Ibid., p. 129.

58. Adam Schaff, *A Philosophy of Man* (London: Lawrence and Wishart, 1963), pp. 124–5.

10. *The Existentialist Dilemma: Camus, Sartre, and Merleau-Ponty*

1. Albert William Levi, *Philosophy and the Modern World,* (Bloomington: Indiana Univ. Press, 1959), pp. 427–30.

2. Germaine Brée, *Camus* (New York: Harcourt-Harbinger, 1964), pp. 9–10.

3. Simone de Beauvoir, *La Force des choses* (Paris: Gallimard, 1963), p. 278. English trans. Richard Howard, under the title *Force of Circumstances* (New York: Putnam, 1965), p. 259. My further references and citations will be to the English edition.

4. Ibid.

5. Francis Jeanson, "Albert Camus ou l'âme révoltée," *Les Temps Modernes,* No. 81 (May, 1952), pp. 2070–90.

6. *Les Temps Modernes,* No. 82 (August, 1952), Camus' "Lettre" ap-

pears on pp. 317–33, Sartre's "Response à Albert Camus" on pp. 334–53. As in the case of Jeanson's original review, I have generally paraphrased, sometimes translated, the contents.

7. De Beauvoir, pp. 259–60.

8. Albert Camus, *The Rebel* (New York: Knopf, 1954), p. 11. All citations from this work are reprinted by permission.

9. Ibid., p. 22.

10. Ibid., p. 104.

11. *Bertolt Brechts Gedichte und Lieder,* selected by Peter Suhrkamp (Berlin: Suhrkamp, n.d.), p. 160.

12. Camus, *The Rebel,* p. 196.

13. Ibid., pp. 120–1.

14. Ibid., pp. 136–40.

15. *Force of Circumstances,* pp. 149–50.

16. Albert Camus, *Caligula and Three Other Plays,* trans. Stuart Gilbert (New York: Random-Vintage, 1962), p. ix.

17. Albert Camus, *Les Justes* (Paris: Gallimard, 1950), pp. 40–1.

18. Ibid., p. 43.

19. Ibid., pp. 69–70.

20. Ibid., pp. 74–76.

21. Vintage Edition, p. x.

22. Jean-Paul Sartre, *Les Mains sales* (Paris: Gallimard, 1948) pp. 205–6.

23. Ibid., p. 209.

24. Ibid., p. 210.

25. Ibid., pp. 212, 13.

26. Bertolt Brecht, *Stücke IV,* p. 290.

27. De Beauvoir, p. 150.

28. Published in English in *The Reporter,* Feb. 4, 1960.

29. "Elle laisse entrevoir cependant ce que sera une éthique qui prendra ses responsabilités en face d'une réalité humaine en situation." *L'Etre et le néant* (Paris: Gallimard, 1943), p. 720.

30. De Beauvoir, p. 7.

31. I have treated this elsewhere in two places: as exposition of *Being and Nothingness* in Levi, *Philosophy and the Modern World,* (Bloomington: Indiana Univ. Press, 1959) pp. 410–427, and in terms of the concept of alienation in the essay "Existentialism and the Alienation of Man" in *Phenomenology and Existentialism,* ed. Edward N. Lee and Maurice Mandelbaum (Baltimore: Johns Hopkins Press, 1967).

32. See *The Marxism of Jean-Paul Sartre* by Wilfred Desan (New York: Doubleday, 1965) which is essentially an exposition and criticism of the *Critique de la raison dialectique.* Desan treats the issue of ethics in Chap. IX and I agree with his general conclusions in Chap. X. Other useful criticisms of Sartre's *Critique* are to be found in Lionel Abel's "Sartre and Metaphysical Stalinism," *Dissent* (Spring, 1961) and in George Lichtheim's "Sartre, Marxism, and History," *History and Theory* (1963, No. 2).

33. Desan, Chap. X, "The Last of the Cartesians."

34. De Beauvoir, p. 199. The italicized sentences are from Sartre's own unpublished notes.

35. Jean-Paul Sartre, "Merleau-Ponty Vivant," *Les Temps Modernes,* numero spécial 1961 (No. 184–5), p. 334 (my italics).

36. *Les Temps Modernes,* Jan., 1957.

37. De Beauvoir, p. 261.

38. "Merleau-Ponty Vivant," pp. 347–8 (my italics).

39. The total essay consists of about 200 pages. It was published in three installments in *Les Temps Modernes* over a two-year period: I. July, 1952 (No. 81, pp. 1–50); II. Oct.–Nov., 1952 (No. 84–5, pp. 695–763); III. Apr., 1954 (No. 101, pp. 1731–1819). Subsequent references to the essay will be to page numbers in these three installments.

40. *Les Temps Modernes,* pp. 4–6.

41. Ibid., p. 49.

42. Ibid., p. 703.

43. Ibid., p. 704.

44. Ibid., p. 732.

45. Ibid., p. 756.

46. Ibid., p. 762.

47. Fyodor Dostoyevsky, *The Possessed* (New York: Modern Library, 1936), p. 409.

48. *Les Temps Modernes,* No. 122 (Feb., 1956), p. 1158.

49. "Marxisme et existentialisme: questions de méthode," *Les Temps Modernes,* No. 139 (July–Dec., 1957), pp. 338–417; No. 140, pp. 658–697. The passage just quoted is from p. 339.

50. Ibid., pp. 346–8.

51. The most important of these (including "Autour de Marxisme," "Marxisme et philosophie," and "La Guerre a eu lieu") have been translated and reprinted in *Sense and Non-Sense,* by H. L. and P. A. Dreyfus (Evanston, Ill.: Northwestern Univ. Press, 1964); it is this edition to which I will subsequently refer.

52. *Sense and Non-Sense,* p. 103.

53. Ibid., p. 118.

54. Ibid., p. 147.

55. Ibid., p. 162.

56. Ibid., p. 120.

57. "Merleau-Ponty Vivant," op. cit., p. 323. See also the account in de Beauvoir, *Force of Circumstances,* p. 111.

58. *Humanisme et terreur* (Paris: Gallimard, 1947), p. 190. Merleau-Ponty also contrasts here the *humanisme en comprehension* of the West with the *humanisme en extension* of the Communists.

59. "Merleau-Ponty Vivant," p. 322.

60. *Force of Circumstance,* p. 106.

61. "Merleau-Ponty Vivant," p. 330.

62. Merleau-Ponty, Maurice, *Les Aventures de la dialectique* (Paris: Gallimard, 1955), pp. 43, 55.

63. Ibid., p. 147.

64. Ibid. These points are developed, respectively, on pp. 207, 213, 216, 275.

65. Ibid., pp. 279, 281.

66. Merleau-Ponty, Maurice, *Signs,* Trans. R. C. McCleary (Evanston, Ill.: Northwestern Univ. Press, 1964), p. 5. The following quotation appears on p. 6.

67. Ibid., p. 218.

11. *Humanism and the Marxist Tradition: The Young Marx, Lukacs, the Yugoslavian School*

1. Merleau-Ponty, Maurice, *Signs*, trans. R. C. McCleary (Evanston, Ill.: Northwestern Univ. Press, 1964) , p. 7.

2. Ibid., pp. 10–1.

3. George Steiner, *Language and Silence: Essays on Language, Literature, and the Inhuman* (New York: Atheneum, 1967). I am thinking primarily of the last section, "Marxism and Literature."

4. Ibid., p. 349.

5. It is quoted complete in Otto Rühle, *Karl Marx: His Life and Work*, trans. Eden and Cedar Paul (New York: New Home Library, 1943) , pp. 366–8.

6. Karl Marx and Friedrich Engels, *Historisch-Kritische Gesamtausgabe*, Vol. II, ed. D. Rjazanov and V. Adoratsky, 1932.

7. Now in English in an incomplete form as *Karl Marx: Early Writings*, trans. and ed. T. B. Bottomore (London: Watts, 1963) .

8. Karl Marx, *Capital* (New York: Modern Library, n.d.) , p. 25.

9. Robert C. Tucker, *Philosophy and Myth in Karl Marx* (Cambridge Univ. Press, 1961) , p. 173. Tucker's book is perhaps the best single treatment of the problems posed by Marx's *Economic and Philosophic Manuscripts* and his Chapter XI "Two Marxisms or One?" its epitome. Further material on the fate of these manuscripts appears in Daniel Bell's "In Search of Marxist Humanism," *Soviet Survey*, No. 32 (Apr.–June, 1960) .

10. M. Merleau-Ponty, *Sense and Non-Sense* (Evanston, Ill.: Northwestern Univ. Press, 1964) , p. 125. The quotation which follows is from p. 126.

11. These are divided into the essays which appeared in the Deutsch-Französischen Jahrbüchern during 1843–44, the *Nationalökonomie und Philosophie* of 1844, and the *Kritik der Hegelschen Staatsphilosophie* of 1841–2. When the German text is cited, it will be *Karl Marx, Die Frühschriften*, ed. Siegfried Landshut (Stuttgart: Kröner, 1964) , referred to as *Landshut*.

12. *Landshut*, p. 181.

13. I have dealt with the development of the modern idea of alienation in Hegel, Marx, and Tönnies in "Existentialism and the Alienation of Man" which is Essay Ten of Edward N. Lee and Maurice Mandelbaum (eds.) , *Phenomenology and Existentialism* (Baltimore: Johns Hopkins Press, 1967) , pp. 245–253.

14. *Landshut*, p. 187.

15. Ibid., p. 188.

16. Ibid., p. 199.

17. Ibid.

18. Ibid., pp. 208–9.

19. Ibid., p. 216.

20. Ibid., p. 222, 3.

21. Ibid., p. 260.

22. Ibid., p. 235.

23. Ibid., p. 281.

24. The issue of Marx's exact relationship to Hegel is a matter of considerable interest and dispute in the circles of Marxists and students of Marxism. Typical and particularly good are the following treatments of the problem: Herbert Marcuse, *Reason and Revolution: Hegel and the Rise of Social Theory* (Boston: Beacon, 1960) ; Jean Hyppolite, *Etudes sur Marx et Hegel* (Paris: Rivière, 1955) ; Iring Fetscher, "Das Verhältnis des Marxismus zu Hegel," *Marxismusstudien*, No. 6 (Tübingen, 1960) .

25. Argued in his *Philosophy and Myth in Karl Marx.*

26. Ibid., pp. 22-4.

27. These details have been derived from Victor Zitta, *Georg Lukacs' Marxism: Alienation, Dialectics, Revolution* (The Hague: Nijhoff, 1964) and from the articles, "Georg Lukacs: An Intellectual Biography," which Morris Watnick published in *Soviet Survey*, Nos. 23-27 (1958-59) . As for these works in other respects, Zitta's book, while containing much useful factual information is wholly untrustworthy from an interpretative point of view. The author's violent anti-Communism is destructively intrusive. Watnick's articles may well have a similar bias, but his evaluations are scrupulously fair and well balanced. Although he gives no real exposition of Lukacs' main ideas, his account of Lukacs' ideological struggles with Moscow and the Party line is subtle and valuable. There is at present no adequate comprehensive study of Lukacs, his life, and thought in English, or, so far as I know, in any other language.

28. In "An Intellectual Disaster," *Encounter* (May, 1963) . The remark is made in passing in the review of Lukacs' little book *Realism in Our Time.* This short review, despite a few excellent points is, perhaps, unduly vituperative against Lukacs. It received some indignant replies in the August, 1963, issue of the same journal. This alone shows how controversial Lukacs remains in the West as well as in the Marxist countries.

29. An excellent brief treatment of Lukacs' debt to Hegel is to be found in Siegfried Marck, *Die Dialektik in der Philosophie der Gegenwart* (Tübingen, Mohr, 1929) , I, 122-130, "Georg Lukacs' historische Dialektik." See also Iring Fetscher, p. 102-113, 121-132.

30. Neither in West Germany nor in Budapest (where I searched all the bookstores, old and new, in the spring of 1965) have I been able to secure a copy of *Geschichte und Klassenbewusstsein: Studien über Marxistische Dialektik* (Berlin: Malik, 1923) , nor has the book ever been translated into English. There is a French translation, *Histoire et conscience de classe*, by K. Axelos and J. Bois (Paris: Editions de Minuit, 1960) , and it is to this that I will refer in the following. Any of my translations, therefore, will be from the French.

31. *Histoire et conscience de classe*, p. 12.

32. Ibid., p. 23.

33. Ibid., p. 45.

34. Ibid., p. 75.

35. It is primarily from this insight of Lukacs that the whole of Lucien Goldmann's valuable work proceeds. His *La Communauté humaine et l'universe chez Kant* (Paris: Presses Universitaires de France, 1948) was an only partly successful attempt to apply it to the philosophy of Kant. His *Le Dieu caché* (Paris: Gallimard, 1955) was an infinitely more impressive application to Pascal and the theater of Racine.

36. *Historie et conscience de classe*, p. 95.

37. Ibid., p. 117.

38. Emile Durkheim, *Les Règles de la méthode sociologique* (Paris: Presses Universitaires de France, 1950), p. 15.

39. *Histoire et conscience de classe*, p. 142.

40. Ibid., p. 171.

41. Ibid., p. 176.

42. Georg Lukacs, *The Historical Novel* (Boston: Beacon, 1963), p. 171. All of Chapter III, "The Crisis of Bourgeois Realism," is relevant here.

43. See Georg Lukacs, *Essays on Thomas Mann* (New York: Grosset, 1965), pp. 13, 15, 163.

44. Georg Lukacs, *Studies in European Realism* (New York: Grosset, 1964), pp. 4–5. All citations from this work are reprinted by permission.

45. Ibid.

46. Georg Lukacs, *Realism in Our Time* (New York: Harper, 1964), p. 34.

47. *The Historical Novel*, p. 44.

48. *Studies In European Realism*, p. 6.

49. Harry Levin, *James Joyce* (New York: New Directions, 1941), pp. 66, 73.

50. *Studies in European Realism*, pp. 8–9.

51. Ibid., p. 13.

52. Ibid., pp. 17, 18.

53. The paper was delivered in French. It has been printed in Serbo-Croatian as "Dijalektika morala i moral dijalektike" in *Smisao i Perspektive Socijalizma* (Zagreb, 1965).

54. This volume has, so far as I know, never been translated into English. The writings of the Yugoslavian philosophers, except for their appearance from time to time in specialized international philosophical journals are not easily available. The best sources are the articles by Korać, Marković, Pejović, Petrović, Supek, and Vranicki which appear in *Socialist Humanism: An International Symposium,* ed. Erich Fromm (New York: Doubleday-Anchor, 1966) and the recently published *Marx in the Mid-Twentieth Century* by Gajo Petrović (New York: Doubleday-Anchor, 1967) to which I will refer more fully below.

55. "Marxist Humanism and Ethics," by Mihailo Marković, *Inquiry,* Vol. 6 (1963), p. 18.

56. Ibid., p. 21.

57. Ibid., p. 23.

58. Petrović, p. 14.

59. Ibid., p. 22, 23.

60. Ibid., p. 81.

61. Ibid., p. 118.

62. Fromm, *Socialist Humanism*, p. 14.

63. Reprinted in *Soviet Studies in Philosophy*, Vol. I, No. 4 (Spring, 1963), p. 12.

Index